GLAMOUR

Stephen Gundle is Professor of Film and Television Studies at Warwick University, having previously taught at Royal Holloway, University of London and both Oxford and Cambridge universities. He has written widely about Italian and European culture in the nineteenth and twentieth centuries, his work focusing especially on the mass media, the cultural aspects of politics and fashion, and the impact of American modernity on European popular culture.

GLAMOUR

A HISTORY

STEPHEN GUNDLE

OXFORD
UNIVERSITY PRESS

OXFORD
UNIVERSITY PRESS

Great Clarendon Street, Oxford OX2 6DP

Oxford University Press is a department of the University of Oxford.
It furthers the University's objective of excellence in research, scholarship,
and education by publishing worldwide in

Oxford New York

Auckland Cape Town Dar es Salaam Hong Kong Karachi
Kuala Lumpur Madrid Melbourne Mexico City Nairobi
New Delhi Shanghai Taipei Toronto

With offices in

Argentina Austria Brazil Chile Czech Republic France Greece
Guatemala Hungary Italy Japan Poland Portugal Singapore
South Korea Switzerland Thailand Turkey Ukraine Vietnam

Oxford is a registered trade mark of Oxford University Press
in the UK and in certain other countries

Published in the United States
by Oxford University Press Inc., New York

British Library Cataloguing in Publication Data

Data available

Library of Congress Cataloging in Publication Data

Gundle, Stephen, 1956–
Glamour : a history / Stephen Gundle.
p. cm.
Includes bibliographical references and index.
ISBN 978-0-19-921098-5
1. Beauty, Personal—France—History. 2. Beauty, Personal—England—History
3. Beauty, Personal—Social aspects. 4. Fashion—France—History.
5. Fashion—England—History. 6. Fashion—Social aspects. I. Title.
GT499.G86 2008
646.7'2—dc22 2008009772

Typeset by SPI Publisher Services, Pondicherry, India
Printed in Great Britain
on acid-free paper by
Clays Ltd, St Ives plc

ISBN 978-0-19-921098-5 (Hbk)
ISBN 978-0-19-956978-6 (Pbk)

For Simona

ACKNOWLEDGEMENTS

I have lost count of the number of conversations I have had about glamour since I first started to reflect on this most elusive yet most obvious of phenomena. Over a good many years, I discussed glamour with friends, colleagues, relatives, and students. At first at least, nearly everyone was happy to talk to me about it and to give me their personal impressions and interpretations. Only occasionally did I meet someone who declared themselves completely uninterested in the topic and immune to its charms. I was glad to encounter such robust rejections of glamour's seductions. They reminded me that it was not impossible to resist the sparkle and dazzle of illusion. But for most people, including myself, glamour was not just make-believe, it was also a source of visual excitement and pleasure. My first discussions about glamour were with Robert Gordon and Nicholas White. I am grateful to both of them for pushing me towards the nine-teenth-century and high-cultural aspects of a phenomenon that, at the time, I was sure was a feature solely of contemporary mass culture. Richard Barraclough, Guido Bonsaver, Rebecca Bonsaver, Stella Bruzzi, Tom Buchanan, Martin Conway, Barbara Corsi, Denise Cripps, Fabrice d'Almeida, Anek Dürig, David Forgacs, Sophie Gilmartin, Paul Ginsborg, Caroline Hollinrake, Claire Honess, Newton Key, Jordan Lancaster, Robert

Lumley, the late Patrick McCarthy, Franco Minganti, Elizabeth Morris, Jonathan Morris, Penny Morris, Anne Mullen, Daniele Nannini, Giuliana Pieri, Katia Pizzi, Veronica Pye, Chris Rigden, Vanessa Roghi, Nina Rothenberg, Sita Trini Castelli, Nicola White, Nikola White, and Susanna Zinato all gave me the benefit of their views or kindly gave reactions to mine. I am grateful to Giulio Lepschy for alerting me at an early stage to the matter of the origins of the word glamour. My sister, Alison Gundle, supplied some important background information and numerous references to mythological and mystical sources. Réka Buckley provided me with helpful advice on the interrelationship of glamour, fashion, and film stardom. Peter Kramer and NoëlleAnne O'Sullivan kindly gave constructive comments on some of my first writings on the theme, while David Ellwood read and provided detailed commentary on an early version of the text. Lucy Riall read part of the manuscript at a later stage and provided me with just the sort of critical stimulus I needed to refine it one final time. Some of the ideas contained here flow from an earlier collaborative project on glamour that I undertook with Clino Castelli, that was in turn partly inspired by Nanni Strada's work with colours and material effects. Pierre Sorlin's observations on the volume that resulted from that collaboration informed my approach in the present work. Simona Storchi was always happy to act as a sounding board during the writing of this volume. She helped me clarify my approach to some questions and also gave me the benefit of her reflections on several issues and personalities. Thanks are also due to the staff of the British Library in London, the Bibliothèque Nationale in Paris, and the Biblioteca Nazionale in Rome, and of the libraries of my former institution, Royal Holloway—University of London, and the Getty Research Institute in Los Angeles. Without the rich resources of these institutions, it would have been impossible to write this book. The patient encouragement of Luciana O'Flaherty and Matthew Cotton at Oxford University Press has ensured that it has been carried through to conclusion.

S.G.

London 2007

CONTENTS

LIST OF PLATES

INTRODUCTION

When he was killed in July 1997, Gianni Versace was hailed worldwide as the master of glitz and glamour. The fashion designer from the tip of the Italian peninsula who had conquered Milan and then the world was one of the best-known names in contemporary fashion. Thanks to eye-catching dresses worn by some of the world's most beautiful women, he had also become a household name. His murder outside his lavishly refurbished villa on Ocean Drive in South Beach, Miami was headline news. News reports and obituaries referred to the brashness and ostentation of his creations, to his love of celebrities and his taste for publicity. It was said that he had established a huge fashion empire by following Oscar Wilde's dictum that nothing succeeds like excess. It was he more than anyone else who turned Claudia Schiffer, Cindy Crawford, Naomi Campbell, and a handful of other fashion models into 'supermodels' and stars. When Elizabeth Hurley, then an unknown minor actress, wore a daring Versace creation to accompany her boyfriend Hugh Grant to the London premiere of *Four Weddings and a Funeral* in 1994, the show-stopping black gown, slashed all the way down the side and joined with gold Medusa-headed safety pins, she attracted front-page coverage in several leading newspapers. For observers worldwide, Versace was the king of glitz, the man who combined beauty

with vulgarity. His style catered to those who desired to flaunt their wealth or sex appeal. The press commented on the designer's penchant for opulent beauty, the dramatic, showy nature of his creations, the mingling in his work of street style and high fashion, the heavily sexual element, his flamboyant lifestyle, and professional and personal relationships with the famous. Glamour was the word that recurred most frequently.

In the contemporary media, glamour is a buzzword with a special resonance. *Vogue, Elle*, celebrity and women's magazines, not to mention glossy newspaper supplements, all employ the term on a regular basis to underline the allure of an occasion, a dwelling, a product, a place, or a person: 'Hollywood: The Power and the Glamour' (*Vanity Fair*, April 1995); 'Glamour! The people who live it—the clothes that scream it—the make-up that makes it' (*Elle*, December 1996); 'The new glamour burns bright' (*Interview*, March 1997); 'What's glamorous now—the cars, the bags, the shoes, cool cocktails, sexy getaways' (*In Style*, August 2001). Many magazines routinely use the word on their covers while one monthly belonging to the Condé Nast stable published in numerous national editions has it as its title.

As a word, glamour carries talismanic qualities. It has a sparkle and glow about it that enhance the people, objects, and places to which it is attached. Yet, despite the ubiquity of the term, glamour is notoriously difficult to define. Everyone has an idea of what they think it means but few know where it comes from and why it is so tantalizing to so many. Even those who are professionally concerned with its evocation and perpetuation often seem nonplussed when invited to provide more than a throwaway comment about it. When fashion periodicals and women's magazines enquire into the meaning of glamour, seeking a range of opinions from experts and celebrities, the results rarely seem to produce any consensus. When in November 1994 *She* magazine questioned a selection of British male personalities known for having 'a touch of glamour themselves', it received responses that included the following: 'A sense of glamour is something you are born with' (John Fashanu, footballer), 'Glamour is something that comes from within—you've either got it or you haven't' (Marco Pierre White, chef), 'My idea of glamour is someone who is chic, well-groomed, cool, not wearing too much make-up and just an understated elegance' (Robert Kilroy-Silk, television presenter), 'Glamour to

me is slightly flashy and sometimes bold' (Paul Costelloe, fashion designer), 'Glamour is not about glitz, red lips and big breasts. It is about being quietly sensuous, knowing your face and figure can make a statement with the rest of your look played down. It's not just about figure-hugging dresses, more the way you wear them' (Nicky Clarke, hairdresser). According to these views, glamour can be showy or understated, a purely exterior phenomenon or a fact of personality. The only point of which all agree is that it is a quality attaching to persons that is instantly perceptible to those who encounter it.

Glamour is often presented as a quality mainly attaching to women. Whether it can apply to all women or only to a select few is, however, a moot point. For some, glamour is an aesthetic cloak ready for every woman who is willing to dress up in a uniform of high heels, coiffed hair, bold red lipstick, strong make-up, and vibrant colours, regardless of her age or position. For others it is a personal attribute of more limited application, something that accrues over a period of time to women who gradually acquire the personal characteristics and aesthetic traits of the recognized figure of glamour. This dichotomy is constantly played out in the press and other media. On the one hand film stars, models, millionaires' wives, pop music performers, and many other people basking in the glow of wealth and success are held up as examples of a fabulously exciting and irresistibly envious lifestyle. Glossy magazines featuring spreads on the glamorous homes and glamorous wardrobes of beautiful people who have glamorous jobs and lives conjure up a world that is familiar as fantasy but utterly removed from the daily lives of average people. The realm of glamour is a universe inhabited by the very wealthy, the talented, the beautiful, the famous, and the lucky. On the other hand, magazine articles, books, and television programmes continually spell out how every woman can glamorize herself. The winter 1997 issue of the house magazine of the British department store chain Debenhams promised readers 'top-to-toe glamour in minutes' by illustrating 'the look—the style—the difference'. These were conveniently divided on the basis of the time required for their assembly: 15 minutes, 30 minutes, and 60 minutes.

Guides of this type are nothing new. In 1938, *Glamour and How to Achieve It* by a now forgotten actress called Sali Löbel claimed that 'glamour is not

the elusive pimpernel attainable only through the god of riches.... It is easy to attain at least *some* of it, if not all of it, and half a loaf is better than none.'[1] The author distinguished between what she called 'photographic glamour', that was the achievement of cinema, and 'the glamour of reality' that was available to all women if they followed her regime of exercise and diet, dressed and made up in a way that highlighted their best features and disguised their worst, and adopted the right determined and positive attitude to life. Of course, the more prosaic glamour of reality was informed and driven by the dazzling images of photographic glamour.

Recipes like this show that glamour is uniquely appealing as a source of self-definition and even empowerment. The trappings of glamour—make-up, clothes, accessories, etc.—give everyone a chance in theory of defying the effects of age and the limitations of the physical body. Through them, a dream version of the self can be forged. Glamour is a weapon and a protective coating, a screen on which an exterior personality can be built to deceive, delight, and bewitch. It is apparently egalitarian; more than any notion of natural beauty, it is an ideal that almost anyone can share.[2] In an effort to pin down glamour, the editor-in-chief of *Interview* magazine asked a drag artist for a description of this elusive effect. In reply, he said: 'On a gray day, the view from my window is ugly, so I turn and face my closet, which is full of makeup and clothes. I see my feather fans, all my jewelry, and I either put some of it on or pretend it's already on.... You know, you have to make your own glamour, but that's what's so great about it—you can.'[3]

The element of pretend or make-believe is a crucial part of the illusion of glamour. Sali Löbel urged her readers always to retain the power to dream. 'Dreaming is good—it beautifies,' she declared.[4] Dreams provide the bridge between everyday reality and the fabulous world of the magazines. They embody commonplace yearnings and our hopes. These may be individual and specific to each of us in the form they take. However, this does not mean that glamour is the product of individual taste or personality. Rather it is a visual effect that is most commonly created by costume or fashion designers, hairdressers, press agents, and photographers. The same designers and hairdressers who create the looks of the stars lend their names to products that are advertised on television, in the press, and on billboards. Indeed it is often the desire to sell

to a mass public that leads a designer to seek the endorsement of a star and it is why such endorsements or testimonials are often paid at fabulous rates. As such, they are powerful mediators of the collective imagination. Our fantasies and dreams of escape are part and parcel of the commercial world; they sustain it and are continually stimulated by it.

The fascination with a man like Gianni Versace was related to his mastery of the mysterious and magical arts of glamorous transformation. He was a modern Merlin with the power to make dreams come true. The unstated promise of every Versace catwalk show and of every multi-page Versace advertising spread was that the man who had created the supermodels and who, by the loan of one dress, turned Elizabeth Hurley from an unknown actress into one of the sexiest and best-known women in the United Kingdom, could do the same for any woman and, even, since the label also did menswear, any man too. The lavish window displays of Versace stores on London's Bond Street, Rodeo Drive in Los Angeles, and Via Montenapoleone in Milan confirmed that the brashest and sexiest garments in the world could be bought by anyone. The only stumbling blocks were cost and also, perhaps, a fear of not being equal to the physical ideal the designer propagated in his advertisements. The price tags on Versace's ready-to-wear clothes were eye-wateringly steep and the models stunningly attractive. For most, therefore, his creations remained tantalizingly out of reach. But this too was part of the glamour. What was accessible and ostensibly available was also exclusive. Conveniently, there were also ranges of products that, while still premium-priced, came more within the realm of possibilities of the average shopper, including diffusion-line garments, fragrances, eyewear, shoes, watches, scarves, and umbrellas. Löbel's 'half a loaf' could also be achieved—people were induced to believe—by buying commodities such as these, which were endowed with a diluted form of the magic.

In my view, glamour is best seen as an alluring image that is closely related to consumption. It is an enticing and seductive vision that is designed to draw the eye of an audience. It consists of a retouched or perfected repre-sentation of someone or something whose purpose it is to dazzle and seduce whoever gazes on it. While a certain confidence and an extrovert personality may assist the elaboration of a glamorous personal image, glamour derives

from something other than those qualities. More important is the social or professional milieu with which someone is associated. People are selected and groomed to be glamorous, but usually their glamour derives in large part from the role they or their image plays in the strategy of seduction and persuasion of an industry, a medium, or an institution. The subjects of glamour are very varied. They may be people, things, places, events, or environments, any of which can capture the imagination by association with a range of qualities, including several or all of the following: beauty, sexuality, theatricality, wealth, dynamism, notoriety, movement, and leisure. The more of these that are present, the more glamorous the result and the more successful the image is likely to be in arousing wonder and envy among those who see it.[5]

I have written this book to try and get to the heart of what glamour is and what it has meant to women and to men. My decision to write a history of glamour is justified by the fact that the history of this phenomenon is one of its least understood aspects. In preparing this book, I came across references to the glamour of ancient Egyptian pharaohs and to Nefertiti, the glamour of the princely courts of the Renaissance and royal courts, especially that of the Sun King, Louis XIV. References to the glamour of the aristocracy of all periods were commonplace, as were modern complaints about the glamorization of crime, prostitution, and drug addiction.[6] I even found a reference to the glamour of monastic life, although quite what was meant by this I do not know.

It is often assumed that glamour is regal or high class in origin. By contrast, I argue that neither monarchy nor the aristocracy was the principal originator or social bearer of glamour. Although monarchs, courts, and aristocrats offered examples of luxurious living and high style, it was the fabrication of these by the emergent men and women of the bourgeois era, by the new rich and commercial establishments and the world of entertainment that was glamorous. In my view, glamour is a quintessentially modern phenomenon. Important inputs came from the lower reaches of society as well as the top. The elite of capitalist society acquired glamour because it was self-created; its exclusivity was relative, not absolute. In the context of an expanding commercial culture, a shared language of allure consisting of materialism, beauty, and theatricality was forged with contributions from

various actors from the higher and the lower echelons of society. Its poly-valent appeals meant that it captured the imagination in an age when deference was giving way to democracy. Glamour contained the promise of a mobile and commercial society that anyone could be transformed into a better, more attractive, and wealthier version of themselves.

As a word, it was first given prominence in English in 1805 when Walter Scott employed it in his poem *The Lay of the Last Minstrel* to mean a magical power capable of making ordinary people, dwellings, and places seem like magnificent versions of themselves. That the term should have been coined by a solicitor's son was not casual. It was precisely this power that the men and women of the middle ranks sought as they acquired wealth and social influence. If glamour could turn frogs into princes then it could surely turn a bourgeois into a stylish gentleman, a provincial writer into a splendid figure of romance, a woman of dubious virtue into a society beauty. Glamour involved a mixture of qualities, some of which had been at one time the near exclusive prerogative of the aristocracy. Others were born from the market, from the particular cultural configuration of the bourgeoisie, from the new patterns of consensus and social integration that, with difficulty, were taking shape in urban environments, and from the world of entertainment. Glam-our was a function not of aristocratic social influence but of the dreams of commercial society. It was not a property of the well-born or well-bred and there was no such thing as pure or off-the-market glamour. It had no prior existence before becoming commodified and commercialized.[7] The dreams of consumers included, of course, fantasies of social promotion and of self-aggrandizement. But the advent of bourgeois society did not result simply in the aura of aristocracy passing intact to the new class or even to selected members of it. Glamour was a result of the release on to the market of the possessions, heritage, prerogatives, styles, and practices of the aristocracy and of the appropriation and manipulation of these by commercial forces and other actors in the urban environment.

The conversion of royal and aristocratic magnificence into modern glam-our occurred as a result of the spread of manufactured commodities, the growth of large cities dominated by widespread anonymous socialization, the replacement of hereditary privileges by meritocracy, the transformation

7

of the urban mob into a modern public, and the development of the press and advertising. It is clear that these developments all were the result of larger processes of economic and political change. These included the end of absolutism and rise of popular sovereignty, the Industrial Revolution and the birth of modern consumption, a transformation of sexual mores, and the emergence of a dominant system of values in which deferred gratification rather than the immediate satisfaction of wants was the norm.[8] The last change is important because it fuelled a process of yearning that sustained an entire culture of dreams. Cultural enterprises sprang up to supply material in the form of novels, periodicals, illustrations, plays, and public entertainments that both provided vicarious satisfactions and channelled desires towards consumption. Consumption and entertainment invariably flourished in areas close to centres of wealth and power and from the early nineteenth century they acquired an allure as tourist sights, places of style and opulence, and homes to all that was modern and fashionable. Such areas became places of fleeting impressions, of encounters with people of unknown provenance. They were labyrinths, or places of riddle, which created forms of social interaction and of fame and celebrity in their own right. In such places, seductive appearances had great currency.[9] As the middle class asserted its influence, its members desired to establish their pre-eminent status and communicate it to their fellow men. One way of doing this was through the assertion of virtue and through differentiated gender roles that consigned women to the home. Another way was by establishing status markers by means of material display. Mostly, this was modulated in such a way as to conform to bourgeois values. For example, the domestic environment was often given priority in the construction of luxury.[10] Attention was also paid to the reform of public places and to the development of the public good. However, in contexts in which the aristocracy conserved social pre-eminence or in which an earlier generation of bourgeois had established its pseudo-aristocratic domination, the main way in which a bid for entry was made was through material competition. The new elite appropriated the cultural heritage of the past through collection and imitation and publicized the fruits of its pecuniary power. Although aristocrats offered examples of luxurious living and high style, it was the fabrication of these by the new rich

8

and by stores and the theatre that was properly glamorous. Popular theatre and spectacle appropriated and re-elaborated signs of exterior success and allure. In the nineteenth century public opinion came to be dominated by the press and publishing, which were increasingly commercialized and permeated by advertising. Public debate was accompanied by forms of consensus that privileged acclamation and applause while publicity created imitation forms of prestige and of staged display of 'showy pomp'.[11] It offered excitement and distraction to build an atmosphere of consent.

The key to the processes whereby glamour took shape as a language of allure and seduction in capitalist society lies in the radically different set of views and values that the bourgeoisie held with respect to the aristocracy. In its formative phase, bourgeois culture developed a moral critique of the aristocracy that was directed not only at its undeserved privileges but at its debauchery, artificiality, and wastage. This was informed by a distinctive set of attitudes and beliefs. The bourgeois was not a man of grand appetites, seigneurial arrogance, or flamboyant dress. He worked for his living and—before the mid-nineteenth century—did not display his material wealth ostentatiously. He was serious and puritanical. His wife and family similarly adopted an ethic of modesty and deferred gratification. In contrast to the refinements of courtly dress and self-presentation, naturalness and simplicity were preferred in matters of appearance.

The bourgeois ethic of deferred gratification was related to its attitude towards sexuality. The aristocratic custom of discreet sexual freedom for both men and women after the production of children was rejected in favour of sexual abstinence before marriage and fidelity during it. This produced two effects: first a rigid distinction between respectable and non-respectable that was mainly but by no means exclusively applied to women and, second, a series of desires and yearnings that were deflected on to consumption and entertainment. Commercial establishments attracted attention and persuaded through suggestions of sex and excess. Merchants and retail pioneers drew heavily on showmanship, magic, and religion. Although many goods were sold on the basis of their practical utility, luxury goods

relied heavily on the ideas that were associated with them, in particular the promise of magical transformation or instant escape from the constraints of everyday life. Theatres too offered dazzling spectacles of colour, excess, and excitement. These provided sensory delights and moments of imaginative transport. They also created platforms for actresses to act out dramatic transgressions of bourgeois norms. By abrogating to themselves regal prerogatives in matters of morality, they occupied a terrain that served as a safety valve for societal impulses. Thus a parallel culture existed of sensuous pleasure, of noise, excess, distraction. Publicity campaigns and store displays offered scenarios of social promotion, escape, and pleasure. These appeals provoked some hostile reactions, especially in countries of Protestant religion. However, sex appeal was often knowing, ironic, or self-referential. It signalled the appeal of the performer and her need to be desired by, and available to, a paying audience.

In several ways, the culture of the bourgeois era was a culture of image-making, of masks and appearances. Creating and maintaining appearances was essential to the bolstering of status, to selling goods, and to providing entertainment. The impact of theatricality on social life, and the consequent importance of the theatre itself, provided unique opportunities for self-invention. Theatres were the site of a visual interplay between performers—who drew their status from their beauty, extravagance, and notoriety—privileged spectators in the boxes, and the mass of playgoers. Audiences looked to the theatre for imaginative stimulus and guides to modern patterns of conduct. They took fashion cues from the stage and followed the exciting personal narratives that performers wove from their roles on and off the stage.

Glamorous people belonged to the world of representation, where play-acting and fakery were commonplace. The political sphere provided a platform for some colourful and unconventional personalities who seemed to make their own rules. The British Conservative Benjamin Disraeli wove a personal mythology around himself that found expression in his dandyism and mastery of language.[12] The Italian adventurer Giuseppe Garibaldi had a huge impact on the public, especially outside his native land; his striking physical appearance, dramatic life, and exotic costumes exercised a sensual

persuasion on the crowds who saw or read about him.[13] However, the human bearers of glamour are most frequently women. Courtesans were among the first fully glamorous personalities. In their playful appropriation of the characteristics of the lady, these flamboyant and luxurious sex objects set themselves up as society figures and pioneers of consumption. In contrast to respectable women, they were rarely tastefully attired or restrained. They were showy and eye-catching in an obvious and sexual way. Glamour is excessive and abundant and it strikes the imagination by bypassing the commonly accepted bourgeois sense of moderation and measure. It is not elaborate style so much as a popularization of style that everyone can understand. It mixes the appeals of class and sleaze in a way that produces unsettling effects that, for its audiences, are predominantly pleasurable.

Glamour took shape as a series of attractions deriving from a variety of sources. It was driven by personalities, both real and fictional, who broke the bounds of convention and configured themselves as exceptional, unusual, and compelling. It was also sustained by lifestyles of great material wealth. Among the qualities that contributed to its functioning were some that were powerful on their own. For example, beauty was a critical feature that would retain over time its centrality in all elaborations of glamour. Beauty of men and especially of women has historically been prized and it possesses intrinsic powers of attraction and persuasion.[14] In commercial society, beauty became an accepted channel of social mobility for women and the selection and presentation of beauty soon became a business. This was not the only catalyst of interest. As its economic and political power declined, the men of the aristocracy competed with those of the bourgeoisie to secure the most beautiful women as wives and lovers. Indeed, there was a triangular competition involving aristocracy, the bourgeoisie, and the world of entertainment. Feminine beauty was an example of a quality that was not limited by social class either in its supply or in its appreciation. Although different classes, regions, and ethnic groups established preferred ideal qualities that varied slightly over time, in essence beauty crosses barriers and draws the eye of all. Beauty was often blended with specific values of commercial society such as fashionableness, expensiveness, and fame. The glamorous woman was not usually drawn from the upper ranks but from humble or unidentified milieux. Indeed, two

patterns of mobility may be identified as typical: vertical mobility involving ascent from the lower reaches of society by means of talent, luck, or sexual favours, and horizontal mobility or geographical displacement. The woman of glamour was often a foreigner who was seen to encapsulate some particular spirit like French eroticism, Latin passion, or Eastern exoticism. In both cases, there was ample opportunity for the construction of dream-inducing narratives about the subject's rise from poverty, her mysterious origins, or her varied life experiences.

The physical body has always been a factor in glamour. It is a project or canvas on which a variety of socially significant meanings may be inscribed. The female body carried special connotations for societies that practised sexual repression. It was a source of fantasies that could be deployed to excite interest, sell goods, and provide entertainment. The male body was not a tool in the same way, although, appropriately costumed and represented, it could nonetheless act as a vehicle for fantasies and dreams. The sexualization of clothes, furnishings, and interiors was one of the central features of consumer culture as it took shape in the nineteenth century. Although the shopper, even at that time, was most likely to be a woman, the particular functions of allegory, metaphor, and desirability conventionally ascribed to the female sex ensured that femininity rather than masculinity supplied the visual imagery of commodity culture. The feminine image aroused particular desires that suited it well to associations with commodities and advertising.[15] The growing visibility of alluring women provided a resource for store display, the periodical market, and the theatre as well as painters, photographers, and the nascent advertising industry. All of these participated in the bringing together of commodities and the erotic.

The use of female allure to tease and to tempt, at once offering and withholding gratification, points to the oxymoronic qualities of glamour. Sleazy elegance, accessible exclusivity, democratic elitism: these are just three of the ostensibly incompatible pairings that lie at its core. The logical incongruity of these helped fuel illusions and deceive people about the hierarchical reality of social relations. In this way, glamour played an important role in the creation and maintenance of a given pattern of power. Its function was bound up with the expansion of publicity and the press. The newspapers and

magazines were vital in fuelling interest in the activities and appearances of an elite that aroused envy and did not disdain the flashbulb and the narrative of the printed page. The alluring image became increasingly important as the mass media developed. Illustrated magazines and, later, cinema and radio provided opportunities for staging, representing, and inventing people, events, and commodities. For this reason they were seized on by the new retail and cultural industries. The media lifted glamour out of specific contexts and made it into a generalized, everyday experience parallel to regular life.[16]

Glamorous people are not rooted but rather are constantly on the move. Images and suggestions from remote periods and places have often informed glamour and the specific imagery of movement and travel has also been important. To be on the move, almost nomadic, is often a feature of the person of glamour. The mode of transport is not in itself always significant, although the shorter the distance and the more familiar the place to be reached, the more important other values are to render the movement interesting or enviable. Travelling in style, in rare or luxurious means of transport, was suggestive both before and after the advent of mass tourism. But the allure of glamorous travel derives mostly from two things. First, from travel that is more frequent than average, indicating leisure and means; second, from the tension between recognition and unfamiliarity. That is to say, in order to resonate, places should have been heard of but should not have been widely visited;[17] they should carry a narrative deriving from suggestions that have entered the popular consciousness. The speed of travel is not particularly important, but a fast pace of movement, whether or not in a competitive environment, often arouses interest and envy.

The representation of travel is often related to fame. At least three dynamics of the social and economic system fuelled a culture of fame that became extensive in modern society. First, there was the dynamic of social mobility. With an established hierarchical order having been smashed open, various channels were opened for the elevation of outsiders to one or more elites. Second, there was the dynamic of novelty. A fluid and constantly evolving economy needed novelty; new personalities were as necessary as new fashions. The thrust of renewal constantly demanded new objects, styles, faces, and stories. Third, competition between forms of entertainment

and, within a sector like theatre, between different companies, fuelled publicity campaigns. All three were sustained by the press and by travel, that with the development of communications and technology became one of the key features of the glamorous personality. Glamorous people 'arrived', they 'made entrances', and they were careful not to tire the public by remaining on view for too long at a time.

Distance is a necessary factor in the maintenance of glamour.[18] It serves to conceal or disguise the aspects of a person's being that are not glamorous. We generally see the glamorous personality they way they want us to see them. At most, we may be allowed glimpses of a process of glamorous transformation; almost never of de-glamorization. For this reason, no one we know intimately can be glamorous for us. Some form of separation or stage is required to stimulate interest. Modern society created all manner of such separations, from the theatrical stage or the bar to delineations between private and public. Glamour is experienced at one remove and sometimes, in the age of the media, at several removes, through magazine articles, photographs, performances, and films. It belongs to the realm of representation not knowledge.

The relationship between fashion and glamour is a complex one. One enduring feature of glamour is its identification with fashion, but it is not always clear which aspects of 'fashion' are glamorous. Is it the latest designer collections, the presentation of those collections, or the representation of that presentation in the media? Or is it something else entirely, such as the perceived lifestyle of designers and models or particular garments or types of garment? If it is all of these things then the two terms are synonymous, but parts even of the visible universe of fashion are distinct from, and perhaps are above, glamour. In an analysis of fashion photography, one author found that in the fashion press 'glamour' was contrasted with 'sophistication'. While the latter was poised, controlled, and upmarket, the former was extrovert, youthful, dynamic, pleasure-seeking, voluble, gregarious, short-term, uncultured, volatile, public, and downmarket.[19] Such a sharp distinction can be questioned, but it highlights how the qualities associated with glamour can simultaneously be 'out of fashion' (if, say, a sophisticated style is in vogue) and at the same time refer to the key structural aspects of the

fashion industry milieu. In any event, glamour is often about excess. It is always *more* than average: more showy, more visible, more beautiful, more sexy, more rich.[20] In consequence, a varied wardrobe, preferably comprised of expensive and fashionable garments, is a sure way to capture interest. However, the role of dress can be overemphasized in glamour. More significant is the general context or the way in which a particular garment or style is worn and publicized, the people these are associated with, and the fantasies with which publicity invests them. Outside of this framework, clothes are often of even more ephemeral interest than the glamorous effects to whose realization they contribute.

Despite their prominence, members of the glamorous elite do not normally hold any political power or institutional role. The fact that they are mostly women also serves to distance them from the formal structures of power. But in economic terms they are significant and influential. They are vehicles of dreams who communicate with the public. Unlike some of the stylish upper-class and artistic figures of the past, who were interested only in impressing a small coterie, the glamorous personality is always performing for an audience, without whose envy or admiration he or she would not exist. Such people live for the publicity that turns them into objects of mass curiosity and individual fantasy. Glamour simply cannot exist without mass involvement. Not even the most interesting, sexy, and fashionable person can be glamorous without venturing into the public realm and winning attention.

The professionally glamorous are often seen to embody the sort of personal qualities that are identified with glamour itself—particularly by those who see it as an adjunct of personality. They are regal, self-centred, confident, polished, and poised. If they have accumulated experience and acquired the patina of a narrative, then they are also configured as survivors. 'Joan Collins has stood the test of time better than all her contemporaries, deftly side-stepping those familiar showbiz levellers such as substance abuse, weight problems and a fickle public, and fairly routing the worst foe of all— age,' reported the magazine *Live Wire* in August–September 1996:

She has beaten Hollywood and emerged radiant from courtroom dramas and ill-fated romances. She is the last true pre-Sixties revolution diva who walks it like she

talks it, the sole survivor of a generation of studio-bred actresses for whom opulence and ostentation were not only a right, but a duty to their public. Big jewels, big furs and big hair were the hallmarks of stardom then, and, in a world where glamour is sorely lacking, today's public wants Joan more than ever.[21]

The survivor, who is almost always a big star, is one bearer of glamour. However, for every survivor there are legions of the once-glamorous who have learned the hard way that the quality is not a permanent attribute linked to personality. It can be lost or simply fade as those who have it get old, hit hard times, or lose favour with the public. For example, few occupations are as glamorous as those of model or film actor. Yet all models and many actors are launched with what may be described as inbuilt obsolescence. Their glamour derives almost solely from the publicity in which the industries of fashion and cinema are drenched and from their commercial power. To some extent, the very anonymity of routine performers allows the glamorous image of their contexts to shine through unchallenged. It was no different a century ago. The showgirls of the popular theatre of the late nineteenth and early twentieth century were anonymous, rootless young women who inhabited symbolic spaces with special connotations. Only by donning feathers, sequins, and furs to seduce and enchant their audience did they become glamorous. Dazzled by their gloss and sparkle, the public did not realize that the image of the showgirl was an artificial contrivance behind which there was hard work, regimentation, and humiliation. While the processes of recruitment to such roles was often publicized, little or nothing was said about the process of selection that weeded out those deemed too old or ill to continue. It took the occasional personal tragedy for people to see that glamour was a system rather than a personal attribute and to reassure ordinary people that maybe it is better to dream about it than actually to live it. Such events show that there is a price to be paid for being blessed with the good fortune to enter the magic realm of the rich and beautiful.

The history presented here is not limited to any specific country. Because the nature of glamour is international, its history needs to be examined in relation to a range of countries and situations. I have chosen to focus on

Britain, France, the United States, and, to a lesser extent, Italy. Although it would certainly be possible to consider the role of glamour in other countries, the privileged place occupied in my investigation of these countries is justified by the decisive contribution they have made to the history of glamour since at least the nineteenth century. The sources I have employed are numerous and varied. They include novels, memoirs, films, photographs, paintings and portraits, biographies and autobiographies, and the press. I have also made ample use of many excellent studies that treat single aspects of the complex phenomenon under examination. To a large extent, this book is a work of synthesis. It maps the origins of glamour and investigates the forms that it took in the nineteenth and twentieth centuries. Attention is paid to the men and, mainly, the women who have embodied glamour, from Napoleon and Lord Byron to the fictional creations of Walter Scott, from the Paris courtesans to Marlene Dietrich, Marilyn Monroe, Jacqueline Kennedy, Princess Diana, and Paris Hilton. The role of writers, journalists, artists, photographers, film-makers, and fashion designers is explored as well as occupations like the model and the air stewardess, cities and resorts such as Paris, New York, and Monte Carlo, and products including planes and luxury cars that have been associated in the public mind with the magical aura of glamour. The book captures the excitement and sex appeal of glamour while exposing its mechanisms and exploring its sleazy and sometimes tragic underside. Its purpose is to provide a first full-length account of something that all too often is considered to have the consistency and significance of candyfloss but which I believe to be significant enough to merit analysis.

Glamour is not to everyone's taste. Even the diehard devotee can find that, like chocolate or heavy perfume, a surfeit is nauseating. For some, the large dose of glamour served up in this volume may provoke a similar reaction. By contrast, it is my hope that readers will be intrigued by my investigation of the extraordinary mixture of themes, periods, personalities, places, and events that make up the history of this evanescent and seductive phenomenon.

GLAMOUR AND
MODERNITY

B etween the 1770s and 1830s, the American and French revolutions, combined with the ideas they championed of liberty and equality, heralded the birth of the modern age. The triumph and collapse of the Napoleonic Empire, together with the spread of industrialization, the development of the commodity culture, and the growth of public opinion, all contributed to far-reaching innovations in patterns of rule and of consent. In an age of turbulence and change, many old certainties were shaken, the position of social classes was redefined, and a variety of new men drawn not from the aristocracy but from the minor nobility and the middle ranks came to the fore. In culture, Romanticism captured the contradictory impulses of the period through highly imaginative works that expressed yearnings for some remote and rich past or escape into alluring alternatives from a world that was increasingly seen as mundane and bourgeois.

Among the many novelties of the period was the birth of glamour, understood as an imaginative synthesis of wealth, beauty, and notoriety that was enviable and imitable rather than a hereditary prerogative. Glamour was not, as has sometimes been argued or more often casually assumed,

a timeless phenomenon. While many different rulers from ancient Egypt to Louis XIV, as well as wider elite groups, had made splendour and aesthetic refinement their vocation, the particular configuration of qualities that are associated with glamour had not existed before and nor had the pattern of social relations that underpinned it and gave it meaning. Glamour was not only about magnificence, which the politician and theorist Edmund Burke referred to in his treatise on the sublime and the beautiful as 'a great profusion of things which are splendid or valuable in themselves'.[1] Rather it involved the superb injection of fantasy into public rituals and consumption practices, and arose from the opportunities that these supplied for possible or imaginary transformations of the self. It was the market and industrial production on the one hand, and equality and the erosion of structured deference on the other, that formed the basis of the diffusion of glamour.

Glamour was born in a context in which the bourgeoisie was contesting many of the hereditary privileges of the aristocracy and in which society was becoming more open than before. However, even though it was losing power, the traditional aristocracy still defined many features of the desirable lifestyle. It had for centuries enjoyed a near monopoly over style, beauty, fashion, luxury, and even fame. Even after the French Revolution and the rise and fall of Napoleon, and beyond the period of the restoration well into the twentieth century, some members of the aristocracy preserved their wealth and status. As a class it conserved social and cultural influence by offering a template for the new men and women who now came to the fore, made fortunes, or occupied the public limelight. Glamour was about the way in which the most visually striking manifestations of aristocratic privilege were taken over and reinvented by newly emergent people, groups, and institutions. This occurred in several realms including the political sphere, the modern city, consumption and lifestyles, and theatre. Commodity culture provided a key channel for this process of appropriation which did not simply take the form of imitation. Rather it occurred in ways that reflected the system of values and culture of the bourgeoisie and its particular imaginative world. This caused problems for rulers and the manner in which they were accustomed to appear to the public, but it also presented

them with some challenges. For figures from the cultural sphere and the commercial world, by contrast, these developments only opened up glittering opportunities.

Glamour did not emerge suddenly as an identifiable phenomenon. In fact the word itself, although it entered the English language in the early nineteenth century, was not widely used until the early twentieth century. Its origins are bound up with the complex process whereby the transition occurred from aristocratic to bourgeois society. In this chapter, these origins will be explored with particular reference to France and Great Britain. The former is important for two reasons: first, because the Revolution and the rise and fall of Napoleon were the great events of the age that profoundly shaped politics and culture across the Continent and beyond. Second, because France retained, with only a brief interruption, the international pre-eminence it had established under Louis XIV in matters of luxury and style. Britain is significant for other reasons. The aristocracy was still the dominant class but, because the country had experienced a revolution of its own a century and a half previously, merchants, business people, and professionals already had a certain role that, with the Industrial Revolution, was expanding rapidly. It also gave rise to the specific imaginative forms that came to be identified with glamour. Walter Scott, one of the key architects of the fabulous dream world that was to establish itself in this period as a feature of bourgeois culture, and the man who brought the word 'glamour' into the English language, was convinced that, in the new world taking shape after the revolutionary upheavals, English literature would have a unique imaginative role to play in Europe.[2]

Glamour required a certain dynamism and flexibility in the economy and social system that were not present in pre-revolutionary France. Rather a static system of privilege combined with economic mismanagement exacerbated the institutionalized gulf between the most stylish court in Europe and a working population that was starving for lack of bread. The royal residence at Versailles had been built by Louis XIV after the Frondist protests had left him feeling unsafe in Paris. He had pursued a policy of magnificence and style to affirm a status gap between royalty and the court on the one hand and the rest of the population on the other.[3] He tied a fractious and

disputatious nobility to the throne by demanding their presence at court, a demand which forced them to spend lavishly and reinforced their dependency on royal favour. The development of luxury also served to establish the pre-eminence of the French court in Europe and to promote French fine goods abroad.

Historians have not hesitated to describe some courts as glamorous. Reference has been made to the desire of nobles in seventeenth-century Vienna and London to match 'the glamour of the monarch's residence'.[4] Renaissance princes have been described as making their courts 'more inviting and glamorous' and the court of Louis XIV has been seen as having 'exclusive glamor'.[5] Indeed, the Sun King has been said to have had a 'program for redefining France as the land of luxury and glamour'.[6] The use of this term communicates to readers something of the fabulous and dazzling facade projected by the courts, and especially that of Versailles and its creator. Yet none of them was glamorous. The French court did not seek to cultivate a dynamic of imitation within France or draw in the bourgeoisie. Everything about Louis XIV's court was stylized and governed by protocol, but any desire to impress or set a trend was either directed inwards (Louis began a fashion for wearing red heels, for example, that was widely copied by courtiers) or was aimed at the king's fellow sovereigns and their diplomatic representatives at court.[7] No self-respecting monarch would have made the impact on public opinion a priority, although pomp may have had the incidental effect of provoking awe or admiration in crowds.[8] One of the flashiest courts in history, that of the Medici in Florence, used magnificence precisely to disguise the ruling family's bourgeois origins and assert its sovereignty.[9] In general, it was the liturgical element at the heart of theatrical ceremonials which gave them meaning and that was far more important than the display of material opulence.[10] In short, courts became centres of wealth, style, and display in order to communicate grandeur and magnificence or to establish legitimacy. Their luxury could be refined and sophisticated; but it was not systematically displayed to the people and still less was it intended to arouse their envy. But there were contradictions in the adoption of material splendour, for this practice shifted the emphasis in monarchy towards wealth and things that could be obtained for money.

Unlike glamour, which was about image, magnificence involved the massive accumulation of treasures and luxuries as a right. It fuelled business and sometimes exports, but it had drawbacks. By the end of the Sun King's reign, a huge national debt was undermining the economy and fuelling resentment at the splendid style of the court. His great-grandson and successor, Louis XV, did little to promote reform or correct systematic abuses. The neglect of agriculture, which was one consequence of the absenteeism of French nobility from their estates and their confinement within the glittering cage of Versailles, persisted. With his notorious indecisiveness and timidity in policy matters, Louis XV has been labelled 'the least estimable of the Bourbon kings' and the 'chief gravedigger of the ancien regime'.[11] He played the part of an imperial king but, unlike the great showman who preceded him, he was not fond of his public duties and hated making public appearances. Some brushes with the discontent of his people, including an assassination attempt in 1757, led him to bury himself further in the cocoon of Versailles. Over time, life in this splendid palace isolated the king from public opinion in ways that would prove fatal to the Bourbon dynasty.

By the late eighteenth century, the conventional pattern of deference was fast crumbling and the material emphasis of the Bourbons was a contributory factor. No French king had to face more public dissent than Louis XVI. Thousands came to present petitions and angry marches to Versailles brought the king and queen into brusque contact with popular discontent. A particular victim of the growing disenchantment with the monarchy was the king's Austrian-born wife, Marie Antoinette, who was made the scapegoat of the situation. When the Revolution exploded in 1789 it was the high point of a long process of change to ideas, customs, and institutions that touched the entire social, moral, and cultural order of society. Such was the force of popular anger that the royals were forced to flee those who held them responsible for the economic disaster into which the country had fallen. The lavish lifestyle of the court was forcefully targeted by the mob. Far from being a seductive means of binding people to the monarchy, it fuelled bitter resentment at embedded and extreme privilege. Although it may have been apocryphal, the claim that Marie Antoinette dismissed

protest about the lack of bread with the injunction to 'Let them eat cake' seemed a plausible reflection of a situation in which the court lived in an utterly different way from the bulk of the French people.[12]

In fact, some modern ideas penetrated court society. Versailles in the 1780s was still a dazzling centre of luxury and cultish ritual, but Louis XIV's successors were less keen on presenting a dazzling mask to the world. They lacked his taste for the ostentatious display of power and they were less personally interested in asserting the divine right of kings through magnificence and obsessive ritualization of all the king's daily acts and bodily functions. The court remained a huge structure that was larger and more costly to run than the government, but court ceremonials were in decline before the Bourbon monarchy was toppled and some prevailing ideas about personal privacy were gaining currency. Louis XV carved out a private space for himself away from the court surrounded only by a small circle. His grandson and heir, too, was a man of quite simple tastes who had little of the grand manner of a monarch.[13] Even Marie Antoinette, who was castigated for her extravagance and wasteful luxury, indulged in the eighteenth-century taste for pastoral simplicity. Royalty no longer seemed like a race apart as some forms of exclusivity relating especially to material goods and celebrity became more available and circulated more freely. Indeed they increasingly came to be seen and ordinary and subject to criticism. These views found an echo well over a century later in the writings of the Austrian author Stefan Zweig, who suggested in a biography written in the 1930s that his compatriot Marie Antoinette was a mediocre woman who merely play-acted at being queen. She was, he argued, 'a tepid creature, an average woman' and 'nothing more than a lay-figure decked out in queen's robes'.[14] One of his reasons for making this claim was the keen interest that the queen took in the frivolities of fashion. Like Louis XV's mistress Madame de Pompadour, who was a bourgeois outsider with a marked taste for material objects, interiors, and decor,[15] the queen did not disdain the influences of the city of Paris, which had a life of its own that produced personalities, novelties, and trends that on occasion permeated the court. Far from being regal and remote, she enjoyed gossip and the excitement of novelty. Yet this still does not mean that there was a fruitful exchange between court and city at this

time. Although the queen was drawn to fun and ostentation, access to the French court was very restricted. While 30 per cent of the 558 individuals who were presented between 1783 and 1788 came from families who had not been there before, most of the newer nobles and all the bourgeoisie were excluded.[16] The court's highly formal procedures and rigid rules of etiquette were not even written down since the vast majority of those who lived by them knew them through long-standing familiarity. When Marie Antoinette granted regular audiences to her couturière Rose Bertin, it was regarded as a scandalous breach of protocol.[17]

For the queen's biographer Antonia Fraser, 'The glamour of Marie Antoinette—to use a twentieth-century word which nonetheless seems appropriate—appeared to fit her admirably for the position of Queen of France.'[18] The use of this term in this context does not seem justifiable. Fraser's hesitation is due to the fact that glamour is a concept which—while not in fact of twentieth-century origin—postdates the feudal court. She substantiates her decision to employ it by reference to the queen's beauty 'or the illusion of beauty she gave', citing 'the radiance of the Queen's smile', 'the brilliance of her complexion', and 'the graceful whole' that made such an impression on those who met her.[19] 'Of course the physical charms of royalty are seldom cried down, the lustre of a crown enhancing even the most mediocre appearance in the eyes of the public,' she adds; 'yet in the case of Marie Antoinette there is such unanimity of report from so many sources, including foreign visitors as well as her intimates, that it is difficult to doubt the truth of the picture.'[20] Such testimonies are indeed plentiful. The painter Elisabeth Vigée Le Brun, seeing her outdoors at Fontainebleau with her ladies, 'thought that the dazzling Queen, her diamonds sparkling in the sunlight, might have been a goddess surrounded by nymphs'.[21] In the main, these were conventional tributes to a female royal personage. Within her circle, Marie Antoinette was constantly 'surrounded by the incense fumes of extravagant idolisation'.[22] For Zweig, 'to be near her was to be in the sunshine for this vainglorious, ambitious crowd; for her to glance at them was the bestowal of a gift; her laugh entranced them; her coming was a festival.'[23] As dauphine, she was popular. Although, following the custom of French royalty, she did not often submit herself to the public gaze, she was

acclaimed in the street by crowds in the early 1770s and the audience rose to applaud her at the theatre. At this time she seemed to have the love of all the people. She became, Fraser says, 'an ideal and idealized French princess'.[24] In his *Reflections on the Revolution in France* (1790), Edmund Burke, a Whig Member of Parliament who had previously supported the American colonies' battle for independence, offered his own personal recollection of the queen. 'It is now sixteen or seventeen years since I saw the Queen of France, then the dauphiness, at Versailles, and surely never lighted on this orb, which she hardly seemed to touch, a more delightful vision,' he wrote.[25] She was, he recalled, 'glittering like a morning star, full of life, and splendour, and joy'.

The enthusiasm Marie Antoinette engendered and her visual allure mean that, to contemporary eyes, she has some features of the glamorous personality. This is how she was portrayed, for example, in Sofia Coppola's 2006 film *Marie Antoinette*, in which she was played by the American actress Kirsten Dunst. Despite a haughty profile, the queen was blonde and alluring and she endeavoured to please people. Frivolous and materialistic, she spent much time gambling, shopping, and having her hair done by her faithful coiffeur, Monsieur Léonard. She also surrounded herself with a riotous, fun-loving coterie and was acquainted with some celebrated English beauties of her day, including the notorious Georgiana, Duchess of Devonshire, but also the actress, author, and courtesan Mary Robinson, who introduced to London some fashions she had pioneered.[26] Yet there was little or nothing about her personally that was geared to the conquest of wide popularity. Fundamentally, her sphere was a narrow one that did not extend beyond the nobility. Despite her grasp of the potential of clothes to capture attention and communicate status, she repeatedly misjudged what the responses would be among her subjects.[27] As a result, she rapidly alienated their sympathies. Used to dazzling courtiers with her mastery of the Versailles glide— a technique for skimming over floors apparently without taking steps—she merely antagonized commoners who saw her as utterly removed from the real world. The pamphleteers of her time did not engage in flattering descriptions of her style and beauty; rather they were ferocious in their criticism. The key medium of public opinion that was the press thus did nothing to enhance her appeal or build potential glamour. Goodwill towards her, such

as it was, had so evaporated by the time of the Revolution that the crowds were baying for her blood; her execution in October 1793 was greeted with general delight. Her allure was not of a type that involved the population in a relationship of admiration and emulation; rather it was a feature of an absolutist society in which the monarchy was supported by a special system of image-building sustained by patronage. As that system crumbled, so the queen's highly institutionalized allure evaporated, leaving only her personal admirers to cultivate fond memories of her kindness and beauty.

Nevertheless, Marie Antoinette is an interesting figure in the history of glamour because she was caught up in the contradictions of a period of transition. She loved both simplicity and material goods, the pastoral idyll of the mock village of the Petit Trianon and the pomp and splendour of Versailles; she was drawn to theatricals and to fashion yet lived in a world of the utmost formality and etiquette. She was highly frivolous, yet, especially during the most difficult phase of the Revolution, behaved with regal dignity. She was mostly a figure of the *Ancien Régime*, yet the connection she established to the commercial styles of the city brought her into contact with the social and cultural humus from which glamour would emerge. In that urban milieu, alongside luxury trades that lived in symbiosis with the court, new ideas about politics, society, and morality gained ground and fuelled the pressures that led to revolution. Critics of the government engaged in a moral critique of the aristocracy and presented themselves as defenders of virtue. Inspired by ideas of ethical rigour and civic passion deriving from Rousseau, their outlook was also conditioned by specific attitudes towards public and private, spending and consumption, work and leisure, luxury and utility, and sex. Far from giving rise to admiration, this sparked a campaign of denigration of Marie Antoinette on the basis of spurious charges of lesbianism, debauchery, and corruption of her children.[28] As would also occur two centuries later, the press pilloried a prominent woman by peddling questionable tales of illicit sex and bad motherhood.

All these currents served to undermine the elaborate system of illusions that surrounded the monarchy. The anti-revolutionary Burke argued that the rise of rationalism and the demise of a natural order of power would inevitably lead to the destruction not only of long-established arrangements

but also of the magical aura that surrounded and legitimated them. 'All the pleasing illusions, which made power gentle, and obedience liberal, which harmonized the different shades of life, and which, by a bland assimilation, incorporated into politics the sentiments which beautify and soften private society, are to be dissolved by this new conquering empire of light and reason,' he predicted: 'All the decent drapery of life is to be rudely torn off. All the superadded ideas, furnished from the wardrobe of a moral imagination, which the heart owns, and understanding ratifies, as necessary to cover the defects of our naked shivering nature, and to raise it to dignify in our estimation, are to be exploded as ridiculous, absurd, and antiquated fashion.'[29]

Burke feared that in the emerging order plainness, boredom, and uniformity would reign and that there would be no place for image-making and visual seductions. In fact, this would not prove to be the case. A complex process of social change would see the rise of a coalition of aristocratic and bourgeois forces. The new ruling elite took over and refashioned many of the attributes of the old regime. No matter how different the basic system of values of the bourgeoisie was, the members of this class admired and envied aspects of the aristocratic lifestyle. They rejected the morals of the aristocracy but did not disdain material manifestations of status. The bourgeois phenomenon of glamour began precisely as a refashioning for new times and new purposes of the exterior glitter that the nobility had sought to reserve to itself to affirm its social and economic superiority. In contrast to splendour and magnificence, it was a flexible attribute that bolstered relative rather than absolute exclusivity.

The political and social transition of which this process of reconfiguration was a part can be read in relation to the rise of a set of interests and ambitions centred on Paris. In this fluid context, Napoleon Bonaparte muscled his way to the fore. The Corsican corporal who rose to become emperor of the French was the key figure in the transition from magnificence to glamour. Napoleon fascinated his contemporaries. His many ambiguities, and especially his mixing of elements of old and new, captured public attention and contributed to his becoming the dominant personality of his age. He was widely seen as a product of the Revolution, yet he also had a

certain appeal for conservatives because he found a new way of organizing the state in which firm authority was exercised in the public good and in the name of the people. In an age in which religious and paternal symbols of royal authority had crumbled, and deference had ceased to act as a basis for political obedience, egalitarian ideas could not be dismissed. The symbols and representations of power therefore had to pass through different routes and take account of different emotional, psychological, and political needs. Some observers saw Napoleon's elevation to emperor as a recrudescence of regal splendour and a betrayal of the egalitarian values of the Revolution. But the style and ritual of the Napoleonic Empire, despite some superficial similarities, were profoundly different to those of the Bourbons.

As a product of the minor Corsican nobility, Napoleon was precisely the sort of man who would never have been presented at court or won preferment under the *Ancien Régime*. He was a new man, a product of the times, whose very rise signalled that there had been a change of era. From the time he established himself as the saviour of Paris by firing on the mob, he plotted his rise to power, making his mark through the largest war the Continent had ever seen. His destiny, as he saw it, was to guide the French out of the instability of the post-revolutionary era and save the country in its hour of need.[30] He dramatically undermined the old order across Europe by replacing established hereditary rulers with his own appointees, leading to the foundation of a new empire on a scale not seen since the time of the Roman Empire. Napoleon was a fabricator of his own myth who forged a system of authority that served his purposes. He was a supreme propagandist who had a strong sense of history. Also significant is the broader cultural impact he and his actions had on the imaginative realm of his time. He repeatedly transformed himself, constructing a life narrative that aroused awe and inspired authors. His coronation as Emperor of the French in 1804—a title, like that of consul, which owed more to Rome than to the *Ancien Régime*—was a sign that nothing could ever be the same again. The lavish ceremony was indicative of a monarchical ambition and a determination to harness grandeur and luxury to the national purpose. A sumptuous spectacle that was hailed as the greatest public entertainment since the time of Louis XIV, it was partly inspired by the rituals of the Bourbon kings although, in contrast to royal

coronations at Reims, it took place at Notre-Dame in Paris. Eight thousand outriders accompanied the emperor's coach, which was pulled by eight horses, the very number that the Bourbons had established as a royal prerogative. In fact, it was Charlemagne, the medieval warrior-king who had been crowned in Rome in 800, who was Napoleon's model. He used the recently signed Concordat to force the Pope to attend the ceremony and then placed the crown on his head himself. It was an eclectic pageant that owed more to theatre than to history. Having transformed himself from general to emperor, after conquering much of Europe, he felt at liberty to bolster his position by raiding the past. 'At that time, very little was known about the early Middle Ages; so it was a romantic and wholly inaccurate notion which prevailed instead,' commented the Duchesse d'Abrantès in her posthumously published memoirs.[31]

Napoleon consolidated his power on the social plane by re-establishing the court. Already some courtly practices had returned under the Directory, which had held receptions for officials and overseen a certain return of pomp. These were formalized and extended by Napoleon, who was sensitive to the view that a splendid court was necessary to France.[32] On becoming first consul of the French Republic in a *coup d'état* in 1799, he had set about establishing a new pattern of rule. Balls, receptions, dinners were held to anchor individuals to the new regime and provide them with the social recognition for which many of them yearned. The court had always shaped manners and customs; it had played a role in national prestige, and it had sustained the economy by promoting luxury trades. Napoleon was most interested in the way that features of the court had their uses as political weapons.[33] He realized that the weakness of modern institutions was precisely their inability to speak to the imagination and he set about using the tools at his disposal to correct this.[34] Visual splendour was a vital way of communicating with the people and capturing their attention.[35] Fundamentally, he was a rationalizer, a reformer, and modernizer of the state and the institutions who saw himself as the embodiment of the best spirit of the Revolution. The recourse that he made to past ceremonials and patterns of power showed the difficulty of finding new ways of representing authority in a context in which its conventional forms had been disrupted and thrown

into question.[36] The irrational appeals of spectacle and magnificence were annexed to secular authority to lend it an imaginative dimension.

Napoleon's court was a public structure rather than a largely domestic one. It was not a product of consolidated traditions and rights but rather the conscious invention of a ruler. It was the emperor's position that was glorified rather than his physical person. Napoleon had been happy to be painted posing in his study by Jacques-Louis David and even as emperor he dressed simply in private. There was none of the ritualized attention to daily acts and bodily functions that had bound senior courtiers to the monarchy. Napoleon was essentially a private figure who cultivated a public dimension; he had many fewer personal attendants than the Bourbon kings. There was also a new distance between ruler and populace. Versailles had been surprisingly open, with visitors able to wander at will not only into the gardens but also into the royal apartments. Despite the growing popular unrest, this had still been the case under Louis XVI since the king was assumed to occupy a position at the top of a natural hierarchy in which people knew their place. Now that such notions had been swept aside, the curious were excluded while formal access was granted to far wider groups. The imperial court was the first where non-nobles held senior posts. Etiquette did not remain unwritten, as in Louis XVI's time, but was set out so that newcomers could study it. The tone was more egalitarian and the emperor mixed with his guests at balls and paid attention to them. Although not well mannered—he was given to shoving and tweaking his collaborators—he exercised some personal charm.

Napoleon behaved clannishly and granted all the members of his family important titles and posts. But in most respects, his court was open to the real configuration of society; both minor nobles and non-nobles gained admission and many more foreigners than in the past were presented.[37] The elite he forged was quite different from the *Ancien Régime* aristocracy; it was not predicated on inherited rights and it was organized and calibrated in a novel way. Its fundamental principles were bourgeois and meritocratic. Valiant generals, civil servants, and bankers were all awarded titles in a drive to manufacture an aristocracy that, unlike the pre-revolutionary one, was expected to command the respect of a country in which, despite the growing

apparatus of censorship, public opinion counted. Napoleon was acutely aware of this and kept a tight grip on the press. He did not intend to allow it to deflect from or undermine the general image of material opulence. Napoleon constructed a system of personal rule that was fantastically opulent and drenched in magnificence. This recalled the cultivation of luxury by Louis XIV. However, Napoleonic splendour was an exterior appropriation, a parvenu emulation, rather than a return to the past.[38] Opulence was not purely viewed as a prerogative. Rather it was used to win the respect of domestic and foreign elites and seduce wider public opinion; magnificence was to offset lack of heritage.[39] It was a means of capturing the imagination of France and the world.

Nevertheless, the sheer scale of this was extraordinary. Royal palaces were decorated with supreme opulence; new furniture of superb quality was installed, and N emblems as well as bee and eagle symbols were affixed everywhere. The bee had been Charlemagne's symbol and evoked immortality and resurrection, while the eagle, the symbol of imperial Rome, was associated with military victory. Napoleon demanded that his dukes, counts, and barons occupy splendid palaces and live in luxury. Their carriages were to be gorgeous and their hospitality lavish. All this with the intention of giving the court the most fabulous visual impact. 'He wanted his court to be the most splendid ever seen,' wrote the Duchesse d' Abrantès; 'he ceaselessly exhorted his dignitaries to live lavishly in splendid houses; he often gave them large sums of money, usually taken from the contributions paid by defeated enemies, and expected them to spend every penny, on the assumption that there would always be more where that came from.'[40] Napoleon's attitude was that the new aristocracy should assert its social prominence through the programmatic display of luxury. This was not wastage; the use of material magnificence was functional. As one French historian has noted, 'he was happy, if necessary, to pay millions for the receptions of the court, *but he did so counting them*'.[41]

There were elements of restoration to the imperial court. Some officials and servants from the past were given new appointments. However, Napoleon's court was not a structure apart, but part of the city. It was not established at Versailles, which remained unused until the Bourbon restoration (it was

eventually turned into a museum by the citizen-king Louis-Philippe after he came to power in 1830). Rather it was installed at the Tuileries, the royal palace in the city of Paris. In the course of the Revolution, the city, with its salons, festivals, and celebrities, had replaced the court as the social centre. Napoleon knew that, despite his accomplishments on the battlefield, his power was contingent and that it needed to be consolidated through public display and ceremonial. His mother had written to him, 'You know how much external splendour add to that of rank or even personal qualities in the eyes of public opinion.'[42]

One marked novelty of Napoleon's court was an unusually high quotient of female beauty. Courtiers were no longer drawn from the narrow stratum of the high aristocracy but from far wider social backgrounds. In contrast to the strange-looking physical specimens thrown up by the hereditary order of the *Ancien Régime*, youth and beauty were very much in evidence. The women who enjoyed especial prominence were striking for their beauty or allure. They included Napoleon's wife Empress Josephine, his sexy sister Pauline, and the young banker's wife and salon hostess Juliette Récamier. These women were not shrinking violets; they had risen to prominence by becoming key social players with power bases in the city and its centres of wealth and hospitality. They were glamorous figures with chequered histories. Josephine herself was the widow of an aristocrat who had thrown his lot in with the Revolution and gone to the scaffold in 1794.[43] She had survived the Terror to reinvent herself as a hostess and a mistress to the rich during the Directory. Although not conventionally beautiful, she was pretty, languorous, and erotically alluring. Born on the Caribbean island of Martinique, she incarnated, along with a handful of other women, the fluid and hedonistic spirit of the times; she shopped, socialized, and spent hours on her appearance. She was an integral part of the fashionable life of Paris. She was linked at once to the old order and the louche salons of financial intriguers and speculators.[44] As such, she was an ideal trophy for the rising Bonaparte who courted and married her in 1796.

Although she was a very different figure from the late queen, Napoleon gave Josephine the task of organizing a court that would be no less brilliant than that of Marie Antoinette. It was expected, though, that she would

overcome the contradictions that had damned the queen and render social splendour attractive. Her talents were deployed to bring together different elite groups and create a single focus for social life, infusing it with brilliance and beauty. The links she maintained to the city distinguished her from Marie Antoinette but also from Louis XV's influential mistress Madame de Pompadour, who, in her time, had been a significant city socialite. On becoming the royal mistress, she was brusquely removed from the urban scene and transplanted at court. She was only sent back after her death for burial. The women of the new era, by contrast, bridged the court and the city and belonged equally to both. The emperor paid great attention to their appearance and had no qualms about telling a lady that she was overdressed, underdressed, or that she did not look sufficiently youthful and radiant.[45]

Despite his attention to feminine beauty, to bolster legitimacy Napoleon insisted on a certain decorum. He acted to suppress risqué fashions and marginalize libertinism. In the new era, rulers could not openly disregard the general morality of the people. Like Rousseau and many revolutionaries including Robespierre, he considered women's role to be subordinate.[46] Burke had noted that the new order desacralized monarchy and produced a new pattern of gender relations. 'On this scheme of things,' he argued, 'a king is but a man; a queen is but a woman; a woman is but an animal; and an animal not of the highest order. All homage paid to the sex in general as such, and without distinct views, is to be regarded as romance and folly.'[47] This was a more accurate prediction than some of Burke's others, for the post-revolutionary order was a decidedly masculine one. Despite the role of the empress and some society hostesses, women were seen mainly in relation to reproduction. That this was more important than decorativeness was illustrated when Napoleon's ambition to found a dynasty led him to divorce Josephine in 1809 following her failure to produce an heir. To confirm his own royal status and embellish his imperial crown, he subsequently married the Austrian princess Marie Louise in a ceremony that, despite its not being recognized by the Pope, was marked in Paris with fabulous public celebrations. Although Josephine was allowed to keep the title of empress, her open-tap spending after her dismissal from court was deeply resented since it was no longer functional but entirely self-serving.

The Napoleonic regime was the first in history than can accurately be described as glamorous. Its image of magnificence was not bolstered by history or divine right. Rather it worked autonomously to seduce the French public and foreign rulers. It was brash and eye-catching, it was colourful and theatrical. It revelled in new money and in the worldly beauty of the women who rose to the top of a heterogeneous urban society. Napoleon himself, for all his narcissism, always knew that he was an upstart. He had transformed himself from a nobody into a magnificent emperor and reshaped his country in his own image. This extraordinary achievement had enormous resonance and communicated a wide-ranging lesson about the decline of hereditary authority and the opportunities that existed for self-invention and affirmation.

Napoleon had a far-reaching impact on the political and cultural landscape in Britain, although he would for many years be a bogeyman. The fact that Britain was drawn into a war with France that lasted on and off from 1793 to 1815 had something to do with this. The Corsican corporal who became a general, then a dictator, and finally became an emperor, before falling from grace and rising again before encountering final defeat and exile, was the man of the age who profoundly influenced the way his contemporaries felt about their time. For many, he was a complex figure of numerous sides who announced the arrival on the scene in many spheres of new men. With his personal odyssey he showed that glory and splendour were attributes that, in the modern era, were likely to be temporary. He and Josephine were utterly different from any other type of contemporary ruling family.

In England, wealth was spread more widely than in France and there were many from middle-class and non-noble backgrounds who were eager for more influence. The public sphere was no longer narrow and there was an awareness of new figures and possibilities for social mobility. Because the country had essentially been a constitutional monarchy for some time, the shift in values and norms was not marked by any dramatic political events. But fear of violence and revolution and the mobilization against Napoleon had the effect of creating a social glue in the form of patriotism combined with an attitude of seriousness and strong support for the dominant moral code that steadily infiltrated even the higher classes.[48]

Because Britain experienced industrial development earlier, modernity manifested itself more on the commercial plane and in the field of culture than in terms of political agitation. The massive disruptions of the era fuelled the Romantic movement, whose members were committed to the development of the imagination as a realm of experience. They were the prime cultural interpreters of the feelings of anxiety and nostalgia that arose in a period of change. It was among the Romantics that the richest and most interesting responses to Napoleon's symbolism emerged. For the Lake poets, Wordsworth, Coleridge, and Southey, as well as Hazlitt, Scott and Byron, he was a remarkable stimulus to their creative work. He was crucial to the way they thought about themselves and their roles.[49] Most of them were hostile, yet they were fascinated by Napoleon. Wordsworth and Coleridge compared him to Milton's Satan, while other authors compiled a fantastic list of historical precursors that included Alexander the Great, Augustus, Julius Caesar, Cromwell, Rob Roy, Macbeth, Moloch, Moses, Genghis Khan, Belshazzar, and Nebuchadnezzar.[50] As hero or villain, he seemed far larger than life. The English Romantics easily grasped the glamour of Napoleon. Coleridge saw that he fascinated, bewitched, and enchanted his contemporaries and pronounced himself utterly averse to 'the great Giant-fiend'.[51] He argued in essays published in the *Morning Post* that, from the time of his Egyptian expedition, Napoleon had become an 'object of superstition and enthusiasm'. His 'splendour' and 'brilliance' had 'dazzled' and 'blinded' observers. As a despot, he had embraced 'splendid robes and gaudy trappings' that were tantamount to a 'miserable masquerade' to disguise his tyranny. Wordsworth too noted the optical seduction of his 'splendour' and 'glory', that he pronounced false, while Hazlitt, who was more positive in his attitude—and who wrote a four-volume biography of Napoleon—argued that his exploits had a 'dazzling appearance' that produced a 'dazzling glare'.[52]

Few British writers of the period enjoyed the great popularity at home and abroad of the poet Lord Byron and the poet and historical novelist Walter Scott. A creative artist of extraordinary range and industry, Scott has been hailed as the greatest single popular imaginative inspiration of the nineteenth century.[53] For his part, Byron effected a uniquely powerful synthesis

of art and life that profoundly influenced his contemporaries. Both were well aware of the susceptibility of the men of their time to glittering facades and to imaginative and alluring descriptions of places and people. They engaged with the Napoleonic cult and drew inspiration from it to develop glamour as an alluring imaginative realm connected to lived reality. Like others operating in the cultural realm, they exercised more flexibility and freedom in this respect than those who occupied the spheres of politics and the state. They were able to exploit to the full the opportunities for fame and profit that the commercial sphere offered.

Both writers skilfully combined elements of the past and present. Scott contributed to the development of the medieval vogue that took hold in the first decades of the century. He was not the founder of this genre of historical fiction. Horace Walpole's *Castle of Otranto* and the Gothic novels of the late eighteenth century had fuelled interest, as had Coleridge with his poem *Christabel*.[54] However, Scott's poems and novels were huge successes and his best-known novel, *Ivanhoe*, sold more copies than any previous literary work.[55] The whole of European culture was influenced by his evocations of medieval and Renaissance chivalry and adventure. He was the first novelist in Britain to become a public figure and to arouse enthusiasms that went beyond the confines of the established reading public. His literary creation of a world of adventure and heroism greatly appealed in a time of uncertainty and change. In his many works, the imaginative realm is stimulated and manipulated with repeated use of picturesque settings, dramatic encounters, beautiful characters, meticulously described material environments and objects, and passionate emotions. The massive quantity of his production (numerous lengthy poems and short stories as well as twenty-seven major novels between 1814 and 1832, plus a long series of historical works) was such that he more than met the demand of readers for exciting and engaging historical fiction. Like few others, Scott caught the mood of his generation. Kings and queens, great aristocrats and minor nobles, squires, businessmen, educated women, and artisans all thrilled to his fabulous tales of a glorious past. Although Carlyle argued that his popularity was 'of a select sort . . . not a popularity of the populace', it extended further than that of any living author.[56] Right across Europe, men and women imagined

themselves drawn into the drama and romance of his works. Many of them belonged to a new reading public that was just taking shape. Byron was, if anything, even more of a celebrity. His title and dark good looks, combined with a prodigious poetic talent, quickly made him into a widely admired figure who attracted devoted followers.

Scott had a deep knowledge of Scottish folklore, ballads, and myths and he often employed picturesque language to supply local colour and a sense of antiquity.[57] Some of the words he employed were antiquated and were merely being reintroduced. Others were of Scottish derivation.[58] Among these was 'glamour'. The word was an Anglicized version of 'glamer' which had been in use in Low Scotch for around a century.[59] 'Glamer' referred to 'the supposed influence of a charm on the eye, causing it to see objects differently from what they really are'.[60] *The Etymological Dictionary of the Scottish Language*, published in 1879, traces the term's origins to two possible Scottish sources: 'glimbr' (meaning splendour) or 'glam-skygn' (meaning squint-eyed).[61] Scott may have had one or both sources in mind when he coined a term that would come to have applications well beyond the usage it had previously had in Scottish. He used the word 'glamour' in his first major success, *The Lay of the Last Minstrel* published in 1805, a long prose poem that pulsated with magic and adventure.[62] The fictional narrator-minstrel, who is reputed to be the last of a race of people who inhabited the Scottish borders, recounts the customs of his partly pastoral and partly warlike fellows. The poem tells of a border feud that takes place in the sixteenth century in which sorcery is employed by a noblewoman to obstruct a marriage of which she does not approve. The convoluted story is permeated with the supernatural. A dwarf page with the appearance of a goblin is charged with procuring for his master a magic book of spells. When he finds it and opens it, he reads one short spell, of which he says:

> It had much of glamour might,
> Could make a ladye seem a knight;
> The cobwebs on a dungeon wall
> Seem tapestry in lordly hall;
> A nut-shell seem a gilded barge,

A sheeling seem a palace large,

And youth seem age, and age seem youth —

All was delusion, nought was truth.[63]

Glamour was used here to convey a capacity to transform, to delude through illusion. Through glamour, something could be made to seem what it is not (the word 'seem' recurs five times in the space of a few lines), and especially something better, more alluring and splendid. It was a transformative force conjured by magic that could make things appear far better than they really were. Although Scott insisted on the Scottish orgin of the word,[64] Such a power alluded, no matter how indirectly, to the extraordinary rise of the Corsican corporal and the fantastic quasi-fictional character of his deeds. The odyssey of Napoleon, whose coronation occurred just one year before the publication of *The Lay of the Last Minstrel*, profoundly shaped perceptions of what men could achieve. His acts of self-transformation were the greatest of an age that was itself marked by far-reaching change.

Scott had had no sympathy with the French Revolution, yet he was powerfully influenced by the legend of Napoleon. He wrote a significant poem *The Field of Waterloo* in 1815 and even composed a lengthy biography in 1827 that was only mildly hostile towards its subject.[65] Bonaparte impressed him because he was a 'new man' who had emerged from nothing, rather like himself. He was also a man of order who willingly drew on the symbols and imagery of the age of chivalry. Of course, Scott's works operated in a very different sphere, but there were strong connections and they had something of the same eclectic quality. Napoleon created a peculiar mix of old and new that the Scottish author identified with.

Napoleon was a compelling and intensely controversial figure and he would remain so long after his time.[66] His concern with image-building and his manipulation of the tools of communication of his time led some to see him as a confidence trickster. Thomas Carlyle, the great champion of heroes and great men, considered him not to be the genuine article but rather a fraud. While he possessed some of the qualities of the charismatic hero, 'outer manoeuvrings and quackeries' prospered until, in Carlyle's view, 'the fatal charlatan-element got the upper hand'.[67]

Others viewed him as a mystery man or sphinx. Writing over a century later, at the end of the Second World War, the Italian historian Luigi Salvatorelli dubbed him 'an unknown'. 'The mystery of Napoleon is to be seen as a spiritual emptiness,' he wrote. 'The "pure activist", the professional hero is empty: at the conclusion of the unleashing of his actions, behind the façade of his gestures, there is nothing.'[68] From the point of view of glamour, precisely this focus on exterior appearances and their effects is significant. The imagination was the realm in which Napoleon built his most enduring empire.

Byron was not merely influenced by Napoleon; he was an admirer. In *Don Juan,* he made explicit his identification with him, referring to himself as 'the grand Napoleon of the realms of rhyme'.[69] Napoleon loomed large in his life and he regarded him as an inspiration, perhaps because, more than any other man, he had won the attention of his contemporaries and expanded the very sense of fame and glory. Byron composed an 'Ode to Napoleon Bonaparte' which, unlike Scott's poem, contained praise and he referred to him in his *Childe Harold's Pilgrimage* as 'the greatest . . . of men'.[70] Byron saw the Frenchman as an outsider of great energy and stamina who, like himself, triumphed over mediocrity and achieved great things. Carlyle and Keats saw the two men as both being histrionic and theatrical. 'In the collective visual imagination they stood fixed in alliance, stocky powerful Napoleon, exquisitely handsome Byron, the superlative odd couple of their time,' writes the poet's most recent biographer.[71]

Like Scott, Byron was part of an emerging world of mass publishing.[72] His early triumph, *Childe Harold's Pilgrimage*, published in 1812, turned him into a contemporary idol. A poem of discovery written in exhilarating language, its questioning of established values led to it being seen as a blast for freedom and a product of the post-French Revolution era.[73] The 'Childe' of the title was part Byron and part modern man. It was subversive in tone and reflected the erosion of deference. Reviewers noted a similarity with Scott's *The Lady in the Lake*, published the previous year, which featured a similar wanderer (in that case a knight) of mysterious origins.[74] The rival authors both catered to a public hunger for escapist romantic narratives unfolding in enticing contexts. Byron fashioned a dream world of his own that was equal in power to Scott's and which would in similar ways

combine the fabulous and the faraway with the particular themes and impulses of the modern era. The difference was that Byron worked in an exotic key.[75] His poetry was infused with images of remote places and unusual experiences that had an authentic ring on account of his extensive travels in Albania, Greece, and Turkey. Through these, he developed an Oriental persona of his own. He cultivated his own image and encouraged an identification between himself and the alluring heroes of his writing. One of the best-known portraits of Byron, by Thomas Phillips, shows him as a dashing adventurer in full Albanian costume.

No more than the medieval vogue was exoticism a true novelty and it also gained new force in the early years of the century. The Orient appealed especially as a place of illusion and transformation in which everything could turn into its opposite.[76] For over a century luxury goods had been imported from the East but the connections increased with the expansion of trade and colonialism.[77] In Egypt, Napoleon had revelled in Oriental magnificence and admired the limitless power of the region's despots. Some of Byron's backdrops were borrowed, others—particularly those of *The Hebrew Melodies*—were largely taken from the Old Testament.[78] Despite this, he was able to provide a plausible rendition of the East and find a winning formula by combining exotic heroes and mysterious, suggestive settings.[79] In his poems *The Gaiour*, *The Bride of Abydos*, *The Corsair*, and *Lara* he fashioned a world of adventure and marvel that proved extremely popular. *The Corsair*, for example, sold 10,000 copies on the first day of publication in 1814.[80]

Byron's celebrity was so instant that it was almost as if there had been a yearning for such a figure in English society. He was at the heart of a bustling scene and, through the mediation of several of his female admirers, including Lady Caroline Lamb and Lady Melbourne, he was propelled into the highest spheres of society. This connection, and the title 'Lord', were key elements of the way Byron was packaged and sold to a reading public that 'still clung to the paraphernalia of aristocracy' and was 'avid for glamour'.[81] He was an unusual sort of aristocrat who cared little for tradition or for his landed possessions. He showed himself quite willing to sell off both his ancestral estates of Rochdale and Newstead for ready cash. In consequence, he possessed deracinated aristocratic attributes that were turned

to commercial ends by the publisher John Murray and which lent allure to his nomadic persona.[82]

Byron seemed to be both embedded in high society and rootless, two ostensibly antithetical qualities that rendered him alluring and saleable to his readers. Byron and Murray showed by their actions that they were well aware that, as the odyssey of Napoleon proved, image-making was a fundamental part of modern society and of commercial society in particular. The poet's biographer claims he had a need for exposure that was his lifeblood.[83] An isolated child who had struggled with disability, he offset feelings of inadequacy by fashioning the image of himself as a romantic idol. There was a strong visual dimension to this. Byron was darkly handsome with a certain androgynous—some said, feminine—appearance. His impact on women—both those he knew and his fans—is well known. The audience for his writings was to be found especially among the increasing numbers of women of the middle class who in the industrial era were left with leisure time as the tasks of breadwinning were monopolized by their menfolk.[84]

Byron not only carefully cultivated his appearance by disguising his club foot (curiously, Scott too was lame), undertaking frequent diets, and choosing his portraits and poses carefully; he also styled his entrances and exits, as well as his costumes and the locations in which he appeared. Always theatrical, his poetry too relied for its effects on showing, looking, and seeing.[85] Murray underlined this by publishing his works in sumptuous editions containing illustrations, drawings, and engravings.

Scott and Byron both produced fabulously imaginative texts and were seen as masters of enchantment. On account of his unrivalled inventiveness, Scott was dubbed 'the Wizard of the North'. Even his son-in-law and biographer, J. G. Lockhart, refers to him as a magician on two or three occasions.[86] The ease with which he produced verse of vigour and energy marked with clear, picturesque scenes struck all readers. In the ten years following *The Lay of the Last Minstrel*, he published many poems inspired by Scottish history. He created an appetite for historical evocations and fictions that flourished during the Napoleonic era. Subsequently, he turned his prodigious energies to prose fiction and produced *Waverley*, a novel of the Jacobite rising of 1745, that was rapidly followed by a sequence of other titles.

In 1819, the still anonymous 'author of *Waverley*' produced his first English novel, *Ivanhoe*, a historical romance set in the twelfth century. The novel is considered to be his finest work and it is certainly today his best-known title. In terms of colour, drama, and brilliance, this tale of chivalry and love is unequalled in Scott's canon.

The mood the novel caught was a quintessentially modern one in which elements of yearning for nobility and grace mixed with materialism, nationalism, and fantasy. The critic A. N. Wilson has referred to the 'spell' of *Ivanhoe* and has sought to uncover the secret of its enchanting effects. Among Scott's tricks, he identifies an atmosphere of excitement, twists and turns of plot, a variety of colourful and contrasting characters, and a sharp dichotomy between good and evil.[87] To this list might be added a love story and some dramatic set-piece scenes including a tournament and a siege.[88] More broadly, the novel offered a fabulous fantasy that was infused with the materialism of modern commercial society. The pageantry is glittering and splendid, and the settings richly described. Garments are detailed in such a way as to throw their magnificence into sharp relief. A Saxon chief's fur-trimmed tunic, golden-clasped sandals, gold bracelets and collar, and richly embroidered cap are minutely itemized, as are the gold rings, precious gems, fine-leather sandals and embroidered cope of a religious elder. Interiors are evoked with a mass of detail and occasional comments connect these to the experiences of readers. Ancient dinner tables, it is said, 'may be still seen in the antique colleges of Oxford or Cambridge', while a mantle of black serge is 'in the shape of something like the cloak of a modern hussar'.[89] Wilson draws attention to numerous improbable details (the Norman nobleman Brian de Bois-Guilbert has black slaves, for example) that merely serve the need for effect. As 'romances', Scott's novels offered images of a fantasy world that was largely unreal even though it seemed to be grounded in history.[90] His writings reflected the sturdy sobriety of the middle classes, from which he came. Unlike the aristocracy, the bourgeoisie did not believe that it had a God-given right to satisfy all its wants and needs; it practised economy, restraint, and measure in matters concerning money, personal consumption, and sex. Yearnings and imaginative pleasures were a key characteristic of its specific mentality.[91]

The decorative focus of Scott's writings was noted by some of his con-temporaries. William Hazlitt believed that the author reflected surrounding objects, and that, like Napoleon in reality, he borrowed his imagined scenery and costumes 'from comparatively obvious and mechanical sources'.[92] He noted that Scott's backgrounds were the most attractive feature of his novels.[93] These were precisely the part that could most readily be assembled by means of compilation and imitation. This eclectic quality was the typical taste of a materially based society. Like the Scottish novels, *Ivanhoe* gave rise to a slew of works with English themes and settings that formed the basis for the extraordinary influence that he exercised over European culture in the nineteenth century.

Byron and Scott adopted different approaches towards their heroes, a fact which reflected their different values. While some of Scott's were notoriously bland and upright (Rob Roy was one exception), Byron's were compelling and unfathomable. Ambivalent in the way that Coleridge and Wordsworth had found Napoleon, they were not moral examples but fascinating traps for the fantasies of readers. According to one critic, 'they gain their power from a quasi-magical ability to attract and retain attention, even though they do nothing to solicit it'.[94] Yet their subversive potential was contained because their adventures were located far from Britain in remote exotic locations. The heroes of *Lara* and *The Corsair* were outsiders and adventurers, men who were modelled on Napoleon or a mixture of Napoleon and Byron himself. By functioning just beyond the realm of the permissible without directly challenging the model of contained, untheatrical masculinity that was fast becoming dominant in Britain,[95] they were vehicles of glamour. Scott's middle-class conservatism prevented him from toying with his readers' values in this way. Instead, he concentrated on detail and backdrop. However, although the right and the moral always won out in the end, alternatives to bourgeois ideals and values were amply explored. His most compelling male figures tended to be villains, who he made more rounded and intriguing than his heroes. In a letter of July 1814, he wrote: 'I am a bad hand at depicting a hero, properly so called, and have an unfortunate propensity for the dubious characters of the Borderers, buccaneers, High-land robbers, and all others of a Robin Hood description. I do not know

what it should be, as I am myself, like Hamlet, indifferent honest, but I suppose the blood of the old cattle-drivers of Teviotdale continues to stir in my veins.'[96] Despite, or perhaps because of, his moralism, it was glamorous rebels who grabbed his interest and fired his imagination.

By the same token, his most seductive female characters were not his heroines, but outsiders. The Whig historian G. M. Trevelyan claimed—not without a touch of sexism—that there was a link between both authors' depictions of women and increasing female leisure. 'Scott's pseudo-medieval ideals of the "lady" worshipped by the enamoured hero, and Byron's sultanic vision of woman as odalisque,' he argued, 'helped to inspire the artificial uselessness of the would-be fashionable sisterhood.'[97] But, in fact, some of Scott's secondary female characters are no less compelling than Byron's ambiguous heroes. The heroine of *Ivanhoe*, the Saxon princess Rowena is blandness made flesh. The novelist Thackeray dismissed her as 'that vapid, flaxen-haired creature' and deemed her 'unworthy of Ivanhoe and unworthy of her place as a heroine'.[98] However, the novel features a much richer and more intriguing female figure in the person of the dark-haired and olive-skinned Jewess Rebecca. Even the wounded knight Ivanhoe, who is promised to Rowena, cannot resist gazing on her 'beautiful features and fine form, and lustrous eyes'. Eyes, Scott adds, 'whose brilliancy was shaded, and, as it were, mellowed, by the fringe of her long silken eyelashes, and which a minstrel would have compared to the evening star darting its rays through a bower of jessamine'.[99] Unlike the Saxon princess, Rebecca is a fascinating outsider. She is exotic and unusual; her appearance is showy and eye-catching. To have a sense of her allure, it is probably best to think of her as the young Elizabeth Taylor, who played her in the 1952 film version of the novel. Rebecca has a sex appeal that the virginal Rowena lacks and which is emphasized by allusions to her physical charms. Scott uses Rebecca's outsider status to construct her as alluring, different, and glamorous. It is the combination of her beauty with her remote, mysterious background and her unconventional dress and priceless jewellery that makes her intriguing and tantalizing.[100] Such a juxtaposition of effects was not new. In eighteenth-century works of fiction, including Daniel Defoe's *Roxana*, in which the eponymous heroine performs at court a Turkish dance in a richly coloured gown and a headdress studded

with precious jewels,[101] the Oriental woman was often deployed as an icon of luxury. Luxury had been associated with the East since ancient times and this was reinforced by a burgeoning trade in luxury goods. By the early nineteenth century, such trade was an integral part of a growing consumer culture. In Byron, such exotic female figures abound. The slave girl Leila in *The Gaiour* was the type of languid, dark female he preferred. The erotic Zuleika in *The Bride of Aydos* was a highly sexualized, if ultimately pure, figure.

Byron and Scott offered two of the staple variants of glamour: one specialized in remote places and compelling people, the other opted for distant times and colourful scenes. The two writers also reflected the ideological ambiguity of glamour as a subversive and alluring power and as a force easily annexed by authority. Byron was the rebel and wanderer, the morally questionable renegade who was compelled to leave England under the cloud of a sexual scandal in 1816. The disintegration of his marriage and allegations of homosexuality led to his banishment from society and turned him into a rootless nomad. Later, with his customary theatricality, he took up the nationalist cause in Italy and Greece, participating in the latter until his death in 1824. Scott, by contrast, became ever more respectable and institutionalized. He was made a baronet and he built an eclectic baronial home at Abbotsford that became a personal medieval fantasy world: his 'romance in lime and stone', as Lockhart called it.[102] It was a flight from features of the modern world he disliked, a revelling in the ancient trappings of feudal nobility and distinction. Scott did in fact embrace technological innovations with some enthusiasm. He installed gas lighting and water closets at Abbotsford, as well as a complex system of air-bells. He would also welcome steamships and the railways. In politics though, he sided with the forces of conservatism.

'When the eldest son of George the Third assumed the Regency, England was in a state of political transition,' Captain Gronow noted in his reminiscences on the period.[103] 'The convulsions of the Continent were felt amongst us; the very foundations of European society were shaking, and the social relations of men were rapidly changing.' This increased after the end of the Napoleonic wars, when agricultural prices suddenly rose with the

result that the poor were driven to near starvation while the rich, aided by the Corn Laws, got richer. The campaign for the repeal of these laws took on a mass character that alarmed the authorities. When one mass protest was violently repressed in August 1919, Scott voiced his backing.[104] He also threw his support behind the monarchy in the person of George IV. Born in 1762, Prince George became regent in 1811 in place of his mentally unstable father. He inherited the throne in 1820 and reigned until his death in 1830.

George was a very different figure from his father George III. While the latter was a simple, easygoing monarch who cared little for pomp, his son loved luxury, pleasure, and colour. The prince regent was another ruler who was caught up in the contradictions of an era in which deference was giving way to citizenship and in which the allure of material goods was coming within the purview of ever wider groups. The few triumphs and many tragedies of his reign show how difficult it was, and perhaps the impossibility of any attempt, to hitch magnificence to the emerging dynamic of glamour. George was a man who indulged in a taste for exteriors. He spent vast sums of money forever seeking to improve his residence, Carlton House (dubbed by one observer, 'one of the meanest and most ugly edifices to disfigure London' and later demolished),[105] he cultivated the most elaborate and excessive exterior appearance and he amply indulged his tastes for wine, food, and women. He personally designed the sumptuous, eye-catching uniforms of his personal regiment, the Tenth Hussars. Taking his cue from the elaborate, fur-trimmed, gold-buttoned, and buckled uniforms of central and Eastern Europe, with their various bells, belts, and epaulettes, he aimed to make this privileged corps into the most visually impressive in the army. The Prince Regent was not an ignorant man. He had a developed interest in the arts and followed all the novelties in literature. He loved Scott's works and was not immune to the delights of Byron's Oriental fantasies. Both the vogue for the Gothic that Scott fuelled and the taste for things Oriental captured his imagination and informed his building projects. In the course of the eighteenth century, Brighton had emerged as a fashionable resort, in part due to the patronage of the prince and his high-living coterie. In their wake would come many middle-class holiday-makers, turning the town into a sort of adjunct of a growing London.[106] The prince's most eye-catching

contribution to Brighton was the Pavilion. The original scheme, by Henry Holland, envisaged French decor with the addition of brighter colours. However, the prince changed ideas as frequently as he did architects and the resulting building was an eclectic Oriental palace in which the outside was Indian-inspired and the interiors informed by a mixture of Chinese and Japanese motifs. It was a fabulous building that was no less informed by dreams and masquerade than Byron's writings on the Orient. Windsor Castle was another of his projects. As a result of extensive rebuilding, it was turned into a Walter Scott-style Gothic fantasy.

The prince did not only seek personally to harness the most popular fantasy worlds, he also wanted to outdo Napoleon in the matter of magnificence. He saw the French emperor as a rival, but only in terms of his opulence, not as a man who had emerged from a political process that dramatically overturned patterns of rule and consent. George repeatedly staged celebrations and festivities and also sought to win popular favour. When he became Regent, Carlton House was thrown open to the public for three days and this rare chance to see the lifestyle of royalty drew 30,000 people on the last day alone. On several occasions, firework displays for the public were held in parks. Not without reason, the historian Steven Parissien has dubbed his reign 'the grand entertainment'.[107] George's coronation in July 1821, when he was 59 and no longer the dashing prince, was a magnificent ceremony for which he persuaded Parliament to vote no less a sum than £243,000. He envied Napoleon's fabulous coronation and sent a tailor to Paris to inspect the robes he had worn in order to ensure that his own would be no less impressive.[108] The splendid descriptions in Scott's Elizabethan novel *Kenilworth* no doubt informed the Elizabethan theme of the coronation.[109] Despite the legitimacy of his position, George's coronation was no less a piece of historical pastiche than his rival's.[110] Such was the sumptuousness of his clothes and coronation robes (over £24,000 had been spent on his robes, £855 on the ermine alone) that one observer suggested that he looked like 'some gorgeous bird of the East'.[111] However, the whole affair nearly turned to farce when the George's estranged wife, Queen Caroline, sought gain admission to Westminster Abbey and had to be barred.

Walter Scott was present at the coronation and he acted as choreographer-in-chief on the occasion of the royal visit to Scotland in 1822.[112] The month-long sojourn was the high-point of George's reign and possibly the moment of his greatest popularity. The king arrived with a fabulous array of costumes made especially for the visit including Highland attire and numerous Scottish accessories. Crowds cheered as he rode through the highly decorated streets of Edinburgh. Streamers and thistles, feathered hats, and displays of crowns and stars marked an occasion that was seen as having consolidated support for the monarchy north of the border. In the course of his visit, the king attended a command performance of *Rob Roy*, merely one of several of Scott's works that were adapted for the stage.

Despite these moments of celebration, George had not been popular as Prince of Wales or as Regent and he was not a popular king. For all his preoccupation with visual effects and appearances, his role was above and separate from the hurly-burly of the commercial realm, even if he chose to immerse himself in it. Like all established royalty, he was on a higher plane. He was not a new man of the modern era and there was no mystique about him since that normally pertaining to a monarch had dissolved in ridicule. In some respects, he was a throwback. He embodied a model of eighteenth-century indulgence and excess at a time when this was ever less tolerated. Although the political sphere was still largely dominated by the aristocracy, public opinion was in the hands of the middle class. In England as in France, the bourgeoisie sustained a polemic against the aristocratic mode of living, its luxury, effeminacy, high living, dissoluteness, and wastage, which were often depicted as feminine.[113] In the aftermath of the Napoleonic wars, this view gained the ascendancy. For many critics, George was the personification of indulgence and excess. As such, he was mercilessly lampooned in magazines like *Satirist* and *Scourge* and was frequently the target of caricaturists.[114] The novelist Jane Austen, whose works he admired, subtlely mocked him in her third novel, *Mansfield Park*. A prime exponent of the respectable provincial middle class, she drew in Tom Bertram a character who runs the affairs of his father while the latter is in the West Indies. Like the Regent, on whom he is modelled, Tom lives well, gambles, runs up debts, and loves ceremonial.[115] Although the press was not as vicious in its attacks

on George IV as regent and king as pamphleteers had been about Marie Antoinette, it was still firmly hostile. The attitude of public opinion to both royal persons shows how pomp and luxury could very easily, if deprived of the necessary legitimation deriving from the practices of bourgeois society, become manifestations of undeserved privilege and lead to a dramatic loss of approval. Glamour in this respect was an articulation of qualities that passed through the market and public opinion rather than through a hereditary hierarchy.

Napoleon and George IV both tried to convey an image of magnificence to impress their countrymen and other rulers. As a result, they were flashy, colourful, and theatrical. However, Napoleon, the new man who transformed Europe, gave rise to a legend that would persist long after his death. The dominant image of George, despite his magnificent garb and some superbly flattering portraits of him by Sir Thomas Lawrence, was of an idle wastrel who was merely a burden on the public purse. Writing thirty years after his death, Thackeray itemized the millions of pounds that the king consumed during the course of his existence and his limitless expenditures on luxury.[116] 'The handsomest prince in the whole world' in his youth, he became a portly, bloated monstrosity by maturity. The novelist deemed his invention of a particular type of shoe-buckle to be one of his most significant achievements.[117] He was also held to have been self-delusional. 'I believe it is certain about George IV', Thackeray continued, 'that he had heard so much of the war, knighted so many people, and worn such a prodigious quantity of marshal's uniforms, cocked-hats, cock's feathers, scarlet and bullion in general, that he actually fancied he had been present in some campaigns... and led a tremendous charge at Waterloo.'[118] From the standpoint of the mid-Victorian era, the lavish spectacles that were associated with him were deplorable indulgences. 'He is dead thirty years, and one asks how a great society could have tolerated him?', Thackeray asked.[119] If Napoleon was, for Carlyle, a charlatan, then George was 'a great simulacrum'. 'After reading of him in scores of volumes,' Thackeray commented, 'you find you have nothing—nothing but a coat and a wig and a mask smiling below it.' The sense of void that commentators found in Napoleon was testimony to the fact that he had risen from nowhere. He was,

in a way, any man. George's lack of substance arose from the fact that he was seen as a type of monarch who had no place in the present age.

English men and women were by no means insensitive to the fabulous seductions of bright colours, precious fabrics, lavish spectacles, and alluring images. But, like their French counterparts, they were not attracted to exhibitions of personal excess on the part of royal persons who openly disdained the egalitarian values that were ever more shared. Much more suggestive were the forms of glamour that were associated with the new personalities that the age of political and industrial revolution created. These shook up the long-standing association of material rewards with the hereditary elite and offered examples of self-creation that appealed directly to the imagination of everyone. This development caused intense problems to royalty and the great contradictions into which two fashionable royal persons such as Marie Antoinette and the Prince Regent fell amply illustrated this. In the sphere of the state, only Napoleon succeeded in developing a combination of appeals and behavioural patterns that resolved these contradictions and harnessed glamour to his purpose. But even he was obliged to impose censorship on the press and the theatre to avoid the perils of critical public opinion. Cultural figures were more fortunate, since they could weave narratives on their own terms and even use negative public opinion to cultivate an alluring image. They were able to employ the market and manipulate the media with strategies that were not conditioned by the requirements of statecraft. More than anywhere else, it was the modern city and its institutions that supplied the stage on which such personalities could flourish. As we shall see in the next chapter, the magic of glamour was inseparable from the hurly-burly of the metropolitan life.

CHAPTER 2

URBAN ENCHANTMENTS

Cities grew exponentially from the mid-eighteenth century and fashion, consumption, and entertainment became increasingly centred on them. Although royal courts continued to be a focus of elite social life for the rest of the nineteenth century, cities were more open to novelty and change and less formal in their rituals and institutions. In France, the court of Louis XIV and Louis XV had had a profound impact on the development of the luxury trades, theatre, and urban development of Paris. But it was always the court that, as the main focus of power and privilege, dominated. It was important in providing a platform for personalities and in forming the social calendar, as well as establishing the extremely refined forms of living, hospitality, and entertainment that bolstered monarchical authority. However, while Paris lost out to Versailles in the seventeenth and during most of the eighteenth century, it continued to expand and increasingly it acted as an alternative pole of attraction. The city offered a social milieu that drew in far more people and was less selective; it was brash, money-centred, and exciting. Its heroes and heroines did not always have much in the way of noble patina but instead they were rich, colourful, varied, eye-catching, good-looking, and stylish.

In London too, the stodgy and dull court of George III was eclipsed by urban events, scenes, and spectacles. In the late eighteenth century, the English capital was the largest city in Europe and around one-tenth of the country's population lived there. It was a city of work and of trade, but also a city of pleasure and display. Social life took place in coffee houses, taverns, parks, theatres, and brothels, and in the streets. London was also a city of shops. Already at the start of the nineteenth century, Oxford Street had over one hundred and fifty. Stores and theatres contributed to the culture of display that characterized the visual experience of metropolitan life and lent it variety and vibrancy. The fantastic range of goods testified to the wide reach of the British Empire and the variety of products that the Industrial Revolution had brought. Foodstuffs, beverages, confectionery, and spices tempted with their smells, while jewellers, silk mercers, drapers, tailors, milliners, and shoemakers offered everything the smart man or woman could desire. All of them aimed to attract the passer-by and customer with eye-catching displays. Meanwhile book and print shops, and newspaper vendors, brought the public events, novelties, and personalities.

The metropolis shaped the customs of the whole country and most especially the urban centres. While Paris emerged as a Mecca of style and luxury not only in France but in Europe and beyond, London established a special dominance in England as the Industrial Revolution undermined village life and fuelled interest in fashionable consumer goods. As early as 1771, the writer and economist Arthur Young noted that, with improvements in travel and communication, young men and women were increasingly drifting towards the capital.[1] Neither city developed in a way that was balanced. The grandeur and glitter of the nobility and the rich existed in sharp contrast to the poverty and degradation of the poor. But there was a mobile and democratic spirit to cities that was completely different from a countryside where the aristocracy still ruled in conventional fashion.[2] London, the actress and writer Mary Robinson observed in 1800,[3] was 'the centre of attraction for the full exercise of talents, and the liberal display of all that can embellish the arts and sciences'.[4] Many cities had some luminaries of national importance, but only in the capital, 'the lustre of these accumulates and collects itself into a focus of dazzling light'. 'The customs, opinions, amusements, and propensities of the community at large,' she

added, 'may be said to derive their leading features from the pursuits and pleasures which are practised in the metropolis of a kingdom.' In other words, the city was alluring and glamorous. Spectacle and display in the life of the metropolis served to unify rather than divide the classes through the common pursuit of certain customs and aesthetic effects. The city's '*spectacles* [are] well attended by nearly all ranks of persons', Robinson observed; 'and even the lower orders of society enjoy the humorous scenes of Sadler's Wells, the wonderful horsemanship of Astley, and the pantomime pageants of similar theatres'.[5] The promenade, especially on Sundays, was also an institution of note that was not exclusive and drew wide participation. The roads 'are thronged with pedestrians of all classes, and the different ranks of people are scarcely distinguishable either by their dress or their manners'. 'Refinement is . . . visible in the exterior ornaments of all ranks of people,' she claimed;[6] decorative accessories were adopted even by those whose general dress was not very elegant. This was not yet the mass age, and Robinson certainly exaggerated, but there was a certain democratization of the life of the capital that was driven by ideas and economic change. It manifested itself in the rough and tumble of low life as well as high life, the wide interest in theatre and fashion, the variety of personalities and their mixed origins, and in the primacy of money, merit, and beauty over birth.

Public opinion in the early nineteenth century was not fully formed but it did have, in embryonic form, some of the features that would mark it in later decades. While Paris, due to the dramatic political events, witnessed setbacks in the development of a free press as well as economic progress, London witnessed steady development on both fronts. In the last decade of the eighteenth century, there were some sixteen daily papers in the capital, while two were published twice a week and a further seven three times per week.[7] In addition to serious papers, there were many others that provided a ready diet of gossip, scandalmongering, satire, titillating sketches. 'The monthly miscellanies are read by the middling orders of society, by the literati, and sometimes by the loftiest of our nobility,' Robinson noted.[8] By contrast, 'the daily prints fall into the hands of all classes: they display the temper of the times'. The press played a crucial role in creating a shared pattern of metropolitan life. Robinson only churlishly acknowledged its

significance, like some celebrities today. 'The press is the mirror where folly may see its own likeness, and vice contemplate the magnitude of its deformity,' she observed, before accepting that 'it also presents a tablet of manners; a transcript of the temper of mankind'.[9] Papers and magazines provided something that was part mirror, part stage, and part social barometer. By recording and commenting on events and personalities, and channelling information, they created the image of metropolitan life. In this era the press was by no means the most important mediator of social relations; it was merely a factor in a complex equation in which personal observation and acquaintance with people, places, and events was more important. But it had a special purchase on the perceptions of those who were not able, for reasons of geographical or, sometimes, social distance to see things first-hand. Even in the 1790s, some 8.6 million copies of London newspapers were sent every year to readers in the rest of the country.[10]

In the history of glamour, cities are always important. The very idea of the modern city is bound up with wealth, power, beauty, and publicity. They are sprawling conurbations where very heterogeneous populations mix and thrive; they are a permanent laboratory of practices and lifestyles, personalities and situations. The press and other media constantly present pictures of fashionable people, events, occasions, places, openings, launches, and ceremonies to a public that is far broader than it was two centuries ago. Yet, even then, many of the characteristics of contemporary metropolitan life were present. Glamour was the aspect of the urban scene that captured and seduced ordinary people. To exist, it requires a high degree of urbanization, the social and physical mobility of capitalist society, some sense of equality and citizenship, and a distinctive bourgeois mentality. All of these were present in cities which increasingly presented numerous visual delights and pathways to self-transformation.

For the critic William Hazlitt, metropolitan life was 'an endless phantasmagoria'; 'even the eye of childhood', he continued, 'is dazzled and delighted with the polished splendour of the jewellers' shops, the neatness of the turnery-ware, the festoons of artificial flowers, the confectionary, the chemists' shops, the lamps, the horses, the carriages, the sedan-chairs'.[11] This visual inclusiveness constituted a vital condition of glamour. The spectacle

was not created solely by or solely for the social and political elite, although its contribution was important. Prominent people were keen to impress each other, but their practices of self-advertisement and display were absorbed into the more general visual festival. Colour, finery, and beauty could be glimpsed in many quarters; fame could spring from any number of public events and commercial institutions; desirability derived not from official sanction but rather from a combination of elements including the place a given personality occupied in the public realm, their physical appearance, and the narrative that was created around them. The buzz of the present, the clamour of novelty, the irresistible beauty of places, people, and events, were all features that arose out of the dynamism of the metropolis itself. This is not to say, of course, that the city was somehow instrinsically democratic, although its inhabitants were likely to have wider experience, more choice and more sense of themselves as individuals than their country cousins. 'In London there is a public; and each man is part of it,' Hazlitt noted.[12] Cities were centres of money and commerce, while also being the setting of a broader culture of leisure and pleasure.

For most of the period between the late eighteenth and the early twentieth centuries, London and Paris were rivals. Rivalry was primarily political; each country wished to have an impressive modern capital that testified to its might and glory. Napoleon wanted to make Paris the greatest and most beautiful city in the world and the leading city in Europe.[13] To this end, various improvements were introduced, new bridges and a new ceremonial route were built, all with the aim of creating new spaces. Monumental building took the form of the Arc de Triomphe and Les Invalides, but there were few demolitions, which were limited to one of the most danger-ous districts.[14] Although Paris became a vast building site, few projects were fully completed. At the end of his rule, there were still virtually no pave-ments, very little illumination, and streets were still used as sewers.[15]

The Prince Regent admired Napoleon's vision and promoted reforms of his own to London. The royal parks were opened to the people on certain occasions and there was some attention paid to the beauty of squares, public buildings, and bridges. He commissioned the visionary architect John Nash to formulate solutions to the problems of communication in central London

and design a processional avenue, with precisely the aim of eclipsing the splendours of Napoleon's Paris.[16] In London too there were new public spaces and institutions. London was a larger and richer city than Paris; by the late century, it was over twice the size. But it was the French who constantly seized the initiative in developing a paradigm of the modern city. This was not only because of the imperial ambitions of the Napoleonic era. After Louis XVI was compelled to leave Versailles and return to Paris in 1789, the previous split between court and city was abolished and the latter became the sole focus of social and political power. Already a vibrant centre, it flourished after the Terror as a glamorous stage. Fashion businesses, jewellers, architects, and decorators turned towards the city and its emerging ruling elite. When war was not on, wealthy Britons used to regarding Paris as the capital of style visited regularly and marvelled at the way beauty and wealth combined. Luxury trades revived and restaurants founded by former chefs to the aristocracy flourished. The institutions of the state held lavish balls and celebrations while a rapidly rising bourgeoisie took over aristocratic palaces, tastes, and luxuries. The new class of nouveaux riches which rose very quickly during the Revolution was louche and ostentatious. Mores were relaxed and some of the sexiest fashions ever seen prospered until the emperor banished them from his court. Although the frenzied social life of the Directory was short-lived, glitz and ostentation continued to flourish under Napoleon. Unlike Marie Antoinette, Empress Josephine, who lived in the former queen's royal apartments,[17] was part of the sprawling texture of the city's visible social life. Every day she selected new goods from the retailers and manufacturers who sought the patronage of the most fashionable woman in Paris.

In terms of glamour, fashionable milieux were crucial because they were the channel through which social privilege was blended with the life of the metropolis as a whole. Certain areas acquired an aura of desirability through the presence of the rich, their patterns of competition and display, and the institutions of consumption and entertainment. It was precisely in such locations that the contradiction of exclusivity and accessibility was played out because the display of privilege was part of the visual experience of the metropolis as a whole. Elite areas were not merely enclaves of privilege; they were central to the new image of the city as a whole. The city image came to

be shaped by the most beautiful and prestigious roads with their ostentation, dynamism, aspirations, and illusions. The commercial and entertainment establishments that sprang up within these areas were crucial tools of reinforcement and diffusion of this image. With the rapid development of the commercial sector, shops and stores came to occupy an increasingly important place in the visual and sensory experience of metropolitan life.

In London, the area of fashion was remarkably small. The so-called *beau monde* or *haut ton* in the early nineteenth century was restricted to the streets and squares of Mayfair.[18] Pall Mall, St James's Street, Piccadilly, and Bond Street were the main thoroughfares. The clubs, restaurants, and shops that catered to the needs of wealthy aristocrats and the men of fashion were all located there. The first luxury hotels were established in the same area during the Napoleonic wars to provide high-class accomodation to army and navy officers on leave.[19] The urban scene was one in which the rich and fashionable were constantly seeking to establish exclusivity in a context in which public places and commercial institutions, to some degree, were open. Pleasure gardens provided one of the more popular entertainments. Ranelagh Gardens in Chelsea enjoyed a heyday in the late eighteenth century before being eclipsed by Vauxhall Gardens, which, later in the century, would in turn be displaced by Cremorne Gardens. These were the amusement parks of their day; they featured theatres, labyrinths, artificial groves, refreshments, bandstands, dance arenas, lighting effects, and other diversions. Respectable during the day, they were more raucous and sexy at night. There was little social selection in such settings. The upper and lower classes mingled as they did at sports grounds. In general, the rich generally preferred a type of rendezvous that, while not private, was less accessible to others. Hyde Park, and especially the area known as Rotten Row, became just this sort of semi-exclusive place. At five o'clock in the afternoon, horses and carriages of striking beauty and expense were flaunted by fashionable gentlemen and ladies, just as they were at the Bois de Boulogne in Paris. However, even with such a cost discriminator, exclusivity was difficult to maintain. 'In the early years of the century,' the social observer Captain Gronow moaned, 'the equipages were generally much more gorgeous than at a later period, when democracy invaded the parks, and introduced what

may be termed a "Brummagem society", with shabby genteel carriages and servants.'[20] In those earlier days, you never saw, he remarked, 'any of the lower or middle classes of London intruding themselves in regions which, with a sort of tacit understanding, were then given up exclusively to persons of rank and fashion'.

Women were generally less prominent than in France except for those who were drawn to or were products of the world of celebrity, fashion, and entertainment. At the interface between this world and high society there was considerable confusion between the grand and the faux-grand since everyone was egocentric, theatrical, visible, and controversial. The portrait painter Sir Thomas Lawrence, whose works were important in fixing the public images of many famous people, could make little distinction between the ultra-fashionable Georgiana, Duchess of Devonshire, and the prominent actress Mrs Siddons. While the former was naturally theatrical, it was said, the latter was naturally aristocratic.[21] In France in the same period, many society women had themselves painted wearing opulent jewels and fashionable dress just like actresses.[22] Glamorous women were not those who conformed to conventional morality and remained confined to approved spaces. They were those who were part of the glitter of fashionable life. They paraded their beauty, they shopped, and they pioneered fashions. They were the objects of a continuous narrative about their lives, loves, and whims.

The *haut ton* seized opportunities for public display. Indeed, it only assembled, Gronow added, 'to see and be seen'.[23] London thrived on the personalities and the doings of the upper classes. Gossip arose out of intimacy; that is to say out of a context in which aristocratic people knew each other.[24] But the press made the circle far wider. In contrast to France, where censorship was heavy and, under Napoleon's rule, the newspapers published were reduced from seventy to thirteen (he personally thought that there should be only one), the press flourished. People enjoyed learning of the pleasures and peccadilloes of the famous, which were conveyed with glee by chroniclers. Newspaper accounts encouraged a certain posturing. 'Men are tempted to make themselves notorious in England by the ease with which they succeed,' noted the poet Robert Southey who, under the pseudonym of Don Manuel Alvarez Espriella, published in 1807 a volume of *Letters from England*:

The Newspapers in the dearth of matter for filling their daily columns, are glad to insert any thing,—when one lady comes to town, when another leaves it, when a third expects her accouchement; the grand dinner of one gentlemen, and the grand supper of another are announced before they take place; the particulars are given after the action, a list of the company inserted, the parties who danced together exhibited like the characters of a drama in an English bill of the play, and the public are informed what dances were called for, and by whom.[25]

The middle classes were fascinated by their social superiors. While they criticized wastage and excess, they enjoyed vicarious escape into glittering high society. This taste inspired an entire literary genre from the 1820s that made a significant contribution to the development of glamour. Appearing after the successes of Scott and Byron, the so-called 'silver fork' novels acquired their name on account of the great prominence that one of their authors, Theodore Hook, gave to grand dinners that he described in great detail right down to the nature of the cutlery used. The creation of an enterprising publisher called Henry Colburn, they were set in the fashionable world of London's West End which was rendered as a fast, refined, materialistic, and eminently desirable milieu.[26] Colburn marketed the novels (which were mostly published anonymously) as though they were the work of authentic members of high society. In several cases this was true, but in others authors were aspirational fantasists with vivid imaginations. The novels appealed to several different constituencies. They entertained the upper classes, who read them as *romans à clef*; they were also eagerly devoured by the wealthy bourgeoisie who gleaned information from them about such things as the rituals of the social season, where to rent a house, which shops to patronize, what was the correct time to take a ride in the park, and so on. In addition, they were consumed by middle-class subscribers to circulating libraries who gained from them fascinating glimpses into the life of the *beau monde*.[27]

The novels always featured balls, dinners, duels, dandies, country houses, ruinous gambling, beautiful ladies, and charming villains, usually drawn from the lower ranks of the aristocracy.[28] They were liberally sprinkled with noble-sounding names and descriptions of material objects and environments.

There was a particular attention to public or semi-public establishments that most readers would have heard of and to which even vicarious access would have seemed more plausible than entry to private houses. These included Almanack's, the exclusive dance club run by women, and Crockford's gambling club. Publishers quickly learned that glamorous elements to captivate the public were best woven into works that dealt with high life, low life, ancient life, and exotic life. All provided fantasies of transformation away from the mundane and the everyday.[29]

Published between the 1820s and 1840s, the novels of Catherine Gore, Benjamin Disraeli, and others were in fact often set during the Regency.[30] Authors used the glitter and style of the period to fascinate audiences for whom its hedonism and excesses were no more than a memory. The exciting age of the Regency was not one that the stolid middle classes of the era of William IV and Queen Victoria wanted to restore. Rather they despised its self-serving indulgence and immorality, but they were drawn to it as imaginative escape, as a beautiful but flawed age.[31] The 'silver fork' genre had first been called the 'Dandy School' and among the real-life personalities who was evoked directly or indirectly in the novels was one of the most notable figures of the Regency era, the celebrated dandy George 'Beau' Brummell, who came to have a significant impact on the dynamics of metropolitan life.

In the past, social leaders had established their superior status by means of refined clothing and accessories. The sheer cost of the clothing of noblemen and women had acted as an insurmountable obstacle to parvenus and social climbers. However, not only was such excess ever less convenient in the prevailing climate but excess had been carried to almost satirical extremes by the eccentrically dressed Macaroni who flourished in the 1760s and 1770s. Flamboyance and foppery were the main hallmarks of young men who mimicked courtly clothing and current French and Italian fashions, which they had picked up while away on the Grand Tour. These men took more interest in themselves and each other than in women and may have been homosexuals.[32] They were certainly labelled as effeminate. They celebrated artifice and self-fashioning but their excesses made extravagance seem ridiculous and vulgar,[33] even when embraced by members of royalty. In the years that followed, consumption became more discreet and subtle.

The pioneer of what would become the dress style of the English gentle-man, Brummell favoured an emphasis on understatement and precision. He disdained the colour and visual flair of flamboyant dandies for a limited palette of black, white, and subdued tones. This was more in line with the sort of clothes that were worn by rough-house Regency bucks, high-spirited aristocratic men who indulged fully in the pleasures of both town and country. But Brummell was less interested in sports than in style. He set great store by scrupulously white, country-laundered shirts and perfectly tied neckties. He was a polished and impeccably groomed man who was perfectly in tune with—and who indeed contributed to create—the fashion culture of the metropolis. For Brummell, fashionable primacy had to be asserted on a terrain where competition was inevitable. For this reason, his most recent biographer, Ian Kelly, sees him as a transitional figure who symbolized important changes in what he describes as 'the semiotics of peacockery'.[34]

Brummell was born into a family that was close to the elite (his father had been secretary to the prime minister Lord North) but he was not socially distinguished and he owed his emergence to a stroke of luck. After studies at Eton and Oxford, he met and impressed the Prince of Wales to the extent that he was granted a commission in the Tenth Hussars, his personal regiment for which he had even designed the uniforms. Brummell allegedly resigned his commission when the regiment was to be transferred to Man-chester. However, this experience placed him at the centre of the London scene and provided him with the platform from which he launched his social career. If glamour is taken to be a melange of bright and not always tastefully arranged materials and effects, then Prince George was a far more glamorous figure than Brummell. At his father's birthday in June 1791, when he was still Prince of Wales, he arrived wearing a striped silk coat and breeches in deep red and bottle green and a silver waistcoat studded with gems. There were even diamond buttons on his coat and waistcoat, a custom started by none other than Louis XIV.[35] But in other, more important, respects, Brummell was at the centre of the social and cultural transformations that brought glamour as a system of relations and effects into being. Although he owed his initial rise to the prince, Brummell's influence was due to a new pattern

of male dressing that did not distinguish so overtly between the rich man and the poor man or the noble and the commoner. A hierarchy of beauty and taste emerged that was distinct from, and, in the context of the metropolis, more important than, lineage or even—to rather lesser an extent—money.[36] Brummell was the first product of this system just as related breaks in the social and political order had permitted the rise of Napoleon and Byron. A man of middle-class origins who mixed in the most exclusive social set, he performed a masquerade of superiority that was admired by contemporaries and seemed to be eminently copiable.[37] He was desirable and desired, imitable and imitated. Moreover, he was at the core of the publicity machine of his day.

In the context of the metropolis, appearances took on a special importance because people were constantly encountering others whom they did not know.[38] This provided opportunities for those who invested time and effort in cultivating a front. The dandy was a figure who was not distinguished by the nature of his clothes so much as by the importance he attached to them. 'A dandy', Thomas Carlyle declared in his satire *Sartor Resartus*, 'is a Clothes-wearing Man, a Man whose trade, office and existence consists in the wearing of Clothes.'[39] 'Appearing at the top of the mode no longer depended on the power of purchasing certain expensive articles of dress, or in the right of wearing them,' Hazlitt observed. Rather, he continued, 'any one who [chooses] might cut as coxcombical figure as the best....A lord is hardly to be distinguished in the street from an attorney's clerk; and a plume of feathers is no longer mistaken for the highest distinction in the land!' 'Clothes and social confidence will set anybody up in the trade of modish accomplishment.'[40] Hazlitt proclaimed this to be a modern achievement: 'The idea of natural equality and the Manchester steam-engines together, have, like a double-battery, levelled the high towers and artificial structures of fashion in dress, and a white muslin gown is now the common costume of the mistress and the maid, instead of one wearing, as heretofore, rich silks and satins, and the other coarse linsey-wolsey.'[41]

By the early nineteenth century, manufacturing had brought fashion and consumer goods within the reach of far wider strata. Fashion was no longer largely a courtly interest but part of the texture of metropolitan life that thanks

to fashion plates and improvements in roads and communications reached even village-dwellers and shops.[42] The duchess and her chambermaid, Mary Robinson argued, albeit with some exaggeration, 'are dressed exactly alike'. She observed that 'the nobleman and his groom are equally ambitious of displaying the neat boot, the cropped head, and the external decorations, as well as the quaint language, of the stable-boy'. These insights point to the existence of metropolitan fashions that were not purely related to the class system; even though status was still and would remain important, there were some modes and manners that were intrinsically metropolitan. 'Refinement is … visible in the exterior ornaments of all ranks of people,' Robinson claimed;[43] decorative accessories were adopted even by those whose general dress was not very elegant. No one was under any illusion that the great cities were places of equality. London was still highly class-conscious and differences of wealth were very marked. The great novelty was that distinctions were no longer seen to be fixed.

Mary Robinson was not the only one to comment on the strangely inclusive nature of the metropolitan parade. Hazlitt, a near contemporary, mused on the way cockneys (by which he meant all Londoners who had never lived outside London) identified with the most desirable environments and pastimes, even those they were practically excluded from. The typical cockney, he observed, 'sees everything near, superficial, little, in hasty succession':

The world turns round, and his head with it, like a roundabout at a fair, till he becomes stunned and giddy with motion. Figures glide by as in a *camera obscura*. There is a glare, a perpetual hubbub, a noise, a crowd about him; he sees and hears a vast number of things, and knows nothing. He is pert, raw, ignorant, conceited, ridiculous, shallow, contemptible. His senses keep him alive; and he knows, inquires, and cares for nothing further. He meets the Lord Mayor's coach, and without ceremony treats himself to an imaginary ride in it. He notices the people going to court or to a city-feast, and is quite satisfied with the show. He takes the wall of a lord, and fancies himself as good as he. He sees an infinite quantity of people pass along the street, and thinks there is no such thing as life or a knowledge of character to be found out of London.[44]

Processes of social selection and exclusion no longer occurred solely on the basis of position or birth.[45] Rather there was a series of institutions and rituals where practices of exclusion obtained, from gentlemen's clubs to the

Hyde Park promenade, from dress style to language. This meant that even some of the well-born could find themselves marginalized on some level, or subject to the capricious judgement of a parvenu like Brummell, on account of their physical or social awkwardness, or lack of wit and style. Through this means, a fashionable coterie was forged that, while not exactly meritocratic, was defined on the basis of the life of the metropolis rather than the aristocratic principle of the land and birth. Exhibitionist and fun-loving aristocrats were fully part of this, but so too were attention-seekers, ambitious creative types, and beauties. They figured prominently in the press and the scandal sheets that reported on them and glorified them. It was this world, where it was ultimately not birth but money that was king, that Thackeray captured in *Vanity Fair*. From his viewpoint the fashionable world was a fair of vanities, a notion that by itself conveyed the idea of noise, crowds, competition, and display.

Brummell was a snob and a social climber who was sometimes seen as a new man like Napoleon. He was a self-aware model for the ambitious. As Captain Gronow put it, 'all the world watched Brummell to imitate him, and ordered their clothes of the tradesman who dressed that sublime dandy'.[46] The man himself spent his days on a round of pleasures that included walking, riding, shopping, gambling, dining, and hanging out with courtesans. According to his biographer, he 'was always drawn to glamour'.[47] He shared with the courtesans a reliance on image in maintaining position. His aloof attitude and position as an *arbiter elegantiarum* inevitably made him intriguing and fascinating.[48] He enjoyed widespread fame and a general desire to imitate his mastery of style spread among men of all classes. By seeking to be 'inimitable', he automatically established a relationship with emulative practices and aspirations. He was the first embodiment of the glamorous paradox of accessible exclusivity.

The dandy phenomenon was one that was widely regarded as intriguing and this ensured that it was continually debated. The author of one satire, entitled *Dandymania*, noted that there were 'Dandy Lawyers, Dandy Parsons, Dandy Physicians, Dandy Shopkeepers, Dandy Clerks, Dandy Authors, Dandy Beggars, and Dandy Pickpockets'.[49] Robert Southey found that in 'the famous Bond-street' there is a 'professor... who, in lessons at half a

guinea, instructs gentlemen in the art of tying their neckerchiefs in the newest and most approved style'.[50] The cult also crossed the Channel as Parisians began to copy English dress styles and 'dandies in black dress coats and shiny riding boots made their appearance on the boulevards'.[51] As a Lakeland poet, Southey had little time for the fashionables. 'These gentlemen stand highest in the scale of folly, and lowest in that of intellect, of any in the country', he thundered.[52] 'It is impossible to describe them, because no idea can be formed of infinite littleness; you might as reasonably attempt to dissect a bubble or to bottle moonshine, as to investigate their characters.' Brummell himself would be ridiculed in several 'silver fork' novels some time after his stiff collars and high cravats had passed out of fashion. Yet he was difficult to pigeonhole. On the one hand, he adapted to the personal reserve and rejection of theatricality that marked the emerging model of masculinity; on the other, he subverted it by making a display of his sartorial and grooming practices.[53] His highly ritualized five-hour morning toilette drew spectators, among whom there was, on a few select occasions, even Prince George.

Like many later arbiters of style who were not an organic part of the social elite, Brummell probably suspected that his position was not exactly unassailable. But the manner in which the prince studied him, adopted the fashion for snuff-taking, and sought tips on male elegance, in addition providing him with frequent hospitality, bolstered his confidence. Brummell often indulged in witty banter but his encounters with the prince lost some of their cordiality. After receiving a snub, Brummell and his friends organized a reception to which they deliberately failed to invite the prince. The ensuing fuss obliged them to back down and issue an invitation. When the prince arrived, he conversed with some of the hosts but turned his back on Brummell. The dandy responded by loudly asking one fellow, 'Alvanley, who is your fat friend?' Brummell owed his entry into high society to the favour he enjoyed with the prince; this insult caused it to evaporate.[54] Soon after, he fled to northern France, where he would spend the rest of his days.

The loss of royal patronage was damaging but Brummell's downfall was not in fact solely due to his falling-out with his one-time patron. He was the architect of his own demise in so far as he, a man without extensive

resources, had been seduced by the ruinous Regency vogue for heavy gambling. Like duelling, the indifference to loss it entailed showed the gentlemanly sangfroid of its practitioners and distinguished them from social upstarts. Ultimately, it was the imminent threat of ending up in prison for debt that led Brummell to abandon the scene and flee to France. His rise and fall was the typical trajectory of the glamorous personality, as the cases of his contemporaries Byron and Napoleon showed. His downfall marked the end of the social career of the man but not the phenomenon in which he had been a catalyst.

A society that attributed importance to front and performance needed mirrors to hold up to itself. In the social relations of the metropolis, theatre won new importance. It was a realm unto itself, a sphere that was both special and separate with respect to society, while also being an integral part of it. It was one of the prime locations for the formation and perpetuation of a common metropolitan culture. It acted as a codifier of behaviour in an impersonal society in which appearances and rituals were important and the deference that was still commonplace in the countryside was lacking. It attracted all classes and was an essential element of daily pleasure.[55] It was the one place where everyone was on display at once.[56] To this extent, theatres had a pedagogical function. For Mary Robinson, 'the open schools of public manners, which exhibit at all times the touchstone of the public mind, are the theatres'. Hazlitt concurred, noting that 'a playhouse alone is a school of humanity'.[57] This was so despite a constant recycling of Shake-speare, as well as of certain standards such as Sheridan's brilliant comedy of manners and social types *School for Scandal*, which remained a favourite for several decades after its debut with an all-star cast in 1777. With its sparkling dialogue and mocking of aristocratic pretensions, the play was one of the channels through which a sense of the new fluidity in social relations took shape. In cities there was a sense of belonging and citizenship and indirect social relations prevailed. Hazlitt added that only in big cities such as London, 'there is a public; and each man is part of it'.[58]

It was through theatre that a special grammar of composed behaviour was forged that was a feature of metropolitan life.[59] A man like Byron, for example, cannot be understood without reference to it. A regular habitué of

theatreland and an admirer of Edmund Kean, he loved the world of profes-
sional illusion and the possibilities it offered for the displacement of conven-
tional morality.[60] Brummell's sense of composure and performance derived
from personal experience of the stage, including acting during his school days
at Eton. The theatre offered him an understanding of how he could occupy a
role in London society and use wit and style as arms of combat.

Theatre was part of the fabric of leisure of the city. Plays were performed
at fairs and in pleasure gardens as well as taverns. It was not just what was
seen and heard on stage that mattered, but the whole experience. People
went to look at the audience as much as the stage and to be seen by others.
Select theatres such as the King's Theatre in the Haymarket, the home of the
Italian opera and the ballet, offered box subscriptions for sale that were eye-
wateringly expensive. For the fashionable elite, men like Brummell and his
friends, the theatre was another opportunity for social performance of their
own. While the middle classes and out-of-towners came for the play, the
haut ton distinguished itself by arriving halfway through the performance of
plays that, for it, were usually very familiar. Its members typically made a
great deal of noise as they occupied the boxes that served as a means to
establish visibility and social prominence. However, theatre audiences were
made up of a cross-section of society and were often rowdy and vocal. Far
from being deferential towards their betters, they often subjected the occu-
pants of the boxes to positive or negative responses according to whim.

In the early eighteenth century, theatres were closely regulated. In Paris,
Louis XIV had established state theatres and given them a monopoly of
certain types of entertainment. Only two theatres in London were licensed
for prose productions and the repertoire of plays was very limited. A century
later, the same two theatres dominated the scene, but, after they were burned
down in fires, Covent Garden was rebuilt to hold 2,500 people and Drury Lane
3,600.[61] When Southey visited the latter, he wrote: 'I had heard much of this
theatre, and was prepared for wonder; still the size, the height, the beauty, the
splendour, astonished me.'[62] To attend them was seen as a right and any rise in
ticket prices provoked protests. Paris was well behind London in the devel-
opment of larger theatres, although commercial theatre developed from the
1760s bringing plays to the poorer classes, who previously had only encoun-

tered performance at fairs. In the following decades, the theatre became a forum of public opinion, with apparently innocuous plays being loudly applauded when a phrase of some possible wider application was pronounced.[63] During the 1790s, royal theatres were stripped of their privileges and restrictions on new establishments were lifted. Professional actors played to a public that often indulged in amateur theatricals and which was said to be gripped by *théâtromanie*.[64] The city had no large theatres under the Empire but a large quantity of small stages. There were so many in fact that Napoleon, who was suspicious of their subversive potential, closed down three-quarters of them by decree, leaving only the four official theatres and four privately owned ones. 'Is it not disgraceful that Paris does not have a sole French theatre or opera worthy of the city that hosts it?', he exclaimed.[65] In consequence, discussions began that would eventually lead to construction of the Opéra Garnier under the Second Empire.

The idea was forged during this period of the metropolis as a place where things happened and where life was lived more intensely. As such, it lent itself to narratives of a fictional and semi-fictional nature. One of the earliest and most successful examples of the way the metropolis bred narratives of itself was provided by Pierce Egan's characters Tom and Jerry (the historical antecedents of the cartoon cat and mouse). First published as monthly instalments in 1821, Egan's 'Life in London' was originally intended to exploit a possible market in the provinces for tales of London life. Its premiss was that 'if Londoners [were] keen on books about country and outdoor pursuits why should not provincials and even Cockneys be anxious to learn about life in London[?]'[66] In the stories, Corinthian Tom, a town dandy, and his country cousin Jerry Hawthorne are Regency bucks who cavort in the canonical locations of Mayfair and go cruising in the Burlington Arcade. They get into scrapes with roughnecks and are drawn irresistibly to gambling clubs. The serial, illustrated by Cruikshank, was a huge success and even reached the attention of George IV, to whom it was dedicated. Tom and Jerry were men about town whose adventures were full of identifiable characters, streets, and gin-shops. The opening song of the stage version celebrated London as 'a dashing place ... where novelty is all the rage—from high to low degree'.[67] As with all metropolitan dramas, much emphasis was

given to appearances. 'A man must have the look of a gentleman, if nothing else,' Tom declared; 'We must assume a style if we have it not.'[68] The stage show was so successful that it gave rise to numerous pirated versions. Other authors imitated the structure of Egan's work, including Bernard Black-mantle, whose *The English Spy* catered to a 'silver fork' public by including more and better-observed high society episodes.[69] Such successes confirmed that London was as much an imaginary place as a real one and that fantasies of London life often provided people with keys to interpret the city as a site of adventure and excitement where fashionable places and people, as well as low-life haunts, were accessible to everyone.

Gossip about the socially prominent that had been the bread and butter of the scandal sheets gave way to more acceptable coverage of performers and theatrical events. The rise of respectability resulted in the world of perform-ance taking on the burden of society's fantasies of transgression. Writing in 1839, Charles Dickens noted how 'theatrical converse' had become common currency in a London that was filled with people aspirant above their social station.[70] Theatre was a key platform in many a launch to fame and notoriety. For example, a prominent figure like Mary Robinson, who enjoyed celebrity status following a brief liaison with the Prince of Wales, appeared on stage, was a fashionable icon who introduced the latest French modes, a professional beauty, a royal mistress, and wrote novels.[71] For someone such as her who, like Brummell, owed some of her celebrity to a royal connection, the metropolis was a great stage; its pleasure gardens, theatres, salons, and social gatherings were all places to be seen. Robinson was a master manipulator of public opinion who regularly reinvented herself. She was a glamorous, much-admired, personality who was regularly to be seen in her superb carriages. For the press, the ongoing narrative of her love life was public property. She was one of the first people to appreciate and exploit the commercial value of celebrity.

The buzz of theatrical novelty did not derive from the established playhouses so much as the new theatres that produced musical entertainments, shows, and dancing. Patrons of theatrical entertainments, regardless of their social class, were fond of variety, colour, and spectacle. Establishments such as Astley's amphitheatre provided a mishmash of drama, circus, horsemanship, and

pantomime that reflected a love of novelty and brightness that characterized metropolitan life in general.[72] Pictorial extravaganzas and visual sensations became more important as the century progressed. In this way theatre provided the regular outlet for the demand for display that modern society generated. Audiences whose lives were marked by routine found an escape in the colourful dramas and personalities of the theatre.

While printed material and books remained important, visual novelties provided a more direct stimulus to the common imagination. Projected images and limelight were deployed in extravagant shows and pantomimes. Giant productions, with huge crowd scenes and spectacular effects were a stock-in-trade at Astley's, which re-enacted great world events such as the fall of the Bastille or the battle of Waterloo, often within days of them occurring.[73] Costumes, 'pictorial splendours', and the pursuit of illusion were feared by some contemporary observers to be displacing the ability to treat human feeling and behaviour.[74] None the less, workers and the middle classes especially found in entertainment a welcome relief from the daily grind. The development of electricity in the last decade of the nineteenth century led to further stress on the brash and garish. So 'profuse and glaring' was the light bathing the stage that, according to one journalistic observer, 'all distance and mystery is lost, while the scene painters are compelled, in self-defence, to make their colours as fiery as possible'. Their attempts were not entirely successful. 'The glare of light in which our stages are bathed is fatal to all illusion,' noted the same observer; 'it reveals everything, the rifts in the boards, the texture and creases in the canvas, the streaks of paint. The light, playing on the edges of the side scenes, would show us that they were mere screens.' However there was a way forward. Once its use could be properly modulated and controlled, electric light could assist rather than undermine illusion: 'with subdued lighting, and low, rich tones and colours, the edges would be softened away, and all made into one whole'.[75]

In his disguise as a foreign visitor to London, Southey found himself 'astonished at the opulence and splendour of the shops.... Nothing which I had seen in the country prepared me for such a display of splendour.'[76] As the city grew as a centre of entertainment, so it expanded as a retail centre. With the early nineteenth-century rebuilding of the West End, which gave

social prominence to new shopping areas, such as Regent Street and Oxford Street, that were near to the fashionable elite and the theatres, more shops sprang up. Even though men like Brummell notoriously ran up huge debts on their accounts, the dandy was a great boon to shopkeepers. The great attention these men gave to their appearance and the extensive publicity they received ensured that tradesmen were able to profit from their custom on a grand scale and benefit from the influence they had on others. Shirt-makers, silversmiths, cobblers, tailors, hatters, glovers, and perfumers took advantage and played on the allure of sophisticated lifestyles to win converts to consumption. In the wake of the dandy craze, many tailors and shops set up in the vicinity of St James's Street and Jermyn Street, which functioned as a sort of open-air salon for men of fashion.[77]

Shopping was already a leisure activity and a pastime in the 1750s. Dr Johnson remarked on the proliferation of fashionable shops in exclusive areas in London, although his distrust of any activity that required new clothes did not make him an ideal customer.[78] The phenomenon was not limited to the rich. The expansion of shops and shopping was driven by the desires and the habits of ordinary people and especially the burgeoning middle class.[79] Business people, professionals, and clerks embraced consumer goods on account of the values of politeness, modernity, respectability, and independence that they conveyed. They were not associated with aristocratic excess but with civility, taste, and moderation. At a time when land was difficult to obtain, even for the rich, or was beyond reach, goods tended to become adopted as the main symbols of distinction. Although British consumption in the eighteenth century was fuelled by the global trade in Eastern luxuries, most new goods were made with modern methods and materials. The process of manufacture created a 'semi-luxury' that lacked the uniqueness of upper-class luxury, even if some of the pleasures provided by sight, smell, and taste were shared.[80] Techniques of selling and presentation developed in tandem as shopkeepers decorated their exteriors with coloured paints and adornments and furnished their interiors to make them inviting. Because of these innovations, the historian Maxine Berg has argued that 'the eighteenth century is the defining moment in the history of consumer culture in the west'.[81] On the one hand consumption was about

lifestyles, on the other it was about dreams and desires. Yearning and longing, phenomena of the imagination largely unknown to the feudal aristocracy, were central to middle-class consumption.[82] In between these poles, there was an intermediate realm of sensorial pleasure that was both stimulated by, and which in turn further stimulated, imaginings and longings. Exoticism was one of the key ways in which these various elements were held together.[83] The success of Byron's Eastern poems and the curiosity his adventures aroused were fuelled by this nascent consumer culture.

The development of a national market and national advertising for manufactured goods began as early as the 1760s. Josiah Wedgwood pioneered mass-produced pottery and developed original ways to sell it.[84] He used press advertising, smart showrooms, and astute self-promotion. An innovative manufacturer, he was also a publicity genius who realized that by attaching an aristocratic or even royal patina to his products he could sell them for higher prices. He went to great lengths to secure customers among the nobility, even to the extent of sending them unordered items for which they were later billed. He then advertised this patronage to promote his wares among the broader public. His greatest coup came in 1773, when Catherine the Great of Russia commissioned a thousand-piece dinner service for state occasions. Before it was shipped, Wedgwood put the service on display and even charged admission to view it. The exhibition drew a massive audience that included even some royals and many nobles. The aristocracy may no longer have dominated consumption but it preserved a role as tastemaker and example that carried great cachet.[85] The street culture of the modern metropolis was populated by the would-be aristocrats, swaggering apprentices, shabby-genteel people, theatrical young gentlemen, and bragging imposters that Dickens observed in his notes on London.[86] Many of these approximated to Baudelaire's Parisian *flâneurs* as observers of the city's novelties and curiosities. They were ostensibly looking up at their betters, but imitation was not, in this instance, the most sincere form of flattery. Consumption was never only about social climbing. It also involved fantasies about individual identity and material gratifications.

Glamour was the seductive and captivating surface aspect of the urban scene. Scintillating occasions caught their attention and provided them with spectacle and amusement. For Hazlitt, the London dweller was a man who

'comes so often in contact with fine persons and things, that he rubs off a little of the gilding, and is surcharged with a sort of secondhand, vapid, tingling, troublesome self-importance'.[87] He is 'dazzled with noise, show, and appearances' and in consequence 'lives in a world of romances—a fairyland of his own'.[88] Baudelaire, more famously, observed similar phenomena in the Paris of the 1840s. His *flâneur*, like Hazlitt's Londoner, was a male figure who delighted in the sights that the city offered, glittering displays, shop windows, pretty women, fine carriages, and so on. But whereas the Frenchman concentrated on the visual surface of modern life, the English critic captured the way urban visual sensations have a remarkable capacity to distort social relations and create a common experience. Fleeting sensations were curiously sticky and memorable. Hazlitt's subject was not the well-to-do idler (or Bond Street lounger, in the London language of the 1820s) but rather a worker: a footman, a tailor, a barker, or a slopseller. It was men like these who were drawn into the milieu of the metropolis and its 'gorgeous, glowing scene'.[89] Glamour was a blend of desirable and opulent lifestyles, spectacle, and sex appeal that became a feature of modern urban society. All classes were susceptible to this, although they each related to it in different ways. The appropriation of elite style and cachet and the remaking of these qualities by the commercial sector contributed vitally to the formation of a common language of allure. Style was only glamorous to the extent that it was perceived as such by the lower urban classes.

Although many people were drawn to shops and fashion, there were cultural obstacles to continuous acquisition. This meant that strategies of enticement were required to manipulate wants and needs, to attract interest, to promote aspirations and create rituals that made consumption satisfying. Merchants and pioneers of retailing drew heavily on showmanship, magic, and religion. Great attention was dedicated to where and how goods were shown and sold, advertising developed as a medium, and technology was harnessed to maximum effect. These efforts served to create contexts that endowed commodities with an aura, a mystery, or an appeal that went beyond their basic essence.[90] The daydreaming to which novelists had become so

expert in catering to was sustained and further stimulated in the arcades and stores that became the new retail outlets of the age of consumption.

While abstraction, rationality, and money became the guiding principles of the economic system, irrational impulses, romantic currents, and illusions prospered. Magic, trickery, and illusion were annexed to the commercial imperative to camouflage it and render banal things desirable, beautiful, enviable, and intriguing. Corridors of iron and glass forming arcades of small shops were the first edifices specifically to be erected as centres of consumption. As enclosed multi-unit environments, they were the forerunners of the shopping malls of the late twentieth century. Specializing in luxury goods and situated in fashionable areas, they drew both the wealthy and curious browsers. The Marxist critic Walter Benjamin, writing in the 1930s, identified commercial arcades of the type that were built in London in the 1810s and in Paris a little later as the prototypical setting of the consumerist dream world. In them, he wrote, 'commodities are suspended and shoved together in such boundless confusion, that [they appear] like images out of the most incoherent dreams'.[91]

As the century progressed, the dreams seemed less incoherent due to the increasing sophistication and scale of work of image-makers. Photographers, graphic artists, industrial designers, architects, and lighting specialists all contributed to the building of arcades, panoramas, winter gardens, theatres, public spas, stores, stations, as well as the great exhibitions. All these institutions distorted reality or created alternative realities. 'All collective architecture of the nineteenth century provides housing for the dreaming collective,' Benjamin argued,[92] although he also found dream material in middle-class interiors. The heavy objects, dark colours, and overworked furniture of the late Victorian era created an aesthetic of excess that was itself dream-inducing.[93] Consumers wanted to be something different from what they were and they shaped their material environments in line with their dreams.[94]

The great exhibitions, which became a hallmark of the industrial age, were ephemeral monuments to the new material civilization. They were huge encampments into which all could gain access and experience the wonders and the abundance of the age of industry. Although the first great exhibition

was held in London in 1851, Paris took over the idea and made it its own. The gigantic spectacles of the great exhibitions that were held in Paris in 1855, 1867, 1889, and 1900 were central to the French bid to establish their capital as the centre of European civilization. Napoleon III presided over a massive increase in French industrial production and promoted prosperity as a diversion from dictatorship. All forms of spectacle, excitement, and display were harnessed to this end. Even after the fall of the Second Empire in 1870, the connections between consumerism and entertainment were especially close in France.

The exhibitions admitted people of all classes and took them into a realm of possibilities that previously could not have been imagined. They brought together art and commerce, and technology and entertainment. Whereas the London exhibition displayed no prices, with the result that the abundance of goods provoked awe rather than covetousness, the Paris exhibition of 1855 displayed goods in a sumptuous fashion with price tags on view, giving people the opportunity to 'browse, explore and dream of potential ownership'.[95] As spectacles, the exhibitions were unrivalled. They were huge in scale, highly innovative in their architecture, and at the forefront of developments in applied technology. At first elites were wary of dropping the entry price low enough to admit the masses. But experience showed that workers were no less fascinated than others by the display of wonder and plenty.

However, they were soon joined and eventually eclipsed by department stores. Outside very large cities, such stores today struggle to survive but, in the middle of the nineteenth century, they were the monuments to the grandeur and wealth of the cities which hosted them. The big stores sold huge quantities of goods to vast numbers of people at prices that were lower than ever before. They contributed to the new function of the city as a pleasure zone by offering the shopper a range of sights, seductions, and services.[96] They also added to the brightness and magical atmosphere that marked districts characterized by wealth, power, entertainment, and consumption.

The Oriental imagery that became increasingly important was informed by France's imperial involvements. The expositions of 1867 and 1889, for example, included reproductions of Egyptian temples and streets, and Moroccan tents. In North America, Eastern enchantments were part of the pedlar tradition in rural

communities. Pedlars who sold clothes, perfume, or jewellery were reputed to deal in glamour and magic because their focus was personal image and transformation.[97] Oriental motifs were employed by New York retail magnate A. T. Stewart in store interiors in 1863 and they would find regular deployment in other large-scale temples of consumption on both sides of the Atlantic. By this means, the link between the market and exotic Oriental goods was firmly established in the minds of female customers in particular.[98] Displays were not, however, accurate reproductions of distant cultures.[99] The journalist Maurice Talmeyr, writing for a high-profile weekly, remarked that the exhibits at one of the great Paris exhibitions were a gaudy and incoherent jumble of 'Hindu temples, savage huts, pagodas, souks, Algerian alleys, Chinese, Japanese, Sudanese, Senegalese, Siamese, Cambodian quarters . . . a bazaar of climates, architectural styles, smells, colors, cuisine, music'.[100] Animals from different locations were mixed up, with stuffed wild boars and elephants filling the Indian exhibit and camels the Andalusian one. Talmeyr cited examples of the 'nullity, buffoonery, gross alteration, or absolute falsity' that abounded, before concluding that behind the mad 'ornamental delirium' and numerous deceptions lay a consistent principle.[101] The aim of commercial exhibitors was not to inform visitors but to amuse and excite consumers. Talmeyr denounced the systematic falsification that was involved. Visitors were drawn into a full-blown substitution of subjective images for external reality. Ultimately they were duped: 'Seeking a pleasurable escape from the workaday world, they find it in a deceptive dream world which is no dream at all but a sales pitch in disguise.'[102]

The flamboyance and eclecticism of the exhibitions were repeated in department stores. Zola's well-documented *Au bonheur des dames* (Ladies' Paradise) contains abundant Oriental decor. 'The counters of the department store present a disconnected assortment of "exhibits," a sort of "universe in a garden" of merchandise. The sheer variety, the assault of disassociated stimuli, is one cause of the numbed fascination of the customers . . . It is a style which may without undue flippancy be called the chaotic-exotic.'[103] Within single exhibits repetition was often employed 'to numb the spectator further'. Rugs, umbrellas, and all manner of other articles were lifted into a festive dimension. The lavish and the foreign, the jumble of striking and unusual images, all served to fuel desire for escape from the ordinary and the everyday. Their

purpose was simply to attract and hold the spectator's attention. Thus questions of taste were irrelevant. Although the stores—in a marked difference to some of the arcades—courted mainly women customers, exotic decor was seductive rather than ladylike.[104] Exotic decor occupied a limbo between art and commerce. It had the stylistic traits of art, yet it had no uplifting aim; artistic trappings served merely to wrap up commercial purpose and lend it a supposed dignity.[105]

The Parisian Bon Marché store, which Zola took as the model for his novel, pioneered the revolution in marketing.[106] Aristide Boucicaut, the store's founder, was a showman who turned it into a permanent happening. He went about this by tantalizing and seducing his customers with special events, fantasies, and promotions. To visit the store was an exciting event that made the act of purchase into an experience. Scale was an important part of this. Unlike the exquisite charm of the gaslit fairyland of the arcades, the store was a monster, a massive structure that made abundance and variety the key to its basic identity. With its enormous open displays of commodities, it became a permanent fair and a spectacle on a grand scale that added to the lustre and image of the city.[107]

Stores could be brash and lurid, but they also embraced pomp and ceremony, mixing stately rituals with baser passions and longings. These were employed to suggest a this-worldly paradise that was stress-free and happy.[108] As part of this, sexual suggestions and appeals were crucial in attracting the attention of the public and stimulating its desires. In consequence, courtesans played a central part in fuelling the development of modern consumption. As professionals of make-believe and living luxury objects, they occupied a special place in the imagination of the nineteenth-century public. The fact that they also hailed, in most instances, from very ordinary or foreign backgrounds made them ideal vehicles for fantasies of social mobility and vicarious pleasure.

THE BIRTH OF SEX APPEAL

Courtesans were the glamour queens of the nineteenth century. They were flamboyant women who, through determination and luck, rose to become icons of beauty and leaders of fashion. They occupied an important place in the social and commercial life of several capitals and they loom large in the art and literature of the period. They were figures of luxury who led extraordinarily opulent lifestyles. Typically, they were young women of lowly or foreign origins who possessed charm, beauty, and steely determination. At one level, they were high-class prostitutes, but they were also much more than this. They were a category with specific features and functions that mediated the complex social and cultural passage from aristocratic to bourgeois society. The courtesans were all distinctive individuals with particular histories and influences. In some instances they were versatile figures, like the actress and writer Mary Robinson, who enjoyed a number of high-profile liaisons from which she drew profit; in others, like the most famous courtesan of the Regency, Harriet Wilson, they were commodities available to the men who frequented the Rotten Row promenade, the theatre and the opera, and Brighton. After the Regency, courtesans

played a limited role in London life, but they prospered elsewhere, and most especially in Paris, where they became part of the city's attractions. They were a feature of the developing consumer economy and of the dream world that it fuelled. As professionals of performance and masquerade, they pioneered the modern idea of sex appeal as an organized tease. By this means, they reinforced the role of sex in glamour and undeline a connection that would never be broken.

In the late eighteenth and early nineteenth century several women, like the wayward duchess Georgiana and Mary Robinson in London, and Josephine de Beauharnais and Pauline Bonaparte in Paris, occupied a blurred area between aristocratic society and the world of fashion and pleasure. The courtesans, as a category with a fairly precise identity and social role, were a product of the new sexual hierarchy of the bourgeois era. Modern cities, as they developed in the early nineteenth century, were male-dominated and were largely geared to male requirements and pleasures. Respectable women could not be seen on the street and were not welcome in the areas of men's clubs, shops, and restaurants. They were confined to specific realms and institutions that were reserved for them. Their social power was exercised in the private sphere, where they determined the rules of entry to high society and ran the marriage market. Men preferred to choose their wives from among the blushing virgins who were presented to them at heavily chaperoned balls, but for fun and frolics they opted for the company of women of few scruples. Prostitution was a commonplace feature of every large city, but the favours of the courtesans could not simply be bought. They were polished up to near respectability and acted the part of ladies of leisure. Choice was one of their prerogatives. They were adept at using their sexual allure to exploit the desires and opportunities that arranged marriages and extensive leisure brought to aristocratic and rich men. Moreover, they were public figures who were vital to the buzz and dash of the modern metropolis. The courtesans simultaneously satisfied the demands of rich men for sexual pleasure and for kudos. The conditions for their existence and their public visibility were twofold: first, a dominant morality which permitted licence to men while denying it to women; second, an attitude towards money that was informed by the aristocratic refusal to be limited by

economy and self-restraint. These practices survived the onset of the industrial era, and indeed, like gambling, flourished within it, as nobles wasted money on a grand scale to distinguish themselves from bankers and speculators. They were followed by some bourgeois men who could not resist aping the aristocratic example.

The courtesans were celebrities, although the degree to which they were socially acceptable varied greatly. In Regency London, the 'demi-reps' or 'Cyprians', as they were colloquially known, conquered a place at the centre of the fashionable world. In the Victorian era, by contrast, they largely disappeared as prostitution in all forms was relegated to the social margins. In Paris, they flourished under Napoleon and the restoration, maintained their place under Louis-Philippe and then enjoyed an unprecedented heyday in the Second Empire. Whereas Great Britain in the Victorian era privileged respectability, France's Napoleon III encouraged a climate of excess and distraction that extended to the sexual arena. The allure of the women of Paris became a calling-card of the city, a key indicator of its legendary 'gaiety'.

Even if not all of them were held to be beautiful, the courtesans were intensely glamorous figures who knew how to make themselves desirable. They were always expensively attired and wore their jewellery as a general would wear his medals, as proof of battles fought and won. They were highly visible figures who pioneered new fashions and whose example was often followed by the women of respectable high society. They thrived on publicity; to feature in the news or to be gossiped about was a way of increasing their notoriety and exchange value. Each of them created a narrative that was made up of her famous liaisons and the celebrated stunts or incidents she had been involved in. The knowledge we have of them derives mostly from the press and the memoirs of those who knew them. Like other figures of fashion whose main concern was with appearances, they invested in surfaces and lived for the moment. Few of them left any testimony behind. They cared little for reflection or self-examination, so they remain mysterious for us, enigmas who will never reveal all their secrets. Moreover, very few of them were painted by the artists of their day, with the result that, for those who were famous before the age of photography, we are forced to rely on the accounts of witnesses to have any idea of what they looked like. One first-person account that we do have is provided

by the memoirs of Harriet Wilson.[1] Written at a time when her fortunes were low, she conceived them as a money-spinner, not so much because she hoped to reap the rewards of a best-selling book, but because she aimed to secure pay-offs from former lovers in return for leaving them out. The Duke of Welling-ton's famous exhortation, 'Publish and be damned!' was his abrupt response to Wilson's request for such a payment.[2] The image that transpires from her prose is that of a woman with a strong sexual appetite who was a master of the sort of faux-respectable appearance and manners that the well-to-do men of her era appreciated. She expected to be courted and to be treated with civility; blunt approaches were regarded as insulting. Wilson grew up in a humble family who lived in close proximity to Mayfair; her education in the ways of rich men thus began early.

The courtesan was a euphemistic figure who disguised her true identity. She was a product of the advance of gentility that affected all areas of society from the later eighteenth century. The slow rise of respectability brought an end to the custom of providing explicit guides to the sexual attractions of London's prostitutes. Crude and to the point, guides such as *Harris's List* did not romanticize or skate over the ugliness, coarseness, and physical attributes of some women of the town. Descriptions of 'squat, swarthy, round-faced wenches' and 'tolerably well-made' plump girls with 'eyes [that look] both ways at once' were provided along with the beauties and all were listed by name and address.[3] In 1795, however, the guides came to an end following a trial for obscenity which resulted in the editors receiving a £100 fine and twelve months in prison. In the period that followed, higher class prostitutes took on the external appearance of respectable women. The colours they wore may have been brighter and their engagement with foreign-inspired fashions more enthusiastic, but in many respects they were not readily distinguishable from high society women. As fake ladies, they were excluded from formal society but were an integral part of the public sphere.

Thackeray's anti-heroine Becky Sharp in *Vanity Fair* has many of the traits of the ambitious Regency courtesan. Unscrupulous and calculating, but possessed of a veneer of refinement due to her half-French background, she worms her way into the affections of several men, marries one, and is mistress to another before a downward spiral leads her to the lower rungs of

prostitution. She reaches the outer edges of high society and mingles with nobility—notably the rake Lord Steyne—but fundamentally she is a sexual opportunist on the make. However, she is presented to the readers of *Vanity Fair* in a way that conceals her true behaviour; she is glossed to make her acceptable to those who preferred not to see vice called by its name. In one of his customary authorial interventions in the text, Thackeray challenges anyone to deny that she has been presented in 'a perfectly genteel and inoffensive manner'.[4] He proudly asserts that everything he has included has been 'proper, agreeable and decorous' and that 'the monster's hideous tail' has remained below water. Only those who 'may peep down under waves that are pretty transparent... see it writhing and twirling, diabolically hideous and slimy, flapping among bones, or curling around corpses,' he concluded chillingly. His concern not to offend was shared, curiously, by Harriet Wilson whose memoirs offer curious vignettes of the men of her day in the boudoir, but only the vaguest allusions to sex. Courtesans always carried an aura of scandal about them, but, outside their immediate circle, their bedroom practices were often the least well-known aspect of their lives. Wilson even wrote to Byron to upbraid him for the lewdness of *Don Juan*.[5] Euphemism was the dominant ethos in representation and glamour was inflected with this. It employed dazzle to ward off scandal.

In nineteenth-century London, scarcely less than in Paris, fashionable public rituals presented prostitutes with opportunities to insinuate themselves. The theatres and smart shopping districts were favourite haunts. Among the horsewomen to be seen taking rides in Hyde Park were elegant women who might have been taken for ladies had it not been for the fact that they were generally more beautiful and even, it was said, more graceful than their respectable counterparts. The pleasure gardens, arcades, and promenades were their natural habitat. In early nineteenth-century London, the Cyprians (as high-class prostitutes were then called) even staged their own balls and were sometimes invited to the masked balls that Brummell and his friends organized. It greatly amused these men that the device of the mask allowed them to draw the courtesans into a respectable context without fear of detection. Their real status was not readily visible except in their more daring manners as well as their studied fashionableness.

The theatre was often the setting that provided a courtesan with the best opportunity to get noticed or to increase her cachet. For most of the nineteenth century, no sharp distinction was drawn between the actress or performer and the prostitute. All women who put themselves on view or embraced different guises were considered to be beyond the bounds of respectability. Actresses were outsiders, at once highly visible and lacking any specific place in the social hierarchy. Often the pay of female stage performers was so low that they were obliged to seek financial support from their admirers. Yet courtesans were not necessarily stage performers, even though several began their careers as actresses. They used the theatre as a place where their social cachet could be asserted. By placing themselves on open view in expensive settings, such as elegant boxes, they advertised their availability and gave a rough indication of their market value. In the meantime, common prostitutes milled in the bars, corridors, and social areas of theatres, or in the street outside. Such practices persisted in some form over a long period. In Victorian London, prostitutes promenaded outside the Empire Theatre in Leicester Square—not far from the vice district of Soho—until the 1890s.[6] In Paris, subscription holders at the Palais Garnier opera house were only excluded from going behind the scenes to pick up dancers in 1927.[7]

As objects of desire endowed with public visibility, courtesans had a special fascination. Due to their wealthy sponsors, the women exercised a power in the field of consumption that was reflected first of all in their wardrobes. This in turn made them trendsetters and taste-makers for others. Mary Robinson noted that the influence of foreign fashion—by which she meant French influence—had led to an improvement in the general stand-ard of dress and that a more natural elegance had displaced 'unmeaning flounces of many coloured frippery'.[8] In 1800 she proclaimed that 'The females of England are considerably indebted to our most celebrated ac-tresses for the revolution in dress. Accustomed of late years to behold the costume of various nations gracefully displayed at our theatres, women of rank, who lead the capricious idol FASHION, through all the mazes of polite society, speedily adopted what they considered as advantageous to beauty.'[9] She might well have been speaking of herself since periodicals gave as much

attention to her toilettes as to her beauty and, unusually for a woman in her position, her wit.

Comments such as Robinson's show that female glamour was the product of very specific processes that defined the industrial age and the modern city. Consumerism placed systematic emphasis on spectacle and display and fostered a commercialization of femininity. Patterns of communication and transmission of ideas about appearance, dress, and self-presentation emerged that did not follow the established social hierarchy but accorded prominence to outsider figures. A process of self-fashioning, and in some cases, of self-invention, developed that relied on clothes, cosmetics, and so on. These developments provided some women with opportunities to take on prominent roles, but at the same time they stereotyped them in ways that fitted in with the requirements of a male-dominated society.

The prominence or otherwise of courtesans in the social life of capital cities depended greatly on the ethos that was transmitted from the top. The sexual licence that characterized the upper realms of society during the Regency gave way to the primness of the Victorian era. By contrast, the modest, respectable rule of King Louis-Philippe, who ruled France during the so-called July Monarchy of 1830–48 and who had no court and even took strolls in the street with his wife,[10] was replaced by the rampant hedonism of the Second Empire. Thus, while courtesans exited the scene in London, they maintained a key place in the social system in Paris. With its emphasis on money, pleasure, and distraction, Napoleon III's regime produced an atmosphere that accorded unusual prominence to a category that consisted in total of perhaps a hundred women. The ceaseless round of entertainments in Paris influenced the attitude towards pleasure at the upper levels of society. Rapid social and economic change and a parvenu elite enabled the two dozen or so most prominent high-class prostitutes to live the most lavish and ostentatious of lifestyles.

The Second Empire used entertainment and consumption as a diversion from dictatorship and widespread poverty. The brash magnificence of the regime was incarnated only to a limited degree by Louis-Napoleon—the self-styled Napoleon III—himself. A man significantly less impressive in his achievements than his uncle, he did not seek monarchical legitimacy but

instead set himself in the context of the Revolution and Bonapartism. Embracing popular sovereignty, he refused a dynastic marriage. On announcing that he would marry for love, he frankly proclaimed himself to be a parvenu, which he asserted was 'a glorious title when one succeeds to it by the free suffrage of a great nation'.[11] He allowed his Spanish-born wife Eugénie to dominate a court in which luxury and excess were the order of the day. The visual splendour of the formal festivities was fashioned by three men: Baron Georges-Eugène Haussmann, the influential prefect of the Seine, who acted as ringmaster-in-chief at the four official balls that were held each year; Charles Frederick Worth, the couturier who was chiefly responsible for the astonishing crinoline dresses that grew ever wider as the atmosphere of excess became more rarefied; Franz Xavier Winterhalter, the German painter who became chief portraitist of the imperial family and of the court. Worth, an Englishman, was a key figure in the commercial fashion of the period and his clients included many courtesans as well as the empress and ladies of the court.[12] Unlike Marie Antoinette's couturière, Rose Bertin, who created new styles in complicity with the queen and acted as guardian of the exclusivity of her patroness's gowns, while treating other clients haughtily,[13] Worth had a more pragmatic approach that made money the sole discriminator. His prestigious fashion house, founded in 1858, developed significant foreign sales, although the association with Paris was now more important than the connection with the court. Worth's most significant innovation in the history of couture was to bring the creative design of dresses and their fabrication together under one roof for the first time.[14] Winterhalter painted separately both the emperor, in a sumptuous dress uniform of vivid colours and with much surface dash, and the empress. His works were in the prevailing style of court painting and were more about status than individual character. Their vivid colours and uncomplicated surface appeal gave them a brash quality that matched the materialism of the age.

The Second Empire desperately sought to present a respectable and composed image to the world. Napoleon and Eugénie were on good terms with European royal families and they aimed to put themselves on a par with them. They developed their own equivalent of Brighton in the fishing village of Biarritz on the Atlantic coast of south-west France. After Eugénie built a palace on the beach, it became a fashionable resort that attracted British and

Spanish royals as well as noble and wealthy visitors. Yet the regime has been said to have been driven on purely by 'the phantasmagoria of money'.[15] The cultivated magnificence of the royal household, with its brightly uniformed and multifarious functionaries and its ostentatious general style, 'made the whole thing even more *parvenu*-like'.[16] Although the courtesans were kept rigorously separate from court society, the latter was regarded by some as the chief focus of louche behaviour and money-driven ostentation. Napoleon's 'carnival empire' had a strongly theatrical dimension which struck foreign aristocratic visitors as fabricated and imitative.[17] Not by chance, opulence, beauty, sensory excitement, and the dream of sudden wealth constituted the stock in trade of operetta, the entertainment form that most characterized theatre in an era of tight censorship. All the courts depicted in the many works of the leading composer of operetta, Jacques Offenbach, were modelled on Napoleon's own.[18] The era was not without its hypocrisies. While sex was widely commercialized, both Flaubert's *Madame Bovary* and Manet's *Déjeuner sur l'herbe* were the subject of prosecutions for offending morals.

Napoleon III harked back, like his more celebrated uncle, to some of the courtly rituals and practices of the Bourbons although, after several changes of regime there was no longer any easy distinction between the Bonapartist and the Bourbon styles. Louis XVIII had remained in Paris most of the time and kept many of Napoleon's ostentatious rituals and furniture, including even some emblems and his throne.[19] More than any of his predecessors, Louis-Napoleon systematically set about transforming Paris into great modern city. He continued Napoleon I's work but on a much larger scale and with the destruction of many buildings. Between the 1850s and the 1870s, old structures that dated in some instances from the Middle Ages were demolished and replaced with modern road systems and more standardized housing and public buildings. Expansions of population and the changing nature of work posed problems of order and integration that necessitated urban reform. The innovations that were carried out in Paris by Baron Haussmann, in his capacity as prefect of the Seine, were far-reaching. The reforms of the Haussmann era saw the blossoming of the image of Paris as a centre of display and distraction. However, the French capital was not alone. Major cities throughout the industrial world witnessed

the development of zones dedicated to consumption and entertainment and Haussmann drew inspiration from changes that were already underway in London and in American cities like Chicago and Philadelphia. Despite a notional sense of equality, the pattern of urban reform catered mainly to the requirements of the wealthy. Public spaces were geared to private display and private enterprise was given free reign. In Paris, the wide boulevards opened out the city and imposed a long perspective that rendered it easier to occupy militarily as well as better geared to ceremonial and display. Reform also involved the relocation of the poor away from emerging areas of prestige. The west, as in London, was turned into a residential area for the rich and a site of social display. It was here that monuments, squares, parks, boulevards, and palaces made Paris a showcase within which political power asserted itself and the wealthy and stylish flaunted their social superiority.[20] Although class and other demarcations remained in force, the new image of the city was the homogenized one of the boulevards, with their ostentation, dynamism, aspirations, and illusions.[21]

Under the Second Empire, social life was endlessly displayed. The play-acting, the pantomime aristocracy, the facade of elegance and refinement which had at its core the courtesan and the racy crowd of *viveurs* who joined her in making over the image of the city had a vibrant and exciting effect.[22] Few notions conjure up mid-nineteenth-century Paris more than the *demi-monde*. Women belonging to it were celebrities who were constantly to be seen at theatres, restaurants, spas, taking rides in the park, celebrating winners at the races, and visiting couturiers. They systematically attracted attention and conferred the buzz of sex appeal on places and events in a way that truly upper-class women could not. The women of the *demi-monde* were not all identical; some were refined or artistic while others were ill-mannered and coarse. But all shared a cult of the self and of the material that made them ideal figures of modern fashion and celebrity. Some figures of a distinctly non-respectable stamp were received at court, such as the Italian beauty the Contessa di Castiglione who set about seducing the emperor with a well-rehearsed repertoire of tricks. Lacking the freshness of youth or an attractive personality, she planned her appearances to ensure that she always suggested a tantalizing

aura of mystery.[23] However, it was mainly in public opinion that the court and the vibrant festivities of the city were confused.

The term *demi-monde* derived from the title of a play by Alexandre Dumas *fils* first performed in 1852. It gained more widespread recognition following publication of the novel *La Dame aux camélias*, Dumas's fictionalized account of his liaison with the consumptive courtesan Marie Duplessis. The novel became an international success and inspired Verdi's opera *La traviata*. These works highlighted the existence of a social milieu that was akin to Thackeray's *Vanity Fair*. It was made up of wealthy men and a range of déclassé women who joined it on the basis of their beauty and notoriety.[24] In the eyes of the ordinary public, there was little difference between the *demi-monde* and the *grand-monde*, or at least the two were not mutually exclusive. In every metropolis, high-class prostitutes haunted the most fashionable districts, placing their goods and promises of pleasure on display together with those of the stores. In keeping with the high tone of the modern city, they had turned themselves into mock-ladies by learning how to ride, speak, and comport themselves.[25] The top stratum of Paris courtesans formed a sort of international star system and several of them were of foreign origin. Cora Pearl was from England, Giulia Barucci from Italy, and La Païva (Thérèse Lachmann) from Russia. Others, like the senior member of the group, Adèle Courtois, or Anna Deslions, Blanche D'Antigny, and Margherite Bellanger—who became Napoleon III's lover in 1863—were of humble French background. Each of them attracted men by developing individual qualities of charm, beauty, and erotic appeal.[26] They all catered to an international clientele that was defined by its leisured lifestyle and disdain for bourgeois convention. Such was the interest in these women among the wealthy visitors to the great exhibitions that the Goncourt brothers lamented that Paris had become a 'foreigner's bordello'.[27]

Due to Dumas's romantic portrayal, Marie Duplessis became, in the guise of her fictional alter ego Marguerite Gautier, the epitome of the courtesan. For film-goers of the middle decades of the twentieth century, Greta Garbo memorably brought her once more to life in the 1936 film *Camille*. The consumptive heroine who sacrifices her personal happiness to save the honour of her lover's family was a noble ideal. She was, however, an

exception in her simplicity and also in the love she shows for Armand. Gautier is constantly described as being pale and wearing white clothing, in reference to her tuberculosis and the purity of her sentiments. But if there was one colour that was most associated with the *cocottes*, it was red. Scarlet carried connotations of the passion of Spain, of the Gypsies, and the Orient. Through these places and cultures—real but also imagined—red's association with sex and the unrespectable was codified in art, literature, and social behaviour. The interiors of theatres were usually plush red as were the bordellos from which they were not clearly distinguished before the twentieth century. In nineteenth-century Paris, red came to be identified as the modern colour of sex. As such it was employed by actresses and prostitutes, and only sparingly by respectable women, unless they were explicitly flirting with the subculture of sleaze. To win the love of a courtesan is exceptionally difficult, Dumas observed, since their bodies have used up their spirits, the senses have burned their hearts, and debauchery has cauterized their feelings. As a result 'they are better protected by their calculations than a virgin by her mother and her convent'.[28] All their efforts were geared to winning and keeping at least one prestigious and well-heeled lover. Like Gautier before she chooses love, the goal of them all was to have a duke at their beck and call. Typically, two or three protectors, usually known to each other, would befriend them simultaneously.

The most famous courtesan of the Second Empire conformed to this pattern. La Païva was the grandest example of the courtesan as a performer who plays at being a lady before public opinion and at being a devoted lover with her protector.[29] In a culture that celebrated wealth and money more than anything else, her avariciousness symbolized the period. Despite acquiring a noble Portuguese title through marriage, La Païva never won official recognition; yet she enjoyed pecuniary prestige and was able to establish a salon that was frequented by leading artists and writers.[30] La Païva's splendid mansion has been described as the most complete example of Second Empire style. Positioned on the most prestigious of the new boulevards, her palace (which was open to the public in the early years of the twentieth century; today it is occupied by the Touring Club) was an insolent affirmation of personal glory.[31] All the interiors, including the

furnishings, were new, and talented, sometimes undiscovered, artists were employed to fashion them. Some would make their reputations through it, even though the styles were drawn from an eclectic range of places and periods. The sculpted yellow onyx bathtub that would occupy pride of place in the bathroom received an award at the 1867 universal exposition. The ceiling of the salon was executed by Paul Baudry, who would later decorate the foyer of the Palais Garnier opera house—the edifice that is commonly seen as the symbol of Napoleon III's regime, even though it was not inaugurated until 1875. Positioned in the heart of the new Haussmann-reformed Paris of the boulevards and the stores, it was a triumph of the eclecticism that the period fostered.

Louis-Napoleon had no personal taste in matters of art or architecture; he merely encouraged others by public commissions and competitions. The style of the period has been described as bourgeois on account of its overt and eclectic materialism.[32] Appropriation and imitation were prevalent practices as the newly rich sought to bolster their position and self-perception by seizing hold of all the previous artistic products of aristocratic society. By the mid-nineteenth century, they were no longer outsiders seeking acceptance but a new elite in the process of consolidation. Convinced that the creations of the past could be refashioned and remade in a more cost-effective way by means of modern manufacturing methods, the new upper class born of speculation and industrial prosperity preferred new versions of the styles it ransacked. Appearances and comfort were what it was concerned with, not authenticity. This extended right up to the imperial family itself.

Louis-Napoleon had sought to compare his wife to his grandmother Josephine, whom he idealized. Eugénie, for her part, was strangely fascinated by Marie Antoinette and often introduced eighteenth-century motifs into her furnishings. However, the colours she chose were the brash ones of the Second Empire and chairs were tufted in the manner of the furniture of a bourgeois household.[33] Winterhalter was such a popular painter with the empress and the new rich of the time because he depicted his sitters as they wished to be presented, or rather, as they dreamed of themselves. His bold and alluring portraits are lifelike, yet elegant and idealized. He placed his

subjects in compositions that often had a theatrical quality. The texture of fabrics, furs, and jewellery is almost tangible. His celebrated portrait of Eugénie surrounded by her ladies-in-waiting is a sumptuous feast of colour and beauty that underscored the primacy of female imagery in the articulation of the public face of the regime. The painting did not succeed in disguising the upstart nature of the imperial court, but it successfully presented the short and dumpy Eugénie as a woman of grace and style.[34]

The courtesans were a dependent category; they existed for men and were reliant on the latter's finances. But although they had often risen from nothing, some of them resented their exclusion from official society and did everything possible to compensate for it. By establishing her name and gaining wealth, the courtesan could mitigate her inferiority complex and mask the source of her success. Yet, for all her luxury, the bawdy aspect of the life of the courtesan was intrinsic and constant. Derided and notorious, it was said that La Païva 'would have given herself to a miner for a nugget'.[35] To her guests, she offered the finest dishes accompanied by vulgar and scatological conversation of the most salacious kind. The social activities of the courtesans were always occasions for the fabulous display of diamonds, pearls, and other precious stones. In 1860, Le Figaro announced a fancy-dress ball at which the goddesses of Olympus were to be represented by the Parisian courtesans. La Païva had, it was said, arranged to come as Juno; the treasures of diamonds, pearls, and precious stones she scattered over her dazzling tunic were valued at no less than 1,250,000 francs. For her part, Anna Deslions went as Venus, with 300,000 francs' worth of gems.[36] The courtesans were distinguished by the fabulous price tags that they indirectly expressed in their glittering jewellery, extravagant toilettes, sumptuous dwellings, and general lifestyle. The display of wealth and luxury made it apparent that a man had paid an exorbitant price for her favours. Social prestige within male circles derived from an individual establishing that he had the massive spending power to be able to waste vast sums on a woman who was not even his wife. The more lavish a courtesan's lifestyle, the more she was desirable as a vehicle of status to very rich men. The publicity that they attracted further enhanced their standing and rubbed off on the men who associated with them. Within the demi-monde at least, the courtesans were celebrities. The two dozen most famous were ostentatious to an extraordinary

degree, dressing and furnishing their residences with every manner of luxury and costly ornamentation.[37] Although their activities were cloaked in the language of love, there was no category on earth that was more calculating. Ambition and money were the twin principles that drove them.

In return for their financial support and gifts, men did not only gain intimate access to a woman celebrated for her desirability. Merely sexual favours, even of the most refined kind, could be had for far less, and for far less trouble since the category of the courtesan was known for its paradoxical frigidity. Rather they acquired a reputation for high living, style, and fashionableness. The prominent aristocrats whose friendship was necessary to win the courtesan her fame were often happy to assert in this way a class difference with respect to the straight-laced bourgeoisie. The pursuit of pleasure for no end other than itself and a disdain for respectability and virtue were the hallmarks of these noblemen. To maintain a courtesan, like fighting a duel, was a futile gesture that showed a certain carelessness about practical matters such as one's fortune and self-preservation. The benefits also appealed to some wealthy bourgeois, who were much less inclined to sacrifice all for a courtesan but who appreciated the indirect advantages that association with one of them brought. For them, it was simply a matter of conspicuous consumption. Wealthy men could and did spend money on their wives but of necessity such expenditures were official, restricted by respectability, and were 'off the market'.[38] Since pecuniary power was typically established through non-productive forms of spending that were visible and acknowledged, the utility of such domesticated forms of expense was limited. To parade as a mistress one of the most visible and notoriously costly women of the day was a true luxury, entirely disassociated from necessity and achieved by beating the financial offers of rivals. In contexts where the values of respectability were not totally dominant, it therefore had greater value. The courtesans functioned as luxury objects and status symbols that appealed to bourgeois men who could procure them temporarily without having to violate bourgeois norms by personally displaying the outward signs of wastage and indulgence. They were emblems of success that were sought after by all those who wanted to establish their fashionable aloofness from all matters of budget.[39]

It was precisely their ostentatious lifestyles that made the courtesans so uniquely desirable. In *La Dame aux camélias*, Gautier confesses to Armand Duval that if a courtesan were to reduce her standard of living all her admirers would disappear: 'It is not, alas, our qualities that they appreciate but rather our faults and our extravagances. It is our luxury that attracts them, like the light draws butterflies.'[40] The courtesans were elaborate, fashionable objects who existed not because of their own will but because they performed a function in the social economy. At the best of times, they provided gaiety, pleasure, and fashionable company. Frequently, however, the feverish hedonism of the fast life into which their friends were drawn led to ruin, since the inevitable complement to a relationship with a courtesan was a taste for other forms of heroic luxury, such as those associated with a big gambling loss or the spectacular blowing of a sudden gain.[41] A courtesan's market value was only enhanced when she caused a lover to suffer a loss of a fortune and reputation. Especially sought after in a time of feverish speculation, they were the most desirable and dangerous of commodities.

Although they presented themselves as the natural companion of aristocracy, the costly novelties preferred by the courtesans owed much to the sort of seductive aesthetic that was associated with the arcades and the stores. The complex bourgeois attitude to sex produced repressions and displacements that were exploited in the commercial sphere. The impulse towards sexual pleasure was employed to attract and hold the attention of consumers.[42] Even more than the new rich, it was the *demi-mondaines* who lived a department-store lifestyle. While the most prestigious craftsmen and tradespeople still sought the patronage of court ladies, high-class prostitutes were often 'launched' by local dressmakers and even laundresses who would lend magnificent garments belonging to well-to-do customers. Various tradespeople including upholsterers and furniture makers set up courtesans in luxurious apartments at exorbitant rents and arranged repayment on instalment plans.[43] In *La Dame aux camélias*, when word spreads that Gautier no longer enjoys the protection of her duke, all her suppliers are quick to demand settlement of their accounts. These women represented the deluxe modern commodity and were packaged and displayed for maximum impact on potential customers and the wider public.[44]

Under the Second Empire, the courtesan dictated fashion trends and was sometimes imitated by the society lady. Some of the latter went so far in their use of rouge, false hair, and so on, that they were nicknamed *cocodettes*.[45] This appellative was not applied to the Empress Eugénie, who some have seen as the last ruling monarch to exercise any direct personal influence over fashion. However, it was not by virtue of her regal status that she was regarded as a model; rather it was a consequence of the 'inevitable element of *parvenu* about the Empress'. As she had 'no royal birth to fall back upon she was compelled in some sort to win estimation by being in the forefront of fashion'.[46] This inevitably brought her into a realm that was also occupied by leading courtesans. Eugénie's ostentation can be compared to the idiosyncratic behaviour of another empress who was even more obsessed by matters of appearance, Empress Elizabeth of Austria ('Sissi'). After her marriage to Franz Joseph in 1854, she was largely absent from court and led a nomadic existence travelling restlessly through resorts in Europe and the Mediterranean. She abhorred protocol and followed her whims while cultivating her beauty and her famously slim physique. Elizabeth had the beauty to win attention and, by stepping out of the court, she gave rise to interest that owed more to popular culture than to deference. Her dislike of photography only served to stimulate curiosity about her appearance. In royal terms, both women were highly unusual and it was these unconventional aspects that made them glamorous. Despite their positions, they were mainly identified with spheres independent of power like fashion and beauty.

Critics of the courtesans and their prominence were legion. Sometimes these directed their disapproval at individuals. The Goncourt brothers wrote that La Païva had a face that 'at moments... takes on some terrible likeness to a rouged corpse'.[47] Her over-use of cosmetics made her seem completely artificial. Cora Pearl was said to behave like a beauty, when in fact she had a plain face.[48] She achieved the illusion by enveloping her body in clouds of fabric and decorating herself with jewels and metal adornments. The prominent novelist Émile Zola offered a more thorough critique. If Dumas provided the most romanticized image of a courtesan, then the most striking negative representation was Zola's powerful literary creation, Nana. Nana first appeared as an adolescent in *L'Assommoir* in 1877 and was then

portrayed in a celebrated painting by Manet before Zola dedicated a whole novel to her rise and fall in 1880. Written several years after the end of the Second Empire but set during it, the novel's heroine incorporates elements of several well-known courtesans.[49] She also draws for some of her features on lower level theatrical entertainers and common prostitutes. Nana is exactly the sort of woman of pleasure who became a celebrity. Before her tragic decline, she is the toast of Paris and 'the queen of first class tarts'. 'Her photo was on display in every shop window; her name featured in the newspapers,' Zola writes.[50] When her landau arrives at the race course, there is 'a stir amongst the spectators as if it was royalty going by'.[51]

To denounce the putrefaction of society as well as the parasitic nature of the cult of commercial sex, Zola likened his heroine to a fly on a dung-hill. She is a gutter Venus whose youthful plebeian beauty is unredeemed by any moral quality. She cackles like a hen, torments her lovers, flaunts her success, and leaves a trail of destruction in her wake. This mix of vulgarity and social prominence revealed the corruption of the Second Empire; its worthlessness was shown by the sort of person to whom it accorded high status. But in fact Nana was not the freak product of a particular moment; her successors would enjoy scarcely less prominence under the democratic Third Republic. Sex and celebrity would remain united in the persons first of courtesan-performers and then of stars of the stage and the silver screen.

Zola deplored the rise of the *demi-monde* and put the blame largely on an established society that had failed to erect proper barriers to maintain decorum. The *demi-monde*, in his view, had spilled over into the main-stream. He describes the ball given by the Comtesse de Muffat, the wife of Nana's protector, to celebrate the renovation of her house and simultan-eously mark the signing of her daughter's marriage contract. The party was not exclusive, the author observes; rather five hundred invitations had been issued to all levels of polite society. 'In this smart, permissive society dedicated purely to pleasure, full of people whom a society hostess would pick up in the course of some short-lived intimacy,' Zola wrote, the sanctity of the family was destroyed and the primacy of the fashionable crowd asserted.[52] Dukes mixed with crooks and 'girls in low-cut dresses flaunting their bare shoulders', while one woman 'was in such a skin-tight skirt that

people were following her progress with amused smiles'. Only the sheer magnificence of the occasion and the setting disguised the 'decline of the ruling classes brought about by their shameful compromises with the debauchery of modern life'.[53]

The glitter that was a trademark of the upper class was appropriated by the new mixed environments that the period spawned. Zola refers to a splendid drawing room chez Muffat in which 'the chandeliers and crystal sconces lit up a luxurious array of mirrors and fine furniture',[54] providing an ideal frame for a 'dazzling, crowded evening'. As the dancing began on one such occasion, 'women in light-coloured dresses were going past, mingling with the dark patches of the men's tail-coats, while the large chandelier gleamed down over the surging heads below with their sparkling jewels and the rustle of white feathers, a whole flower garden of lilacs and roses'.[55]

Zola describes Nana's environments meticulously. It is striking how similar the jumble of periods and colours is to his evocation two years later of the Oriental decor of the department store. The Renaissance–style mansion she inhabits, purchased for her complete with all furnishings by the Comte de Muffat, contains 'a ragbag of knick-knacks, of wonderful Oriental hangings, antique sideboards, and huge Louis XIII armchairs'. Nana found herself surrounded by 'a mass of expertly chosen artistic furniture, a jumble of various periods'.[56] The small drawing room that leads off her bedroom is 'an amusing hotch-potch of exquisitely crafted objects of every style and every country'; wide armchairs and deep sofas set the mood for 'the drowsy existence of the harem'. Such eclecticism perfectly matched bourgeois taste and confirms the view that maintaining a courtesan was quite literally like buying a building and furnishing it. The tastes of Nana herself, the former flower-girl 'who once used to stand day-dreaming in front of the shops of the arcade', was apparent in touches of 'gaudy magnificence', although nothing was 'too conspicuously tartish'.[57] As her extravagance mounts and luxury is piled on luxury, this relative restraint is submerged in an orgy of excess and glitz.

A typical juxtaposition of the Second Empire, that would persist afterwards as the sign of the courtesan, was that of jewels and naked flesh. On the stage of Bordenave's theatre, at the start of her rapid career, Nana appears

naked before the silent gaze of a male audience. Protected only by a simple veil, her whole body can be glimpsed through the transparent gauze. Her red hair, firm breasts, sturdy thighs, broad hips, and well-rounded shoulders bewitch her many admirers. Although established courtesans normally masked their physical appearance to a greater extent, titillating appearances remained their stock in trade. 'The men who buy love like to inspect the merchandise before taking it,' Gautier writes to Duval.[58] In 1864 Cora Pearl made her entrance to the Jockey Club ball clothed in nothing other than her long red hair. La Barucci is reported to have excused herself for arriving one hour late for a meeting with the Prince of Wales by turning round and exposing her bare buttocks—a free view of her best feature, she said. Alice Ozy appeared almost naked in one play—save for a tiara worth 200,000 francs. These women were scandalous figures who challenged and parodied respectability and whose celebrity relied on occasional exhibitions of just this sexuality.

Throughout this period the issue of nudity was controversial. The controversy caused by Manet's paintings *Le Déjeuner sur l'herbe* and *Olympia* in 1863–4 derived from the realism of the female subjects. In place of highly idealized goddesses and nymphs that featured in academic painting, he offered striking depictions of ordinary prostitutes—in the first case in an open-air location and in the second in a boudoir. The shock value and complexity of these pictures turned them into founding statements of modern art.[59] His paintings were at one level the opposite of glamorous; they were unsettling rather than pleasurable. They did not gloss reality or seduce through visual tricks. But by situating the naked female body (rather than the academic nude) at the centre of modern culture, Manet created a premiss that would be widely imitated in art but also in entertainment. Revealing glimpses of flesh and nudity became less abstract and more a feature of urban popular entertainment in general. However, nudity was only glamorous as a suggestion or lure since the sex in glamour was never explicit. Glamour was often scandalous and transgressive but, since it was generated by the hierarchies and boundaries of bourgeois society not by their denial, it was rarely outrageous.

The fall of Napoleon III in the wake of the Franco-Prussian War of 1870 signalled the end of the frenetic hedonism that had characterized his rule. Yet the courtesans did not disappear as they had done in England with the onset of the Victorian era. Rather they were absorbed by an expanding entertainment industry that placed great emphasis on female spectacle. The sensual ideal of Paris and the Parisian woman emerged as a distinctive trait of French national identity in the aftermath of the war because it was seen as a civilized characteristic that was utterly alien to the Prussian mentality. What was termed *galanterie* (which the boulevard newspaper *Gil Blas* defined as a light-hearted, uninvolved attitude towards love and sex that was refractory to routine and uniformity)[60] was originally a feature of the aristocratic milieu of the pre-revolutionary era. In a context in which the French required consolation and pride, it was recuperated by *nouveau riche*, middle-class, and even lower-class milieux.[61] Here it served not merely to justify adultery but create a mood that served the cause of entertainment. Theatre managers and impresarios realized that the huge popular interest in the great *demi-mondaines* of the Second Empire could be exploited as entertainment for mass audiences. The last two decades of the nineteenth century witnessed the development of a star system that was sustained less by a dependent *demi-monde* and more by popular theatre, the press, and photographic studios. Carolina Otero, Liane de Pougy, Émilienne d'Alençon, and Cléo de Mérode all achieved international celebrity in the period between 1890 and 1900 and would retain it until at least 1914. Otero, de Mérode, and de Pougy were dancers while d'Alençon was primarily a variety artiste. Views differ as to their talents. None can truly be said to have a left a mark by her art that outlived her time. It was the physical appearances and reputations of these women that served as the main attraction.

The Folies Bergère provided them with their most celebrated platform. This theatre was a veritable forging ground of stars. Founded in 1869, on the model of London's Alhambra Theatre, a Leicester Square institution that resembled an enormous Oriental palace, it was the first Parisian music hall. Relaunched under new management in 1886, it provided a forum for every kind of famous performer from France and abroad. It was a sort of cabaret that was a *café-chantant* writ large. The principal stars of the 1890s were the

grandes cocottes who offered themselves as female spectacles refined into a sort of art form. People came not to see a show but to see them, their legendary bodies, their fabulous costumes, and their priceless jewels. If the belle époque was in large part a celebration of female sexuality and beauty, as has been claimed,[62] then the Folies Bergère was the main temple in which the cult was celebrated. It provided spectacular shows while also featuring a *promenoir* that was frequented by the most notorious prostitutes of the district.[63] The theatre drew vast numbers of foreigners for whom the combination of erotic spectacle and sexual commerce was irresistible. Manet's celebrated painting *The Bar at the Folies Bergère* captures the surface glitter and gaiety of the Folies, while the unsmiling face of the barmaid at the centre of the picture alludes to the joyless resignation of at least some of the women who in one capacity or another worked there.

Carolina Otero was already well known when she made her debut there in 1893. A fiery Spaniard, she became the symbol of the Folies for ten years. She had acquired an international reputation on a series of engagements abroad beginning with a triumphal visit to New York in 1890.[64] Every spring she embarked on a series of foreign engagements, appearing in London, Vienna, Berlin, Rome, Zurich, St Petersburg, Budapest, and other cities. On each occasion, she seduced her audiences in an utterly self-aware manner. Otero impressed observers with her Andalusian features and colouring and her captivating dancing. The combination of richly coloured costumes, jewels, and erotic dance, led some to see her as exotic. 'She has all the spells of the Orient in her hips,' exclaimed Hugues Le Roux.[65] One of her specialities was the tango, while many images show her holding castanets. All her performances evoked the passion and colour of Spain or Latin America. Her movements were said to be agile and seductive. She could switch from fast dramatic steps to slow rotations on an axis that tantalized audiences already transfixed by the close-fitting costume and black stockings that outlined the curves of her figure once her bejewelled outer garments were removed. Her performances consisted of a physical spectacle in which each part of her body in turn was used as a lure. The male spectator was in this way teased and induced to imagine himself having sex with her. As she would later muse in her memoirs: 'Isn't the true sense of dance a pantomime of love?'[66] The

writer Colette, who was a friend and admirer, and who refers to Otero in *Mes apprentissages*, commented on her greedy appetite for food and the way she loved, even in later life, to dance into the early hours of the morning.[67] Responses to her shows were enthusiastic and impassioned wherever she went. Otero was hailed as the best and most seductive dancer, the most beautiful and luminous of women. Honours and gifts flowed and invitations multiplied. She was initially contracted to the Folies Bergère for 5,000 francs per month but this figure increased to 35,000 francs in the course of her ten-year winter residency at the theatre.

Liane de Pougy was Otero's greatest rival. As a French national, she aroused special interest at home and even became a sort of national symbol.[68] Looking back from the 1950s, Jean Cocteau memorably described all these women as 'the geishas of France', but only de Pougy was singled out for inclusion in his book on female icons, *Reines de la France*.[69] In contrast to the tempestuous Otero, she was cultivated and ethereal. Her reputation rested largely on her amorous adventures with both sexes and her exploitation of these in a series of *romans à clef*. De Pougy took acting lessons from Sarah Bernhardt, who had built her reputation by playing a series of decadent femmes fatales including Cleopatra, Tosca, Phaedra, and Fedora, all of which, in her hand, became creatures reminiscent of the Parisian *demi-monde*. But it was in the domain of self-publicity that she most closely resembled the great actress.[70] De Pougy was a master of the publicity stunt who was highly adept at drawing the press into her triumphs and tribulations. She ensured the success of her debut performance at the Folies Bergère in 1884 by writing to the Prince of Wales, inviting him to attend—an invitation he accepted. On another occasion, she shocked newspaper readers when she claimed that her celebrated jewellery collection had been stolen, thereby initiating a trick to secure news coverage that would still be practised by press agents fifty years later.[71] She endorsed a fragrance that was named 'Liane' after her and appeared in fashion advertisements. Her greatest moment of notoriety came when she reacted to her abandonment by her lesbian lover, the American heiress Natalie Barney, by publishing the thinly disguised story of their affair in a novel entitled *Idylle sapphique*. The following year a spoof marriage announcement appeared linking her name

to the notoriously camp writer Jean Lorrain.[72] Even carefully staged suicide attempts were geared to ensuring press coverage. As her career drew to a close, she married the Romanian prince Georges Ghika. When, fifteen years later, he deserted her for a younger woman, she withdrew to a convent. She inspired Proust and some have seen her as the model for the character of Odette de Crécy, the courtesan whom Swann falls for and marries.[73]

This group of women was not particularly good on stage. De Pougy was probably the least effective as a performer, although Émilienne d'Alençon too had something of Max Beerbohm's beautiful but untalented Zuleika Dobson about her.[74] While the fictional Dobson performed magic tricks, d'Alençon showed pink-dyed performing rabbits. Otero was said to transfix audiences with her dramatic fandangos, although she had had no training and, some said, no technique. In her memoirs, she breezily admitted: 'I never learned to dance; I dance as naturally as a bird sings.'[75] By contrast, Cléo de Mérode began her career in the ballet of the Paris Opéra before she was lured into a more lucrative, if less cultivated, sphere by the manager of the Folies Bergère. It was in the realm of publicity that they made their true mark.

The highly public rivalry between Otero and de Pougy was encapsulated in an episode that, in different versions, is recounted in a host of memoirs and biographies. In an uncertain location that might have been the chic restaurant Maxim's or, more plausibly, a Riviera hotel, the two women were struggling to outdo each other in the matter of jewellery display. Like her courtesan predecessors, Otero exhibited ostentatious jewellery on- and offstage as proof of her amorous conquests. Commenting on one perform-ance, *Le Figaro* wrote: 'Her bosom is more covered with jewels than a Chief of Protocol's chest is with medals and crosses. . . . They are in her hair, on her shoulders, arms wrists, hands and legs, and dangle from her ears, and when she ends the dance, the boards continue to glitter as if a crystal chandelier had been pulverised on them.'[76] The Spaniard thought she had triumphed when, one evening at dinner, she made a dazzling entrance covered in jewels, necklaces, bracelets, rings for every finger, and even a tiara. However, she was humiliated when de Pougy responded by arriving in a black dress devoid of adornment. The gasps of surprise from other diners gave way to delighted applause when she stood back to reveal her maid, who was wearing a

servant's cap and a dress with diamonds sewn all over it.[77] As a cultivated courtesan who, unlike the fiery Otero, surrounded herself with artists and writers, de Pougy could allow herself the luxury of dressing down. Yet even she later went on a tour organized by an impresario who exhibited her under the slogan: 'Liane de Pougy will appear on stage in a million francs' worth of jewels.'[78]

Material performance and competition were the public dimensions of the materialism and self-gratification that Simone de Beauvoir argued were the key characteristics of the courtesan. In contrast to the artist, the courtesan does not reveal herself to the world or in any way question the social order. Rather she exploits the world as it is for her own benefit. She places herself before the judgement of men and in so doing confirms a passive idea of femininity. However, 'she endows it with a magical power that enables her to catch the men in the snare of her presence and batten off them; she engulfs them along with her in immanence.'[79] De Beauvoir's forthright condemnation rings true on one level, but ignores the fact that these women were part of a burgeoning commercial sphere. There was a complex industry that staged them and whipped up interest in them. Prestigious lovers and admirers brought wealth and notoriety that in turn generated publicity for their shows. The magical power they exercised was born in the nexus of femininity, commercialism, theatre, and publicity. They offered a phantasmagoria of glamour as a commercial aesthetic of illusion and fascination.

The courtesan-performers of the belle époque were figures whose lives were a constant parade. They lived like modern celebrities in the public eye and their various activities were eagerly covered by a press that was happy to weave around them legends and stories that were often exaggerated. They were manna to publications like *Gil Blas*, *L'Echo de Paris*, *Le Figaro*, and *La Vie parisienne* that thrived on their activities and conveyed them to a mass readership. As women on the make, they counted on a good measure of popular sympathy in France, as well as curiosity. Although several of them performed on stage in London, it was only in Paris that their erotic life was a matter of continuous press interest and comment. Otero, de Pougy, and company were true stars whose images were reproduced on thousands of postcards as well as in magazines and posters. The Reutlinger studio

specialized in images that captured their specialized sex appeal. Founded in 1850 by Charles Reutlinger, his studio on the Boulevard Montmartre produced magazine illustrations, postcards, and sumptuously bound volumes of women in a variety of sensual and leisure-oriented settings including the beach, the boudoir, the theatre, and the bustling boulevard. Women were sometimes featured singly and at other times in groups, but men were rigorously absent. As a result, there was 'a distillation of the image of femininity to a subject in and of itself'.[80] The human bearers of this image were self-aware performers engaging in allusive but unquestionably sexualized display.[81] They included the most famous courtesans but also some professional female performers and many anonymous young women.

Although they were often grouped together with Otero and d'Alençon, and featured on numerous Reutlinger studio postcards, both Cléo de Mérode and the Italian singer Lina Cavalieri enjoyed an artistic reputation. De Mérode came from an aristocratic background (her 'de' was genuine, not a pseudo-aristocratic affectation) and accounts suggest that she was a highly accomplished dancer. Even after she left the opera for more profitable work in the popular theatres of Paris, London, New York, and St Petersburg, her shows were typically of classical inspiration. She also worked in an exotic idiom; at the 1900 universal exposition, she appeared in a cycle of Cambodian-inspired dances. Cavalieri first appeared on the Paris stage at the Folies Bergère in 1895, when she substituted for de Pougy in a production of Jean Lorrain's pantomime *L'Araignée d'or*. In her later career she emerged as one of the first women to become a star in a contemporary way, using several media and all her attributes to promote herself incessantly. In an Italian book of interviews with most of the famous figures mentioned here, published *c.*1903, Cavalieri showed an awareness of what she termed 'the psychology of the public'.[82] About to make her debut in *Manon Lescaut*, Puccini's adaptation of Abbé Prevost's tale of a young beauty lured into a life of wealth and immorality, she was alert to the need to appear serious and avoided responding to the interviewer's frivolous questions about her shoe size or the number of gloves she possessed. None the less, the male author indulged his readers at length with considerations on her eyes, her skin, her neck, her hair, and her hands.[83]

The courtesans displayed their jewels, not as a badge of their husbands' worth like respectable women (since, with just one or two exceptions, they did not marry), but as an indication of the devotion they had inspired in admirers. Cocteau said that maintaining one of these women was as complex as buying a house and furnishing it room by room. However, they had a magpie's eye for diamonds. Ever since Louis XIV studded his garments with them, diamonds had been a mark of status. In the course of the nineteenth century, they became a female prerogative. More jewellery indicated more generous and richer suitors and therefore higher status. The courtesan-performers were the first to insure their bodies and announce the fact—as Otero did when she rejected an assessment of the value of her legs at $10,000 and insured them for $80,000 each. Even if the particular conjuncture of the belle époque favoured the public emergence of women whose every gesture was designed to attract publicity and further their notoriety, the heritage of the old-style *demi-monde* was constantly evoked. Sarah Bernhardt frequently appeared in plays such as *La Dame aux camélias* and *Salomé*. In the variety theatres, a singer like Yvette Guilbert happily made reference to a variety of sensual characters and experiences in her 'Chansons Pompadour' and 'Chansons Crinoline'. The Folies Bergère ran a number entitled *Une soirée chez la Païva*. But in time their own legends overtook these in the public imagination. Otero's popularity reached such a pitch that the Théâtre des Mathurins in Paris even put on an entire musical comedy entitled *Otero chez elle*, starring Otero herself, in which she re-enacted episodes from her life and colourful professional and amorous career.

Although the courtesan-performers, and also actresses, were often experts at self-fashioning and publicity, their individual images always required some assistance from professionals. In the Regency era, Sir Thomas Lawrence had played a crucial role in forging a language of allure for actresses like Mrs Siddons and Elizabeth Farren. His outdoor portrait of the latter was a masterpiece of coquettishness; smiling and sexy, her head turned flirtatiously, she was at once an object of desire and a free spirit.[84] In the second half of the century, the couturier Charles Frederick Worth and his successors, Paquin, Doucet, and Poiret; painters including Boldini, Helleu, and Sargent; and subsequently photographers, all created image techniques that did not rely

on specific subjects. Such men helped forge glamour as a structure and as a system. Occasionally working in cooperation (the artists often borrowed gowns from the couturiers), they combined material seductions with poses, attitudes, and looks that could be conferred on any subject to create panache and arouse desire. Boldini often painted anonymous prostitutes and his pictorial sexiness was informed by his familiarity with the world of commercial sex.[85] Typically, all performers chose a style marked by flamboyant excess, with more eye-catching jewellry, stronger perfume, brighter colours, and more revealing gowns than were worn by upper-class women. They also made ample use of cosmetics to enhance their beauty, something that was forbidden to respectable ladies for whom modesty and understatement in public were de rigueur.

The courtesan-performers boasted of their liaisons with royalty. Among Otero's many suitors, she counted some of the most prominent members of Europe's royal families who, no less than more ordinary men, were bewitched by the aura of glamorous sin that surrounded her. These included at least five present or future monarchs: Kaiser Wilhelm II; Edward, Prince of Wales; Grand Duke Nicholas of Russia, Alfonso XIII of Spain; and Prince Albert of Monaco. Some of these encountered Otero when she was on tour in their capitals; others benefited from a Parisian rendezvous. Needless to say, news of these royal liaisons travelled far and wide and added greatly to her fame and to the legend of her beauty. Such tales fuelled the public's imagination and wove around the leading figures of the belle époque a legend of transgression, beauty, and fearlessness.

De Mérode owed a considerable part of her fame to the attention she received from an infatuated Leopold II of Belgium. Unlike d'Alençon, who had accepted both his lavish gifts and his amorous overtures, she accepted the former while rejecting the latter. Despite this, his attentions became public knowledge and the unfortunate monarch was irreverently nicknamed Cléopold. The brouhaha that ensued permanently tainted her with the brush of the *cocotte*. In later years de Mérode repeatedly denied that she had conducted liaisons for gain, even suing Simone de Beauvoir (and winning symbolic damages of 1 franc) when the latter referred to her as a great *hetaera* in *The Second Sex*.[86] In her support, she could have cited de Pougy's *roman à*

clef entitled *Mademoiselle de la Bringue*, that featured a certain 'Mademoiselle Méo de la Clef' who 'personifies *Love* WITHOUT MAKING IT'.[87] Yet few believed that de Mérode was not a courtesan, for all her understated delicacy and background in classical ballet. People preferred to imagine her as erotically available. She indulged moreover in gestures that were reminiscent of the courtesan. When the sculptor J. A. J. Falguière exhibited a magnificent statue of a nude dancer in 1896 that closely resembled de Mérode, the dancer asserted to general disbelief that she had posed only for the head.[88]

Liaisons with royalty were good publicity but increasingly it was relations with the super-rich bourgeois of their day that sustained these women. Otero boasted of the necklaces she received from the wealthy Viennese banker Baron Ollstreder that had once belonged to Empress Elizabeth of Austria. The new rich also competed for the mercenary affections of the most fashionable women of Paris as they took over the social position and exterior lifestyle of the aristocracy. The wealthy of the United States, Britain, and Europe needed such women in the way they needed a yacht, a stable, or a hunting estate. According to the writer and journalist Octave Uzanne, 'what they want from her is neither love nor erotic pleasure but the consecration of their renown as men-about-town (*viveurs*)'. In a passionless contract, she is annexed by the bourgeois as 'the friend, the representative of his elegance, the mascot of his chic'.[89] For intimate business, Otero's price in 1897 was said to be 25,000 francs for fifteen minutes.[90] However, for a woman as instinctive and passionate as Otero, purely instrumental deals were unsatisfactory. She left Ollstreder because all he wanted was to be with a famous *demi-mondaine* whose luxury would bring him honour.[91] She perceived that this embourgeoisement of *galanterie* eliminated its spontaneously gay character. It reflected a luxury that had become predictable and systematic. Instead of receiving gifts of champagne, performers like Otero were invited to appear in branded champagne advertisements.

Otero's special resonance derived from her identification with Spain. As Mario Praz showed in his magisterial study *The Romantic Agony*, the powerful misogynistic trope of the femme fatale was born in Spain, albeit the imaginary Spain of Prosper Merimée's *Carmen*. She then moved to Russia, before Théophile Gautier and Flaubert located her definitively in 'an atmos-

phere of barbaric and Oriental antiquity, where all the most unbridled desires can be indulged and the cruellest fantasies can take on concrete form'.[92] Many of the character traits or costume features of the femme fatale were drawn from an Oriental repertoire. Her morbid associations with death, the natural, and the supernatural fitted the image of the East as a place of cruelty, superstition, and danger. But Spain carried strong associations of female fire, passion, and sex. Otero comfortably fitted the stereotype. A force of nature, who was renowned for her fiery spirit, in February 1892 she was even said to have fought a duel against an actress who had joked at her expense. This incident was rendered even more scandalous by the rumour that both parties had fought topless.[93]

Whatever their imaginary associations, the stamping grounds of the courtesan-performers were the institutions of the commercial public sphere that, formed in the mid-nineteenth century, blossomed in the 1890s. These included hotels like the Ritz, the racetracks, restaurants, theatre premieres, and the Bois de Boulogne as well as some salons and the artistic community.[94] Especially popular was Maxim's, the legendary establishment that was frequented by all the rich and beautiful people of the period and which was immortalized in several plays and books including Georges Feydeau's comedy *La Dame de chez Maxim*. The Rue Royale restaurant was notorious for its clientele of courtesans, including a quota who did not yet have a permanent protector. In his memoirs, the one-time *maître d'hôtel* of this unique establishment did not hesitate to reveal the contents of a notebook he kept listing available smart women.[95]

The distinction between respectable society and the world of spectacle and seduction was supposed to be rigid. But in an age of publicity, the emergence of theatre to social prominence, fashion, and the internationalization of the season, the barriers between *monde* and *demi-monde* were not what they had once been. The most socially heterogeneous locations were those spas and resorts that were developed especially by the British, including Biarritz, Deauville, Dinard, Cabourg, Monte Carlo, and the Riviera. Monte Carlo thrived on its racy reputation, to which the casino and its clients greatly contributed. Kings, princes, nobles, bankers, rentiers, artists, writers, actresses, and many others arrived in the resort in early summer, retreating

once it became too hot. The courtesans were always on the move, either touring or looking out for new patrons. Such an appetizing place attracted them like magnets. Otero was a regular visitor and her legendary wins, and especially losses, at the gaming tables contributed to its image as a 'dazzling center for chance and caprice'.[96] The Riviera was a place where, it seemed, anything could happen and quite often did. The simple fishing villages that marked the highly picturesque coastline developed into a stage for the public and private rituals of a heterogeneous international elite that, because it was constituted temporarily away from conventional expectations and power structures, was relatively unrestricted by responsibility, decorum and social distinctions. The Riviera was a place of imagination that produced a powerful mythology.[97] The social mix of royals, the rich, courtesans and gold-diggers, gigolos, writers, exiles, newspapermen, and publicists fuelled the dreams and aspirations of magazine readers who thrived on gossip and sensation. This mix was often not spontaneous but the deliberate strategy of publicists who invented events, invited celebrities and wove legends around them. The queens of the *demi-monde* were vital in adding a pinch of high-class sleaze. Although they frequented all the Riviera resorts, they left their mark especially on the environment of Cannes and Monte Carlo. The Salle Blanche at the Casino de Monte Carlo is dominated by a large-scale 1903 painting that depicts La Belle Otero, Liane de Pougy, and Émilienne d'Alençon as the three graces,[98] while Otero's opulent breasts served as the model for the twin cupolas of the Carlton Hotel in Cannes.

In what was seen of the fashionable life, the courtesans were prominent and they had precisely the attributes of beauty, desirability, wealth, and immorality that were associated in the popular mind with the upper class. Their backgrounds endeared them to the masses while their stunts kept everyone interested. But the fascination with the upper class never went away. Indeed, in bourgeois society, it increased not as deference but as curiosity and envy. Due to economic development and the spread of democracy, people felt themselves to be part of a collectivity that included the rich and famous. The glamorization of the upper class of the turn of the century is the subject of the next chapter.

WEALTH, STYLE, AND SPECTACLE

B efore the last few decades of the nineteenth century, the new rich were rarely richer than those who had inherited land and wealth. The expansion of industry in the late nineteenth century and the growth of the American economy created for the first time new fortunes without parallel. The men who accumulated them saw themselves as an emergent new elite and they craved acknowledgement. Because they had neither heritage nor breeding to draw on, they set about winning this by fashioning a lifestyle of great ostentation. Massive palaces, ultra-refined interiors, enormous yachts, grand summer houses, glittering parties, elegant weddings, and international travel became the key markers of status of the super-rich. A correlative of such ostentation was publicity. Much of this was deliberately sought, since one sure way to attract the attention of the established holders of social power was to occupy the social pages and set new standards of luxury and elegance. At this time, New York was already the Mecca of American high society. To win recognition there was a guarantee that one had truly arrived. Needless to say, there were risks in attracting attention in such a highly competitive location, since the press was not subservient or

particularly deferential. The American rich who flocked to the city found that several publications were pleased to cultivate the curiosity of their readers for every aspect of their domestic and private lives. The press was a product of a fast-developing urban society and, by its gleeful intrusions, it turned the doings of the wealthy into a source of diversion and mass entertainment.

Much of the public interest in the new rich derived from their highly publicized battles to gain access to high society. They found that gaining admittance was by no means straightforward. The established elite, which was made up of families whose wealth had been accumulated two generations previously, modelled itself on European court society and granted itself prerogatives that were hereditary. The forms taken by upper-class life were developed precisely in order to guarantee the pre-eminence of this restricted group that was commonly referred to as the 'Four Hundred': the number of people who supposedly could fit into the ballroom of Caroline Astor, wife of William Astor, who occupied the pinnacle of New York high society between the 1870s and the 1890s. It was she who, with the aid of her social ringmaster Ward McAllister, determined who got in and who did not.[1] The Vanderbilts, for example, whose fortune was based on railroad expansion, were long regarded as too uncouth to be admitted, even though Cornelius ('the Commodore') Vanderbilt, at the time of his death in 1877, was the richest man in America. The exclusion of the new millionaires from the inner sanctum of high society compounded an outsider image that won them sympathy. Everyone could identify with their battle against snobbery and prejudice.

The wealthy families of the American 'gilded age'—an expression coined by Mark Twain—mesmerized their contemporaries with their enormous and recently acquired wealth. People of all classes were riveted by the ever-spiralling luxury of elite life that was recounted in great detail in the newspapers and magazines. The families seemed to many to be living the American rags-to-riches dream. The beauty and style of some of the women also enhanced their glamour. People identified with them and their rites of passage were treated from the 1880s as public festivities in which everyone had the right to participate at some level.

The case of the Vanderbilts shows that social progress was a complex matter. Even after the Commodore's demise, his handsome and more polished son William K. (Willie) Vanderbilt faced obstacles. Despite installing themselves in a huge and dazzling house on Fifth Avenue, and winning invitations to some events, he and his wife Alva remained outside the core elite. To rectify this, Alva waged a concerted campaign that culminated in March 1883 with what would become known as the Vanderbilt ball. By inviting 1,600 members of the elite and succeeding in making this house-warming event the social occasion of the season, she created the necessary pressure to cause Mrs Astor's resistance to crumble.[2] Such public assaults on the citadel of the elite inevitably meant that the new rich lived in a goldfish bowl. Messy divorces, adultery, and other scandals all received ample coverage and, while they brought condemnation from some quarters, enhanced the soap-opera quality of the lives of the protagonists. The mass public was fascinated by their extravagances and followed them as it did the actresses and courtesans.

The sudden rise of new industrial fortunes had a significant impact beyond the United States. In their search for embellishment and recognition, the rich travelled to Europe, notably France and Great Britain, countries in which wealth was blended with institutionalized social privilege. American millionaires found in the France of Napoleon III that new money was not disdained at the very top of society.[3] Their lavish spending contributed to the festive elegance and ostentation of social life that was the means whereby a parvenu court secured its pre-eminence. It was also welcomed in England, especially in the late Victorian and Edwardian years. Edward, Prince of Wales cared little for the stuffy formalities of court society and happily mixed with what the American novelist Edith Wharton called 'gentlemen with short pedigrees and long purses'.[4] A variety of bankers and millionaires who would previously never have come near the royal family were inducted into high society, which at this time had two of its major centres in Edward's London and country homes, Marlborough House and Sandringham.[5] Some came because they had been shunned by the American elite, others because they admired England's 'true aristocracy'. William Waldorf Astor turned his back on 'vulgar' America in 1890 and set up home in England, buying Cliveden, a Restoration baroque mansion that was one of the most beautiful

houses in the country.[6] He filled it with treasures accumulated on his travels in Europe. The prince shared the plutocrats' love of luxury and he appreciated their willingness to support his costly lifestyle.[7] He also found that the men often shared his passion for theatre and its female performers.

The first American arrivals were surprised by the sheer cost of taking part in London life, with its many rituals and social occasions. The highest standards of hospitality were obligatory and the women especially were expected to dress to impress at all times. However, the newcomers were not easily deterred. American millionaires were wealthier and more materialistic than most Europeans. Their acquisitiveness contrasted with the English nobility's conventional (if sometimes feigned) disinterest in material objects.[8] Unless they were recent inventions, new things were generally not of much interest to the aristocracy and old ones only had value if they were inherited. As Vita Sackville-West wrote in *The Edwardians*, typically 'they thought more of a small old family than a large new fortune'.[9] The emphasis shifted as the plutocrats introduced a sharpened element of competitiveness into upper-class lifestyles as they used luxury to overcome social barriers.[10] The 'intrusion of money' was seen as a characteristic of both the Americans and of the Edwardian years, the period of their greatest ascendancy in British high society.[11] One contemporary observer denounced the 'insane competition' that accompanied the rising standard of living. 'Where one house sufficed, now two are demanded; where a dinner of a certain quality, now a dinner of superior quality; where clothes or dresses or flowers, now more clothes, more dresses, more flowers.'[12] For the English landed aristocracy, all this was alarming, not least because agricultural rents were falling. With wealth becoming the key factor in determining status, their ability to remain pre-eminent was threatened.[13] The influx of wealth, and in particular of American wealth into British high society, had the added disadvantage of intensifying competition within the aristocratic marriage market. The naked ostentation of wealth led to denunciations of 'cash power' and 'money-dominance', with particular hostility being reserved for the displacement of older standards by vulgar ostentation and greed.[14]

Although the outlay of capital was a means of winning recognition and prestige, pecuniary strength alone was never enough. To win social recognition,

the money values of Wall Street needed to be translated into the cachet of Fifth Avenue or, failing that, a European title. The new rich were intrigued by the example of the courts and the aristocracies of the past. In an effort to mitigate or camouflage the novelty of their wealth, they sought to acquire the attributes of taste and culture by appropriating historical styles and objects.[15] Art and architecture of the classical and Renaissance periods were especially favoured by those with aristocratic pretensions. But the borrowing of taste was rarely tasteful. The extraordinary competition to build European-style stately homes on Fifth Avenue in New York and in the summer resort of Newport led to a proliferation of 'great gawdy palaces' in Italian, Gothic, and Oriental styles.[16] These were not private residences in the strict sense, but material manifest- ations of wealth and theatres of status.[17] The Vanderbilts' Marble House on Ocean Drive in Newport reflected its owner's obsession with Louis XIV. The house not only had a gold ballroom, portraits of the Sun King, and period bronze furniture in the dining room, it also featured a copy of Bernini's bust of Louis XIV on the first-floor landing. A portrait of the house's architect was placed next to one of an architect of Versailles.[18] In the USA, no less than in Britain, writers and cartoonists lampooned the eclecticism of the new rich and their pretensions. Negative comment, however, was mainly confined to an elite of taste; others found the display awe-inspiring and utterly admirable.

The heiress was the figure who, in the public imagination, embodied the millionaires' aspirations for recognition and acknowledgement. Her efforts to net a suitably prestigious husband received much coverage. There were several reasons for this. In the first place, women played a symbolic role for the rich. According to the eclectic American academic Thorstein Veblen, who in 1896 wrote a tongue-in-cheek account of the American 'leisure class' that remains widely cited, wealth and leisure were displayed in order to establish gentility and civilization.[19] Women were the prime vehicle of this since the duties of vicarious leisure and consumption had devolved to them. Thus a daughter who con- formed to prevailing ladylike standards of appearance and deportment was a valuable asset.[20] In addition, the press found that its readers, who were used to seeing news and pictures of actresses and performers, could relate to heiresses, who were more appealing and picturesque than crusty millionaires. Some heiresses were of more interest than others. The extraordinary fame of the five

Langthorne sisters of Virginia in the 1890s was due to their beauty, spirit, and elegibility.[21] The marriage of each attracted frenzied publicity. A new dimension was added to the narrative when some heiresses headed for Europe in search of a titled husband. These young women, whom Edith Wharton memorably labelled 'buccaneers' in her last, unfinished, novel, were not on the whole treated with respect or deference abroad. Outside their native context, they were detached from 'certain signs of social position' and were regarded as fair game by the press and others.[22] The nobility was lured by their lucre and it was this that propelled some of them into matrimonial alliances with families whose gentility they doubted. For the same reason, the press latched on to them and turned them into personalities.

No single young woman embodied the role of the golden heiress more than Consuelo Vanderbilt, the daughter of Willie and Alva, who, at the age of 18, married the ninth Duke of Marlborough in New York in November 1895. The wedding was one of the most spectacular that the city had ever seen and curiosity about every aspect of it was intense. Consuelo herself was a refined and educated young woman whose long neck and graceful figure marked her out as a physical embodiment of what Veblen called pecuniary beauty.[23] The couple's engagement was presented to New Yorkers as an all-American tale that confirmed the ascendancy and vitality of the new world. The most eligible peer in England had chosen for his bride the most sought-after heiress in America. In fact, this alliance was more or less a simple trade between money and titled distinction in which the bride was little more than a pawn in her mother's schemes for social aggrandizement.[24]

The celebrations, which began with the announcement of the engagement in September, sparked a wave of publicity. This was fed by Alva Vanderbilt, who released full information about the wedding dress (made of cream and white satin, with a 15-foot train, it cost $6,720), the bridesmaids, and the guest list. Samples of her daughter's trousseau were even delivered to the offices of *Vogue* magazine.[25] Many years later, Consuelo disingenuously gave the impression that she was a victim of press intrusiveness. She wrote that while 'reporters called incessantly, anxious to secure every particle of news...little news was given out'.[26] This, she claimed, led them to fabricate information to pander to readers' appetites. 'I read to my stupefaction that my garters had gold

clasps studded with diamonds, and wondered how I should live down such vulgarities,' she wrote. It is not clear which she regarded as more vulgar: the publicity given to her undergarments or the implication that she indulged in such jaw-dropping refinements. On the day, thousands of enthusiastic on-lookers thronged the streets waving handkerchiefs and cheering loudly. The bride, however, recalled that, as the couple exited the church, 'the crowd surged towards us and women tried to snatch flowers from my bouquet. There were spasmodic cheers and less friendly sallies.'[27] Although the American rich were viewed with more sympathy than those of other countries, there was always some envious resentment of their lives of privilege.

Unlike high society in the United States or France, in England it had always been an adjunct of politics. Its existence was based on the assumption that those who were politically pre-eminent were also socially pre-eminent; high society and political society were coterminous.[28] The rationale of the social season, with court functions, Royal Ascot, the Cowes yachting events, and so on, lay in its connection to the parliamentary calendar. Its more frivolous aspects were not ends in themselves, but a balance to serious work, that had the added advantage of providing a forum in which the marriage market could function. In the 1890s, however, the two worlds grew apart as other factors, including consumption, the press, and social competition as an end in itself, took the place of politics as leading dynamics of high society.[29]

In this context, there was a marked increase in what, some years earlier, Walter Bagehot called 'the theatrical show of society'.[30] In place of stuffy private rituals, more glittering events were staged that gratified not only the participants but also the wider society's demand for spectacle. These pro-vided a stage for the rich and famous, on which the titled and the powerful had influential but not necessarily leading parts. 'A fine dress was no longer something to be worn at court or at selected private assemblies; it was something to be worn in the most public manner possible,' the fashion historian James Laver observed.[31] 'Strange hocus pocus, that juggles certain figures into prominence, so that their aspect is familiar to the wife of the bank-clerk, and their doings a source of envy to the daughter of the chemist in South Kensington!', a character muses in *The Edwardians*;[32] 'With what glamour this scheme is invested, insolent imposture!'

115

In New York, the theatrical turn of high society is regarded as the achievement of Mrs Astor's lieutenant, Ward McAllister. A born courtier, who had acquired on his travels in Europe a veneer of taste and style, he persuaded Mrs Astor that he could produce a show in which she would be the leading lady.[33] As a Southerner from Georgia who had reinvented himself as a social grandee, McAllister played on the myth of antebellum Southern courtesy and grace. Northerners viewed the old South in a manner similar to the Napoleonic bourgeoisie's outlook on the *Ancien Régime*, as a world of courtly manners and style to be annexed or drawn on in their own pursuit of refinement.[34] Thus the Virginian Irene Langthorne, who had already won some attention in the New York papers as a Southern Belle, found herself personally invited by him to lead the grand march at the super-prestigious Patriarch's Ball in 1893. Paradoxically, the exclusivity of such events added to their appeal as spectacle. 'The 400 are in the social business,' commented the magazine *Town Topics* in 1896. 'They do not spare pains, expense or advertising for the sake of maintaining a brilliant and refined series of continuous social performances. They are the actors, the rest of us are the spectators; but there is this difference between their show and all other shows, that they not only give the performance, but they do not charge anything for the privilege of looking at it.'[35] At this time, it became common to refer to high society as a circus and to social events as theatrical displays,[36] a perception that gave rise to criticism. 'We protest against . . . the tendency manifest in some quarters to hold such a class of frivolous drones up to the public gaze as "society",' commented the *Los Angeles Times*, adding that 'the rising generation . . . are too apt to be impressed by the glamor of wealth'.[37]

Society journalism emerged at just the moment that competition for high status was growing. Publicity became a weapon in this competition. By the early years of the twentieth century, the interiors of the millionaires' homes had become the subject of photographic features in illustrated magazines.[38] This showed that new members of high society were happy to play to the gallery.[39] The press won readers by offering them the spectacle of the lives of the wealthy and fashionable, while the latter enhanced their status and kudos by acquiring a broader stage. Old elite members often considered publicity to be vulgar or intrusive, but it soon became a crucial tool not only in

mediating relations between elite and mass in modern society but also in determining the rhythms of elite life itself. 'The signature of pecuniary strength should be written in characters which he who runs may read,' observed Veblen.[40]

Magazines like the *World* in London or *Town Topics* in New York served high society while also providing information for the curious and the ambitious. Edith Wharton's upwardly mobile character Undine Spragg in *The Custom of the Country* has been 'nurtured on Fifth Avenue'; she 'knew all of New York's golden aristocracy by name, and the lineaments of its most distinguished scions had been made familiar by passionate poring over the daily press'.[41] Specialist reporters were employed to gather news, gossip, and pictures, and to describe events and romanticize them. Apart from cases of divorce, murder, or suicide, high society material did not feature in the news pages. It was a self-contained realm that provided readers with a tantalizing escapist dream.

The press was not the only institution that afforded a public stage to the rich and famous. The increasing numbers of rich people, and their tendency to congregate in the capitals, fuelled the development of luxurious commercially run establishments. Grand hotels, expensive restaurants, theatres, and nightclubs were founded to cater for the wealthy elite. The Paris Ritz opened in 1898 and its London sister hotel in 1906. When the Waldorf-Astoria opened in New York the 1890s (the two constituent hotels were respectively opened in 1893 and 1897), on the site of the present-day Empire State Building,[42] it immediately became synonymous with the Four Hundred who stood at the apex of New York society. The *maître d'hôtel*, Oscar Tschirky (known to all simply as 'Oscar'), was expected to greet each member of the leading families by name. It was also his task to bar non-members from the Palm Garden dining room and divert them to secondary rooms. The management sought to attract middle-class custom by means of its elite connections (which were also exploited in advertising material) while keeping the two categories of guests separate.[43] All parts of the hotel and even the staff were organized on a rigidly hierarchical basis. But this sort of practice was difficult to maintain in the long term. Exclusionary mechanisms could only be partial in establishments that were by definition within

the reach of anyone with money and which seemed to invite everyone else to aspire one day to be a guest. The Waldorf-Astoria's lavish charity balls were themselves significantly more open than Mrs Astor's since its Marie Antoinette drawing room, which was a reproduction of the queen's private apartments at Versailles, could accommodate 1,500 people. Oscar, moreover, also offered advice to businesses, national organizations, alumni groups, and regular guests on how to entertain.[44] It was this very mix of the exclusive and the accessible that made such places glamorous to the wider public. They helped render elite lifestyles and personalities intriguing, exemplary, and imitable.

Specialist publications aimed to cater to the elite by making themselves into indispensable aspects of the wealthy lifestyle. In this way publishers could provide advertisers of luxury goods with a select audience who would be interested in their wares. *Vogue* was the pioneer publication of this type. Everything about the magazine was designed to appeal exclusively to the cultivated and the moneyed. It was not, in those days, primarily a fashion journal. It ran many articles on the arts, on domestic interiors, gardens, and even sport. It featured a wide range of personalities drawn from established families and theatre and it ran short stories as well as bringing news of new trends. The latest fashion information from Paris was just one feature, albeit an important one, in a complete package.[45] Under Condé Nast, a Midwesterner who bought it in 1909, *Vogue* was a magazine that recounted 'society, fashion and the ceremonial side of life' to the social elite of America's East coast.[46] Nast had no interest in reaching a mass readership and instead aimed to make the publication essential reading for the celebrated top Four Hundred people. In his aim, he certainly succeeded; he once claimed that every single member of the Four Hundred was a subscriber.

Needless to say, the magazine was also read by the Undine Spraggs of this world, who combed it for tips on elegant living. Stories of the lives, houses, wardrobes, and travels of the rich were fascinating and helped fuel interest in consumer goods. Commerce prospered on the back of the appetites of the rich for ever more refined goods, services, and entertainments.[47] Newspaper coverage of their activities was punctuated by advertisements for furnishings, alcoholic beverages, holiday resorts, and other goods. Through a

variety of associations between places, images, and people, glamorous im-
ages were created. Entrepreneurs around the world saw the value of these
attributes both as a guarantee for upper-class clients and an allure for
aspiring ones. Stores, in particular, traded on this. An editorial writer for a
British trade magazine called *Modern Business* observed in 1908 that 'People
shop in the magic West End because in some mysterious way they believe
they get better goods there.... By years of suggestion [it] has created a
special atmosphere.'[48]

Atmospheres and suggestions permeated the whole of commercial cul-
ture, often mixing motifs of class and spectacle. *Vogue* portrayed socialites in
ways that highlighted their elegance, grace, and mystery. The magazine
featured elegant cover illustrations of women in fantastic hats with generous
plumes; the subjects reclined on chaises longues or were depicted gliding
over carpets made of stars of the Milky Way.[49] The American upper-class
female ideal was encapsulated in Charles Dana Gibson's graphic creation, the
Gibson Girl. After first appearing in *Collier*'s magazine in 1890, Gibson's line
drawings grew so much in popularity that they had become, by the early
1900s, 'the foremost image of female perfection for Americans.'[50] Every
young woman in America envied her slim waist, long neck, regal bearing,
and air of remote self-satisfaction. 'The Gibson girl was the first great
American glamour girl long before there were movie stars,' wrote the
legendary fashion editor Diana Vreeland in 1975; 'Every girl in America
wanted to be her... Every man in America wanted to win her.'[51] As an
angular, elongated figure, of the Consuelo Vanderbilt type, the Gibson Girl
symbolized confident grace. She was often depicted in motion. Her tall, slim
body, and swan neck automatically signalled the woman of fashion and, by
implication, the woman of high status. She always had poise and a certain
composure that together indicated refinement and leisure.[52] Her flowing
skirts and dreamy eyes were regarded as sexually alluring.[53] Although more
wholesome than decadent, in keeping with the American emphasis on health
and pioneer endeavour, she was later seen as a New World counterpart to the
femme fatales of nineteenth-century European decadent literature.[54] As the
first American dream girl, she served various decorative or status-related
purposes in the applied arts and advertising.[55] The original models were

New York high society girls who Gibson, the charming scion of a respectable Boston family, personally knew. One was Irene Langthorne, who married the illustrator in 1895. Their wedding, which was seen as one of several symbolic reconciliations of North and South, turned Irene into 'the' Gibson Girl. In this way, her family's biographer asserts, she 'turned the vanishing Southern Belle into a modern media fantasy'.[56]

These innovations bore directly on the manner in which the women of the new rich were represented in other media. To depict socialites as simultaneously fashionable and noble, alluring and virtuous was not an easy task. Upper-class women always had to be respectable. Unmarried women were expected to be pure and married women to maintain a good reputation. The strong emphasis on female modesty was an important feature of bourgeois morality that was applied rigidly. Anyone who flouted social convention was subject to swift censorship or, in extreme cases, ostracism. This meant that any reference to sexuality, a key element of glamour, was controversial. Even *Vogue* only featured hints of sexiness; the drawn female subjects of its covers have been described as 'a little perverse, given to aloof pursuits and secret smiles'.[57] The problem was exacerbated by the fact that Parisian associations were employed to confer values of fashionableness, worldliness, and desirability on both women and goods. As the world's most dynamic and alluring capital and a city that had made luxury production a key hallmark, Paris offered a variety of attractions to the American rich. Wealthy and upper-class women were eager to appear fashionable, and this could not be achieved without some suggestion of the spirit of gaiety and hedonism that was associated with the French capital. The very richest regularly visited Paris and did their shopping there. In New York fashionable dressmakers and hairdressers affected French names and manners in the knowledge that this would appeal to the vanity and aspirations of their clients and enable them to charge more.[58] Images of the Paris courtesans were also used to promote some luxury goods.

Painters like John Singer Sargent and Giovanni Boldini were kept very busy producing portraits of the richest and most ambitious men and, especially, women of their day. The Italian-born American Sargent, in particular, eventually became expert in conferring an air of relaxed superiority

and comfortable composure on subjects who had elbowed their way to the front of the social pack. However, both artists struggled to forge a style that was simultaneously sexy and classy, candid and alluring, dignified and attention-grabbing. Both men ran into trouble in the course of their careers for erring too far towards the sexy. The young Sargent's promising career in Paris ground to a halt after his daring portrait of the eccentric young American-born French Creole socialite Virginie Gautreau (in which the subject was only identified as 'Madame X') was greeted with derision when it was shown at the salon in 1884. The 23-year-old Madame Gautreau was depicted wearing a simple, but exceptionally low-cut, black gown with a shoulder strap hanging down over one arm. Her skin tone was bluish and her attitude, underscored by a head turned in profile, at once immodest and haughty.[59] This louche depiction, which was taken to suggest that its subject was either about to have—or had just had—sex, produced a horrified reaction.[60] Not even the capital of sex appeal was ready for a society portrait that presented its female subject as a debauched woman of pleasure. Sargent's commissions dried up over night and he was forced to leave Paris. An Italian who took over Sargent's rooms after the latter's departure, Boldini found several prominent women refused to sit for him, while the husbands of others demanded that portraits be retouched to restore them to respectability. Italy's Queen Margherita, for example, declined his offer to paint her and his sensual portrait of the Sicilian industrialist's wife Donna Franca Florio so enraged her husband that the artist was obliged to make modifications.[61]

It was often the menfolk who were most protective of their wives' reputations. The former Consuelo Vanderbilt recalled a stopover at the Hôtel de Paris in Monte Carlo shortly after her marriage in the course of which she ate her meals 'among a lively crowd of beautiful women and elegant men, many of whom were acquaintances of my husband. When I asked him who they all were I was surprised by his evasive answers and still more startled when informed that I must not look at the women whose beauty I admired.' 'It was only after repeated questioning', she continued, 'that I learned that these were ladies of easy virtue whose beauty and charm had their price.'[62] She was also instructed not to acknowledge the men who were accompanying the courtesans even if she knew them personally. These exclusions did

not apply universally and they were sometimes broken by the courtesan performers on their tours abroad. Otero won acclaim in New York and was temporarily accepted by sections of high society. She even attended a ball at Consuelo's parents' Newport residence Marble House.[63] However, while women were drawn to Parisian gaiety, they had to be careful not to become contaminated by it.

Both Boldini and Sargent later painted Consuelo as Duchess of Marlborough, although not in isolation. Sargent painted the Marlborough family group (the Duke, Duchess, and their two children) at Blenheim Palace, producing a large-scale work that was graceful and stylish, if a little over-composed. For his part, Boldini created a more intimate and beautiful picture of Consuelo, seated in a reception room at Blenheim Palace with her young son Ivor. The painting, which was deemed superior to Sargent's, was both elegant and domestic. It managed to show its female subject as both maternal and fashionable. On the whole, Boldini ably managed to balance the different demands of his clients. Unlike the well-bred Sargent, he developed a system of representation that drew on his own low-life experiences. Throughout his career he frequented the *demi-monde* and he counted the great actress-courtesans among his friends. He happened to work at just the time when the fashionable society beauty was being challenged and to some extent replaced by the professional beauty who had risen through the *café-concert* or the theatre.[64] This process was caught and possibly accelerated by the artist, who derived a technique of representation from the entertainment world that he then transferred to new rich and aristocratic subjects in a diluted form. Boldini conferred on the wives of financiers and industrialists, as well as society figures keen to show off their status, a fashionably elongated physique complete with small head, delicate features, a long neck, and trailing arms. He twisted and turned the female form into the serpentine poses that had come to be identified with the femme fatale.[65] In brief, he turned them into Parisian-style Gibson girls. Boldini did not derive his model—save in small part—from the tradition of aristocratic portraiture; rather he forged a new one that merged and catered to the tastes of the new rich and the show-business elite. His trademark style blended sensuality—in the form of twisting figures, swagged gowns, and uncovered

flesh—with a theatricality that was evident in bright colours and a subdued exoticism. His female portraits were always elegant but at the same time he conferred on his subjects a certain daring attitude that was drawn from the *demi-monde*.[66] To arrive at this model, Boldini drew on his long experience of painting small-time actresses and prostitutes.

Boldini was especially good at portraying strong and daring women. His most striking portrait is a magnificent full-length painting of the Italian aristocrat the Marchesa Luisa Casati, in which the subject is swathed in black and accompanied by greyhounds, all rendered with the artist's customary bold diagonal brushstrokes. It is the perfect blend of high style and eye-catching visual effects. Casati was an eccentric noblewoman who was interested only in establishing her striking originality. She was painted and photographed by many leading artists who considered her to be something of an art object. A wealthy divorcee who lived mainly in Venice, where she kept a menagerie in her palace and staged magnificent parties in St Mark's Square, she was the embodiment of the sort of high society femme fatale that the Italian writer Gabriele d'Annunzio depicted in his racy novels. Like Benjamin Disraeli, the author of several imaginative 'silver fork' novels in the 1820s and 1830s before he entered Parliament, d'Annunzio was a poet and novelist who gave readers the impression that his highly refined and often perverse depictions of elite society were a mirror image of the real thing. He conducted a rich and refined lifestyle, mostly on credit, that was fed to his readers as 'unimitable'. In fact, he had a wide impact on fashion, interior decoration, the applied arts, and literature, above all in his native Italy.[67] Like Disraeli, he was a trendsetter of relatively undistinguished origins who, by sheer force of talent and self-invention, turned himself into one of the most prominent men of his time. His elegance, love affairs, fine living, and series of triumphs and setbacks made him a beacon of glamour. On the model of Byron, he crowned his career by throwing himself into nationalist politics. Adopting the mantle of the man of action, he made himself into a symbol of the Italian cause during and after the First World War.[68]

A Boldini of the pen, d'Annunzio contributed to the styling and mystique of the Marchesa Casati and formed a unique creative and sexual bond with the great naturalistic actress Eleonora Duse. Prominent, exhibitionist figures

such as these, who moved at will between major European (and, in the case of Duse, American) cities were part of the current of new wealth, glamour, and social ambition that was taking shape in partial opposition to exclusive, hidebound, aristocratic rituals. They were important in eroding the barriers dividing the worlds of theatre and high society.[69] This was ocurring in a number of ways. The uprooting and relocation of tradition and material artefacts by the new rich created a precedent for imitation and appropriation. The elite lifestyle was no longer the organic expression of a way of life developed over time, but a superficial pastiche that was vulgar in taste and easy in its impact on the senses. It was an artificial facade, a fashioned image that was part of a newly dominant commercial aesthetic. Remoulded in this way, upper-class lives gave a recognizable shape to dreams of wealth and social elevation.

By the 1880s, theatre was fully exploiting links with display, fashion, and shopping. It conveyed the visual impression of class and exclusivity with the specific end of cultivating interest, desire, envy, and emulation. Much to the dismay of some critics, it 'mimetically produced the spaces and commodities of an ideal bourgeois material world'.[70] In London in 1893, Gilbert and Sullivan's *Utopia (Limited)* featured a drawing-room scene that, according to the advertising, was an exact replica of one of Queen Victoria's reception rooms. Such re-creations simultaneously stimulated curiosity in the lifestyles of the upper stratum of society and satisfied it.[71] Retailers contributed by filling store windows (which, after Selfridges pioneered the practice, would even be illuminated after dark) with scenes from life, with shop dummies dressed and posed in a way that permitted the best display of goods as objects of desire. The realistic element in such scenes was intended to induce onlookers to project themselves imaginatively into them.[72] Thus high society dinner parties, drawing rooms, and weddings were all represented in a variety of contexts: the press, theatre, and shop window tableaux. Such practices brought theatre and high society closer as manifestations of a society that encouraged the quest for status, comfort, and happiness through display and consumption.

At one time, it would have been inconceivable for actors and actresses to be presented at court or even received in society. Even afterwards it was rare, but by the end of the century, due to the material opulence of theatre, the

theatricalization of high society and the role of the press in projecting personalities, the two worlds were in some ways linked. While the press reported elite events and lifestyles, sometimes embellishing or injecting fiction into them, theatre actually manufactured them. English actresses on the whole were modest and rather domestic. Madge Kendall's genteel ladies and Ellen Terry's romantic heroines were anything but disturbing figures. However, they remained on the margins. Only male actors could simultaneously enjoy all the honours of official acceptance while continuing in the profession. For women, acting was not seen as an art, or a way of earning a living, so much as a vocation for those who rejected the usual rules and norms of society. The public at large perceived actresses as mysterious and even dangerous. According to the *Englishwoman's Review*, 'the life of an actress is to the world at large a curious *terra incognita* peopled by forbidding phantoms of evil or seductive visions of pleasure and success'.[73] This perception was magnified where continental European actresses were concerned. French and Italian actresses exploited fully the opportunities that arose for tantalizing audiences obsessed with respectability. The London appearances of such Continental exotics as Ristori, Réjane, Bernhardt, and Duse provided a fabulous gallery of queens, empresses, courtesans, and freedom-loving women that contrasted with more modest home-grown products.[74] These actresses were often powerful personalities whose offstage reputations and activities added value to their performances. No less than courtesans, they traded in transparent make-believe; their art involved the construction of a personality in which distance from reality was an accepted norm.[75] It was Théophile Gautier, 'the true founder of exotic aestheticism',[76] who turned Cleopatra into 'a sort of oriental Lady Macbeth' and made her a prototype of the femme fatale.[77] This figure was the product of a profoundly misogynist culture.[78] She encapsulated and played out all the fears of the feminine, the irrational, the degenerate, and the racially impure which permeated Victorian culture. As such it mesmerized and fascinated. Although some examples, notably Salomé and Salammbò, the heroine of Flaubert's novel of the same name, were colourless, the opposition the femme fatale offered to the standard image of virtuous womanhood lay rather in the way she combined 'authority and vigor with intense sexual

power' and 'imperiously [expressed] her disdain for the world and values of men'.[79] For this reason, she appealed to some women; certainly the great actresses of the period revelled in such roles. Their costumes bore exterior witness to prevailing ideas about the eternal animal in woman.[80] Feathers, elaborate headgear, animal skins, capes, an abundance of jewellery, and make-up testified to the role of woman as nature and as the chief artificer of civilization.[81]

The leading actress of the age, Bernhardt thrilled audiences with a passionate emotional style in which actress and character were seen as indistinguishable. She built her reputation by playing a series of decadent femmes fatales including Cleopatra, Tosca, Phaedra, Théodora, and Fedora, in many roles written especially for her by Victorien Sardou. Sardou's repetitive and historically inaccurate melodramas all showcased Bernhardt's talents and confused the Oriental and the modern. In *Théodora*, for example, Bernhardt played a whorish dancing girl who rises from a life of debauchery to become the glorious empress of Byzantium.[82] A tortuous plot allowed the actress to display a wide variety of attitudes and costumes. Her unique stage presence stemmed from the way in which she used her whole body to establish a style consisting of a hypnotic tone of voice, majestic and daring poses, spasmodic bodily movements, and piercing eyes.[83] Tears could be summoned up at will. However, more than an actress, Bernhardt was a modern celebrity who practised conspicuous self-display and deliberately sought sensation. She was self-consciously artificial and made ample use of cosmetics and jewellery. Exoticism and eccentricity were her hallmarks, and were reinforced by stage cross-dressing and tales of her unusual diet, a menagerie of pets including monkeys, a cheetah, and jewel-encrusted snakes, and her custom of sleeping in a coffin lined in pink silk. Her performances and offstage publicity stunts blended seamlessly in a continuous effort at startling and dazzling her audiences. She was seen as the Sphinx of Paris, a symbol and ideal more than a woman.

Bernhardt tapped into a new and fast developing culture of spectacle that linked theatres, metropolitan newspapers, print and billboard advertising, international exhibitions, travelling entertainments, as well as stores, dance halls, and other sites of amusement and pleasure.[84] She knew that one

function of the actress was that of populating the fantasy world of the people. Her constructed femininity provided a resource for store display and the periodical market photographers and the nascent advertising industry. All of these participated in the process whereby commodities and manufactured eroticism were blended. In this way, she helped attach glamour to these means of communication. Whenever she travelled abroad, Bernhardt's reputation preceded her and massive crowds turned out to see the world's most famous and most scandalous actress.[85] She undertook regular London engagements between 1879 and 1913 and nine American tours between 1880 and 1918. On her eleven-week tour of Australia in 1891, her carriage was mobbed, her hotels besieged, and theatres overrun with unprecedented demand for tickets.[86] Churchmen railed against her immorality, little realizing that in so doing they only increased the public's fascination. She was the exact antithesis of Victorian puritanism and bourgeois gender values and was seen as a real-life femme fatale. As such, she was irresistibly glamorous. The glamour of the actress derived from her fame and her lifestyle but also from her capacity to merge her personality with the roles she played.[87] Details of her lavish and costly dresses were extensively reported in the press. Such was the quantity and variety of garments and accessories deployed by the actress on- and offstage that newspapers were able to talk about them for the duration of a tour.[88] She favoured soft and floating fabrics, richly embroidered and beaded, that were draped around her body in a way that suggested freedom. Press articles speculated about their value and discoursed at length on the way she wore them. In the United States, her Parisian provenance meant that women scrutinized her wardrobe for fashion tips. In this way, she contributed to the constitution of the feminine self as desirable, and desiring became a key feature of the new publicly focused female culture of the second half of the nineteenth century.

Theatregoers were spellbound by such actresses. The romantic novelist Elinor Glyn felt that her whole imaginative world opened up when, at age 16, in 1880, she was taken to see Bernhardt perform *Théodora*.[89] Marcel Proust offered a fascinating account of the processes whereby a young man was drawn into the fascinations of theatre by the image of the great actress 'Berma' (a composite of Bernhardt and Réjane, according to Proust's recent

biographers).[90] Every morning he goes to view the Morris column near his house to see the announcements of new plays—an experience that nourished his imagination with daydreams. Stimulated by strange titles and bright colours, he conjures up 'vivid and compelling pictures' of plays of different types that he equates to desserts presented at the dinner table.[91] In contrast to Glyn, when finally he is taken to see Berma, he is initially disappointed. Faced with the inconveniences of spectatorship in a real-life theatre and a mannered performance, he finds the work of his imagination superior.[92] But the enthusiasm of others highlights for him the interrelationships between stage performance, imaginative hedonism, fashion, and femininity. The glamour of a great actress is revealed to be less distinctive than was widely supposed: far from being the personalized, unique experience that the young narrator had expected, it was imaginative, sensual, absorbable, and ostensibly available for appropriation through consumption. The enticing image of the actress was a constructed one that the spectator could partially reconstruct in private fantasies, but most especially in relation to collectively sustained imaginings.

Actresses were bearers of collective sexual fantasy who occupied the public scene in a hundred ways. Where most upper-class women held back, they appeared on the stage, frequented hotels and restaurants, appeared in magazines and the newspapers, and circulated widely as images on picture postcards. On- and offstage, they attracted interest and gave rise to exploits that the press followed with glee, finding the theatre to be a source of excitement and interest for its readers. A performer like Lillie Langtry, a clergyman's daughter from Jersey who became a society beauty, artists' muse, and actress, as well as the lover of several royal men, was intensely fascinating. Guided by Oscar Wilde, in whose *She Stoops to Conquer* she made her stage debut in 1881, she appealed to different sections of the public by developing a persona expressed through poses, performances, and adventures.[93] Her image was widely reproduced and she also provided celebrity endorsements of cosmetics and soaps. While print culture offered men new opportunities to acquire titillating images of compliant femininity and indulge in fantasies of possession,[94] magazines and shop windows exercised a special fascination for women.[95]

The lower-class origins of stage performers gave every girl the hope that she too, one day, might bask in celebrity and enjoy a life of charm and luxury.[96] The growth of the service sector brought thousands of young women to big cities to work in shops, bars, restaurants, and other places of leisure and entertainment. Such women were caught up in the metropolitan culture of images, dreams, fashion, and aspiration. The very arrangement of their places of work, such as the introduction of the public bar in the late Victorian period, which separated the female server from male customers, provided them with a simple staging. Although their class and regional origins were rarely mysterious, the fact of their being on display and the distance separating them from consumers endowed them with a residual form of the glamour that attached to professional image-makers.[97] For these women, as well as young female magazine readers of all classes, actresses were an ideal projection of themselves.

The lure of the theatre was so strong that many young and not so young women, even from comfortable families, were willing to throw caution to the wind and pursue a career on the stage. 'The glare, glitter and glamor of the dramatic stage, it seems, never ceases [sic] to attract giddy heads, notwithstanding the trials, hardships and reverses that are daily experienced by theatrical people,' commented an American newspaper.[98] Very often, stage-struck youngsters saw theatre purely in terms of fame and their own ability to achieve it by achieving the right visual effects. One young woman who replied to an advertisement seeking an amateur actress for a new drama told a theatre manager:

I should not have answered that advertisement, for I have never been on the stage, and I know nothing about theatricals. No, I have never even taken part in amateur theatricals. But I am just dying to be an actress; I just know I would succeed. My friends and relatives would seriously object to my adopting the profession; but I would just do it anyhow; and after I became a great star it would be all right, I guess. Now I know that to be a success on the stage one must wear fine dresses, and I have got any number of them. . . . Do they compel you to wear rouge when acting? If so, I would have to, I suppose. You see I have almond-shaped eyes, and can make them appear a little larger by painting under the eyebrows[99]

The theatre was a channel of dreams through which an ordinary life could be transformed into an extraordinary one. Any girl could dream of achieving a magical makeover that appeared to require little or no talent or work. Such beliefs were mostly delusional but the theatre did in fact offer opportunities to some young women of little talent, so long as they had a pleasing manner and an attractive appearance. The development of female spectacle did not rely solely on the great actresses. Rather theatres increasingly specialized in entertainments that were systematic rather than dependent on individuals. A particularly influential model was provided by the 'Gaiety Girls', who were world-renowned for their refined beauty and decorative elegance. Invented by George Edwardes, the manager of the Gaiety Theatre on London's The Strand, they were the world's first branded showgirl. These women some-times sang and danced, while some were required merely to decorate the stage and respond with individual mannerisms to what was going on around them. They looked like ladies, except they were widely held to be prettier. Within a strict paradigm, each one cultivated a different stage identity.

The Gaiety Girl phenomenon was closely linked to the rise of musical comedy which began in 1886 when Edwardes took over the Gaiety and launched a highly successful musical show entitled *Dorothy*. It offered some sort of story, tuneful music, witty lyrics, sumptuous and varied sets, exquisite costumes, and pretty girls. This show did better business than any Gilbert and Sullivan operetta and inaugurated a new genre. Many of the shows at Edwardes's theatre featured the word 'girl' in the title (*The Shop Girl, The Circus Girl, The Quaker Girl*, etc.) and the girls were often the biggest attraction. He carefully selected, groomed, and glorified them, pro-viding lessons in elocution, singing, dancing, and fencing. Their costumes were always in the latest fashions and their elegance was much celebrated. Tanning was forbidden in order to preserve an aristocratic whiteness of complexion and make-up was never worn offstage. The girls were reputedly always polite and very well behaved. Selected from hundreds of young women who came each week for chorus auditions, they became a British female ideal of the 1890s. They can be compared at some level to the Gibson Girl, but they lacked the American's outdoor qualities and their frame was show business. Edwardes encouraged them to go out and be seen in elegant

places, since this would drum up business for the theatre. They were generally treated respectfully by the admirers who pleaded to take them to supper at the Savoy Grill after a show. They could be spotted dining at the best restaurants, enjoying Henley and Ascot, and other society occasions.

The Gaiety Girls were extremely popular with young men about town. They were mock-aristocrats who were sometimes more genteel that the originals. Their fame was compounded when Gertie Millar became Countess of Dudley and Rosie Boote Marchioness of Headfort. For traditionalists, the phenomenon of stage girls marrying into the aristocracy was confirmation that the established order of society had gone into irreversible decline. The scale of it, however, was less than that of transatlantic marriages. It has been estimated that there were 102 marriages between American women and English peers (or sons of peers) between 1870 and 1914, while there were 21 marriages between peers and stage players between 1879 and 1914.[100] In a contest between money and beauty, the former was most likely to win. 'A lovely face is very attractive, and men pay much attention to its happy possessor,' argued an article in the *Los Angeles Times*, 'but there is a wonderful glamour surrounding a woman who is popularly supposed to curl her hair with banknotes, which no amount of personal charm can ever supercede.'[101] In the popular imagination, though, debutantes and chorus girls were rivals. Not by chance, money and the desire for it was one of the stock themes of popular entertainment. The rags-to-riches theme was often present. In *The Shop Girl*, for example, a good-hearted millionaire, who has struck it rich in Colorado, comes to London to find and bestow riches on the daughter of his old, but now deceased, friend from the mining camps. The daughter of course, is none other than the eponymous shop girl.

The Gaiety Girls were manufactured as socialites, but there was a strong showgirl element to them that inevitably entailed sex appeal. For all his insistence on respectability, Edwardes never failed to ask his scouts, when they were recommending a girl discovered in the provinces, 'Would you want to sleep with her?'[102] Sexual desirability was a key attribute for a theatrical performer, and especially if she was a young woman. Male theatregoers, including the fashionably attired and socially polished, were enchanted by the girls of the chorus. "The chorus girl is sometimes pretty

and always interesting to the young man who haunts the front row and lingers after the [show] is over,' commented one newspaper. The reason why they were 'bewitched by ladies of the chorus', however, had more to do with their own fantasies than the talent of the women or the success of a show. While many companies went out of their way to assert the good behaviour of their employees, 'there seems to be a very general impression among young men that the girls in a comic opera company, or any other theatrical company, will readily surrender to their advances, and are not restrained by the ideas of propriety of conduct generally recognized by girls in good social standing'.[103] Such beliefs did not stem only from established perceptions but were actively encouraged by leading performers.

For all the developments in popular theatre and extravaganza in London and in the United States, only Paris was capable of forging original forms of spectacle that harnessed the energy of the metropolis to fantasy and eroticism. France led the world in entertainment and it proved this by supplying an endless series of personalities, performing types, dances, visual motifs, and artistic expressions. After the Folies Bergère, the Moulin Rouge was the second most famous burlesque theatre in Paris. An architectural oddity designed by the artist Willette, the Moulin Rouge featured on the outside a windmill and—from 1890—a lifesize model elephant, while the interior was extravagant in the eclectic, Oriental style. Far more even than the department stores, it was gaudy and confusing. 'The architecture is full of surprises', remarked one observer; it 'is transformed by its arches and brightened by its mysterious vaults. It is Granada, it's Spain. Here it's a cottage which reminds me of Normandy. There it's a windmill which makes me think of Holland ... it's surprising, it's charming, it's mad.'[104] The memorable, bold posters of Toulouse-Lautrec further enhanced the lurid, vivid appeal of the place and its performers. The poster image of the Moulin Rouge, bright red and redolent with sexuality and personality, was so powerful that the journalist Maurice Talmeyr exclaimed that 'the wall poster... is the natural language of the lowest excitements'. Prostitution and exhibitionism were its sources of inspiration, he argued, and as a consequence of its influence 'each resident of Paris carries within himself a sort of perpetual interior "Moulin Rouge" '.[105]

Established to capitalize on the large crowds that flocked to Paris for the exposition of 1889, it turned the frenetic dancing of the nightclubs of the artists' district of Montmartre into a world-renowned spectacle. In the 1890s the club became bound up with the image of Paris. It drew many celebrated visitors including, inevitably, the Prince of Wales (among whose mistresses were Lillie Langtry and Sarah Bernhardt). In its first incarnation, the theatre retained the mark of the street. The coarseness of the performers undiluted by any sprinkling of refinement. La Goulue (Louise Weber), the most famous dancer of the quadrille, who was immortalized by Lautrec, was renowned for her blatant exhibitionism, her sexual excesses, and a refusal to mask her vulgarity. It has been said that her accessibility—she danced topless at street parties and posed for photographs with her legs open as she held a glass of champagne in one hand and a pipe in the other—was a direct emanation of the brothel.[106] The Moulin Rouge did not specialize in star performers (most of the dancers were just known by nicknames). Rather its forte was the marketing of overt female sexuality for entertainment. The leading cancan dancers usually began as amateurs before being picked out for the stage because they were popular with audiences. They mingled freely with customers and were sexually available to them.

In the early years of the twentieth century, the theatre's overt sexual exhibitionism was moulded into something less explicit and more polished.[107] Image and spectacle took the place of semi-spontaneous euphoria and erotic commerce. At the Moulin Rouge itself, fully fledged shows were staged that were produced by Jacques-Charles in company with a Briton, Earl Leslie. These revues employed two categories of female performer, the chorus girl and the showgirl. The former was an invention of the 1890s and she has been compared to other new figures such as the shop girl, the barmaid, and the typist.[108] All of these were roles that were seen as typical of the evolving nature of work and of leisure. They were urban jobs that were generally performed by young women. In the public imagination, chorus girls summed them all up. They were breezy, cheerful, and carefree girls on the make whose dancing and singing reflected a modern, vital spirit. By contrast, showgirls were purely icons of visual pleasure and fantasy. They did not really perform but, like the Gaiety Girls, posed, adopted attitudes and presented themselves as

constructed ideals of femininity and consumption.[109] However, the two were often blended and the public usually made little distinction between them.

While the British showgirl was generally a mock aristocrat, the Parisian showgirl had a more democratic image. She was seen by no less a figure than Edward VII as 'both a great lady and a woman of the people', able to switch between the manners of a society hostess and an actress. 'Only in Paris does one meet with anything so complete,' he is reported to have said.[110] One of the most remarkable stars of the period was a French performer whose stage name was Gaby Deslys. An extremely seductive stage presence, who has been described as an Edwardian Marilyn Monroe, she was a bridge between courtesan-performers like Otero and the highly professional showgirls of the interwar years. She was also one of the first to enjoy equal fame in France, England, and the United States and to offer audiences cultural novelties imported from each of these countries. After being spotted in France, she made her first appearance in London at the Gaiety, which had a long history of staging French plays.[111] She featured in a musical comedy as 'the charm of Paris', who appeared as if by magic out of an enormous basket of flowers, like the genie from Aladdin's lamp. Dressed in the full regalia of the Paris music hall, complete with fluffed-out skirt and a fabulous hat, she flashed her smile at the audience and winked at them with her pale blue eyes. In this show she sang a couple of numbers but such was her reception that in all her future appearances she would top the bill.

Gaby Deslys was an utterly theatrical phenomenon who also created a sensation by scandalous dalliances with a number of prominent men. Her admirers were legion and were utterly smitten by a figure who appeared frivolous, excessive, and artificial. Publicity was like oxygen to her; 'her life had the aura of a fireworks display, a series of breathtaking explosions of light and colour', her biographer claims.[112] She lived in the glare of publicity and seemed to have no existence outside it; certainly she revealed very little of herself. Physically, she was fresh-faced and curvaceous. According to the choreographer Jacques-Charles, when he first saw her, she struck him as 'of compact build, with rounded breasts, hips and rump; her pins were imprisoned in high boots. She had a mountain of fake blonde curly hair that was covered with an amazing mixture of flowers, tulle, bird's feathers and sequins.'[113] Her personal style was hyperbolic; ostrich

feathers and giant hats were her calling cards. In London, she embodied 'le chic parisien'. She communicated youth, *joie de vivre*, and hedonism.

Deslys was a commercial icon who was paid to be seen wearing the clothes of designers including Doucet and Paquin. Indeed, her eye-popping stage costumes were always exaggerations of the most current modes. Deslys's sets included such scenes as a luxurious boudoir and the deck of an ocean liner, while wide staircases allowed her to make protracted entrances. Her collection of jewellery, which she wore constantly in public and only removed for her performances, was astonishing. She understood perfectly that 'men have more respect for my jewels and my beauty than for my talent'.[114] She also knew that as long as she had her mansion, car, and pearls, she could 'hold [her] head high'. 'No-one will dare insult me,' she asserted. By her wealth she could pass over rumours that she could be had by the quarter-hour.[115] Gordon Selfridge, of department store fame, lavished vast sums on her upkeep, turning her into a brilliant instance of conspicuous consumption.[116] When she returned to Paris in 1917 to inaugurate the Casino, her notoriety had been embellished by a notorious affair with young king Manöel of Portugal (a liaison that allegedly contributed to his overthrow). She had also acquired the patent of Gaiety Girl and a slight English accent and she brought with her a jazz band. Before her early death in 1920, at age 36, she had become the stuff of legend.

The writer and photographer Cecil Beaton offered a memorable posthumous portrait of Deslys. 'She was a marvellous creature, of brillantine and brilliance, and Christmas-tree tinsel—madly artificial and so gaily irresponsible, the epitome of self-consciousness and at the same time utterly childish; a little ragamuffin playing on the sands with pearls, but she knew the value of the pearls!', he wrote.[117] 'She had the incessant vitality of an over-excited child, and oh! what sex appeal, oh! what glamour! It was impossible to look at anyone else while she was on the stage: not one of the glorious chorus behind her would be noticed, for Gaby riveted all attention with her fantastic affectations.' 'After every performance,' he continued, 'the entrance to the stage door of the theatre at which she happened to be playing was surging with a crowd of feverishly excited hoboes, Guardsmen, aesthetes and filberts, who cheered while Gaby made her way to her huge black-and-white motor-car, that had many more than the usual number of large windows, and her initials

blazing on its doors.' Her influence, Beaton asserted, was far-reaching: 'How well she realised the value of overdoing everything: the feathers soared to the ceiling! She is entirely responsible for Mistinguett's head-dresses, for the glut of spangles at the Casino de Paris, and for the window displays at Selfridge's store.'[118]

Money was always a key theme for showgirls. Deslys's successor, Mistinguett, made explicit and repetitive reference to money and the love of money.[119] These also provided her with many of her themes—most notably her signature song 'Je cherche un millionaire'. Just as the courtesan-performers exploited and helped create popular perceptions of the female entertainer as femme fatale and gold-digger, so Mistinguett, in her many performances and songs that irrevocably linked love and money, reinforced the myth.[120] Mistinguett was an original type whose rootlessness enabled her to forge a personality that was a reflection of mass desires for material well-being and happiness. She was aware of the need to put on a good show and be upbeat at all times in order to please her working-class admirers ('twenty-four hours a day I wore a gay smile clamped on my features like a carnival mask', she wrote in her memoirs).[121]

The embodiment of Parisian glamour for a generation, Mistinguett was similar in many respects to the courtesan-performers. She was on intimate terms with kings and she gambled on the house at casinos to stimulate clients. Like Otero, she insured her legs, for 500,000 francs in 1919. She endorsed beauty products in the United States, and she played various mistresses of the past, including Louis XV's Madame Du Barry. However, she saw herself as being on a lower rung of the ladder than the courtesan-performers. As the star attraction at the Casino de Paris, she was located more firmly within the world of theatre and for this reason she was seen, like Bernhardt, as embodying the theatre and a particular version of theatrical Parisian-ness. She was devoted to maintaining a relationship with the public—which she called 'the most demanding of lovers'.[122] Her life was not a comedy of front stage and backstage; everything was subordinated to the parade. 'I knew how to run my private life so that I should be talked about,' she recalled. 'I knew how to rub shoulders with the crowd—but just enough to intrigue them without making a nuisance of myself. I could be seen everywhere; at the races, in restaurants, at charity

balls and midnight matinées. I displayed, for the public's delectation, my pearls, my dresses, my pet dogs and my leading man.'[123]

Critics saw the rise of an organized show-business dreamworld as the Americanization of a Parisian idiom.[124] The influences that Deslys brought to the Casino de Paris were certainly American and so too was the emergence of the new role of producer. But other changes were more due to the need to address a different and wider clientele that was taking on mass characteristics. In an era of motor transport and sport, the public demanded from entertainment the same sort of movement and variety that it experienced in life.[125] The professionalization of the performer led to observations that Paris was witnessing the application of mass production methods to entertainment and that the theatres were becoming factories of pleasure. To go to a show became the ordinary man's equivalent of the rich man's ostentatious maintenance of a wasteful mistress. It was a luxury expenditure that was utterly unproductive save for the status it brought and the temporary gaiety it afforded. Accordingly, the shows offered sensual pleasure in the form of the decor, the costumes, the female bodies, and the brash comfort of the theatres themselves. They offered not merely escapism on a par with alcohol (*l'oubli*), but a systematic dreamworld informed by eclectic appropriations from other cultures and eras. By the 1910s, performers were definitively distanced from audiences and prostitutes were banished from the environs of most theatres.

However, France remained a crucial reference point. The American producer Florenz Ziegfeld specialized in the appropriation and reinterpretation of French qualities for an American audience. Initially, Ziegfeld employed European exoticism, importing and presenting Anna Held, a young musical performer who, despite a friendship with Liane de Pougy, traded on her innocence. Held had been born in Poland but was seen as a French music-hall star who was qualified to represent Parisian fashion and style. Ziegfeld married Held and invested great efforts in promoting her as a desirable role model for American women.[126] She became the most publicized woman in America thanks to a series of stunts that included buying and refurbishing Lillie Langtry's old rail carriage to take her on tour around the country.[127] However, the showman's main contribution was in evolving a brand name

chorus girl on the George Edwardes model: the 'Ziegfeld Girl'. A key figure in the French-inspired Ziegfeld Follies, which in various versions ran from 1908 until 1931, the girl was a standardized patriotic product for whose authenticity and quality Ziegfeld personally vouched. Like their European counterparts, his chorus girls were generally lower class in social extraction and they were trained in the British way to walk and to dress offstage like ladies. As decorative ornaments they were packaged as high class and expensive. The 'work' element of their performance was always concealed beneath their visual effects. Ziegfeld Girls were always posited as first-class products in the genre of female spectacle. Although the shows and the girls' costumes were extravagant, they enjoyed a reputation for good taste. At a time when divisions between high and low entertainment were quite rigid, the Ziegfeld Follies occupied a curious median position. A key element was the blending of high- and low-class codes that is essential to glamour. Even his moulding of Anna Held originated in a desire to replace the coarse atmosphere of vaudeville with glamour, taste, and charm.[128] At a time when fashion was coming within the purview of wider social groups, beautiful costumes were a way of attracting a female audience and holding its interest. The performers also taught women that, in the words of a contemporary newspaper, 'the little air of conscious beauty, which is not vanity, but assurance of a stable fact, throws a glamour over its wearer's appearance that is marvelously flattering. Indeed it is far more effective in establishing her reputation for being beautiful than regularity of feature or harmony of coloring.'[129]

The showgirl became a national institution in the United States, where the Folies Bergère manager Paul Derval noted acidly that she was 'mass produced like a Chevrolet or a tin of ham'.[130] Lacking the means to train vast numbers of girls, Derval aimed for diversity rather than uniformity. 'A firm believer in the French maxim that uniformity breeds boredom,' he selected dancers 'in the hope that each one will claim the attention of a certain number of spectators'.[131] Champions of the primacy of French charm believed that it was Paris itself that produced and shaped a special type of seductive femininity that was unrivalled. 'At every step of the social ladder, a woman is a hundred times more woman in Paris than in any other city of the

universe,' commented the writer and journalist Octave Uzanne.[132] The city inculcated special smiles, glances, ways of walking, and a seductive charm that turned the *Parisiennes* into 'an aristocracy among the women of the globe'.[133] The appeal of this special quality also derived from the sense that it was a fragile one that would not last much longer. 'Every year the city becomes more Americanised and loses, under the ugly thrust of progress, one of the attractions that were its glory and its charm,' lamented Uzanne.[134] Yet mass entertainment was not a purely American phenomenon. An average 500,000 people went to the theatre every week in Paris between the 1880s and 1910; in 1900, 274 *cafés-concerts* operated in the city.[135] In such a context, rationalization was unavoidable. In practice, ideas and techniques were regularly exchanged between the USA and France. However, the American custom of thinking of markets in terms of masses of consumers rather than sectoral interests and tastes was the way of the future. In the years following the First World War, the American impact on glamour would be even more pronounced than it was in the gilded age.

CAFÉ SOCIETY AND PUBLICITY

I n the years after the First World War, a series of changes occurred in the relationship between the upper classes and the press, between the older and younger generations, and between the mass public and the communications media. The conflict had a major impact on social relations because women had been drawn into the workplace to an unprecedented degree and millions of men had been killed. Moreover, the classes had been thrown together somewhat, lessening the distinctions between them.[1] On account of the 'democracy of suffering', a more widespread democratic ethos permeated society. For the first time, ordinary soldiers and not just the generals were commemorated and their names inscribed on monuments. The sense of the masses, and indeed use of the word 'mass' to describe the lower classes, was a feature of the age. The masses were not passive but turbulent and demanding. The rise of left-wing parties and movements demonstrated that discontent was widespread. Although the political consequences of this varied from country to country, everywhere there was a widening of public opinion that was formed increasingly through the press. The emergence of a new type of middlebrow newspaper catered to the demands of its readers for excitement,

novelty, and escapism by creating an image of upper-class life that high-lighted the activities of the young and especially young women. Young men and women of privileged backgrounds participated fully in this scene-making and even on occasion worked for the press. Their unconventional antics provoked much criticism but their high visibility and ready superficial embrace of styles and fads originating in the United States and in the movies turned them into figures of glamour. Their taste for fun, fashion, and adventure made them desirable and enviable to those whose lives were more restricted and whose income did not allow them to hop every night from club to restaurant by taxi or to own one of the superbly stylish sports cars that were so beloved of the fast set.

In America first, and then Britain, newspapers pioneered a more popular type of journalism that was heavily illustrated, personality-oriented, and sensational. Tabloid papers like the New York *Evening Graphic* and *Illustrated Daily News* abandoned the formality of the established newspapers for short stories, personal details, lurid crime reports, and scandal. In England, the old-style provincial press that privileged liberal opinion and rational debate was gradually superseded by new, mass-circulation, London-based papers like the *Daily Sketch* and the *Daily Express* that were brash and xenophobic.[2] In the early twentieth century, newspapers had served less as a connecting tissue of society than as a means of conveying facts and articulating opinion, mainly within the educated elite. After the war, the popular press began to cater more to mass audiences. It aimed to shape events as much as to report them.[3] Entrepreneurs like Lord Beaverbrook, the founder of the *Express*, grasped that there was a widespread desire for heroes and celebrities. He understood that the curiosity about high society was an aspect of this and sought to exploit it.[4] The public took an interest in society figures for several reasons. Their doings provided a narrative that amused and titillated, while also giving rise to puritanical disapproval. They were unusual, privileged, and yet not immune from setbacks and disappoint-ments including heartbreaks and other personal tragedies. At a time of economic hardship, they offered an image of a gilded existence that was intensely enviable. They also functioned as a channel whereby novelties and fashions were imported and presented. For these reasons, interest in them

was almost obsessive and focused on the minutiae of upper-class homes, opinions, dress styles, and language.[5]

Beaverbrook and other proprietors began to take on well-connected people to write their social news, with the result that social columns became more vibrant and well informed, something that caused indignation in some quarters.[6] The better information and livelier reporting turned them from a minority interest into a mass recreation. They featured prominently in the morning papers and were read by a huge middle- and working-class public. For the first time, members of high society were permanently on view, a fact that was noted by Patrick Balfour, a British aristocratic commentator who experienced these changes first-hand. 'The public that in the past had stood on chairs to see Lily Langtry in the Park and had blocked Bond Street as it gazed at the Society beauties in the photographers' windows, could henceforward gratify all its curiosity about all the Lily Langtrys without stirring from its breakfast table,' he observed.[7]

Debutantes were one of the main subjects of this type of reporting. Margaret Whigham (who subsequently became the Duchess of Argyll and is today best remembered for her involvement in a scandalous divorce case in 1963)[8] was the most striking example of a new breed of debutante. Born into a Scottish aristocratic family, she had spent her childhood in the United States and came to England in 1926, aged 13. When she came out in 1930, she was hailed as the most beautiful girl of the year. Unlike the debutantes of an earlier generation, she did not solely inhabit a world of private houses and balls; she dined out in restaurants, attended functions in hotels, and was a constant presence in the press. Formally, she was still chaperoned. In reality, it was left to the family chauffeur to ensure she got home after a series of dates for dinner, dancing, and late night club-hopping. The only rule imposed by her parents was that, whatever time she went to bed, she had to be dressed for breakfast at nine. With her unusually hectic social life and distinctive beauty, Whigham was the centre of attention. Gossip columns detailed her numerous social engagements and her varied wardrobe in a way that at once delighted and horrified readers. She was said to have invented almost single-handedly what was known as the 'deb-ballyhoo industry'.[9] She was regarded as a trendsetter after she became the first girl to wear

pearl-coloured nail varnish that was luminous at night. For charity, she once appeared on stage in a production entitled 'A Day in the Life of a Debutante'. With her square face, sunken eyes, and elongated neck, she became an easy subject for cartoonists. Whigham was treated like a star and became as well known as one.[10] Suddenly, young women still in their teens had to cope not only with the judgement of the adult members of their own restricted circle but with the scrutiny of the social columns.[11] They became public figures and bearers of glamour.

The debutantes undoubtedly appealed to the press and the public because they were upper class. The sheer unusualness and privilege of their lives lent them mystery and made them fascinating to readers of the press. However, it was never debutantes in general who won coverage but bold and daring individuals who broke with some established upper-class patterns of behaviour. A few controversial or original gestures turned young women like Whigham into attention magnets who aroused curiosity whenever they dined out, attended a public event, or were spotted in the company of a suitor. These girls were treated not with the deference of a hierarchical order but with the curiosity of a fast-moving, mass society. The cult of the debutante was a result of the popular newspapers' search for colourful personalities around whom a narrative could be built. It was part of a trend whereby the most beautiful or privileged women and men were singled out for extended coverage and turned into front-page news together with royalty, politicians, and actresses. Alongside the sporting hero, the actress, and the great criminal, there was a place in the papers for an eye-catching debutante.

The transformation of a select group of debutantes from gauche girls into savvy celebrities was part of a wider process that saw high society become ever more completely penetrated and remoulded by publicity. Whigham emerged at a time when sections of the press were beginning to treat socialites as celebrities and gossip about them. The English aristocrats who wrote social columns, like Balfour in the *Sketch* and the larger-than-life Valentine Charles Browne—Viscount Castlerosse—in the *Sunday Express*, were anomalous figures with feet in two spheres. In some ways, they were not dissimilar to the men satirized by Evelyn Waugh in his memorable novel

Vile Bodies, published in 1930. But whereas Waugh's impoverished aristo-cratic gossip hunters were desperate men who begged invitations to this or that occasion, the best-known columnists were quite powerful since their coverage could determine the significance and success of a social event. They could make, and even break, some would-be celebrities. A good deal of the attention Whigham and a handful of other debutantes received, she later revealed, was due to their friendship with popular social columnists.[12] These men attended many parties and balls and they referred in their columns to the comings and goings of the most high profile and ubiquitous of the debutantes. They wrote them up in a hyperbolic way because they liked the girls and they assumed readers would be charmed by them too.

The frenzy around debutantes was not an exclusively British phenomenon. The American press pursued one or two debutantes each year with no less enthusiasm. A girl was selected not on the basis of the importance of her family but because she was good copy, someone who fitted the need of the press for a photogenic, emblematic figure who could act as an ornament for its col-umns.[13] Brenda Duff Frazier, who made her debut in 1938, fitted the bill to perfection. The daughter of the twice-married heir to a grain-broking dynasty and an ambitious but unconventional Canadian, she had striking blue-black hair, deep-set eyes, and full, round cheeks. Her features were described as doll-like and ample use of heavy red lipstick made it look as though her lips were painted on. She was described as beautiful and composed, although a photo-graph of her used by *Life* on its cover made her look like a 17-year-old ingénue. Frazier became a star of the press, a girl about whom five thousand articles were written and whose every act seemed to result in a photograph. She was called, in a term invented by a prominent New York columnist, Maury Paul, 'Glamour Girl No. 1'.[14] According to Paul, the girl who received this unofficial title should be monied and mysterious, exotic in appearance, and daring in her gestures— in brief, she should have the potential to be glamorous. Although no one could explain quite why it was Frazier and not someone else who attracted so many headlines, she received hundreds of fan letters, some of which were simply addressed to 'Brenda Frazier No. 1 Glamour Girl' or 'Brenda Duff Frazier, The World's Prettiest Debutante'. Even more than Whigham, Frazier was drawn into a realm that had more to do with showbusiness than elite living. She

mingled with film actors and sportsmen, a perfume was named in her honour, and her likeness was borrowed by department stores for fashion illustrations.[15] She was even photographed dunking a doughnut. When she went to the Metropolitan Opera, the special arena of bejewelled high society matrons, she was applauded to her seat. All this led to negative reactions from upper-class traditionalists but helped foster her popularity among those for whom she was a fad and a celebrity.

Although deference was declining in favour of an emphasis on the amusing, the curious, or the extravagant, the temptation of irreverence, in England at least, was tempered by the fact that the aristocracy was tied to the monarchy, an institution that commanded near universal respect. In America, a more abrasive style of reporting was developed by the sharp-tongued print—and later radio—journalist Walter Winchell, who pioneered a variety of journalistic voyeurism. Such was his influence that he is said to have acted as midwife to the creation of a mass culture that was fixated with personalities.[16] With his familiar tone and focus on individuals, he judged society figures according to the criteria of the street. Winchell was a tough New Yorker who had little time for upper-class frivolity or debutantes, whom he called by their first names and disparaged as 'debutramps'.[17]

Such practices were part of the process whereby following elite events became a mass spectator activity. This was a double-edged development as far as the social elite was concerned. On the one hand its social prominence appeared to be confirmed but at the same time its members were turned into creatures of publicity. As high society was opened up and made more visible than ever before, it was exposed to popular judgement and brought into competition with an expanding entertainment industry. This was just one of the changes that the 1920s brought. Communications and transportation improved as automobiles and public transport made travel easier and the telephone entered more common usage. Photography and the movies altered perception by expanding the realm of the visible. In the large cities, advertising hoardings, neon signs, and places of entertainment including dance halls and cinema all aimed at an undifferentiated audience. Radio and spectator sports further contributed to the emergence of a unified mass audience.

After 1945, those who participated in high society in the 1930s liked to remember it as a world of grace and refinement. It was an era in which the aristocracy still commanded substantial public attention and its rituals, from debutante balls and grand society weddings to visits to the opera and theatrical premieres, continued to affirm its social superiority. 'Looking back now on the glamour of it all, the first summer season seems like a dream,' Whigham wrote. 'It belongs to another world—a world of manners and elegance that has now vanished.'[18] However, while the particular grace and style of the upper-class world of the 1930s may have disappeared after the Second World War, the developments of the period in terms of publicity and glamour would remain. As a young woman in 1930, Whigham perhaps did not realize how far upper-class life had already evolved. Although the aristocracy formally maintained its historic position at the top of the social hierarchy, the way some of its members became well known and which of them were most popular was changing fast. The socially prominent were ubiquitous—the British newspapers were full of the doings of society beauty Lady Diana Cooper and eccentric heiress Nancy Cunard—but a great deal progressed in the society around them and this affected the way they were viewed. The upper classes were mainly of interest when they met certain criteria of newsworthiness or gave rise to sensations. Some were even employed in advertisements.

All this served to create a different sort of relationship between the social elite and the broad mass of people. When Whigham used 'glamour' to evoke the whirlwind events of her debut year, she did so as though it were synonymous with upper-class living. In fact, in 1930 the term was more widely understood as a quality of excitement and magnetism that was associated with some famous men and women regardless of their background. Not by chance, the word 'glamour' entered common usage at precisely this time, a fact that by itself shows how images of wealth, luxury, and beauty were more widely deployed than ever before and were consumed by an eager audience. How far people took these images seriously or how they affected their views of the upper classes remains unclear, although it has been argued that they functioned to promote the interests of the social elite if only by perpetuating the idea of high society as a necessary institution.[19]

In May 1930, Cecil Beaton wrote an article in the London *Sunday Dispatch* in which he described glamour as the attribute of those who were 'surrounded perpetually by a roseate aura of excitement and thrill'.[20] He did not regard this as a modern quality; indeed, he wrote that it was striking that there should be 'a chosen few who stand out as radiant favourites and figures of mysticism and interest in these frank days of Christian names, dial telephones and skyscrapers'. But in his evaluation of various people whom he considered to be glamorous, Beaton did not solely consider the high-born and the privileged. Royalty by definition was glamorous, he argued, but otherwise it depended on a person's profession or personal qualities. Movie stars, some artists and writers, actresses, and sportsmen were just as likely to be alluring as a beautiful socialite. Glamour, in short, was random. 'There is hope for everyone,' Beaton concluded, since there was no way of knowing who or what would emerge as the next phenomenon.

Beaton adored both aristocracy and the theatre and it was probably this that led him to insist that glamour was inimitable and to discourage the efforts of the unworthy to appropriate it. 'By being under the impression that you have it and by giving yourself airs and graces,' he cautioned, 'you will most likely become uncontemporary and result in being a crashing bore.' Beaton was right to argue that glamour could not be possessed by everyone. What he did not fully grasp was that awkward attempts to do so were not a result of misplaced ambition. They were triggered by the nature of glamour itself as an effect arousing envy and desire. Precisely because glamour could almost never be obtained, it led to an unquenched yearning. At the time he was writing, professional stylists, publicists, decorators, couturiers, social organizers, and the luxury trades in general were all learning how to fashion images and confer an allure that the mass public would find intriguing and enviable. The paradox of magical allure in an age of increasing homogenization and declining individuality lay in the fact that it was constructed and moulded in a systematic way and sold to people on the basis that it was indeed imitable. Even when it was applied to members of the titled aristocracy, as it sometimes was, glamour referred not to their inherited qualities or natural leadership but to their newsworthiness, physical beauty, material ease, and leisure.

Many of those involved with commercializing style and luxury were impoverished aristocrats. Members of the elite were lured towards commerce because, after the war, inflation and tax increases reduced both the ranks of the established wealthy and the quantity of the income of those who retained their wealth.[21] Even for those without money problems, the increasing appeal of factory jobs made it difficult to recruit domestic servants. Not even in its new form, blended with the new blood of international plutocracy, could aristocracy continue as before. As a result, ostentation and privilege on the scale of the Edwardian years declined. At the same time, many fortunes were made quickly in the boom period of the 1920s, some of them legitimately by industrialists and entrepreneurs, others less legitimately by war profiteers, financial speculators, and bootleggers. Most of those who came to the fore were outsiders with no claim to social distinction yet, like the new rich of earlier generations, they paraded their new-found wealth and sought recognition from other sectors of society. In this they sought assistance from the male and female members of high society who entered the world of business. Some ran boutiques and gift shops, while others took positions in department stores or went into the theatre. Yet others worked for the press or became public relations advisers and consultants. More aggressively and systematically than ever before, the symbols of the wealthy lifestyle were appropriated by outsiders and newcomers. This in turn aroused the interest of the mass of ordinary people.

The sense of glamour was related to these changes in the way the social elite was formed and in the distribution of wealth. The wealthy lifestyle was no longer something that was seen as remote and hidebound. Tableaux of upper-class life were often employed in the advertisements of the time as advertisers and publicists, sensing a widespread interest in it, sought to evoke such milieux, if possible using authentic exponents to market goods.[22] American manufacturers above all did their best to win endorsements from aristocratic beauties and wealthy women. Royalty was normally exempt from this but, among others, Queen Marie of Romania lent her name to a great many products, including Pond's face cream. At one level, this trend was the inevitable consequence of the publicity that illuminated the lives of the privileged, for publicity heralded commercialization. As the

poster artist Cassandre expressed it, 'publicity is not a medium for self-expression, it is a means of communication between the seller and his public'.[23] At another, it was an indication of the way exclusivity acquired a market value and upper-class lifestyles became part of the imaginative realm of wide groups of people. This was facilitated by the way the life of the privileged was blended with modern innovations and entertainments. Through this change, it became more widely desirable and, in theory at least, imitable.

Of all the novelties of the period, none was more far-reaching than the movies. From 1918, the American film industry began the conquest of world markets that would give it an unrivalled purchase on the popular imagination in the twentieth century. Film would make a huge contribution to the development and diffusion of glamour because it was a medium that provided a unique connecting tissue between classes and nations and because it was infused with images of heroism, luxury, and beauty. The first generation of movie stars enjoyed unprecedented fame and financial rewards. Charlie Chaplin, Mary Pickford, and Douglas Fairbanks achieved worldwide prominence and held a power in the industry that virtually no subsequent star would obtain. Pickford and Fairbanks were seen as the 'royal couple' of Hollywood. Each was a major star who drew people in their millions to the cinema. For audiences, Pickford was the 'Girl with the Golden Curls', the little girl who could do no wrong, while Doug, the star of the swashbuckling epics *The Mark of Zorro* and *The Thief of Baghdad*, was the ever-smiling, ever-cheerful athletic adventurer. Together they lived in a luxurious twenty-two-room mansion (the first in Los Angeles to have a private swimming pool which, in the sort of excess people would come to expect of Hollywood, was set in a formal garden) which they dubbed Pickfair. They conducted two major European tours in 1920 and 1924 and impressed everyone by their combination of showmanship and charm.

In conventional terms, the stars were not socially distinguished. Typically, in fact, they hailed from humble and sometimes troubled backgrounds. Fairbanks, for example, was born Douglas Elton Ulman in Denver, Colorado to an alcoholic father of Russian Jewish background, who abandoned his wife a few years after his son was born. But this was of no significance at all

compared to the personality he had become. Visiting movie stars were welcomed into salons and private palaces everywhere they went. They were regarded as trophies to be exhibited by upper-class hostesses who competed with each other in staging the most glittering social events. Those who had once sought to secure the presence of the most noble and distinguished of guests now also pursued athletes, entertainers, speed kings, aviators, fashion designers, as well as film stars. No longer was it necessary to be bound into the upper class by close family ties to secure invitations to dinners and soirées. Money or celebrity were often sufficient qualifications to find a way in.

In the interwar years, high society was more fluid and less exclusive than its pre-1914 predecessor. It was increasingly evolving into a stage for the rich, the famous, and the beautiful, in which the titled and the powerful had influential but largely background roles. There were still grand hostesses like the London-based Americans Lady Astor, Emerald Cunard, and Laura Corrigan, but they conserved their role by offering co-optation to a wider range of people than ever before. In London above all, high society acquired a unique ability to bring together the worlds of fashion, learning, power, and sport, which in continental European countries scarcely met at all. As its political role declined, London high society presented what historian Ross McKibbin describes as 'a picture of metropolitan glamour'.[24] Its exponents were no less eager to maintain their prominence and role at the peak of the social order but to achieve this they had to seek celebrity guests and sensations more than ever before. This sharply undercut the continuity of family and tradition that had held the old upper class together and placed it at the mercy of trends and innovations that started elsewhere.

Although the movies were a phenomenon that aimed at, and attracted, a mass audience, they were intensely fashionable as a novelty. As such, the youthful vanguard of high society embraced them with fervour. 'By 1921 everyone had gone "movie-mad" and *The Glorious Adventure*, which was the first British film in colour, had a society cast which reads like a page from *Debrett*,' gushed Barbara Cartland in her memoir of the period.[25] In America, the upper class was more staid but F. Scott Fitzgerald's 1922 portrait of young New York café society, *The Beautiful and Damned*, revealed an upper-

class obsession with glamour, performance, and movie styles. When the Hollywood actress Gloria Swanson visited Europe in 1925, she noted that 'snobbish Parisians' were not above asking her discreetly 'what people did at parties at Pickfair and what kind of pomade Rudolph Valentino wore on his gorgeous hair'.[26] The upper classes were genuinely curious about the people they saw on the screen but they also marvelled at Hollywood's ability to arouse the enthusiasm and adoration of the masses.

Even a few core members of the British elite were not exempt from movie-star gestures. The honeymoon sojourn in 1922 of Queen Victoria's great-grandson Lord Mountbatten and his wife Lady Edwina at Pickfair shocked members of high society on both sides of the Atlantic, but the couple evidently revelled in the Hollywood environment. They toured film sets, appeared in a Charlie Chaplin film, and posed for photographs in the Grand Canyon dressed in Wild West outfits. Other young English high society figures followed and found diversion in the not quite real houses and fabulous luxury of the stars. Any reader of newspapers and magazines in the interwar years would have been accustomed to seeing pictures of Lord Mountbatten in remote places, in modern poses, or dressed stylishly. He acquired a debonair, 'American' veneer that lent him a 'dashing style and easy charm as he sailed through life without dropping anchor'.[27] He and Lady Mountbatten were probably the only prominent members of the British Establishment to have a penthouse flat in Park Lane designed entirely in the modernist idiom that had the advantage of being fitted with the most up-to-date conveniences. They showed that, to distinguish itself, the upper class did not have to be stuffy.

Edward, Prince of Wales, the future Edward VIII, was also influenced by American movies and modern fashion. He was the leading example of a young man who stood out against those who regarded conservatism and continuity as always best. The first heir to the throne of the era of publicity, Edward adopted an affected accent, used American slang, and displayed a taste for ostentatious leisure wear that led him to be seen as the world's fashion plate.[28] He helped popularize skiing and, later, air travel, showing an open-mindedness that led the hostess and heiress Emerald Cunard to tell him that he was 'the most modernistic man in England'. Edward seemed to

know instinctively that his every gesture was a matter of interest. He was especially alert to questions of image, cleverly giving up polo when he realized that the public regarded the players of that elitist sport as no more than playboys. He wore generously cut suits in colourful tweeds and was amused at the anger of courtiers and the king when he was photographed walking in the street with an open umbrella. The prince enjoyed the spotlight and he mixed mainly with people, including entertainers and film stars, who shared his tastes. He preferred informality to the ceremonial aspects of royalty and cultivated a taste for showbusiness, jazz, and interesting foreigners. Much to the displeasure of the establishment, Edward's colourful inner circle resembled that of his grandfather Edward VII.[29] By contrast, Edward's father, King George V, was the very embodiment of instinctive conservatism. Among the many things he viewed with distaste were 'Soviet Russia, painted fingernails, women who smoked in public, cocktails, frivolous hats, American jazz, and the growing habit of going away for weekends'.[30] He even had to ask his son to stop whistling at Sandringham a melody he had picked up at the Ziegfeld Follies in New York.

Like his younger friend Louis Mountbatten, Edward was an example of upper-crust glamour. He was a good-looking public figure who had a modern buzz about him. He was widely thought to be a trendsetter, but this was mainly because, as a royal, his departures from tradition seemed more striking than they really were and his sartorial choices received more coverage. In fact, most of the novelties that emerged at this time, and which he embraced, hailed from the United States as the leading industrial nation. The spirit of the Roaring Twenties, or what F. Scott Fitzgerald called the Jazz Age, crossed class lines. For Fitzgerald, who knew little about jazz music, this term was used to denote a state of permanent nervous stimulation to which sex, music, and dancing all, in their own ways, contributed.[31] Dance fads, cocktails, sportswear, and movie palaces were among the most evident features of an extraordinary influx of American ideas and novelties. New fashions, tastes, and customs were eagerly absorbed by youth, with the result that a gap soon opened up between the old generation and those who reached adulthood in the post-war years. The young upper classes were by no means the only section of society to enjoy novelties or be attracted by

them. Indeed, the chief departure was precisely this, that the privileged were appropriating products aimed at a mass market of ordinary consumers. By indulging in the vogue for jazz and other recorded music, they renounced for the first time a leadership in the consumption of culture that had once been unquestioned.

Neither Edward nor Mountbatten belonged strictly speaking to the so-called 'Bright Young Things', but there were connections. This term was widely used in the press to describe the colourful antics and attitudes of a variable and multi-tiered group of young people who seemed possessed of a particular generational ethos. With millions of men wiped out by the First World War, the gap between the generations was stark. The young fashionable set found conventional rituals tedious and they resented the funereal atmosphere that followed the conflict. They were animated by a ceaseless pursuit of fun and novelty.[32] Cocktails, dancing, and all-night parties were among their passions, although a bohemian element also brought a taste for theatre and art.[33] London socialites held treasure hunts and fancy dress parties so frequently that some feared ideas for them might dry up. A Baby Party was once held, for which old nannies were reluctantly brought out and obliged to lead their fully grown charges on donkeys round Rutland Gate. Fashion designer Norman Hartnell organized a Circus Party, complete with performing animals and acrobats. A particularly shocking event, widely reported in the press, was a Bath and Bottle Party, held in July 1928 at a London swimming bath. Guests arrived in outlandish bathing dresses and danced to a band composed of black musicians, while rubber horses and flowers floated in the pool. The whole thing was illuminated with coloured lighting. In this instance, the high jinks reached such a level that the police arrived to break up the party and send everyone home.[34]

Such parties were all about ventilating stuffiness and throwing off inhibitions. The atmosphere was not that of a private gathering but rather that of a nightclub. For this reason, it seemed natural to those involved to invade public spaces with their frivolity. In consequence, uninvited guests made their appearance at parties. The festivities of the Bright Young Things were often drunken, hedonistic affairs with few holds barred. 'Sexy was not a word we threw about much in the twenties,' Barbara Cartland recalled, 'but

that is what the parties became, orgies which shocked and disgusted not only the newspapers and the older generation, but also ourselves.'[35] Some put the blame for the spread of vice and degeneracy not on the young members of high society but on the social climbers and hangers-on who easily gained access by donning a costume or otherwise looking the part. However, this was to ignore the fact that carefree manners were endorsed as fashionable and were reasonably widespread.

The young bloods who belonged to the Bright Young Things were a mixture of hedonists, trendies, artistic types, and fools. The principal figures were intensely committed to modernity but without ever renouncing the privileges of their coterie. Their love of fancy dress was a sign of refusal of the regular world. They may have been envied by some, but they were also regarded with distaste. Pictures that show them laughing and joking as they 'borrow' the tools of workmen repairing roads do not show smiles on the faces of the workers. They were widely despised for their antics and their careless display of privilege without responsibility. Their stunts caused shock and outrage among the older generation, the Church, and sections of the press. After a Wild West party in which the emphasis was on the 'wild', Harold Acton recalled that servants handed in their notice and he and his friends were warned that they had done untold harm to the Conservative Party in the local parliamentary constituency.[36]

The emphasis on fun was not itself new. Members of the upper class had notoriously short attention spans and, because conventional rituals were repetitive, they lived in fear of boredom. Like Mrs Stuyvesant Fish in New York in the 1890s, the London-based American hostess Laura Corrigan amused her guests with tombolas, in which the most costly prizes were always won by the most noble guests. Once, she let it be known that if Edward's brother, Prince George, were to turn up at one of her soirées, she would mark the occasion by standing on her head. He heard about the promise and duly arrived; without a single qualm, Mrs Corrigan performed the anticipated headstand. The difference between the 1890s and the 1920s was that, whereas many of the innovations of the earlier period occurred in private (even if they were then reported), the events of the latter spilled over into the public realm and attracted widespread attention. Responses were

complex and by no means always positive. Upper-class frivolity and eccentricity often appeared clownish or pointless when depicted in the press. Moreover, they aroused antipathy that on occasion extended more widely. When debutantes queued in chauffeur-driven limousines down The Mall as they waited to be presented to the king, they often had to bear abuse and derision from a disrespectful crowd. At best, the interwar years were an Indian summer for an aristocracy that was no longer sure of its role.

Through the 1920s and 1930s, hotels, restaurants, and clubs in fashionable districts became meeting places of the elite. Although some of the great houses continued to function, many others gradually closed. In London, only one or two Park Lane mansions remained while others were demolished.[37] A similar fate befell the Fifth Avenue palaces built by the Astors, the Vanderbilts, and others. The first of ten Vanderbilt mansions on Fifth Avenue had been completed in 1883. The first was demolished in 1914 and by 1947 the last had gone.[38] Instead, the economic and social changes of the period gave a big impulse to the expansion of costly and elegant commercial establishments. In itself this was not a new development. From the late nineteenth century, socializing became less domestic and more public. After the war there was a significant development of this trend. Habitués of high-class commercial establishments found themselves dubbed members of a new 'café society'. The precise origins of this term are unclear. In London it was assumed that it was inspired by the Mayfair club, the Café.[39] In New York, it was attributed to the gossip columnist Maury Paul, who one night in February 1919 noticed how many members of high society were dining at the Old Ritz.[40] This was taken as a sign that high society was going out and that barriers of exclusion were coming down. In many establishments dancing took place and old assumptions that dance clubs were not suitable places for respectable married women, let alone the unmarried, fell by the wayside.[41] In addition to men, respectable women occupied these public-private places and not just the courtesans and prostitutes of the past. At the London Savoy, it was acceptable for women to dine in public, even unescorted, from 1907.[42] Formal entertaining at home lost a good part of its appeal as the 'restaurant habit' took hold.[43]

Café society was most significant and identifiable as a phenomenon in those countries where high society remained insular. It existed in London

too, even if in that city it was not so easy to distinguish where high society finished and café society started. It was a development that followed from the expansion of the commercial sector and the growing heterogeneity of the social elite. Once, barriers of exclusion had been constructed largely on the basis of personal familiarity within the elite. Now the widening of the environment of socializing undermined this barrier. Three other factors served to bring upper-class privilege under pressure. First, the international nature of wealthy socializing meant that processes of selection and filtering based on conventional criteria no longer functioned so effectively. Second, criteria of distinction such as fashionableness, good looks, and creativity, that were related to the new configuration of modern society, led to the emergence of new figures of influence. Third, new money clamoured for admission and could easily find it in the commercial sphere and in resorts.

Secret codes and rules of taste and behaviour were the traditional way the socially prominent wrapped an aura round themselves and barred, or at least significantly delayed, the access of the bearers of recent or dubious fortunes into high society. By this method they drew a line between correct form and vulgar efforts at imitation. Fitzgerald's celebrated novel *The Great Gatsby* drew a portrait of one man who built an illicit fortune in the Prohibition era and set about building a social career. Fitzgerald cloaked his hero in romance and tragedy to turn him into one of the great figures of American fiction. Jay Gatsby has vitality and drive but his inexperience leads him to wear pink suits and to choose a car of monstrous length and 'so bright with nickel' that it is described as 'being terraced with a labyrinth of wind-shields that mirrored a dozen suns'.[44] His parties are held for the sole purpose of attracting attention and are filled with people of dubious background who he does not know. Gatsby is a fake, an 'Oxford man' purely because he once followed a short course for former servicemen at Merton College. But he is treated sympathetically by the novel's narrator and, through him, by the author. He is not just an ambitious individual but a man who has a dream, a dream that can be seen as the American dream of success and personal happiness. He is a New Man who represents his age.

The emphasis that was increasingly accorded to publicity undermined the balance between ostentation and restraint that was the hallmark of the

established rich. Publicity fuelled vulgarity or at least did nothing to discourage it since the grand gesture, the gaudy house, and the surfeit of display were all effective as a strategy of communication. They were readily understandable even to the least sophisticated of audiences and therefore became the common currency of the press and the movies. A man like Gatsby was certainly glamorous (a point that was magnified by the 1974 film of the novel which starred Robert Redford in the title role) even if gauche. In time he would have evolved into something smoother and more polished. Social promiscuity, restaurants, and the movies all contributed to a change in customs. In place of the aristocratic principle, a new standard of behaviour was emerging that was cosmopolitan and standardized. Patrick Balfour described this as a norm that members of the elite conformed to and sometimes embodied in the eyes of the public, but which they did not invent.

In shaping this, it was not individual social arbiters who played a crucial role but guides and style bibles. Condé Nast had turned *Vogue* into vital reading matter for the American elite. He repeated the trick with the arts-based magazine *Vanity Fair*. In the twenties, Nast ceased to be an outsider who serviced the needs of the rich. He became a major player himself and was indeed the first major ringmaster of café society. The heterogeneous content of his magazine—features juxtaposed socialites and artists, debutantes and playwrights, models and singers, sporting figures and politicians—led him to foster the real-life equivalent in the regular parties that he held in his magnificent Manhattan apartment.[45] After successfully inviting Alva Vanderbilt and composer George Gershwin (whose 'Rhapsody in Blue' was a sort of soundtrack to the period) to the same party, he created a social cocktail that was novel above all in its breadth. *Vogue* reached beyond the top of society and ultimately assisted its expansion and transformation. The journalist Cleveland Amory later argued that, through *Vogue* and *Vanity Fair*, 'high society was redefined, no longer as the "Four Hundred" but as a complex entity embracing the arts, theatre and later cinema'.[46] Nast was able to achieve this in part because the times were changing, but his personal role was important.

Vogue was a pioneer in the use of photography. This medium was a vital factor in the affirmation of appearances over breeding and money. Initially,

photography was not prestigious and there was resistance to it on the part of prominent subjects. These were overcome largely due to the photography of Baron de Meyer, who worked exclusively for *Vogue* and *Vanity Fair*. His characteristic soft-focus settings and lighting came to decorate every issue of the magazines. It became a mark of elegance for a New England aristocrat or a musical star to have her portrait, signed by de Meyer, in *Vogue*. It was said that the photographer gave them all an aura of elegance derived from English chic, Slavic charm, and Parisian dressmakers.[47] After he was lured away by *Harper's Bazaar*, the baron's place was taken by others who built on his artistic style. Edoard Steichen, Hoyningen-Huëne, and Cecil Beaton all brought to the magazine individual trademarks that mixed elements of the classical and the fashionable. They also flattered their subjects. Beaton in particular extensively retouched his portraits of society women in order to rejuvenate and slim down subjects.

The creation of a distinctive elite look in photography was a true example of glamour, in that a mode of representation took shape that was merely conferred on the socially prominent while not being exclusive to them. By virtue of its easy reproducibility and capacity for making the false seem true, photography was the medium that was most becoming to glamour. It allowed for the secret weaving of myths and enticements that caught spectators unawares, enchanting them under the guise of a true representation. It was also a medium of mass society, profoundly linked to modernity and to the emphasis on visual wonders and effects that had marked commercial promotion since the early nineteenth century. Even more than the text of Nast's publications, photographs of the privileged and the prominent entranced aspirant middle-class readers and unleashed the dynamic of envy that was central to glamour. In keeping with the general tone of the magazine, its photographs were always evocative and flattering. *Vogue* never criticized or ridiculed the rich and famous. It never dedicated any space to scandal or gave anything other than a brilliant portrayal of them.

Vogue was also significant because it was part of a growing internationalism among the arts and in high society. One of the keys to its success with the American elite lay in its regular accurate reports of Paris fashion. Fashion was already highly international and Nast's magazine played a part in bringing American clients into contact with Parisian designers and thereby

in reinforcing the mythology of Paris as the centre of all that was fashionable. English and French editions of the magazine (that were promptly nicknamed *Brogue* and *Frog* in the New York office) were created in 1916 and 1921 respectively, and these further underlined its importance as a style bible. *Vogue* was by no means the only factor in the emergence of what would become known as the 'international set', but it played a key part in depicting a smart world that was perennially in motion, leisured, stylish, and beautiful.[48] This set was composed of chic transatlantic travellers who were seemingly on permanent vacation. Numerous articles and photographs about Americans abroad, Europeans in New York, and the fashionable world in general were printed.[49] They also appeared in the daily press and became a key component of the dreamscape of the period. The magazine always aimed to be at the forefront of fashionable life and it came to dedicate far more space to the wealthy, the talented, and the good-looking than to stately aristocrats.

More than any other group, it was young women who were at the forefront of the new era. Even high-born young women rejected the ideal of the aloof and reserved aristocratic woman. 'We didn't want to be ladylike in 1920,' recalled Cartland. 'We wanted to be dashing, we wanted to be gay, and most of all we wanted to be romantic.'[50] In the 1920s, modernity was defined through women who quite literally made spectacles of themselves, in the sense that they became, and often sought to become, the objects of the collective gaze. This phenomenon extended to all those who were engaged in activities that were seen as new or controversial. Women still had decorative and ornamental functions, but they were much less static or statuesque than before. Bright young women like Brenda Dean Paul and Elizabeth Pononsby, as well as certain debutantes, seemed to live wholly in public. Their visibility and their engagement with all the novelties of the urban environment served as a codifier of modernity, a visual representation of everything that the modern age had to offer.

The modern female was given a variety of labels by observers, including the New Woman, the Modern Girl, and the *garçonne*. However, the flapper was the figure who first embodied in the public realm a desire for personal freedom and self-definition. The term flapper had once been used to refer to very young prostitutes and sexuality was central to the popular image of the girls of the 1920s. They were slim, angular, energetic, and sexually charged.

An American invention, the flapper was moulded by fashion influences from Paris and modern advertising. Flappers were by no means always upper class; in fact their class origins were usually disguised by the fact that they behaved and dressed in a boldly unconventional manner. In the modern city, class was blurred rather than immediately legible. In the fast-paced life of the metropolis, it helped to be rich and privileged, but it was more important to have an up-to-date wardrobe and an athletic body, and to be always on the move. The flappers wore short, bobbed hair, lipstick, cloche hats, and dresses that only came down to the knee. They were enthusiasts of fashion and they loved novelty in music and dance (the Charleston was indelibly associated with them). Depicted as flighty and déclassé, they were all young and were avid consumers of the popular media. Flappers gave rise to narratives and stylized representations in advertising. The press on both sides of the Atlantic was full of their doings, and novels, plays, and films perpetuated and elaborated their image.

The elements of glamour that were associated with the new women of the 1920s included being at the centre of a public discourse sustained by publicity, being associated with fashion, movement, and modern ways, and deliberately stepping over the boundaries of conventional, respectable behaviour. Their beauty was not natural but unusual and artificial while their lean bodies suggested a modern dynamism. The fact that several film stars, including Clara Bow, Louise Brooks, and Greta Garbo, took the part of flappers on screen added glamour to every fashionable young woman by making her part of a larger modern narrative. Bow and company embodied the 'fast' and stylish women of the age and were the first film stars to define a look that impressed the fashionable social elite.[51] There were even a few London debutantes who, taking their cue from Bow, cut their hair short, dyed it red, and wore make-up.

Who invented the flapper? Scott Fitzgerald is often credited with creating the type in his first novel *This Side of Paradise*, although Zelda Sayre, whom he married in 1920, not only personified the phenomenon but wrote about it in her short stories.[52] On the other side of the Atlantic, the dress designer Gabrielle 'Coco' Chanel claimed some credit since the simple, practical clothes, youthfulness, and slimness of the flapper were her invention.

The flapper soon evolved in the popular imagination into a new type, the sophisticated metropolitan woman. The mass media, patterns of consumption, and sexual emancipation eroded the once rigid distinctions between the high society woman, the actress, and the young city girl and created a fascinating new blend. Even upper-class young women, who previously had been chaperoned everywhere, went out alone and did what they pleased. 'The blushing débutante is as dead as the English breakfast in Mayfair,' concluded the gossip columnist Patrick Balfour.[53] The London-based writer Michael Arlen's hit novel *The Green Hat* contributed to this phenomenon in that it presented a stylish and restless heroine, Iris Storm, who drove a yellow Hispano-Suiza car, had nicotine-stained fingers, and whose sexuality was unabashed. It was the first best-selling novel to describe a female libertine without depicting her as a victim or a fallen woman.[54] Various socialites claimed that they had been Arlen's inspiration, although two had a better claim that most. Nancy Cunard, daughter of Emerald, heiress to the shipping company of the same name, had shocked by her eccentric ways, that included taking a black man, the jazz musician Henry Crowder, as a lover. For Harold Acton, she was a woman with an 'electro-magnetic' personality who was 'the Gioconda of the age'.[55] Another real-life equivalent who made a special mark, not least because of her utter disregard for convention, was Tallulah Bankhead, an American senator's daughter who illuminated the London stage in the 22-year-old Noel Coward's comedy of lust and memory, *Fallen Angels*, and the theatrical adaptation of *The Green Hat*, before being talent-spotted and tempted to Hollywood by Paramount Pictures. Her smouldering sexuality and uninhibited ways marked her out from even the most daring of modern English women.[56] Her female following was extensive. She was a trendsetter whose appeal was such that she produced a female mob hysteria in London that was unprecedented.[57] Arlen's success was capped when Metro-Goldwyn-Mayer decided to film *The Green Hat* and cast Greta Garbo as Iris Storm. Even though the resulting film was not very good, it gave his novel a resonance it might not otherwise have had.

Arlen's fortunes would eventually decline, but while he bathed in public recognition he was generous with younger writers. He financially supported the first production of Coward's sex and drug abuse drama *The Vortex* in

Hamsptead, unaware that the actor-author would soon take his place as the most fashionable literary figure. The themes of decadence and affluence that he had introduced would be elaborated to a higher pitch by Coward in a series of controversial plays including *Fallen Angels*, the nervous and indolent country house comedy *Easy Virtue*, and the louche *Semi-Monde* (that was so controversial that it did not receive its premiere until 1977). His plays were set in hotels, country houses, and drawing rooms but instead of light banter between the players there was razor wit, drug-taking, and depravity. The plays were usually brilliantly designed using contemporary props and fashionable costumes. At a time when theatre was fashionable, and was seen as a central vehicle of society's reflection on itself, they produced a picture that was at once sophisticated and sleazy.

In the early 1920s, a great premium was placed, especially by women, on being 'original'. In an era when it was fashionable to be fast and bold, daring gestures were crucial attention-grabbers. By the second half of the decade, originality was displaced by commercialized stylishness. In an age when appearances counted for much, clothes were primarily statements of attitude and status. Sophistication and elegance in day- as well as eveningwear were at a premium and this was expressed through streamlining and bias-cut garments. Fur of every type was used although silver fox epitomized stylish luxury. However, the fast-changing fashions and improved technology made it difficult for wealthy women to keep pace and avoid confusion with the less well-off. Instead of relying on their own taste and initiative, wealthy women were obliged to seek guidance from a source such as *Vogue*. A new breed of fashion designers also created exclusive couture and ready-to-wear garments that provided a short cut to stylishness. Whereas society women had once sought to establish individual wardrobes that matched their means, personality, and age, now they tended to conform to trends determined by professionals. The theatre and the movies were important factors in this new mix that tended to be international.

The greater openness of society and the prominence of women helped a designer like Coco Chanel become the glamorous embodiment of her own creations. Couturiers like Worth in the mid-nineteenth century, or Paul Poiret in the early twentieth century, had embraced creativity and adopted

the guise of the artist. They were not themselves part of the high society to which their customers belonged. Chanel, by contrast, did not just dress women. She emerged as a public personality who was the best testimonial for the products that her company produced. The quicker pace of life saw a throwing-off of the fussy and the complex in favour of simple, practical solutions. Women's fashions were the first to reflect this change while even buildings were designed on more sleek and functional lines, without the ornamentation and intricate exterior styling of the pre-war era. Chanel sold a new casual look made of jerseys, blouses, sports dresses, and low-heeled shoes that fell between sportswear and formal afternoon attire. Her clothes were youthful and simple and ideal for a range of new leisure pursuits including motoring, sailing, tennis, and sunbathing. She opened her first store in the aristocratic resort of Deauville in 1913, with the help of the wealthy polo player Arthur 'Boy' Capel, and steadily built an empire that was to embody the understated essence of modern fashion. Chanel benefited from the interest of the press in fashion and the development of international high society. She was friends with many Paris-based artists and members of café society and was welcomed into English high society. She enjoyed a long friendship with the super-rich but unconventional Duke of Westminster, whom it was even thought she might marry.

Chanel had worked in a cabaret in her youth and was sophisticated and worldly. She understood that modern style only worked if it was subtlely infused with sexual suggestiveness and that this infusion was what made the style photogenic and glamorous. This use of sexuality had been a trait of the Paris courtesans. Even though the age of the courtesan was now over, sex appeal still had a place in fashion. Chanel's designs may have looked simple 'in the flesh' but in photographs they were highly seductive. Chanel was a favourite with *Vogue* and other fashion magazines and her garments appealed well beyond the rich clientele who frequented her boutiques. One of her friends was the American socialite Wallis Simpson, who would become the Duchess of Windsor. Mrs Simpson was an eye-catching, ambitious woman who was precisely the sort of hybrid figure the age produced. Slim and hard-faced, neither beautiful nor pretty, even by her own reckoning, the twice-married Wallis had a strong personality and an undeniable

sexual allure. Her magnetism derived from this combined with other characteristics that British upper-class observers found distasteful, such as her blatant social climbing and the garish colour of her lipstick.[58] Even Lady Diana Cooper, a beauty who had acted on stage and screen, commented on her 'commonness and Becky Sharpishness'.[59]

Although she was mentioned in the social columns and was regarded by *Vogue* as an authority on finger food, Mrs Simpson was not well known enough in the early 1930s to be glamorous. To be stylish or chic was a help but it was not sufficient in order to be glamorous. With the rise of the press and the entertainment media, it was also necessary to be available to the public and to be committed to the development of a theatrical public image. The type of personality who was glamorous was generally available to the public and, for commercial or professional reasons, regarded this availability as an important part of their being. This included royalty and some aristocrats but Mrs Simpson, for example, had little interest in cultivating a public image even though she had some of the qualities to become a personality. Increasingly, it was professionals who performed this task. In the end, it was not debutantes or wealthy socialites who were the best examples of glamorous personalities but people from commonplace backgrounds who by chance or talent had blossomed in the public eye.

Women like the aviators Amy Johnson and Amelia Earheart, and the French racing driver Hellé Nice, were glamorous because they were good-looking and were directly associated with modern technological advancements. Each belonged to an exciting realm since travel, in its various forms, was one of the great innovations of the age. Each, moreover, knew how to exploit the situation to personal advantage through the adoption of a carefree attitude, fashionable dress, studied gestures, personal magnetism, and planned stunts. Their prime audience was not high society but the social body as a whole.

Aviation was a great mania of the second half of the 1920s. People of all classes and nations were enthralled by the adventure of the skies. The press gave great attention to daredevils and record-breakers of all types, even putting up prizes for some achievements. There were air weddings, air christenings, acrobatics, and even air-related songs. Intense public interest led newspapers to build up aviators into stars, a phenomenon that reached

an extraordinary zenith after Charles Lindbergh single-handedly crossed the Atlantic in a mono-plane in 1927.[60] Titled adventurers were keen to get in on the act and pioneer airmen were joined by a series of smart rich women who took advantage of the drive for female emancipation. These amateurs were supplanted by women of a more professional outlook, of whom Johnson was one. The popular press latched on to the fact that she was not titled but an ordinary girl trying to fulfil her dreams.[61] Dubbed the 'flapper ace' in the press,[62] she was referred to, somewhat romantically, as a 'penniless nobody' or 'the little typist', although in fact she had been to university.

A photogenic young woman with a good figure, 'Johnnie'—as she liked to be called—was given full celebrity treatment by the *Daily Mail* in particular. Each of her long-distance flights was heralded as a triumph and she was greeted with frenzy when she returned. In 1930 a song composed in her honour, 'Amy', which proclaimed the nation's love for her, was a popular hit. After she became a public figure, she underwent a notable makeover. She did not go as far as her American colleague Earhart, who created her own signature line of clothing but, with the aid of the Irish-born dress designer Captain Molyneux, she learned how to wear fashionable clothes, furs, and diamonds. She found her celebrity value and newly polished look aroused the interest of managers of luxury hotels, jewellers, vendors of fast cars and *maîtres d'hôtel* of smart restaurants, all of whom were keen to win her patronage.[63] After she had her hair set in waves, streamlined her eyebrows, and adopted discreet make-up, she took on the appearance of a Mayfair socialite. Johnson was briefly welcomed into society salons, but she retained her northern English accent and her unhappy personal life won her widespread sympathy.

Like aviation, automobiles had a special romantic allure and motor racing was a field in which rich men dominated. Race tracks lacked the other-worldly appeal of the skies, but speed had a special fascination and thrill of its own. As a spectacle, racing offered many promotional opportunities that were exploited by advertisers and publicity-seekers. Competitive events offered an exciting spectacle and there were even championships for actors. Moreover, the personal risk involved was, if anything, greater than with flying since there was a high rate of racing fatalities. Hellé Nice had been a dancer at the Casino de

Paris, an experience that prepared her for the publicity she received when she won several major mixed and all-female races in her gleaming blue Bugatti.[64] Manufacturers were keen on female drivers because of the modern allure they added to vehicles that were already crafted like beautiful mechanical beasts. Photographs show Nice sitting in her vehicle applying her make-up before a race, wearing striking white overalls and flashing a 100-watt smile at cameras. She also did handstands on the bonnet of her car. Whenever she won, she was careful to slip out of her overalls and into an elegant gown in order to receive her prize. Even more than Johnson, she lived extravagantly, revelling in the trappings of wealth, and mixed with noblemen, several of whom became her lovers. While Johnson endorsed Castrol Oil and Shell petrol, Nice advertised Lux soap and Lucky Strike cigarettes as well as Esso petrol.

In the mind of the public, figures like Michael Arlen and Noel Coward were the epitome of male glamour. Unlike upper-class moderns like Mountbatten, who used contemporary fads and fashions to update the public image of the privileged elite, they took contemporary style and moulded it into something enviable and imitable. They created a lifestyle that was entirely publicity-oriented, in the sense that they were constantly in the press and delighted in presenting their homes, wardrobes, travel plans, and tastes to the public. They were men who had propelled themselves upwards socially by means of their talent, their nose for controversy and novelty, and their personal self-fashioning. Both of them moved easily between London, New York, and the French Riviera. After the success of *The Green Hat*, Arlen became a figure of the moment who, for a short period, was the highest-paid short-story writer on either side of the Atlantic. He adopted a public persona to match the extensive newspaper coverage he received. 'Young, full of dash, and neither quite a gentleman, and neither not,' as his son would later describe him,[65] he dressed impeccably, lunched at the Ritz, drove around London in a yellow Rolls Royce, and established his main residence in Cannes.

If Arlen was a Romanian refugee who invented a glamorous identity for himself, Coward was scarcely less an outsider. Born in unfashionable Teddington, it was said that his mother had been a charwoman. In fact his family was middle class but impoverished. His daring plays, in which he usually acted himself, brought much publicity and connected Coward in the

public mind with cocktails and decadence.[66] He embraced an appropriately elegant and urbane lifestyle complete with luxurious trappings including new suits, silk shirts, a car, and large quantities of pyjamas and dressing gowns (which became his trademark garment). For Cecil Beaton, he embodied 'the glamour of success'.[67] He was photographed everywhere: in public places, in his dressing room, at the piano, and even sitting up in bed in a Chinese dressing gown, while making a breakfast telephone call supported by an ample cushion. The latter image, reproduced on the cover of *The Sketch*,[68] brought accusations of degeneracy.

Coward knew that publicity and controversy were good for business. For the world he acted the part of a symbol of the Jazz Age. More than any other English writer he seemed to understand the turbulent era of which he was a part.[69] He was also versatile. After a sequence of topical and controversial plays, he decided to go for pure style and to try his hand at a revue, to which he gave the title *London Calling*. A hugely popular entertainment form of the 1920s, revues were pure escapism. They were opulent stage shows that transported their mainly middle-class audiences into improbable worlds of glamour and romance. They depended for their success on a skilful combination of well-known performers, sumptuous costumes, lavish scenery, catchy songs, and brisk, well-timed choreography.

The king of the London revue was another middle-class man who constructed for himself a theatrical persona. One of the most popular stage figures of the period, Ivor Novello was a Welshman who had been born David Ivor Davies. He was a handsome songwriter and performer who was always thought of in association with revues like *Careless Rapture* and *Glamorous Night* (the latter was sold to the directors of the Drury Lane theatre purely on the basis of the combination of the two words that made up the title—a fact which by itself perhaps offers an insight into the 1920s mind).[70] For audiences, the stars of revues were magic people who had no real existence outside the romantic make-believe world of the stage. According to Novello's biographer, the public was not wrong in its assumption in his case since he was only ever fully at ease in the illusory world of the footlights.[71]

Arlen, Coward, and Novello were all manufactured, self-made men who impersonated the upper class. They looked and sounded like gentlemen and

they always situated themselves in contexts that were polished and worldly. At the same time, they offered the wider public an image of upper-class life that was more stylized and appealing than the reality. This work of fabrication heightened surface appeal and contributed to the process whereby 'class' was turned into a question of style, pose, and performance. This rendered it both interesting and accessible. Coward and Novello did not always enjoy an easy relationship with those who assumed that no one could be more stylish than themselves, and who knew that they were impostors. As a personality and acknowledged trendsetter, Coward was welcomed into salons as an equal, but found himself cut dead by the Prince of Wales on at least one occasion. Nevertheless, he became a major influence in fashionable society and had a broader impact on customs. He gave rise to a clipped, wise-cracking manner of speaking that was adopted by upper- and middle-class men throughout the English-speaking world.[72]

Beaton, who went to Harrow and Oxford, was not a social upstart to the extent of Arlen and Coward, although his family was more upper-middle than upper class. At a young age, he learned the advantages of publicity and even succeeded in propelling his mother into the social columns of The Times.[73] He devoured magazines and learned to identify well-known faces in Hyde Park on Sundays. His infatuation with high society persisted through his time as a student, little of which was spent studying. He regularly sent pictures of himself to magazines and made sure that all his work on the costumes and sets of student production won recognition. He loved the fancy dress parties that were so much in vogue and his taste for all things theatrical made him a natural soulmate of the Bright Young Things. His sketches of the fashionable provided his first work for Vogue, although he was soon also supplying photographs. Beaton set himself up as an authority on matters of beauty and style and wrote regularly for fashionable magazines and for the press. Before long, he became a key figure in the stylish world that he so admired. In the late 1930s he became the official court photographer.

The stylish facades constructed by these men not only camouflaged their social origins, it also concealed their sexual orientation. This element of concealment added a touch of danger and mystery to their personae and, as such, it was a component of their glamour, albeit a less obvious one than

their aura of sophistication. Coward and Novello were both homosexuals who, in intolerant times, went to some lengths to disguise their sexual preferences. Their highly aestheticized exteriors were part of the disguise, although there was always the risk, as Coward's bed photograph showed, that an ill-judged pose might give the game away. The playwright once gave a lesson to Beaton on how to build a personal facade composed of speech, gestures, and dress that would make him acceptable in heterosexual company. 'You should appraise yourself,' he advised. 'Your sleeves are too tight, your voice is too high and too precise. You mustn't do it. It closes so many doors... It's hard, I know. One would like to indulge one's own taste. I myself dearly love a good match, yet I know it is overdoing it to wear tie, socks and handkerchief of the same colour. I take ruthless stock of myself in the mirror before going out. A polo jumper or unfortunate tie exposes one to danger.'[74]

Behind the scenes a large number of professionals played a vital role in creating and sustaining the contexts, events, and individuals that basked in the aura of glamour. These were not just impoverished aristocrats but salaried experts, men and women who were masters of techniques including photography, dress design, fashion illustration, journalism, and popular literature. In the past many of them would have been regarded as little more than tradesmen, background figures who would rarely if ever have commanded public attention. This was still the case with some, such as the American *Vogue* editor Edna Woolman Chase, who had no special social connections and avoided events.[75] Others, like the legendary networker and party organizer Elsa Maxwell, occupied a median position. An American lesbian who was anything but personally glamorous, Maxwell was not known to the public before the 1950s. Yet she was friends with Coward, Laura Corrigan, and many other key figures in the arts, commerce, and high society in the United States, Britain, and continental Europe. Neither stylish nor young, she was so ugly that she quite plausibly dressed up as US President Harding or German President Hindenburg at the fancy dress balls she adored. However, she was a publicity genius who single-handedly bestowed a magical allure on places, people, and events. More than anyone else, she was the *éminence grise* behind the 'international set'.

Maxwell launched the career of the fashion designer Edward Molyneux, by bringing him into contact with an international clientele. It was her idea that he should found and run the smartest nightclub in Paris. She also played a key role in creating a high-living image for Jean Patou. The Parisian designer is today remembered mainly for the perfume Joy, that is still on sale. In the 1920s, he was a highly fashionable figure whose modern sports and leisure wear perfectly suited the androgynous woman of the time. Like his rival Chanel, he forged a public image that complemented the universal appeal of his modern women's clothes and fragrances. Many of his clients were Americans and he fashioned an elegant facade to appeal to them. Maxwell helped him to see the publicity value of having famous clients, such as the film star Gloria Swanson, who embodied his idea of modern luxury.[76] Perhaps his most famous client was French tennis star Suzanne Lenglen, who pioneered his pleated tennis skirts and sleeveless dresses. In reality, Patou was a family man but, with Maxwell's help, he used his business to sustain a social world around himself. He became a leading figure in international café society known for his extravagance and cultivated an image based on the allure of the Riviera, fast cars, and legendary gambling.

The authorities of the Venice Lido commissioned Maxwell to promote it as a fashionable summer resort. Using her ample address book and her organizing skills, she lured numerous wealthy and prominent people with the promise of fun and hedonism. The parties that Maxwell organized on behalf of her wealthy friends were usually fast and colourful affairs that gave the idle rich ample opportunity to show off. They were also notorious for their debauchery. Distant from the social controls of the capital cities, guests were able to indulge themselves as they wished. In Venice, she could rely on the support of the singer and songwriter Cole Porter, whose circle practised a relaxed hedonism that appealed to Coward. He delighted in the heavy drinking, cocaine, and indiscriminate sexual experimentation that were commonplace among members of the Lido set.[77] Like the Riviera and other watering holes, Venice was a great scene of social mixing. It was a place where American heiresses, British aristocrats, and elegant French women mingled with writers and artists on an equal basis.

Maxwell understood the importance of entertainment and surprise in socializing and she also knew how important it was to calibrate press coverage. It was, she later wrote, 'the life-blood of fame. It spells the difference between legend and oblivion.'[78] She sought coverage for the events and people she staged but, at the same time, she knew that privacy was necessary if celebrities were not to be always 'on guard'. Oddly, for such a key figure in several of the developments in modern glamour, Maxwell was a snob who had little time for the mass public. She lived entirely in a world of rich people, grand houses, and fabulous hotels, where she could always be sure of free hospitality. Although she could not have existed without the development of travel, the emergence of the mass media, and social practices such as popular fashion and dance music, that all brought people of different classes and nations into an unprecedented set of relations with each other, she resented the social climbing and ambition that they brought.

In the 1920s, the general public was fascinated by technical innovations, record-breaking, gossip, and style. It loved reading about the rich and famous. The rise of the movie star, the record-breaker, the sports hero, the pioneer aviator and racing driver signalled the arrival of a society based on publicity and entertainment. From the moment it first came into being in the early nineteenth century, glamour had functioned as a visual repertoire of seduction that drew on a plurality of ostensibly incompatible sources. It evolved as a quality forged through the reciprocal influence of commerce, popular spectacle, and social prestige. Now it was refined into a structure that was sustained principally by modern communications and the commercial public sphere. This both gave members of high society a new platform and undermined the special access to public attention that they had previously commanded. This led to a transformation of the role of the aristocracy and ultimately contributed to its decline. In the years of the Depression, the cinema offered the public all the glamour and romance it needed.

THE HOLLYWOOD STAR SYSTEM

The most complete embodiment of glamour that there has ever been is the Hollywood film star. In the period in which the major studios established their dominance over the leisure of the entire industrial world, no one was more highly polished, packaged, and presented than the men and women who became the majors' main lure in their efforts to captivate the public. Suspended between the ordinary and the extraordinary, the real and the ideal, the stars were the gods and goddesses of a modern Olympus. To the man or woman in the street, it did not seem as if they worked at all for a living. Their fabulous lives were choreographed, pictured, described, and evoked by publicity departments that drip-fed the world's press with news and information. For audiences worldwide, these alluring personalities were the stuff of fantasy. A fantasy, however, that was somehow accessible. Although several early stars were packaged as extreme or unusual personalities, the star as a fabulous everyman or everywoman emerged fully in the 1930s. Among the many and varied appeals that Hollywood cinema developed in its golden age, one key one was the premiss that anyone, potentially, could be a star.

The greatest Hollywood star of all was a mixture of the mysterious and exotic elements that marked the star system before the advent of sound film and the more general characteristics that emerged later. She was a woman whose legendary self-containment made her a compelling player of a wide variety of historical and contemporary roles. When she arrived in Los Angeles in 1925, the future Greta Garbo still bore the surname Gustaffson, she was just short of 20 and looked like what she was, an unsophisticated girl from the backwaters of Sweden. Her front teeth were crooked, her hair was frizzy, and there was a hint of a double chin. She was taller than average and she had a boyish frame. But there was something about her, some hidden potential was waiting to be discovered.[1] However, bringing out her star quality on screen was no easy task. Garbo did not photograph well under strong lights and initially had developed a nervous tic in her cheek when filmed in close-up. Her first MGM screen test had not made a good impression due to poor lighting. Only when the master of soft-focus effects, cinematographer Henrik Sartov, was brought in was her potential fully revealed. According to her biographer, Sartov's lens and its magical ability to 'clean out' the face through spot lighting finally brought out her beauty.[2]

For some twelve years, Garbo reigned supreme as the queen of the largest and most prestigious of Hollywood studios. Her films were always the most costly and fabulously confectioned products of a studio that specialized in total perfection. She was almost always cast in European roles of a marked erotic connotation. She repeatedly played performers, courtesans, or fallen women in films including the title role in the biopic of the ill-fated dancer and spy *Mata Hari*, a seductive opera singer in *Romance*, a cabaret singer in *As You Desire Me*, a kept woman in *The Fall and Rise of Susan Lennox*, a tormented actress in *Grand Hotel*, and Marguerite Gautier in *Camille*. In perhaps her greatest part, she played the title role in *Queen Christina*, a film biography of the androgynous seventeenth-century Swedish queen. Close-up shots established the iconic status of her extraordinary face and presented it as the most intriguing blank canvas in cinema. She offered to the viewer's gaze 'a sort of Platonic Idea of the human creature', the critic Roland Barthes later wrote.[3] Garbo's erotic appeal was always underlined by the most extraordinary and imaginative screen costumes, which were designed for her at MGM by Gilbert Adrian.

Although she could neither sing nor dance convincingly (a fact glaringly demonstrated in *Mata Hari*), she was packaged as a rare luxury object and presented as a supremely sexual woman. She had a world-weary, melancholy air and a distinctive style. Her films were adult and were shot through with a decadent, sensual atmosphere. In the 1920s, her screen partnership with John Gilbert, her off-screen lover, held audiences entranced. Their long horizontal kisses were among the most suggestive ever seen on film. Unlike Gilbert, whose squeaky voice ensured that his career declined sharply with the end of the silent era, Garbo had a timbre that seemed entirely to match her enigmatic image. Her husky tone, European accent, and slow, drawn-out enunciation added to her allure and brought her new fans. Her long reign at MGM only came to an end when the closure of overseas markets weakened her position at the studio and she refused to make films that were not equal to her particular talents. Wartime audiences, her biographer has observed, preferred Betty Grable's great legs to Garbo's great art.[4]

The key to Garbo's personality was mystery. She was never the most pliable or cooperative of stars. Even at the peak of her success, she often threatened to return home to Sweden and she refused, famously, to allow her private life to be exploited for publicity purposes. Instead of putting audiences off, this aloofness would drive them into a frenzy of curiosity. The celebrated sentence, delivered in the 1932 film *Grand Hôtel*, 'I want to be let alone' (in which 'want' was pronounced with a Germanic 'w'), became her trademark. Garbo at times infuriated studio head Louis B. Mayer, but her stubbornness taught the studios that star images were complex and that sometimes an appeal could be enhanced by holding back, by not being everything to everyone. Film-goers wanted to know everything about their idols but it was the maintenance of this yearning, rather than its satisfaction, that was the necessary condition for a star's continued box-office success.

Hollywood was an American industry that was founded, run, and largely peopled by immigrants. For at least the first twenty years of its existence, it was dominated by men who had been born in Europe and who had fled to America to escape war, tyranny, racial prejudice, and economic crisis. The creators of Hollywood glamour were émigrés and exiles from Germany, Hungary, Russia, France, and Britain.[5] American cinema was all the more

powerful because the men who built the film industry were themselves refugees who gave rise to an imagined America as a land of freedom, tolerance, wealth, and personal realization. There were connections between cinematic fascinations and the earlier techniques of salesmanship.[6] Nineteenth-century pedlars were often German or East European Jews too and this was a factor in their marginality and their association with the mysterious East, as well as sorcery and magic. Like the pedlars, the movie moguls offered dazzling images that promised instant personal transformation and provided rich material for daydreams. The difference was that these images were no longer conjured up by the oral and presentational skills of individual salesmen operating in face-to-face situations. They were embedded in a new second-order reality that overlay daily life and was experienced purely through the media.[7]

Hollywood films, produced by companies that had a firm stake in the exhibition and distribution sectors, conformed largely to the escapist imperative. They offered a range of options for audiences to choose from, including European-style decadence, American aristocracy, theatrical opulence, showgirl glitz, and youthful beauty as well as city savvy, down-home Americanism, and pioneer virtues. But above all Hollywood created a unique blend of the aristocratic, fashionable, sexual, theatrical, and consumerist appeals that had emerged and uneasily coalesced in Europe and America in the preceding period. This blend, which emerged as the American motion picture industry's signature style from the 1920s, exercised an unprecedented influence over global aspirations, desires, and lifestyles. The strong traces of European decadence and exoticism that were apparent in the films of one of the five major studios, Paramount, were balanced by the predominant emphasis on optimism and democracy in the output of others. Because it was located in California, far from the main centres of privilege and style, the film industry reinvented glamour as an enticing image that relied solely on technique, artifice, and imagination and was remote from specific social referents.

The consolidation of the industrial structure of Hollywood in the second half of the 1920s ensured that production strategies were stronger than any individual performer and that corporate power was the determinant factor in

the industry. The arrival of sound and the impact of the Depression in the early 1930s reinforced the near monopoly of the five major film studios. In a situation in which the mass-production methods of Fordism were finding application in the film industry no less than the rest of the American economy, the production of star figures also became an assembly-line matter subject to precise codes, procedures, and practices. The American film industry in the 1930s and 1940s was widely known as 'the dream factory' or 'the glamour factory'. Like the automobile industry, it furnished products in large numbers for mass consumption. The only difference between the motor cars, household products, and clothing produced by American manufacturers and the movies furnished by the motion picture industry was the fact that the latter catered not to practical needs and situations but precisely to the imagination. Of course, more practical goods were often sold in alluring settings (stores, catalogues, etc.) and modern advertising, which developed from the 1920s, weaved spells of aspiration and desire around even those that were not. The movie star was a standardized product that came in a limited number of varieties and was subject to continuous revision and modification. What distinguished Hollywood stardom from that of other cinemas was precisely the systematic nature of star production and distribution.

More than any other studio, MGM turned glamour into a corporate product. It was the largest and most successful studio of the sound era; in 1932 *Fortune* described its list of stars as 'vastly the most imposing' in the industry.[8] Paramount was its only serious rival in the matter of star production. The other studios, 20th Century Fox, Warner Brothers, and RKO plus the minor companies Columbia, Universal, and United Artists placed less emphasis on stars. Fox, for example, had under contract only four top-ranking stars between the mid-1930s and the late 1940s: Shirley Temple, Betty Grable, Tyrone Power, and Gregory Peck; Warners relied on James Cagney, Bette Davis, and Humphrey Bogart.[9] The point, ultimately, was one of cost. 'There are only two kinds of merchandise that can be made profitably in this business—either the very cheap pictures or the expensive pictures,' wrote David O. Selznick to his treasurer when he left MGM to found his own company. This was as true in the 1930s and 1940s as it had been in the 1920s.[10] Companies like Warners which did not share MGM's commitment

to 'general finish and glossiness',[11] or smaller companies which could not afford the luxury of high cost production values, did not develop promising actors or invest in lavish sets, but instead concentrated on familiar genres, characters, or settings. Although some performers went over with audiences without any particular preparation, the heavy investment that was normally required to mould and successfully launch a star persona could only be made by the big studios. Stars alone could not bring success to a film, but they could account for around a 15-per-cent variation in box office.[12]

Hollywood acquired a distinctive style leadership in the 1930s. The films themselves were the most important factor in giving the movie capital a design edge. Although art directors do not normally receive anything like the attention accorded to producers and directors, the house style of the major studios, as well as the particular appearance of given films, was largely their work. While the Oriental imagery of the early 1920s testified to cinema's reliance on the stage, the clean deco lines of the 1930s were products of a process that saw moves towards an independent concept of set design. The most prominent art director was MGM's Cedric Gibbons, an influential figure who took overall responsibility for the look of every single film produced by the studio between 1924 and 1956. He personally designed the sets for several of MGM's most luxurious film vehicles. Gibbons was responsible more than anyone else for linking the manufacture of glamour to contemporary aesthetic trends. He maintained a simple approach to designing for film, abandoning cluttered grandeur for art deco and turning this modern style into a potent symbol of transatlantic glamour.[13] Starting from 1925, the year Gibbons undertook a visit to the Paris Exposition of Decorative Arts that pioneered what, at the time, was known as the *moderne* style, art deco furnishings and geometric interior designs were used to frame and locate screen characters who were associated with jazz music, 'fast' behaviour, and a generally decadent lifestyle.[14] Cecil B. De Mille was the first director to use upper-class settings and MGM in particular persisted with the upscale image; the studio boss Louis B. Mayer thought that wealth would automatically be assumed to be moral. Whereas 'good' women in films were placed in traditionally decorated contexts, sexually promiscuous, independent, modern women were often associated with architectural modernism as well as the exterior trappings of wealth: furs, jewels,

fashionable attire, cars.[15]Although, with hindsight, the Hollywood deco style looks spare and elegant in its emphasis on streamline and two-tone effects, it was in fact a promiscuously eclectic style that drew on the art of many cultures, countries, and periods.[16] In this sense it tied in well with the eclectic jumble of sensations and effects that marked mass culture.

'The glamour of MGM personalities is part of a general finish and glossiness which characterizes MGM pictures and in which they excel,' wrote *Fortune* magazine: 'Irving Thalberg subscribes heartily to what the perfume trade might call the law of packaging—that a mediocre scent in a sleek flacon is a better commodity than the perfumes of India in a tin can. MGM pictures are always superlatively well-packaged—both the scenes and personalities which enclose the drama have a high sheen. So high a sheen that it sometimes constitutes their major box-office appeal.'[17] Mary Astor wrote in her memoirs that, at Metro, 'all automobiles were shiny. A picture never hung crooked, a door never squeaked, stocking seams were always straight, and no actress ever had a shiny nose.' If an actor or actress was spattered with mud in one scene, somehow the mud had disappeared by the next.[18] More than at other studios, actresses looked at all times as if they had just come from the beauty parlour. 'You practically had to go to the front office if you wanted something as real as having your hair mussed,' Astor recalled. This improbable perfection was a crucial aspect of Hollywood glamour.

As human commodities, movie stars were the main object of Hollywood fantasy. In the 1930s and 1940s vast amounts of effort and money were invested in their creation. The construction of a star was no less a process of transformation than the turning of a bare set into a fantasy environment. In contrast to the theatrical impresario Florenz Ziegfeld, who concentrated on transforming raw young women into one-dimensional stage icons who neither spoke nor emerged as individuals, the studios took Broadway actors, foreign starlets, athletes, beauty pageant winners, and others and moulded them into fully fledged screen personalities. The sort of beauty that showed up well on screen featured good bone structure, an oval or square-shaped face with a high forehead, expressive eyes, generous lips, possibly of an interesting shape, and a winning smile. Personality had to shine through on screen. Stars had to have magnetism and a talent for holding attention.

'I always looked for the actor with personality first,' talent scout Al Trescony said; 'I've found that a person with a fantastic personality will attract the attention of everyone in a room, not unlike a beautiful young woman. But people will look at the beauty and after a moment return to their conversation. The one with personality will hold their attention.'[19] A performer had to be able to make people believe him or her and this too was perceivable mainly through the eyes. 'The eyes show everything a person is thinking. It comes through the celluloid right out to the audience,' Trescony continued.

The initial material was not always promising. When she arrived from Berlin, Marlene Dietrich was plump by American standards; she had a wide nose and a strong, square face. Her manners are said to have been coarse and Teutonic. Joan Crawford was a brassy and unsophisticated working-class girl. She was shorter than most, had wide eyes, flared nostrils, and freckles. Even as a chorus girl, she had not demonstrated any great talent. Carole Lombard's curvaceous figure and athletic ability seemingly suited her to be one of Mack Sennett's swimsuited Bathing Beauties but nothing more. There was little to suggest that any of these women had star potential. Yet each had some special quality that persuaded studio bosses that she could be transformed into a magical, alluring figure who would exercise a magnetic influence over film-goers. In addition to some acting ability, youth was important as a criterion for star-building and so was beauty, but more significant were two more elusive attributes: a photogenic quality and personality.

To enhance audience interest in them, stars were wrapped in a romantic aura; biographies were falsified or invented, and names were often changed (just as Greta Gustaffson became Greta Garbo, so Joan Crawford had originally been Lucille LeSueur, while Carole Lombard and Cary Grant had been respectively baptized Jane Peters and Archie Leach). Often the humble origins of American stars were played up while aristocratic or well-to-do backgrounds were developed for Europeans. Stars were portrayed as confident, seductive, exotic, debonair, paternal, or funny in accordance with the type of roles they played. The intention was to mingle reality with illusion and fantasy to make quite ordinary people into fascinating ciphers of individual dreams and aspirations.

The special allure of Hollywood cinema derived from a combination of factors including the genre system and screenplays, as well as the great

investment in the overall look of films. But the importance of the stars was such that every aspect of their being was subject to meticulous grooming and manufacture. Hollywood moguls had precise ideas about the way a star should look and they remodelled their new talent accordingly.[20] Women were usually put on a rigid diet and subjected to intensive massage treatment to lose excess pounds that would look unflattering on the screen. In this way cheekbones showed through and the face acquired an angular quality that the light could capture and the body took on a sleeker look. Teeth were fixed, corrective plastic surgery was applied if necessary, hair was smoothed out.

After this, the make-up department went to work, thinning out and redesigning eyebrows, lengthening eyelashes, enlarging eyes, reducing noses, removing beauty spots, and covering freckles. The intention was not to make the stars more pronounced as individuals but rather less. Make-up depersonalized the face in order to turn it into something artificial and alluring. This did not, contrary to popular opinion, turn stars into godlike beings. In the view of the French sociologist Edgar Morin, who in the late 1950s wrote a penetrating analysis of stardom, 'make-up in cinema does not counterpose a sacred face to a profane, everyday face; it raises everyday beauty to the level of superior, radiant, incontrovertible beauty. The natural beauty of the actress and the artificial beauty of the make-up join in a unique synthesis.'[21] Perhaps the most obvious point of synthesis was in hairstyling. Mary Pickford's curls, Jean Harlow's platinum blonde tresses, Claudette Colbert's bangs, and Veronica Lake's 'peek-a-boo' style were all influential.

Stars were presented to the public primarily as objects of sexual desire. To achieve this effect, film companies seized hold of the culture of sexual representation that had developed in the theatres of Europe and the United States. Writing in 1932, Gertrude Aretz argued that 'the chosen beauties of the film world' had become the bearers of the erotic femininity that was previously the preserve of the *Parisienne*. There was a continuity, she argued, between their tastes and 'the luxurious *demi-monde* of the Old World'.[22] However, the 'sex appeal' that was a vital quality for every star was not the same as the commodified sexual appeal of the courtesan and showgirl.[23] Indeed, it was regarded by some European observers in the 1930s as a mysterious quality.[24] French journalist Blaise Cendrars found that in

Hollywood great emphasis was placed on symmetry and harmony of the face and body in achieving the 'flash', the 'magnetic attraction' that was central to sex appeal; the contribution of the artifice of hairstyling was also deemed of central importance.[25] Perplexity arose because there was no immediately recognizable connection between the calculated strategies of the professional seductresses of a previous generation and the less explicit, subdued fascination of the stars. The latter combined class and sleaze no less than the Parisian courtesans but, instead of holding the two qualities in precarious equilibrium, they blended them in a fascinating original synthesis.

The inventor of 'sex appeal' in cinema was in fact Elinor Glyn, the English aristocratic author of a scandalous novel entitled *Three Weeks* that portrayed the passionate seduction of a young British aristocrat by a Balkan princess.[26] Glyn taught the popular actress Gloria Swanson and other protégées how to project 'star quality', that is 'a kind of ever-warm but slightly aloof benevolence when seen socially or at public functions'.[27] Crucially, she also taught film-makers how to encode sexuality, first coining the term *It* (the title of one of her stories, which gave rise to a 1927 film of the same title featuring Clara Bow—the 'It' girl) which evolved into sex appeal.[28] The point was to make sex secondary to magnetism. Women, Glyn advised, 'ought to remain mysterious and elusive in order to keep their men interested, even after marriage' and the same applied to movie stars and their audiences.[29] This view reflected the background of Glyn, who was basically a romantic conservative, but her usefulness lay in providing a bridge between turn-of-the-century innocence and modern customs that saw men and women regard each other as friends, work colleagues, and potential sexual partners.[30] One of Glyn's favourite motifs was the exotic. One way in which sex appeal was generated was through contrasts between light and shade; these were usually mapped on to the cultural differences that were highlighted through the use of light and shadows. The light skin of white actresses was deployed to express purity, cleanliness, godliness, nobility, and the generality of humankind against supposed lower orders of humanity who were distinguished by darker complexions. This presumed cultural supremacy made itself felt forcefully in early cinema. In D. W. Griffith's 1915 racist extravaganza *The Birth of a Nation*, Lillian Gish was bathed in light as the embodiment of the

myth of a racially pure American South.[31] However, there was also room for diversity, and ethnic difference was turned into an exotic spectacle. In keeping with a view of the swarthy foreigner, whether of Southern or Eastern extraction, as a source of sexual danger, and therefore sexual excitement, Rudolph Valentino, a dark-haired Italian, donned the exotic persona of an Arab in *The Sheik* and *Son of the Sheik*. Chinese, Hispanic, and Arabic motifs were also employed to add mystery, sultriness, and allure.[32]

As Glyn and others conceived it, sex appeal was primarily a feminine matter. In this sense its cinematic application opened a new chapter in the culture of woman as spectacle. The development of cinema allowed male producers and artists new possibilities for moulding women and creating figures of fantasy, even to the point of reconstructing ideals of femininity. The practical aspects of stardom, with its attention to beauty, artifice, display, fashion, luxury were considered by many to be exquisitely female. However, American audiences and fans were largely female and several male stars were also packaged and costumed in a similar way to their female colleagues.[33] Such stars could find themselves under attack for effeminacy. Valentino's masculinity was questioned because women fawned over him, he was a skilful dancer, and wore a bracelet given to him by his wife. A notorious attack by the Chicago *Tribune*, in which he was dubbed a 'pink powder puff', was said to have contributed to his final illness and death.[34] In general, the acting profession, in particular when this involved a male setting himself up as an object of desire, was deemed an inappropriate activity for a man. Men did not pose and costume themselves; they performed real physical work or took part in sport.

Hollywood offered its audiences a wide variety of entertainments and glamour was present in several popular genres. However, it was especially present in contemporary films which breathed some of the modern spirit of the period. Clara Bow, Louise Brooks, and Joan Crawford were American girls from humble backgrounds who conferred their own distinctive traits on the flapper phenomenon. They all played socialites even though they did not physically resemble conventional upper-class girls. Indeed, in their films, their vibrancy and energy are explicitly contrasted with the colourless, respectable young women who are presented as typical of the stuffiness of

formal high society. Bow was the biggest idol of the mid-1920s. A Brooklyn girl who won a fan-magazine contest and did a successful screen test, she found herself catapulted to stardom in the 1926 film *Dancing Mothers*, an adaptation of a Broadway play in which she played the part of Kittens, the flapper daughter of a high-society matron. She injected such vitality into her playing that Paramount gave her a cameo appearance as herself, Clara Bow, movie star, in the film *Fascinating Youth*. The interplay between biography, personality, and fiction was strong in the case of an actress who had red hair, drove a red open-top sports car, and owned a dyed-red dog. The opening sequence of her film *Red Hair* was even shot in colour at exorbitant cost to show audiences her flaming tresses.

In one of her first major films, *Our Dancing Daughters*, Crawford—who would become one of the biggest stars in the 1930s—plays a freewheeling socialite who loves jazz and takes off her skirt at a formal event to dance the Charleston more easily. This too was a biographical reference since the actress had first come to public attention as the winner of a Charleston competition. Like her fellow flappers, Crawford's character still lives with her parents, yet she shocks and alienates the man she loves with her carefree mores. She eventually wins back her beau, but she remains modern and sexy in a way that marks her out from more conventional members of her circle. In the film, she seems just like she was, a brash working-class girl who had risen beyond her station. Films like this created the illusion for audiences that fashion and novelty created patterns of shared experience that did not just blur but actually erased class boundaries. This reflected and magnified the extent to which invention or self-invention were common features of an age in which appearances were important for all modern women.

The star image was also shaped by a variety of extra-filmic elements. The off-screen lifestyles and personalities of prominent film actors were not simply part of the paraphernalia of movie marketing but an integral part of what made an actor a star. The aura of stardom was generated as much by magazines, photographs, advertising, and audience perceptions as screen performance.[35] The public image of movie people was derived from the super-rich, although its main purpose was not to establish status within the group so much as to impress the public. Large houses,

private swimming pools, limousines, fine clothes, and an exciting social life were the recurrent features of the Hollywood lifestyle. The producer Thomas Ince was the first movie figure to take up a way of life that in California had been adopted by oil magnates. He built a Spanish-style villa and developed a leisure-oriented way of life based on outdoor sports pursuits, large automobiles, and weekend entertaining.[36] Others followed with dream castles and lavish mansions above Hollywood and in Bel Air and Brentwood. Although the homes of the stars were featured more regularly in the press in the 1930s, even the first mansions were regularly photographed, with the result that tourists and autograph hunters descended on Hollywood.

From the point of view of established social elites, Hollywood was a vulgar and ostentatious place, characterized by excess and idiosyncracy. In an industry peopled by newcomers, nobodies, and the deracinated, social life was marked by the sort of hedonism that exploded with the Fatty Arbuckle trials, in which the corpulent actor was accused—and eventually acquitted—of causing the death of a young actress by rupturing her bladder during a sex game. With the help of aristocratic advisers such as Elinor Glyn, more accurate imitations of elite customs were developed on- and off-screen. Glyn wrote screenplays, acted as a consultant on several films, and tried to introduce criteria of taste to Hollywood living—dispensing judgements on dining rooms, gardens, fashions, colours, food, and anything else that caught her eye—although the results often fell short of her intentions. The larger-than-life image of the star involved, typically, exaggeration and attention-grabbing at the expense of taste. But for the masses, the Hollywood version of high society was more comprehensible and accessible than the closed world of the established rich, based as this was on family line and tradition, more than money and success. Mary Pickford and Douglas Fairbanks were the first stars to introduce an element of sobriety and dignity into a community that was typified by parvenu excess. Richer, more powerful, and better-known than those that followed, they had seen how the European upper class lived on their travels abroad during the early 1920s and aimed to create their own version of a courtly social elite. Under their influence, the film community set about creating a replica high society in Los Angeles. This involved a hierarchy based on earning power that also prescribed a certain decorum. There was a rigid process of selection that

marginalized those who failed to match up in terms of acceptability. This was not based on social origins of course, but on the success or otherwise of a given person's efforts to transcend their background. Clara Bow found herself ostracized not because she grew up in a slum community but because she had dreadful manners and retained her Brooklyn accent. At a time when formal dress was de rigueur, she once turned up for a dinner at the Beverly Hills Hotel in a belted bathing suit.[37] By contrast, Crawford (who married Douglas Fairbanks junior in 1929) made a point of studying etiquette manuals. To cultivate a glamorous appearance, it was crucial to strike the right balance between old and new, and high and low. The absorption of elements drawn from the upper classes had to blend seamlessly with the modernity, good looks, and the commonplace characteristics of the star.

Although status anxiety was pronounced, several stars laboured under the illusion that Hollywood society was the *ne plus ultra* until they came face to face with the European nobility. One of Glynn's protégées, Gloria Swanson, was the most photographed woman in America in the 1920s, yet she was not at all worldly. The embodiment of what one commentator dubbed 'the shopgirl's dream of glamour', she travelled to Paris in 1924 to star in the first Franco-American co-production, *Madame sans Gêne*. Appearing in a Napoleonic-era drama and mixing in Parisian society provided her with her first encounter with art, culture, and history. From this, Swanson, who many years later would play a forgotten silent-era diva in Billy Wilder's *Sunset Boulevard*, drew the conclusion that 'The glamour of Hollywood illusion dimmed to nothing beside the real glamour of the European rich, whether they were heading for Ascot or driving through the Bois de Boulogne in a Hispano-Suiza'.[38] The elitist lifestyle appealed to her greatly and she embraced it with the enthusiasm of a novice, spending a fortune in the fashionable boutiques of Patou and Chanel. In true gold-digger fashion, she set about integrating herself in a more stable way. When she returned to Los Angeles after a two-year absence, having married a minor French nobleman in Paris she was feted on a grand scale like the new rich of an earlier generation. In fact, what she had seen was not glamour but rather the lifestyle of a wealthy hereditary elite. For the world, it was the stars of Hollywood who were the epitome of glamour.

The stars travelled far and wide; as ambassadors of the movie industry they were an invaluable marketing tool. When Pickford and Fairbanks undertook world tours in the early 1920s, they were mobbed wherever they went. Photographs of movie actors in stylish coats and furs, standing by trains, planes, and luxury automobiles, with quantities of leather luggage, convey something of the identification with modernity and mobility that they embodied. The audiences never saw their promotional tours as work. Like the upper classes, they seemed to live a magical, leisure-oriented *vie sans frontières*. A few stars with well-to-do backgrounds possessed enough taste and self-confidence to assert their own style. The producer Irving Thalberg's actress wife Norma Shearer was known for her understated allure. Although she put on the movie star look for parties and premieres, informal publicity shots show her as the epitome of casual style. Together with Thalberg, she provided a patrician image that was closer to East Coast elegance than Hollywood glitz.[39] Claudette Colbert also offered a well-bred, fashionable look that derived in part from her upbringing in Paris. The public appears to have been fascinated by stars like Constance Bennett and Katherine Hepburn whose very physiques expressed their upper-crust backgrounds. However, behind most of Hollywood's refined appearances were English aristocratic advisers like Glyn or Richard Gully, an illegitimate son of the second Viscount Selby, who was an important figure on the Hollywood social scene between the 1930s and the 1960s.[40]

Hollywood did not have much confidence in the early years in its own potential to create fashion. It copied European theatrical uses of costume and fashion for publicity and made ample recourse to Parisian haute couture. This appropriation, like that of French deco, was a transitional phase to a context in which Hollywood acquired the resources and know-how to assert itself as the primary source of glamour. However, collaborations with French fashion designers like Coco Chanel, who, at the behest of Samuel Goldwyn, worked on two MGM productions in the early 1930s, were not very successful. No resource was spared, but Chanel's pared-down approach did not translate well into the exaggerated idiom of film costume. Although Paris never ceased to be a reference point, the film companies found ways of their own to produce garments and accessories that were

effective on screen. The wardrobe departments of major studios were small factories employing hundreds of workers and it was the job of chief designers (Adrian at MGM, Travis Banton and Edith Head at Paramount, Orry-Kelly at Warner's) to provide costumes for the stars and to develop detailed wardrobe plots showing the sequence of ensembles a star was to wear in the scenes shot.[41] The designer had to conceal defects—often using special undergarments—and stress good points in order to create an illusion of physical perfection. Stars like Garbo, Dietrich, or Crawford could have as many as twenty costumes for a film, each requiring up to six fittings.[42] The costliest materials were used and clothes were designed cinematically, that is in an exaggerated manner and using textures, colours, and effects that would achieve the greatest impact on screen.

The moguls, several of whom had begun their working lives in the garment trade, attached great importance to costume. For millions of women film-goers, star personas were associated with fashion and there was intense interest in what new costumes actresses would wear in a film. Film publicity agents promoted the idea that every woman should draw inspiration from a star personality whose face, figure, or temperament broadly resembled her own. To assist the process, fashion and beauty advice ostensibly dispensed by stars appeared regularly in magazines and stores, and pattern companies made garments seen on film commercially available.[43] These of course were cheap adapted versions, for actual star looks were extremely costly and incorporated the fantastic as well as the realistic. Adrian added greatly to Garbo's allure with his elaborate work on *Queen Christina*, *Mata Hari*, and *Camille* and Travis Banton's exquisite costumes for Dietrich helped turn her into the orchid of Paramount. Stars like Joan Crawford, Kay Francis, Rosalind Russell, Constance Bennett, and a few others were little more than elegant clothes horses. Although she was Adrian's greatest challenge owing to her broad shoulders and imperfect figure, Crawford made fashion news when she wore a sensational ruffled gown in the 1932 success *Letty Lynton* which was widely copied.[44] In the late 1930s Adrian developed the wide-shouldered, narrow-hipped silhouette that became her fashion trademark. In a market in which there was as yet little interest in labels and brands, the stars were vital to the launch of new fashions.[45]

As fashion icons, stars exercised a new and highly important role. They introduced a marked element of fantasy that spoke directly to the dreams of the masses. Expensive materials, creative designs, original gowns, and furs, all of which had connotations of high society, European 'taste', and exclusiveness,[46] were now deployed to dazzle an audience. In essence, stars dressed to excite attention, their look was sumptuous and theatrical; 'Dietrich's things were more than fashion—they were superfashion,' Head once said.[47] They suited Dietrich's own definition of glamour as 'something indefinite, something inaccessible to normal women—an unreal paradise, desirable but basically out of reach'.[48] On account of their enormous following, the stars inevitably invaded the fashion magazines that had once been the preserve of the social elite. For example, Horst P. Horst photographed Dietrich and many others for *Vogue*. It was a measure of Hollywood's growing confidence and autonomy in this sphere that in the late 1930s designers like Orry-Kelly and Head were releasing their own retail collections. Although the European associations of fashion were never eliminated, the presentation was distinctively American.

The stars were often dressed in dramatic or unusual ways. Both Garbo and Dietrich cross-dressed and sought to confound conventional expectations of elegant clothing.[49] At a time when independent women still aroused curiosity, the androgynous aspects of these stars aroused widespread fears and aspirations. By contrast, Luise Rainer, who won an Oscar two years in a row in 1936 and 1937, completely rejected movie-star fashions in favour of simple beige dresses and shoes. Whatever form it took, the display of fashion became a key element of many movies as well as of the public images of stars and was sometimes incorporated formally as part of the overall spectacle. Many films either featured fashion shows or were little more than a sequence of episodes linking display set pieces. *Roberta*, *The Bride Walks Out*, *Artists and Models*, *Vogues of 1938*, and *Mannequin* all relied on fashion as spectacle and took advantage of the opportunities for luxurious display that the fashion show offered. Several of these films were musicals and the fashion parade blended with revue sets and musical performance.[50] These elements of film glamour drew on the carnivalesque traditions of popular theatre. They were playful and deliberately exaggerated, stimulating the imagination

by stressing the entertainment value of luxury and style.[51] It is this reliance on vaudeville that reveals the populism of Hollywood fashion. It was not on the whole deferential towards established style hierarchies or the class images associated with them. Haute couture was often parodied and demystified, its elitism and eccentricity becoming an object of mirth. In this way elite forms were appropriated and rendered accessible. Hollywood effected a major shift in the way fashion worked by creating a glamorous blend of high fashion, popular spectacle, and street style that was both theatrical and reproducible. Such was the impact of this blend that Paris itself was forced to take notice. In the 1930s designers took inspiration from costume dramas and Elsa Schiaparelli even based a whole collection on the 'Mae West look'.[52]

During the Depression years, the image of celebrity in popular magazines was domesticated and turned into an exaggerated version of the typical. This coincided with glamour's becoming became fully Americanized and democratized. Previously, there were those who had considered it to be a foreign import. In the 1930s it was standard in the United States to spell the word with a 'u', a usage that would return fully only in the 1990s. 'Why is the English form of "our" preserved in this word? The u could be left out without hurting the pronunciation, as in labor, honor etc.,' wrote one newspaper correspondent.[53]

More than anything else, it was the Depression that was directly responsible for the emergence of glamour as Hollywood's most marketable commodity.[54] At a time of widespread poverty and hardship, the masses lived vicariously through stars who knew that they were offering a fabulous escape from everyday worries. A special role in turning them into an image of a sexual and material heaven for poor and hungry people who needed a dream of perfection was played by the studio photographers. These professionals were past masters at making the stars into Hollywood icons. George Hurrell, Clarence Sinclair Bell, and others worked in studio photographic galleries and sometimes in their own studios. The stars who came to them, usually at the end of a long day of filming, were not always appreciative of their efforts. But their work appeared very widely, above all in fan magazines, and was crucial in making them into desirable images. In contrast to photographs of royalty or other important personages,

the shots of stars lingered on their physical perfection and communicated seductive appeal. Highly retouched, the stills revelled in artificiality; indeed precisely their abstract, constructed character made them 'consumable' by the viewer. The aim of the photographers was to create a mood through the use of light and props. They emphasized sensuous surfaces of skin and hair; dwelt on furs, silks, and satins; they alluded to sex by having actresses lie on rugs or wear loose gowns or a negligee. Hurrell found that some of his subjects had a natural aptitude for projecting themselves. Even when they entered a room, 'they had internal trumpets that blew for them just as the door [opened]'.[55]

The 'glamour look', in Hurrell's view, was quite simply a 'bedroom look'.[56] 'You know, glamour to me was nothing more than just an excuse for [taking] sexy pictures,' he told John Kobal. 'In other words, my interpretation was entirely one of saying "Come on, we're going to take some sexy pictures."' 'You can create glamour totally, I think. But a woman in our business generally has some quality of it,' he added. By this, he meant that they were often exhibitionists or professionally seductive. Another photographer, Paul Hesse agreed. It was important to capture 'that look', he claimed; without it 'you won't get much of a picture. The beautiful exterior is not what I am after. I want that inner person who speaks through her eyes.'[57] However, this quality was something that some at least were able to learn and to turn on at whim. Hesse's idea of a sexy and provocative face was Lana Turner's, but her full, parted lips and invitational eyes were composed in an instant. 'Lana is so busy that whenever I have photographed her I have had the feeling of catching a bird on a wing,' Hesse said.

On occasion still photographers like Hurrell and Sinclair Bull were engaged on the set to shoot close-ups, but there were some directors who had a great technical grasp of the camera's possibilties. First among these was Josef von Sternberg, the man who discovered Marlene Dietrich. The actress had earned just $5,000 for her debut film in Berlin *The Blue Angel*, while the film's star Emil Jannings had been paid $200,000.[58] But after its triumphant release, she eclipsed him. Her role in the 1930 film *Morocco* turned her into a Hollywood star. She was, by her own account, largely created as a screen persona by von Sternberg. Although his decorative style was often considered to be trashy and

kitsch, he found a way to illuminate her bone structure, emphasize her deep-set eyes, and achieve a halo effect that made her hair glisten. By bathing her in light, he created a moody, seductive effect.[59] 'In my case the face was *created*,' Dietrich affirmed, remarking that she became the vehicle of the director's aspiration to bring to life on the screen 'the dream of the little man'.[60] After they parted, following the making of the Spanish drama *The Devil is a Woman*—a title that was imposed on the director—von Sternberg looked back at what he had achieved with her and mischievously repeated, 'I am Marlene Dietrich'.[61] In her memoirs, the actress seemed to concur. 'Before von Sternberg took me in hand, I was utterly helpless. I was not even aware of the task awaiting me,' she wrote. 'I was a "nobody", and the mysterious energies of the creator breathed life into this nothingness. I'm not entitled to the least recognition for the roles I played in his films. I was nothing but pliable material on the infinitely rich palette of his ideas and imaginative faculties.'[62] Far from regarding such comments as flattering to his genius, von Sternberg responded with great irritation. He perceived that, by this means, Dietrich was seeking to highlight the tyrannical moulding to which she had been subjected and win the sympathy of audiences for her courage and capacity for survival.[63] Nevertheless, the actress learned a lot from her Pygmalion—according to Hurrell, she knew everything there was to know about photography and lighting—and developed a sharp sense of herself as a glamorous star. Off-screen, she exercised a high degree of control over her public image. As she put it, an actress is 'a woman who must always appear impeccable'.[64] 'I find all that pretty stupid,' she added. 'Of course, we're beautiful in the photos and also in life; but we were never as extraordinary as the image that was drawn of us. We clung to this image because the studio demanded that we do so. But none of us enjoyed it. To us, it was just a routine job and we just did it well.'[65] People only very rarely saw the discipline and sacrifices that the stars made in order to shine for the public.

One of the closest relationships that stars had was with studio publicity departments, which played a crucial part in building their careers and forging their images. Together with the advertising and 'exploitation' departments, these were vital institutions that employed at their height between sixty and one hundred people per studio.[66] As MGM publicity chief, Howard Strickling was responsible for constructing and maintaining star

images. In his accounts actresses did not drink or smoke, they did not even have babies; each of their usually many romances was made in heaven. They were presented and photographed only in the most ideal circumstances. Metro staff were instructed never to mention what stars earned, as quoting money placed commerce ahead of glamour. Moreover everything was puffed-up.[67] 'If you had a farm, it was an estate. If you had a field it was full of horses,' said Warner Brothers' Celeste Holm.[68] By these means, stars were turned into larger-than-life figures who everyone, including even the publicists themselves, believed were special.

The stars were commodities and the way they interacted with their fans was conditioned by the developing object world. Stars shone, glittered, and enchanted as they took on the personalization of novelty and the appearance of wealth. Because they were commercial and available, they spoke directly to the dreams and aspirations of the masses. Watching films in the dark on a big screen, people projected on to the protagonists their own interior lives and aspirations.[69] 'On the plane of daily emotions', Edgar Morin argued, the class struggle 'translated itself into new aspirations, new forms of individual participation'. Improvements in material conditions combined with new leisure practices to produce a situation in which workers and salaried employees 'join the spiritual civilisation of the bourgeoisie'. Alongside material demands, they made a new 'basic demand: the desire to live one's life, that is to say to live one's dreams and to dream one's life'.[70]

The movies were both product and spell and this latter aspect was underscored by the environments in which they were shown. First-run movie theatres were often situated in the immediate proximity of stores and a mutual dependency soon developed.[71] While stores advertised films and featured still pictures of stars in their window displays, films and related publicity directed the material desires of the public towards given products. For their part movie theatres offered opportunities for commercial enterprises to exhibit their goods. Through the 1920s and 1930s, picture palaces grew larger and ever more elaborate, taking styles from all manner of places and periods. Each contained an elegant, plush lobby area resembling that of a grand hotel, while uniformed staff attended customers and guided them to their seats. Only the inevitable queues for tickets undermined the sensation that film-goers were experiencing some luxuries once

reserved for the rich. The most famous movie theatre in the world was Grau-
man's Chinese Theater on Hollywood Boulevard in Los Angeles. Opened in 1927,
five years after the nearby Egyptian Theater, it was built to a Chinese-inspired
design and was decorated with authentic objects including pagodas and Fu dogs.
The theatre seated 1,500 and was the location of the Academy Awards ceremony
in the mid-1940s. Unlike many movie theatres of that period, it is still in regular
use and often hosts film premieres. It is famous as the site of the many hand
prints left in wet concrete by film stars dating back to Norma Talmadge and Tom
Mix. Grauman's was special but every large city in the Western world had its own
dream palaces, and even more modest establishments rejoiced in opulent-
sounding names like Roxy, Rialto, Rex, Alhambra, Palace, Majestic, Coronet,
Grand. Even in provincial towns, Moorish domes, marble columns, Oriental
decor, plush interiors, and American-style streamlining flourished.

The press was a crucial mediator between the studios and the public. It
provided information, explanations, and advice relating to readers' everyday
lives. The most influential fan magazine, *Photoplay*, treated Hollywood as a
dream capital, a place full of glamour, adventure, and excitement.[72] The
magazines promoted youth, beauty, love, and leisure rather than work,
family, routine duties, and limitations. This was first because they were
mainly read by young people, and young women in particular, but also to
provide a world of desire in contrast to the humdrum. 'The place to study
glamour today is the fan magazines,' wrote the author Margaret Thorp:

Fan magazines are distilled stimulants of the most exhilarating kind. Everything is
superlative, suprising, exciting . . . Nothing ever stands still, nothing ever rests, least of
all the sentences . . . Clothes of course are endlessly pictured and described usually with
marble fountains, private swimming pools or limousines in the background . . . Every
aspect of life, trivial and important, should be bathed in the purple glow of luxury. . . .
However thick the luxury in which a star is lapped, she takes care today to make it known
that she is really a person of simple wholesome tastes, submitting to elegance as part of
her job but escaping from it as often as possible. It soothes the fans to hear that luxury is
fundamentally a burden.[73]

Writing in 1939, she defined the principal characteristics of glamour as 'sex
appeal plus luxury plus elegance plus romance'. In the same year, Condé

Nast founded a new magazine: *Glamour of Hollywood*. The aim was to make available to ordinary women the knowledge about how to maximize the appeal and attractiveness that movie designers, costume departments, and make-up artists had developed for the stars. The magazine exploited the sex-and-style publicity power of the film industry and signalled this by publishing the picture of a film star on most covers.

The promise was that anyone could benefit from the application of the techniques of the glamour factory. Beauty had become more a product of modern science than a God-given endowment. 'Why do the glamour girls of Hollywood usually look like ordinary women when you run into them on the boulevard, while on the screen they are alluring, mysterious and beautiful?', asked the *Los Angeles Times*.[74] The answer was simple. At their service they have beauty specialists, hairdressers, dress designers, and photographers. To prove that any woman, given the same advantages, could become glamorous, the newspaper took a local typist of average appearance named Nina Peron and put her step by step through the process by which the studios created glamour. The final result, it claimed, put her on the same level as Norma Shearer, Garbo, and many other stars.

The impact of the movies on everyday life was far-reaching. By drawing attention to appearance, clothing, and self-presentation in general, they stressed the fact that maintaining a good appearance was an important part of the performance of daily life. Women in particular were encouraged to see parallels between the studios' struggle to maximize their stars' glamour value and popular appeal and their own efforts to make the best of themselves.[75] Cosmetics companies led by Max Factor highlighted the artifice of Hollywood make-up, celebrating the artificiality of the made-up face as proof of the democratization of beauty.[76] Although cosmetics were still widely regarded as not respectable, especially for young women, the years between 1909 and 1929 witnessed a doubling in the United States of perfume and cosmetics manufacturers and a tenfold increase in the volume of sales.[77] After the First World War, they became more widespread and entered the repertoire of middle- and working-class women.

Like mannequins, stars showed clothes, cosmetics, and other products to excellent effect. The movies helped people to dream and the apparatus of

consumerism assisted them in partially turning those dreams into lived experience. Commercial tie-ups were a central part of movie promotion; some involved national deals between studios and manufacturers over specific films, while others were left to the local initiative of exhibitors. However, some stars and some producers were uneasy about practices that undermined the element of mystery that was essential to glamour. Mary Pickford turned down a potentially lucrative advertising contract on the grounds that it would be undignified and risky to have her name 'bandied about in all sorts of good, bad, and indifferent commercial projects' and other top stars followed suit.[78] *Gone With the Wind* producer David O. Selznick even expressed reservations about the free endorsements that stars very regularly offered to Max Factor and which appeared in magazines throughout the world.

The magical transformative power of the glamour factory helped promote the clothing industry. The sale of women's apparel brought $1,205,000 to Los Angeles County in 1914, while by 1935 it was $28,104,000. 'It is the proximity of the movie stars which lends an enchantment to products from California,' reported the *Los Angeles Times*.[79] 'Hundreds of millions of women see Hollywood's motion pictures and all of them are subtly but gently persuaded into the ways of cinema glamour, into the art of wearing their hair down as it's more flattering to their faces, into the technique of adorning the figure in sleek, streamlined clothes because they set off to perfection the feminine form.' Bathing suits, made in Hollywood and photographed in Palm Springs, had a special allure. The extra push from a massive quantity of publicity 'emanating from the movie capital to cities all over the world...gives Los Angeles merchandise a colourful promotional quality to stores over America and other sister countries,' the paper commented, adding that 'the rest of the world wants Hollywood glamour and is willing to pay for it'.[80]

Throughout the world, young women were finding ways of integrating elements of Hollywood glamour into their everyday lives. Young men were often equally dazzled, but it was the 'movie-struck girl' who summed up the phenomenon of the fan. Unlike young men, girls took their cue not only from the movies but from numerous related magazines and advice manuals.

The author of one of these, the actress Sali Löbel, told her readers: 'Glamour is not the elusive pimpernel attainable only through the god of riches. . . . It is easy to obtain at least *some* of it, if not all of it, and half a loaf is better than none.'[81] 'It is unfortunate', she added, 'that the very word has such an expensively euphonious atmosphere. It must be the "Gl" at its commencement—those two consonants close together are sound-dangerous!' In her view, health, determination, hard work, and an ability to laugh and love were important elements of the glamorous personality, but so too was the power to dream. 'It is this aesthetic quality'—which could be stimulated by a few moments spent looking at a shop window—'which will create around you that atmosphere of beauty and glamour which is for ever green.'[82]

Such advice encountered a great deal of success because it keyed into real changes in aspirations. Young women in the interwar years wanted to live their lives differently from their mothers and, if education had failed them, this feeling derived enormous impetus from the cinema.[83] 'Via the high street or the sewing machine,' one British historian argues, 'the mantle of glamour passed from the aristocrat and courtesan to the shop, the office, or factory girl via the film star.'[84] The advantage of the American film stars was that they were unlike either women of the older generation or actual aristocrats. Far more than the courtesans of the nineteenth century, the glamorous screen heroine offered the fantasy that she was little more than the girl next door who was her fan. Although the abundant, elaborate femininity of the stars was unattainable for most British women, fans enjoyed the fantasy and were 'full of envy and admiration' for their looks and lifestyles.[85] Even in Fascist Italy, girls embraced commercial culture and its pleasures as a way of defining themselves as modern and asserting some independence not only with respect to their families but also to the regime.[86] Mussolini's followers loathed the made-up, fashionable look that they associated with Paris and Hollywood, but their efforts to suppress it proved ineffectual.[87] Shop girls, typists, students, and even factory workers found rare avenues of self-definition through the movies.

In the 1930s, glamour was ubiquitous. The phenomenon became so widespread that it was freely attached to the most diverse people and roles. Appearances suddenly counted for more than ever before. In the United

States, the phenomenon of the 'glamour boy' was widely noted. The top 'glamour boys' of course were the good-looking young men who appeared in the movies, but they could be found in a variety of service industries where a handsome and charming man was deemed a boon to business.[88] He was a recognized feature at soda fountains, at service stations, on the staff of estate agents, and even in politics. Always he was to be found in urban contexts. Because there was 'no glamour on the farm', young men were leaving the land in droves, it was claimed, with the result that the whole system of food production was at risk. 'What the farm needs today is some glamour,' the American House of Representatives Agriculture Committee was reported to have demanded in 1942.[89] However, even this unlikely field was not entirely devoid of the magical brush of glamour, at least so long as it was not too far from Los Angeles. The Guernsey cows to be shown at the western states breeders' cooperative show at the Los Angeles Union Stock Yards were dubbed 'Guernsey Glamour Girls' in the local press.[90] Root vegetables had for several years been considered ripe for glamorization and the Los Angeles Times cookery columnist advised readers that 'It's easy to put carrots in the glamour class when you use a can of cream of mushroom soup for the sauce'.[91]

Inevitably, such an overdose of glamour produced some negative reactions. The phenomenon that most distilled glamour was the 'glamour girl'. These were 'the most artificial creations of an artificial-loving business'.[92] Some, it was claimed, were 'little more than animated mannequins daydreaming through movies', store-window dummies whose individuality was entirely overridden by the professional grooming and image-making to which they had voluntarily submitted. 'Hollywood's de-natured dream girls are, of necessity, spiritually static, with no more "soul" than a geisha,' wrote B. R. Crisler in the New York Times.[93] 'With the make-up man constantly standing by to pat the perspiration from her face and with "wardrobe" dancing attendance to guard her gown (specially designed to minimize anatomical defects) from wrinkles, she is as far above the plane of mortal infirmities, and consequently is as uninteresting, psychologically, as a statue in a museum.' Glamour was a quality in which the whole of Hollywood was wrapped, but there were particular film genres, actors, and studios where it was present at a much higher pitch than elsewhere. When Universal

Studios tried to dub its wholesome teenage singing star Deanna Durbin 'glamorous' there were protests from those who disagreed. 'Glamour indeed! as if it had not been her very freedom from glamour, Hollywood style, that has endeared her to millions! Glamour! as if that word were more precious than the freshness, the gay vitality, the artful artlessness and the youthful radiance she has brought to the screen!' exclaimed Frank Nugent.[94] Praise was heaped on the actress Helen Hayes, who starred opposite Gary Cooper in the 1932 version of *Farewell to Arms*, since she was deemed 'a girl without glamour' because 'she has never needed any'.[95] Her talent alone was held to be sufficient box-office attraction.

By the mid 1930s, even independent producer Samuel Goldwyn claimed that the public was tired of glamour. 'Overdressing the movies is going to cease. The audiences are fed up with too luxuriant costumes and sets; they want what is simple,' he argued.[96] With the exception of musicals, where exaggeration and spectacle were obligatory, films needed to be closer to reality. Producers, he continued, should not 'thrust expensiveness into [the] face' of audiences by means of 'overdone backgrounds', 'too much flashiness in dress', and 'the made-up look of many of the stars'. The recognized expert on feminine beauty Cecil Beaton caused a stir when he announced that 'the glamour girl is as dead as mutton'. 'There is a swing back to naturalness,' he claimed, 'a girl today must show signs of being human and real—she must have a sense of humor and a spirit of camaraderie.'[97] In fact there was no real swing back, but there were some important shifts of emphasis. Although it was far from true that glamour was coming to an end, its production would never again be concentrated so powerfully in the hands of relatively few men. The Second World War produced a widespread demand for glamour and created new conditions for its becoming once more a phenomenon with a strong European inflection, albeit a phenomenon that the whole world by now identified as American.

PARIS, ROME, AND THE RIVIERA

W hen Christian Dior unveiled his debut couture collection in February 1947, he was aware that his opulent fabric-rich dresses and coats would cause a stir. By presenting garments that flouted the prevailing climate of post-war austerity, he made a statement that inevitably provoked a reaction. All the dresses belonging to the collection were long and were constructed using many metres of material. The most famous one consisted of a jacket nipped in at the waist that then opened over a wide pleated skirt. Immediately dubbed the 'New Look' by the American journalist Carmel Snow,[1] the collection was widely perceived as a bold rejection of economy and privation at a time when rationing and hardship were still widespread. Although Dior himself insisted that it was not revolutionary, his collection proclaimed the desirability of conspicuous extravagance.[2] Reactions, it would be fair to say, were mixed. Official opinion everywhere in Europe at this time favoured restraint and low consumption to help stabilize war-torn and debt-burdened economies. Moreover, those who had promoted the reforms that had brought women the vote for the first time in France and Italy were suspicious of the return of conventional elegance. In the United

States, women's organizations expressed strong disapproval of the return of long skirts. One British Member of Parliament, Mabel Ridealgh, pronounced the new look to be 'too reminiscent of the "caged bird" attitude' and urged women to reject attempts to curtail their freedom.[3] For the left, which was politically influential in the years after the war, it smacked of a restoration. When models were sent to Montmartre for a photographic session, where they were to display Dior's clothes against the backdrop of a street market, they were insulted, pelted with vegetables, and physically assaulted by class-conscious stallholders.[4]

The New Look quickly became a talking point throughout the world. As the most ready vehicle through which people could change their appearance and adopt a new persona, clothes occupied a special place in the hopes for material improvement that had blossomed amid the privations of the war years. Especially among women, many of whom had been drawn into the war effort, there was a strong desire for feminine garments that were not utilitarian. They had been deprived of cosmetics and fashion for too long for a collection like Dior's not to attract massive interest. The French fashion houses discovered the potential of fashion to capture the imagination when, in March 1945, before the war had ended in much of Europe, a reduced–scale fashion exhibition had opened at the Pavilion Marsan of the Louvre. Keen to show that they were still in existence, the houses had presented their latest designs in miniature on specially made artistic dolls. The exhibition was an unexpected triumph. It was not only visited by industry insiders, clients, and well-wishers, but by tens of thousands of ordinary men and women. Within a few weeks, over 100,000 people had visited it.[5]

Dior did not seek popular appeal, yet within weeks of its presentation, the New Look was seen widely on the streets of Paris. Although the designer had mainly been concerned to attract an established clientele of elegant women,[6] his idea was widely imitated, albeit without the complex and elegant construction that marked the original. For the first time haute couture had an impact on the mass imagination. Only in fiction could a Battersea cleaning woman like Paul Gallico's character Mrs Harris not only crave beauty and colour but actually save up and go to Paris to fulfil a lifelong ambition to buy a Dior dress.[7] However, thanks to the presence in many households of a

sewing machine, imagination could be turned surprisingly quickly into reality. Billowing skirts, narrow shoulders, and curves suddenly abounded. 'It was as if all [women] had ever dreamed of, no matter what their social standing, was to play the femme fatale or the grand lady,' remarks Marie-France Pochna.[8] Dior's backer, textile manufacturer Marcel Boussac, was keenly aware of the knock-on effects that the designer's innovative styles would have at all levels of the industry. Not by chance is he said to have encouraged Dior to put even more fabric into his skirts, knowing that this would stimulate ordinary women to think more about appearances and want to buy more clothes.[9] Even in Britain, where the fiscal policies of austerity chancellor Sir Stafford Cripps kept taxes high and reduced surplus spending to a minimum, the ready-to-wear industry quickly latched on to the demand. Shorn of Parisian extravagance and modified to meet the needs of working women who travelled on buses and the Underground, the new look became an expression of the democratic luxury of the post-war years.[10]

The success of the collection re-established the pre-eminence of Paris in matters of fashion. Given the disruptions of the war years, this was by no means a foregone conclusion. It also turned Dior into a fashion authority with more influence even than Charles Frederick Worth a century previously. Until his untimely death in 1957, Dior had an unrivalled ability to determine what women wore and what they desired. He was seen as a dictator of hemlines who could, apparently by whim, fix the precise length of the skirts that the women of the world would wear in a given year. Because he sanctioned the return of wealthy ostentation, some saw in his influence evidence of a broader social restoration. Following years of mass privation and what Dior called 'the coarse feasts' of black marketeers,[11] the rich gradually re-emerged and displayed their stylish cars and huge yachts at resorts, regattas, polo matches, and race meetings. The Paris season re-established traditional elegance and the balls of the aristocracy provided old and new rich alike with opportunities to dress up and show off.[12] Dior's special prominence meant that his showroom was taken by storm as hordes of wealthy French women demanded fittings. American and British socialites also converged on Paris.

One of the great novelties of the post-war years was the presence in Europe of large numbers of wealthy Americans. Dior was not slow to appreciate that the

prestige of Paris fashion depended on a close relationship with the American market. He curried favour with American buyers and with the press (a *Life* article about him prior to the unveiling of the New Look was a crucial factor in its success). He struck deals with leading American stores and even licensed name brand stockings which were manufactured directly in the United States. Subsequently, he established a branch of his house in New York and designed separate, simplified collections for the wider American market.[13] He also developed a series of deals whereby manufacturers and retailers could sell an 'original Christian Dior copy' and clothes made from paper patterns licensed by Dior.[14] While the Americans were most advanced in understanding how fashion could be sold to a broader public, the wartime streamlining of the ready-to-wear industry in France meant that Parisian couture was not a separate sphere but the prestigious tip of a whole system of production. As a result, high fashion styles, which were always highly publicized and featured heavily in the press, had an influence on the entire market. While houses were always concerned about pirated versions of their creations, their models were legitimately disseminated through official copies, approved modifications, sketches, and patterns. Dior also lent his name to a fragrance and a variety of accessories.

Hollywood stars were crucial to Dior's success and they were among his most notable clients, with Olivia de Havilland buying a 'Passe-Partout' suit priced at 30,000 francs and Rita Hayworth opting for an evening gown with two tiers of blue taffeta pleats to wear to the premiere of the movie *Gilda*. Margot Fonteyn chose a suit, while Marlene Dietrich and Ava Gardner also placed orders. Their patronage brought Paris fashion to the attention of Americans of all classes and added to its desirability. British theatrical couple Vivien Leigh and Laurence Olivier viewed Dior's 1947 collection at his house's headquarters in the Rue de la Paix and were struck by the number of American accents they heard among the customers.[15] In bridging the gap between the once-closed world of haute couture and the dreams of the masses, the stars played a critical role. Figures of glamour par excellence, they were aware of the importance of fashion to their image. By embracing the New Look, they brought it within the realm of the desires of ordinary women. Elegance no longer seemed like a source of distinction but rather a realistic aspiration for people in all social classes.

Hollywood stars enjoyed great cachet in a post-war Europe that had seen several monarchies toppled and the aristocracy lose influence. Their arrival in significant numbers was greeted with massive public curiosity. Dreams had been woven around them before the war and now they seemed, by their presence in Europe, to be holding out a promise of prosperity for all. They brought a practical demonstration of wealth and style that was more appealing and democratic than that offered by local elites.

Although female stars were usually the focus of most interest, it was a male actor who was one of the first to spend time in Europe. Tyrone Power was a leading heart-throb of the silver screen and the star of the hugely successful bull-fighting drama *Blood and Sand*. A dark-haired man of charm and fine features, he was mobbed wherever he went. The announcement that he would marry in Rome in January 1949 mobilized newsreel companies, photographers, and the press of two continents. For months they talked of the forthcoming 'wedding of the century'. The event was a great attraction but there was also a political aspect to it. Rome was the centre of the Catholic Church and a capital that, after the left-leaning coalitions of the immediate post-war years, now had a centrist pro-Western government. Since Italy no longer had a monarchy, the marriage of a Hollywood star was the nearest it was likely to get to a royal wedding. As such, it was a quasi-high society matter. However, in contrast to royal rituals, the entire event was conceived and staged for public consumption. Power was at the height of his fame and an enormously popular figure in Italy, which he had visited several times. His bride was a European-educated American starlet named Linda Christian whom he had fallen for when she asked him for his autograph in Rome's Hotel Excelsior. At that time, Power was still married to the French actress Annabella, whom he had married in 1939 in a civil ceremony. On the assumption that divorce would be straightforward, the couple were soon planning their nuptials. The preparations were highly publicized, and Christian's visits to the Fontana sisters' fashion house for her dress received ample magazine coverage. She also appeared on the cover of magazines in the company of Italy's Christian Democrat prime minister, Alcide De Gasperi. Cameras filmed Power's six stag nights and the hen night of his bride.

Newspaper accounts of the wedding spoke of the huge crowd which filled the pavements along the Via dei Fori Imperiali, from the Piazza Venezia to

the Colosseum. It was bigger than any of those mustered by Italy's large Communist Party and its leader Palmiro Togliatti. 'For once the crowd did not gather to protest and the police did not have to protect ministries or politicians,' wrote one journalist.[16] He observed that he could not remember seeing a gathering of similar size in Rome since before the war—'it had what might be termed an "oceanic" character. One could say that Tyrone Power has beaten Togliatti.' The crowd was composed of 'gossiping girls and mop-headed adolescents', 'hundreds of youth who wear their hair like Power and who gesticulate and walk in a manner copied from his films. . . . hundreds of girls who had bunked school or slipped out of offices . . . elderly ladies, women of the people, and old folk, modern girls, hysterical widows, and young dandies covered in brillantine right down to their toe-nails', 'groups of young girls carrying books under their arms', 'smart young guys wearing sky blue ties, striped nylon socks, scruffy hair and suede moccasins', and 'distinguished ladies in furs'.[17] It was a lively gathering which 'hundreds of Carabinieri, policemen, and police on horseback struggled to keep in check'. Comments and appreciations were shouted, especially by 'youths with grease-backed hair' at the arrival of Linda Christian, although cries of 'Come on Tyro' were heard from the girls. But it was also a gathering that had its commercial side. While many of the young people present had clearly abandoned the classroom in order to attend, others had merely taken time out from shopping ('the halls of the big stores were rather empty yesterday morning, like during the flu epidemic', wrote one daily).[18] Newsvendors waved copies of a one-off paper bearing the enormous headline 'Ty e Linda sposi' (Ty and Linda Are Married) while tradesmen sold coloured balloons, almond bars, and other confectionery.

The wedding itself was an event conceived and executed as one to be consumed by a mass, worldwide audience. Italian and foreign broadcasting companies won unprecedented permission for radio equipment to be in-stalled in the church of Santa Francesca Romana and photographers took shots during the ceremony; the films were then rushed by motorcycle to the central telegraph office from where they were wired to newspapers around the globe. Indiscreet photographers emerged from bushes and hedges around the church as soon as the couple appeared and made towards a

waiting limousine. Christian later recounted that she and Tyrone 'pushed slowly forward through the almost impenetrable mass around us. Smiling, cheering faces pressed against the car windows. People jumped on the moving car—on the front and back, even on the roof—and it rocked under their weight.... When we arrived we discovered a torn coat-sleeve caught on one of the door handles.'[19]

For many Italian commentators the jamboree was reminiscent of an American B-film, vulgar and commercial, and marked by unseemly enthusiasm. The fact that Power's divorce from Annabella only became legally effective hours after the ceremony added to these feelings. The event was described by Rome daily *Il Messaggero* as 'more picturesque than a technicolor film'.[20] The 'wedding of the century' was seen as a modern fairy tale, particularly by older women and young girls. The romance and marriage of the handsome actor and his beautiful starlet bride was a distraction from prevailing problems. That the dream was an eminently material one was evident, however, in the extraordinary publicity machine that surrounded it. The wedding was a mock high society event attended by a mixed bag of publicity-hungry aristocrats and celebrities that provided newspapers and magazines with glamorous copy. Special attention was reserved for Christian's dress, which was described in minute detail; according to one newspaper, 'pearls were distributed like constellations along the Milky Way of the silver embroidery; here and there, golden touches highlighted the embroidery'.[21] The wedding offered Romans a rare chance to see Hollywood aristocracy with their own eyes. Although the crowd soon broke up, leaving the road and pavements clear once more, it was a significant, if temporary, public coming-together of film fans, magazine readers, shoppers, and cultivators of celebrity.

After the war and the disruption it brought, the stars were very prominent. They were untainted by any connection with recently fallen regimes and they were alluring. Of course, they were not perfect, and several of them made controversial choices in their personal lives. Yet the desire for modern fairy tales was so strong that sometimes it even eclipsed the scandal that surrounded any illicit liaison. One of the most shocking scandals of the period involved Rita Hayworth, who began an affair with Prince Aly Khan while she was separated, but not yet divorced, from the

actor-director Orson Welles. Her adultery provoked outrage throughout the Western world.[22] Khan was heir to the Aga Khan's throne of gold as well as a legendary playboy, of whom the social organizer Elsa Maxwell said that his 'animal magnetism...shaped his celebrity'.[23] For her part, Hayworth had become one of the top Hollywood stars during the war years and had also been a popular wartime pin-up. In some ways she was the epitome of the studio-manufactured star. Originally a dancer of Mexican origin named Margarita Cansino, she had been physically transformed by Columbia Studios into the ideal all-American girl. The star of wartime Technicolor extravaganzas including the musical *Cover Girl* and *Blood and Sand*, in which she was Power's co-star, she had consolidated her popularity throughout the world with *Gilda*, which upped the erotic content of Hollywood-style sex appeal. A beauty whose signature features were her legs, smile, and luxuriant auburn hair, she was seen abroad virtually as the embodiment of the United States. Her likeness was even placed on the first nuclear bomb to be tested after the Second World War, which was dropped by the Americans on the Atoll Bikini in the Marshall Islands in 1946. This fact earned Hayworth the enmity of Europe's Communists, who were already suspicious of American foreign policy intentions. But even some left-wing activists could not resist the fabulous allure of Gilda, as French film director Vera Belmont would reveal several decades later in her screen evocation of her Communist adolescence, *Rouge baiser* (1985).

When Hayworth and Prince Aly announced their intention to wed, she was redeemed. Her period of disgrace ended and she was recuperated and repackaged for the public as a Cinderella princess. Before they came together, the two couple's two worlds had been largely separate. For Hayworth, Khan was a virile and charming man who also had the allure of royalty. For him, the actress was a completely novel prospect, a trophy movie star, who provided an introduction into 'an unexplored sphere of glamour'.[24] The couple had sought privacy, but their notoriety precluded that. Despite its remote location, the civil ceremony at the town hall of Villauris on the Côte d'Azur was anything but low-key. Much to the chagrin of the bride and groom, the Communist mayor of the village refused to conduct the ceremony behind closed doors and ordered that they be literally thrown open to 'let the

peasants in'.[25] The ceremony became a media event with reporters and photographers struggling to see and speak to the bride and groom. The next day a further ceremony took place according to the rite of the Shia Ismaili branch of Islam, of which the Aga Khan was the hereditary leader. This was followed by what had been called 'one of the biggest, gaudiest wedding receptions ever held on the Riviera'.[26] Hayworth had invited over five hundred guests, among them representatives of every major American and European press organization. These managed to consume six hundred bottles of champagne and fifty pounds of caviar as well as other delicacies. Aly Khan, who was not unused to publicity, seems to have been dazed by the whole experience. In his memoirs, he recollected, 'This was a fantastic semi-royal, semi-Hollywood affair; my wife and I played our part in the ceremony, much as we disapproved of the atmosphere with which it was surrounded.'[27]

The enthusiasm and interest that surrounded these celebrity weddings revealed that, despite the prevailing austerity, people clamoured for glamour and spectacle. They also showed a strong attachment to the institution of marriage after the wartime disruption to family life and sexual mores. Governments, like Britain's avowedly egalitarian Labour administration, had little idea how to respond to this. The Attlee government was more concerned with social justice and the collective project of economic recovery than it was with the aspirations of individuals. The way it dealt with popular demand for a tonic and a signal that a better future reflected this. Held in 1951 on the South Bank of the Thames, near Waterloo station, and in smaller versions around the country, the Festival of Britain carried the mark of the age of the welfare state, the commitment to planning and paternalism. The Conservative administration which succeeded Labour was not enthusiastic about the festival and instead decided to make the monarchy the focus of patriotism and spectacle.

The royal family enjoyed great popularity after the war and much attention was focused on the young Princess Elizabeth, whose marriage to Philip Mountbatten in 1947 was a great public event that attracted massive press coverage.[28] When the health of her father, King George VI, began to fail four years later, she stood in for him on several public occasions. After he died, in February 1952, *Time* magazine selected the 27-year-old English princess as

the world personality who most embodied the hope of the times. She captured on an international scale, the magazine asserted, the mysterious power of ancient monarchs 'to represent, express and effect the aspirations of the collective subconscious'.[29] In fact, the era had seen the overthrow of more than one monarchy and it was the youth and beauty of Elizabeth that appealed most.

The coronation on 2 June 1953 was a grand affair in which pomp and established ritual combined with modern techniques of mass communication. Despite the continuing atmosphere of austerity, the celebration created a new sense of enthusiasm and optimism. Faultlessly planned and executed as a ceremonial ritual by the Duke of Norfolk in his capacity as the Earl Marshal, the coronation was both a national communion and an injection of lavish display into the dingy world of post-war Britain. Hundreds of thousands of people took to the streets of London to glimpse the procession. Many more took part in street parties up and down the land. International interest was high and the Queen's diamond tiara, sash, and Garter star captured wide attention. The first significant public event to be televised, it was viewed by some twenty million people in the United Kingdom and many more abroad. Only the sacred moment of the anointment was concealed from the cameras. The merchandising of the ceremonial was extensive. Mugs, plates, flags, booklets, special newspaper editions, magazines, badges abounded while street parties and church services turned the event into a community celebration. A lavish Technicolor documentary film of the day, narrated by Sir Laurence Olivier, was released in record time to capitalize on the enormous interest the coronation aroused. For royal biographer Robert Lacey, 'the house records which the film *A Queen is Crowned* broke in New York, Boston and Detroit confirmed the global glamour Elizabeth II possessed'.[30]

The success of the event showed that colour and spectacle did not necessarily have to be surrounded by the disorderly hullabaloo that often accompanied the stars. On the contrary, the lavish spectacle of the coronation and images of a happy young queen elevated the monarch to the status of star of stars. At a time when Britain's influence in the world was fast declining, she provided glittering proof that there was nothing more dazzling than a queen. To foreigners, the British royals possessed considerable

appeal as celebrities. Magazines like *Paris-Match* in France, *Stern* in Germany, and *Oggi* and *Epoca* in Italy, all of which imitated the highly visual recipe of the American illustrated weekly *Life*, mixed the Windsors into an upbeat diet of leisure and consumption, liberally sprinkled with personalities, gossip, and images of faraway places.[31] Even in Britain newspaper and magazine editors created a soap opera around the royal family and elected the Queen as its star.[32] They regarded the Queen and the royal family as the sole element of hereditary power to be worthy of intense media coverage. For one social historian, 'the monarch was processed into a super personality in whom . . . the audience naturally possessed proprietary rights'.[33] As a newsworthy phenomenon, the monarchy underwent a change that the Queen's consort, Prince Philip, later acknowledged. 'I think the thing, the Monarchy, is part of the kind of fabric of the country. And as the fabric alters, so the Monarchy and its people's relation to it alters,' he reflected.[34] By the late 1960s, he felt, 'I would have thought we were entering probably the least interesting period of the kind of glamorous existence,' whereas fifteen to twenty years earlier 'young people, a young Queen, and a young family [were] infinitely more newsworthy and amusing'.

Royalty encouraged and collaborated in the processes that turned them into star-like figures. In various concealed ways, members of the royal family benefited from the techniques of Hollywood glamour. They were often photographed, for example, by photographers like Cecil Beaton and Dorothy Wilding who had refined their craft on the stars and who knew how to create flattering likenesses, also with the aid of props and retouching techniques.[35] The Queen's official dress designer Hardy Amies confessed that he sometimes drew inspiration from cinema and that one royal gown was modelled on one of Marlene Dietrich's outfits.[36] Yet there was still a significant difference between even an attractive young queen and a film star, whose great appeal lay, first, in being of the people and, second, in being groomed and presented solely for public consumption. In 1957 the author Martin Green argued that one distinction between royal and Hollywood glamour was that the former 'remains essentially well-bred and, as it were, unconscious of the public, so that the latter gets a rather snubby lesson in good behaviour as well as the thrill it came for'.[37] The respectful, not to say

submissive, attitude that persisted at least among the British press testified to the continuing prerogatives of the monarchy within a traditional power structure and to the limited nature of pageantry as necessary concession. The hereditary nature of monarchy contrasted with the availability and imitable qualities of the stars. Moreover, even the young and better than averagely good-looking Queen Elizabeth and Prince Philip were deprived of sex appeal by their utter respectability,[38] which had been grasped as a core part of royalty's pact with the nation after the abdication crisis of 1937.

Within a flamboyant ceremonial like the coronation, royal conduct was marked by an element of restraint and inhibition. This expressed a detachment from a public composed not only of spectators but also of subjects from whom deference was expected. The Queen's own view of her role was infused with mysticism.[39] She had prepared for the occasion not by receiving coaching in public relations but by undertaking daily readings from the Scriptures and meditations prepared for her by the Archbishop of Canterbury. In his account of the coronation, the fashion designer Norman Hartnell, who created the coronation dress, stressed the magnificence of the procession, which, he wrote, was 'as though a jewel box has become unloosed and the precious jewels of myriad colours spill upon the velvet floor'.[40] Evoking the fabulous costumes of foreign guests, he described 'an Eastern Imperial Highness [who] gleams in silver and violet tissue, with strange feathers curling from a headgear of purple and amethyst' while 'peacock glory' was offered by another prince, who was adorned with 'brocade of lapis and malachite and ornaments of sapphire and emerald'. However, his tone was far more measured when he referred to the Queen. 'A slight and gentle figure, graceful in her glistering gown, her hands clasped and her eyes cast down,' she advanced 'in beauty and solemnity, most slowly... to her great and lonely station.'[41]

The great and the good of the aristocracy were present in large numbers at the coronation but they counted for even less. The milieu the Queen mixed in seemed to magazine readers to be one largely populated by political figures and celebrities. One of the most notable events in the royal calendar from this point of view was the annual Royal Film Performance. This institution had a long history dating back to 1896. Up until 1948, it was known as the Royal Command

Film Performance. The removal of the imperious 'Command' from the title marked the more democratic atmosphere of the post-war years. Nonetheless, it was clear for whom the event was supposed to be an honour. The arrival of the royal couple was greeted with the national anthem and, at the conclusion of the screening, world-renowned actors lined up to receive the privilege of being presented to Their Royal Highnesses. The Queen, in short, was special and different. The place of movie glamour in the official British scheme of things was decidedly secondary.

Royalty was not so much unglamorous as more than glamorous; precisely because it was something even more magnificent, it exercised a huge appeal. The coronation was widely seen as having consecrated the success of the medium of television not only in Britain but in several continental European countries. The extraordinary interest that had built up around the British monarchy was something that the commercial fabricators of glamour could not ignore. In particular, Hollywood cinema saw in the allure of royalty a repertoire of suggestive associations that could be appropriated or reproduced. After the fall of several monarchies in the aftermath of the First World War, more countries, including Italy, Romania, Bulgaria, and Hungary, and slightly later Egypt, became republics, while others reduced their royal families to the level of state functionaries. This created a gap that the dream merchants were not slow to exploit. At a time when the major film studios, for political and economic reasons, were beginning systematically to make movies on location in Europe, regal elements provided a way of reconfiguring glamour as a blend of upmarket themes. From the American point of view, royalty was a phenomenon of the European past that only made sense when conceived through the prism of glamour. This cultural project fitted very well with the United States' broader aim to remodel West European economies and promote consumerism. The partial absorption of the British royals into a celebrity culture suggested that there was a market for more accessible versions of the royal mystique. Spectacle, beauty, theatricality, and publicity were best organized by the movie studios on a professional basis rather than being left to institutions inherited from the past.

The film that first harnessed the allure of royalty to the practical dreams of the movies was the Paramount light comedy *Roman Holiday*, starring

Gregory Peck and, in her American debut, Audrey Hepburn.[42] Released in the USA in September 1953, the film was an utterly charming story of a princess who briefly escapes from her royal duties while on an official trip to Rome and enjoys a series of incognito pleasures in the company of an American journalist. Hepburn was a completely new type of star. Slender and waif-like, she had the physique of a ballet dancer and the elegance of a fashion model. *Roman Holiday* offered up to film-goers a new and entirely plausible princess figure who, as chance would have it, was descended on her mother's side from the Dutch aristocracy. The film absorbed the public's fascination with monarchy, presenting the female lead as a contemporary version of royalty, and proposed the filmic spectacle itself in the place of rare, time-honoured ritual.[43] By implication, the film declared that from now on it was Hollywood's role to identify and present the new European royalty and to carry out the largely symbolic duties of monarchy. Its task was to transcend national boundaries, create a common cultural currency, and help to imagine and to bring about a future Europe that was peaceful and integrated.[44] The film benefited from an unexpected tie-in when, immediately prior to its release, a scandal exploded over the relationship of England's Princess Margaret with a divorced man, Group Captain Peter Townsend. Both the real and the fictional princess renounced love for duty and appeared to be condemned to sadness.

European cinema did not allow Hollywood a free run in the field of imagined royalty. But it made more use of history to capture the attention of its audience. An actress whose screen persona was endowed with royal elements from the start was Romy Schneider, the Viennese daughter of actors who made her screen debut at the age of 15 in 1953. In a trilogy of lavish German-made colour films about the early years of the beautiful Empress Elizabeth of Austria, which employed the empress's familiar name Sissi in their titles, she provided a charming and nostalgic picture of nineteenth-century Austrian court society. Released between 1955 and 1957,[45] the movies were huge hits with audiences across Western Europe. In consequence a significant fusion occurred between Schneider and Sissi, with the actress being referred to in the German press as 'our "Sissi"' and the 'Crown Princess of German Cinema'.[46] It was assumed that the virginal and

girlish qualities attributed to Sissi in the romantic portrait of the films were also attributes of the young actress.

Unusually for an American star, albeit of Dutch–British origins, Hepburn cultivated her own image on screen. By rejecting studio costumes for haute couture, she established herself as a fusion of European and American allure. From the Billy Wilder film *Sabrina*, yet another modern Cinderella tale which was released in the USA a year after *Roman Holiday*, she insisted that her costumes for every contemporary film be designed by the couturier Hubert de Givenchy.[47] As Sabrina, a gardener's daughter who is transformed into a sophisticated young woman by her stay in Paris, Hepburn confirmed her status as an icon of taste and dignity. This began with the scene in *Sabrina* when she makes her appearance in her father's employers' house for her first dance with the debonair playboy David Larrabee, played by William Holden. 'Her dress is sumptuous, her movements aristocratic, her essence fragile. This image was to reverberate like a drum roll,' one commentator noted.[48] Not by accident, some of her most successful films were made with Cary Grant, another actor who personally fostered a highly polished, groomed image that appeared to blend with his personality.[49] More than any other actress, she proved that it was possible simultaneously to be a major star and a fashion leader. It was she who enhanced the clothes she wore rather than vice versa.

In an age when fashion was central to dreams of self-improvement, female fans liked their favourites to be elegant. Following her marriage to Aly Khan, Hayworth became a familiar figure on the European scene. She was often spotted at the racecourses where her husband's thoroughbreds were a prominent fixture, and at fashionable nightclubs. She was also a regular visitor to Paris fashion houses, although, according to the model Bettina, who saw her view the creations of designer Jacques Fath, she was generally bored and irritable on such occasions.[50] Typically, it was the sophisticated Khan who chose the dresses for her. Like many playboys, he had a great knowledge of women's fashions and prided himself on his taste. The refined image that Hayworth acquired enhanced her appeal to fans like Renée Arter, a British film-goer, who years later wrote: 'Although I wished to look like a different star each week depending on what film I saw, I think my favourite was

Rita Hayworth, I always imagined if I could look like her I could toss my red hair into the wind . . . and meet the man of my dreams.'[51] Other stars followed in her wake. Like Hayworth, Ava Gardner came from a very humble background, in her case in North Carolina. A sultry, dark-haired actress who was regarded as one of the world's most beautiful women, she developed an interest in couture clothes while she was filming *The Barefoot Contessa* in Rome. The film told the story of a poor Cinderella who rose to be a star and a countess. It seemed to have been based on a mixture of her own and Hayworth's life stories. During the shoot, Gardner, who at the time was still married to Frank Sinatra, forged a collaboration with the Fontana sisters, who had made Linda Christian's wedding dress. Thanks to Gardner's patronage, the house achieved unprecedented visibility and its creations became the envy of women throughout the world. Few of the couturiers of the post-war years were society figures. Dior was a private man who knew publicity was important but did not enjoy it. Several of his colleagues were remote figures. Only Jacques Fath, whose matinée idol good looks and showy personality made him the darling of the magazines until his untimely death in 1954, followed Jean Patou in mixing with the famous and living ostentatiously.

In a continent that was ravaged by the experiences of dictatorship, war, and foreign occupation, and in which economic hardship and political unrest persisted well into the 1950s, the stars of Hollywood were an ideal and an inspiration. They offered a spectacle of luxury and glamour that was associated with the glamorous impression of America itself as the land of prosperity, sex appeal, and excitement. For the public, the stars were enviable role models who appeared to be living the dreams of millions. They served as a focus not of deference or resentment but of imitation and aspiration. The formation of a new, more attractive, and more public aristocracy of beauty and talent created new centres of prestige and exclusivity, new rituals which drew in younger traditional aristocrats, creating a new more visible, open hierarchy of status that was style imbued with elements of heritage. The old scenarios and palaces continued to serve a role, but mainly as backdrops to an elite that was more open and accessible.

The stars seemed to be independent and free; only one or two voices queried the nature of their position. Simone de Beauvoir, the feminist

author of *The Second Sex*, a book which had a wide impact following its publication in 1949, saw Hayworth as a totally dependent figure who, even after she had left her film career, required the constant support of a man 'for her weapons are magical and magic is capricious'.[52] She owed her fame to her face and figure and these were not her property so much as that of Columbia Pictures, which had moulded and polished them for public presentation. Even where they were not tied firmly to a studio, female stars often remained the protégées of a given producer or director. 'The industrialist or producer who offers pearls and furs to his friend affirms through her his fortune and power,' de Beauvoir asserted; 'whether the woman is a means for earning money or a pretext for spending it is immaterial; the servitude is the same. The gifts with which she is weighed down are her chains.'[53] De Beauvoir viewed the female star as a new version of the courtesan adapted to the age of publicity and the mass media. In a context in which the *demi-monde* had become the *monde*, 'the latest incarnation of the *haetera* is the star', she observed. Like the prostitute or courtesan of the past, the star was the modern embodiment of a type of fantasy female that men adored and to which they offered fortune and glory.

By claiming that the *demi-monde* had become the *monde*, de Beauvoir meant that, in the era of mass civilization and publicity, stars had taken over from the established elite in what was dubbed 'the monkey cage of Society'.[54] No longer economically or politically powerful, aristocrats were fast losing their residual social pre-eminence. The historian David Cannadine argues that they were 'inadequately glittering in the age of Hollywood film stars... their bright day was done'.[55] In the United States, Britain, and France, the post-war years witnessed significant changes in high society rituals and practices. In Britain the period saw 'the almost total disintegration of patrician high society', while in the United States the world of celebrity eclipsed café society the way this had, in the 1920s, displaced the old elite.[56] In New York, the social commentator Cleveland Amory noted the rise of 'Publi-ciety'. This, he wrote, was 'a combination of publicity and what people used to think of, in happier days, as Society.... [It] is the actual ogre under which, whether we like it or not, we all live today. It is a world in which the arbiter is the gossip columnist or, outside of the gossip areas, the

Society columnist. He or she alone, decides who, socially speaking, is who.'[57] In the old days, the high society fixer Elsa Maxwell observed, 'the "old guard" stuck together, saw only each other, talked only about each other. They were the "right people" and they knew it. They were thoroughly satisfied with themselves and the *status quo.* ... Today all that has changed. Society is mobile, flexible, changing.'[58] It was now common for members of the upper class to work and for debutantes to do things other than wait for a marriage proposal. Social climbers were less concerned to win the accept- ance of the socially prominent than to get their name in the papers. 'It's my firm belief that today, everybody—or nearly everybody—dreams of a star- ring role in the celebrity circus,' Maxwell argued; 'deep down in some secret heart, almost everyone wants to make the headlines.'[59]

The merger of Old World tradition and New World glamour was an irresistible combination. It was one that was constantly evoked in movies, including Grace Kelly's last film, *The Swan*, that eerily foreshadowed her future romance and marriage. Directed by Charles Vidor, the film told the story of a prince, played by Alec Guinness, who is combing Europe in search of a bride. When he is on the point of giving up, he falls for Kelly's Princess Alexandra, leading to a fairy-tale wedding. Kelly was a star whose subtle sex appeal was evident just beneath the surface of her icy exterior.[60] With her fair hair, porcelain complexion, and poise, she had the bearing and appearance of an East Coast debutante. When he first met her, the director Fred Zinne- man 'was astonished and delighted by her demure appearance'. 'She was', he said, 'the first actress I ever interviewed who wore white gloves.'[61] She was of monied Irish stock from Philadelphia and had played socialites in hugely popular films including the musical *High Society* and the Riviera adventure *To Catch A Thief*, for which Edith Head pulled out all the stops to make the actress's costumes among the most elegant ever seen on screen. This image served to mask the director Hitchcock's overtly sexual presentation of the actress in the film. So refined and poised was she that, when her engagement was announced to Prince Rainier of Monaco, it was widely believed in America that she was marrying beneath her. To those Americans who had heard of Monaco, it was a fading resort city best-known for its financial scandals. 'He's Not Good Enough For a Kelly,' headlined the *Chicago*

Tribune, in reference to Prince Rainier, adding boldly: 'She is too well bred a girl to marry the silent partner in a gambling parlour.'[62] It was public knowledge that the controversial Greek shipping magnate Aristotle Onassis had bought a controlling share in the Société des Bains de Mer which owned Monaco's casino, leading hotel, and various other facilities.

The marriage of Grace Kelly and Prince Rainier in April 1956 constituted the acme of the process of appropriation that began with *Roman Holiday*. Although, as in the early twentieth century, there were several weddings in the period between aristocrats and actresses, nothing staged subsequently would eclipse this event. The evolution of Grace Kelly into Princess Grace of Monaco offered a vindication of the dream factory's ability to invent social types. It also showed that the language of glamour of Hollywood could absorb older images of luxury and splendour.[63] The ceremony was orchestrated by the Metro-Goldwyn-Mayer studio. In return for suspending Kelly's film contract indefinitely, the studio exercised considerable control over the organization of the nuptials. It made a gift to the bride of all the clothes she had worn in *High Society* and it also paid the Oscar-winning costume designer Helen Rose to create a magnificent wedding dress. The making of this stunning gown required six weeks' work by no fewer than three dozen seamstresses. The designer claimed that it was the most expensive she ever made.[64] Rainier also dressed up, designing himself a sky blue, black, and gold uniform based on those worn by Napoleon's marshals. Metro owned the exclusive film rights to the ceremony and installed its lights and cameras, alongside television cameras, for both the civil and religious ceremony. The civil ceremony was staged a second time purely for the benefit of the studio, which made a documentary, *The Wedding of the Century*, that was later shown in cinemas throughout the world. The religious service in Monaco's cathedral was viewed on television by thirty million people in nine European countries. Among the six hundred guests were many royals and several film stars. A handful of reporters sneaked in disguised as cassocked priests while one of the most notorious Riviera jewel thieves was a chauffeur in the wedding party.[65] 'In the mid-Twentieth Century, somehow it was extremely fitting, in the general picture of Society, that the crowning climax to the long history of America's title search should be delivered by an American movie

star,' Amory reflected. The marriage was also a landmark event in another way for, in contrast to the respectful treatment of Queen Elizabeth's coronation, it fixed a new benchmark in the power, prestige, and pushiness of the press.[66] According to celebrity social organizer Elsa Maxwell, 'the ceremony itself, a beautiful old-world extravaganza, was reduced in newsprint to a large and rather gaudy carnival.'[67]

The wedding consolidated the popular passion for fashion and elevated aristocratic-type stars and models to a central position in its diffusion. The mania that the event unleashed in the United States created an appetite for a certain type of sophisticated woman. One figure who catered to this was a journalist called Eugenia Sheppard, who wrote a fashion column for the New York *Herald Tribune*. Like the gossip columnists of the 1920s, who chased after the chic and the stylish women of their time, she elevated a category of women into heroines of her reports. In contrast to the interwar years, her 'fashion-society celebrities' were solely heroines of consumption. What they did and who they mixed with was of much less interest than what they wore. Sheppard began her column immediately after Grace Kelly's wedding and became a cheerleader for the fashion industry, 'one of fashion's go-go girls' as she was once dubbed.[68] She became an indispensable fixture on New York's party lists and was soon the darling of wealthy women who relished the chance to join the envied realm of publicity. Her rise marked a peculiar kind of inversion. Whereas, before the Kelly wedding, female stars had aspired to marry into aristocracy or even royalty, achievement of this objective heralded a new phenomenon according to which society women became as hungry for publicity and as eager and desperate starlets.[69] In earlier decades they had sought recognition in the press of their pre-eminent status. Now they wanted acknowledgement of their pre-eminent stylishness. In Sheppard's writing, clothes were always central. They were the vehicle through which women gained citizenship in the realm of publicity and acquired a position of dependency on the garment industry.

The style leaders included women like C. Z. Guest, the Duchess of Windsor, and Princess Grace. Barbara 'Babe' Paley, Gloria Guinness, Slim Keith, Marella Agnelli, and other trophy wives were women who had married men so rich that they had the freedom to pursue an aesthetic quality in life.

Sophisticated, beautiful, and stylish, they set the standards of chic in their time. In Europe and America they were regarded as 'high priestesses of the social arts, avatars with a secret knowledge of beauty, fashion, decorating and entertaining'.[70] The press fawned over them and they attracted some notable flatterers, including the writer Truman Capote, who became the confidant of several of them. A gossipy charmer, he idolized the wealth and style of women he saw as elegant swans. It was striking that almost none of them was in fact high-born. What appealed to Capote about them, beyond their wealth and style, which invoked in him—and many others—feelings of awe and envy, was the fact that 'they all had stories to tell': 'Few of them had been born to wealth or position; they had not always glided on serene and silvery waters; they had struggled, schemed and fought to be where they were,' his biographer commented. 'They had created themselves, as he himself had done. Each was an artist, he said, "whose sole creation was her perishable self".'[71]

Like Jacqueline Bouvier, who, as the wife of President John F. Kennedy, would be credited with restoring aristocratic taste to the White House, these women presented a version of upper-class manners that was appealing and comprehensible to a broader public. To adopt the historian Paul Fussell's classification of the American class system, they belonged not to the 'top out-of-sight' class but to the more visible 'upper' or 'upper middle' brackets.[72] Even Babe Paley who, between her marriages to two of America's richest men, had been a fashion editor of *Vogue*, was essentially a figure in this category. She and her second husband, CBS chief William Paley, lived in a suite at the St Regis Hotel in New York during the week and on a huge estate on Long Island. Although they preferred to socialize privately, Babe was a public figure who was regarded as an icon of elegance.[73] She regularly appeared on best-dressed lists and was always immaculately turned-out. As one of the first 'fashion-society celebrities',[74] she provided American women with an example of a picture-perfect glamorous lifestyle. No-one guessed that behind the image there was the heartbreak of a marriage that was based more on ambition than love.[75]

By contrast to the pre-war era, socialites were fully immersed in the commercial sector. For companies engaged in the various branches of the

luxury trade, they had immense promotional value. The great cosmetics houses traded on ideas of exclusivity and refinement and they required the validation of great names. For example, Elizabeth Arden aimed to 'capture the aura of the drawing rooms of the great mansions that lined upper Fifth Avenue'.[76] At her New York beauty salon, consultations were held in the white-and-gold Oval Room, while treatment rooms were decorated in subdued pastels. Touches of gold and silver, a combination signalling wealth and taste,[77] were also regularly used on Arden packaging. Revlon's salons were no less striking. Clients were dazzled by the extravagant gold-and-white decor and the innovative lighting design.[78]

Estée Lauder also sought to capture the mystery and glamour of elegant society and market it to a wider public. She associated with Princess Grace, the Duchess of Windsor, and others. Lauder herself was the result of a feat of self-creation. Born in New York in 1908 to a humble Jewish family, she completely erased her origins in order to turn her name into a signifier of glamour, exclusivity, and social cachet.[79] She sold not just fragrances or cosmetics, but dreams, fantasies, and ideals of beauty.[80] The Lauder name signified domestic luxury and gracious living. Her aspiration, she claimed in her memoirs, was to use elegance and class rather than sex appeal to sell her products. The Lauder woman was 'classic', 'a sophisticated woman with charm and éclat, as well as beauty' who was 'sensual rather than sexy'. She was 'successful' and 'had that certain, indefinable air known as class'.[81] In particular she pursued good taste, which meant 'classic design for image and packaging'. To this end, Lauder even marketed solid perfume in elegant porcelain eggs, trimmed in gold and etched in enamel, which looked in every way like Fabergé eggs. She also incorporated aristocratic resonances into the advice she offered on elegant living, for example on table decoration. For fifteen years a single model of unmistakable WASP appearance, Karen Graham, was the face of Estée Lauder.

There was undoubtedly a conservative aspect to the preoccupation with style and status. Right-wing writers seized the opportunity to turn aristocracy into an aesthetic curiosity bathed in nostalgia and near-extinct beauty. For example, in his 1944 novel, *Brideshead Revisited*, English Catholic Evelyn Waugh offered an alluring portrait of the 1920s world of the aristocratic

Flyte family. The novel was narrated from the point of view of an outsider who meets the golden boy Sebastian Flyte at Oxford and is drawn into a magical world whose existence he had barely dreamed existed. Far from being a careful evocation of a bygone world, this was a false picture for the consumption of middle-class readers. Informed observers noticed that, in his fawning passion for the upper classes, Waugh had 'overdrawn the aristocratic glamour'.[82] Like the 'silver fork' novelists of one hundred years earlier, he conveyed his own enthusiasm for a partly imagined aristocracy to eager middle-class readers.

At precisely the moment when conventional high society ceased to be the aristocratic ideal prospered as a deracinated mood or look. The reworking of refinement that marked the 1950s was accompanied by a flowering of feminine images shot through with aloofness and elitist chic. The idea of class, breeding, taste, refinement, and style enjoyed widespread currency. Indeed, as qualities detached from any direct and structured social referent, refinement and sophistication were appropriated by a wide variety of commercial activities and professions. In this sense, the Paris couturiers were the handmaidens of a new sort of aristocracy. The tall, slim, angular woman, perfectly groomed and cool, proliferated in magazines and advertisements. Although these images were unapproachable for some women, they were not as far removed from the average as might be thought. They often showed women acting in a confident and sophisticated way in public places, unencumbered by family and domestic duties.[83] Others, in particular those of Richard Avedon, whose photographs for *Harper's Bazaar* in these years established him as the world's leading fashion photographer, were passionate, adventurous, and imaginative. His models were not static; they laughed, smiled, and held the stage. His famous picture of the model Dovima in a Dior evening gown standing arms aloft between two elephants seemed to say that couture could astonish even in the jungle.[84] Images of models like Lisa Fonssagrives and Bettina, and by extension those of other models of their type and some sophisticated film stars, actually seemed accessible to all women. In contrast to the indistinct debutantes that Cecil Beaton continued to photograph, they offered grace, balance, and reserve, combined with a certain energy.[85] Such women appeared to be in control and true to themselves.

Fonssagrives's background in dance gave her a sense of theatre so that her outfits never looked mannered or awkward. Rather she appeared to be engaged in a comfortable masquerade that could be copied by anyone.[86] In fact, the models of the post-war years sometimes only had the appearance of refined women. The most celebrated French model was Praline, who for Ginette Spanier of the Balmain fashion house was 'the last of the great French mannequins—the Mistinguett of the Haute Couture'.[87] As a working-class girl who joined the elite caste of haute couture models, she became a popular figure who embodied French beauty and chic. In addition to her fashion work, she won several competitions including Miss Cinémonde. In an autobiographical book published in 1951, she described how her life changed as she became the first 'mannequin volant'.[88] Dior and other designers had begun the custom of sending French models abroad to promote their creations and Praline was among the pioneers. She recounted at length her travels, especially a trip to Hollywood during which she met many stars, offering a picture of a lifestyle that to readers will have seemed highly glamorous. Thus the rise of the pedigreed woman blended with a popularization of elite images. It did not amount to any sort of social restoration. In fact, the last English debutantes were presented at court in 1958.

Due to commercial air travel and faster communications, international society developed a genuinely cosmopolitan flavour. Newport, Nassau, and Montego Bay, together with old elite centres such as Cannes, Nice, Monte Carlo, Capri, Ischia, and Portofino, became the playgrounds of a cosmopolitan coterie of wealthy nomads. Paris too, with its unrivalled night life and high style, and Rome, with its cafés, restaurants, grand hotels, and expanding film industry, attracted fun-seekers. Monaco developed into a glamorous Mecca for film stars and celebrities. The principality had languished since Elsa Maxwell had been hired in the 1920s to update the Casino and the Hôtel de Paris and to stage events that would draw the cream of international café society. Despite the influence of Aristotle Onassis, it now acquired an unfamiliar air of respectability that was heightened by the presence of Princess Grace. She was a fairytale princess who in an instant brushed away Monte Carlo's louche and declining image and made it once more a focus of international society. Due to her influence, traditional customs, such as the annual pigeon shoot,

were done away with and replaced by grand charitable fund-raising events at which Frank Sinatra, David Niven, and Cary Grant were regular guests.[89] Thanks to an injection of Hollywood glamour, the royal family acquired celebrity value. By blending the mythology of the princess with the allure of the star, Grace became something uniquely appealing, a modern hybrid of class and style. Although some observers in the early 1960s still found that 'Monaco in those days was something out of Central Casting. Dowager Russian princesses and out-of-work Balkan kings.... a very stodgy watering spot for European millionaires and down-at-heel aristocrats,' things soon changed.[90] A building boom reflected the new aura that the principality acquired. With its white buildings and palm trees and its fairytale princess, it took on a new Ruritanian charm.[91] Hotels were revitalized, races and rallies sponsored, and artistic events held. By inviting actors and celebrities in her capacity as president of the Monaco Red Cross, Grace provided the magic touch that Monaco had lacked since the belle époque.[92] Other resorts, notably Capri, retained the hedonistic reputation that they gained earlier. Invaded by movie stars and wealthy Americans, the island became the synonym of money, extravagance, and excess. With its numerous famous, wealthy, and artistic visitors, it became a breeding ground of casual fashions, images of relaxed pleasure, and legends of sexual indulgence.[93] All this gave it the glamour of a modern paradise.

Grace and Rainier became central figures in the glittering Mediterranean social carousel. They were joined by several deposed and exiled former rulers who congregated in capital cities and watering holes. The Duke and Duchess of Windsor were one of the most prominent couples in international café society. Ever since the Duke's abdication from the British throne in 1937, they had moved between Paris, New York, Biarritz, Cap d'Antibes, and the Bahamas, where they were welcomed with open arms. Edward had never liked solemnity or ritual but, in exile, he and Wallis sought perfection in their immediate environment and in the construction of a ritualized life-style. Wallis became a fashion icon who endlessly pursued style, obsessively attending fashion shows and beauty salons, going shopping, and attending parties. She became an expert on interior decoration and jewellery, of which she had a most extensive collection. They were a king and queen of café

society, who were sustained by rich friends who derived social cachet from their association with them. They became the epitome of the international jet set, a glamorous couple who lived in the same realm as movie stars.

The increasing internationalization of social life was accompanied by the expansion of American business abroad. Hotelier Conrad Hilton emerged in this period as the proprietor of a chain of luxury hotels that extended from the United States to Western Europe and beyond. He regarded his foreign hotels as outposts of American civilization and he sought to attract to them the same mixture of crowned heads, celebrities, prime ministers, diamond millionaires, and admirals that patronized the Waldorf-Astoria in New York, which he had bought in 1945. 'Rome and Madrid interested me mightily from the standpoint of building hotels,' he wrote. 'An integral part of my dream was to show the countries most exposed to Communism the other side of the coin—the fruits of the free world.' In Rome he found much support among the ruling Christian Democrats for his project of a new hotel, but considerable opposition from Communists, who were a significant opposition force on the city council. Hilton understood luxury but lacked extensive experience of women. 'My first five years as an innkeeper in Texas involved me in . . . a series of romances in which girls played little part,' he later wrote.[94] 'I found myself developing a real crush on each potential hotel. . . . Romance blossomed the minute I could see through a frowsy facade to potential glamour—the inherent ability to make money.'

On one occasion that he would come to regret, he succumbed to the lure of glamour instead of deploying it to entrap others. His short marriage to the Hungarian actress Zsa Zsa Gabor, who in total would marry eight times, taught him that glamour could also be costly. With hindsight, he regarded her as a luxury too far. 'Glamour, I found, is expensive, and Zsa Zsa was glamour raised to the last degree,' he wailed.[95] 'She also knew more days on which gifts could be given than appear on any holiday calendar. And then, of course, you could always give gifts because it was no special day at all and thereby transform it. Zsa Zsa was not always on the receiving end by any manner of means. She herself loved to give. She showered presents and attentions on my mother . . . and for me there were custom shirts and solid gold cuff links, most of which showed up mysteriously on my charge accounts.'

Foreign cities and resorts resonated with tradition and style, but they also, in some instances, had strong bohemian associations. They provided opportunities not so much for formal socializing, with all its protocol and stiffness, but for the rich and famous to let their hair down. The rapid transformation of Italy from a Fascist dictatorship and backward economy into a dynamic centre of style and beauty saw the capital, and the country's most beautiful coastal resorts, develop into elite playgrounds. Thanks to the presence of the American film studios and the expansion of the local film industry into one of the largest in the world, Rome became a magnet for a heterogeneous mixture of deposed monarchs, displaced aristocrats, gold-diggers and playboys, artists, and actors. When the Swedish starlet Anita Ekberg, who had arrived in Italy in 1955 to take a supporting role in *War and Peace*, married the English actor Anthony Steel in Florence six weeks after the Monaco extravaganza, the event was deliberately low-key and informal. A woman whose curves were so generous that one journalist observed, after her arrival in the Italian capital, that the hills of Rome were no longer seven but nine, Ekberg acquired a reputation for refusing to cooperate with the press. American reporters dubbed her 'Anita Iceberg'. Her civil wedding was intended to be simple and definitely not grand 'à la Kelly'. However, Steel gave her an engagement ring that was proclaimed as the biggest in the world and press curiosity was intense. She chose as a wedding dress a daring off-the-shoulder gown that provoked condemnation in the British press. For some observers, it was more suited to Tarzan's companion Jane than a bride.[96] The couple were followed everywhere by photographers, who even broke into the apartment they had rented to snap their bedroom and living room. Despite these and other difficulties with the press, Steel and Ekberg smiled and waved endlessly for the curious public who stopped to applaud them as they drove through the streets in an open horse-drawn carriage.

No star was less associated with formality than Brigitte Bardot and no star was more adept at making her off-screen life just as newsworthy, and sometimes as remunerative, as screen performance. Bardot became famous above all for her look—the pouting lips and tousled, apparently sun-bleached hair—and for her amorous liaisons. The latter were publicized more heavily than her films. She rejected many aspects of the official imagery

of the star in favour of a more apparently natural manner. From the 1956 film *Et Dieu créa la femme*, which turned her into a star, she was associated with St Tropez, a small fishing village that in time would become no less exclusive than Monte Carlo while preserving a casual feel. Thanks in part to Bardot, the Côte d'Azur was reinvented in the 1950s as a paradise where the sun always shone and the beautiful people were at play.[97] The consequences of the association of star and place were perceived by the celebrity photographer Edward Quinn, who spent the 1950s looking for opportunities for unlicensed snaps outside the Riviera's great hotels and at gala evenings in Monte Carlo—places that had once been the stamping grounds of La Belle Otero and Liane de Pougy: 'The worldwide fame of St Tropez, on the extreme west of the Côte d'Azur, dates from the Fifties, thanks partly to that new vehicle of liberty, the motor car, partly, of course, to Brigitte Bardot,' he observed. 'Until then only a few artists and aristocrats had heard of the place and it was visited by a small elite. It was very hard to get to then...but after popular tourism reached it in the Fifties, St Tropez was invaded. It became overcrowded, especially during the summer, and it lost its former charm.... The Côte d'Azur during the "Golden Fifties" was one of the largest and most beautiful stages in the world. Its actors were magnificent and glamorous. And though the curtain has gone down, the memories remain.'[98]

Bardot struck a blow against some of the traditional canons of movie star glamour. She rejected the costly gowns and rigid formality of previous French stars and instead proposed a casual, yet sexy and glamorous, alternative that consisted of gingham dresses, Capri pants, and striped tops, that were left cheekily unbuttoned.[99] Her imperfect, bottle blonde mane symbolized her casual, carefree manner. In an era in which stiffness reigned, she offered a dream of emancipation and an image of unlimited desire. Bardot was hugely successful abroad but highly controversial at home. French women in particular disliked her, but so too did some critics. 'Paul Reboux said of me that I had the physique of a servant girl and the way of speaking of the functionally illiterate,' Bardot later wrote.[100] For over a decade, Bardot would attract the photographers at the Cannes film festival like nobody else. 'She was so world-renowned by 1957 that when she hosted her own "BB"

festival party,' the festival's historians write, 'the Hollywood trades reported it had to be held in nearby Nice to accommodate the four hundred policemen necessary to guard the event. Other papers concentrated on the fact that the hostess was clearly without underwear beneath her T-shirt and jeans.'[101] Bardot herself acutely perceived the nature of her rebellion: 'Sophia Loren and Gina Lollobrigida, the big stars of the festival that year would only appear in public with their bosoms and diamonds on show, in costly fur coats, sumptuous gowns and Rolls... in other words in all the indispensable finery of cinematic *noblesse oblige*. I was not part of the system and this was the original and worrying thing.'[102]

Bardot's men included some of the many playboys who made the Mediterranean their special stage. These were men like David Larrabee (William Holden), the charmer who, in *Sabrina*, woos the eponymous heroine before she opts for his dour, but safe, brother Linus, played by Humphrey Bogart. Like birds of prey, they gravitated around upwardly mobile women, whether they were film stars, heiresses, or beautiful ingénues. Both Prince Rainier and Aly Khan were men of this type. Like other men who led lives of privilege, they were attracted to the stars like bees to a honey-pot. At a time when male screen actors did not necessarily have to be likeable, rather they were expected to reveal a troubled side, a malaise, or a concern, the playboys caught the public's imagination. Stars like Yves Montand or Marcello Mastroianni combined physical authority with a certain authenticity. For each of them, acting seemed like an extension of a persona forged through real experience. According to French author Pierre Cendrars, postwar films 'no longer offered perfect heroes or shop dummies. To please, the leading man, he had for better or worse to be sincere... To last, a young actor had to make people forget that he was handsome.'[103] No such strictures applied to the heroes of the gossip pages. Fiat heir Gianni Agnelli, Brazilian entrepreneur Francisco 'Baby' Pignatari, Dominican diplomat Porfirio Rubirosa, and others avoided steady work and instead devoted themselves to life's pleasures. They loved fast cars, dangerous sports, luxury yachts, air travel, gambling, fine tailoring, nightlife, and the pursuit of women.[104] Like the *viveurs* and devotees of *galanterie* in the belle époque, they were engaged in a constant competition with each other and with

themselves. They were rarely in one place for more than a short time and set great store by whim. With his marriages to Flora, the daughter of the Dominican dictator Trujillo, French actress Danielle Darrieux, and the heiresses Doris Duke and Barbara Hutton, the handsome gold-digger Rubirosa was a gift to the news media. With his legendary virility and range of questionable diplomatic and financial dealings, he was a regular hero of the celebrity gossip features that replaced the old society pages in the press.

The playboys usually saw their women as temporary appendages or transient passions, but there were a few who figured more prominently. These included Anita Ekberg after the failure of her marriage, Linda Christian after her separation from Tyrone Power—and the latter's sudden death from a heart attack—and the English socialite Pamela Churchill, who was linked to Agnelli and who was with him when he suffered a car crash that nearly cost his life. Rome became their preferred destination as the city's once tame nightlife came to life with the opening of numerous bars and nightclubs in the vicinity of the glittering Via Veneto. However, they found themselves at risk from packs of young freelance photographers who hung around on street corners or on Vespa scooters ready to snap the illicit behaviour of celebrities who were away from home. Even playboys like Baby Pignatari—who enjoyed a turbulent on-off relationship with Linda Christian—found themselves caught in their lenses. Gianni Agnelli escaped his liaison with Ekberg from being exposed by paying off reporters and editors. The birth of the 'paparazzi' phenomenon in Rome signalled a change in the nature of modern celebrity. Stars were no longer aloof figures to be placed on a pedestal and worshipped, but ordinary mortals who succumbed easily to the temptations of the flesh. In the eyes of readers of Rome's *Lo Specchio*, or of the *Paris-Match* or the London *Evening Standard*, the film colony in Rome provided a continuous feast of scandals including adultery, attempted suicides, orgies, and drugs. The New York gossip magazine *Confidential* and other scandal sheets with names like *Hush-Hush*, *Whisper*, *Wink*, and *Inside Story* supplied the salacious details and speculation that even these publications shied away from.

Scandals did not damage the glamour of Rome, but rather lent it a dark but compelling hue that director Federico Fellini would exploit in his

masterful depiction of the cosmopolitan Rome, *La Dolce Vita*. This was a film that both absorbed all the movie glamour that had assembled in the Italian capital, and presented it in concentrated form, and explored the disintegration of this in a series of set piece scenes that registered the decline of the intellectuals, the break between generations, the meaninglessness of contemporary religion, the hypocrisy of the famous, the irrelevance of the aristocracy, and the worship of the worthless. Through all this, Marcello Mastroianni as a press agent and the bored socialite Maddalena, played by French actress Anouk Aimée, cruise as two stylish black-clad nightowls who glide over the surface of the human debris that surrounds them.

La Dolce Vita consecrated the eternal city's reputation for sex and sensation. It became, in the public imagination, a place where the dominant moral values of society were routinely transgressed. For public opinion, the most scandalous event of the period was the flagrant adultery that was committed by Elizabeth Taylor and her co-star Richard Burton during the filming in Rome of Joseph Mankiewicz's blockbuster *Cleopatra*. Taylor was already a legend and was by far the bigger star in 1962. Burton impressed her with his theatrical credentials. Despite the fact that both actors were in Rome with their respective spouses, they were drawn irresistibly to each other. When they were snapped kissing on set, the press and the public assumed that their playing of two of history's greatest lovers had spilled over into reality. Immediately their liaison—which was not yet admitted by either party—became a matter of speculation on the part of columnists. For months, they dominated the headlines and when their adultery was incontrovertible, they were sternly condemned by the Church and sectors of the press. However, in contrast to the early 1950s, the scandal did not lead to disgrace. Neither actor cared much for public opinion or for convention and they revelled in being at the centre of press attention. Their messy and drawn-out separations from their spouses and emergence as a couple transfixed the public. The fact that the tryst had begun in Rome made it all seem understandable and even forgivable.[105] Moreover, there was a great rush to cash in on the part of 20th Century Fox and the press, while Burton found that his link to Taylor had turned him into a superstar. Offers of work poured in provided that both of them were in the cast. The second film they

made together, a Terence Rattigan-scripted drama set largely in the VIP lounge at London's Heathrow airport, was released with the title *The VIPs*. The parts they played seemed not unlike their real selves, a fact that was not accidental since Rattigan had more or less written them directly into his screenplay. It was released not long after *Cleopatra* and was a hit, even eclipsing the notorious blockbuster in box office revenues. For several years, Taylor and Burton defined the meaning of glamour as their disregard for conventional mores made them seem larger than life and their lavish lifestyle caught the public imagination. In an age in which movement and international travel were coming within the reach of middle-class families, they were pioneer members of the 'jet set'. By breaking the rules of respectability and getting away with it, they showed that celebrities were no longer subject to the same moral judgements as everyone else. Their glamour lifted them into a realm that was beyond the reach of the guardians of social order.

GLAMOUR AND MASS CONSUMPTION

A merica in the 1950s was a land of optimism and plenty, a land where all the problems of man seemed to have been solved and where prosperity was no longer a dream but a lived experience. Scarcity was gone for ever and the healthiest and wealthiest generation in history was living a life that was projected towards a future of ever greater opportunities and comforts. Despite the Korean War and fears, in the early part of the decade, that the cold war would lead to another major conflict, the period was America's golden age. It enjoyed a far higher average standard of living than anywhere else in the world. More than at any other time, the world looked at the United States with wonderment at the abundance of its goods, the dynamism of its entertainment, and the lavishness and ease of its citizens' lives. For hard-pressed Britons and French people, many of whom were still living in wartime conditions of scarcity, America was nothing short of a dreamland. However, unlike in the interwar years, when Hollywood's images of American life were experienced as pure fantasy, after 1945, these were connected to a realizable future. For the first time, the lifestyle of a whole country appeared to resonate with glamour. In its involvement in European reconstruction and development, the United States

made great play of its success in combining democracy and prosperity. It promised, through the Marshall Plan, to help convert economies to the mass production systems that it had pioneered in the 1920s. Europeans were led to believe that, if they voted for pro-Western parties and worked hard, then they too would be able to live in the American way and sample the fruits of prosperity. The propaganda effort that was developed to support the Marshall Plan told Europeans 'You Too Can Be Like Us'. Through trains, exhibitions, talks, slide shows, posters, magazine articles, and many other means, the way ahead from economic recovery to modernity and progress was indicated by means of economic know-how, modern techniques, fashions, personalities, and lifestyles.[1] The plan's cheerleaders did not just seek to persuade governments and business organizations, they also reached out to ordinary people and sought to influence their dreams and aspirations.

The post-war United States was an imperium with the outlook of an emporium, the historian Victoria de Grazia has written.[2] It made use not just of economic power and political leverage but 'soft power' to persuade Europeans towards its model of mass consumption for all. It did not just wield a stick to make its allies fall into line, it offered a carrot in the form of movies, stars, and a stream of new products and lifestyle suggestions. One of the features of this soft power was glamour. There was a feminine sensibility to the way American consumerism presented itself as the housewife's friend and promoter of familial domesticity. But there was also a systematic use of female imagery to sell products including motor cars, hotels, vacations, grooming aids, and fragrances to men. The tensions between domesticated and eroticized female appeals was played out not only in the mass media and the leisure industries but also in the new dialectic that the American-led consumer revolution created between the United States and Western Europe.[3] Although the United States was far ahead of Europe in its experience of mass consumption, this could not evolve without constant new stimuli. While Europeans were exposed to far more American and American-inspired images than vice versa, Americans were drawn to European ideas of sophistication, class, taste, and sex and to the products that somehow embodied them. Air travel boomed, facilitating tourism, while magazines, continental movies, Hollywood runaway productions, and imported goods

fuelled regular encounters and exchanges. Although American-style glamour was dominant in the post-war decades, it incorporated a significant European component that was made up of national elements that on occasion took on the form of variants on the dominant model.

Various facets of the American lifestyle were dressed with glamour, but none was more immediately attractive than the motor car. The mass production motor car had been a phenomenon of the 1920s and it remained, through the 1950s and beyond, the cornerstone of the American economy. It drove the American consumer society and it was also what would propel European economies towards growth and development. In the projection of the United States, cars were not merely useful appliances that Americans owned, but fabulous wonder vehicles that seemed like a mixture of a warplane and a living room. The American car, on the basis of size alone, kick-started the imagination. The fact that it was also styled in the most impossibly alluring of ways gave a potent symbolism to mass motorization. It was inconceivable that anyone driving such a triumphant blend of fact and fantasy was not filled with optimism and confidence.

As early as the late 1920s, American manufacturers realized that customers did not just see cars solely as utilitarian tools but as objects of status and desire. Ford's strategy of cutting the price on his model T and making cars as basic as possible was replaced by a new emphasis on styling which ensured that cars first, and then many other material objects, became associated with images and ideas that were highly symbolic. The development of styling came to a halt during the war years only to be resumed from the late 1940s. The form it took was the tail fin, a design touch that at first provoked perplexity and then became associated with prestige. Due to wartime advances in electronics and moulded plastics, as well as assembly-line production, the hugely productive American economy was transformed into a consumer economy on a scale without precedent. Every manufactured artefact—from the motor car and the refrigerator to the toaster and the teapot—was redesigned to include a quotient of fantasy and style. Colour and shape were the twin tools of this reconfiguration of the object world.

The first suggestion of tail fins appeared on the 1948 Cadillac, but for the most part goods conserved a streamlined appearance until the mid-1950s,

when the end of the first, tense years of the cold war gave way to a more optimistic mood. The 1955 Chevrolet has been seen as the turning point. This was not a luxury brand like the Cadillac, but a routine one that hitherto had been associated with basic transportation needs. This affordable model marked the first of a series that looked exciting; it had a mildly futuristic appearance, was available in lively colours, and gave its driver a sense of prosperity. Not only had the one-time luxury become a necessity; it had done so without losing the air of luxury that made it desirable in the first place. In the following years a whole repertoire of motifs and decorative features were incorporated into cars that grew larger and larger. From the bottom of the range Chevrolet to the top of the range Cadillac, every car became in some measure a dream car. The man who is credited with having turned styling into a key part of the design, manufacture, and selling of automobiles, Harley Earl, headed the Art and Colour department at the General Motors (GM) Corporation from 1927 until 1959. He had been born in Hollywood and began his career as a customizer of cars for the stars. His main task at GM was to invent dream cars that would present new ideas and test public taste.[4] Visual ideas were meant to stimulate aspirations and build the market for the models of the future. The first dream cars were large in size and had a sculpted look to them. The bends and curves of their chassis reflected the fact that they were first modelled in clay rather than the conventional wood. Earl himself would often use test vehicles for his personal transport, delighting in astonishing the members of the golf and country clubs he frequented. His aim was not to come up with the perfect design but rather to offer a variety of different ones that would appeal to different fantasies.

Optimism and opulence were not just moods of the time but qualities that were incorporated into generously styled vehicles available in a range of colours and models. Fabulous and enormous American cars were the product of a series of developments whereby objects took on a special exaggerated quality that expressed confidence, excitement, and even joy.[5] The fantasy element in the American automobiles of the 1950s came from two sources. The first of these was aviation. Earl was fascinated by planes, especially military fighter planes such as the Lockheed P-38 Lightning.[6] He took the impression of sleekness and speed that they had and used it to create cars that were longer

and lower than before. He named his first post-war dream car the Le Sabre XP-8 after the F86 Sabre jet of the US airforce. Later he took inspiration from the delta-wing, needle-nosed Douglas F-4D Skyray, whose spectacular appearance would influence the entire automotive industry.[7] Several companies manufactured cars with aviation features; one of the earliest being the bullet-nosed 1950 Studebaker. Cars often incorporated aviation imagery into their advertising or directly into their names, such as the Thunderbird, launched by Ford in 1953. Earl's second source of inspiration was Hollywood. In his view, design was about entertainment and he wrote in numerous magazine articles that he particularly admired Cecil B. De Mille, from whom he learned large-scale theatricality, and Al Jolson, who taught him how to understand and respond to an audience. He connected with the public by providing it with emotionally satisfying signs of stylishness and prestige.

In the age of Earl, the presentation of cars itself became a branch of show business. At the Motorama shows that were held in various cities, new ideas and prototypes were presented in a theatrical fashion. Placed on stages and illuminated to maximize their dramatic presence and gleaming allure, they dazzled a public that was alert to visual novelty. The aim was to stimulate its desires by holding out the prospect of something new and better that was two or three years away. The unveiling of new models each year, a novelty of this period that reflected the development of planned obsolescence, was treated in a manner akin to the exploitation of a new film. The public had to be wowed and persuaded to buy in large numbers while the item still had the appeal of newness. The epitome of what Chrysler called the 'Forward Look' was its slogan for 1957: 'Suddenly it's 1960!'[8]

Even though American cars were unashamedly mass manufactured, few standard models were sold. Optional extras, customized details, and colours chosen from an ample range, including two-tones, meant that each vehicle had something different. Cars became fashion statements and were dispensed with as soon as their shape or colour was no longer the mode. A vehicle's appearance gave some indication of the taste and attitudes of the person who drove it. This applied even to the more economical makes and models. Styling was not for the privileged few, like the stars whose cars Earl had once customized. Everyone was willing to pay a little extra for some

additional non-functional mark of luxury.[9] The car designs of this period were not tasteful. Nor, despite their jet-plane echoes, were they particularly fast. They were eye-catching celebrations of individuality and status, expressions of 'rampant vulgarity and joy'.[10] The car that more than any other exemplified the exuberant design excesses of the decade was the 1959 Cadillac Coupe de Ville. This enormous vehicle was the motoring equivalent of an all-singing, all-dancing stage-show. Fantastically long and wide, its hyperbolic tail fins and bullet lights gave it the appearance of a vehicle more geared to space travel that cruising along freeways. Adorned with acres of chrome on its front and rear, it screamed luxury and limitless opulence.

For the Canadian Marshall McLuhan, one of the most attentive observers of the impact of mass communications in the age of high mass consumption, the car was a great unifier that had reduced social distance as well as physical space. It bypassed all differences of class and race, uniting motorists and making pedestrians into second-class citizens. The car 'more than any horse ... is an extension of man that turns the rider into a superman', he declared, observing that 'an American is a creature on four wheels'.[11] By labelling it a 'mechanical bride', he alluded to the powerful sexual symbolism of the car. For men, ownership of a vehicle became a sign of virility and sex appeal as well as status. While sports models functioned as a means of peacock display to attract women, the softer curves and friendlier grille designs that in mid-decade substituted the aggressiveness of models like the Plymouth Fury turned the car itself into a woman who had already been captured and tamed. The connection between cars and sex was deliberately exploited by advertisers and marketers following the discovery, by pioneer advertiser Ernest Dichter, that glamorous convertibles in a showroom had the appeal of a mistress to men who came looking for a wifely family vehicle.[12] The theory was that, if they could be induced to fantasize about the former, they would end up being seduced into buying one of the middle-of-the-road saloons on offer.

In the USA, the automobile was fully integrated into the routine pattern of everyday life where it fulfilled practical functions. 'The automobile is part of domestic life and is an extension of it—a means to connect the home to the shopping center, a sort of modern equivalent of a wind-tunnel connecting

two wood huts,' observed one American author.[13] The fantasy factor in automobile design derived precisely from a desire to offset this humdrum dimension. For Europeans, by contrast, cars were not so quotidian. They were objects of a certain rarity and fascination that were often contemplated more than they were used, even by some of those who were fortunate enough to own one.[14] The pictures of cars that adorned Marshall propaganda posters and that were seen in Hollywood movies and occasionally at motor shows, testified to the great gulf that separated the old continent from the new. Even in 1961 only one in eight French people owned a car, as opposed to one in three Americans.[15] The cheapest Fiat 600 model, launched in 1953, had a cost equivalent to a year's wages for a worker at the company and half the annual salary of a white-collar worker.[16] In Europe, the glamour of cars derived not from the fantasies that were built into them by astute designers and manufacturers but rather from the suggestions of writers and film-makers, the popularity of motor racing, and their associations with celebrities. This gave European sports cars and some other vehicles a special allure for wealthy Americans for whom they were external to the pre-packaged dreams they were accustomed to. They had the same appeal as Continental movies that were exhibited not in mainstream movie theatres but in specially designated art houses.

One of the most innovative inventions of the post-war years were the Italian Vespa and Lambretta scooters. Designed in 1946 by Corrado d'Ascanio, who adapted it from a simple transport vehicle used for moving goods on military airfields, the Vespa would prove to be much more than simply the precursor of the motor car in a country where few could afford them. With its smooth curves and practical allure, it would prove to be a design classic and a market hit throughout Europe.[17] Piaggio, the producer of the scooter, cleverly wrapped glamorous imagery around it, employing pin-up art and female film stars to give the Vespa sex appeal.[18] Although most purchasers would be men, who often used Vespas to get to work, it was sold as a tool of freedom and leisure. To own a Vespa was to belong to a new universe of weekend travel, trips to the seaside, and courtship away from prying eyes. After Audrey Hepburn and Gregory Peck rode a Vespa in *Roman Holiday*, it was associated by foreigners with fun, tourism, and Italy itself.

European manufacturers had been making prestige and sports vehicles for decades. Motor racing had been a prestigious, if highly dangerous, sport in the interwar years. After 1945, it flourished once more as some competitions of the pre-war years, such as the Italian Mille Miglia rally and the Le Mans 24-hour race resumed. From 1950, the Formula One World Championship was introduced and immediately caught the imagination of the public with exciting races that, through the first decade of competition, were dominated by the ace Argentine driver Juan Manuel Fangio. His great rival, Stirling Moss, was never able to win a single championship. The period largely featured teams run by car manufacturers including Mercedes, Alfa Romeo, Ferrari, and Maserati. All of these manufacturers, and others too, also produced road vehicles. The challenge for most companies was to produce stylish vehicles for the masses that were not simply pared-down imitations of more costly models. The resulting automobiles, perhaps not surprisingly, took inspiration from the United States. Even the shark-like Citroën DS, first introduced in 1955, owed something to the streamlining of American designer Raymond Loewy. With its futuristic shape, long body, and colour options it clearly had an American inspiration, even if a series of technical innovations including front-wheel drive and hydro-pneumatic suspension gave it a profoundly original character. Its unveiling at the Salon de l'automobile in Paris inspired the critic Roland Barthes to his famous observation that cars were the modern equivalent of medieval cathedrals in that they were the highest expression of the civilization that created them.[19]

The excitement that cars like the Citroën aroused could be measured by the extraordinary coverage they received in the press and magazines. Cars also featured frequently in the novels and films of the period where the thrill of speed and the power of narration endowed them with near-mythical status, even if the sense of independence driving afforded, especially when the vehicle in question was an open-top sports car, often combined with the horror of a fatal accident.[20] The intense depiction of cars in the period before they became a commonplace fact of European life testified to the differences between the two continents. In Britain, motor cars remained outside the reach of the majority of the population until 1958 when the last restrictions on hire purchase were abolished and instalment buying suddenly widened the market for larger

consumer goods. The mass cars that captured the attention were no longer the staid vehicles produced by Austin and Morris with fuddy-duddy names like Oxford and Cambridge, but popular dilutions of the styles that proved popular across the Atlantic. The Ford Zephyr and the more expensive Zodiac were chrome-decorated six-cylinder cars that had touches of American glitz. Indeed, it was Ford USA that initially determined their look. They were fresh and bold in their styling and incorporated transatlantic optimism into their front and rear design, while remaining comparatively modest in their overall proportions. Produced by Ford's Dagenham factory, they were affordable symbols of status and modernity. They were the automotive equivalents of local crooners and pop stars. These cars lacked conventional taste but they had panache and a certain swagger, qualities that were enhanced by Ford's practice of using them in rallies and their regular appearance in the popular BBC television police drama Z Cars. The screen police officers who drove them were not old-style 'bobbies' on the beat but tough and gritty US-style cops with attitude. The fact that the series was set in a nondescript 'new town' lent it a certain glamorous rootless-ness, even though the north-western English accents of the protagonists added a regional flavour. Although this depiction offended some senior figures in the police, it influenced the manner of some policemen who imagined themselves to be protagonists of a real-life version of the TV show.[21]

The car was the protagonist of a society on the move, that was increasingly mobile and in which people travelled more, also to foreign countries. Travel became big business in the 1950s as it came within reach of many Americans and smaller numbers of Europeans. Around one and a half million Americans were going abroad every year by the end of the decade. Passenger airlines had appeared in the 1930s, but only after the war did they flourish. The introduction of commercial jet travel at the end of the 1950s reduced the length of the journey between New York and Paris to six hours. During this period, aviation lost little of the glamour that it had acquired during and after the First World War. However, travel was no longer glamorous because it was heroic, but rather because it was practised by the rich and the well-known, and because it opened up the possibility of reaching exotic and unfamiliar places. Its allure was no longer associated with the dashing personas of the pioneer aviators. What Barthes called 'the glamorous

singularity of an inhuman condition' was replaced by a new breed of jet pilots who belonged to 'a new race in aviation, nearer to the robot than to the hero'.[22] The increasing enclosure of travel in the contained units of the motor car and the aeroplane isolated the passenger and reduced the experience of movement to one that could be largely controlled and managed. Daniel Boorstin, whose powerful book *The Image*, published in 1961, aimed to identify the ills of modern man, lamented this tendency to homogenize life. 'If we go by air,' he commented, 'then we are encompassed in music, and enjoy our cocktail in a lounge with the décor of the best resort hotel.'[23] In-flight movies were introduced by TWA in 1961, while the German company Lufthansa promised in its promotional material that every flight was 'a charming, informal Continental supper party, eight jet-smooth miles over the Atlantic'. When they arrived at their chosen destination, tourists were often accommodated in hotels that replicated the same conveniences that they were used to at home. The expansion of international hotel chains facilitated this process. The great pioneer was Conrad Hilton, who opened hotels in Puerto Rico in 1947, Madrid in 1953, and Istanbul in 1955, and then in Rome, West Berlin, Montreal, and many other world cities. Each opening saw Hilton fly American celebrities to the city concerned, both to secure publicity and create a glamorous buzz around the new hotel.

Although travel to Europe boomed, for many Americans, the high life was associated with resorts that were closer to home and which skilfully developed irresistible appeals to the middle-income vacationer. Las Vegas had developed as a gambling paradise in the interwar years and witnessed the development of a rash of new hotels and casinos in the 1940s. The emblematic resort of Miami Beach was born in the same period as a man-made getaway for wealthy winter holiday-makers. Its numerous art deco hotels lent it a festive and contemporary air. During the war, thousands of servicemen were stationed there and the appeals of its warm climate became more widely known. In the years that followed, it used its elite associations to promote itself to middle-class Americans. As garish and enormous new hotels including the Fountainbleu, the Eden Roc, and the Deauville, opened on the North Beach, publicity promised visitors variously Hollywood-by-the-sea or an American-style Riviera experience.[24] The eclectic mix of styles,

themes, and inspirations of the architecture of the hotels recalled department stores of the nineteenth century, a model that they did not disdain. They offered 'packaged happiness' and flattered people by serving them, entertaining them, and making them feel they were indulging in the glamorous life of the rich.[25] Casinos and nightclubs provided a buzz that, while not as brashly vulgar as Las Vegas's 'sin city' reputation, mixed strong doses of luxury, sex appeal, and spectacle. Between 1949 and 1964, Miami Beach grew into the biggest single resort in the United States thanks to packaged air tours and regular shots of glamour in the form of the Miss America and Miss Universe pageants and super-shows drawing on the top show-business and sports stars of the day. Resort advertising always featured beautiful girls cavorting on the magnificent beaches.

Feminine imagery and mass consumption seem to go together hand in glove. As tourism became a feature of the American lifestyle, the air hostess replaced the pilot as the emblematic figure of air travel. United Airlines had hired the first stewardesses in 1930, recruiting 'attractive, personable young women who were not pilots'.[26] Women were preferred to men because they would better allay passengers' anxieties and make air travel seem safe and comfortable. The hostess quickly became a popular cultural icon. Even in the interwar period, there were movies such as *Air Hostess*, released in 1937, and romantic novels featuring stewardesses. Feature articles on some of their number outlined their daily lives, stressed their practical, no-nonsense approach, even when dealing with celebrity passengers, and their eminent marriageability.[27] They confirmed that immaculate appearance, movement, and the contemporary spirit were not necessarily antithetical. According to Boorstin, the airline stewardess, 'a breed first developed in the United States and now found on all major international air-lines', was 'a new sub-species of womankind. With her standardized impersonal charm she offers us, anywhere in the world, the same kind of pillow for our head and the latest issue of *Look* or *Reader's Digest*. She is the Madonna of the Airways, a pretty symbol of the new homogenized blandness of the tourist's world.'[28]

In the fifties the air stewardess emerged as a glamorous figure who embodied many of the dreams of the moment. It was more realistic for girls to aspire to be a stewardess than a fashion model, yet they were no less

likely to travel to exotic locations or meet the rich and famous. Stewardesses were usually trained nurses acting as waitresses and hostesses, women whose jobs were rendered alluring by the mystique of air travel, stylish uniforms, and their public visibility. One of the first post-war British hostesses, Joyce Tait, who was an object of such curiosity that she wrote a book about her experiences, stressed the many practical aspects of a job that continually presented new challenges. She did this because the drudgery and discipline required of the stewardesses was normally entirely concealed from the public.[29] Any dream Tait and her colleagues may have had about becoming 'glamorous queens of the air' were cancelled even before the end of their training by the discovery of discomforts and innumerable rules. 'Only one thing could restore it,' she acknowledged, 'and the glorious day actually came at last when we were sent to be fitted for our uniforms.'[30] As with several European carriers, these were designed with a keen fashion sense (the uniforms of the stewardesses of the Italian company Alitalia, for example, were designed by the Fontana sisters, who had made Linda Christian's wedding dress and Ava Gardner's costumes for *The Barefoot Countess*). Great emphasis was placed by airlines on the image of the hostesses. 'Appearance was a great thing. "Neat but not gaudy" was the rule,' Tait asserted. Style and status were the rewards for women who were seen almost to be as glamorous as Hollywood stars.[31]

Achieving the right balance of efficiency and sex appeal was not always straightforward. Stewardesses were selected from single, girl-next-door types but they had to be sufficiently polished to blend easily with wealthy passengers. In addition, they had to be cool, competent, and sympathetic in manner. Brought up in Lisbon, Tait found that her way of walking was deemed by her instructor to be too obviously sexy. It gave her a provocative air that an initial make-up trial did nothing to dispel. 'It was bad enough having a Continental wiggle; with that *and* the sort of face that had been painted on me no one in London would have had any doubts about my origin—or my profession,' she wrote.[32] Tait soon adopted a modest, pared-down look that left space only for the regulation matching lips and nails. Differently to their European counterparts, for whom para-aristocratic manners were important, American stewardesses aimed to please like the

stars and 'learned to *smile*!' 'On the Continental airlines like Air France, Alitalia, Lufthansa, and SAS, it was the norm for flight attendants...to behave most haughtily or at least cooler than their American counterparts,' Pan-Am stewardess Aimée Bratt observed. 'It was unacceptable on the American carriers in the cabins...In America, you have to smile or at least give the appearance of friendliness.' 'Nevertheless, in Pan-Am we still acted a bit "superior", or call it sophisticated, which was simply a result of flying the world for years.'[33]

At a time when mass air travel was starting and the romance of the skies seemed like a mixture of the adventure of the aviation pioneers and Hollywood, the stewardess embodied an ideal type who in her smiling, unruffled perfection seemed like nothing so much as a uniformed Ziegfeld Girl. Bratt recalled that she and her colleagues were rigorously moulded to a standard pattern: 'I don't know how it is possible, but we were glorified and humbled at the same time. We were molded into perfect stewardesses. Like soldiers in an army we had to cut our hair (it could not touch the collar), lipstick and nail polish had to be red or coral, make-up applied according to regulation, uniform skirt not too tight or too loose, and undergarments were mandatory—full slip, nylon hose, full bra, panties, and girdle—and we were checked periodically.'[34] Airlines gave their stewardesses a look whose maintenance required an ongoing performance in testing conditions. Like Tait, she gained some compensation from wearing the uniform. 'The Pan-Am uniform was actually great-looking,' she acknowledged; 'blue-grey gabardine, a pillbox hat (the fashion of the sixties), black high-heeled shoes, leather over-the-shoulder handbag, and white, white gloves! Some people thought of it as oppressive, but one has to admit—we had *style!*'[35]

Stewardesses were always associated at some level with sex. Even in the 1950s, when they were pictured as the perfect bride, their cordial smiles lured passengers to the companies. In his contribution to the collective film *Rogopag*, an episode entitled 'Illibatezza' (Purity), the director Roberto Rossellini explored a demure Italian stewardess's efforts to shake off the attentions of an amorous American businessman.[36] 'Something about plane rides gives some men the irresistible temptation to slap a stewardess' backside as she walks by,' *Life* had reported in 1941.[37] In the sixties, the airlines

ceased combating this image and worked explicitly to turn hostesses into flying sex objects, 'the carefree envy of women, the sexual fantasy for men'.[38] As competition for custom hotted up in the United States and advertising spending increased, they became the official face of airlines which turned them into the main attraction of air travel.[39] For Paula Kane, a stewardess of the 1960s who would revolt against being regarded as a 'sex object in the sky', 'the airlines...cleverly constructed the airborne fantasy world'.[40] Safety matters took second place in their recruitment and training to appearance and grooming. 'I don't know exactly what I expected in flight training school, but it was certainly not what I got,' she later wrote: 'the school was more like a crash course for the Miss America pageant. We were forced into a total, narcissistic self-absorption. Girdles, fingernail polish, false eyelashes, ratted hair, make-up, how to walk and sit down and climb stairs—these were our obsessions for the next six weeks.'[41] From the blonde bombshells of Pacific Southwest to the girls-next-door of United, 'We are supposed to be the fresh, wholesome girls who love men, the quiet concubines of the pilots, and the submissive partners to male sexual fantasies,' Kane lamented.[42]

The stewardess fantasy became embedded in the popular psyche at precisely the time when travel was separating work and domicile, loosening the bonds of family life and turning even next-door neighbours into strangers. For the public, hostesses led glamorous lives. They dated sportsmen and movie stars, they visited far-flung locations and were at home in cocktail bars, with which commercial planes were fitted in the 1950s. They were not imprisoned in a pattern of fixed obligations and social controls and were seen as sexually available. They went skiing in Switzerland, shopping in Hong Kong, and nightclubbing in Las Vegas. The glamour image was not entirely false and determined why some women joined the airlines and how passengers perceived them. 'Men dream of escaping their families for a few days of romantic freedom to another city, perhaps picking up a stewardess on the way,' Kane observed.

The male fantasy of quick and obligation-free sex was a product of the sensory environment of the American suburban dweller. Mass surburbia was a phenomenon of these years into which many middle-class Americans were

willingly integrated. New towns and residential communities were based on a pattern of standardized living that matched the domination of the economy by large corporations and the development of the mass consumer economy. They also met the strong post-war desire to settle down that fuelled the trend towards early marriage and the baby boom. In the suburbs, families lived the lifestyle of the modern home, family motor car, and stylish furniture, while continually being solicited to yearn for improvements. The range of goods and the choices they were presented with were astonishing. Surburban dwellers were not traditionalists; they were mobile, both socially and geographically, and their attitudes towards goods were similarly provisional. Only a minority of Americans in fact lived in the new suburbs, but these set the tone for modern lifestyles in the way that cities had done in earlier decades. In advertisements, television comedies, and even school textbooks, the average American had left the city for the practical paradise of suburbia.

Commentators and sociologists were intrigued by the new lifestyles and the sort of culture that was taking shape in an era of standardized prosperity. The suburban dwellers were participants in what the British writer and commentator J. B. Priestley called 'Admass', that is 'the whole system of an increasing productivity, plus inflation, plus a rising standard of material living, plus high-pressure advertising and salesmanship, plus mass communications, plus cultural democracy and the creation of the mass mind, the mass man'.[43] The journalist William H. Whyte, in his classic text *The Organization Man*, was the first to highlight the extreme conformity of the white collar workers who were the typical suburban dwellers. Although McLuhan would insist that the car had levelled Americans up towards the aristocratic idea rather than down, since it 'gave to the democratic cavalier his horse and armor and haughty insolence in one package',[44] Whyte found that suburbanites did not struggle to keep up with the Joneses but *down* with them. *Inconspicuous* rather than conspicuous consumption was the rule in settings where houses and lifestyles were broadly identical. 'When they see a neighbor vaunting worldly goods, they can see this as an offence—not to them individually, mind you, but to the community,' Whyte noted.[45] However, he added that, while people passed negative comment on conspicuous

display, they were always careful to add that they themselves saw nothing wrong with it; it was *other people* who might object. In other words, the downward pressure arose from fears of being left behind, but a leap ahead for oneself was not disdained as a prospect. The conspicuous display of the celebrities fed such dreams; their glamour provided a vicarious outlet for the secret aspirations of the masses.

The nervy concern with what others were doing and consuming, that Whyte highlighted, derived from a phenomenon that had been noted a little earlier by a prominent sociologist. David Riesman stimulated a wide-ranging debate with his idea that there had been a shift in the structure of human behaviour from what he called 'inner-direction' to 'other-direction'.[46] Other-directed behaviour was not reliant on values assimilated at an early age and held to be positive in themselves. It was, on the contrary, a behaviour pattern in which the individual was moulded by external pressures and suggestions. The sort of 'other-directed' personalities that Riesman saw as the new American character-type emerging with consumer society were typically young working women in their late teens or early twenties who were particularly reliant on their contemporaries and the mass media for their sources of orientation.[47] They were less 'inner-directed' than the older generation and placed more importance on exterior self-fashioning and personal relationships. Even in the workplace, they were less likely to think of themselves as loyal and efficient assistants than as 'glamor-exuding personalities'.[48]

The 1950s were the great heyday of American sociology and social psychology. New forms of living and working presented scholars with opportunities for all manner of inquiries. Glamour never emerged as an independent topic for the sociologists who studied American society. However, it can be glimpsed here and there in the interstices of their writings. Riesman mentions it a handful of times. In his view, glamour had been democratized along with consumption and as such had lost much of its capacity to enchant: 'Whereas the deprived inner-directed person often lusted for possessions as a goal whose glamour a wealthy adulthood could not dim, the other-directed person can scarcely conceive of a consumer good that can maintain for any length of time undisputed dominance over his imagination.'[49] Yet glamour remained a key tool to stimulate interest in goods. Glamour, he asserted, was 'one sovereign

remedy... to combat the danger of indifference and apathy'.[50] In packaging and the advertising of products, it substituted price competition and in politics it took the place of self-interest. In each case, it involved the use of psychological and aesthetic appeals attractive to the customer or voter.

In the era of high mass consumption, the home was a crucial counterpart to the new emphasis on mobility and travel. The British cultural critic Raymond Williams coined the term 'mobile privatisation',[51] to describe the transformation of the motor car into a travelling living room and the living room into a miniature cinema. The domestic environment had been a site of the reproduction of the bourgeois dream world since the mid-nineteenth century. Now this function was confirmed. The declining female presence in the labour market in the 1950s, coupled with the growth in the United States of the suburban ideal, heralded a renewed emphasis on the feminine in marking the visual appeal of the object world. In mass consumer society, the suburb—and the consumption in Europe of its idealized representation in advertising, film and television shows—stood for status, perfection, and domestication. Lacking the chaos of the street and the flux of the city, it offered an enclosed, privatized world that excluded the natural and took the place of the spontaneity of earlier versions of modernity. Competition over status and appearances centred on the home, especially the kitchen, the motor car, and the personal presentation of the housewife and mother. The primary mirror of this new world was no longer cinema but television. Visual broadcasting brought new faces into living rooms and added a new layer to family life. The television set replaced the hearth as the focal point of the home and its output provided a second-order experience of company.

If, in Europe, television was a powerful means of integrating rural and peripheral populations into urban ways, in the USA it was rather suburbia that triumphed. What defined television was its low intensity and its small size. This meant that the sort of environments that were best depicted on the small screen were either small and contained or varied in surface texture. Westerns seemed to work particularly well, whereas slick and glamorous metropolitan environments, such as stylish nightclubs and other places of entertainment, were better suited to the movie camera.[52] Presenters, entertainers, and situation comedy families were cordial familiar presences in an imaginary world.

Unlike cinema the medium did not provide detailed information concerning objects and the close-up was not the exception but the norm. As McLuhan observed, 'the audience participates in the inner life of the TV actor as in the outer life of the movie star'.[53] In contrast to the movie star, the television actor had a quality of ordinariness that blended in with everyday life; people seeing him on the street often could not place him or remember his name.

Despite its domestic focus and the important role of women in managing the home environment, television was a predominantly masculine medium in which women were severely underrepresented.[54] Newsreading, announcing, presenting, and even entertaining were exclusively or largely performed by men. Women, by contrast, played supporting or decorative roles. The women of the small screen were always polished and groomed, young or youthful, and smiling. In the gendering of roles, glamour was their prerogative. A striking number of quiz shows in the US and Western Europe deployed entirely mute hostesses who merely adorned the screen and provided a visual foil for male presenters. In the US, Marie Wilson and the curvaceous blonde Dagmar (born Virginia Egnor) provided the small screen with pin-up appeal while in Britain, the curvaceous blonde Sabrina, who appeared alongside comedian Arthur Askey in *Before Your Very Eyes* in 1955, offered a highly artificial, hyperbolic female image. Every time she was about to say something, the band, in a running gag, struck up to silence her. After becoming one of the most talked about and depicted people in the country, the former waitress moved on to more varied work in films and the theatre.

The few women who performed more serious roles often faced difficulties. These problems are exemplified by the case of Faye Emerson, who was a more complex figure of American television. A former B-film actor, Broadway performer, radio host, and newspaper columnist who presented a series of interview programmes in the early 1950s, Emerson was dubbed 'the first lady of television'.[55] With her famous décolletage, she presented a 'visual image of vivacious beauty' while also enjoying a reputation for intelligence. She initially presented a fashion programme on local television in New York before hosting late evening and prime time talk shows for CBS in which she would converse with guests on topics ranging from current stage shows to the Korean War. Emerson's shapely figure and groomed appearance were

always presented as being natural and genuine, in accordance with the medium's preference for the everyday. However, her unrehearsed braininess was less easily absorbable. Despite her sexualized persona, she was deemed an emasculating presence who did not fit in with television's emerging pattern of comfortable and passive female stereotypes. In Italian television, the only female presenter, Enza Sampò, was always paired on screen with a man. She was not permitted to undertake external broadcasts without the presence of a chaperone whose task was to protect her physical and moral integrity.[56]

The domestic ideology of television was not readily compatible with the highly constructed image of the film performer. Indeed, one commentator in the early 1950s argued that 'television, by bringing celebrities into every home has murdered glamour'.[57] 'Old fashioned glamour and mystery', Mary Margaret McBride asserted, had been eroded by greater accessibility. Others felt that even the movie stars of the 1950s 'have sex appeal but they don't have that old-time mystery'.[58] Too much was known about their lives for them to be intriguing. They no longer even received the sort of build-up that was usual in the past, largely because the studios did not have the same degree of ownership over them and control over their careers. Nevertheless, there were stars who had been forged a little earlier whose larger-than-life images were not compatible with television. For McLuhan, this was because television was a 'cool' medium and the movies a 'hot' one. Television made fame look banal and challenged the premiss that notoriety and success were absolute values.[59] The exceptional qualities ascribed to the big stars clashed with the commercial and domestic nature of the medium.[60] Thus it was mostly second- or third-rank film stars, like the redhead Lucille Ball, whose domestic situation comedy *I Love Lucy* was a worldwide hit, who migrated to the new medium. After her big-screen role as dancer Jane Avril in John Huston's *Moulin Rouge* and her headline-grabbing marriages and affair with Porfirio Rubirosa, Zsa Zsa Gabor found that there was a more ready audience for her glamorous mixture of gold-digging tips and European sophistication on television. In dramas and talk-show appearances, she translated a real world of international café society into suburban commercial terms and became the fantasy alter ego of every housewife. She appeared regularly on *The Jack Paar Show* and told audiences of the three telephones

she had at her bedside in Bel Air (to receive regular calls from London, Paris, and New York, she said) and her liking for wearing three perfumes at once. She sponsored so many products and spent so much time on her public presentation that, she claimed, she became 'Zsa Zsa Incorporated'.[61]

The sort of female image that television conveyed to housewives was a man-made one that was accessible to everyone so long as they bought the right products. The mass media of the period demanded of women a continuous self-scrutiny that was crucial to the selling of cosmetics, clothes, and domestic accessories. Quizzes and magazine articles compartmentalized women in terms of acceptable traits, creating pigeonholes for them to slot in to.[62] In American society, cosmetics companies like Max Factor put all their discoveries immediately at the disposal of everyone and took on the task of spreading the word about beauty.[63] The Revlon company reached a huge market by sponsoring the popular television programme *The $64,000 Question*, but in the process lost much of its class appeal. One of the most striking features of the beauty industry at this time was the diffusion of hair dye.[64] Companies like Clairol and L'Oréal vied to tie their products to evolving feminine ideals. They promised customers that by going blonde they would fully enter the world of glamorous modernity even while staying within their own homes. The perfect tableau of domestic life was completed by a housewife who resembled a star. The genius of L'Oréal lay in its tying domesticity to self-confidence with its 'Because I'm worth it' slogan.

Goods were packaged in the 1950s in ways that blended artificial femininity and glamorized objects. This practice had a number of precedents. Cellophane, originally invented in France, was a perfect example of a man-made product that became the epitome of glamour and elegance in a society that had displaced the natural. Even when no protective wrapping was needed, when visibility was of no obvious value, cellophane's shimmering presence provided ordinary, everyday products with a strong dose of what retailers coyly referred to as 'eye appeal'.[65] It lent a touch of glamour and gloss to the most mundane objects, lifting their appeal by enhancing the context in which they were sold. It had something alluring, even cinematic, about it. In Cole Porter's song 'You're the Top', the line 'Your Garbo's secretary' was immediately followed by 'You're cellophane'. In the exuberant

style of the Busby Berkeley musicals, it encased mundane reality in a shiny new outfit and made it look like a Christmas gift.[66] This effect of cellophane packaging was similar to striptease, which achieved its effect by constantly making the unveiled body more remote. Products were available but untouchable and therefore inaccessible. Ostensibly, everything was there to be seen but their packaging associated them with an icy indifference, a haughty distance from the grubby fingers of the masses.[67]

Glamour, in its American application, implied a democratic making available of the discoveries that scientists had made. It was infused with novelty and mass appeal. This notion was especially pronounced in beauty advertising but it also transferred to domestic goods. A product of applied technology, plastic was a great innovation that somehow encapsulated the pliant femininity of the period.[68] This aesthetic lives on in the Barbie doll. A product of the late 1950s, it offered an image of perfect, constructed femininity in moulded plastic form. As a toy, it provided girls with a consumption ideal; as an exaggerated, inorganic feminine image, devoted to waste and self-fashioning, it also offered a new version of the artificial female model of the late nineteenth century. Like a film star, Barbie offered a face full of nothing that demanded that she be transformed into something.[69] Barbie was the ultimate conformist, a truly malleable woman, and her willingness to please led her to adopt every new style.[70] Her 'availability' was intrinsically linked to her being made of plastic.

Plastic came in a variety of forms, some of which carried upmarket associations while preserving the mass appeal of a manufactured product. They added a fantasy dimension to daily life, taking sex appeal into the home. The new plastics, many of which had been developed during the war years, reshaped the domestic landscape. Their inorganic allure came to be associated with the explosion of synthetic colour and pinks that was bound up with technological development and the extension of consumerism to wider sections of the population.[71] In the form of small kitchen accessories and items of tableware, they performed the role of units of pure colour which could be arranged in the interior like paint marks on a canvas.[72] In this way, they matched the garish Technicolor movies of the fifties. 'Plastic is wholly swallowed up in the fact of being used: ultimately, objects will be invented for the sole pleasure of using

them,' Barthes predicted in 1957. 'The hierarchy of substances is abolished: a single one replaces them all: the whole world *can* be plasticized, and even life itself since, we are told, they are beginning to make plastic aortas.'[73]

Tupperware was the emblematic American plastic product of the 1950s, the epitome of the attempt to glamorize the domestic environment. Invented by an entrepreneur named Earl Tupper, it was tough, mouldable, and frosted translucent. Unlike the hard, monochrome, and masculine Bakelite, it was soft and sensual and available in a wide range of pastel hues. Through the innovative selling device of house parties, Tupperware became a central part of domestic feminine culture. Plastic containers for preserving food may seem far from glamour, but Tupper's world has been seen by some observers as one that oozed sexuality and kinkiness. It was a fantasy world of garish colours and girly goodies dispensed by a big daddy who understood all the fetishes and obsessions of his female customers.[74] Colour mania was ultimately the sign of a definitive cultural shift away from the natural. Barthes noted that the spread of 'chemical-looking' colours derived from plastic's inability to retain any other type; 'of yellow, red and green,' he wrote, 'it keeps only the aggressive quality and names, being able to display only concepts of colours'.[75]

Brash pastels subsequently became linked with what was seen as the vulgarity of 1950s consumerism and its particular manifestation in the appearance, homes, and possessions of the Hollywood film stars of that period.[76] In fifties' America, Beverly Hills was not so much a dreamland as an exaggerated version of suburbia. If, as has been claimed, glamour is 'the ugly stepsister to elegance',[77] then it was exemplified by the lifestyles of stars like Kim Novak, who lived in a house in the Bel Air district of Los Angeles that had colour-themed rooms. When press agent Bill Davidson visited her, he was offered a breakfast that consisted of caviar, pickled green tomatoes, French toast, Roquefort cheese, and champagne.[78] The star herself was wearing a skintight black leotard. 'You can't just have a plain old Rolls-Royce in Hollywood,' he wrote; 'it must be a custom-made Rolls-Royce fitted with liquor bar, make-up bar, reclining seats and two telephones.'[79] Quantity and novelty were just as important as quality in a society that was dominated by the newly rich.

In the 1950s, Hollywood glamour presented itself with at least two faces. On the one hand, there was the lady, on the other there was the sex goddess. Although the golden age of the studios was coming to an end and film-going was in decline, the majors responded energetically and in various ways to the challenge of television and consumerism. Colour film and the widescreen Cinemascope were two strategies employed to differentiate the experience of film-going from that of television. Another was a greater emphasis on sex. Marilyn Monroe provided 1950s audiences with an unrivalled body-spectacle. Instead of the porcelain-hard artifice of a figure like Jean Harlow, she offered a pliable, vulnerable humanity that was trusting and available. In keeping with her origins as a pin-up, she was a persona created for male pleasure and male consumption. Monroe was the emblematic star of the 1950s, the last and most perfect product of the studio system. With her trademark blonde hair, perfect white complexion, and shiny red lips, the sensual curves of her body, and her infantile manner, she was the star par excellence, the figure who most completely represented the concept of Hollywood glamour for the world public. Modelled by 20th Century Fox as the stereotypical blonde, the physical incarnation of the idealized pin-ups that soldiers had known during the war, she became the ideal woman and the embodiment of America at the time of that country's ascendancy. She was neither the first sex symbol nor the first dumb blonde, but somehow she managed to combine these qualities and dress them with an air of healthy innocence.

Monroe was highly sexualized as a star figure. Her breasts, the famous wiggle of her hips as she walked, and her parted lips all signalled availability. In contrast to stars like Joan Crawford and even Rita Hayworth, whose elaborate wardrobes and grooming signalled their particular relationship with female audiences, Monroe relied to an unprecedented degree on her body for her appeal to men. Although the sexualization of star figures dovetailed with the central importance that sexuality was assuming in the dynamics of individual identity in consumer society, Monroe's compliant availability was far more restrictive a view of femininity than had been offered by any previous major star.[80] Her full-colour nude calendar shot published in the first issue of *Playboy*, but taken several years earlier, opened the way to a narrow but persistent definition of glamour as soft

pornography. Her image was not a total invention. Whereas Grace Kelly's wealthy, genteel background was used to cultivate her image as 'elegant' 'lady-like', 'patrician', Monroe's youthful waywardness and early marriage were used to bolster a more sexually connotated and vulnerable image.[81]

Monroe's success in films including *Niagara, Gentlemen Prefer Blondes, How to Marry a Millionaire*, and *Some Like It Hot*, served as an example to other studios. In the era of high mass consumption, production took place in series and this applied no less to stars than to automobiles. Hollywood had cloned copies of successful originals from the 1920s and this was even more the case in the 1950s. Indeed production and reproduction occurred simultaneously. Mamie van Doren, Sheree North, and the British Diana Dors were all Monroe imitations, while Jayne Mansfield and Anita Ekberg, with their outsize breasts, seemed more like parodies. Mansfield was the type of star who believed that it was her duty to bring the public into her life. Groomed explicitly as a rival to Monroe, of whom she imitated the giggly 'the girl can't help it' screen persona, she lived with her muscle-builder husband Mickey Hargitay in a pink palace with a heart-shaped pink swimming pool. She represented the same opulently synthetic aesthetic that produced the monstrously kitsch 1959 Cadillac Coupe de Ville.

Dors was one of the products of the British studio Rank who lived out the dream of the ordinary girl who wants to be a film star. Although she was trained by the studio's famous charm school to speak properly, dress well, and behave with good manners, she had an earthy quality that made her ideal for promotion as a home-grown sex goddess.[82] Her success was based on her being, according to the film critic Raymond Durgnat, 'a happy rendezvous of old vulgarity and new affluence'.[83] She was the highest-paid film star in Britain in 1956 and she cheerfully embraced every aspect of the materialism of the age. She was a bottle blonde, exuberant, and vocal; she made no secret of her ambition for celebrity and wealth. She even exceeded Mansfield in her numerous publicity stunts, which included wearing a mink bikini in a gondola at the Venice film festival and arriving at the Cannes festival in a pink Cadillac. Sex and glamour were what the public expected from her and they were what it got. Although she was lured to the United States by the offer of a contract with the minor studio RKO, she became

better known for her personality and appearance than her films. A brassy East End girl made not quite good but at least an eye-catching phenomenon, she filled magazines with the soap opera of her personal life. She had a strong American veneer, but her British fans related to her real-life struggles against adversity.

In an era in which publicity was as omnipresent as plastic, the stars were no less subject to planned obsolescence than the electrical appliance. They were disposable figures for whom publicity was a lifeblood that spelled 'the difference between legend and oblivion'.[84] Because, beneath the image, there was a human being, this process produced tragedies. To bear the burden of constant scrutiny and figure as a cipher for all collective aspirations and preoccupations—from beauty and fashion, to love and sex, and leisure and lifestyle—was too much for several stars. The intolerable pressure on the apparently carefree Bardot was fearlessly scrutinized by Louis Malle in the film *Vie privée* (A Very Private Affair), which was closely modelled on real life. Marilyn Monroe was the last seductive image produced by the studio system before its final demise. The ending of the old studios' domination of distribution and exhibition, as well as declining audiences, brought a whole phase to a close. Her death in August 1962 signalled the end of an era. It revealed that tragedy lay behind the polished image of the wonderful, rich, happy life of the stars. For Edgar Morin, 'the death marks the end of the star system. It is the natural demythologising element, the dam through which the truth flows: there no longer exists a star-model, there no longer exists a happy Olympus.'[85] After her death, stars were no longer seen as perfect or even necessarily as happy.

The desire to be famous, to step up into the limelight, was none the less widespread and was encouraged in various ways. The role that had been occupied in the press of the interwar years by the debutante was taken over by the beauty queen. The formation of national communities through the media and the egalitarianism of the age led to mechanisms of selection of candidates for fame that were more open and transparent. Beauty contests had existed since the early years of the twentieth century but in the 1950s and 1960s they developed into national spectacles and big business. Originally devised to promote holiday resorts by lengthening the season, they evolved from beachside

amusements into glitzy spectacles that provided work for numerous organizers, choreographers, beauticians, consultants, sponsors, journalists, and broadcasting executives.[86]

The Miss America pageant, which had been established in 1921, was brought to the centre of the mainstream in 1935 when the its image was recast as one of respectability by Lenora Slaughter. It was due to her influence that Miss America became 'the ultimate celebration of the girl-next-door'.[87] The wide coverage of the contest in newsreels and the press and the proliferation of local contests turned hundreds of thousands of young women into potential contestants. While spreading the dream of a glamorous new life, the pageant demanded that the winner be an icon of virtue, innocence, family values, and patriotism. Contestants were chaperoned to ensure respectability and a clean moral image. It required ordinariness and a commitment to self-improvement and rewarded the chosen few with a car, a glamorous wardrobe, jewellery, scholarship funds, and an exciting life for a year. The contest was broadcast live on American television from 1954. Miss Italia attracted national attention from its creation in 1946 and Miss France from its resumption in 1947. The first Miss World competition took place within the Festival of Britain in 1951. All these events were covered in newsreels and on television from the 1960s.

Although the contests were strangely unmemorable, efforts were made to turn the finale into something that seemed substantial. The investment of money in evening dress parades, 'personality' competitions, and the crowning ceremony itself all contributed to the artificial creation of a fantasy event. The illusion of substance rested on all concerned, organizers, spectators, press, and contestants, taking it seriously.[88] The choreography of the contest was pioneered in the United States and then widely adopted elsewhere. Eric Morley, the creator of the British-based Miss World, availed himself of American expertise in the field of showmanship to bring glamour to the occasion.[89] By staging a lavish final in the style of a musical show, that was broadcast on television, he introduced what he called 'the charms of the surface' and '*professional* glamour'.[90] For many contestants, the pageant final was the concluding stage of a long process of competing in local and regional competitions, gaining experience, and honing their presentational skills.

While most of the audience viewed pageants as the lightest of light entertainment, they required of participants determination, self-confidence, congeniality, poise, beauty, and polish.

Each contest followed the same basic format although the criteria of selection were variable. Following parades in swimsuits and evening gowns, the final five contestants were summoned forward to hear the announcement of the winners.[91] Finally, the ecstatic winner, unable to control her emotions, was crowned with a tiara and adorned with a sash that proclaimed her title. Winners received many lavish prizes and they travelled the world on jets, visiting far-flung places, meeting celebrities, heads of state, and religious leaders. They were accorded extensive media exposure. As queens of the people, they were given royal treatment. 'Who isn't jealous of Miss World?', asked one journalist. 'Millions of ordinary hard-working girls would like to exchange positions with her, to taste the nectar of her exotic life even just for a day. It would make a pleasurable reprieve from the office or factory, where they are incarcerated.'[92]

The beauty contest turned the everyday practices of feminine grooming into a spectacle to be scrutinized and assessed by all. They existed in a context in which the feminine ideal was constantly being redefined and they became televised spectacles that were followed by everyone.[93] Newspapers and magazines found that coverage increased sales massively. The fashion element made them fascinating to women and girls. The winner was expected to behave with a majestic mixture of cordiality and reserve; she had to be friendly but elegant, forever smiling but spontaneous. As Miss Great Britain 1960 later said, 'I had to be immaculately turned out, but not flashy, look like a film star, but act and walk like a lady and talk well.'[94]

'Beauty contests on TV were a magic mirror that, willy-nilly, made every girl and woman into a participant . . . and recalcitrant tomboys like me were not exempt' recalled the author of a book about the contests.[95] 'In our dizzy identification with winners and losers alike,' she added, 'a whole generation of women and girls in the fifties and sixties tumbled in a narcissistic dream of our own potential perfection.' Those who took part in the contests found that they were an ideal way to reinforce their fantastical, secretly glamorous self-image by arousing the admiration and envy of others. Wearing elegant

evening dresses made them 'feel marvellous', 'glamorous', and 'dreamy'.[96] As one British contestant later recalled, 'Dressing up always makes you look and feel good.'[97] While the custom of high grooming and costly outfits aroused the hostility of some left-wingers, many former contestants recalled that their self-confidence was boosted by the experience. 'The only negative thing is that everyone expects me to look 22–24 for ever, [which is] an awful strain,' commented one.[98]

The driving aim, however, was commercial. It was to find girls who went over well with the public, who created something akin to a sales atmosphere. They could then be used to market any product or cause. Contests were a huge industry that helped sell newspapers, promote resorts, advertise products, and maintain interest in beauty products. Sponsors were an important feature of the American competition from the earliest days and they became increasingly important in Europe in the 1950s. It was this commercial exploitation of beauty that provoked the first feminist critiques of beauty contests and the first revolts against them in the late 1960s. Winners were generally expected to conform to standardized ideals and when they did not, like Bess Myerson, the only Jewish Miss America, who won the contest in 1945, they were ignored.[99] Many contestants dreamed of becoming film stars and they were comforted in this by the knowledge that some of the most famous stars had first emerged in the pageants. Diana Dors, for example, had first been spotted at a beauty contest in 1945 and in Italy, Gina Lollobrigida, Sophia Loren, and many other post-war actresses had reached the finals of the national Miss Italia competition. The opportunities available to finalists in the beauty contest heyday of the 1960s were numerous. Television rather than cinema offered multiple possibilities for ornamental femininity: hostesses, link announcers, and game-show assistants were all recruited from the pageants.

The wide use of 'the sexual sell' in mass consumption was a phenomenon that feminist Betty Friedan related to the increasing depersonalization of social relations and the focus on suburban domesticity.[100] A society that relied on the mass media and consumer goods for its connecting texture transferred human instincts to the vicarious realm, she argued. This was a more complex position to that of the author of *The Lonely Crowd*. For David

Riesman, sex was important in modern society as a response to apathy. Because it was a biological impulse that could not be ignored, sex provided 'a kind of defense against the threat of total apathy'.[101] The other-directed person gave prominence to sex because 'he looks to it for reassurance that he is alive'. Curiosity about—and envy of—the sex lives of others was enhanced because 'sexual glamour' had been democratized: due to 'the mass production of good-looking, well-groomed youth' it was available to all. As such, sex manuals had become 'matter of fact, toneless and hygienic'.[102] By contrast, he argued, cookery books had, in the era of other-direction, become more glamorous. They privileged visual effects to attract readers and help them embellish their tables with eye-catching dishes. 'The sphere of pleasure and consumption is only a side show in the era of inner-direction, work of course being the main show. This is truer for men than for women,' he noted.[103] For outer-directed people, this sphere was absolutely central. While Riesman assumed that improvements in health and standards of living meant that sex was more widespread, Friedan argued that commercial fantasies in the form of 'sex-glutted novels, magazines, plays and films' were the corollary of the disappearance of sex from suburban marriages.[104] The 'spurious senselessness of our sexual preoccupation' stemmed from this paradox.

While women were not supplied with many fantasies, there was an extraordinary variety and sophistication of the forms of female spectacle that were available to men. These accustomed them to think of women in terms of their conformity to a standardized model. The leading sociologist C. Wright Mills drew a striking picture of a feminine type, which he called 'The All-American Girl', who had absorbed all the lessons of female spectacle of the previous half-century. This category included both professionals and young housewives:

In any New York night club on a big night at the time of the two o'clock show her current model can be found: with the doll face and the swank body starved down for the camera, a rather thin, ganted girl with the wan smile, the bored gaze, and often the slightly opened mouth, over which the tongue occasionally slides to insure the highlights. She seems, in fact, always to be practising for those high, nervous

moments when the lens is actually there. The terms of her competition are quite clear: her professional stance is the stance of the woman for whom a haughty kind of unconquerable eroticism has become a way of life. It is the expensive look of an expensive woman who feels herself to be expensive. She has the look of a girl who knows her fate rests quite fully—even exclusively—upon the effect of her look on a certain type of man.

This is the queen—the all-American girl—who, whether she be debutante or fashion model or professional entertainer, sets the images of appearance and conduct which are imitated down the national hierarchy of glamour, to the girls carefully trained and selected for the commercial display of erotic promise, as well as to the young housewife in the kitchen.[105]

If modern society indeed organized women in terms of a hierarchy of glamour, and housewives were at the bottom of it, then even the most domesticated of men were systematically led to explore higher levels, or at least were being tempted by them. There had been major developments in erotic display since the war. During the conflict, men had got used to vicarious sexual satisfaction in the form of idealized pin-ups. Stars like Rita Hayworth and Betty Grable, or the fantasy illustrations of artists like Alberto Vargas ('Varga') and Gil Evgren, presented soldiers with pictures of healthy, optimistic, and erotically desirable women. As the conflict receded and organized leisure developed on a new scale, the pin-up girl also moved closer to the mainstream in the advertising culture of post-war consumerism. Having burgeoned in a subcultural milieu of men without women, she became the embodiment of the male-dominated American dream ('To a Frenchman, a pretty girl drinking from a Coca-Cola bottle is a gangster's moll or a hippie or some other out-of-the-ordinary personage. To an American, she is simply thirsty,' remarked one observer of the phenomenon).[106] At the same time, fantasies of eroticized femininity prospered in live entertainment. Burlesque stage-shows were offered by dedicated theatres, vaudeville houses, and nightclubs. These varied greatly in quality and sophistication from down-at-heel 'bump and grind' acts to lavish and ritzy striptease shows. On account of local censorship, performers seldom offered the sort of nude show that had been honed into a fine art in Paris. Instead, they developed elaborate stage personalities and used props and gimmicks to signal

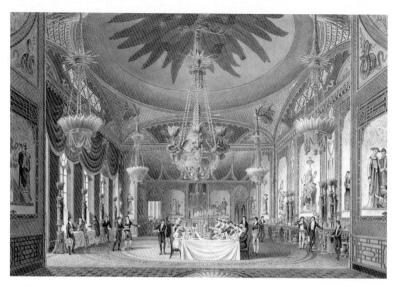

1. George IV, as Prince Regent, encouraged the creation of the Royal Pavilion in Brighton as a fabulous building of dreams and desires. The outside was Indian-inspired, while the interiors were Chinese and Japanese.

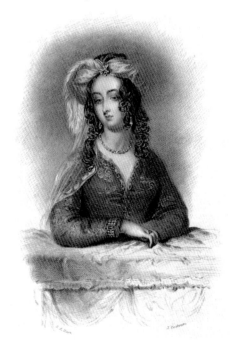

2. Rebecca, the fascinating and beautiful Jewess from *Ivanhoe* whose elaborate dress and ornate jewellery broke the rules of good taste.

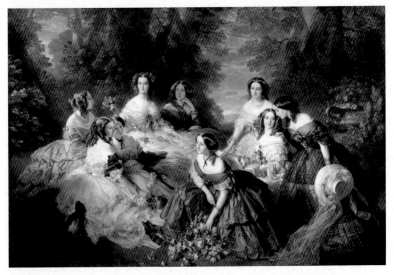

3. Winterhalter's sumptuous portrait of Empress Eugénie surrounded by her maids of honour depicted a dumpy royal consort as an icon of grace and style and furnished the parvenu imperial court of Napoleon III with a seductive élan.

4. The Moulin Rouge music hall was marked by an eclectic jumble of styles and artefacts (the model elephant came from the 1890 international exposition) where overt female sexuality was marketed as entertainment to wealthy customers.

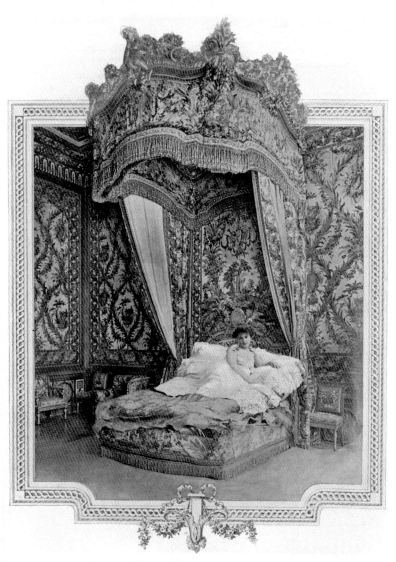

5. 'Si j'étais reine': Parisian courtesans and showgirls lived out popular fantasies of wealth and upward social mobility; as such, they were dazzling role models for thousands of ordinary women.

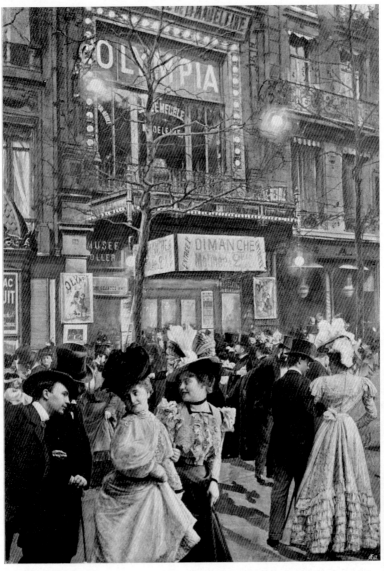

6. 'Sur le Boulevard': The Paris boulevard in the evening was a place of glittering commercial enchantments where smart men and women promenaded and engaged in flirtatious exchanges.

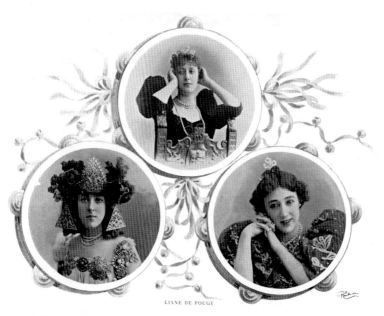

LIANE DE POUGY

7. Émilienne d'Alençon, Liane de Pougy and Caroline Otero were the top three courtesan-performers of the Belle Époque. Arch rivals, they competed over the size of their jewellery collections and for space in the gossip columns.

8. Paris in the nineteenth century was the capital of eroticism where photographic sex appeal was first developed as a subtle tease for male consumers.

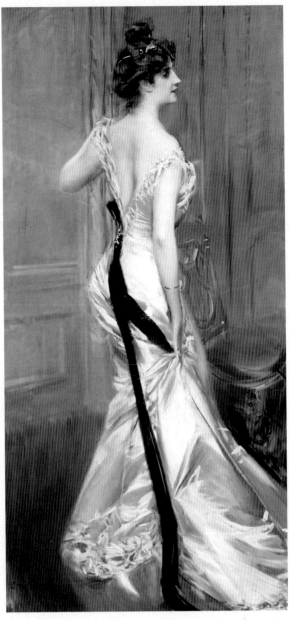

9. Italian painter Giovanni Boldini developed a uniquely potent pictorial style based on high fashion and sex appeal that he drew on to depict numerous wealthy female subjects as stylish seductresses.

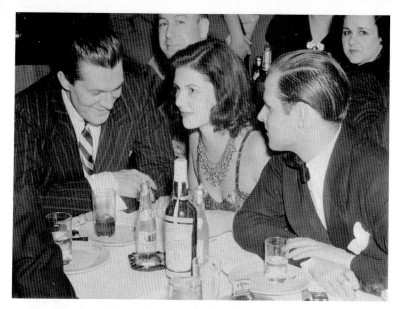

10. (*Above*) Brenda Frazier, American 'Glamour Girl No.1' of 1938, was a popular debutante who became a publicity-magnet and a press personality.

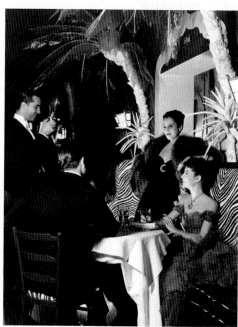

11. (*Left*) New York café society in the 1920s met at clubs like El Morocco where photographers were on hand to ensure socialites and celebrities were always pictured for the papers.

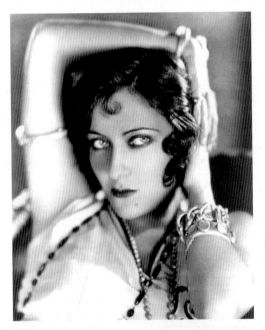

12. The shopgirls' idol, film actress Gloria Swanson was the most photographed woman of the post-World War One era. Groomed for stardom by British aristocrat Elinor Glyn, she married a minor French nobleman in 1925.

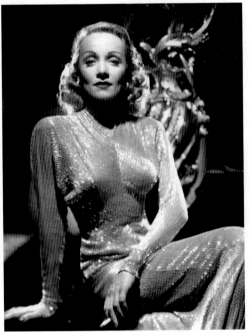

13. Marlene Dietrich was turned by Josef von Sternberg into a dazzling photographic illusion but her screen image owed much to Paramount's costume designers and her own steely professionalism.

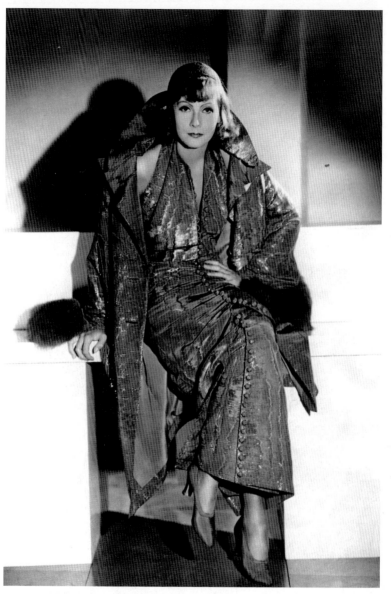

14. MGM's glamour queen Greta Garbo tantalised film audiences by projecting a sumptuously-costumed, world-weary sexual allure while refusing to pander to intrusive publicity.

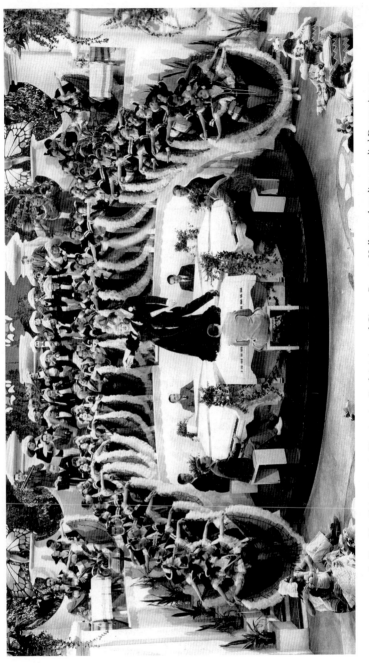

15. In films like *Flying Down to Rio*, starring Fred Astaire and Ginger Rogers, Hollywood studios supplied Depression-era audiences with superlative spectacles blending luxury, excess, optimism and mass enchantment.

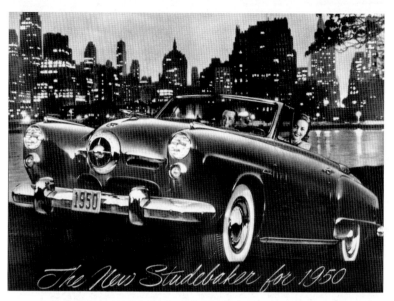

16. The bullet-nosed 1950 Studebaker seduced suburban American consumers with fantasy-laden design features which advertisers combined with sophisticated suggestions of the urban nightscape.

17. Rome's Via Veneto, as depicted in *La Dolce Vita*, was a nocturnal meeting point of international café society and a hunting ground for scandal-mongering Paparazzi.

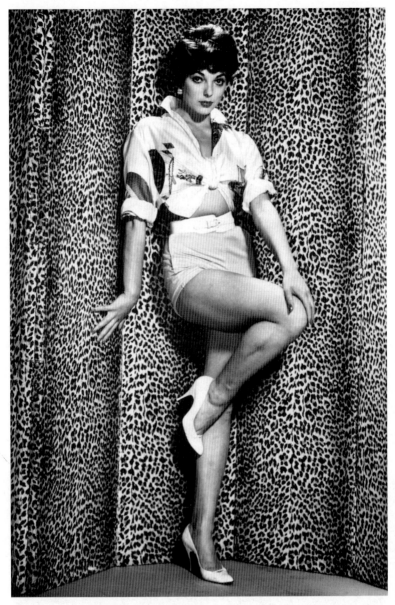

18. In her early career at Rank, where she was promoted as 'the British Ava Gardner' Joan Collins mastered a repertoire of seductive poses and calculated sex appeal that she later deployed in her role as Alexis Carrington in *Dynasty*.

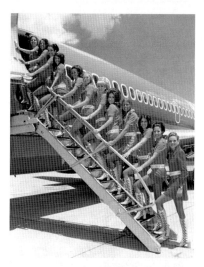

19. (*Right*) In the 1960s, companies like Southwest Airlines turned stewardesses into brand images and replaced the traditional emphasis on their efficiency with explicit sex appeal and the buzz of showbiz.

20. (*Below*) Beauty contests like Miss World 1970 offered a mixture of glamour and showmanship in which grooming and deportment were as important as physical perfection.

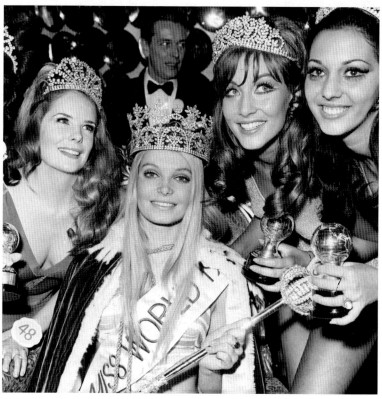

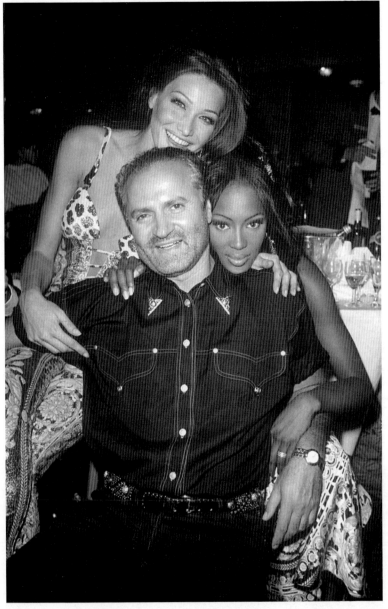

21. The fashion designer Gianni Versace, shown with models Carla Bruni and Naomi Campbell, was labelled on his death as a master of glitz and glamour who glorified sex and excess.

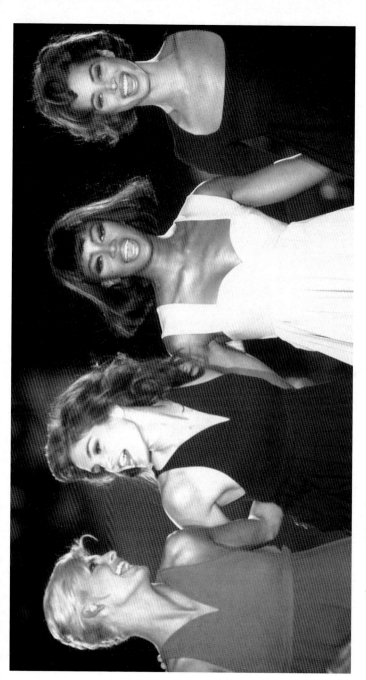

22. The supermodels Linda Evangelista, Cindy Crawford, Naomi Campbell and Christy Turlington were latter-day silent stars whose glamour concealed the sleazy underside of the model industry.

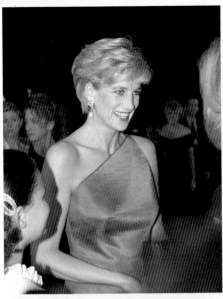

23. *(Left)* Diana, Princess of Wales stepped out of the frame of royalty to develop a powerful personal allure based on beauty, style, sex appeal and individual charm.

24. *(Below)* Paris Hilton (right), shown here with Nicole Richie, her partner on the TV reality show 'The Simple Life 2', marketed herself as the embodiment of the Beverly Hills heiress and party girl.

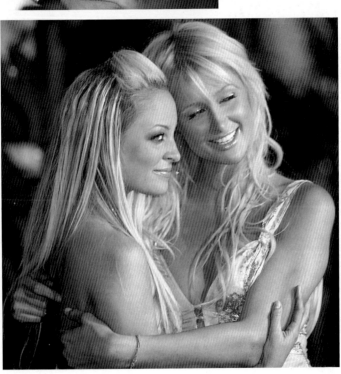

individuality. The top performers became part of integrated programmes of entertainment in upmarket supper clubs and the large hotels of Las Vegas and Miami Beach. The flame-haired artiste Tempest Storm, who was widely seen as the queen of burlesque, matched the period's taste for the outsize. Her curvaceous figure suggested an 'excessive sexual appetite and the fantasy of sexual appetite'.[107] A larger-than-life figure, she owned Cadillacs, dressed in Cassini and Dior, and had a diamond collection to rival those of the Paris courtesans of yore. Like them she numbered some of the most celebrated men of her time among her lovers.[108] Her films of the mid-1950s included such masturbatory delights as *Hollywood Peepshow* and *Teaserama*.

Burlesque performers were sometimes launched by photographers who eagerly supplied a whole market of clandestine and semi-clandestine magazines for male consumption. Often short-lived, due to both the threat and reality of prosecution, titles like *Gent, Frolic, Show, Vue,* and *Escapade* featured nude or semi-nude models in a variety of standardized erotic poses and costumes. In Hollywood, nude photography was a commercial milieu parallel to cinema in which both aspirant and downward-sliding women found a role. There was a whole clandestine photographic market in the United States. Some of this operated on the basis of private commissions. Even the studio photographers occasionally took naked shots of female subjects for private use. George Hurrell claimed that he personally 'was never asked to do any private shots of stars for any of the executives in the studios' but he implied that other photographers were.[109] To avoid prosecution, photographers claimed that their work was pro-health or art-related. The most common camouflage, however, was glamour. Since glamour and sex appeal were so closely related, the term was widely used from the 1950s as a synonym—and sometimes as a euphemism—for erotic or soft-pornographic photography. A glamour photographer was a specialist in the polished presentation of female nudes.

Bruno Bernard was one of the more legitimate practitioners of this applied art. A German Jewish exile who set up in Los Angeles in 1940, he traded off the Hollywood name. 'Bernard of Hollywood' was one of the major signatures of pin-up photography. His aim was to 'sell' actors to the studios and, reputedly, he was expert at transforming 'nice-looking' women

into larger-than-life illusionary beauties. One aspiring actress who entrusted herself to him was the future Marilyn Monroe. She was convinced that a portfolio of sex pictures would get her work. Bernard disagreed and told her that she should counterbalance her curvy figure with a look of complete innocence. 'Blend waif with Venus and you'll create combustion in photos,' he affirmed.[110] Under his tutoring, 'she changed the French baby-whore look into a variety of child-woman expressions'.[111] Sexuality remained her platform but it was moulded and contained by the criteria of the time. The result was a fabricated identity that would shortly evolve into 'Marilyn' the sex goddess.

A photographer who pursued a more specific erotic agenda was Russ Meyer, who would make his name in the 1960s with a series of low-budget erotic adventure films featuring large-breasted women. Meyer had no time for pseudo-artistic pretension. 'I am clearly in the business of producing glamor pictures for magazines for the express purpose of making money. I won't go as far as to say this is the only reason, but I will say it is the primary one,' he admitted.[112] He based his whole approach on the conviction that full-figured actresses like Marilyn, Anita Ekberg, Jayne Mansfield, and Sophia Loren succeeded at the box office due to their physique: 'if I may draw a parallel, my own production of glamor photographs has been greatly affected by my choice of full-bodied subjects,' he declared.[113] He made his base in Hollywood because of its marketing appeal but also because he found that there was no shortage of suitable subjects to be encountered even on the streets of the movie capital. Meyer began by photographing burlesque artistes, chorus girls, dancers, and so on. He claimed to have discovered Tempest Storm, who he photographed on several occasions.

With his forthright appreciation of the shapely female figure and adolescent references to what he called 'tittyboom',[114] Meyer exemplified the organized lechery that characterized this sector. However, the lucrative nature of the market and the opportunities it offered for female exhibitionism appealed to some women. Bunny Yeager established herself as one of very few all-round female protagonists of the art of male entertainment. A blonde beauty with a tanned body who loved southern California's beaches, she was a pageant winner who became a pin-up cover girl. Then

she took up designing swimwear and turned her hand to photography. Yeager quickly established herself as a leading 'photographer of female pulchritude', to use her own description.[115] Several of her typical scenarios were reminiscent of movie scenes and she played herself as a photographer commissioned to capture Las Vegas showgirls in the film *Bunny Yeager's Nude Las Vegas*. Compared to Meyer's preference for the outsize, Yeager's models were lithe and she photographed them with a certain grace. However, both favoured movement in their models and preferred to shoot in the open air. Meyer talked of 'outdoor glamour', that is to say a natural look where nature contributed to the overall effect, while Yeager often used jungle settings and went for beach and swimsuit shots.

Both of them recognized the importance of a model having the right sort of face. 'Attractive facial characteristics' were vital both to delight the consumer and create a mood reminiscent of the pin-up. Yeager shot hundreds of models in the course of her career. Her most significant discovery was Bettie Page, the one erotic model who became well known not only because of her popularity but also because she was called before a Senate committee investigating obscenity. Page was not the most beautiful or striking of models. Nor, with her long, dark hair and averagely proportioned but toned physique, was she a product of the prevailing taste for artifice and excess. She established a huge following among men, it has been argued, because she was able to cover in a convincing way a wide range of niche tastes, from the beach shot to the sinister darkness of fetish wear, through the exoticism of jungle settings. Her 'on-tiptoes' poses and looks of innocent surprise meant that glamour pictures featuring her were always closer to tease than sleaze.

Yeager made Bettie Page famous by sending her pictures to *Playboy* founder Hugh Hefner who made her 'playmate of the month' in January 1955. Yeager had appeared in *Playboy* herself and was aware that the magazine, founded in 1953, was qualitatively different from the small-time publications that dominated the sex market. By virtue of its status as a class publication, it gave glamour photography legitimacy. It presented a curious mixture of luxury goods, conspicuous consumption, and airbrushed sex appeal. It was ostensibly aimed not at the furtive reader of men's

magazines, but at the affluent, sexually attractive bachelor who was stylish and uninhibited. Hefner himself lived a lifestyle that was footloose and swinging. Perennially attired in pyjamas and dressing gown, he gave the impression that his main business was conducted at night, in strip joints, clubs, and casinos. Packed with upmarket advertising, *Playboy* deployed its centrefolds to guarantee the heterosexuality of its consuming male readers. At first, it employed professional models like Page, but then Hefner hit on the idea of recruiting girls-next-door such as contestants in the Miss America pageant.[116] This decision propelled the magazine to the centre of mainstream culture.[117] Several of the centrefolds were photographed by Meyer, including one featuring his wife Eve. As his profile grew, he also did portraits of female stars including Anita Ekberg, who, he said, was the most beautiful of all his subjects.[118]

Europeans often found it difficult to understand the whole business of pin-ups and centrefolds. 'Examine a group of modern pinups: at first they look extremely suggestive and in some ways they are,' wrote Richard Hoggart in his analysis of post-war British working-class culture.[119] 'And yet they are strangely ersatz, the sex has been machined out of them; at least all has gone except a strange kind of sex. They inhabit regions so stylized, so pasteurized, that the real physical quality has left them. But they have an unreal and remote perfection in their own kind of "sexiness". Everything has been stripped to a limited range of visual suggestions—can one imagine a mushy body-smell, un-artificially disordered hair, an uneven texture to the skin, hair on the arms and legs, beads of perspiration on the upper-lip, on one of these neatly-packaged creatures?', he wondered. During his journey through the United States in the mid-1950s, English writer J. B. Priestley noted many 'good-looking girls who have slender and almost boyish figures, with no pelvis to suggest maternity...yet carrying breasts that are exceptional among young white women, [yet which] are now the favourite erotic symbols of *Admass* men'.[120] He argued that the ubiquity of breasts showed the domination of the masculine principle; they did not suggest any true feeling for Woman but rather revealed a perversion of femininity at the hands of men with the appetites of a 'famished and frustrated baby, never finally weaned, still eager and hungry for the breast'.

European photographic eroticism had a different feel. In France, the traditional supplier of erotic images and ideas to the world, the market was dominated by the magazine *Folies de Paris et de Hollywood*, which began publishing in 1947 and sold 80,000 copies per fortnight. It presented scantily clad models and starlets cavorting in boudoirs, cabarets, or in the open air. Models posed directly on film sets or in saucily connotated Parisian cabarets. The culture of Parisian striptease was employed to turn the model into a sophisticated package that was distinguished from 'its sassy, bare-all, occasionally bargain basement American counterpart'.[121] In fact there was some cross-fertilization between the two countries, as the magazine title itself suggests. American artistes sometimes affected French attitudes, while some leading French performers, like Rita Cadillac and Dodo d'Homberg, spoofed American excess and glitz. In Britain, semi-clandestine suppliers of erotic material mostly imported their wares from France, although some was home-made. The 'Argyle Studios' in suburban Ealing peddled black-and-white and colour booklets of models with exotic names like Candita, Venecia, or even Nudita. Professional temptresses in various guises of semi-nudity flashed cheeky smiles and offered their untoned bodily charms in a range of kitsch settings and poses. Themed issues bore titles like 'Nude Charm', 'Nudes in Focus', 'Tropical Eves', or 'Modern Eves'.

Not by chance did the improbable, exotic names of the models in pornographic or glamour magazines belong to the same realm as the sequence of disposable nymphets that figure in Ian Fleming's spy novels featuring his character James Bond. Pussy Galore, Honey Rider, Kissy Suzuki, and Vesper Lynd are not real women but glamorized figments of a pornographic imagination. They are luxuries to be surveyed and enjoyed for recreational purposes.[122] In conception, they were elaborations of all the female figures of glamour modern men knew, from models to the air stewardesses whose charms were so blatantly plugged by the companies they worked for. Fleming's fantasy world would find a grand cinematic projection in the James Bond films from the first of the series, *Dr No*, in 1962. Like the novels, the films were riddled with the atmosphere of the cold war. But they were also glamorous fantasies of consumerism and hedonism.[123] The screen Bond was less of an establishment figure and more of a mongrel than he was in the

novels. Sean Connery, for all his earthy authenticity, assembled agent 007's screen persona from elements taken from several older stars, including Clark Gable and Cary Grant. The former provided a template for the character's macho attitudes and the latter for his style and sophisticated tastes.

Grant was one of the most bankable stars of the 1950s and early 1960s and, despite the fact that he was well into middle age (he was born in 1904), he was among those considered for the Bond role. He was the ideal star of the age of affluence. His unique synthesis of British reserve, American optimism, urbane *savoir faire*, and fine tailoring created an irresistible hybrid that was lower class in conception. Grant, like Jay Gatsby—to whom his persona has been likened—was a common man who was living a dream of fulfilment that was exhibited for all to see.[124] He was a walking manual of how a modern gentleman should look and behave that was available for anyone to consult. A product of the big city, he had a holiday aura and was always 'triumphantly suntanned'.[125] Although Connery projected a more violent and carnal profile than Grant, the constructed nature of the Bond persona allowed male spectators to project themselves on to him.

Glamour in the 1950s was all about the attachment of dazzle and enchantment to mundane goods and routine lives. It was about the corporate orchestration of dreams and desires along scientifically programmed lines. The most common ciphers of these were feminine. In some quarters, glamour came to be defined as little more than the presentation of female beauty for the camera. The surrounding material environment was, however, always important. The fantasies of the era of mass consumerism were shaped by the product world. Yet the forms of living that took shape in the post-war years did not lead to universal acceptance of packaged lives and predictable temptations. Innovations in travel and communications, the demise of high society, and the rise of youth all brought new innovations in patterns of visual appeal. In consequence glamour, as a language of allure and desirability specific to capitalist society, also underwent changes. One consequence of these was that the focus on photography and female imagery expanded further. The photographic image became the mirror of a society in which glamour was a routine feature.

CHAPTER 9

PHOTOGRAPHY AND
THE FEMALE IMAGE

Jacqueline Kennedy Onassis was the most photographed woman in the world in the 1960s. An ostensibly shy woman of semi-aristocratic American background, she became the most famous face of a decade that witnessed radical changes in politics, society, and culture. As the wife of President Kennedy, she redefined the image of the first lady; as his widow, she held a special place in the imagination of the nation and the world; later, as the wife of the Greek shipping millionaire Aristotle Onassis, she became a queen of café society—no longer a saint, she became a super-celebrity. 'Jackie' was the informal sobriquet by which everyone knew her. Most people, of course, 'knew' her only through the press, where she was not a person so much as a series of images. The most memorable of these were etched on the consciousness of the world because they were associated with the assassination of her first husband in Dallas on 22 November 1963. The pictures of her climbing over the back of the open-top limousine following Kennedy's shooting; the images, taken hours later, of her standing, mouth open in shock, in the same blood-spattered coat next to Lyndon Johnson on Air Force One as he was sworn in as president; her veiled face full of dignified

sadness at her husband's interment at Arlington Cemetery—all of these contributed to her beatification. Her 'baptism by gunfire', to borrow Camille Paglia's expression,[1] situated her in a special place in the collective imagination. Not by chance, these were the images that Andy Warhol chose to incorporate into his celebrated silk screen portrait 'Sixteen Jackies', which was in fact just one of many single and multi-image depictions of her that the artist made using colours including red and gold.

By the time of the assassination, Jackie Kennedy was already a figure with a very precise image. She had married John F. Kennedy, the junior senator from Massachusetts and one of the most eligible bachelors in the United States, in September 1953, when she was 24, and she achieved nationwide fame during his election campaign in 1960. As first lady, she embarked on the highly publicized project of redecorating the White House. Moreover, she brought a particular fashion dimension to her role. *Women's Wear Daily* cheekily dubbed her 'Her Elegance' and she quickly rose to the top of best-dressed lists worldwide.[2] Her appointed couturier, Oleg Cassini, a naturalized American of Russian stock who had been raised in Florence, provided her with garments of a refined elegance. Her aim was to avoid sensationalist fashion stories or charges of extravagance. She did not wish to be 'the Marie Antoinette or Empress Josephine of the 1960s', she told Cassini.[3] Instead she informed him that she wanted to dress as if her husband were the president of France. She demanded approval of any publicity that he should issue and also instructed him to ensure that her dresses were unique. Her inauguration wardrobe marked the beginning of what would become known as 'the Jackie look'. While the department store Bergdorf's made her dress for the swearing-in ceremony and Cassini created a fawn-coloured coat with sable collar and muff to wear with it, it was the fur-trimmed pillbox hat created by the couturier Halston (the professional name of Roy Halston Fowick) that captured most attention. It was youthful and playful and, although not a novelty, it became identified with her more than anyone else.

Together Jack and Jackie Kennedy were one of the most glamorous couples in world. They created a special dynamic with the public that sprang from their youth and good looks as well as their wealth and style. Jack had become the Democratic Party's poster boy soon after he was elected to the

Senate in 1952 at age 32. He was aware of the political utility of his handsome looks and used to send signed 'glossy glamour-boy photographs' of himself to constituents.[4] When the party leadership opted for a political figure rather than an actor to narrate a Metro-Goldwyn-Mayer produced documentary on its history, he was an obvious choice for the role.[5] A female dimension to his image was added when, at his father Joe's instigation, Jack's presidential campaign mobilized the women in the family clan as cheerleaders. With their strong looks and fine heads of hair, they aroused the curiosity of the electorate. None, however, had more impact than Jackie. Some supporters feared that, as a couple, they would be too polished and glitzy for the voters in the Democratic primaries. According to Charles Peters, editor of *Washington Monthly* and one of JFK's Democratic nomination campaign organizers in West Virginia, the effect was in fact the reverse. 'What amazed me most, I think, was the way people reacted to Jackie,' he later recalled. 'I first got the sense through Jackie's emerging popularity, of what was happening in American society. There was no question that instead of identifying with the woman who was like them—Muriel Humphrey [wife of Kennedy's rival for the nomination, Senator Hubert Humphrey]—they identified with the Princess. You could just tell they wanted Jackie. They had a wondrous look in their eyes when they saw her. After the dowdiness of Eleanor Roosevelt, Bess Truman and Mamie Eisenhower, they were looking for an aristocratic image. And the Kennedys did a superlative job of merchandising that image.'[6]

What was meant in the America of the late fifties and early sixties by 'an aristocratic image'? No return to the extreme inequalities of the gilded age was desired, nor was there any appetite for the hauteur of the mid-nineteenth-century social elite. The idea of aristocracy still implied some element of breeding and taste, but in the era of mass consumption and rising living standards this was conceived as a template rather than an inherited attribute. In the age of Audrey Hepburn and Grace Kelly, the idea of aristocracy evolved into an image of accessible class that combined elements of glamour, taste, and manners. This was not quite the 'more than glamour' of royalty since it was moulded for public consumption and lacked the bolster of history. Something akin to Grace Kelly's 'sexual elegance' was regarded as the modern equivalent of

female aristocratic style and Jackie supplied this.[7] She was contemporary, steeped in French culture, and was highly photogenic. Although, as the first lady, she occupied a terrain removed from the hurly-burly of celebrity, she was drawn by events into the realm of glamour.

Over the decade, the nature of Jackie's image changed significantly in ways that were related to the broader changes that the decade brought. While the 1950s had been marked by a return to family, authority, and religion in the aftermath of war, the 1960s saw the emergence of youth culture and protest, changes in personal relationships and behaviour, freer expression in literature, the arts and the mass media, and attitudes towards life and life goals.[8] A loosening of conventions and standards occurred in a context that witnessed the affirmation of television as the dominant medium and a sudden multiplication of theatres, nightclubs, discotheques, photographic and model agencies, film companies, and magazines.[9] With mass communications taking such a central role, it was not without reason that the French situationist Guy Debord formulated the idea of the 'society of spectacle'.[10] The commercialism of the era and the development of electronic media broke down barriers and facilitated mobility and exchange between continents, classes, and cultural forms. All public acts entered the realm of the media, thanks to the complex interaction of the press, public opinion, and commercial interests.[11] These innovations had the effect of sidelining conventional high society—which no longer attracted the intense curiosity of earlier decades—in favour of metropolitan elites of youth, beauty, talent, and creativity. The consequence of this was a new informal focus on glamour. Jackie's personal trajectory after the assassination of her husband made her into a symbol and conduit of some of these transformations.

Jackie's background prepared her well for the type of sympathetic, attractive upper-class image that went over well in the media. She did not in fact belong to the upper crust of American society. Her stepfather, Hugh Auchinloss, belonged to one of the oldest families in America but her own father, John 'Black Jack' Bouvier, was a disreputable rake. He had been born into a rich Long Island family and made money in the stock market, but he was best known for his movie-star good looks, fastidious dressing, and womanizing.[12] Jackie's mother's social background was less exalted and

she was seen as a social climber. Jackie's sophistication came from having grown up in New York, attending the best schools, and taking vacations in Europe.[13] She studied at Vassar and the Sorbonne; she had also been debutante of the year, and had won the *Vogue* Prix de Paris contest for college seniors, although she had not taken up the prize of a year-long *stage* in Paris. She could speak reasonable French, Spanish, and Italian.

The first to realize the potential of Jackie's curriculum was Joe Kennedy, who thought that her Frenchness could balance and correct the Kennedys' Irishness. She was the ideal mate for his son because, while also being Catholic, she brought the possibility of upward social mobility. Joe had made his money bootlegging and producing B movies and had no social cachet. The Kennedys, moreover, were not an accepted part of the Boston social scene.[14] He decided to put his sons into politics by way of compensation. He was sure that the American public would be no less wowed by Jackie's poise and manner than he was, precisely because her patrician image was more stylized than real.[15] Despite appearances, she was neither rich nor possessing lineage. Indeed, she behaved like a social climber. She liked to meet the rich and famous and had aimed to marry well. Although the Kennedys lacked the refinement to which she was accustomed, they had money.

A core aspect of the glamour of both Jack and Jackie was that they offered an image of accessible class. They were not wrapped up in the aloof remoteness of the long-established rich; rather they had a touch of vulgarity that made them understandable and popular. They revelled in the public realm and they were public property.[16] As the president's wife, Jackie was inevitably forced to live in a way that was less than private. She struggled to make her life in the White House and that of her children as much of a normal domestic environment as possible. However, the frenzy that surrounded her went well beyond that accorded to previous first ladies. She was charming, refined, and fashionable. Her ability to fascinate was the product of the training she received from her father in how to keep herself intriguing and slightly aloof.[17] Even in the smallest gatherings, her magic was not dimmed. She delighted numerous political figures by becoming, according to one observer, 'a bewitching lighthouse beacon of charm'.[18] In the popular imagination, Jackie was often treated like a star, but, like Grace Kelly, one with a

difference. American celebrity magazines happily placed her on their covers alongside TV and movie stars. *Photoplay* and other magazines paired her with Elizabeth Taylor. In the early 1960s, with Liz's affair with Richard Burton at its height, the two women were contrasted: 'Marriage and Taste' marked Jackie's life, while Liz's was mired by 'Passion and Waste'.[19]

Jackie, it was said, made Washington a brighter and gayer place to be. She ensured that the style of entertaining became grander and more formal. She raised the quality of cuisine and introduced French chefs and menus. Her favourite historical figure was Madame Récamier, the beautiful *saloniste* of Napoleonic France.[20] The presidential couple were bathed in an unprecedented glow of publicity and their every move was recounted and scrutinized. What surprised some was that the first lady received more of the limelight than the president. Whole swathes of the press found her female glamour more interesting than his male charm. Nowhere was this truer than during the presidential visit to Paris in May 1961. Relations between France and the United States were not very good at that time, and for that reason much attention was fixed on the president's Francophile wife, who was identified as a bearer of goodwill between the two countries. Eyes were trained on her to such an extent that Jack quipped during a speech at the gala dinner at Versailles: 'I do not think it entirely inappropriate for me to introduce myself. I am the man who accompanied Jacqueline Kennedy to Paris,' adding, lest anyone think he was resentful, 'and I have enjoyed it'.[21] Her styling for the occasion was in expert hands. Her hair, worn down rather than up on formal occasions, was entrusted to Alexandre, hairdresser to Greta Garbo and Elizabeth Taylor, while Hubert de Givenchy, Audrey Hepburn's favourite designer, designed the gown she wore to the state banquet at Versailles. Her make-up for that occasion was executed by the well-known artiste Nathalie.

Photographic images of Jackie are very numerous. She was probably the most photographed woman of the 1960s and at least some of her appeal derived from the fact that she was also 'the most photogenic woman in the world', to quote Cecil Beaton.[22] In this sense she was a highly emblematic figure of the period and a part of pop culture. Not only was she prominent and glamorous, she was also a founding member of a new

community of famous people whose fame derived partly or wholly from their relationship with the camera. These were people who inhabited the post-war world of the illustrated magazines. Photography was a feature of Jackie's existence right from her engagement in June 1953. After the announcement, she and Jack spent three days posing for a *Life* magazine photographer for a cover story about their romance. Her wedding too was a media event. Jackie's mother had intended a small, exclusive ceremony in Newport without pictures or crowds but was informed by Joe Kennedy that publicity was inevitable so it might as well be harnessed from the start. As he saw it, the aim was not to hide Jackie but to show her to best advantage.[23] Her magazine life continued with a fashion shoot with her sister Lee for the *Ladies' Home Journal* in December 1957 and beyond. Jackie always expected to be photographed in a flattering way and to exercise control over her image. As a woman whose smile lit up a thousand magazine covers and who was perpetually on 'best-dressed' lists, she was a publicity magnet.

Jackie's appeal cannot be separated from her physical being. Young, and slightly taller than average at 5′ 7″, she had high cheekbones, sensuous lips, wide-set eyes, and a sleek athletic figure. She had a wild, earthy beauty, one observer noted, that seemed fragile in photographs.[24] She had the grace of a ballet dancer and was seen to have the same refined brunette appeal as Audrey Hepburn. Totally different from the buxom blondes who were regarded as the embodiment of post-war America, she was distinct from the erotic ideal of consumer society. Her sex appeal was contained and subtle rather than up for grabs. She was imagined by Cassini as 'an ancient Egyptian princess'. 'There was her sphinxlike quality and her eyes, which were classically, very beautifully set. When I thought of Jackie, I saw a hieroglyphic figure: the head in profile, broad shoulders, slim torso, narrow hips, long legs, and good carriage,' he later wrote.[25] Her fascination was enhanced by the fact that she did not give interviews; she was an icon and a cipher whose silence betrayed an emptiness into which everyone could project themselves. Not by chance, she was drawn to Greta Garbo, who, long after her sudden retirement from the screen, was still an object of curiosity.[26]

Jackie's initial image as first lady was bound up with her restoration of formality, fine dining, and high taste to public life. She was keen on history

and was very sensitive to it in the project of redecoration she undertook on the White House. However, her close association with the world of fashion meant that she was alert to trends that would undercut the continuity of social rituals and radically shake up relations between the old and young generations as well as between rich and poor and black and white. As photography acquired a special role in creating as well as recording and spreading fame on the international level, youth and beauty won out over power or pedigree. Changes followed in relations between the rich and powerful, the fashion world and the press. These were not peculiar to the United States; they occurred with equal force on both sides of the Atlantic.

A key figure in the process of rejuvenation was the fashion editor Diana Vreeland, first of *Harper's Bazaar* then—from 1962—of *Vogue*. Vreeland was a key mover and shaker of the decade. She had the appearance of a high priestess; she loved gold jewellery and adored vivid styles and artifice. She invented the role of the contemporary fashion editor, not as a society figure but as a mediator and innovator. In this capacity, she made connections between high fashion and the social currents of the period. She mixed celebrities, political figures, and artists with coverage of new trends and the Third World. She glorified influential individuals and made them current through make-up and fashion.[27] To assist her in her revolution, Vreeland mobilized a variety of talents. She turned first to one of the most long-established figures in the world of fashion. Cecil Beaton had been a royal favourite since the 1930s and was responsible for the official portraits at the 1953 British coronation. He had photographed the exiled royals of Italy and Romania and the Hollywood elite; he worked for leading fashion magazines on both sides of the Atlantic, often featured on lists of best-dressed men, holidayed with socialites and millionaires in the Mediterranean, was the house guest of British aristocrats, and designed films and stage shows including a highly successful *My Fair Lady* in London. He often commentated on beauty and glamour and published a first volume of memoirs, *The Wandering Years*, in 1961.[28]

Despite his long experience, Beaton was always keen to remain at the head of the pack. By virtue of his position, he was drawn into the reconfiguration of glamour that began to take shape in the early 1960s. Even though he was

still photographing debutantes, Vreeland told him in 1961 that high society was no longer interesting; 'today only personality counts, with very few exceptions unless it is a "new beauty",' she wrote.[29] He was asked to get 'some very young, raky types that would be amusing for us also etc. Youth is the best thing we can get.' One of the key developments of the 1960s was the emergence of beauty as a quality equivalent to material success.[30] Vreeland was quick to see this and coined the expression 'the beautiful people'. By this she simply meant 'people who are beautiful to look at'.[31] 'It's been taken up to mean people who are rich,' she later clarified; 'we mean the charmers but there is no harm to be rich.' The members of this new estate were able to bypass the social thresholds of the 1950s because they had qualities of youth, health, and sexiness. A few years later, in May 1965, Vreeland was on the prowl for more beauties and new stars and told Beaton: 'only you can give the super duper quality and make the choices'.[32] By this time, the photographer was 61 and had recently completed what would remain his best-known work—designing the Edwardian sets and costumes for the film version of *My Fair Lady*. He was happy to immerse himself in the new culture of the day. It has been said that Vreeland's 'greatest contribution is to have understood the 1960s immediately'.[33] She saw that the dramatic changes in taste of the period were liberating to style. She made the most of the explosion of energy in art, pop, and society and was open to alternatives to Western beauty and style. Democratic in attitude, she 'stood for the accessible ideal'.[34] In glamour this is crucial and would become ever more so in the age of youth culture and mass consumption.

As an older generation photographer who conserved a notable influence, Beaton was not alone. Norman Parkinson was another eccentric gentleman photographer who had begun work in the 1930s but who remained active into the 1960s and 1970s. Like Beaton, he was a man of middle-class origins who reinvented himself as a quasi-aristocratic personality and who maintained a theatrical public image throughout his career—complete with trademark dress style and quirky touches (notably, the invention of the Porkinson sausage).[35] Born Ronald Smith, he had grown up in the comfortable London suburb of Putney and attended Westminster school. However, his aristocratic stature (he was 6′ 5″ tall) and right-wing views

somewhat offset his middle-class origins (his father had been a shopkeeper). In stark contrast to Beaton's highly artificial compositions, he preferred the dynamism and energy of the modern world. Even in the 1930s, he shot in the street, embracing the freedom of the open-air. The invention by Leica in 1935 of a new camera with a shutter speed of 1/1000 second allowed fashion photography to take to the streets. New York news photographer Martin Munkacsi first photographed clothes in real life situations where they might actually be worn. Then Edward Steichen synchronized the new shutter speed with flashbulbs permitting faster movement in a wider range of contexts to be captured. Parkinson learned from their work even as he continued with society portraiture and conventional fashion pictures. In the 1940s and 1950s, he worked for *Vogue*, for which he shot many pictures of fashionable women on stations, in public houses, and in ordinary places. The effect was twofold: the models looked extraordinary in contrast to their inelegant surroundings, while they and their sumptuously styled garments were made to look part of the real world.

The press was an important innovator of the period and, while some established magazines were swift to change, important headway was made by new titles or new editorial directions. *The Queen* was a house magazine of the British landed and moneyed classes that was bought in 1957 by Jocelyn Stevens. Nephew of Edward Hulton, the publisher of Britain's post-war illustrated weekly, *Picture Post*, Stevens gradually reinvented the magazine.[36] In the mid-1950s, the British press regarded debutantes as good copy and their activities as ideal fodder for the mass of newspaper readers. 'What the papers really wanted was debs, hundreds of them, preferably photographed having a jolly nice time dancing the night away at some high-society party,' recalled upper-class photographer Patrick Lichfield.[37] By sacking the fashion editor and clearing out the former debutantes who staffed the magazine, Stevens opened the way for the unconventional. Steadily, he turned it into one of the conduits of the new energy that would shake up society and its rituals. He hired Cartier-Bresson to provide the pictorials of Queen Charlotte's ball, the traditional first engagement of the debutante season, while his Cambridge contemporary Antony Armstrong-Jones was allowed to inject irony into his pictures of the Chelsea Flower Show and the Trooping

of the Colour. Cruft's was similarly subjected to mild lampooning. This did not win him any credit with Beaton who only ever worked for the most prestigious publications. He took the view that, by working for magazines and newspapers, the younger man had sullied himself.[38] In Beaton's aloof view, this was second-rate drudgery. Nevertheless, Armstrong-Jones was vital and charming and was much in demand. His witty and informal pictures were unusual and started a trend that would prove influential. In the sixties, Parkinson left *Vogue* for *Queen* (Stevens dropped 'The' from its title) and brought his trademark fluency and sense of movement to the magazine. He engaged with the artistic trends of the time, for example translating the geometrism of op art into his work. The magazine also accepted early photographs of Chelsea designer Mary Quant's boutique wear and published Helmut Newton pictures that had been rejected by *Vogue* on the grounds that they were indecent.[39]

Vreeland and Stevens were very different individuals but they were on the same wavelength in seeking to move their magazines towards a new way of relating to society. Before, no one had got into *Queen* who was not a member of high society. Now new talents were emerging and youth culture was making its presence felt as the post-war baby boomers took on the configuration of a new generation. Like Vreeland, Stevens took 'the view that society was dead', and 'began to promote the alternatives'.[40] Although neither of them completely bypassed debutantes, they only selected the most interesting or modern for coverage.[41] Together with their collaborators they contributed to the transformation and opening-out of high society.[42] Photography provided a key channel through which the feel of these and other publications was updated. While the writing was also given an adrenalin shot, in *Queen*'s case with gossipy reviews and features, photographs were crucial in widening the visual horizons of a publication and bringing new people into the mix. They did not attack the existing structures of society but cut coverage of the aristocratic and wealthy elite and published pictures that reflected the real world. The new visual horizon of fashion and high society magazines was increasingly international. Models were photographed in Kenya and nearly a whole issue of *Queen* was devoted to Cartier-Bresson's photographs taken in Communist China. In consequence, the

doings of debutante Charlotte or baronet Sir Charles seemed small and uninteresting. *Queen* boldly declared in 1964 that haute couture, which in the late 1940s had seemed on the verge of a renaissance, was dead. Although several new houses had opened at that time, the overall number dropped in the years that followed as fewer women had the time or resources to devote to its demanding perfection and the occasions on which formal dresses might be worn diminished.

One consequence of the shake-up in society was a larger role for the press and for photographers in particular. They found themselves performing a crucial role of social mediation in the more fluid social context that was taking shape. With just a handful of exceptions, photographers were still background figures. Former Eton pupil and Cambridge graduate Armstrong-Jones first covered debutantes' parties for *Queen* magazine while he was apprenticed to a society photographer. Despite his well-to-do background, he found that upper-class hostesses treated him as a workman and more or less showed him to the tradesman's entrance when he arrived.[43] Even Beaton was sometimes given brusque treatment by the royal family.[44] Armstrong-Jones's courtship of, and marriage in 1960 to, the Queen's playgirl sister Princess Margaret instantly transformed the position of the photographer. Although some old fogies wondered if the Princess's home of Clarence House would soon be invaded by beatniks demanding all-night bottle-parties, most of the establishment did not openly question his suitability.[45] As the Earl of Snowden, Armstrong-Jones brought kudos to his profession and lent it social visibility. No more would the photographer be seen as little better than a glorified hairdresser or plumber. 'Almost overnight', Jonathan Aitken wrote, 'lensmen became invested with glamour and prestige.'[46] Advertisers, newspapers and magazines, and fashion companies suddenly realized their power and influence and their earnings went up dramatically.

The collapse of interest in debutantes did not mean that there was a lack of curiosity about young beauty. If the debutante was a dying breed, then the world of the media found a replacement in the form of the fashion model. Models had become better known as individuals in the post-war years. Magazines liked them because they helped simplify and humanize

fashion by creating clear and identifiable 'looks'. Young, beautiful, and photogenic, models provided the bridge between the remote realm of haute couture and the real horizons of their readers.[47] Their status was further enhanced by a series of feature films based on their worlds, including the 1957 Audrey Hepburn vehicle *Funny Face*. For Ginette Spanier, director of the Balmain fashion house, this elevation was an effect of publicity that was especially marked in the English-speaking world. 'In England and America mannequins are regarded with awe-struck fascination as though they were a new part of the aristocracy,' she lamented. 'Just like the Gaiety Girls and the chorus girls of the 1890s, they are capable of escaping from their environment. But this means they usually create a furore in their own right: as the "Most Beautiful Deb" of the year might do...as Miss World usually does.'[48] However, even in France models were taking on new functions distinct from their specific roles in fashion houses. The mannequin Bettina was one of the first to leave her employer, Jacques Fath, to embark on a new career as a photographic model or 'cover-girl'. 'In those days, being a cover-girl was something new in France,' she recalled. 'It involved quite different techniques from those used by a mannequin and required altogether different qualities.... Just as the mannequin collaborates with the couturier. So the model collaborates with the photographer. A good cover-girl takes up her stance immediately, and is paid more because she saves time and money.'[49] Even more than mannequins, the photographic models had to convey an idea that met the needs of the moment. 'When I was at the height of my career,' Bettina noted, 'fashion decreed very sophisticated photographs. Models never smiled, but stood with half-open lips in stiff, dramatic poses, and were represented as impersonal creatures, unreal things.'[50] She found that in New York the spontaneity of Paris was replaced by 'factory-like discipline': improvisation and good humour had no place in a system that privileged speed, uniformity, and efficiency. There was less difference in the results, though, since American cosmetics companies preferred elitist aloofness like the French.

Models were mostly photographed in studios where they worked with photographers to create sophisticated and elaborately artificial images. However, although the posed, highly artificial studio shot created by

photographers like Horst P. Horst, Beaton, and Hoyningen-Huené persisted well into the post-war years, street photography of the type favoured by Parkinson became more popular. Despite the debacle of the attempt to shoot Dior models in the working-class district of Montmartre, Russian exile Alexander Liberman imported the unposed realism of news photography into Paris fashion coverage. The aim was to overcome the mannered exercises of the past and allow fashion to breathe the air of contemporary life.[51] The new style generated some classic images of fashion photography such as Lisa Fonssagrives modelling dresses on the Eiffel Tower, while many other models were posed with scenes of everyday life as their backdrop. Although he became the most famous couturier in the world after he took over the mantle of Christian Dior, the man who stood for Paris fashion more than any other in the world's eyes, Yves Saint Laurent, was far from being a defender of tradition. He boldly challenged expectations by presenting in 1960 a 'Beat' collection, consisting of black turtleneck sweaters in cashmere, shiny crocodile-skin jackets, and leather boots, that was inspired by the Left Bank beatniks. Although high artistry and exquisite quality were not lacking, it was the first time that street styles had been seen on a couture catwalk.[52]

Although Beaton and Parkinson contributed to the process of rejuvenation, there were limits to their powers of adaptation. In 1963, Parkinson was 50 and Beaton well into his sixties; inevitably some of the energy of the 1960s passed them by. It was the younger photographers who captured the urban street buzz of the moment and who moved beyond the old styles of fashion and portrait photography. David Bailey served his apprenticeship as an assistant to John French, a prominent British fashion photographer of the 1950s who stole a march on his contemporaries by perfecting a crisp and clear black-and-white photography that worked well in newspapers. French was a photographer of the old school who saw himself as a composer of works of art. He dressed formally and spoke in a clipped manner. Bailey, by contrast, was an unrefined and uneducated East Ender who made no attempt to disguise his origins. He was good-looking and cocky, but not too arrogant to realize that he could gain much from his boss. While French composed his models into marvels of poise and static elegance in his studio,

Bailey's job was to arrange the props and carry out what was regarded as the menial task of clicking the camera.

French's connections with the daily press would be crucial in allowing Bailey to build a career of his own. At the start of the 1960s, he had the great advantage of being in the right place at the right time. The press was discovering youth, old rituals were being shaken up by wider access to education and the spread of consumer society, and there was a more casual atmosphere. British *Vogue* was aware of being a bit stuffy and looked to him to provide some rejuvenation. His work was featured in a rubric called 'Young Idea'. Bailey was the first new man of the sixties, a good-looking charmer who forced his way into a glamorous world without in any way reinventing himself as faux-posh. He was an East Ender who spoke with a cockney accent and revelled in his street credentials. Soon, totally new photographers like Bailey and his working-class colleagues Terence Donovan and Brian Duffy were everywhere. They forced their way into a profession that was the preserve of men of a different stripe by capturing a mood and a moment in a new way. They were almost all young men who had a healthy disrespect for the conventions of their trade and for social hierarchy. With their carefree manner and unique way of turning their trade into a lifestyle, they situated themselves at the heart of a cultural transformation that deposed conventional glamorous imagery and replaced it with something younger, more casual, and breezy. The photographers did not offer real or simulated images of grand style but instead captured the spirit of their times and of the cities they worked in.

The young photographers had a number of things in common with the Roman photographers of the *dolce vita*. Both were young men from outside the establishment; they were of working-class origin and they would play a part in shifting public attention away from the social elite towards the casually famous. However, although some of the paparazzi, including Tazio Secchiaroli, the most prominent of their number, would become set photographers working closely with film directors, none of them would ever enter the inner circle of Italian fashion. The Londoners by contrast stormed the citadel and revolutionized the way in which fashion was narrated and

depicted in specialist magazines and the daily press. They achieved this by bringing in a breath of fresh air and introducing excitement and sex appeal. Using youth as their calling card, they pioneered a whole new way of picturing fashion that restored its connection with the buzz of the city and its personalities. They did not use statuesque ladylike models but girls they found on the street, ordinary young women who became at their hands contemporary icons.

Bailey and his protégée and lover Jean Shrimpton were at the forefront of a transformation in the relationship between fashion and society. They were able to seize centre stage because the cult of the fashion model was not a new phenomenon but one that had been taking shape for several years. In Britain, informal, accessible pictures came into their own in the 1960s. While John French insisted on white gloves, pearls, and stud earrings as props to an idea of femininity, Shrimpton was always more down-to-earth. Although her difference from earlier models can be exaggerated, as she had poise and some class, she struck her contemporaries as a new type. Duffy used her at the start of her career for a Kellogg's cornflakes advertisement because they wanted 'an ordinary girl who looked as if she might come from the country'; 'Duffy had chosen me because I was the epitome of ordinariness,' she later claimed.[53] In fact, she was privately educated and was not at all 'working class', despite her own claims to this effect; but she was certainly not upper class or rich. Shrimpton always made a point of being a scruff. 'In those early days, at a time when model girls and young actresses were bandbox perfect, I had little flair for fashion.... I have always been a bit of a mess. Yet somehow there are people who seem to warm to this messiness,' she self-deprecatingly recalled in her autobiography.[54] She had acquired poise and confidence on a Lucie Clayton modelling course but, despite some assignments for *Vogue*, had little idea about cosmetics, grooming, or clothes. Bailey spotted in her some waifish, coltish quality that he could mould into what became the Jean Shrimpton look, a look that required little hairdressing or make-up.[55] One of the first English models not to have a cut-glass accent, she had an ironical, detached view of fashion.

Shrimpton became, in Bailey's hands, the first model in England to become famous solely on the strength of her photographic work. Prior to

her, the models in the magazines had been anonymous. With only one or two exceptions, no one beyond the cognoscenti knew who they were. Shrimpton was immediately distinctive. She had blue eyes, exotic eyebrows, a perfect squareish face, generous lips, and a pointed nose. Stiff and gawky, she looked like a cross between Vivien Leigh and Brigitte Bardot, a look that also applied to the actress Suzy Kendall. Bailey groomed her and arranged for her to be photographed by Beaton and other established names. However, his own pictures were what made Shrimpton into 'The Shrimp', a face and name everyone knew. He did not focus on the clothes in his fashion pictures but rather on the model. 'The girl is always the most important, then the dress,' he declared. 'If she's not looking stunning, then I figure the dress doesn't, either. The girl is the catalyst that brings it all together.'[56] Diana Vreeland, the then newly appointed editor of American *Vogue*, was receptive to the novelty Bailey represented. He had worked in the United States before and had sent shock waves through the magazine world by turning up in jeans and leather jacket. Vreeland, however, took to him immediately and hailed his and Shrimpton's arrival in her office with a peremptory, 'Stop! They are adorable! The English have arrived!'[57] Bailey's shots of Shrimpton on the streets of New York for an April 1962 *Vogue* feature entitled 'Young Idea Goes West' were striking for the originality of the urban compositions and the mood of reality that permeated them. Shrimpton was shot in Harlem, Chinatown, and Greenwich Village with passers-by included.

Between 1962 and 1964, Bailey photographed Shrimpton almost exclusively, turning her into the most famous model in the world. The one-time country girl became a girl-about-town and she was drawn into Bailey's mainly low-life milieu. Although he was earning a lot of money, was constantly travelling abroad for work, and even drove a Rolls Royce, he preferred to relax on his own territory. He had a wide network of acquaintances but always preferred to hang out with photographers, models, and musicians in the informal offbeat cafés, pubs, and dives of the East End. After Shrimpton left him for the actor Terence Stamp, her lifestyle changed. Although Stamp was also an East End boy, he had undergone a metropolitan makeover and he was aspirational. Unlike Bailey, he had a taste for the high

life. He and Shrimpton were hailed as the two most beautiful people in London and they enjoyed lavish living that was no longer the preserve of the established rich. 'No more driving down to Chang's in the East End for chow mein,' recalled Shrimpton:

night after night we went to the White Elephant Club in Curzon Street or the Caprice in Arlington Place just down the road from the Ritz. In these watering-holes for the rich and famous we sat in pink satin and red plush surroundings while the waiters fussed over us. Everyone watched us as we sat at our usual table eating off fine china set on pink linen tablecloths and, equally curious, we watched back. The clientele was mostly celebrities—people like Richard Attenborough and his wife, John Mills and his wife, and Elizabeth Taylor when she was in town. In those days film people lived grander lives than they do today. We made our appearances in these obligatory restaurants with clockwork regularity. Terry and I were the young glamorous couple around town, on display each night with whoever he had invited to join us.[58]

The East End photographers propelled their discoveries into the public eye and made them into emblems of the moment. In this, they were assisted by a press that was fascinated by beautiful models of run-of-the-mill origins. Celia Hammond, originally discovered by Norman Parkinson, was taken up by Terence Donovan, while Brian Duffy made Paulene Stone into a household face. The 'model makers' themselves achieved almost as much coverage and they were equated with the pop singers who were giving the period its soundtrack. Although they did not consider themselves to be an organic part of the fashion industry, they became the new gatekeepers of a world that more disposable income had turned into a central arena of contemporary culture. Pop music, television, advertising, art, design, and architecture were all new or rapidly changing spheres generating new money and new faces. Soon a new elite had emerged of pop bands, actors, models, and new-style entrepreneurs, plus a few privileged and moneyed types who were hip enough to fit in.[59] Pop music proved to be an instant launch pad and *Queen* itself helped turn pop stars into celebrities. In 1964, for example, it published a Parkinson photographic feature under the title 'How to Kill 5 Stones With 1 Bird' that juxtaposed a female model with the Rolling Stones.[60] New acts could be conjured up out of almost nothing. To take one example, Marianne

Faithfull was a former convent girl with long fair hair and a husky voice, who was spotted by record producer Andrew Loog Oldham at a Rolling Stones launch party in 1964 and signed up on the spot. Her record 'As Tears Go By', penned by Oldham with Mick Jagger and Keith Richard, was a hit and she was photographed by Bailey. Soon she was a part of the metropolitan milieu and enjoyed a much-publicized relationship with Jagger.

A 1965 *Queen* article on 'The New Class' argued that the 'pop revolution' had heralded the emergence of a new publicity-hungry class based on income not capital. It featured, among others, Andy Warhol, the Beatles, the Rolling Stones, designer Terence Conran, and Princess Margaret.[61] Such people, it was claimed, 'were bred from the Affluent Arts out of the Consumer State. The Arts have blossomed into Entertainment. They have swallowed up Media and Communication. They are now swallowing up the World.'[62] Bailey added his contribution with the publication in December of the same year of his *Box of Pin-Ups*.[63] This was a collection of thirty-six stark black-and-white portraits of the famous faces of the day and included top models and pop stars as well as Stamp, Michael Caine, David Hockney, Vidal Sassoon, and, most notoriously, the East End gangsters the Kray twins. In his introduction to the collection, Francis Wyndham argued, 'Glamour dates fast, and it is its ephemeral nature which both attracts Bailey and challenges him.'[64] By glamour, Wyndham did not simply mean 'fame', but rather a type of celebrity aura in which novelty, youth, beauty, and controversy were all important elements. The people pictured knew that it was this quality that was being photographed and this was reflected in their insouciant or arrogant attitudes. The fact that Bailey also included the image-makers Brian Epstein, manager of the Beatles, and Andrew Loog Oldham showed that he was keenly aware that glamour was closely related to the manipulation of the image of fame. The makers of fame became in the process famous themselves.

The in-crowd of the sixties bore some resemblance to café society and its publicity-driven successor—'publi-ciety'.[65] It was visible and public, it was reasonably accessible, it was mixed and exciting; in addition, it included the best-looking people and those who were currently most famous. It relied heavily on publicity and indeed was dominated by it. But whereas café society and

publi-ciety were subordinates or emanations of high society, the new in-crowds were born outside and were distinct from the social elite. However, like Hollywood in the 1920s, rarely were they entirely separate for long. The excitement they offered drew young and déclassé aristocrats, who bonded by virtue of youth with the new talents and drew them towards the places and manners of the elite. Some pop stars, perhaps most strikingly Mick Jagger, eagerly socialized with the upper class and a number of them would later follow the American millionaires of the nineteenth century in buying up aristocratic piles and living in the country like landed gentry. In the process, the image of formal, dressed-up elegance that had been the sign of aristo-cratic good taste lost influence. The formal elegance of debutantes' balls, which persisted even after palace presentations were discontinued, simply crumbled under the impact of high jinks and simple disaffection. Upper-class young people took their lead from others. 'People stopped wearing white ties and stumped around in dinner jackets...they just arrived in whatever they were wearing,' Philippa Pullar lamented: 'there was a new class image and pop stars were the new elite, the whole of society was mostly made up of restless rootless people with no connection to the soil, spending most of their time in cities.'[66] The new milieu often first took shape outside established zones of prestige and wealth, for example in Chelsea not Mayfair in London, on the Left rather than the Right Bank in Paris and in Greenwich Village rather than Fifth Avenue in New York. But the input of new money often brought a new atmosphere to nightlife in or near the most prestigious zones. In London, pop stars, models, hairdressers, sportsmen, actors, and others gathered in clubs like the Bag o'Nails in Soho or the Ad Lib in Leicester Square.[67] The newly famous cheerfully marked their success by appropriating established symbols of wealth such as the Rolls Royce, sports cars, jewellery, champagne, and exotic travel, often stripping them in the process of their class connotations.

One of the most important features of all the new industries of the 1960s was that they connected with mass audiences and evolved in close relation with their tastes and preferences. The old trickle-down model whereby innovations in fashion, style, and entertainment started at the top of society and then gradually worked their way down to the lower levels,

provoking—as it became diffuse—a differentiating action from the elite that produced innovation and a new cycle, no longer applied.[68] The channels of transmission and innovation were quite different, as Yves Saint Laurent's appropriations of youth themes and reworking of African and Oriental motifs showed. Moreover, it was not necessary even to have wealth to be able to live the desirable lifestyle. Youth, and especially girls and young women, took up ideas that had a contemporary feel and that matched the greater independence and sexual freedom that marked the age. Energy, vitality, and pleasure were more desirable than the virginal glow that, save for its brief eclipse in the 1920s, had conventionally distinguished young upper-class feminine beauty. In the fashioning of a new glamour, informality, sex appeal, and movement were central. Girls were active and on the go.[69] Mary Quant, whose boutique fashions were defining the contemporary youthful look, championed them and often acted as their spokesperson. The miniskirt was in fact invented by the Parisian designer Courrèges but it was adopted and democratized in London and became forever associated with Quant. She achieved prominence when *Queen* ran some pictures of her creations after other magazines rejected them. Her 'Chelsea set' had a vibrant contemporary feel that contrasted with the official quasi-high society world of fashion everywhere. The new modes were often intensely controversial and provoked much disapproval. When Shrimpton wore a miniskirt and no hat, gloves, or stocking to Derby Day at Flemington racecourse in Melbourne, Australia in 1965, sartorial choices that in her environment would have seemed natural, it caused outrage among those who thought the world's highest-paid model was cocking a snoop at polite convention.[70]

Both within Britain and in international popular culture, London established an enviable primacy. It was seen as the heart of a loosening of social and cultural hierarchies and of a cultural renaissance. Mass fashion, pop music, and style all seemed to emanate from the British capital. The American magazine *Time*, which devoted its cover to 'Swinging London' on 15 April 1966, also commented on the 'new and surprising leadership community' that was taking shape.[71] It was, the magazine declared, a classless phenomenon, 'a swinging meritocracy'. Needless to say, this was the ideology of sixties' London rather than the reality but it was not without significance

that 'everyone looks at England, London has become the target, the beacon, the "city of youth"'.[72] Although New York had its heterodox star-like 'fashion-society celebrities',[73] and Paris had its own subcultures and a pop culture with its own young female stars in Françoise Hardy and Sylvie Vartan,[74] it was London that constantly generated novelties.

The most striking novelty of 1966 was Twiggy. The young model was not a protégée of any newly established image-maker or the creation of a cultural industry. Her emergence was a phenomenon that would have been un-imaginable elsewhere. It showed both a receptiveness to novelty and the importance of the interaction of different facets of London's media. Aged just 16, Lesley Hornby—to give Twiggy her real name—was an ordinary girl from Neasden working in a hairdressing salon when she was spotted by Nigel Davies, who, as Justin de Villeneuve, would become her Pygmalion.[75] Like all girls of her age she was outer-directed; she loved shopping, fashion, and pop music. She was truly everygirl and much of her popularity derived from her ingenuous reactions to being suddenly elevated into the glamorous world of modelling, magazines, jet travel, celebrities, fashion, and money. Her path to fame was brief. Given a new twenties-style haircut by Leonard of Mayfair, her picture was taken by Barry Lategan and seen by Deidre McSharry, fashion editor of the *Daily Express*. As soon as the journalist caught sight of her, she dubbed her 'the face of 1966', a label that made her famous overnight. 'I was an instant celebrity,' Twiggy later wrote.[76] Unlike all previous models, she was invented through public opinion and owed noth-ing either to a fashion house or a photographer. While *Vogue* ignored her and Bailey briefly boycotted her, the daily press could not get enough of her. She was not just a face but the cheeky, unvarnished voice of modern youth. The *Daily Sketch* sent her to Paris to watch the fashion shows; predictably, she declared them middle-aged and old-fashioned, a comment that led to her being banned. With her stick-thin figure and large eyes, she seemed half-orphan and half-Martian but, as a teenager who liked to dance and loved music, Twiggy was a product of sixties' London. She was a lower middle-class girl who had grown up with post-war suburban consumerism: 'the suburban influence was important because it meant that all my tastes were suburban, and that meant I liked all modern things,' she recalled. 'Anything

modern was wonderful, and anything old was terrible. It has a lot to do with the middle-class, suburban way of thinking, to revere new things, everything up to date, up to the minute, brand new and streamlined and contemporary—that's what everything has to be—houses, home décor, ornaments, clothes!'[77] Within a year, she was not only voted one of the most influential people in the United Kingdom, but was granted her own waxwork at Madame Tussaud's.

Reactions to Twiggy in some quarters of the fashion world were horrified. Compared even to the unconventional style of Shrimpton, she was novel and unrefined. However, because her capacity to sell clothes was remarkable and her own-label merchandise was a sell-out, the fashion establishment could not long ignore her. US *Vogue* selected her to model the Paris collections, photographed by Bert Stern, and she was also shot by Richard Avedon. When she arrived in New York, she unleashed a pandemonium. Stern was commissioned by the ABC network to make a series of television films of the whole US trip: *Twiggy in New York*, *Twiggy in California*, and *Twiggy Who?* The 'Twiggy look' proved hugely popular and was copied throughout the world. Two features were important: the legs, that were encased in coloured tights and composed in knock-kneed fashion at a gawky angle; and the face, to which a boy's haircut and big eyelashes gave a doll-like quality. Twiggy was a constant presence in the press. She was youth, androgyny, lower-class aspiration, outspokenness, pop music, and image all rolled into one. Unlike previous models who seemed like still-life compositions, Twiggy moved; she had great sense of rhythm and many of her best-known poses were the result of her body's responses to pop music.

Twiggy and Shrimpton were the consecration of youth and beauty. They had perfectly proportioned faces and were intensely photogenic. Both seemed quite natural, although their appearance was, however, only natural up to a point since they used eyeliner, lipstick, and mascara to create individual looks. 'Makeup old-style is out,' declared Mary Quant; 'it is used as expertly as ever, but it is not designed to show, the ideal now is to look as if you have a baby skin untouched by cosmetics.'[78] Suddenly, the ideal body was young and adolescent beauty was discovered to possess a selling power that exceeded all the classic appeals of class, tradition, luxury, and fantasy. Twiggy was even dubbed, by one observer, an 'elongated

matchstick'. However, there was still a 'right' way to do hair and make-up, a 'right' way to wear clothes, and 'right' fashions to adopt. Style was no longer bound up with breeding and was presented as a disposable quality whose content at a given moment was determined by professionals with their finger on the contemporary pulse. It was a widespread, shared phenomenon that came from a variety of places and which was diffused by recognized stars.

According to older definitions of glamour, Twiggy was not glamorous at all. She was not rich or sexy and she had had no time to build a personal narrative. The term was still widely taken to apply most accurately to a star like Elizabeth Taylor or a fashion leader like Jackie Kennedy, that is to say women who were somehow associated with luxury, movement, and high style. By contrast, Twiggy's authentic personality and cockney accent lent her the quality of *My Fair Lady*'s Eliza Doolittle before Professor Higgins begins his experiment of transformation. Everything about her domestic, familiar, and teenage persona contradicted established ideas of glamour. She had raw charm but no obvious sex appeal. The teenage 'dolly birds' in any case were neither prey nor honeytrap; their sexuality was provocative in an assertive way that suggested self-determination.[79] Yet there were three ways in which Twiggy mobilized the magical aura of enviability for her contemporaries. In the first place, she was down-to-earth and accessible; she seemed to be acting the part of a successful model in a way that unleashed a 'me too' response from her contemporaries. Secondly, she was a photographic personality. Hornby herself was well aware of this and worked to enhance her visual appeal. She took as her example American model Penny Moffat, whom she happened to see at the start of her modelling career. Moffat moved her head and arms, creating designs with her body, turning it into an artistic construct. 'She's one of those who looks better in pictures than in life, because she really works at presenting herself to the camera,' Twiggy declared.[80] Although there was a sultry aspect to Moffat's persona that did not carry over to the young model, Twiggy nevertheless established a uniquely imitable visual presence. As photography theorist Clive Scott argues, the fashion photograph must not present its image as reality but rather negotiate between the image's origin in false reality and its future in real possibility.[81] Thus there is always a falsity to the model who has this element of unreality built into her. This is

the part that determines her image for the viewer and in which her glamour is largely invested. 'Twiggy''s pictures, in this sense, carried a high quotient of glamour.

Thirdly, Twiggy's lifestyle became intensely glamorous. She recounted her experiences in the press and her first-hand accounts preserve the wonder of the ordinary girl at the sudden change in her existence. Instead of tending to customers at the hairdresser's, she received red-carpet treatment wherever she went. 'Whenever I appeared in town I was big news and there were private Lear jets and Cadillacs to pick me up and whisk me to some reception or other,' she wrote of her experiences in the United States.[82] In California, she stayed in the Bel Air Hotel and, at her request, met singers Sonny and Cher, who held a party for her at which the guests included Eve Marie Saint, Tony Curtis, Robert Mitchum, and Steve McQueen. Being so new to fame, she experienced the life of limousines, aeroplanes, and hotel rooms as an outsider. 'It sounds so glamorous, but would you like it?', she asked her readers rhetorically. 'Even my short experience of it was enough for me.'[83] However, the pose of detachment was not consistently maintained, not surprisingly considering that perks not normally available to Neasden girls were involved. 'Life was pretty glamorous for us,' she wrote, referring to her life with Villeneuve. 'For our holidays, we used to rent a whole island— Five Star Island, off Bermuda. Six acres to ourselves, and two landing jetties. We almost bought the island at one point.'[84]

Part of Twiggy's appeal, especially abroad (in Italy, she and Shrimpton were affectionately dubbed 'Grissino' and 'Gamberetto', the former being the Italian word for a bread stick and the latter for a shrimp), was due to the emerging awareness of Swinging London. There was a coming together of a variety of currents in the English capital that, according to Quant, 'grew out of something in the air which developed into a serious effort to break away from the Establishment'.[85] The outsider status of people like Bailey and Twiggy, and Quant herself, was a crucial catalyst in overturning established social and cultural preconceptions and propelling painters, photographers, architects, musicians, writers, socialites, actors, racing drivers, sportsmen, television producers, and advertising men to the centre of national culture. Creativity and originality were the driving impulses of a whole variety of

cultural industries. Quant's Chelsea coterie, with its stress on vibrant youth, coffee bars, and Italian restaurants gave an alternative feel to the new London, but the media, fashion, pop music, sport, and publishing were powerful industries that very quickly shaped the image of the country. They all offered a premiss that was ostensibly democratic: anyone of talent or beauty could be suddenly transformed into a celebrity.

Similar patterns were emerging everywhere in the Western world although not always so vigorously. In Paris, boutiques were opening by the dozen on the Left Bank and even couturiers were getting in on the act.[86] Yves Saint Laurent more than anyone else was responsible for challenging the traditional exclusivity of couture and shifting the focus of fashion from couture to prêt-à-porter. He opened his Rive Gauche boutique in 1966, which was followed by branches in London and New York.[87] It sold casual creations to fashionable customers at prices that were not cheap by normal standards but which were lower than those of couture. The Left Bank hosted a thriving milieu of artists, intellectuals, jazz and pop musicians, and media professionals.

Beaton played a key role in fashioning the elite of the new age of the photographic image. He ranged over periods, classes, and countries and could photograph Queen Elizabeth just as he could Mick Jagger, Twiggy like Princess Alice, Countess of Athlone, or the elderly dancer Cléo de Merode. His worlds included royalty and aristocracy, fashion, the theatre and films, plus the rich and famous of at least three continents. Beaton was accepted by the young talents as a figure who had knowledge and experience and was open to new things. He was never ridiculed and was able to mix at the interface of young talent and young aristocracy. Among the few who turned him down was the French photographer Henri Cartier-Bresson, the father of modern photo-journalism who was just four years younger than himself. Rejecting Beaton's overtures, he declared: 'there are three categories of people who should never be photographed—prostitutes, private detectives and photographers'.[88]

Beaton saw that the end of a certain way of dressing among women and the unusual physicality of some pop musicians had brought the sexes together and made a new form of male glamour possible. It was not just youth but also gender that was being redefined. Mick Jagger, for example, intrigued him; he had a mystery about him. His face, Beaton confided to his

diary, reminded him of the ballet dancer Nijinsky. When he eventually photographed him in Morocco, he found him to be a compliant yet unsettling subject: 'He was a Tarzan of Piero di Cosimo. Lips of a fantastic roundness, body white and almost hairless. He is sexy, yet completely sexless. He could nearly be a eunuch. As a model he is a natural,' he noted.[89] Vreeland was fascinated by Jagger's generous lips which she saw as a pop cultural phenomenon rather than a feature of the man. They simply could not have existed, she believed, without the precedent of Bardot's pout.[90]

The sexual ambiguity that Beaton and Vreeland saw in some male stars was in part a matter of costume. Many pop performers had been to art school or, despite their regional or affected working-class accents, came from creative middle-class backgrounds. Dressing up in vibrant colours and dandyish outfits and wearing long hair was part of their rebellion against arid normality. It was also a deliberate challenge to established gender codes. Compelling and ambiguous men came to the fore in several fields. Rudolf Nureyev, the Kirov ballet dancer who defected to the West in 1961, was one of the most prominent. His unfamiliar physical beauty, technical mastery, arrogance, and personal flamboyance turned him into an icon of the decade. He was the first male ballet dancer of the second half of the century to take ballet to a wider audience. His talent, exoticism, and voracious bisexuality made him into a something of a Byronic figure and the dancer played up to this image explicitly in his public image and his later work.[91]

Despite the importance of pop musicians, models, and hairdressers in giving a recognizable sound and shape to London in the mid-sixties, the photographer was the crucial figure in shaping the impact of almost every personality and cultural phenomenon. It was his ingenuity, flair, and imagination that moulded the natural attributes of his subjects into fashionable images. Thus it was entirely natural that the Italian film director Michelangelo Antonioni should have made a fashion photographer the protagonist of *Blow Up*, a film that would stand as one of the most representative films of the era. Despite his early background in Italian neorealism, Antonioni was a director who preferred to explore modernity and in particular the alienation of modern life. His desire to make a film about the fashion world led him to consider Rome and then Paris and New York before he opted for London.

He arrived in the city in 1965 to begin research for his film.[92] He had already shown a special interest in fashion in his work, notably in the films *Cronaca di un amore* (Chronicle of a Love) and *Le Amiche* (The Girlfriends). He had also made by then the trilogy of *L'Avventura* (The Adventure), *La Notte* (The Night), and *L'Eclisse* (The Eclipse) that would later be regarded as his best work. His 1961 film *La Notte* was a sort of *La Dolce Vita* remake set in Milan, in which Marcello Mastroianni (the star of both films) exchanged the decadence of the aristocracy and the film world for the thrusting ambition of the bourgeoisie and the publishing industry of the Italian economic boom. *Blow Up* can be read as yet another take on Fellini's film, this time set in the British capital. His decision to shoot the film there says much about the way London was seen abroad.

Antonioni had wanted to cast many people as themselves, including Bailey and Twiggy. In the end, after rejecting Stamp—who had allegedly paid too much attention to the director's lover Monica Vitti—he cast Bailey lookalike David Hemmings as the photographer, while the real-life models who took part in the film included the German Amazon Verushka and Jill Kennington. *Blow Up* reinforced the idea of Swinging London and was widely seen as a celebration of a city in vibrant transition. In fact it offered a penetrating critique of a civilization that had exchanged surface for substance. The preoccupation with image is so strong in the film that no one is at all interested in the possible murder that the photographer uncovers in the blown-up detail of one of his photographs. The concluding scenes of a tennis match being mimed without balls, while the sound of them being struck features quite normally in the soundtrack, exemplifies the emptiness of a world in which the attention was being focused on nothing.

In contrast to *La Dolce Vita*, *Blow Up* did not arouse any political controversy since the critique it offered did not touch the ruling elite.[93] Instead it was controversial for its fleeting nudity and sex scenes. The film's protagonist is not a modern lothario; rather he has a wife and children off screen. But a scene of an orgy at the end of a photo session, in which the photographer engages in a tumble with a couple of models, nonetheless confirmed the idea that the contemporary fashion world was imbued with sex. In the mid-1960s, the representation of sex was still a delicate matter and nowhere more

than in England where the trial for obscenity of the English publisher of D. H. Lawrence's 1928 novel *Lady Chatterley's Lover* (which had initially been published in Italy) in 1960 was still recent, and the unseemly revelations of upper-class depravity at the Duke and Duchess of Argyll's divorce trial and the Profumo scandal in 1963 had received sensational coverage. One of the key impulses of the sixties was towards liberation of sexual mores and the practical behaviour of the protagonists of Swinging London exemplified this. But in the matter of representation, artists and film-makers were bound to encounter prevailing values and brush up against legal restrictions as well as shape emerging standards.

For Susan Sontag, the photographer had become a modern hero by the 1920s.[94] The capacity of practitioners of this art to expand visual horizons brought them a crucial role in capitalist society, which by its very nature required a culture based on images. However, in sixties' London a new socially and geographically mobile group of photographers were active public figures who were often as well known as their subjects. *Blow Up* consecrated the photographer as the hero par excellence of the decade. It also put paid to the residual idea that photographers, like hairdressers, were mainly homosexual. It highlighted the fact that the new fashion photographers were heterosexuals who often enjoyed relationships with their models. In this they differed from the earlier generation whose imagery was as desexualized as their personal relations with their models were platonic. In contrast to the stiffness and formality of the recent past, photographs were sexed-up; they were infused with the new atmosphere breathed in the studios. As Shrimpton confessed, 'Photographers do have a lure for models, and a photographic session can be a very seductive time.' Locked together in the studio, they experienced a sexual buzz that, she was keen to stress, normally ended when a session ended.[95] But there is no question that both the relationships between models and photographers and, more particularly, the public presentation of them in the media, brought the allure of sex to the way in which the whole work of photography and fashion marketing was seen.[96] Helmut Newton noted that the sexy image made photography irresistible as a profession. In Paris, he said that,

after *Blow Up*, 'the young people, everybody, wanted to be a fashion photographer. It became a big cult.'[97]

The sexual revolution was about the loosening of mores but it entailed numerous contradictions since it was as much about the representation of sex and the sexually titillating as about changes in sexual behaviour. More relaxed censorship opened opportunities to film-makers and publishers to cater to demands for explicit material. The sexy image of the fashion world provided a cover for an expansion of a different type of modelling related purely to the gratification of male sexual appetites. Sontag argues that the main effect of photography is 'to convert the world into a department store or a museum-without-walls in which every subject is depreciated into an article of consumption, promoted into an item for aesthetic appreciation'.[98] The term 'depreciated' is only appropriate here because Sontag was discussing human beings; in terms of commercial aesthetics what was being referred to was an enhancement—or the formation—of an image. In his examination of British working-class culture, Hoggart noted that many working-class sex magazines were marked by 'a pseudo-sophisticated and knowing urban coarseness'.[99] The models had vulgar faces and 'a large-mouthed and brassy vulgarity of expression'. They were close to the reality of street prostitution: the images were not erotic or psychological but 'real' and immediately sexual. The debut in 1965 of a new men's magazine, *Mayfair*, heralded a change that was informed by, but not reducible to, the example of *Playboy*. Like Bob Guccione's *Penthouse*, which was founded in the same year, *Mayfair*'s title suggested wealth, sophistication, and pleasure. Semi-nude models were inserted into a dream world of exotic leisure and turned them into component parts of consumer culture. The glamour photography of the 1960s differed from the film studio portraits of the heyday of the Hollywood studio system. The demand for that sort of highly artificial photography evaporated in the sixties and instead 'glamour' was taken to be a genre of photography that was solely concerned with the heightened presentation of female beauty for male consumption. Its techniques were applied not to create a complete illusion but to emphasize the sex appeal of the model. Thus, while George

Hurrell claimed to be able to glamorize anyone, even if some subjects were more suited to the task than others, later more stress was laid on the physical characteristics of exclusively female models. A 'glamour model' was a woman whose physical attributes suited her to representation for the pleasure of heterosexual men. Most often, she was a teenager or in her early twenties, with a fresh, natural look and a slim body, unlike some of the older professional models who appeared in the erotic magazines of the 1950s. While beefcake magazines catered to male homosexual tastes, the models were not presented according to the same visual language. Body-building and sport were the main inspirations.

The 1960s witnessed a boom of 'glamour photography'. This involved the 'deliberate effort to create visual pleasure and heightened femininity'.[100] It was a contrived idealization that used both truth and fiction to create a new synthetic quality to feminine allure. The label signified at once a link with Hollywood sex appeal and a differentiation from cruder products. There was enormous interest in glamour photography among amateurs and this was demonstrated by the number of manuals that were published for their benefit by professionals. The best models were deemed to be the women who were able to communicate without too much artifice a sense of refined sex appeal. One Italian guide suggested that any items of clothing should not be too luxurious as they would take attention away from the model.[101] Much better were either specialist sexy garments, or modish youth clothes. A minimum of props in the form of a bed, divan, cushions, plants, mirrors, or a fireplace was necessary to contextualize the model's body, for 'nudity alone does not constitute glamour; photography must induce the imagination to develop nudity but it must not present it totally'.[102] The photographer Rayment Kirby (Ray) argued that glamour 'consists of using every technical trick and artifice to create an effect; to turn an ordinary human being into an illusion of complete fantasy'.[103] However, the results should be ostensibly natural. 'The word glamour, as applied to photography today, is in simple terms making women look their best,' he asserted. 'The glamour photographer, whether male or female, is in much the same position as that of the model's hairdresser or mirror.' It was all about imagination; the subject was simply a prop for erotic fantasies. He advised eager amateurs that 'healthy

looking girls with good figures are what you need for your pictures'.[104] A cheerful attitude was also important. Closed or pessimistic characters were unsuited to the work in the view of one author, for 'they will never be able to produce good glamour photography because they cannot sense the atmosphere and therefore will be unable either to stimulate or capture in the model the necessary sex appeal'.[105]

Modern glamour girls, more natural and no longer groomed, polished, and bleached to within an inch of their humanity, were widely employed in movies and television programmes. In the James Bond films, including *Dr No* and *From Russia With Love*, they were impersonated by Continental actresses, in these cases the Swiss Ursula Andress and the Italian Daniela Bianchi, who were packaged and presented as the objects of male fantasy. They were beautiful, rootless women of a certain spirit and independence who were available to the male protagonist and, as filmic images, to the film-goer. Similarly refined, but home-grown sex symbols populated British-produced, Bond-inspired television shows like *The Saint*, *The Avengers*, and *Department S*, which featured precisely the sort of exotic locations and alluring places like nightclubs, grand hotels, and casinos that filled upmarket magazines. Although they attracted sizeable audiences, the shows were dismissed in some quarters as 'glossy British rubbish' with characters taken from advertisements for hair shampoo.[106] Roger Moore, who took the lead role in *The Saint* and would later replace Sean Connery as James Bond, was the perfect vehicle for upwardly mobile dreams. His character's smooth bachelor manner and transatlantic accent made him a small-screen Cary Grant, whose suburban polish and flawless modern wardrobe matched his taste for pretty girls, cocktails, and Continental sports cars. Even more than his model, his screen image was that of a glamorous persona from nowhere who had kicked away the ladder on which he had climbed up from nothing.

Movement and travel were crucial to the new glamour of the 1960s. The most suggestive source of ideas of glamour and travel were supplied by members of the jet set. Elizabeth Taylor commanded more attention than most. She was, wrote Francis Wyndham of *Queen*, who visited her on the set of the airport drama *The VIPs*, 'the most film-starry film star in the world'.[107] She was 'the one film star who can still impose her whims on any producer and get away with it because she has the box office solidly

behind her'. Bardot was another globetrotter, who married her playboy lover Gunther Sachs in Las Vegas in 1966. She consistently rejected the conventional idea of the star and drew criticism from the French and international press for her bad taste and bohemian ways. The casual allure of her simple dress style, however, made her a model for thousands of French girls.[108] High living and consumerism were bound into notions of travel at precisely the moment that foreign tourism took on mass proportions. Airlines traded shamelessly on this in their advertising. The cordial and caring presentations of stewardesses that had been used in the previous decade were replaced by highly sexualized images that portrayed them as swingers and playmates. Southern airways even swopped traditional uniforms for miniskirts while Southwest adopted hot pants and boots. Such blatant exploitation of women who were workers rather than airborne party-goers gave rise to an increase in instances of harassment which contributed to an unexpected growth of militancy on the part of stewardesses.[109] Protest invested numerous spheres towards the end of the decade and even the Miss World contest was disrupted by feminists in 1969. Television stations, however, continued to make ample use of decorative femininity and several Miss World winners and finalists, including Austria's Eva von Ruber-Staier, who won the title in 1969, found employment on game shows.

The relaxed spirit of the age and the greater informality can be seen in the field of 'How To' books about glamour written by women for women. These were no less popular in the 1960s than they had been in previous decades, but they placed less importance on exterior artificiality. Two popular manuals of the fifties, *Anita Colby's Beauty Book* and *Glamour School*, stressed the need to mould the figure and personality by working on clothes, make-up, hair, posture, and social skills.[110] Disguising a woman's worst points was no less important than dramatizing her best ones. Later works tended to stress personal discipline as the basis of glamour. 'Makeup, hairstyle and chic can add the dazzle that makes you a striking beauty, but their effects are transient unless they are sustained by stringent living habits,' observed the lean-figured sportswear designer and Roman aristocrat Princess Luciana Pignatelli in one guide.[111] In the cultural flux of the period, 'casual glamour' in the form of sports clothes and loose hair was contemporary, but good hair and

bone structure and a candid outlook on life were required to carry it off.[112] 'There is no longer a fashion center that can dictate,' Pignatelli argued. 'You have to think out your own style, your own brand of glamour. Anything goes so long as it goes together with you.'[113] The end of the option of simply conforming to the prevailing fashion template presented a considerable challenge.

The international celebrity circuit was a mixture of playground and publicity stunt for a select group of people. At its centre was the shipping magnate Aristotle Onassis. Unlike many international businessmen, he did not disdain publicity but actively sought it with the aid of a public relations adviser whose task was to enhance his glamorous image. Onassis was not a good-looking man but he had charisma and was associated with glamorous places and activities. This gave him leverage over public opinion and concealed the sordid or questionable aspects of his business dealings.[114] Celebrities including the Kennedys, the Earl of Snowden and Princess Margaret, Elizabeth Taylor and Richard Burton, Cary Grant, and Margot Fonteyn, as well of course as his lover Maria Callas, accepted invitations to join him on his cruise ship *Christina*. They enjoyed his hospitality while he, in turn, used them as decorations for his various activities.

Jackie Kennedy first travelled on the *Christina* while she was still first lady and was recovering from a miscarriage. After the interlude of her mourning period, she entered the realm of the jet set, becoming a regular social presence on both sides of the Atlantic. In 1964 she moved back to New York and, when she was in Europe, she mingled with the beautiful people in resorts like Gstaad, Capri, and Rome. Like any young widow, she found that with time the circle that she had frequented with her husband dwindled. She was obliged to seek new pastures and forge new friendships, which she found in the ranks of the flotsam and jetsam that comprised the international jet set. She had got used to the high life and became accustomed to private planes, yachts, and the lifestyle of the super-rich. This milieu provided her with a form of protection. Jackie craved privacy but everywhere she went there was excess attention. Even in moments that she regarded as private, away from Washington, she was tailed by photographers

and reporters. She had a special draw that turned her into a prisoner. She was a dazzling celebrity who could not live normally even in New York.

At this time her fashion influence reached its height. Travel was crucial to her glamorous image and, like Empress Sissi a century before, she always seemed to be in the most desirable and evocative places. 'To be in fashion means to be on the go,' remarked journalist Marilyn Bender; 'the important thing is to keep moving, to arrive after everyone has heard of the place but before everyone has been there. Acapulco, Antigua, Gstaad, Hawaii, the Greek islands have all had their moment of glory.'[115] American women in the sixties did not find models they could emulate in the movies which had lost some appeal and were producing more male than female stars. Consequently, the fashion industry elected Jackie as its patron saint. Once removed from the White House, she seemed to get younger, at least in terms of her personal style, which reflected the youth-orientation of the era.[116] According to Cassini, she did not want to be regarded as a trendsetter, but rather as stylish in her own right. She was fascinated by facades and appearances of all types: furnishing, decorating, and staging events were her favourite pastimes. She was attentive to her personal style and kept faith with it. Her high visibility and distinctive beauty made her more influence than influenced. Her basic look consisted of Chanel-style suits, bright colours, and low-heeled shoes. It was sufficiently casual and youthful to amount to a contribution to the fashion trends of the 1960s. However, little or nothing was left to chance. Jackie was a poseur in a literal sense; there was a premeditated, quasi-theatrical quality to her actions. She cultivated her image and choreographed her life. In the autumn of 1966, she shortened her skirts to near-mini length, a move that immediately legitimated the mini and turned it into mainstream fashion. This is just one example of how fashion influence no longer trickled down but instead was diffused in different ways through the media and key mediators. A mass audience eagerly studied the details of Jackie's wardrobe as well as the broader style choices she made.[117] Her trademark huge dark glasses and her wide smile were unmistakable. Jackie spent prodigiously, forever changing outfits and accessories, sometimes idiosyncratically, a fact that caught the attention of consumer-oriented and upwardly aspiring women in the United States.[118]

Jackie offered a walking style lesson. Her life, moreover, appeared to be choreographed; nothing was casual, it was like the unfolding of a play; every action had significance. However, a significant shift occurred when she took up with the Greek shipping magnate Aristotle Onassis. For the American people, the announcement of the couple's engagement broke the spell. It was as if the queen had abdicated. It was felt that she was betraying her husband's memory and demeaning herself. Onassis was widely seen as a Greek pirate, a vulgar tycoon and a figure of the jet set, a nightclubber and womanizer who compulsively pursued beautiful and famous women.[119] Like the *viveurs* of the belle époque, he frequented Maxim's in Paris and vulgarly exhibited the symbols of his wealth. Jackie was the ultimate trophy wife and by winning her he scored a huge publicity coup. He showered her with jewels and indulged the spending splurges for which she had become known even before entering the White House. Like the Duke and Duchess of Windsor, with her wedding in 1968, she came down from Olympus and joined café society, where she 'migrated from taste to waste and joined Liz'.[120] She was depicted as a pleasure seeker and big spender whose love life was of no less interest than a movie star's. She was snapped dancing the Twist, in bathing costumes, and even while sunbathing nude on Onassis's private Greek island of Skorpios.

The paparazzi were forever on the lookout for revealing shots of celebrities in the Mediterranean. In Jackie's case her fame ensured that her image always had value and the attention did not stop when she returned home. Between 1967 and 1973, the year she went to court to end his alleged harassment of her, she was assiduously pursued by the paparazzo photographer Ron Galella. The first photographers to fashion new images of celebrity were the freelance snappers who pursued the celebrities in Rome and on the Côte d'Azur. The paparazzi were insolent and aggressive towards many of their subjects. They were concerned simply to exploit the fame of the latter to maximize their earnings. But their photographs had a striking immediacy. When they caught illicit couples in a furtive embrace, snapped an inebriated celebrity husband or his wife in a dishevelled state, they gave the public an insight into the disorderly hurly-burly that characterized the leisure of the rich and famous. Famous punch-ups on the Via Veneto

between paparazzi and their victims only served to enhance the public's fascination with the lives of its favourites.

Galella, by contrast, was in fact one of her greatest fans, who saw her as 'the perfect model of wife, mother, woman—someone whose ways of being should exist as instruction to all wives, all mothers, all women'.[121] 'I admit', he later wrote, 'to being obsessed with tearing after every reasonable and fair opportunity to photograph this splendid woman—to make a lasting record of her infinite moods and endlessly varied comings and goings.' In his many disguises, Galella succeeded in capturing his idol in numerous instances when her guard was down. His portraits were none the less very different to the snaps taken of celebrities by the Roman paparazzi because they never showed Jackie in an unflattering light. On the contrary, the celebrated picture he took of her near the intersection of Madison Avenue and 88th Street in Manhattan is the most iconic picture of her post-White House period. Striding confidently forward with sunglasses in hand, her hair blowing in her face as she turns towards the photographer, she is dressed simply in faded jeans and a ribbed woollen top. Shot from a taxi, the picture, for Galella, said something like 'see the thoroughbred striding'.[122] The photograph has a sense of the instant, of real time, of the trivial made eternal. It is the exemplification of critic Susan Sontag's observation that photography 'offers instant romanticism about the present'.[123] Its very ordinariness disguises what is extraordinary about it: although her clothing is merely functional, Jackie appears as a fit, trim woman in complete charge of her body and its movements; she is unencumbered by any excess baggage; even the wind contrives to blow her hair in such a way as to enhance her mystery.[124] It posits its subject as supremely enviable and naturally impeccable.

Jackie remained a figure of the imagination and a woman of great popularity despite her brushes with public opinion. As others rose and fell—even Bailey fell from grace and Twiggy retired at 19—she was a continuous presence. She had many fans, one of whom was the popular author Jacqueline Susann, whose best-selling potboiler *Valley of the Dolls* explored the perils and tragedies of misplaced ambitions. Susann strongly identified with her namesake's elegance and beauty, even though, with her big hair, sequins, hard-living, and high heels, she always looked like show

business on legs.[125] She even wrote a quasi-*roman à clef*, *Dolores*, her last novel, in which she dated her heroine's transition from ornament to personality from her visit to Paris as the wife of the American president. In that moment, 'Dolores had come into her own as a full-fledged glamorous personality.'[126] The novel can only be termed a quasi-*roman à clef* because Jacqueline Kennedy Onassis also appears briefly in the text. Dolores is a sort of meta-projection of her alter ego: 'Jacqueline Onassis was already established "news" like Elizabeth Taylor. Now *she*, Dolores Ryan, was the new glamour girl of the world.'[127] The former first lady's transformation was that which Dolores's sister Nita spells out to her several years after the assassination of her husband: 'the real society is gone. Finished. Except for a few seventy-year-old dowagers. You take a good look at today's society, gay Princes and Lords, rock stars, plus any beast from the States with over a million. Even movie stars make it! And you, my dear, you're not social anymore, you're a celebrity. You are on all the magazine covers.'[128]

Jackie's glamour was the result of the interaction of factors: her borrowed auras and superficial similarities to Princess Grace and to the screen princess Audrey Hepburn, combined with the constancy of her visual appearance to make her an icon of popular culture. She was also a factor in the political sphere; through her role she brought a new attention to surface, to the feminine, and to style. 'Her political role is mostly visual,' *Time* noted; a statement that one acute observer remarks could be reversed.[129] Her visual image was her armour, her defence against a hostile world and a weapon against her neglectful husband. She was remote and one-dimensional in the public mind but this absence enhanced rather than diminished her allure. In this sense, perhaps it is right to say that 'Jackie is glamorous because she seems not thoroughly here'.[130] However, she could electrify places and spheres by association; for example, by becoming an editor at Viking after the death of Onassis in 1975, she single-handedly glamorized the world of New York publishing.

The modern glamour of the 1960s was different from that of the past. It was more youthful and dynamic, as well as pleasure-seeking. It was separated from sophistication and freer of the social hierarchy that had born on it up to that point.[131] It was no longer mock-upper class but instead was

imbued with a sense of the current moment, of nowness. Youth and beauty were the key dynamics, although material attributes continued to exercise a far-reaching appeal. In the interrelation of wealth, sex appeal, and beauty, the balance shifted in favour of beauty. In the past, only monarchs, members of the fashionable elite, and professional performers of various types had been interested in the cultivation of a saleable exterior. In the 1960s, this became a widespread phenomenon. Image was a matter of fashion and fashion was widely communicated. Everyone wanted to be part of it, to feel as though they were not merely spectators at someone else's party but that they were participants. As a consequence, the backroom boys and girls of glamour emerged into the daylight and became key players. Photographers, models, hairdressers, make-up artists, boutique and club owners, and designers became as famous as the objects of their ministrations. They lost their previous anonymity and became the principal artificers of their own images, which were also important factors in their commercial success. The new creative elite did not hail from conventional metropolitan or upper-class backgrounds. Consequently, they did not style themselves on the social elite but rather maintained a distinctive and sometimes overtly lower-class profile.

STYLE, PASTICHE, AND EXCESS

G lamour, for Andy Warhol, was a passion. Throughout his career as photographer, film-maker, artist, publisher (of *Interview* magazine), author, cultural commentator, personality, and social gadfly, he was fascinated by appearances and images, especially those that were resonant of fame, mass consumption, popular culture, and style. He was not a detached observer of the surface phenomena of contemporary life but an active participant in the cultivation of celebrity and image. He was eclectic in approach, collecting images and inspirations from the most varied of sources, high and low, which he then interrogated and deconstructed before reinventing and reproposing them in new ways. His best-known work consists of his repeated screen prints of the movie stars Marilyn Monroe and Elizabeth Taylor. Dating from the 1960s, these works took emblematic images of the most famous and glamorous people of the era and subjected them to repetition, with minor variations of colour and shade. Like his celebrated prints of multiple cans of Campbell's soup, these images acknowledged the special resonance of the mass-produced object in contemporary culture. Many of his creations explored the particular artificial aura that was

associated with these objects and indulged in the possibilities it offered for further reproduction. Although Warhol was intrigued by many everyday products, it was the stars that fascinated him most. Growing up in industrial Pittsburgh during the Depression, he was drawn irresistibly to the larger-than-life personalities who populated the movies of the period. Hollywood glamour was a fabulous confection that entranced and seduced him, shaping his whole subsequent outlook on art, film, fashion, and advertising. The aura of beauty, wealth, desire, and scandal that celebrities emanated was something that Warhol experienced mainly through magazines and tabloid newspapers.[1] Like many fans, he collected press and publicity photographs and kept old magazines and memorabilia. Mostly, it was female stars like Greta Garbo and Jean Harlow, as well as later actresses including Monroe, Kim Novak, or Brigitte Bardot, who grabbed his attention, but he also owned a pair of shoes that had reputedly once been worn by Clark Gable.

Glamour became a constant theme of all Warhol's work. 'He had one motivating idea. Absolutely central.... He was interested in the idea of glamour. Glamour fascinated him,' declared the art critic Robin Pincus-Witten.[2] Unlike most observers, he believed that it was not just a property of the stars he adored. Rather it was an effect that emerged also through the admiration and involvement of ordinary mortals. Glamour did not hinge on deferential awe but an attitude of participation and appropriation. In other words, it was something that could be taken over and refashioned by its consumers. Most especially, the stars of the recent past, whose images had been widely diffused by the media, were public property. Since Hollywood no longer forged stars in the manner of old, Warhol's screen prints did not merely record the aura of Marilyn or Liz; by elaborating and manipulating it, they had the effect of underlining the iconic status of these stars in the collective consciousness.

Inspired by the example of the great studios, Warhol fashioned his own stars in his famous sixties' studio, the Factory. In this industrial loft space in New York, he painted and, with his colourful entourage, created films, rock music, and happenings. Acolytes including the socialite Edie Sedgwick, the handsome hustler Joe Dallesandro, and the transvestites Candy Darling and Holly Woodlawn, were turned into 'superstars' by the Factory publicity

machine. Warhol invented a series of star vehicles, such as 'The Thirteen Most Beautiful Women', 'Fifty Fantastics', and 'Fifty Personalities' into which a changing selection of people were placed.[3] He presided over a hip milieu that drew in artists, models, poets, fashion designers, as well as musicians including John Cale and Lou Reed, whose Velvet Underground became the Factory's house band. Warhol revelled in his power to shape and mould his discoveries. By forging his own stars, and blurring the boundaries between art, film, fashion, and publicity, he was able to grasp and reproduce in his own way the elusive aura of glamour that had intrigued him since his youth.[4] The Factory was a marginal, underground experience even though the news media by no means ignored its doings. The scene it represented was also documented by such luminaries as Richard Avedon and Cecil Beaton as well as house photographers. The pictures, featuring artfully composed groups of outlandish personalities in various playful and frivolous poses, captured a certain mood that was later seen to embody the spirit of the sixties. Warhol's own look changed in accordance with his new status as an avant-garde artist. The bow-tied and besuited appearance of the commercial artist of the 1950s gave way to a more 'artistic' look that reflected his growing interest for painting, film, and music. In his guise as director of the Factory, he wore leather jackets, striped smock shirts, polo neck sweaters, dark glasses, jeans, and a silver wig.

Warhol was tantalized by glamour's capacity to transform a commonplace individual into a dream-being. With the aid of its magic, a nobody could be somebody, a boy could be a girl, and anyone, in theory, could be a star. In the lights-and-cameras playground of the Factory, everybody could invent themselves and have their close-up. Warhol's superstars had theatrical standout names that disguised their prosaic origins. His best-known protégé, Candy Darling, was a pre-operative transsexual who shared his love of old Hollywood films and who had learned to imitate stars like Joan Bennett and Kim Novak. An elegant blonde with a pallid skin and large, sad eyes, she appeared in the Factory film *Flesh* in 1968 and took a central role as a Long Island socialite who joins a women's liberation group in *Sex* (later retitled *Women in Revolt*) in 1971. Her arch, actressy, and emotional acting style reflected her make-believe persona and derivative femininity. Born James

Slattery, she subordinated her whole existence to the project of being Candy Darling. Her blonde hair, pale face, unsmiling mouth with strong red lips, and Monroe-esque beauty spot featured in movie-star style portraits of her by Bill King and David Bailey, as well as by Warhol himself. One of the best-known images of Darling appeared on a mock-up of a *Cosmopolitan* cover by the magazine's regular cover photographer, Francesco Scavullo. Her commitment to artifice and self-invention led her to take hormone pills that caused her tragically early death aged 29 in 1974 from cancer. Behind the construction of her glamorous persona was a mixture of discipline and suffering. Few images are more poignant than the claustrophobic black-and-white studio-style photographs that show her wrapped in shiny black sheets, reclining on what she knew would shortly be her deathbed.

Darling was a female impersonator who donned a 'real disguise' to conceal her residual masculinity and turn herself into a fully feminine figure. She was more subtle than the drag queens whose 'fake disguise' meant that they always looked like men dressed as women.[5] Both were drawn to the stars, but it was the latter who were most committed to recreating film-star personae. This aroused Warhol's interest in them. 'Drag queens are living testimony to the way women used to want to be, the way some people still want them to be, and the way some women still actually want to be,' he wrote.[6] 'Drags are ambulatory archives of ideal moviestar womanhood. They perform a documentary service, usually con-secrating their lives to keeping the glittering alternative alive and available for (not-too-close) inspection.' 'It's hard work to look like the complete opposite of what nature made you and then to be an imitation woman of what was only a fantasy woman in the first place,' he continued. 'When they took the movie stars and stuck them in the kitchen, they weren't stars any more—they were just like you and me. Drag queens are reminders that some stars still aren't just like you and me.'[7] For Warhol, the only unequivocal beauties were to be found in the movies, 'and then when you meet them, they're not really beauties either, so your standards don't even really exist.'[8] In his view, for example, Monroe's lipstick lips were not kissable—rather they were 'very photographable'.[9] Drag queens worked off the photographic and movie representations of beauty. These had an unreal, quasi-fantastical

allure that seemed like a neat dose of vintage glamour in an era in which there were no more old-style, studio-groomed stars. Warhol was not averse to personally embracing a glamorous feminine persona when it suited him.[10] A closet homosexual who was obsessed with his appearance,[11] he posed for a series of head-and-shoulders self-portraits from 1981 that show him being made-up and trying out a series of female wigs. The poses reeked of wannabe movie star glamour. Warhol's ageing, pock-marked face is transformed by artifice into a series of grotesque drag portraits that make a play of femininity and of glamour's man-made beauty.

In the Warhol persona there was something of the blandness and repetitiveness of modern consumerism. His film *Kitchen* (1965), a minimalist plotless work that mimicked the humdrum everyday ordinariness of domestic America, reflected this, as did his famous Campbell's soup cans. In *The Philosophy of Andy Warhol*, he indicated airports as having his favourite kind of atmosphere, his ideal city as being completely new (Rome, he said, was an example of a city whose buildings had lasted too long),[12] and declared his love of American standardization. The most beautiful things in Tokyo, Stockholm, and Florence, he provocatively affirmed, were the branches of the McDonalds hamburger chain.[13] He was aware that mass-produced plastics shaped a new man-made environment that carried connotations of sameness and repetition.[14] Unlike many, he celebrated the fact that it was banal and disposable as well as synthetic. 'I love plastic idols,' he proclaimed.[15] He has even been seen as a 'plastic celebrity' who personally evoked artificiality.[16] Yet, at the same time, he preferred what he called 'properly-made clothes' and expressed the opinion that man-made fibres looked awful. He loved stars as they used to be and yearned for the time when 'things didn't change so fast' and it was possible to hope to realize a fantasy image before it was swept away by the next trend. Nostalgia and regret informed many of his insights. He noted that whereas once people used to idolize a whole star, following one and loving everything about them, modern-day fans were more fickle and picked and chose the bits they liked.[17] Stardom was also becoming less rare as new categories of people were put up as stars, such as sports personalities and pop performers. His celebrated 1968 statement, 'In the future everybody will be world-famous for

15 minutes' had actually come true, he noted in 1979.[18] Despite some reservations about the end of select fame, Warhol approved the fact that glamour was not unattainable but obtainable and available to all. If he had a dream, it was of a world in which the magical and the commonplace merged; in which people became the artificial surfaces they embraced. 'I don't know anybody who doesn't have a fantasy. Everybody must have a fantasy,' he noted,[19] adding 'I've never met a person I couldn't describe as a beauty.'[20]

Warhol was an avant-garde artist with very close links to the commercial mainstream, in which he began his career. Many of his artistic practices worked off cultural currents that in some instances he helped render visible. In the history of glamour he was an innovator who followed a well-established pattern by mixing elements of nostalgia with an attitude that was informed by the more democratic and egalitarian climate of his time. In the Napoleonic era and after, the rising bourgeoisie had appropriated and refashioned aristocratic styles. In the gilded age, new millionaires had endeavoured to harness and replicate these to bolster their self-image as a new aristocracy. Hollywood cinema in the interwar years had in turn remoulded the lifestyles of the wealthy elite and presented them for mass consumption. Warhol too looked back at the past and drew on it to fashion a popular allure. In his case the template was provided by Hollywood cinema and its applications in mass consumption. The stars, in his outlook, were a meritocracy whose fascination could be recaptured by anyone who took over and re-enacted their way of being. There were, however, significant differences with respect to the past. First, Warhol was not a socio-economic force but an artist, albeit one who devised practices that mobilized the energies of a range of people. Second, the source of his remixes was not a societal elite but a collection of images supplied by an industry. In consequence, his appropriations were doubly derivative. The strong sense of the superficial in his work derives precisely from this. However, his originality lay in showing that surfaces, paradoxically, were not always superficial or at least that superficiality had potential and a strange depth of its own. Without in any way undermining the specific historical qualities of glamour's original bearers, he at once demystified their aura and re-enchanted it. The allure of glamour could never be fully appropriated, but he rendered it more available than before and

showed how it could be made into a repertoire for everyone. It could even become, if one wished it, an aspect of the self. This had a special appeal for those like transvestites and homosexuals who felt marginalized from mainstream life.

Warhol's DIY approach to fame was unusual in the early 1960s but it was much less so in the 1970s, when the innovations of the previous decade spread among the wider population. His work anticipated but was not in contrast with a major trend of the period towards individual expression. A cultural revolution had undermined conventional structures of authority and legitimated lifestyle experimentation, permitting women's liberation and gay pride to emerge as vehicles for further change. These processes were politicized but they were also fostered by forms of small-scale entrepreneurialism that evolved into rampant commercialism as the utopian impulses of the late 1960s receded. The long hair and vibrant colours worn by the hippies were turned into mass fashions that broke the clear visual and sartorial language separating men and women. The fashion industry and the mass media helped make what had initially been marks of distinction with respect to the mainstream into modish trends available even to people of middle age living far away from metropolitan or other cultural centres. In this way they contributed to a change in the nature of glamour, that ceased to be the exclusive prerogative of a mainly female metropolitan elite and was turned into a repertoire of props and hints also available to provincial young men.

The desire to throw off sartorial conventions, dress up, and create a fantasy persona fed into 'glam' or glitter rock, a circumscribed phenomenon that exploded in Britain in the early 1970s and which also found a limited following in the United States, especially in New York. Between 1971 and 1973, a range of musical performers including Marc Bolan of T. Rex and David Bowie, as well as Roxy Music and the less artful Gary Glitter, Sweet and Slade, championed an aesthetic of glitter and slap. Although the music could be raunchy and rock-driven, the lyrics of these bands explored various responses to sexual or teenage angst and feelings of displacement. None of the leading exponents of glam rock was openly homosexual—although some minor ones, including Jobriath and Wayne County (who had been

part of the Factory fringe),[21] were—but it was a product of a distinct conjuncture in which rigidly gendered behavioural models were being questioned and challenged by innovations in dress, hairstyles, and sexual mores. Recent reforms to the law on homosexuality (which was effectively decriminalized in England and Wales in 1967) and open protest against police discrimination, symbolized by the Stonewall action in New York, led to a more visible gay milieu in large cities and in nightlife, and to distinctly gay fashions. Bowie was one of several artists to proclaim his bisexuality (in *Melody Maker* in January 1972). In his Ziggy Stardust and Aladdin Sane periods, his groomed, long hair, gaunt figure, and androgynous, made-up face were set off by a range of costumes. His glittery Ziggy outfit and the elegant white satin Aladdin skirt and boots were widely copied by his legions of fans. Although astronauts never enjoyed the glamour in the 1960s and 1970s that pilots had in the 1910s and 1920s, Bowie played on a certain popular fascination with space travel. His alien guises suggested that he belonged to another realm. Dandified, effeminate appearances evoked at turns Hollywood glamour, Las Vegas glitz, and voguish sci-fi. Warhol's drag queen superstars, especially Jackie Curtis, whose glitter-surrounded eyes, frizzy hair, and torn dresses first came to public attention in the New York nightclub Max's Kansas City, inspired a riot of cosmetics, glitter-covered costumes, platform boots, gold trousers, leopard skin jackets, capes, and elaborately styled hair.[22] Extravagant costumes and cosmetics made all the glam bands, some of whom hailed from the deeply unglamorous 'black country' in the English Midlands, look flamboyant and out of the ordinary.

In contrast to the United States, dressing up and camping it up were not very controversial in Britain, where cross-dressing was a staple element of popular entertainment.[23] One exuberant drag performer, Danny La Rue, regularly featured on prime-time television. Resplendent in his trademark figure-hugging sequined gowns and magnificent wig, he offered a visually exhilarating parade of middle-of-the-road songs and mild comedy. His act, it has been said, was 'the epitome of glamour in a glamour-starved country and a final gasp of British music hall and variety'.[24] Thus working-class bands like Sweet and Slade seemed just to be having fun and indulging in a spot of pantomime. For others, the theatrical turn was more programmatic.

David Bowie declared, 'I think rock should be tarted up, made into a prostitute, a parody of itself. It should be a clown, the Pierrot medium.' While the counter-culture of the late 1960s despised glamour as symbolizing affluence, capitalism, and show business,[25] art school rockers like Bowie saw artifice as a way of rendering musical performance more visual and complex and, through this, of blurring gender boundaries. Glam rockers mostly did not have the sophistication of Warhol but they drew inspiration from his example. In the USA, the New York Dolls offered a shambolic form of dandified rock that seemed inspired by a drawing-board cross of Bowie with the lace blouse-wearing Mick Jagger of the late sixties. Theatrical American singers and bands like Alice Cooper and Kiss pushed the idea even further, the latter even performing in full-face make-up.

Glam rock became a channel whereby show-business razzamatazz of the type embraced by Elvis Presley in his Las Vegas shows was reconciled with pop and rock.[26] With his gold lamé and white, stone-encrusted costumes, Elvis entered what the critic Karal Ann Marling terms his Byzantine period.[27] For rock and pop bands, the influences were mostly more prosaic. Television and more ambitious stage shows fuelled interest in the visual imagery of music on the part of musicians and their fans, a development which itself showed that rock was fast evolving into mass entertainment. Sparkle and glitter became a way of inventing a new more radiant persona and the contrived singing voices of many performers, including Bolan and Bowie, highlighted the extent to which they had transformed themselves. Paradoxically, this artifice made it easy for fans to imitate their style and manner, something that was difficult if not impossible with artists who only highlighted their musical brilliance. In this way, the more innovative glam rockers established a community of feeling with their followers. At a time of economic recession, following the oil crisis of 1973, glitz and glamour offered a glorious escape.

More than any other band, Roxy Music toyed with meanings of glamour. Formed in 1972, most of the group's five original members were art school graduates from the provinces who looked as though they had travelled to earth from another planet.[28] 'Our costumes were quite deliberately takes on those Fifties visions of space nobility—the masters of the galactic parliament

and so on,' declared keyboard player Brian Eno later.[29] 'We were looking to the past in a kitsch way, and imagining the future as it might be—but perhaps in an equally kitsch way.'[30] While the band's members had the swagger of futuristic dandies, their songs had a wistful, nostalgic air. The group's very name was evocative of the picture houses of the golden age of cinema. Names like Gaumont, Rialto, and Locarno had been considered before the decision was taken to opt for Roxy.[31] The band's first album cover featured a model posing in Betty Grable's wartime pin-up style, while the sleeve of the second album 'For Your Pleasure' was a fabulously glossy confection featuring a model in stiletto heels that was redolent of the allure of metropolitan nights. Subsequent sleeves all featured models and drew on the repertoire of pin-up photography. Singer Bryan Ferry cultivated the manner of a lounge lizard and appeared in a variety of costumes including a GI uniform and a tuxedo. 'I don't really have a fixed notion of glamour; I love the glamour of Las Vegas, for instance—the extravagance of showgirls with long false eyelashes, masses of hair and high heels. I think that's fabulous, even though it's completely tacky,' he declared.[32] The band found a rich visual and thematic vein in the history of glamour that its members turned through sophisticated art direction into a contemporary blend of style, fashion, and image. Antony Price, the fashion designer who styled the band, always regretted that he had been born 'too late for the glamorous Hollywood period'.[33] With Roxy, the look was always paramount. The band, one journalist has said, 'represented a world of glamorous fantasy which brought the avant-garde to the British High Street by way of the catwalk'.[34] Roxy fans were mostly ordinary young men whose aspirations had been lifted from the level of the High Street by the movies and the getaway world of glossy magazines.

The vogue for masquerade represented a new stage of the other-directed personality type that David Riesman had identified in *The Lonely Crowd* in 1950.[35] He had argued that peer groups and the media were replacing conventional institutions as the main influences on modern behaviour. The result was a more malleable personality that needed external validation. A focus on exterior appearance and personal self-fashioning was an unavoidable consequence and the sources of inspiration were precisely the mass media. This idea

was further elaborated by Christopher Lasch, one of the leading social critics of the period, who deplored the development as an impoverishment of the human condition. 'To the performing self,' he wrote, 'the only reality is the identity he can construct out of materials furnished by advertising and mass culture, themes of popular film and fiction, and fragments drawn from a vast range of cultural traditions, all of them equally contemporaneous to the contemporary mind.'[36] In his view, 'the disparity between romance and reality, the world of beautiful people and the workaday world gives rise to an ironic detachment that dulls pain but also cripples the will to change social conditions, to make even modest improvements in work and play, and to restore meaning and dignity to everyday life.'[37] He noted that the erosion of meaningful projects of social and political change had brought a new focus on individualism and pleasure. With social life less structured around social institutions following the cultural revolutions of the 1960s, and the concomitant displacement of collective sensibilities, what the writer Tom Wolfe referred to as the 'Me Decade' had heralded a widespread turn to self-expression and personal gratification.[38] One of the prime examples Lasch gave of the type of the 'new Narcissus' was, perhaps not surprisingly, Andy Warhol. His detached and pseudo-self-aware persona embodied exactly the shallow sense of self that the critic deplored. Yet, in another perspective, it was precisely the importance attached to surface that made Warhol's glamour recipe so seemingly empowering for those who preferred to create a glittering exterior persona rather than face the mundanity of their everyday lives.[39] The subjugation of the individual to a media panorama in place of the institutions of family, religion, and community authority freed him or her to construct an individual story or identity, albeit within the range of possibilities suggested by media that were organically part of the consumer economy. Warhol's focus on 'deep surfaces' perfectly fitted this atmosphere.[40]

Bands like Roxy Music created dream worlds that consisted of images and suggestions taken from films, magazines, and television. They evoked the privileged world of the beautiful people, the nomadic lives of the jet set, exotic paradises, and stylish romance. In their songs, the Riviera, Palm Beach, and Hollywood, the past, the present, and the future, all merged into one portmanteau fantasy. In this way, they promoted a cult of pop

glamour that fuelled their fans' desire to live glamorously and act out their dreams. This imaginary uplift from banal quotidian experience was not new but in the 1970s it took on a new significance as it coincided with the disappearance of a distinctive elite of style, taste, and privilege. Whereas, in the not so remote past, women like Babe Paley or Mona Bismarck had belonged to a tiny international elite of style, now the rich had multiplied and the special grace that had once touched the fashionable few had evaporated. According to Truman Capote's biographer, Gerald Clarke, 'a new kind of glamour, based solely on publicity, had taken its place'.[41] In this vacuum, pop offered an alluring pastiche of sophistication. Roxy Music brought an intoxicating air of louche elegance to Britain's high streets and precincts, launching an epidemic of copycat haircuts and attitudes.[42] In this, they were a major influence on later bands, and notably on the champions of 1980s' New Romantic glamour, Duran Duran. As the band's fortunes increased, Bryan Ferry's lifestyle came to resemble his fantasies. He had set his sights on turning himself by means of his art, clothes, and music into a modern aristocrat. He stepped out with the Texan model Jerry Hall and then married the daughter of a well-connected Lloyd's broker. The couple were fixtures of the London party scene and occasionally joined the international jet set.[43]

Once, picture houses had been the theatres of dreams, vehicles of fantasies, and sensory stimulations. In the 1970s, discotheques and nightclubs brought a whiff of excitement to the lives of young people living in provincial towns and cities. They were tempting and alluring places where the workaday world receded and everyone could indulge in escapes from the everyday. Various currents brought about a situation in which the nightlife of leading cities began to sparkle and sizzle with unprecedented intensity. After the 1960s, more people had surplus income and demanded leisure opportunities that provided an alternative to the regimentation of the workplace. This contrasted with earlier leisure, which had been predominantly collective and often voluntary, in the form for example of working men's clubs and organized outings, with only cinema and dance being mainly organized through the market. A general enthusiasm for dressing-up and exhibitionism combined with the burgeoning gay subculture and the mood of escape to generate an atmosphere of hedonism.

Discotheques had begun in France in the 1960s as a type of nightclub where, instead of there being a live band, recorded music was played through a sound system. They had quickly spread to London where drinking and dancing clubs in Piccadilly and Soho adopted the name. These were often hybrid establishments, however, that still featured some live music and occasionally even included a casino. Their clientele was more moneyed than young and stylish.[44] In fashionable clubs in Paris and on the Riviera, disc jockeys created sequences of sounds, blending one disc into another to ensure that dancing was uninterrupted. Paris clubs such as Flamingo and Club Sept, which opened in 1968, created a semi-clandestine scene that was distinct from conventional social life. There was an openly gay element that was disguised by the general emphasis on dressing-up and escapism.[45] Light systems coordinated with sounds and glass dance floors with coloured lights added to the experience. Discotheques soon spread to major cities throughout the Western world and then to smaller towns and the provinces. But the impulses that came to bear on the industry of after-hours entertainment were most evident in locations in which the mix of money, creativity, and beautiful people was most intense, that is to say in New York, Paris, Los Angeles, Miami, and on the Riviera. The music that able producers created for disco dancing contributed to the atmosphere. They mixed soaring vocal sounds with a steady beat and a pulsating bass line. Forsaking the guitar-dominated sound of rock, they made recourse to horns, strings, and electric pianos and guitars to create a powerful, swirling rush of sound capable of rousing even the most reluctant dancers to their feet. Donna Summer, Barry White, Chic, and the Jackson Five were the leading exponents of a musical genre that would dominate the hit parades between the mid- and late 1970s. Rooted in the Tamla Motown sounds of the 1960s, disco evolved into a distinct musical style through the soul sounds of Philadelphia and New York contaminated with pop and funk. It was loathed by rock fans who clung to the counter-culture's unglamorous masculine aesthetics and insistence on the authenticity of live music.

The disco music boom brought to the fore a series of behavioural tropes that were further codified and amplified by the movie *Saturday Night Fever*, which was released in the United States in December 1977. Tony Manero's sharp white

suits and black shirts (which were in fact inspired by Marcello Mastroianni's costume in some later scenes of *La dolce vita*), his strutting his stuff with physical self-confidence, his living for the night as a sphere of self-realization opposed to the banality of his daytime life, and the syrupy ecstasy of the Bee Gees soundtrack all turned disco from a subculture into into a social and cultural phenomenon. Played by John Travolta, Manero was an example of a young working-class man who was a king while he was in the discotheque. With his sharp suits and dance-floor magnetism, he was untouchable; outside that context he was hemmed in by drudgery, squabbling parents, deadbeat friends, and community tensions. The discotheque provided him with a platform to realize his dream self. There he was the supreme dancer, the sexual magnet, the fashion leader, and the master of all he surveyed.

No club would mark the disco experience more than New York's Studio 54. It only had a brief heyday (from April 1977 to February 1980), but during that time it enjoyed an unrivalled reputation. It was flamboyant and excessive, decadent and debauched, and desirable in the extreme.[46] Situated on West 54th street in Manhattan in an old CBS television studio from which many popular live television shows had been broadcast, it boasted a 5,400-square-foot dance floor and stunning lighting effects. Created by nightclub promoters Steve Rubell and Ian Schrager, it was a concentration of disco, glitter, celebrity, libertinism, and gay culture. Studio 54 was quite unlike old-established New York clubs like El Morocco and Le Club that were reserved for the rich. Its sheer scale distinguished it from clubs in London and Paris that had brought together heterogeneous groups of celebrities, arts and fashion, socialites, and beautiful people but which were small. Studio 54 brought a new dimension to New York nightlife that was seductive, hedonistic, exuberant, and wild. It flourished at a time when the city had one of the highest crime rates in the world and was on the verge of bankruptcy. It was a counter to stagnation and a diffuse sense of decline. It was also the tip of an iceberg of semi-clandestine entertainments geared to every type of hetero- and homosexual taste.

The club was located far away from the fashionable parts of Manhattan in a rundown area known for its pornographic cinemas and gay brothels. Despite this, it was launched with a bang. Gossip columnists built expect-ations and 5,000 famous people drawn from fashion, film, music, and the jet

set were personally invited to the opening. Shortly after, a birthday party was held for Mick Jagger's Nicaraguan socialite wife Bianca (the couple married in St Tropez in 1971) that propelled the club on to the front pages as a place of glorious excess. Her sensational entry into the disco on a white horse instantly made Studio 54 the most famous nightclub in the world. 'Bianca's party was the catalyst,' observed the club's doorman Marc Benecke, 'it just snowballed from there.'[47] It was busy every night of the week and became the preferred hang-out for celebrities including Liza Minelli, Truman Capote, Elizabeth Taylor, Elton John, Cher, Andy Warhol, Margaux Hemingway, Brooke Shields, Rudolph Nureyev, Sylvester Stallone, Diana Ross, Grace Jones, Gloria Vanderbilt, Donald and Ivana Trump, the fashion designers Calvin Klein and Roy Halston, and Diana Vreeland and former first lady Betty Ford, who was a more suprising guest than another former first lady, Jackie Onassis. Everyone wanted to be there. From one day to the next, it seemed, the tabloids became obsessed with the personalities, eccentricities, sensations, and gossip of Rubell and Schrager's glamorous hothouse. At the centre, the ringmaster was the highly visible and charismatic Rubell. He directed an ever-changing show that relied on lots of theme nights, including evocations of the Folies Bergère and a Shanghai street as well as novelties like the 1-foot-deep gold glitter that was spread over the dance floor on New Year's Eve in 1978. In a bold endorsement of drug culture, a sculpted figure of the man in the moon snorting cocaine from a spoon hung from the ceiling. A huge circular bar was staffed by bare-chested bartenders in tight jeans.

In keeping with the conventions of glamour, Studio 54 was at once accessible and exclusive. Rubell attributed great importance to getting the right mix of people in his club. A strict door policy ensured that undesirables were excluded. This did not mean, however, that the habitués consisted solely of the rich and famous. This was simply not possible given the club's great size. Every night, under a black marquee with a silver art-deco-style logo bearing the club's name, hundreds pushed to gain admittance. Many queued and clamoured and never got in. Having the right look was crucial, as Rubell liked an unpredictable assortment of people. Drag queens, gays, and preppy types were favoured, and a sprinkling of roller skaters, mafioso types, hookers in hot pants, and disco fans welcomed, while ethnic minorities were heavily filtered, and provincial lotharios

and star-watchers excluded. While John Travolta gained admittance with no difficulty, his character Tony Manero might have struggled to receive the nod from the door staff. As Rubell once said, 'if you let in too many people who look as if they come from the outer boroughs, no one will be interested in coming next week.'[48] 'The grey people' therefore had to be kept at arm's length. Getting the mix right, he asserted, was like casting a play or 'tossing a salad'.[49] While around 150 friends and celebrities had free entrance, as well as access to the balcony and a reserved VIP room, everyone else faced the challenge of the velvet rope on the street. One of the appeals of Studio 54 was that it was impossible to buy one's way in. Notoriously, some celebrities were barred or ejected.

The elect of Studio 54 became, through the press, an elite based on appearance and style. This was extremely exciting for men like Warhol, who had never previously enjoyed tabloid fame and gossip column status, or like Capote who, following publication of chapters from his unfinished confessional novel *Answered Prayers* by *Esquire* magazine, was no longer persona grata in the homes of the rich.[50] For them, the club was both a recreation ground and a showcase that turned them into fully fledged celebrities. The club's reputation for glorious excess, drug-fuelled hedonism, men dancing with men, and casual sex even on the premises made it seem like a fantasyland for adults. Above all, it was a place of transformation where dreams and desires found an immediate realization. A handful of journalists freely gathered stories while photographers took innumerable pictures of wild abandon and groups of inebriated guests. Warhol's posthumously published diaries show the extent to which his social world was defined by a seamless sequence of celebrity parties, dinners, and soirées and Studio 54. On Saturday, 21 January 1978, despite a blizzard, he 'cabbed it' over to the club with a female companion and found Rubell turning people away as usual. Among the dancers, he spotted former heavyweight boxing champion Ken Norton. 'Then we wanted to go down to a place called Christy's restaurant on West 11th Street where there was a *Saturday Night Live* party for Steve Martin,' he wrote:

We went outside to try and get a cab but we couldn't. Then along came a white guy and a black girl in a car who offered us a ride anywhere we wanted to go and we took it. They said that Stevie wouldn't let them in to Studio 54 because they didn't look

right, but they looked okay to me—I mean, he looked like a fairy and she looked like a drag queen, it was the Studio 54 look. As we were going along Catherine looked out the window and said wasn't that Lou Reed on the street, and it was. He was with a Chinese chick, and they got in and he was very friendly. When we got to Christy's, Steve Martin was great, he seemed thrilled to meet me.[51]

This entry shows the transformation that occurred in Warhol's life. By the mid-1970s he preferred to frequent the rich and famous instead of the motley gaggle he had hung out with previously. In the past, only Edie Sedgwick had connected him vicariously with the uptown social world. After he was shot and badly wounded in 1969 by a woman who had appeared in some of his underground movies, he avoided former cronies and became friends with people like Bianca Jagger. With her dark hair and full lips, she bore a curious resemblance to her husband. For fashion writer Kennedy Fraser, the Nicaraguan socialite had a grace and style that came from her wealthy background; she was 'like a jungle orchid...both fragile and luscious'.[52] She wore white satin trouser suits and wielded a dandyish Regency cane that testified to her artistic conception of her persona. Bianca was already an activist for women's rights and humanitarian issues, but she was also exceptionally photogenic and glamorous. Unlike most Studio 54 regulars, she did not use drugs, Warhol noted.[53] For this reason, she was able to skate over the surface of the human wreckage of the night world and always appear fragrant and fresh. She made the crossover smoothly from international high society to modern celebrity thanks to her looks, connections, poise, and ubiquity.

The press was a crucial factor in turning Studio 54 from an important but circumscribed phenomenon into a focus of mass dreams and aspirations. The club did not just attract enthusiastic coverage; it also gave rise to strong criticism from social conservatives. Most significantly, it was a factor in the birth of a new type of reportage in which the doings of celebrities took the place of hard news. As a continuous feast of familiar and not so familiar faces, the club provided almost limitless opportunities for new photographs of the beautiful and the famous, and for gossip, profiles, and style pieces.

Many of the new ideas came from *Interview*, the magazine that Warhol founded in 1969. This was the vital platform that enabled him to move from the margins and from experimental art to the mainstream of contemporary celebrity. Having the power to grant magazine space to individuals suddenly made him a highly desirable friend or guest. The monthly was a mixture of fan magazine, film bulletin, art journal, and style glossy that covered all areas of popular culture. It anticipated a contemporary preoccupation with celebrity and style at the expense of traditional cultural products such as film and music. Its most original contribution was the featured celebrity interview, in which the famous were interviewed by their peers in a relaxed, conversational manner that was neither inquisitorial nor fawning. An air of intimacy permeated the magazine, giving readers the sense that they were part of the elect community of the stylish and famous. Celebrity was explored from the inside with young photographers being given early opportunities for exposure and encouragement to experiment. *Interview's* stars were not perfect confections, just beautiful people with individual profiles playing at glamour. Instead of established high society, Warhol and his editor Bob Colacello ran features on social climbers, heiresses, and young and beautiful wannabes. The visual design was bold and unconventional, with the covers featuring tacky yet alluring coloured paintings of famous faces made from photographs that mimicked Warhol's own silk screens in an outsize, simplified way.[54] Although the connection was not direct, it can been seen as the inspiration for British magazines like *The Face* and *Blitz* that were less interested in the socially visible than in music but which shared the passion for style and surface. In the British context, they turned style culture from a clandestine pursuit into a pervasive cultural phenomenon of which they proposed themselves as leaders and guides.[55]

One of *Interview's* most significant contributions was to draw fashion into the mainstream by pioneering a certain type of coverage that treated designers, models, make-up artists, and anyone who looked good in clothes as a celebrity. This type of coverage came at a time when fashion was undergoing a series of changes. Haute couture had declined dramatically since the 1950s as society had evolved and formal rituals had dissolved. Instead, boutique fashion, pioneered in London by Mary Quant and Biba, and in

Paris by Sonia Rykiel, prospered because its focus on the casual was more suited to changing lifestyles.[56] Between 1971 and 1973, no Saint Laurent couture collections were presented, as the designer preferred to concentrate on his more casual and leisure-oriented line. He also branched out into menswear. He became the idol of the young and fashionable, grabbing the headlines with his de luxe hippy styles, velvet jackets, kaftans, printed silk shirts, chain belts, and safari suits. He developed new styles every season that reflected the contemporary mood and set trends which reverberated through the mass market. He also helped redefine perceptions of beauty by becoming the first couturier to work with models from a wide variety of ethnic backgrounds, including Africa and Asia. Saint Laurent was himself a glamorous figure whose friends included Rudolph Nureyev, Andy Warhol, and Paul and Talitha Getty, at whose Marrakesh house he started experimenting with drugs. In 1971, he consolidated his personal reputation for daring, iconoclastic stances when he posed for Jeanloup Sieff cross-legged on a leather cushion, naked save for his trademark rectangular spectacles.[57]

Saint Laurent's image was that of an aloof genius. However, his partner in life and in business, Pierre Bergé, was always attuned to new ways of taking the label to the wider market. Through his endeavours, a new business model for fashion houses was pioneered. Without losing the association with luxury and elite style that was fundamental to whipping up the glamour that was needed to be able to sell goods at premium prices, he developed strategies to raise profits through licensing agreements. These put the house's name on goods including fragrances that created brand awareness and thereby reinforced the status value of the core collections. These in turn gave licensed goods their glamorous desirability. In a context in which the desire to look alluring and sexy was not unusual or restricted to a select few but widespread, fashion houses began to see that there were opportunities to reach wider strata of potential customers by deploying glitz and glamour. This led to changes in presentation and a more marked accent on mass culture and show business.[58]

Like many designers of his generation, Saint Laurent's imagination was fired by iconic stars like Greta Garbo, Joan Crawford, and Marlene Dietrich, whose mannish costumes inspired his celebrated trouser suits. He admired

strong women and always selected models with a determined attitude. There was a lot in common between his vision and that of the photographer Helmut Newton and the two men inspired each other reciprocally. They were both thoroughly imbued with bourgeois culture while being sceptical of its values and critical of its hypocrisies. As a refugee from Nazism, Newton knew only too well that corruption, authoritarianism, and sexual perversion were never far from the centre of the bourgeois subconscious,[59] while Saint Laurent, as a homosexual born in Oran, Algeria, then a French colony, had seen racism at work and had personally experienced discrimination on account of his orientation. The cultural climate of the seventies allowed them to bring their convictions about the bourgeoisie into the commercial and artistic mainstream.

Fashion photography had always had a fantasy function. For decades, its ideal had been the imaginary lady. In the 1960s, this was displaced by the girl. In the 1970s, the imagination of fashion was increasingly shaped by a loose concoction of decadent themes including sex, money, and luxury that often merged in a sleazy melange. In Newton's work, these themes were brought boldly to the fore. No one more than him stamped his mark so fully on the image of glamour at the time. In his editorial work for French *Vogue*, he developed a highly material fantasy world that caught the sexual climate of the period and blurred the boundaries between fashion, the movies, sadomasochism, soft pornography, and travel advertising. The world he created from his base in Monte Carlo resonated with jet-set values and glossy high consumption.[60] It was not artistic but brashly materialistic. In its suggestions of adventure, it was, according to one journalist, 'a bit James Bond and, sometimes, even a bit Milk Tray'.[61] His work had a stylized, hyperreal quality to it that was striking especially for its overt sexualization of his female models, who were always Amazonian. His vision, he declared, 'was of a highly sexual woman, in all respects Western, whose native habitat was Paris, Milan, and maybe New York'.[62] Newton's photographs were widely criticized for their relentless objectification of women and the overt voyeurism of the point of view.[63] None was more controversial than the shot he took for the French luxury company Hermès of a model in riding gear on all fours on a bed with a saddle on her back. His photographs had a shiny,

glossy appeal that highlighted their production values: his preferred settings were luxury hotels, millionaires' villas, penthouse apartments, swimming pools, and beaches, preferably in Paris, New York, Los Angeles, or on the Mediterranean. Models were made-up, oiled, dressed in PVC, stiletto heels, or items of lingerie, or were posed totally or partially nude, with their pubic hair often on full view. Rarely well-known, they were treated as mannequins or props in scenarios that reeked of money and/or perversion. Many of Newton's photographs, while indisputably luxurious, exude menace and even an atmosphere of impending doom.

Born in Berlin in 1920, Newton (his real surname was Neustädter) was a German Jew who, as a boy, was in thrall to the movies and stars like Marlene Dietrich. After leaving Germany in 1938, he lived in Singapore and, for nearly twenty years, in Australia before moving to Paris to work for French *Vogue* in the mid-1950s. The influence of old films was clear in his work, as was a whole tradition of open-air and real-life fashion and news photography that blended artificiality with everyday life. Although he disdained the studio and special effects, his images always had a strong fantasy element that he claimed was completely personal.[64] In the 1970s, they were erotic and kinky, sophisticated in atmosphere, and utterly frigid in tone. Like Guy Bourdin, his rival and colleague on French *Vogue*, whose imagery was no less sexualized and glossy but darker and tendentially macabre, he had a strong vision that had nothing to do with conventional good taste. Indeed, he frequently spoke in favour of vulgarity, as he did of artificiality. The great theme of his artwork was the female nude. Two of his most famous pictures show the same group of four models walking in formation with an air of insouciance and self-possession. In the first black-and-white picture, they are wearing fashionable street clothes; in the second, they are naked, save for—a typical Newtonian touch—high-heeled shoes. In the 1930s and 1940s, Hollywood studio photographers sometimes used the time at the end of photo sessions to take nude pictures of female stars and starlets for clandestine sale or private use. Newton similarly took his nude shots at the conclusion of commercial shoots, but his work was in all but a handful of cases destined for galleries and books.[65] He also took portraits of many of the leading figures of his day from the worlds of fashion, the arts, and politics.

Saint Laurent and Newton were both drawn to the actress Catherine Deneuve, who had played perverse bourgeois women in *Belle de Jour* and *Tristana,* two art house films made, respectively in 1967 and 1970, by the iconoclastic surrealist director Luis Buñuel. Newton took her as a subject, Saint Laurent as a muse. A cool blonde of great poise and personal elegance who made her film debut at the age of 13 in 1956, Deneuve was widely regarded from the 1970s as a symbol of the cultivated but unconventional bourgeois Frenchwoman. Aloof both to gossip and petty exhibitionism, she lived her life freely, marrying photographer David Bailey and having children out of wedlock with Roger Vadim and Marcello Mastroianni.[66] Men found in her an irresistible mix of detachment, self-control, ambiguity, and transgression. For Newton, as for Saint Laurent and Buñuel, she was at once an 'official' bourgeois icon, an embodiment of France (she would be chosen by French mayors to be the model for a bust of the national symbol Marianne in 1985), a model of elegance (for many years she was the face of Chanel No. 5),[67] a sex symbol, and a glamorous film star. These multiple identities gave them the opportunity to highlight one or more over others, or even to play one off against another to suggest an air of sinfulness and decadence. She was the perfect vehicle for increasing the sexual element in glamour while maintaining class and a high-end commercial appeal. Deneuve's ultimate appeal was her mystery; she was a modern sphinx into which directors, designers, photographers, and the public read what they wanted.

It would not be the French, but rather the Americans and the Italians, who would most clearly see that the interest in glamour and appearances opened the possibility of reorganizing the fashion industry on new bases. The large American stores had always been keen promoters of fashion and they had long bought Paris couture designs and had them remade for sale under their own labels. When Jacqueline Kennedy was in the White House, fashion became of much wider interest. Her stylish appearance mesmerized millions. The press and American women more generally started to pay attention to the names of designers she patronized. This began a trend that led to the designer's name becoming more prominent on ready-to-wear garments. By the mid-1960s, designer labels were already beginning to displace those of the stores as indicators of quality and style.

New York was host to a garment industry at least as large, if not as prestigious, as Paris. There was a top echelon of couture designers like James Galanos and Pauline Trigère who dressed the famous. Below them was a tier of less well-known designers, including Bill Blass, Oscar della Renta, and Geoffrey Beene, who not only catered to rich clients but also designed for the stores. These men were the troupers of American high fashion who travelled the country doing trunk shows for wealthy local matrons. None of them could hope to replicate the unique allure of Yves Saint Laurent or other Parisian designers, who exercised an irresistible appeal for the wealthiest and most cosmopolitan American women. American and Italian fashion producers had always been poor relations who, lacking the immense prestige and historic pre-eminence of Paris, had aimed to sell on price and quality. Despite this, established names were not generally well equipped, on account of their close links to the social elite, to reach out to a fluid and heterogeneous market. New names were called for who were in touch with contemporary culture and who could therefore interpret social trends and respond flexibly to changing demands.

In the 1970s, there was a thirst for prestige and originality that stretched well beyond the upper tier of the market to the middle and lower levels. There were also significant middle-level markets for two types of clothing. These reflected the 'disparity between romance and reality, the world of beautiful people and the workaday world' that Christopher Lasch identified.[68] On the one hand, practical clothes were required for the 'workaday world'. However, these were likely to be more appealing if they incorporated some suggestion of romance, permitting the wearers to lift themselves on the imaginary level out of the quagmire of banality. Glamour, as David Riesman had shown, was likely to enter the workplace when that was the main arena of an individual's social interaction.[69] This was important because changes in women's education as well as the expansion of the tertiary sector brought radical changes in the structure of the labour market. Many women were mobile professionals who needed wardrobes to match their new-found status. They did not want conventional seasonal styles but practical designs that could be worn over more than one season. They were especially drawn to garments that combined this necessity with romance. The latter also

fuelled a demand for leisure wear that allowed those who wore it to vicariously join the beautiful people. The attitude of ironic detachment that Lasch saw as the key trait of the contemporary personality was assembled with the support of suggestions taken from advertising, popular music, and films and fiction. In this context, elegance diminished as a value, while seduction and sex appeal became central. The distinctions of the past between formal and informal gave way to a more fluid style in which the body was the starting point. As people saw themselves increasingly as sexual beings, it became a locus of fantasies and a project of self-construction. It was not a given but a modifiable reality that was as much imagined as it was experienced.

The rise of designer ready-to-wear is an important chapter in the history of glamour. In the decade from 1978 the fashion business witnessed a revolution as prêt-à-porter ceased to be a poor relation of couture and emerged as the neo-couture of mass society. The Americans and the Italians were quicker to seize the potential than the French. Firms like GFT (Gruppo Finanziario Tessile), which produced ready-to-wear in Turin, did not back haute couture, as Marcel Boussac had done when he supported Dior in the 1940s;[70] rather they showed that fashion stars could be created in a short time if there was heavy investment in production and advertising. All the new designers were to some degree or other trend-spotters and style magpies. Typically, they were also outsiders as far as the conventional elite was concerned. A striking number of them were drawn to Studio 54 because it was a world unto itself that created legends and myths. It generated forms of glamour that were no longer related to, or derived from, the social hierarchy. The American designers Halston and Calvin Klein were regulars, while Yves Saint Laurent and the Paris-based German Karl Lagerfeld were occasional visitors. The latter was less interested in the jet set than Saint Laurent; an early convert to ready-to-wear, it was the trends that fascinated him.[71]

The first new fashion star was not in fact an outsider. Although he had been born in Des Moines, Iowa, Halston was a milliner by training who worked for the Bergdorf Goodman luxury goods department store and was admired by such prominent journalists as Eugenia Sheppard and Diana Vreeland. As hats lost popularity, he branched out into informal ready-to-wear before setting up his own couture house in 1968. He had a client list

that included Princess Grace, Babe Paley, Jackie Onassis, Lauren Bacall, and Liz Taylor as well as many society mavens. He also attracted a following from a more eccentric clientele, including drag queens, who met at his salon, which was seen as a sort of sartorial parallel to Warhol's Factory. Halston emerged as a glamorous personality through Studio 54. Always dressed in black and often wearing mirrored sunglasses, he became the 'personification of glamour', the 'king of New York nightlife'. According to journalist Steven Gaines, another Studio regular and author of the designer's biography, 'so tall and thin [was he] in his black cashmere turtleneck and sports jacket that he looked like a giant exclamation point, stern and final'.[72] A star of the social scene and the media, he was hailed as the designer of disco wear. He at once combined the snob appeal of a society couturier with the fashionable allure of a New York night owl. He was present at the famous Jagger party that won the club its reputation and then was there almost every night. The elegant casual wear for which he was known suited a time in which conventions and formality were giving way to more relaxed styles. Halston knew that American fashion was turning into a manufactured product to be sold through advertising and promotion. He opened several boutiques that connected him to a wider market, where he came to be seen as a master of US classics. The supple, unreconstructed style he was associated with was perfectly suited to mass production.[73] His perfume 'Halston' became a bestseller. More than any other designer, Halston reinvented himself through the nightclub. However, as cocaine addiction progressively dominated his life, he ceased to be a force in fashion.

Calvin Klein was also drawn to the flamboyant but ambivalent world of Studio 54, which he cruised with a loosely knit circle of celebrity cronies. In the club's atmosphere of feverish excitement he discovered his bisexuality and became a creature of the night, 'acquiring through gossip columns the status and glamour of a rock star'.[74] Like Halston, Klein first made his mark in the 1960s. However, he was never a couturier and had no high society clients. Fashion writer Alicia Drake's observation that 'fashion has always had a tradesman's fascination with nobility' did not seem to apply to him.[75] He got his first break thanks to the Bonwit Teller store in New York, for whom Warhol had dressed windows in the 1950s.[76] The store pioneered the idea of the designer

boutique and sold the work of European and American designers. Bonwit's buyer, Mildred Custin, liked his detailed feminine blouses with delicate tucks and elegant well-cut trousers. The influence of early Chanel was evident in his collarless jackets and in the simplicity and wearability of his creations. Custin saw Klein as an 'American Yves Saint Laurent' and promoted his clothes in window displays and advertisements in the *New York Times*.[77] Klein adapted Saint Laurent's innovations to the American market, copying the latter's trenchcoats and pleated trousers and selling them much more cheaply. By 1973, Klein had defined a signature style of clean, sharp lines and a lack of frills. Like Giorgio Armani in Italy, who would present his first GFT-supported collection in 1975, his main colours were grey and camel, basic shades that advertising wrapped with images of old Hollywood.

In 1976, when he was still aged only 32, Klein's business had revenues of $40 million. These rose dramatically to $90 million in 1977.[78] The designer was young and good-looking, a sex symbol even, who had married his childhood sweetheart from the Bronx. But success changed him. As he became famous, he reinvented himself, dropping his Bronx accent and associations. He started going to fashionable restaurants and acquired new homes in more fashionable districts. A new world of glamour and style was opened to him that involved world travel and a new tenor of life. He soon became a polished PR version of his former self. From the start, Klein had been a salesman and communicator. He appointed an in-house publicist, realizing that a symbiotic relationship was developing between designers and the fashion press. He was also highly alert to trends and made it his business to be on the cutting edge of everything that was new and hot. In the night world he found the ecstasy of sex and drugs but also ideas that he would translate into lucrative innovations.

To develop the middle market, what was needed was not a prestige product stripped of quality and offered to the mass, or a run-of-the-mill item with a designer's name arbitrarily attached to it. Rather something entirely new was required to catalyse the passions of a market that was tending to connect personal happiness and fulfilment with the possession of prestigious material goods. While elite connotations were still marketable, these needed to be cleansed of snobbery and fused with modernity. While the customers for couture dwindled, the middle market showed a great

desire for prestige products that carried a reputation for quality and exclusivity. Yet, to endow these with the right quotients of accessibility and rarity was not straightforward. The French designer Pierre Cardin had been the first to establish multiple licensing deals for clothes, allowing a French manufacturer to adapt his designs for sale at a lower price.[79] He had then licensed numerous other products including home-ware and furniture. However, Cardin failed to limit the number of deals or exercise control over his licensees, with the result that his name soon became linked with a variety of low-quality merchandise available in low-grade stores. In consequence, his label lost kudos at the crucial couture level and declined sharply in prestige. As a business model though it worked somehow, since his empire continued to be very profitable even without glamour.[80] But it only prospered at the low end. Halston too saw the potential of the mass market and even sold his own name to a corporation, Norton-Simon Industries. He also designed a line of clothes for the budget store chain J. C. Penney, which controversially brought his work to lower income brackets. However, as his drug addiction took hold, he was sacked from his own label in 1984 for poor deadline keeping.[81] The lesson of all this was that the aura of glamour that was so vital in driving the desires of consumers and that could induce them to pay high prices for a given brand could easily evaporate.

The winning formula was discovered when Warren Hirsh, the president of Mujani International, a Hong Kong-based manufacturer, invented the phenomenon of designer jeans. Up until the middle of the decade, such a notion would have been oxymoronic. Jeans were not high-style items but work-wear that had been taken up from the 1950s by youth. Even though some variations of shape and cut had been introduced to appeal to the youth market, they were still sold mainly as goods that were practical, tough, and egalitarian. Most makes did not do jeans for women and the most common motif of brands like Levi's, Wrangler, and Lee was the cowboy. Hirsh had wanted to make mass-market clothing with a designer's name on the label. After some rebuffs from leaders in the field, he embraced instead the idea of women's jeans bearing the endorsement of a social figure. When Jacqueline Onassis, not surprisingly, refused him, he turned to Gloria Vanderbilt. Vanderbilt was already a commercial figure who had recently launched her own line of home furnishings.

But she was also American royalty, the great-granddaughter of Cornelius Vanderbilt and niece of Consuelo. She not only agreed to the remunerative proposal but also modelled, which proved to be a vital factor in the product's astonishing success. Television commercials showed the smiling 40-something socialite wearing super-slim-fitting jeans that featured her elegant signature above a swan on every pair. Suddenly, well-dressed women started wearing jeans and the concept of designer denims was born. Vanderbilt's runaway success showed that socialites still exercised market appeal as examples of taste and style provided they positioned themselves in a way that could be conveyed as sexy and desirable through the mass media. The product, though, was not one that had trickled down from the top social echelon; on the contrary, crucially, it was a mass product glammed up. This success also showed that the marketing of leisurewear worked best through lifestyle examples. These made fashion seem an essential component of modern life and turned it into a collective preoccupation.[82]

Although this success had the air of a fad, it set a precedent. Ever quick to spot a trend, Klein developed a line of own-name jeans that had more immediate sex appeal than any other brand.[83] Within a short time, his sales were second only to Gloria Vanderbilt's. Once the novelty of the latter had worn off, they moved into first place. Drawing inspiration from his experience of nightclubbing, he took conventional denims, accentuated the crotch, and gave more shape to the buttocks. Launched in 1978, they were sold only in select stores. Klein boldly used billboard advertising to promote them, engaging the young Brooke Shields as his model and having her photographed in black and white by Richard Avedon. An astute move was to label the garments 'Calvins' in advertisements, rather than jeans. Klein repeated this success several times in the years that followed, most notably with men's underwear, which was also given the designer treatment and sold with added sex appeal, and with fragrances including the first successful unisex product CKOne. With products like these, Klein touched something at the core of modern identity. To assert a sexy, modern identity that was utterly contemporary, the message seemed to run, there was no alternative but to wear Calvin Klein. Sex would remain a key inspiration for all fashion advertising and presentation but no label would use it more sensationally.

Klein's sexy buzz won many followers but it did not exhaust the range of suggestions available to the fashion business. Another designer found that the idea of the desirable wealthy lifestyle could be deployed in new ways to promote merchandise. Ralph Lauren (born Ralph Lifschitz—the family name was changed when he was 16) was no less a self-made man than Klein. Born like him to a Bronx Jewish family, he grew up without any connection to elite society or fashion, but soon developed a taste for expensive clothes. After working for the preppy outfitter Brooks Brothers, he founded a luxury necktie business called Polo. The name Polo evoked a sense of elegance and Europe, it mixed sport and lifestyle, it had cachet, and it was playboyish, international, and glamorous.[84] Classic rather than fashionable clothes followed, with womenswear being added from 1972. Lauren built an empire on the observation that certain basic and iconic items of clothing, like tweed jackets, Oxford shirts, Shetland sweaters, and chino pants, were no longer well made. A popular item like the polo knit shirt, that was closely associated with the French firm Lacoste and its crocodile symbol, was commonly made in poor artificial fibres and in a limited range of colours. What Lauren did was to take over these staple items, make them in a well-designed way, and ensure that they were available season after season in an impressive range of colours.

Compared to Klein, Lauren was a traditionalist. He was a family man who preferred home life to socializing. Despite their different temperaments, the two men had much in common. Although Klein came from a more conventional garment industry background, neither designer had a training in couture. Their role was closer to that of the *styliste* rather than the couturier. This was the term that had been used to describe any ready-to-wear designer who worked for a fashion company that was not his or her own.[85] However, even this label was not quite right, for Lauren and Klein were not employees but the founders and creative forces of their companies. Moreover, in addition to designing and selling ready-to-wear clothing,[86] they were purveyors of dreams, fabricators of lifestyles and themes.[87]

Lauren's main inspiration was classic Hollywood movies. Like Warhol, he adored the films of the 1930s and 1940s and in particular the smooth elegance of Grace Kelly, Audrey Hepburn, and Cary Grant. He was visibly

star-struck when he met people like Hepburn or Grant. He dreamed of being a movie star and played up his associations with film-making. He also saw the utility of films in fashion promotion. When it was announced that a film version of F. Scott Fitzgerald's *The Great Gatsby* was to be made in 1974, he latched on to the project. Although the Academy Award for the film's costumes went to Theoni V. Aldredge, he made some suits for Robert Redford that featured on screen. He also claimed some credit for Woody Allen's film *Annie Hall* on the grounds that a few Lauren items had been used by Diane Keaton in assembling her character's look.[88]

Like the old studio-era moguls, Lauren conjured up an idealized America from a range of imagined sources. 'Everyone really liked the idea of Cary Grant,' observes one of the debonair star's biographers,[89] reflecting exactly the view that Lauren repeated to himself. The actor's classless and self-assured persona and his role as 'a democratic symbol of gentlemanly grace' were the premiss of the Lauren label's appeal to a mass market.[90] More than anyone else, Lauren understood that evocations of the wealth and glamour of the past, provided they were stripped of any precise connotations of class or place, were intensely appealing and very accessible.[91] The designer also developed western, American looks, drawing inspiration from Robert Redford and Steve Mc-Queen, to offer urban Americans a fantasy of a rugged casual lifestyle. Lauren had something of the Gatsby character about him. He was a self-invented persona who drew on a mix of Hollywood style and preppy insouciance, combined with a strong sports emphasis and some Old West touches. An inveterate role-player, he put himself in his own advertisements, in which he acted various parts such as the sports legend, the cowboy, 'Cary Grant', and so on.[92]

The advertising for Ralph Lauren and Calvin Klein took many different forms, as a variety of images were deployed to seduce the public into accepting the atmospheres that they wanted to create around their products. Despite the differences between them, their fundamental similarity of approach was demonstrated by the fact that they used the same photographer, Bruce Weber, to produce some of their best-known advertising campaigns. Weber was a master of the mythic photograph. His black-and-white images always featured clean-cut men and had a distinctively American feel. For Klein, he created homoerotic images of sculpted masculinity that suggested

a raunchy, subversive sexuality, while for Lauren he produced more wistful and heritage-laden pictures that evoked scenarios of endeavour and leisure. He drew inspiration from the American photographers of interwar years and from the movies. Reduced to a formula, what he provided was heroic realism plus Hollywood glamour.[93] His images appeared at once to be classic and contemporary, out of time and in tune. Weber was able to use sex appeal in different ways, so that it was upfront and explicit for Klein and subtly woven into the context for Lauren. Aspirational themes were prominent in both cases and were crucial to the appeal that their advertising built up through a heavy magazine presence.

The designer of dreams with a special purchase on collective motivations and desires emerged as a figure at a crucial moment of transition in the economic, social, and cultural climate. Studio 54 was a vital experience that crystallized sixties' notions of freedom, openness, hope, sex, fun, and drugs. However, it did not connect these to any political project but rather to a commercial venture that encouraged individual expression and pleasure. Its heyday came at a time when Western economies were in the doldrums and older forms of leisure were in decline. The conjuncture produced a conservative backlash that won ground as the final radical impulses born in the late 1960s petered out. Studio 54 itself was raided and, after a system of double-accounting was discovered, Rubell and Schrager received a five-month jail sentence for tax evasion. Before going to prison, they held one last party entitled, in mock reference to the scandalized press coverage the club sometimes attracted, 'The End of Modern-Day Gomorra'. Following a closure and reopening, it steadily declined. While interest in disco music waned, the AIDS epidemic was a watershed. This cast a great shadow over the sexual excess that the club had celebrated and propagated. The philosophy of economic liberalism that won ground at this time complemented the ascendant social conservatism.

The election of Ronald Reagan in 1980 signalled a radical change in many areas of policy. It also heralded the first systematic use in a Western democracy of myths and images in the service of political power. Having a former Hollywood actor as president sanctioned the role of illusion and imagination in politics and culture. The particular combination of themes that was bound up with Reaganism was not taken up across the Western world, but

the great power of the American economy and the international appeal of American music, films, and other cultural products ensured that it was influential well beyond the United States. The style that was associated with the era was not very distinctive. It had something in common with the ferocious eclecticism and exhibitionism of the Second Empire. Money was the cardinal value and its brashness was welcomed rather than disdained. In practical terms this was filtered through the opulence of old-style Hollywood glamour that provided the most recognizable template of the period. Whereas Jacqueline Kennedy had attempted to connect the past to the present through her careful restoration and tasteful entertaining, Nancy Reagan presided over a reckless appropriation of symbols of luxury and aristocracy. The former admired the style of the First Empire; the latter might have felt more affinity for the Second.

The opulence of the Reagan era was simultaneously elitist and populist. It mixed high and low themes, seduction and beauty, the classic as well as outright novelty. Diana Vreeland was one of the key tastemakers. By now a curator at New York's Metropolitan Museum, she chose ahistorical arrangements for a series of exhibitions on the material grandeur of the past. These promoted a deracinated cult of display and served to establish unabashed opulence as the cultural style of the period.[94] For example, the exhibition on 'La Belle Époque' was devoid of historical and contextual references and purely geared to visual pleasure and the celebration of pure style. Vreeland saw the *demi-monde* not as a specific social configuration but as a world of glamour 'full of laughter and fun, marked by lots of noise, lots of romance, and *great* style'.[95] Exhibitions like this were social events that were launched with the support and involvement of the city's elite and promoted as mass events not to be missed. They therefore had a significant impact on popular culture. Vreeland had been a great innovator in the 1960s and she championed the structural role of low culture in modern style. 'Vulgarity is a very important ingredient in life. I'm a great believer in vulgarity—if it's got vitality,' she declared. 'A little bad taste is like a nice splash of paprika. We all need a splash of bad taste—it's hearty, it's healthy, it's physical.'[96]

For the mass public, the maximum expression of glamour at this time was the television series *Dynasty*. Launched in the very week of the Reagan

inauguration in January 1981 by the ABC network in response to CBS's success with the saga of a Texan oil family, *Dallas*, which had premiered three years earlier, it featured an oil family from Denver, Colorado. Although *Dallas* fielded a number of minor stars and sex symbols, it could not match the glamour quotient of *Dynasty*, which included in its cast a former matinee idol, John Forsythe as the patriarch Blake Carrington, and the film and television actress Linda Evans as his second wife Krystle. The latter show was also more woman-centred and glitzy. No one could say of *Dynasty* that its wealthy protagonists did not look rich or live opulently.[97] This was because its producer Aaron Spelling, who was also responsible for such hits of the period as *Charlie's Angels* and *Love Boat*, aimed to create a fantasy world of the rich and famous. The show entered its heyday when Joan Collins joined the cast in the role of Alexis, the businesswoman first wife of Blake, mother of his oldest children and rival of Krystle. A dark beauty who had been taught charm, posture, and elegance by the British Rank studio,[98] Collins had been groomed as England's answer to Ava Gardner in the 1950s. She knew the job of a star backwards and had no qualms about playing up to her role. The show's costume designer favoured power dressing and fitted her with Joan Crawford big shoulders that outdid even those that were in vogue at the time. Scarcely an episode passed without the actress donning some hyperbolic retro-styled outfit that underlined her status as a femme fatale. However, Linda Evans's ostentatious evening gowns, which functioned as a badge of her husband's competitive success in business, were also symbolic. They were compared to outfits created for Nancy Reagan by New York designers like Bill Blass and Oscar de la Renta.[99] *Dynasty* has been described as an hour-long commercial for clothes in which the dominant style was 'a kind of out-of-date glamour with ornate clothing in bold colours and glitter'.[100]

The show captured the spirit of the times. Former President Gerald Ford and his wife Betty guested as themselves in scenes of lavish Carrington parties, as did former Secretary of State Henry Kissinger. Department stores offered *Dynasty* fashions, a fragrance, accessories, and lingerie, inviting consumers to 'share the luxury' and 'share the magic' of the show's wealthy clan by buying goods stamped with their imprint.[101] A popular show that complemented the fictions of the Carrington family was *Lifestyles of the Rich and*

Famous, which offered a voyeur's glimpse of the lives of the happy few. In such shows, the rich were humanized and shown to have personal and family problems like everybody else. Wealth was turned into spectacle and infused with entertainment values. Material objects, stylish living, and exotic travel were depicted not as privileges but as glamorous attributes which could enhance the life of anyone. This message contributed to the huge popularity of such shows across the world. The glamour of Collins/Alexis was powerful enough to make the return trip across the Atlantic. 'In so far as the public's appetite for glamour is satisfied today,' the British historian of the aristocracy David Cannadine affirmed, 'it is more likely to be by Joan Collins than the Duke of Westminster.'[102] The international rich and media stars had, he appeared to be saying, finally laid the ghost of the old aristocracy to rest.

In contrast to previous periods of major economic growth, there was no consolidated elite of taste and style to guide or contrast with newly emergent wealth in its customs and consumption. As at the time of the Empress Eugénie, a key role fell to fashion designers, as well as interior designers, architects, and other masters of style. Unlike the couturier Charles Frederick Worth, however, the new designers were not confined to the backstage. They formed a world with their clients and lived a superbly luxurious way of life, owning gargantuan apartments, entertaining regally, and travelling by private jet or yacht. They collected classic cars, old masters, and eighteenth-century furniture. They manufactured not just clothing but the contexts in which clothes were to be worn. Designers emerged as masters of style who showed people how to enjoy the finer things in life. 'Collectively, they [constituted] a society of material luxury' that was keen on going to the right places, seeing and being seen with the right people.[103] This was possible because designers became huge economic players in the 1980s. Ralph Lauren's personal fortune was estimated at $300 million in 1986.[104] He bought a Jamaican villa that had once been the home of William and Babe Paley, he owned a Colorado ranch, and a stone manor near Bedford, New York that he regarded as his 'family seat', and he collected vintage cars.[105] A little like Walter Scott at Abbotsford, he created a personal world in which he could live out dreams that he had grown rich on selling to a wide audience. In 1986, he opened his flagship Rheinlander store on Madison Avenue that was

'his glittering dream made concrete'.[106] It was a hymn to a charmed WASP lifestyle that Lauren himself had glamorized and made accessible even to ethnic minorities.[107] Sensing a shift of climate, even Klein once more reinvented himself. He married a former Ralph Lauren employee, Kelly Rector, in September 1986 in the Campidoglio, Rome. Showing that he was fascinated by the high life after all,[108] the couple moved to the Hamptons, on the south fork of Long Island, 100 miles from Manhattan, where they socialized with the wealthy bankers and stockbrokers that the economic boom of the mid-1980s spawned.

The lifestyles of the fashion designers were not private; rather they were endlessly publicized and exhibited. At the turn of the twentieth century, Thorstein Veblen had written that the new rich needed to advertise their wealth in such a way that even a running man could read its signature.[109] It seemed that little had changed, except that the motivation was no longer just vanity. The Americans and some continental Europeans understood that the way to sell basic items like casual shirts and lipstick was to connect them to a lifestyle so fabulous and alluring that everyone would want to buy into it.[110] The overt exhibition of lifestyle for commercial purposes had been used many times in the past but not on quite such a routine basis. Now it was favoured by the hegemony within the media system of television, which tended to normalize the thrusting of the private realm into the public arena.[111] The press slowly became beholden to the designer and adopted a sycophantic tone like the press that had covered Hollywood in the 1930s and 1940s. All the top designers had well-oiled publicity machines, vast advertising budgets, and were constantly in touch with fashion and women's magazine editors.[112] But the press was complicit. At a time when few Hollywood actors wanted to be glamorous, new heroes of consumption were needed. 'We were the ones to recognize designers as designers and "stars". We had started covering designers' every move—where they lived, what they ate, how they dressed, who they saw. Humanizing them was not difficult, because for the most part they are such lively subjects,' declared John Fairchild Jr., the editor of *Women's Wear Daily*.[113] Fashion designers acquired social power in a context in which a significant diversification of the sources of celebrity was occurring. 'The fashion for a schematic

individuality that begins and ends with the image of one's material circum-
stances is the domestic aspect of what becomes on the grander and glossier
public plane the cult of "celebrity",' Kennedy Fraser observed.[114]

Italian fashion was a significant new player in this conjuncture and its
leading names quickly acquired mass recognition. The resurgence of a
national industry that had once been a poor sister to Paris, known only
for casual wear and accessories, owed much to the keen perception of the
enormous potential of ready-to-wear. In contrast to Paris, where the couture
tradition made innovation controversial, Italian fashion was dominated by
textile industries that were powerful and ambitious. Also, it had acquired
experience, during the period of American film-making in Italy in the 1950s,
of contributing to American glamour. It had the advantage of having devel-
oped its own identity as a variant of this.[115] One of the most significant
Italian designers had in fact been in business since the later period of
Hollywood on the Tiber. Although he was frequently mentioned together
with newly celebrated Italian colleagues, Valentino was not primarily a
creator of ready-to-wear but a couturier, indeed the only prominent
French-trained Italian couturier. He had founded his own fashion house
in Rome in 1962 and had dressed many important international clients
including Audrey Hepburn, Princess Grace, and Jacqueline Kennedy. For
the foreign market, he represented the verve and style of the years of the
dolce vita. His main interest was in designing ravishing gowns for the women
of the international jet set.[116] Beauty for its own sake was Valentino's
apparent motto and his best-known creations were evening gowns in his
signature red, or scenic dresses for the rites of passage of the rich. However,
thanks to the acumen of his business partner and partner in life, Giancarlo
Giammetti, he branched out into the middle market, where the prestige of
well-known couture clients brought kudos to the brand. Like Giorgio
Armani and Gianni Versace, Valentino headed a fashion empire with
ready-to-wear branches and diffusion lines, including jeans, as well as
licensing deals. With the profits, he fashioned a fabulously luxurious life-
style, surpassing all rivals in projecting himself as the epitome of all things
luxurious, tasteful, and elegant. Not content with having a workplace situ-
ated in a Renaissance palazzo near the Spanish Steps in Rome, he acquired a

villa on the historic Appian Way, a Fifth Avenue apartment in New York, a chateau near Paris, a London house, and residences on Capri and at Gstaad. He also owned a 152-foot yacht and maintained a personal staff of fifty, including a chauffeur and a butler. By comparison, other Roman couturiers, like the Fontana sisters, who had also catered to American visitors since the 1950s, lived like seamstresses.

A personal friend of queens, aristocrats, the wives of financiers, and film stars, Valentino created eye-catching garments that combined old glamour with taste and distinction. As always, the Americans were his best clients and most of them were concentrated in New York. Historically, the city's distinctive glamour, its sense of style, came from its high society. However, New York personalities of the 1980s were not generally well-born but rich trend-followers. Many socialites hired PR firms to package their image. Opulent couples like Ivana and Donald Trump, the larger-than-life real estate developer and entertainment magnate who put his own surname on every prestige property he built, lived and breathed brash big-money values. They belonged to what *Women's Wear Daily* editor John Fairchild Jr. cheekily dubbed 'Nouvelle Society', a category that was entirely based on the calculated ostentation of money and success. Many women in this category were quite happy with the local couturiers that Nancy Reagan patronized, Blass and della Renta. Others, usually those whose wealth was a little less recently acquired, were more European-oriented. But this does not mean that they were less exhibitionist. The leading hostess of the period Nan Kempner, who had been a socialite since the 1950s and was reputed to have the largest couture collection in New York, was anything but a wallflower. She had been a Studio 54 regular and was perennially at the centre of the fastest and richest social set. Stick-thin and chronically gregarious ('I feel terrible when I am alone,' she declared),[117] she adored the spotlight and was scarcely out of the public eye (among her bons mots: 'They say the camera loves me; the truth is I love the camera' and 'My theory is, whatever it is, if it's in print, it's gotta be good for you').[118]

The relation between contemporary New York high society and the media was complex. At one time, the social world would have found a mirror in Condé Nast's *Vogue*. However, the American edition of the magazine had

broadened its appeal and now addressed the middle market. Its conventional role in representing the North-Eastern American elite to itself was taken over in part by *Women's Wear Daily* (*WWD*), a trade publication founded in 1890 that had evolved into a social gazette. The editor John Fairchild was as interested in personalities and gossip as he was in the facts and figures of the garment industry.[119] The periodical created a cast of fashionable New York women and recorded the social ostentation of the city. It determined who was in and who was out. It offered advice on where to go and who to talk about. The new rich had, Fairchild found, an insatiable desire for publicity. As he saw it, modern high society was not stable but subject to a constant game of snakes and ladders. With the multiplication of fortunes in the 1980s, ladders were plentiful and the jostling for position sharp. 'What the social world of New York really comes down to is that anyone—and I mean anyone—can become an overnight attraction of *W* or the gossip columns if he or she has enough money and stamina,' he declared.[120] The publication pioneered a type of social coverage that both provided a platform for the new rich and subjected them to ridicule; if they were too visible or too brash, then they would find themselves lampooned in *WWD*, or worse, subjected to a publicity blackout.

Valentino found many of his best clients in this milieu. He offered them the reassurance of prestige fused with the glamour of spectacle. He shared with them a common idea of glamour that was not complex or refined but which was rooted in popular culture and which drew from the cinema of the past. He happily acknowledged his debt to cinema, admitting that he had been obsessed with glamour from the time he was a teenager: 'I was a big dreamer, always a big dreamer. Vivien Leigh, Hedy Lamarr, Lana Turner, and Katherine Hepburn—I am a designer today because I would dream of those ladies in fox coats and lamé, coming down those grand staircases they had in the movies.'[121] 'When I was a boy, I used to steal film magazines from my sister,' he admitted; 'I dreamed of Lana Turner, Rita Hayworth, Elizabeth Taylor.... Even at that time, I was attracted by the shiny world of celluloid, I gorged on films.'[122] Yet, despite this, glamour for Valentino was never vulgar for it was filtered through Italian art cinema. 'It was the director Luchino Visconti who transmitted to me this limitless love for elegance that for me has the taste of an enchanting romanticism,' he claimed.[123]

Foreigners were often surprised by the Roman showiness of Valentino. Although his public declarations appeared to infuse glamour with taste in contrast to the cheerful populism of Vreeland and others, much about his lifestyle and work struck observers as flash and exhibitionist.[124] When a journalist asked him about the ostentation of his lifestyle, he responded tetchily, correcting the man's premiss by affirming, 'It's not opulence... it's elegant'.[125] The letter V is 'a worldwide symbol of luxury and not-so-discreet glamour,' remarked fashion journalist Georgina Howell.[126] For British Condé Nast editor Nicholas Coleridge, 'Some of the colours of his couture—the rich reds and blues—have a high Renaissance hue to them, but they are also the colours of Disneyland.'[127] The socialite Lily Safra recalled once being invited to dinner at the designer's villa on the Appian Way. 'After passing through tall, electronically controlled gates at the front entrance, we moved into Valentino's garden, something straight out of *Ben Hur*, with the grass dazzling emerald green and every plant bathed in light. There was a pool grand enough for an Esther Williams production number, and the palazzo, its already perfect lines enhanced by Italian Nouvelle Society decorator Mongiardino, would have made a Caesar smile. Yet across the road from Valentino's palazzo is a hamburger stand!'[128] Of this, Andy Warhol, who died in 1987, would certainly have approved.

Other Italian designers, including Giorgio Armani and Gianni Versace, were no less familiar with the heritage of old Hollywood than the Americans. They made much of the inspiration they drew from it. The champion of subdued hues, Armani won much success in the United States with his unstructured garments and flair for blurring the divide between casual and formal wear. In 1982, *Time* granted him the cover, which acclaimed 'Giorgio's Gorgeous Style'.[129] In interview after interview, Armani claimed that he drew inspiration from the costumes of American cinema and this was reflected in period-style advertisements for his label that evoked the Hollywood glamour of the 1930s.[130] The complex nature of modern mass society meant that all designers had to keep abreast of trends in popular culture, even if they were not interested in being at the cutting edge. The domination of a shared media-based culture meant that keeping in touch was paramount and all of them had staffs and muses to assist them with this.

For designers like these, Hollywood glamour was a very useful repertoire of proven persuasive efficacy that also had the advantage of being an international lingua franca.

Designers needed different, more contemporary appeals to communicate effectively with younger consumers. The mystique of Marlene Dietrich or the sensual allure of Rita Hayworth so beloved of middle-aged male designers were suggestive but remote and unrealistic. Modern glamour relied on fast-moving, dynamic lifestyles, on beautiful bodies, and on objects and environments that were not imbued with class connotations but rather with pleasure and escapism. These values were strongly present in some television series, the production quality of which improved significantly in the 1980s, rendering them more seductive and glamorous than ever before. For five years from 1984, NBC broadcast *Miami Vice*, a new-style police show about two undercover cops working in the South Florida city. Starring Don Johnson and Philip Michael Thomas, the show presented complex plots of corruption, drug-trafficking, and prostitution in the exotic, subtropical setting of Miami. As a cop show, it differed in many ways from the standard series (such as *Kojak*, *Cannon*, and so on) that featured eccentric personalities and neat plots. Its most striking innovations were in the field of visual imagery and style. Directed by Michael Mann, the show blended music, cinematography, fashion, and high-production values in a way that gave it a fast, upbeat, and materially opulent feel. The good-looking male protagonists demonstrated an acute sense of fashion, dressing informally in Italian labels and branded sunglasses. The producers made every effort to ensure that the show reflected the latest European styles with the intention of making it a model for menswear.[131] Macy's even opened a *Miami Vice* section in the young men's department of the store. Shows like this were vital in showing how fashion labels functioned as tools for glamorizing the self and how glamour could blend with everyday life both as entertainment and as imaginative projection. Their protagonists were eager consumers like their spectators, men who revelled in the way aspects of luxury lifted them out of the humdrum and the mundane.

Changes in the communications system in the 1980s, including the advent of the video cassette and the birth of the music video, radically changed the

way people consumed media products and the impact they had on their lives. Sampling from high and low culture, and from past and present, became commonplace as choice widened. Designers including Versace and the Frenchmen Jean-Paul Gaultier and Thierry Mugler developed vibrant personal elaborations of glamorous themes that matched the demand for ever new eye-catching and dream-inducing visual experiences. They took advantage of the way the contemporary media tended to disassociate high social status from social prominence and wealth and instead bind it up with fame and with the fashion world itself. The master in this respect was Karl Lagerfeld, who single-handedly turned the Chanel label into a vibrant contemporary brand while also producing collections under his own name. He had always worked in ready-to-wear and was therefore a key player in its expansion. Constant renewal was his credo and 'vampirizing' trends and the ideas of young collaborators his method.[132]

Glamour became in the 1970s a paradigm of distinction that was more widely available than ever before. Rock performers and innovators like Warhol showed that dressing up and constructing a fabulous self with elements of media heritage, cosmetics, and coloured costumes was available to all, regardless of whether they lived in New York or Wolverhampton. Discotheques offered a stage for everyone to escape from everyday hum-drum and present their glamorous persona at least once a week. The huge emphasis on physical beauty and sex appeal in the formula of contemporary glamour was testimony to this. Glamour has always had an appeal to the marginal and the oppressed, who have seen in its techniques of self-improvement and self-invention a way out of their situation, or a fuel to dreams of escape. At the same time, it has also been a fabulous platform for the new rich. It was the fashion designers who brilliantly bridged the gap between these two social strata and wove magical spells of seduction and self-transformation that enchanted the world.

CONTEMPORARY GLAMOUR

W hen Lady Diana Spencer became engaged to Prince Charles in February 1981, she was a young woman from an aristocratic family whose modest education and limited experience of life were reflected in her demure appearance. A pretty and naïve 19-year-old, she seemed the archetypal English Rose. Thrust unknowingly into the media spotlight, she quickly became the nation's darling. Her wedding to Prince Charles in St Paul's Cathedral in July 1981 was given blanket press coverage and was watched by an estimated worldwide television audience of one billion people. The marriage was presented as a fairy-tale union of an eligible prince and a beautiful commoner, the aristocratic standing and royal ancestors of Diana's family receiving less emphasis than her more commonplace status as a young working woman. A decade later, Diana's public image was quite different. Her marriage to Charles bore two sons, but by the late 1980s it was on the rocks. The Prince and Princess of Wales formally separated in December 1992 and were divorced in 1996. Throughout this period, the press scrutinized every aspect of their body language and public appearances, separately and together, for indications of the state of their

relationship. Both the prince and Diana briefed the press through friends and blamed each other for the breakdown of the marriage. Public sympathy was firmly with Diana and the affection for her was amply demonstrated in the emotional public reaction to her death following a car accident in Paris in August 1997. As she emerged from the shadow of her husband, Diana invested ever more energy in charitable works. Having herself suffered from the acrimonious divorce of her parents, and living the breakdown of her own marriage, she was in a position to offer comfort to others. Subsequently, she helped publicize the international campaign against landmines and to overcome discrimination against AIDS sufferers. Like a secular Mother Teresa of Calcutta, with whom she established a connection, she became identified with selfless devotion to the causes of the ill and suffering.

Diana was not originally associated with glamour. Mainly, she was presented within the framework of royalty. In the course of the twentieth century, the British royal family had had a complex relationship with glamour. It had flirted with the press, the movies, and publicity, but fundamentally it remained a thing apart, an institution that was theatrical, certainly, but respectable and not a little stodgy. Its capacity to enchant was founded on history and tradition, and was more ceremonial than personal. Thus Diana's spectacular wedding endowed her with a conventional aura, that of the fairy-tale princess. With its puffed sleeves, nipped waist, embroidered pearls and sequins, and 25-foot taffeta train, the bride's creamy silk dress contributed to the fantasy. The pomp of the wedding impressed not only the thousands who lined the streets leading to St Paul's, but the millions who watched the ceremony on television or read about it in the press. Over time, Diana's image evolved as she became more womanly and the press found that use of her image never failed to boost sales beyond measure. Designers competed to dress her and magazines ran features on her wardrobe, knowing that women regarded her as an inspiration. In subsequent years, as she acquired an independent profile and began to detach herself from the royal family, her conventional aura was displaced by glamour. She became a figure of beauty and style whose photogenic qualities turned her into the most photographed person of the age. Speculation about her love life in the final stages of her marriage and in the period

prior to her death intensified interest in her to the point that almost her every move was tracked by paparazzi.[1]

Diana's beauty was central to the transition she made from demure and virginal princess to woman of glamour. Her girlish good looks at the time of her courtship and engagement drew some favourable comment but no one in those early days saw her as a great beauty. Rather, Diana grew into her body, which she turned by sheer dint of effort into one of her main tools of communication. A tall and well-proportioned woman, her appearance became splendid; she was toned, tanned, slim, blonde, and radiant and at no time more so than in the five years between her separation and her death. 'Providence gave her beauty, but it was she who contrived to project it until it radiated to every quarter of the globe,' noted the historian Paul Johnson in the days after her death.[2] The most important thing about her in this regard was that she was superbly photogenic. 'This was not merely beauty,' commented another senior male observer; 'this was beauty that lept through the lenses. She seemed chemically bonded to film and video.'[3]

The most remarkable series of photographic portraits appeared too late to shape responses to her, although they may have had some small influence on the reaction to her death. In 1997 *Vanity Fair* published in its July issue a series of pictures under the title 'Princess Di's New Look by Mario Testino'. The Peruvian photographer's work ensured that she exited the world at the height of her splendour. More than any of his colleagues, Testino had a gift for giving his subjects an electric charge of fabulousness. They positively glowed and glistened and always looked like euphoric, yet not unnatural, versions of themselves. In Testino's lens, Diana looked relaxed, rich (her rumoured £80,000 per annum grooming budget was evident in her beautiful skin, cropped and highlighted hair, and movie-star smile), and totally confident. The spectator could not but be mesmerized by her relaxed air and sleek surface.

It took Diana some time to understand how she could use fashion to establish a public identity and communicate messages but, once she did, she harnessed its power to maximum effect. Her glamour was inextricably bound up with her dazzling use of fashion. In 1994 one newspaper estimated that her wardrobe had a value of around one million pounds.[4] In fact, the charity auction of seventy-nine of her dresses in New York in June 1997 (for which the

Testino photographs were a promotional pitch) raised a total of $3.25 million. As the Prince of Wales's wife, her choice of designers was limited to the British or British-based, with exceptions being made only on royal visits for designers from the host countries. The London designers Catherine Walker and Bruce Oldfield were perhaps the first to see her glamour potential. They helped her forge a fashion identity that was varied but generally discreetly eye-catching during the day and fabulous for evening occasions. Diana dressed at first to please—to please above all her distracted husband by showing she could win the adoration of the gallery—but then increasingly for effect.[5] Demure dresses gave way to striking red and black gowns, chic pastel combinations, and toned-down looks for everyday charity work. By the mid-1990s, she had turned into a toned, tanned, and designer-clad blonde vision of incomparable allure. She wore international labels and showed a particular predilection for the creations of Gianni Versace, the Italian designer who was hailed after his murder in Miami Beach in July 1997 as the 'king of glitz'. Versace showered her with suits and dresses and she became a regular customer at the label's Bond Street store. She did not wear his starlet numbers but rather opted for the simple, sexy outfits that suited her fashion persona. One of the last memorable pictures of Diana is of her comforting a disconsolate Elton John at Versace's funeral in the Duomo in Milan.

Diana's glamour also derived from the spectacle of her personal transformation. At one level, this was composed of the narrative of her life, which dramatically shifted genre from fairy tale to soap opera. Diana's personal story and her great gift for empathy created a favourable predisposition towards her. But no less important were her obvious breaks with royal custom and determination to establish an original public presence in her own right. Her popularity destabilized the conventional relationship between monarchy and the mass media. From being the icing sugar doll on the cake of monarchy, she turned into the sexy covergirl who found her peers in the worlds of fashion and celebrity. This transformation occurred quite literally before the eyes of everyone, as her body took on the glossy, honed appearance of the professional publicity-seeker. The more she suffered in private, the more she looked fabulous to those who met or saw pictures of her. The whole process was a visual phenomenon acted out largely as a mime

show, without the benefit of words save for the confessional television interview she released to BBC reporter Martin Bashir in 1994.

Initially gauche and inexperienced, Diana learned to shape and manage her own image. At first, she studied her own press coverage and learned what sort of effects she could provoke by a choice of dress or gesture. Later, she enlisted the assistance of fashion advisers and designers, and grooming experts. These people provided her with a support system that was geared to maintaining and enhancing the value of her image. In this way, she created a world around her that maximized her ability to shine. She became the director and leading cast member of her own one-woman stage-show.[6] There was no shortage of people willing to testify to the effect that seeing or meeting her had on them. 'It's funny but when I met her I could swear I could tell she had come into the room even though my back was turned. The first thing that struck me was her glamour,' one charity lunch guest declared in the days after her death; adding, 'she had the most beautiful skin. The other thing was that she seemed genuinely interested.'[7] 'She had glamour in spades and, more than that, she reached out to the people in a way that none of the rest of the family did or could. Even the Queen Mother, who has had star quality (if not physical glamour) all her life, never received the same adulation as Diana,' observed biographer Sarah Bradford.[8] Testimonies like these suggest that Diana's glamour was a personal quality that was related to, but not entirely reducible to, her beauty. The references to her skin and physical being imply a bodily magnetism that amounted to an 'instant radiance' that lit up rooms and generated a rush of excitement.[9] Male observers often described this as sex appeal. In fact, such effects were the result of a predictable structure of relations between subject and audience.

Diana was not the first British royal to be fashionable or to be explicitly described as glamorous, since Edward, Prince of Wales had often been referred to in that way in the 1930s,[10] as had Princess Margaret in the 1960s. But since their time, both mass communications and the social scene had undergone major changes. Above all, entertainment had evolved into a lingua franca. Whereas she had at the outset been the perfect embodiment of virginal innocence, by the 1990s Diana had acquired a powerful allure that led her to be compared to stars like Grace Kelly and Marilyn

Monroe. Comparisons between Diana and other figures from the firmament of mass culture served to underline her iconic stature. The testimonies of her collaborators reveal that this was not accidental.[11] Movie stars provided her with a template for capturing public attention. She liked to camp it up like Marilyn Monroe in *Some Like It Hot*, and she carried over some of Marilyn's seductive demeanour into her public persona. Pictures of her imitating Audrey Hepburn in outfits taken from *Breakfast at Tiffany's* were kept on display in her private quarters at Kensington Palace.[12] Diana was an avid consumer of popular television and, it is said, never missed an episode of *Dallas* or *Dynasty*.[13] Joan Collins's strong femme fatale persona in the latter show appealed to her and taught her how to be strong and radiant in the face of personal adversity.

In the final years of her life, Diana became much more a figure of the celebrity realm. She found friends in show business, the fashion world, and among the international rich. Separation and divorce led to her being deprived of the prerogatives of royalty and she turned into a 'Jackie Onassis Diana who lolled sensuously on rich men's yachts',[14] a potential 'Diana Fayed of St Tropez and Knightsbridge'.[15] She was at once a princess, a celebrity, a clothes horse, a supermodel, a pin-up, a diva, a role model, a jet-setter, a super-consumer, and a movie star. Like all people for whom publicity is oxygen, she was as much a symbol and a signifier as a person. After the princess's death, these comparisons abounded. She became the rock'n'roll princess, the latter-day Eva Peron, the saintly supermodel who died at the same age as Monroe.

Diana's significance was by no means limited to glamour.[16] But it is around the theme of glamour that a significant number of the reflections on her life and meaning revolved. In her later years, she was either part of, or acted as a vehicle for, a series of phenomena that were concerned with image and appearance and with the effect of these on individuals, institutions, commercial practices, and communication. In the 1990s glamour became a social and cultural lubricant on an unprecedented scale. As a readily comprehensible visual repertoire that aroused responses of desire, envy, and emulation, it found more applications than ever before in a world in which people increasingly defined themselves by what they consumed. Its

creation depended on a highly organized structure. Glossy images, sleek surfaces, and groomed exteriors were cultivated by swathes of professionals, including fashion producers, beauty consultants, hairdressers, stylists, photographers, and publicists, who were ready to turn every personality into a glistening object of desire, a walking cover shot.

The ubiquity of images of glamour was related to two things: the multiplication of media and the increasing interaction between them, and the huge development of fashion and luxury industries which these new media opportunities made possible. Synergies between cinema and television, popular music and television, the press and television combined to enhance the role of celebrity and image. Upbeat, consumer-oriented television shows featured good-looking, well-groomed people and ever more numerous magazines produced glossy, uncritical editorial content. When the Spanish magazine *!Hola!*, which had published in Spain since 1944 and also had a wide circulation in Latin America, launched a British edition in 1988 and named it *Hello!* the event was greeted with amusement. Fawning pictorial features on celebrities lavishly paid to open their luxurious pads to the prying eyes of the photographers or to have their wedding snaps taken exclusively by them did not seem like a recipe for success. In fact *Hello!* was the precursor of a wave of what the journalist Tina Brown calls 'fabloids', that is magazines that 'combine the tabloid hunger for sensation with the requirement to always look fabulous'.[17] These extended the personality formula developed in the 1970s by weeklies like the American magazine *People* and were soon contaminating the mainstream press with their style of presentation. Magazines of this type worked on the assumption that famous people could be bought and that their acquisition would in turn sell magazines. They quickly bloomed and multiplied, even spawning raunchy and ironical competitors that offered a less enchanted view of celebrity lives.

The second development was the transformation of the consumer economy. In the 1970s, as we saw in Chapter 10, fashion designers emerged as lifestyle mediators and architects of glamour. In the course of the following two decades, they consolidated this position. They pursued a strategy of 'capture' towards public events and personalities in a concerted effort to gain publicity and establish their labels as indicators of status, style, and sex

appeal. In this they were joined by producers of luxury goods of every type. On account of a trend towards corporate ownership of both fashion houses and producers of luxury goods, there was a general trend towards market expansion and the democratization of luxury. This term had first been used by department stores in the nineteenth century as industrialization made possible the production at low prices of goods that had once been reserved for the well-off. In the late twentieth century, consumers were, by contrast, given the impression that mass-produced goods were rare and desirable. Leather goods, jewellery, watches, and fashion were wrapped with the mystique of style and luxury and sold as superior indicators of taste and status. Companies that previously had been solely concerned with supplying elite customers sought to maximize profits by reaching the middle market.

Both these developments were facilitated and encouraged by a demand to accede to the higher realms of consumption on the part of middle-class and some working-class people in Western countries, as well as in the expanding economies of the far East and Asia. The far-reaching economic changes of the Reagan and Thatcher era saw a rise of the service sector and a historic decline of conventional primary activities like fishing and mining as well as manufacturing. Tax cuts fuelled consumer spending and produced a new demand for status symbols. Also important were cultural changes relating to the shift that occurred in the West towards secondary goals and aspirations once the satisfaction of primary needs of food, shelter, and clothing had been achieved. In addition, the loosening of social ties and of the institutions of civil society, as well as connections to place, through economic change, mobility, the diversification of family life, and the multiplication of the mass media broke old class and region-specific cultural boundaries.[18] Social mobility in this context ceased to be a matter of moving between established classes and more a matter of moving away from them. An important consequence of this was an increased focus on consumption not only as a measure of success but as a vehicle of personal expression and of emotional satisfaction.[19] This produced pressure for the 'democratization of formerly exclusive types of consumption and styles of living'.[20] There was an established curiosity for wealthy or privileged lifestyles that dated back at least to the eighteenth century and which, more recently, had been institutionalized

in the American TV show *Lifestyles of the Rich and Famous*, that broadcast from 1984 until 1995, and the British *Through the Keyhole*. Wealth, especially of the new variety, engendered not resentment but envy and admiration because it was given an appealing and accessible face by celebrities who seemed just like everyone else except that they were more successful.

Diana was a crucial factor in the development of a new buzz in a social scene that was stylish, fashionable, and money-oriented. Far more than any pop stars, models, or dashing entrepreneurs, it has been claimed, she single-handedly made Britain glamorous.[21] Like Jacqueline Kennedy in the 1960s, she did much to raise public interest in fashion. She was no mere local personality but something akin to a worldwide brand. Tina Brown, who was editor of the *Tatler* between 1979 and 1983, noted that a new synergy came into place between commerce, society, and philanthropy.[22] Companies that were seeking to take advantage of the booming economy of the mid-1980s were desperate to attract some of the stardust that was associated with Diana's glamorous presence. As the Princess of Wales, she could not get involved in anything nakedly commercial, but if a charitable veneer was added to a launch or a trade show, then she could attend and bring much-desired media attention. Her appeal was such that car and fragrance companies, jewellers, and luxury goods labels all rushed to sponsor events at which advertising would neatly combine with support for a worthy cause. *Tatler* itself hugely increased its circulation as the formerly stuffy society magazine experienced its own synergy with commerce and celebrity.[23] By the same token, virtually every cultural and sporting event, from pop concerts and football matches to polo tournaments, was sustained by sponsors who pumped in money and injected razzamatazz. Scarcely a single appointment in the once exclusive English social season, including Ascot, Henley Royal Regatta, Wimbledon, and Cowes week, was not branded and packaged by a producer of champagne, a chain of luxury hotels, or a travel company. The social pictures that once used to record the balls and dinners of high society, providing its members with a warm glow of superiority, were replaced by party pictures recording the presence of miscellaneous celebrity invitees and decorative aristos at a bash to mark the opening of a new

restaurant, fashion store, or the premiere of a film.[24] Their presence was a guarantee that the event would be covered by news organizations.[25]

The visual language of glamour had not significantly altered for several decades nor had the functions it performed. As in the past, it was flashy, eye-catching, sexy, and sometimes outrageous. Covered with the veil of glamour, people and places took on a special sparkle that dazzled and bewitched those who cast their eyes on it. What changed in the 1980s and 1990s was the *quantity* of glamorous images, the sheer number of people that to different degrees conveyed them and the wide variety of places, media, and media outlets that transmitted them. This meant that a new tension emerged between, on the one hand, a visual repertoire of glamour that was increasingly familiar, standardized, and quotidian, and an ever-wider desire to grasp the magical, exclusive, and exceptional qualities of glamour. Thus a distinct hierarchy emerged in which, on the one hand, certain individuals, categories, and contexts were seen to stand for relatively pure glamour, while others offered partial and temporary glamorous effects geared to given moments. In these circumstances three responses flourished: irony and pastiche; revival of the gestures and visual clichés of the Hollywood glamour of the past; invention and deployment of new vehicles of visual seduction by adapting old codes to contemporary conditions. All these strategies were employed by media, companies, and personalities who had a vested interest in manufacturing mass desire.

In Western Europe and North America, societies which had a high level of media development and media penetration of social relations, glamour's core appeal of magical transformation of the individual through the manufacture of a new self had the widest impact. It formed a collective discourse that did not merely complement social relations formed in primary contexts such as the family or the workplace. Rather it functioned in social settings that had been reorganized by the media and in which conventional ties such as the once strong relationship between physical place and social position had been weakened.[26] Glamour privileged fame, fashion, beauty, and feminine life narratives. These commanded widespread attention, but especially they touched those who found themselves on the margins of society on account of their economic position, ethnicity, or sexual orientation. This

explains, to some extent at least, the public fixation with Diana. 'Diana's appeal as a postmodern icon resides solely in her ability to renew and transform herself—and by racing just slightly ahead of our imagination, to hold us in constant thrall,' wrote *Vanity Fair* one month before her death.[27] The princess's 'postmodernity' stemmed precisely from the changes that resulted in her role following the collapse of her 'fairy-tale' marriage and the efforts she made to establish and renew an identity in relation to the public sphere.

Diana's ascendancy occurred at precisely the time that ready-to-wear was being revolutionized and the public was showing signs of enthusiasm for designer labels. The attributes of a glamorous lifestyle were communicated widely by companies which promised that ownership of desirable goods would bring status and transform the consumer's life by making it enviable and exclusive. A key player in the field was Bernard Arnault, the French businessman who acquired Christian Dior in 1984 and went on to construct a major luxury group by creating the Christian Lacroix couture house, buying Céline, and aggressively taking over LVMH (Louis-Vuitton-Moët-Hennessy), which owned Louis Vuitton, Givenchy, and the Moët-Hennessy drink company. He consolidated his leading position by adding the smaller fashion houses of Michael Kors and Marc Jacobs. Other group players included Richemont, the Swiss-based firm that owned Cartier, Van Cleef & Arpels, Dunhill, Mont Blanc, and Chloe, and the Italian Gucci group, which warded off takeover by joining in 1999 with the French PPR (Pinault-Printemps-Redoute) company that also acquired Yves Saint Laurent ready-to-wear and cosmetics. PPR went on to acquire the historic label Balenciaga (originally founded by the Spanish couturier Cristobal Balenciaga in 1937), the Italian leather goods manufacturer Bottega Veneta, and the jeweller Boucheron, as well as launching the new labels of Stella McCartney and Alexander McQueen.[28]

Brand-building was the key strategy of luxury goods companies which first sought to consolidate their basic identity and then aimed to diffuse an image by advertising, sponsorship, and lifestyle endorsements.[29] All the luxury groups and many companies operating in the sector pursued a similar strategy. Old-established luxury companies had often existed for a century or more and had acquired over time reputations for excellence in craftsmanship and quality.

They advertised little or not at all and catered to a narrow clientele of wealthy people. More recently founded houses, like Dior and Givenchy, had similar reputations but had developed strategies to reach the middle market through licensed fragrances and other products. They seduced middle-class customers with atmospheres of refinement deriving from the cachet of couture. In the course of the 1980s, the enormous expansion of ready-to-wear clothing led established couture houses to follow the example of newcomers like Ralph Lauren and Giorgio Armani by producing diffusion lines and by expanding product ranges. The formation of conglomerates consolidated and rationalized this process along predictable business lines and heralded the end of old niche market practices.[30] Each individual company stressed its culture and heritage, its traditions and custom of excellence. It claimed its goods were manufactured to the highest standards of quality and it established a semblance of rarity by charging premium prices even for basic goods like jeans and T-shirts. Low quality licences were eliminated to preserve the image of exclusivity. Young designers were appointed to bring verve and controversy to once stuffy, if fine, products and to attract attention. Massive advertising campaigns were launched to arouse public awareness, that were consolidated through endorsements of events and associations with famous men and women. Finally, sales environments were carefully organized on a pyramid pattern. Flagship stores on key roads in major capitals were sumptuous, prestige outlets that were opened with much fanfare and publicity. Diffusion products were sold through branded second-level stores or prestigious department stores in large cities. Excess product was sold off through special outlet complexes.

One of the most striking developments was the expansion of luxury shopping in non-traditional locations. Companies backed up their desire to capture the global middle market by creating new sales outlets that lacked the intimidating atmosphere of the flagship stores or leading department stores. Carefully avoiding opening stores in unglamorous cities or shopping malls, they established outposts in second-tier large cities and high-profile tourist locations like Las Vegas and Miami Beach, as well as European airports. Las Vegas became a leading luxury resort and one of the principal shopping destinations in the United States. The one-time 'sin city' was a fabulous place of invention that lavished glitz and glamour on its visitors. The hotels and casinos on the famous

strip were designed in the most eclectic and fantastic manner imaginable and they were continually being knocked down and rebuilt. From 1982, when the Mirage hotel opened, a shift occurred away from the emphasis on gambling towards entertainment and hospitality.[31] Fantasy and escape were always present—the Mirage featured a fake volcano while dolphins swam in a pool—but it was the total experience that counted. The gambler's paradise was the perfect location for designer brand stores because the entire city was founded on the dream of wealth and the possibility for self-transformation. Moreover, most of the 35 million people who visited each year only stayed a few days and, during that time, they were keen to pursue pleasure and move themselves temporarily upscale. Flashy and glitzy goods caught their eye in stores that were easy to enter and browse in and whose staff, unlike the notoriously ofhand salespeople in stores in capital cities, were relaxed and welcoming.[32]

Glamour was the motor of sales and it was carefully created and perpetuated by producers who knew that popular perceptions of a brand were what counted most. More important than the sheer quality of a garment or accessory in such a context was the recognition factor supplied by visible labels and logos, exterior signifiers of opulence in the form of gold or brillante touches, and the narrative forged by advertising and celebrity links. Unless genuine artisan work was involved, for example in the haute couture of Chanel or Saint Laurent or the luggage of Hermès, manufacturing methods were concealed to facilitate the creation of a neo-artisan mystique. It was not the products that were emphasised so much as what they *represented* in terms of cachet, status, fashionableness, novelty, and celebrity.[33]

While the brands in the Arnault stable sought to shake off staid images and win popular recognition by embracing sex appeal and celebrity, no designer more than Versace made these values his own. Versace was seen as the master of contemporary glamour. In contrast to most of his Italian contemporaries, who embraced bourgeois notions of taste and measure, he provided spectacle, luxury, colour, and sex appeal. He understood that to have an impact on the mass imagination, luxury could not be understated. A southerner from the city of Reggio Calabria, Versace launched his own label in Milan in 1978 and quickly opened a series of boutiques in prestigious locations around

the world.[34] By the mid-1990s, these sumptuous emporia bore witness to the designer's trademark lavish, luxurious, and overtly sexual style. The explosion of colour, the sharply revealing cuts, and luxurious fabrics that characterized the Versace range were geared to those who wanted to be noticed, to assert their wealth and sexuality, to feel they were at the cutting edge of a rock'n'roll lifestyle. Versace offered customers the promise of standing-out, being noticed, and, almost, of wearing a price tag. His designs shouted wealth and status through a megaphone. This ostentation was enhanced by lavish advertising that ensured label recognition and public identification of the style. It was further charged by an insistent link with movie and rock stars in a reciprocal effect that added drama and value. His idea of glamour worked on the long-established combination of wealth and sex. Many noticed the sex first. Indeed he was often accused of dressing women like whores. In particular, his use of lurex and rubber, sometimes together with studs, safety pins, and rhinestones, recalled fetish wear. Versace, it was said, 'sold sex and glamour and he sold it with the gusto of the most garrulous second-hand car dealer'.[35] This did not undermine the appeal of the label. 'A strappy Versace evening dress which curves around the body before flaring out into a flirtatious kick, slashed to the thigh and with the deepest neckline in the business, is quite the most sensual garment any woman can hope to wear,' commented one woman journalist.[36] The designer always claimed that his supersexy clothes were inspired by the exaggerated finery of the prostitutes that came into his mother's dressmaker's shop in Reggio Calabria. He disliked modesty and promoted an 'if-you've-got-it-flaunt-it' outlook that cultivated a show-off attitude in his customers. Wealth took the form of eye-watering prices but also a photogenic lifestyle that was unashamedly materialistic.

Versace became a household name in Britain in 1994 when Hugh Grant's then little-known girlfriend Elizabeth Hurley wore one of his creations to the London premiere of the British comedy *Four Weddings and a Funeral*. The extraordinarily low-cut and revealing black gown was split down the side and held together with safety pins featuring the designer's Medusa's head logo. Front-page pictures in the tabloid and broadsheet press massively increased the curvaceous Hurley's profile and made Versace into a byword for show-stopping sexy clothes.[37] In the wake of this event, every publicity-hungry

starlet in Britain aimed to grab the front page by turning up for a premiere or launch in a garment that showed off her figure to effect. Many of these were created by the London designer Julien Macdonald, who specialized in ultra-revealing evening wear.

Versace did not rely solely on show-business glitz. He liked to construct noble pedigrees and establish cultural kudos for his brand of glamour. In keeping with his eclecticism, themes, motifs, objects, and styles drawn from a wide variety of sources including ancient Greece and Rome, Byzantium, the Italian Renaissance, and the Baroque period marked Versace's home furnishings, fragrances, stores, advertising, and numerous coffee-table books. His books, including *Men Without Ties* and *Rock & Royalty*, were sumptuous productions. In his search for recognition, Versace sponsored exhibitions of his work in such august institutions as the Metropolitan Museum of Art in New York and the Victoria and Albert Museum in London. Like his rival Giorgio Armani, who also opened his archive for high profile exhibitions, he believed that such forays into the cultural sphere lifted his creations on to the plane of art and guaranteed them a place in posterity. However, it was the catwalk that was the scene of Versace's greatest innovations. Collections had once been presented in-house by fashion companies for clients and foreign buyers. The press was allowed in but publicity was carefully restricted to avoid pirating. Versace and his fellow Italians turned the catwalk into a stage and the show into pure theatre. They became large-scale productions, complete with music and lighting, that were aimed at gathering maximum coverage.[38] As such they were 'pseudo-events', to use the sociologist Daniel Boorstin's term for activities whose sole purpose was to garner publicity.[39] For seasoned fashion journalist Colin McDowell, catwalk shows were at the core of 'the deception which embroils the fashion industry in its attempts to keep us thinking "designer" and buying the clothes that bear the label'.[40] They were fashion's theatrical blockbusters that seduced commentators and critics 'into accepting anything and lauding it to the skies provided it is on a runway and the music is right'. In the high voltage setting of the Versace catwalk shows, models strutted their stuff with the confident sassiness of the dressed-up but none-too-respectable starlet. The shows were spectacular events with huge press appeal that were bathed in laser light and accompanied by

pulsating beats; his front rows were stuffed with rock stars and actors whom he treated as friends and often hosted lavishly at his gorgeous homes, including the Casa Casuarina villa on Miami's South Beach where he would be killed.

Versace is often credited with having created the phenomenon of the 'supermodels'. While several models had individually and collectively achieved high exposure in the 1980s, and *Time* magazine devoted a cover to them in September 1991,[41] Versace enhanced their profile. He signed models exclusively for his shows and then used them collectively in his 1994–5 advertising campaign, shot by Richard Avedon.[42] Other fashion houses followed suit and soon no show was complete without them. Christy Turlington, Naomi Campbell, Linda Evangelista, Cindy Crawford, and Claudia Schiffer, plus a handful of variable others,[43] became as well known in the 1990s as the Hollywood stars of the golden age. They appeared on innumerable covers of the leading fashion magazines; they wowed the public through press coverage of spectacular catwalk shows; the top few became known by their first names only. In addition, they reached beyond fashion to undertake calendar, pin-up, and general magazine and advertising work. They became all-purpose celebrities who wrote books, made films, hosted television shows, made records and fitness videos, and whose lives were the stuff of dreams. Their rise was the product of three distinct trends: the globalization of the model industry, which occurred in the 1970s; the ready-to-wear revolution that took fashion to the masses; the absence of other figures capable of generating sufficient attention and interest to harness collective dreams. The supermodels were different from their predecessors in the sense that they were not drawn from a relatively narrow social environment; rather they were girls who had been spotted as teenagers in diverse local settings, mostly far-removed from conventional fashion strongholds. Schiffer was a lawyer's daughter discovered in a Düsseldorf discotheque; Turlington was noticed by a photographer at a local gymkhana in San Francisco; Campbell was spotted on the street in London's Covent Garden; Crawford was raised in the Illinois countryside and did not even seem physically suited to modelling; the Canadian Evangelista was the only one who admitted to always having wanted to be a model and was already on

the books of an agency by the age of 12.[44] Each of them had a quality that distinguished her and rendered her iconic: Crawford's beauty spot, Evangelista's penchant for chameleon-like changes, and Turlington's pout were traits that were endlessly debated. Only the wholesome and strapping Schiffer was a conventional blonde, while Campbell was the first black model to reach the peak of the profession.

These women became the idols of an era.[45] More people were aware of them on a global level than any previous fashion models. The supermodels were the product of a period obsessed by image and glamour. They epitomized contemporary ideas of beauty and inhabited a world of dreams and fantasies. They began in the world of image as recruits of model agencies, who were packaged and shaped by photographers. In the 1970s and 1980s, a star-like approach to the grooming and presentation of models had emerged. According to fashion editor Polly Mellon, the founder of the Elite model agency—John Casablancas—was chiefly responsible for bringing sex appeal and sensuality to the business and making it much more profitable. 'He took a sleepy backwater business run by a dowager empress [i.e. Eileen Ford, who had founded the Ford agency in 1946] and turned it into Hollywood,' she declared.[46] Photographers including Patrick Demarchelier, Peter Lindbergh, and Steven Meisel shot the models for magazines and turned them into icons, while magazines across the globe clamoured for them. Even before they won general recognition, they were undertaking work outside the fashion field. They won lucrative contracts with cosmetics companies and undertook pin-up work for *Sports Illustrated*'s annual swimsuit issue and the Pirelli calendar. The shapely all-American Crawford even posed for *Playboy* magazine in 1988. Agencies were marketing them globally for ever-increasing fees and began insisting that they be given name credits by magazines. As their fame increased, *Vogue* and other publications began to appreciate the impact they had on sales and featured them heavily. In January 1990 British *Vogue* dedicated its cover to Turlington, Evangelista, Crawford, Campbell, and Tatiana Patitz, impressing pop singer George Michael so much that he cast them all in the video of his song 'Freedom'.[47] Paris-based agency boss Gérald Marie, who at the time was Evangelista's husband, persuaded Versace that it would work to his

advantage to pay photographic models way over the usual rates and send them out on the catwalk in groups.[48]

Crawford, Schiffer, and company had glamour because of the special place they occupied in the dreams of society. They could persuade people to buy even at a time when spending was down by investing salesmanship with class and seductiveness. 'They have replaced the Hollywood stars in the hearts of a public starved for glamour,' proclaimed the first issue of a magazine from the *Elle* stable that was wholly devoted to them: 'They are real trend setters of our time; everything they do and say is talked about and imitated. They bring us beauty and the illusion of eternal youth. They are neither American nor Swedish nor Italian, but rather come from an imaginary land that knows no border. They speak without words, their faces and bodies spell the meaning of grace in a universal language that needs no translation.'[49] They were about selling. As novelist Jay McInerney expressed it in his *Model Behaviour*, they were women 'whose photographic image is expensively employed to arouse desire in conjunction with certain consumer goods'.[50] The supermodels were one-dimensional—no one heard them speak, but they none the less dazzled as protagonists of a world that had all the features of glamour. Their lives appeared to unfold between the catwalk, first-class cabins on planes, five-star hotels, photo shoots, millionaire or rockstar boyfriends, and extensive grooming. The distancing mechanisms that helped keep them remote were their silence, their cosmopolitanism, their physical beauty, and their belonging to a realm of dreams. Their accessibility derived from their visibility in the press, their ordinary origins, and their apparent lack of any real talent.

The supermodels were promoted because movie stars, once the prime bearers of glamour, were no longer able or willing to project the kind of enthusiasm and emotional involvement of their predecessors. Contemporary cinema had global reach but it allotted only a small place to glamour and stars like Meryl Streep, Jodie Foster, Sigourney Weaver, or Winona Ryder were unlike the goddesses of the past for whom it was a duty to look sensational at all times. Rejecting glamour in favour of an idea of acting as art, they did not mind being snapped looking less than bandbox perfect. At the same time, various industries needed dreams of allure and perfection to

sustain business. The materialistic dream of beauty, success, luxury, fame, and sex was the lubricant of modern capitalism, a seductive magic that tied people to consumption by colonizing their aspirations and wowing them with visual effects. In the past, cosmetics, lingerie, fashion, photography, television, and popular spectacle had all based part of their appeal on the special allure of Hollywood. In consequence, the old glamour that, in its time, was seen as seductive and even vulgar in its desire to please, took on the air of the classic and the artistic.

The ready-to-wear designers all loved classic Hollywood cinema and often spoke of it. They knew that it was an unrivalled template and that its fabulous images were part of a repertoire of allure that was available for appropriation. Although no longer recent, the glamorous legacy of the major Hollywood studios of the past remained available to be imitated and reconfigured. Versace talked about drawing inspiration from ancient and early modern civilizations but what he served up was a 'raunchy and ersatz version of the ancient past'.[51] His 'Roman inspirations seem to stem from nothing more ancient than Fifties gladiator films starring Victor Mature and Gina Lollobrigida in the romanticised Technicolor world of Hollywood', observed Colin McDowell.[52] To convey the sort of women Versace might have dressed, one commentator suggested that Cleopatra, Jezebel, Delilah, Madame de Pompadour, Jean Harlow, Jane Russell, Lana Turner, Gina Lollobrigida, Marilyn Monroe, Brigitte Bardot, Claudia Cardinale, Cher were all 'Versace girls', 'glitter queens to a woman'.[53] Versace's models resembled fifties' film stars and they wore the make-up to match. Their faces were powdered pale and their lips pouted with brilliant, shiny red. Their appearance was exceptionally pliable. Schiffer and Crawford emerged because of their resemblance to films stars of the past—Brigitte Bardot and Marilyn Monroe respectively—while Evangelista was renowned for her chameleon-like changeability and Campbell reprised the looks of twenties' music-hall star Josephine Baker and other icons of colour. In 1996, French *Vogue* photographed leading models disguised as Marlene Dietrich and Ava Gardner. The supermodels were blank canvases of perfect but depersonalized femininity on which dream identities could be painted. Schiffer even posed as Barbie for more than one photo shoot.

The yearning for old-style glamour manifested itself throughout the cultural system. Volumes such as Len Prince's *About Glamour* or Serge Normant's *Femme Fatale*, that featured contemporary stars photographed in the manner of the old, covered their subjects in an aura of shadows, light, glistening surfaces, and seductive materials.[54] In this way, they recalled George Hurrell or Clarence Sinclair Bell's stills of Clark Gable, Joan Crawford, and Jean Harlow. At a time when celebrity was widely thought to have become irredeemably cheapened, the images of a handful of stars who enjoyed almost universal admiration in the 1930s and 1940s stood as a paradigm, or at least as a possible cloak, for the hundreds of television and film actors who sought to hold the attention of the public for more than the blink of an eye. The deaths of numerous old stars in the early 1990s projected their unrivalled allure once more into public consciousness. In 1990 the greatest star of the interwar years, Greta Garbo, died and so did Ava Gardner, one of the sultriest actresses of the 1940s and 1950s; in 1992 it was the turn of Garbo's one-time Paramount rival, Marlene Dietrich, in 1993 of Audrey Hepburn, and in 1996 of one of the most popular romantic heroines of the 1930s, Claudette Colbert. Each received fulsome obituaries and reverent evocations in the illustrated press.

In the heyday of Hollywood, stars were remote and fabulous beings who were none the less connected to the public by means of various devices dreamed up by the studios. Now the old idea of the star system was replaced by a wider category of celebrity whose members were omnipresent and produced by a variety of entertainment media. The 'blatant shallowness' of the celebrity arena was frequently deplored,[55] along with the personalities who inhabited it, but precisely this made it useful to cultural industries and to the sphere of consumption. It was a parallel world that was both superficial and alluring, amusing and enviably free of routine oppression. It appealed because it seemed accessible, especially to the young. Versace was well aware of the modern public's thirst for celebrity and often used references to it in advertising spreads. For example, in 1996 Bruce Weber shot for the Versace diffusion label Versus a series of black-and-white photographs that used the idea of young stars arriving somewhere, dressed up for an event and surrounded by paparazzi.[56] None of the faces in the photographs,

however, was well known. Like Andy Warhol, from whom he occasionally drew inspiration (one gown featured a design based on Warhol's silk screen 'Marilyn'), Versace played with the language of fame. He was aware that it was detachable from famous people and could be fragmented into accessible parts. It could be appropriated, reproduced, and turned back on itself. It could be made to seem at once remote and magical and yet be made available to all.

Like film companies in the 1920s and 1930s, the leading model agencies organized worldwide competitions for new faces, while scouts of varying degrees of reputability were constantly on the lookout for the next Cindy or Claudia. The promise of model glamour was in fact that any girl could suddenly be propelled to the stratosphere. If a girl of West Indian origin from the backstreets of South London like Naomi Campbell could become a fashion superstar (working, in the process, 'on every inch of herself, from her accent to her taste in champagne'),[57] then in theory there was hope for everyone. Even those lacking height or classical features might appeal to a photographer or benefit from an unexpected turn towards the quirky. In a typical blurring of front- and backstage, magazines that specialized in revealing the 'real lives' of models ran features on the everyday lives of freshly recruited 'mini-tops' and promised readers the chance to join them.[58] The depiction of young models' lives in such publications was highly selective and focused mainly on its most attractive or commonplace aspects.

In his exploration of the world of modelling, *Model*, subtitled *The Ugly Business of Beautiful Women*, Michael Gross highlighted the risks that faced teenage models in the world's fashion cities. Although the old-established New York-based Ford agency was known for its chaperoning approach to young models, often they were unprotected and unguarded. In foreign cities—notably Milan, that was the leading forcing ground of models—they fell prey to local playboys offering them dinners, country weekends, parties, and drugs. It was not merely the sleazy milieu that formed around the girls that entrapped the weak and the guileless. Rather it was the agents themselves who often refused to promote models who declined to perform sexual favours. Some were quite simply 'glorified pimps' who realized that 'beautiful girls could be fucked in every way'.[59] In the case of one model

agency boss, whose alleged weakness for teenage girls was legendary, naïve teenagers reportedly required sexual burnishing before they were ready to be promoted as the bearers of sexual fantasies. The boss in question had apparently 'long been a proponent of the theory that models were raw stones that needed work to become glittering diamonds'.[60] 'European men are important abrasives in the finishing process; they tend to be male chauvinists,' he had said; 'that attitude . . . gives the model an awareness of her femininity, which is an indispensable quality'.[61] Playboys or agents were ideally placed to perform the task.

Sex appeal in the fashion world may have been largely an artificial allure that was manufactured by designers, make-up artists, hairdressers, and photographers, but sexual exploitation was rife. The glamour of the model elite was dependent indirectly on the existence of a sub-world of debauchery and misery. Male models no less than female ones were liable to find themselves faced with demands for sexual favours in return for work. As in the nineteenth century, the world of prostitution was but a few rungs down the ladder from the glittering surface of famous men, fine restaurants, and elegant resorts.[62] Contrary to its dominant myths, the fashion industry was a dangerous game of snakes and ladders. In the dialectic of class and sleaze that is crucial to glamour, it positioned itself as a switching station, finding them both equally suggestive and remunerative. Consequently, it drew on them alternately. Versace was the leading designer to take inspiration explicitly from the worlds of prostitution and fetishwear in creating his more daring designs, but many others took cues from the brash flaunt-it and flog-it world of the street. Even Princess Diana's speech coach suggested that she could enhance her delivery by thinking of herself as a hooker.[63] The occasional model overdose and periodic revelations of sexual exploitation were scandals that the fashion world preferred to keep at arm's length, but they also endowed it with a frisson of danger that somehow made it more intriguing and desirable. Diana's sexed-up image was informed by the contact she had with this environment.

As with the courtesans of the nineteenth century, and the film stars of the middle decades of the twentieth, the models were bearers of the sexual fantasy of their age. Their notoriety rested on their desirability and their sexuality, their

beauty being bound up with both. Just as a Parisian *viveur* might have courted a courtesan for the kudos it brought, so an ambitious late twentieth-century man-about-town like writer Toby Young could confess: 'Like most heterosexual men, I'd grown up fantasizing about sleeping with models. It wasn't the act of having sex with them I found so appealing... but the bragging rights afterwards. To be able to walk past a newsstand, point at the cover of a glossy magazine, and say, "been there, done that"—that was my idea of heaven.'[64] The magnetic allure that the models had for some men—who were infamously dubbed 'modelizers' by *Sex and the City* author Carrie Bradshaw—was the contemporary equivalent of the glamorous aura that golden age film stars had transmitted ('Men go to bed with Gilda and wake up with me,' forties' actress Rita Hayworth used to lament).

The allure of the models was shallower since they were not fully fledged public personalities and the narratives that were woven around them were flimsy. For teenage girls though, the dreams were powerful and they were fuelled by a para-literature sometimes sponsored by the agencies. Ford Models lent its imprimatur to a series of teenage novels published by an offshoot of Random House. With titles like *The New Me* and *Party Girl*, they appealed to the fantasies of pubescent readers keen to escape humdrum lives. *Party Girl* features a girl who fails to win the real model contest Supermodel of the World but is selected anyway by Ford. 'I was heading to New York, the modelling center of the world! I'd shop at fashionable boutiques, go to exciting parties, and entertain glamorous friends in my own chic little apartment. I had it all planned out,' she muses.[65] The sleazy underside of modelling was absent from such works, but it was highlighted in more adult novels set in the fashion milieu. Former model Judi James's *Supermodel* ('The looks of an angel, a heart of glass' warned the cover blurb) explored the secret hard-core past of a Russian model. A model who objects to nude work is bluntly told: 'It's porno darling, do you understand what I mean? Did we cover that term in our language education classes? Porn, porno, pornography. I fuck—you fuck—they fuck—we all fuck, get it? Every model's done it some time or other—it's part of the rites of passage.'[66]

The supermodel elite exploited its unique position and diversified into acting, singing, writing, photography, TV presenting, and even fast-food

sponsorship (Fashion Café). They also became fodder for the gossip press. Cindy Crawford's engagement and marriage to Richard Gere, Stephanie Seymour's relationship with singer Axl Rose of Guns and Roses, Claudia Schiffer's curious pairing with magician David Copperfield, and Naomi Campbell's string of affairs with boxer Mike Tyson, musician Adam Clayton of U2, actor Robert De Niro, Formula One team boss Flavio Briatore, and others were as talked about as any movie star liaisons of the past. Having extended their reach from the world of fashion to the realm of pin-ups and men's magazines, the supermodels found that they were in demand from a wide range of manufacturers that wanted to reposition their products by adding some of their gloss. Although even some top models experienced drug addiction and other serious personal problems, the huge increase in their earnings in the 1980s was accompanied by a high degree of professionalism. They fulfilled fashion's need for a star system and contributed significantly to the rise of image and celebrity culture. But the models who followed the original five or six supermodels only in one or two instances achieved the same level of global recognition. Michael Gross believes that a backlash began after Linda Evangelista was quoted in *Vogue* magazine saying, 'We have this expression, Christy and I: we don't wake up for less than $10,000 a day.'[67] By putting a price tag on themselves, the models dissolved their own mystique. The comments were labelled greedy and tactless and the models denounced as over-priced packaged commodities. In fact, while some resentment was undoubtedly caused, the real problem was what underlay the remark, namely that they had become expensive and ubiquitous. Crawford was simultaneously advertising Pepsi, being the face of Revlon, and fronting her own fashion show on MTV, while also doing editorial work for magazines and catwalk shows. Schiffer became Chanel's favourite model while doing Citroën ads on television. By 1994, she had her own waxwork at the Musée Grévin in Paris, while all the supermodels had personalized Barbie-style dolls.

The derivative nature of the supermodel personae as they were forged and presented to the public may be explained in relation to the fact that contemporary glamour is itself derivative. It is not only an aspect of the particular drives of consumer society but of the sleek surfaces of an image

culture that is often self-generating and self-referential. Up until the 1960s, magazines and photographers worked off real social environments or they imitated and elaborated on them. After the collapse of formal high society, and the demise of the well-bred or debutante model, it was the photographic styles and iconic images of the past that provided the most potent source of inspiration.[68] The globalization of fashion and its supporting structures in publishing, marketing, and advertising produced a certain standardization similar to that experienced by the Hollywood studios in the 1950s. Despite a wider ethnic and physical variety than at one time, the imagery surrounding models was repetitive. Photographers, in conjunction with editors and stylists, were the crucial players here. Contemporary fashion professionals are highly knowledgeable about the past of their profession and explicitly evoke the styles, iconic moments, and people that have defined the collective imagination. Indeed, the main role of photographers is to achieve this evocation in a contemporary way that dovetails with the requirements of advertisers and magazine editors.

The Canadian Steven Meisel, who became the most regular Italian *Vogue* photographer of the late 1980s and 1990s, was renowned for his postmodern appropriations and reworkings of the masters. He consciously mimicked the styles of every major photographer from the 1930s to the recent past, posing his models in the manner of the actresses and mannequins of earlier eras.[69] Lacking a distinctive style of his own, he was regarded by some as a 're-photographer' and dubbed 'Xerox' by one unimpressed gallery-owner.[70] Herb Ritts, who was responsible for some of the best-known group pictures of the supermodels also owed much to older photographers including Richard Avedon and Irving Penn. His fashion shots glorified gym-toned bodies while his mannered celebrity photographs relied heavily on masquerade and revival. Model-turned-photographer Ellen von Unwerth's fuzzy and aggressive black-and-white shots also had a strong retro aspect to them, although this was blended with upfront sexuality. Best-known for casting an unknown Claudia Schiffer in a campaign for the Californian denim company Guess, she specialized in assertive but provocatively sexualized pictures of women that replaced composure with immediacy. 'She deals with a 90s version of glamour: the shiny, neon-lit attractions of pretend

sleaze,' commented one observer.[71] In this way, she remained within the idiom of male fantasy even if she supplied ironic twists on standard scenarios.[72] Surface visual effects—shiny plastic, glass, lipstick, and cosmetics—triumphed in her images.

In general, photographers did not object that their work was the subject of homage and appropriations on the part of younger colleagues.[73] Portrait photographers like George Hurrell and even *Vogue* master Horst had been out of favour for decades and the revival of interest in their work led to reappraisals, books, and exhibitions. A crucial supporting role here was played by John Kobal, who rescued many Hollywood studio stills from oblivion and placed them in his collection, from which several books were drawn.[74] When Hurrell and Horst died, respectively in 1992 and 1999, they received fulsome obituaries of a type that would have been unlikely two decades previously. Helmut Newton was less keen on the sort of tributes that he was paid by the fashion world's self-conscious revivalism. In their editorial work, Michael Roberts, Inez Van, and others created pastiche versions of Newton's trademark deluxe nudes that were sometimes indistinguishable from the real thing.[75] However, unlike the others, Newton was still at the height of his powers. He even created a new star to add to the supermodel firmament, the Teutonic Nadja Auermann, whose other-worldly appearance he connected to the classic canon of artificial sex appeal.

The fashion industry often works by proclaiming a seasonal 'look' to persuade customers of the need to renew their wardrobes. In autumn 1994 it launched 'glamour' as its seasonal watchword. 'Hard core glamour, high gloss and bright colour are back,' announced British *Vogue* in its October issue.[76] 'New glamour', another magazine declared, 'has evolved beyond the clichéd head-to-toe sequins of 50s Hollywood glitz. It has eased up from the 80s *Dynasty* suit with its galaxy of gilt buttons and flaunt-it jewellery.'[77] Instead, it was more 'pared-down, more self-assured and sexy'. This 'new glamour' took inspiration from various sources, including the sleek elegance of the 1930s and the sexy styles of the 1970s. All demanded poise, panache, and polish. The season's top lines consisted of sharply cut suits, classical evening wear, full accessories, high heels, and bold lipstick. It was striking that the interpretations of glamour that were offered at this time in women's

magazines placed the emphasis squarely on polished, refined images of formal outfits. 'The story of glamour through the century is the history of women and their strengthening self-image,' wrote *She*.[78] It added, 'Glamour is make-believe, a veneer anyone can apply with the right clothes, strongly-defined make-up, coiffed hair and red lips.' Adult sex appeal with a sophisticated spin was the season's watchword. It was one that especially suited Versace, Valentino, Dior, Chanel, Alexander McQueen, and Helmut Lang. Another beneficiary was the Italian label Gucci that, under the creative direction of Tom Ford, sexed-up its ready-to-wear and embraced a widely praised and commercially successful, but fundamentally dull, corporate glamour reminiscent of the Yves Saint Laurent of the 1970s.

The launch of the look gave rise to reflections on the meaning of glamour and the range of its applications in fashion. 'Is glamour glitter—or a graceful line?', asked Brenda Polan in the *Financial Times*.[79] Was it in short the sort of flamboyant, eye-catching, colourful, and sexy look associated with Versace and his flashy clients, or the subtlety, harmony, and simplicity of the more restrained and classy creations of a designer like Giorgio Armani. This was matched by another tension, that between the lady and the tart, or between the dressed-up and the undressed. In this case the dichotomy was not within the world of fashion but between fashion as a whole and the sphere of male entertainment. Writing in *Vogue*, Sarah Mower powerfully asserted the female prerogative. 'For too many years glamour has been a joke—repudiated by feminists, used, tackily, by the pop industry from glam rock onwards, hijacked by the sleaze merchants of "glamour photography",' she argued, before lauding its reappropriation by models who were reconnecting it with 'a glorious, noble, stirring sense of womanhood'.[80] The history of glamour shows in fact that the unresolved dichotomy between class and sleaze lies at its core. Glamour is never so subtle that it is not eye-catching at some level, and the 'sex appeal of the inorganic' that Walter Benjamin identified as a core feature of modern fashion is always present. Even when there was a clearly defined high society, the language of glamour was defined by contributions from popular entertainment and the street. Ostensibly, there may be nothing in common between, say, Jacqueline Onassis and Madonna or between Princess Diana and Pamela Anderson. In fact all four women invested heavily in their physical

appearance and were considered sex symbols. Their clothes and their bodies were key aspects of their public personae. All of them were part of the realm of the visual image and the magazine community. All of them, moreover, transgressed social and sexual norms and brushed with scandal. One of Princess Diana's defining moments came in 1994 when she confessed her infidelity on television.

Glamour was part of a complex and variegated media scene. The sampling of old Hollywood that became a trademark of fashion advertising and promotion gave rise to further derivations such as the 1993 success of drag artist Ru Paul's dance record 'Supermodel (You Better Work)'. He went on to score a top ten hit in a duet with Elton John. Paul became the first drag queen supermodel when MAC cosmetics signed him to a modelling contract. Proving that cosmetics really could transform their wearers, billboards of the 6-foot-plus African-American performer were adorned with the slogan 'I am the MAC girl'. His look, he claimed, was 'total glamour, total excess, total Vegas, total total'.[81]

The birth of the pop video and of MTV introduced a marked emphasis on the visual within popular music. Perhaps no one more than Madonna turned twentieth-century glamour into a repertoire to be harnessed and manipulated at will. After winning recognition as a New York City drifter in Susan Seidelman's *Desperately Seeking Susan* in 1985, she scored a worldwide hit with 'Like A Virgin' and went on to become the most successful female recording artist ever, selling an estimated 175 million albums and 75 million singles in a career lasting, to date, 28 years. She polarized public opinion by acting the part of the rebel and outsider, marginal and disruptive, above all by rejecting established female roles. Although Madonna's music was derivative, if catchy and often danceable, her visual style was an original concoction of virgin and whore, Catholic and pagan, high fashion and Hollywood parody. In a series of high-production music videos, she embraced a variety of gold-digger, showgirl, and bad girl personae and even cast herself as Marilyn and Marlene Dietrich, as well as Mexican painter Frida Kahlo.[82] In some respects, she used the strategies of a female impersonator by donning a series of guises. She received a high degree of attention not merely from the establishment and the press but also from academics fascinated by her impact on mainstream culture and subcultural domains.[83]

A barometer of cultural moods and conflicts, she attracted more publicity than most heads of state. Madonna was at one level a sex star. 'A certain sleaze factor was undoubtedly an important element of Madonna's initial rise to fame,' noted one keen observer of her career,[84] and in 1985 *Penthouse* and *Playboy* magazines published black-and-white nude photographs for which she had posed several years earlier.[85] She responded in 1992 by publishing her own coffee-table book of nudes by Steven Meisel, entitled *Sex*. This overt display of shiny, confectioned sexuality placed her in direct line from the soft-pornography of 1950s burlesque.[86]

Madonna's success has been traced to the high degree of personal autonomy she exercised. In contrast to many pop stars, she was a powerful player who was defiantly independent of labels and media corporations. Moreover, she cheerfully engaged in self-commodification, transforming herself at will and pushing an inauthentic identity in contrast to rock's dominant, if often false, ideology of artistic integrity. She moulded her body with diet and exercise, turning it into a powerful tool of her various personae. Her tour titles, Blond Ambition, Girlie Show, and Re-Invention testified to her show-girl-inspired stage presentations. Curiously, for such a visually aware star, Madonna's numerous forays into the movies, including the big budget productions *Dick Tracy* and *Evita*, fell flat. Rather, it was still photographs and videos that best captured her allure. Meisel photographed her many times, while Helmut Newton revealed that, save for Elizabeth Taylor, she was the only subject to whom he had granted a right of veto.[87] Madonna's glamour was of a ruthlessly eclectic kind. She fashioned a persona across several media and bridged several glamorous contexts. She forged a collaboration with designers including the Italian duo Dolce & Gabbana and appeared in a Versace advertising campaign. However, it was the idea of glamour that she derived from childhood memories of watching old movies that was her biggest influence. The video for her song 'Vogue' recreated the atmospheric style of the studio photographers and witnessed the singer disguise herself as the stars who inspired her, while the lyrics provided name checks to Dietrich, Monroe, Harlow, Grace Kelly, Katherine Hepburn, Bette Davis, Sophia Loren, Lana Turner, and Ginger Rogers as well as Brando, Dean, Astaire, and Gene Kelly.

The collaboration of Madonna with fashion designers inspired a whole series of developments in popular music and entertainment. New synergies occurred between different sectors. In pop, the showgirl-dance music pairing that Madonna pioneered was taken up by many artists, including Kylie Minogue, who exchanged her girl-next-door image for that of a feathers-and-sequins showgirl with a sexy image forged through relationships with INXS singer Michael Hutchence (who boasted that he had corrupted her) and French actor Olivier Martinez. First as singer of No Doubt and then as a solo performer, Gwen Stefani operated her own knowing blend of street style, movie glamour, and high fashion, while Christina Aguilera's overtly sexual image mixed old Hollywood and grunge with a mastery of soul, jazz, and blues music.

The appropriation of glamour by the music industry brought pressure to bear on Hollywood. This applied less to film production than to the public moments when the industry was on show. Many stars were no longer accustomed to dressing up as a matter of course and were clueless when required to do so. One of the most prestigious and valuable platforms in this sense was the Academy Awards ceremony in Hollywood every spring. Giorgio Armani established an office to lend dresses and outfits to the stars as early as 1983, while Valentino retained favour, especially but not only, with older stars. Fashion designers won a strategic place in the preparations for Oscar night because a successful and admired choice of gown could add glamour to a star as well as increasing the cachet of a designer. In the 1990s, just a handful of stars were willing to join veterans like Joan Collins and Sophia Loren in reminding the public of Hollywood's heritage of fabulous grooming and drop-dead queenly good looks. While Joan was happy ironically to dispense lessons in old-time big hair, big jewels, and big personality glamour, and join her sister Jackie in peddling pop literary doses of it in genre fiction,[88] only Kim Basinger, the star of *L.A. Confidential*, and an Oscar winner in 1997, and *Basic Instinct*'s and *Casino*'s Sharon Stone were willing to follow them. 'Sharon Stone is not in the Winona Ryder, Jodie Foster style. She's an old-fashioned star, the way they used to be,' noted one newspaper.[89]

This changed in the late 1990s and the early years of the new century. Luxury companies followed the fashion designers in targeting celebrities. The publicity to be derived from seeing a leading actor or personality wear a watch,

jewellery, or shoes, was so valuable that goods were offered on loan or more often given as gifts. In the companies' strategies, celebrities took the place of models as they were deemed to be more effective at promoting goods. They were not shallow ciphers but realistic individuals whom consumers felt familiar with and could relate to.[90] This more than anything else brought ostentation and material goods squarely to public attention and popularized labels that had previously not been widely known. It complemented the strategy of establishing sales outposts in airports, second-tier large cities, and high-profile tourist locations like Las Vegas and Miami Beach.

Advertising, celebrity linkages, and visible logos made prestige goods desirable for all and brought the glamour of luxury within the purview of groups which had no previous contact with it. Such strategies turned them into aspects of popular culture. The appropriation of signature products by fast-money and downmarket celebrities, and even working-class subcultures, soon followed. This could not readily be prevented even though the potential damage for labels could be considerable.[91] The flamboyant styles popular in the Afro-American community in the 1970s created the precedent for 'bling' in the 1990s. Born within the urban musical community of hip hop, bling was all about the wearing of expensive gold and diamond jewellery and the ostentation of a highly materialistic lifestyle of cars, yachts, beautiful girls, designer clothes, and furs. Related to the 'ghetto fabulous' fashions of earlier decades,[92] it was a product of the ghetto rather than a denial of it. Rap artists vaunted gold and diamonds as rewards for success on a par with crime, that was itself often romanticized in hip hop lyrics. While Jay-Z and others launched fashion labels and spent fortunes making jet-set music videos, only producer and singer P. Diddy (Puff Daddy, aka Sean Combs) embraced every aspect of the movie-star lifestyle from the enormous entourage and summer encampment at St Tropez to Savile Row suits and outsize cigars. As with Beyoncé Knowles, the former member of the girl group Destiny's Child who established herself as a modern urban music performer in the showgirl tradition, his links to a predominantly poor black community withered over time. The glamour of bling was a powerful counter to the corporate control of luxury. But the new money of black entertainment inevitably found designers who were willing to cater to it and

the sector also spawned artists who designed their own ranges of clothes and accessories. Far from being critical, bling was soon absorbed into a trash glamour aesthetic that celebrated the most brash, nouveau riche, and sleazy of styles and accessories. After the death of Versace, the Roman designer Roberto Cavalli emerged as the champion of the latter-day jet-set look. His beautifully made garments featured the boldest of animal prints and were covered with gold motifs.[93] Bling was even cautiously embraced by Armani's youth-oriented Emporio Armani line and especially by the Emporio fragrance Diamonds (which featured an image of Beyoncé on the presentation box).

Glamour at the turn of the century was a complex enchantment that was primarily connected to commercial milieux. The tight linkages between the press, television, merchandising, and fashion produced a striking glamor-ization of sectors once largely immune to its magic. A sport like Formula One had always attracted a high degree of glamour. Not only were races held around the world in alluring locations but the concentration of money, risk, speed, and possible death rendered the spectacle compelling. The racing community, moreover, was populated by young drivers who often enjoyed the fast life away from the track. In contrast to the interwar years, when there were a number of women drivers, Formula One drivers were uniformly male. The presence of models and beauty queens at races and on their arms confirmed a gender hierarchy and made ample use of ornamental femininity to enhance the sexual buzz of the occasion. However, the same could not be said of football which lacked the romantic appeal of individual sports and was strongly rooted to community and place. In the course of the 1990s, this changed as the sport's upper reaches became globalized and footballers' earnings spiralled. An elite of rich, stylish footballers made lucrative spon-sorship deals, were recruited by fashion companies and were turned into all-round celebrities. David Beckham, the England captain from 2000 to 2006, was the most prominent of these. A certain feminization accompanied glamorization, provoking a rift with the unvarnished masculine values that in Britain had long dominated the game.[94] The glamorization of tennis followed conventional feminine lines. It produced a flurry of sponsorship deals and heavy coverage of a minor player, the blonde Russian Anna Kournikova, whose achievements on the court were outweighed by her

good looks. Glamour was a distorting factor in the distribution of rewards that could not be entirely resisted because of the advantages it brought in terms of publicity and income to sport.

More than any other medium, it was the press that provided the key platform to make events and personalities glamorous. Glossy illustrated monthlies and weeklies possessed a unique capacity to distil lives and lifestyles into desirable capsules. They produced narratives of transformation that connected the ordinary and the extraordinary, the unlikely and the possible. As a heroine of the press, Princess Diana was a constant feature of readers' lives, her saga a mega-narrative that provided a screen on to which dreams were projected. But it was not only personalities of her elevated status that received this treatment. Magazines existed at every level and in several varieties to cater for the specific needs of readers of different ages, interests, and income brackets. At the apex of the press pyramid were magazines belonging to the Condé Nast stable. Nearly one hundred years after the Midwesterner Nast had turned *Vogue* into the bible of the American rich, the magazine and its foreign editions occupied a different but not unrelated position in the creation and diffusion of desirable lifestyles. Never merely a fashion magazine, *Vogue* was always a style guide, trend-former, and cultural weathervane. The classic glossy magazine, under the Briton Anna Wintour's direction American *Vogue* maintained a sharp focus on high fashion while not disdaining popular culture. She applied the group editor-in-chief Alexander Liberman's injunction that what was needed was a glitzy mix of celebrity and sensation inspired by the supermarket tabloids.[95]

A similar mix characterized the content of another Condé Nast publication, *Vanity Fair*. With a title taken from Thackeray, *Vanity Fair* was edited in the interwar years by Nast's colleague Frank Crowinshield. It was revived in the 1980s under the editorship of another Briton, Tina Brown, who would later author a gossipy biography of Diana, Princess of Wales. Before ceding the editorship to Graydon Carter in 1992, Brown moulded it as a magazine dedicated to worship at the altar of celebrity, while championing quality writing, investigative journalism, and provocative photography. A typical issue at any time between the 1990s and the present might include a feature on a current celebrity, a reportage on a gruesome crime of the recent past, a picture sequence of groups of media industry professionals, a comment on

politics, and an essay on some semi-forgotten glamour figure. In its pages, criminals, film stars, artists, politicians, heiresses, and tycoons all mingled without discrimination, while gossip took the place of reflection. By the early 1990s, it had become an upmarket version of the *National Inquirer*.[96] Even in its foreign editions, *Vanity Fair* breathed the high-pressure atmosphere of Manhattan, of which it became a social bible, and positioned itself as a guide to the zeitgeist. Although it retained editorial control of content, the magazine was utterly in thrall to show-business celebrity and the industries that sustained it. Its tie to Hollywood was demonstrated by its annual hosting of an exclusive after-Oscar party in Los Angeles. When he briefly worked for the magazine, British journalist Toby Young found that the shine and sparkle of Manhattan social life depended on a public realm in which notoriety had led to 'the disintegration of the self, or, at least, the transformation of the self into something less recognisably human'.[97]

Mario Testino, whose iconic portraits of Princess Diana graced *Vanity Fair* in 1997, was one of the preferred photographers of this age of celebratory celebrity. Like his professional colleagues, he had a keen awareness of heritage. However, only some of his work bore a resemblance to that of other photographers, such as his shots for the 2001 Pirelli calendar, which featured Newtonesque portraits of semi-naked supermodels in luxurious indoor and outdoor settings. In general, he did not explore the darker reaches of the imagination or resort to bizarre personal fantasies like Newton. Nor even did he use light and shade to create pure artistic effects. Rather he developed a sun-drenched style of celebratory photography and, in his many celebrity portraits, he always produced a result that flattered. Every one of them seemed to have been sprinkled with the distilled euphoria of a carnival in Rio. Not by chance, he discovered and (despite the initial scepticism of some fashion editors) launched the big-haired and moderately curvaceous Brazilian model, Gisele Bündchen. He created in his photographs a world that always looked glamorous, sexy, and fun and Gisele, with her expensive and unapproachable air, perfectly encapuslated this.

Testino was disdained by some photographers, such as Lord Snowdon, who snootily referred to 'that ghastly Peruvian'. 'All he does is: "Lovey, lovey, lovey, come on, smile,"' he grumbled.[98] His preoccupation with surfaces led to

accusations that he 'sprinkled fairydust over eveything' and saw the world 'through a haze of Prozac'.[99] He belonged, it was said, to a tradition of sycophantic portraiture that went back to Sargent and to Gainsborough. When an exhibition of his work was held in London, the Communist *Morning Star* newspaper accused him of representing 'an unappealing and superficial world' and of providing 'an overly flattering and wholly dishonest view of what London is like for the majority of its inhabitants'.[100] Without doubt, his work was unmarked by the taint of harsh realism. Testino was a jet-setter who worked all over the globe and his world was one in which everyone was beautiful. One of his famous subjects once said that he brought out people's lightest side. His ostensibly natural pictures made their subjects look beautiful and happy, and situated them in a realm far removed from the mundane. Yet Testino was no simple snapper of beautiful people. To arrive at the euphoric results for which he was famous, he worked hard on his subjects, relaxing them with humour and creating an atmosphere of intimacy. They were made to feel safe and sexy through charm and flattery. Models were 'worked' at length, with a stylist, make-up artist, and hairdresser experimenting with numerous different looks to reach the clearest expression of their beauty.[101] On an assignment, an entire troupe would be present, including, other than the above, three assistants, a hair assistant, a prop stylist and his or her assistant, plus several production people and sometimes art directors and clients.[102]

No less than in the past, glamour was often a matter of men producing idealized or manipulated images of women. However, it would not be correct to conclude that female appearances were simply controlled and dictated by men. In an era in which sensibilities and attitudes had been shaped by feminism and the women's movement's message of empowerment and self-determination, things were more complex. In the so-called post-feminist era, women took over a range of female roles and images that had initially been produced for male pleasure and turned them to their own ends. Madonna was the pioneer here, a powerful entertainment innovator who selected roles from a wide repertoire thus highlighting her capacity for choice and her distance from each. But revivalism was complicated, particularly in a culture in which the perfection not only of the visual image but also of the physical body was highly prized. While some women saw personal

and professional potential in it, the manufacture and distribution of superbly glossed female images had complex implications. These had elements of irony but they were sometimes outweighed by the persistence of the conventional functions of female spectacle. One example was the reinvention of the pin-up, not as a marginal commercial form solely for male consumption, but as a crucial vehicle for the formation and diffusion of ideals of contemporary femininity. The focus on the female body that had always been the key feature of the pin-up was now complemented by a pronounced standardization that was shaped more by the work of 1940s' illustrators such as Varga and Gil Evgren than by creative contemporary photographers. The female flesh of the contemporary pin-up was firm and pneumatic, her appearance perfected, and her curves improbably rounded. The most high-profile exponent of this modern take on retro glamour was Pamela Anderson. The Canadian model and actress first came to prominence in *Baywatch*, the popular television series about Los Angeles county lifeguards that ran from 1989 to 2001. With its slow-motion shots of Anderson, Yasmine Bleeth, and other female lifeguards running in swimsuits, the show won a reputation for its voyeuristic moving pin-ups ('Baywatch Babes'). Its male guards were tanned and muscular, while female ones were mostly slim-hipped and large-breasted. Anderson had appeared in *Playboy* prior to being cast in the series and her public personality would remain that of a centrefold. Hailed in the press as a 'living doll', she played cartoonish characters in several movies. Her surgically enhanced figure, bleached hair, and porn-star lips were admired and attacked in equal measure as signs of a femininity that was a pure projection of male dreams. She was an uncomplicated object of desire who had turned herself into a modern American icon.[103] Other women found that moulding themselves into figures of male desire was remunerative and a sure way to attract publicity. But tragedies also ensued. The early deaths of the French porn star Lolo Ferrari, whose body had been transformed beyond all recognition to resemble an inflatable doll, and former Playmate and millionaire widow Anna Nicole Smith revealed that behind their Barbie-fied facades lay messy lives and serious personal problems.

Other forms of female spectacle flourished in the 1990s as retro entertainments which were embraced by their practitioners as forms of empowerment. Burlesque was one of these. Retro-striptease began in upscale

nightclubs in New York and Los Angeles and then spread more widely. The burlesque museum in Helendale, California also promoted it. The post-feminist mood witnessed a reflowering in new and old guises of a variety of entertainment forms that had been thought defunct. Pole-dancing, lap-dancing, and striptease were the tip of a recrudescent phenomenon of female spectacle that also saw the return not only of pin-ups, but of television hostesses and service industry beauties.[104] The allure of upscale settings was, as so often in the past, employed to disguise a direct or indirect commer-cialization of sex. The revival of burlesque was, however, an exception that was more or less single-handedly thrust into the mainstream by Dita von Teese, an artiste who aimed at an authentic reinvention of a show-business idiom that had died in the 1950s. Born Heather Sweet in Michigan, she reinvented herself as a persona with a unique retro allure. With her trade-mark acts, such as bathing in a Martini glass or emerging from a giant gold compact, she created a magical world of dreams and illusion. With her straight black hair, creamy white skin, blood-red lips, and shapely body, she was as much a photographic icon as a stage performer and in fact her fame derived largely from coverage in *Vanity Fair, Vogue, Playboy,* and other magazines as well as her picture book *Burlesque and the Art of the Teese.*[105] Always exquisitely attired, whether in a sheer evening gown, pretty lingerie, fetish wear, or feathers and sequins, her perfection was that of a plasticated mannequin. She was sex appeal without sex, an icy composition of material goods and dead dreams. Von Teese's mortuary sheen was programmatic. 'I live out my most glamorous fantasies by bringing nostalgic imagery to life,' she declared; adding that she advocated glamour 'Every day. Every minute'.[106] Precisely this lack of warmth and refusal to drop her stage mask gave her act a stunning artificiality. Whereas the theatrical excess of the original burlesque artists was demeaned by the harsh eye of photog-raphy, which revealed their physical imperfections, von Teese deployed the medium as a crucial prop to fantasy. She also revived the kinky style of pin-up art of the 1950s, posing as one of the leading models of that era, Bettie Page.[107]

Contemporary glamour is often a mix of ideas and themes drawn from the past and rendered contemporary by some skilful blending and fashioning.

Although men may sometimes enter the realm of glamour, it is still predominantly feminine—and it is often assumed to be naturally so. The most contemporary forms of glamour are supplied by young starlets like Lindsay Lohan, Nicole Richie, Mischa Barton, and Jessica Simpson. For a whole generation, they are idols who have enviable, if sometimes turbulent, lifestyles. In contrast to the studio-formed and studio-protected stars of the Hollywood golden age, they are continually forced to make choices about their own presentation. It is the task of publicists and other image-makers to 'gift wrap' such personalities and insert them in semi-fictional narratives comprised of simulated events and partially revealed lives.[108] Lohan and company are the sort of people whose wardrobes and red-carpet outfits are masterminded by the leading celebrity stylists. One of these, Rachel Zoe, developed a trademark style suited to younger female stars that was a clever mixture of street style and stage costume, with elements of early Bardot. Tousled hair, cropped jeans, little jackets, gold chains, and stilettos marked her signature day looks while designer wear and occasionally vintage wear was preferred for the evening.[109] Classic bags and jewellery were vital attention-grabbing extras (or 'excessories', as she termed them). She also addressed the issue of weight and was accused of encouraging the stick-thin 'size zero' look among her clients.[110] Like a handful of other stylists, Zoe became a public figure, who appeared on television, commented in magazines and authored a book entitled *Style A to Zoe: The Art of Fashion, Beauty and Everything Glamour.*[111] 'I've always been obsessed with style and glamour,' she told one interviewer,[112] while declaring in her book that 'My kind of glamour combines California ease with New York high life. It favors modern, even if it's vintage. It's browned to a deep Bain de Soleil tan and best served up with a crisp glass of champagne.'[113] She claimed that the key factor in achieving a glamorous identity was to create oneself: 'build, shape, construct, deconstruct, form—all terms conveying a work in process and one that's open to experiment'.[114] 'And it all begins with dreaming,' she added. Zoe saw herself as a fairy godmother, not just to her young stars, but to any woman who dreamed that she could 'create a better reality' for herself and who applied the lessons set out in her book.[115] Glamour was about trying harder and wanting a better life and then enjoying the rewards of designer clothes and a

flashy car. 'There *is* something magical about glamour, but it doesn't just happen with a twitch of the nose or snap of the fingers,' she warned her readers.[116]

The marketed dream of a better life has always required role models, people who illustrated enviable lifestyles and gave them concrete form. In October 2005, *Vanity Fair* featured on its cover a young woman who was neither a movie star, nor a recording artist, nor even a model or a sportswoman, although she would have liked to have been most if not all of these things. Yet she was indisputably glamorous. By late 2005, the 24-year-old Paris Hilton had become 'The Inescapable Paris',[117] an ubiquitous presence on the American party circuit and the latest incarnation of the phenomenon of the heiress that had transfixed the United States from the middle decades of the nineteenth century.[118] Like Barbara Hutton and Doris Duke before her, Hilton was a product of an established commercial dynasty, in her case the Hilton hotel chain founded by her great-grandfather in 1919. Strictly speaking, Paris was not an heiress at all; with both parents living, she had no immediate prospect of inheriting a fortune. What is more, her father Rick was only the sixth child of the second son of Conrad Hilton. Nevertheless, with its base in Beverly Hills, the hotel chain was one of the largest in the world, with over 220 hotels in the United States and worldwide belonging to the group. Rick and his wife Kathy controlled a $70 million fortune and lived between a $6.5 million home in Bel Air, California, a $4 million house in The Hamptons, the Long Island summer playground of America's super-rich for over a century, and a permanent suite at New York's Waldorf-Astoria hotel. The family was rich and self-assured, almost American royalty.[119]

The Hilton family had always courted publicity and no one more than founder Conrad, who died in 1979 at the age of 92. He invited celebrities to hotel openings and mingled with the stars, marrying Zsa Zsa Gabor in 1946. His first son Nick, who died in 1969, was briefly married to Elizabeth Taylor. From an early age Paris featured in magazines, along with her younger sister Nicky. Her teenage years were spent not at any regular school but hopping between hotel suites. For a period, home was the Beverly Hills Hotel. She quickly learned that media interest could be turned to her advantage and she became a professional party girl, appearing in the tabloids at numerous events and learning that she could charge merely for turning up.

Her public personality is that of the carefree and not very bright girl having fun, trying her hand at whatever takes her fancy. Unlike heiresses of other eras, she does not appear to be the product of an inaccessible realm of privilege but rather to be imbued with pop culture. She has appeared in several movies, made a pop record, appeared on the catwalk, and authored a handful of books. 'I love junk food,' she proclaimed in her best-selling *Confessions of an Heiress*,[120] while simultaneously saying, 'I always try to travel first class or private' and turning up her nose at the New York subway ('It literally smells like pee').[121] She offers herself as an ideal for the lazy and unambitious, a young woman whose main interest is herself and her life-style. 'My life is a party,' she announced, while responding to those who had described her as 'Paris Barbie' by asserting that she regarded such a desig-nation as a compliment. 'My total fashion icon!' was how she described the celebrated doll.[122]

Paris Hilton's glamour is bound up with the image of Beverly Hills, that is of a residential district that is both impossibly rich and privileged but also brash and ostentatious.[123] Paris is the pink-clad, super-tanned spoilt child who has a customized Ferrari and a chihuahua named Tinkerbell. Like the Californian 'Valley girls' of the 1980s, whose self-obsession and materialism was satirized in the teen movie *Clueless*, she is vitally concerned with self-fashioning, regularly changing her hair colour and style to suit her mood. She is never very serious and is constantly photographed smiling. Like glamorous figures of the past, she is an astute merchandiser of herself. She has a profitable line of jewellery that bears her name, and also a line of fragrances. Her fame was boosted when she appeared in two series of a television reality show entitled *The Simple Life*, which saw her and her friend Nicole Richie abandon their golden lives for a period on a farm. Like Marie Antoinette at the Petit Trianon, Paris revelled in the artificial simplicity, sure in the knowledge that her real realm was the privileged one she knew best.

Hilton owes much of her fame to the internet and in this sense her glamour is mediated in a way that is original. She became a household name after a former lover released a sex tape on the net that was seen by millions. Indeed, thanks to this, 'Paris Hilton' became one of the most Googled terms. Far from damaging her reputation irretrievably, this scandal

put her on the cover of tabloids and made her into a transgressive figure. As had previously occurred with revelations about Princess Diana's lovers, or the distribution of a similar sex-tape featuring Pamela Anderson and her then husband Tommy Lee, the brush of sleaze added spice to the cocktail of fame. She became a 'bad girl' in the eyes of the popular press, even if her boyfriend had betrayed her trust to release the film. It is noteworthy that her jewellery line is sold mainly through the internet. Hilton straddles celebrity and notoriety, switching between a lifestyle that is a fantasy for millions and real-life falls from grace. In 2007, her imprisonment following driving offences achieved front-page coverage around the world. She was described as 'oozing glamour' even in her jail pictures, while British tabloid the *Sun* described her transfer from a movie awards ceremony to a public penitentiary on the evening her sentence was to begin as a slide 'from glamour to slammer'.[124] After her release, she underwent a brief period of public repentance before resuming her party lifestyle as though nothing had happened.

Paris Hilton is the current embodiment of society's fascination with rich, beautiful, exhibitionist women. Her saleable self corresponds to a widespread desire for self-transformation and vicarious living that continues to fuel dreams of glamour. The modern media work to render everything immediately visible and blend the private with the public. This undercuts the distance usually held to be necessary to cultivate mystery and arouse envy. Yet, in a culture in which consumerism remains a central experience and in which media images are ubiquitous, glamour has not disappeared. The very plurality of enticing images, produced by magazines, the fashion industry, film and television producers, advertisers and public relations companies, fosters an idea of glamour as an accessible ideal, a touch of sparkle that can add something to every life. It is this idea that continues to work its magic even in the niche forums of new media.

CONCLUSION

From its origins, glamour has been associated with dreaming. The yearning for a better, richer, more exciting, and materially lavish life accompanied the development of modern consumerism and fuelled innumerable fantasies and fictions. Glamour took shape as an enticing image of the fabulous life that was lived before the eyes of everyone. Glamour provided the illusion that individual lives could be enhanced and improved by ostensibly magical means. The image was sustained and perpetuated by cultural products and commercial entertainments. It could also be approached through the practices of consumption, since goods carried ideas and suggestions that were as important as their practical uses. The power of transformation lay with anyone or anything that could persuade an audience that they or it possessed it.

Glamour was born and took shape in an age in which structured inequalities were in decline and were being replaced by ideas of formal equality combined with flexible economic inequalities. The industrial economy was producing consumer goods and the means of communication were providing new and powerful platforms for personalities and channels for information and

entertainment. For most of the period covered in this book there was a gulf between the types of lifestyles associated with glamour and the modest and contained lives of the public. Glamour was experienced mainly in the press, novels, at the theatre, and though visual ephemera. Those living outside capital cities only occasionally might glimpse it with their own eyes. Its fascination depended on the glorious enviability of images that were far removed from the everyday experience of people whose possibilities for surplus spending, self-expression, travel, and sex were limited. Its appeal was most powerful to those who lay outside the realm of privilege and success.

As the consumption economy and the mass media developed, so the spectacle became more systematic: shop windows, posters, commercial publicity stunts, and professional performance gave the world of glamour a stable and predictable form. Cosmetics, fashion goods, accessories, and other goods that could be worn or carried fuelled the imagination. They were especially suggestive since they bore directly on personal identity and promised the immediate realization of a transformation of the self into something different and better.

The most glamorous figures of the past two hundred years have not been the hereditary rich or legitimate holders of power. They have been outsiders, up-starts, social climbers, and parvenus. Actors, socialites, politicians, and celebrities who have come up from the lower social reaches are always the most effective bearers of glamour. This is because they have a popular touch. They have a narrative that arouses not deference or resentment but admiration or envy. The rise from nothing is a powerful story that not only provokes sympathy and identification, it also reinforces the crucial promise of self-transformation. The pioneers of glamour were figures such as Napoleon and Byron, two men who profoundly upset the political and social order of their day and who shaped the mental horizons of the age. They were outsiders who dazzled their contemporaries with their achievements and who weaved myths around them-selves. They were eye-catching and fascinating figures who inhabited the realm of the imagination while also giving a solid rooting to the idea of personal transformation.

Glamour is always theatrical; it is a performance or parade that has no meaning unless it is widely viewed. Indeed, it is only through the perception

and reception of visual effects that it comes into existence. For this reason, it is rarely subtle or complex. Glamour is an image that attracts attention and arouses envy by mobilizing desirable qualities including beauty, wealth, movement, leisure, fame, and sex. Bright colours, ostentatious signs of wealth, showy beauty, visible suggestions of sex are required to reach a mass public. There are, of course, differentiations internal to glamour. Certain qualities may be played down at times for reasons of variety or because of the particular nature of a target audience. A less overtly sexualized and ostentatious image may work better with urban middle-class audiences, for example, while working-class and rural publics may prefer a bolder approach. Further modulations cater to ethnic minorities and to gay and lesbian audiences. But, broadly speaking, glamour is always a fusion—if often a problematic one—of class and sleaze, of high style and lowly appeals. It is not conventional or, usually, institutional. Rather it works as a vaguely transgressive explosion of visual effects and publicity-seeking fireworks.

Mainly, it is the image of a category of big spenders and high consumers organized around these values that is the social bearer of glamour. Directly or indirectly, explicitly or implicitly, the attributes of this elite are made to appear imitable. This occurs in a number of ways. For example, its patterns of recruitment, in theory, are open. To have a chance of joining it, it is not necessary to be rich or well-born, since anyone of the right age and physical characteristics can be spotted by a model agency or signed up by a movie director. In addition, glamour is not a natural attribute but a manufactured one. Because image is so important in glamour, it has always required mediators. Painters, interior decorators, architects, fashion designers, novelists, photographers, film-makers, journalists, publicists, and stylists have been crucial in fashioning desirable images and glittering facades with which the rich, the famous, and the beautiful have seduced their fellow citizens. The many techniques that can contribute to the construction of a glamorous persona are publicized and their practitioners often well known. In more recent times, many have come from outside the elite and precisely this has helped them create images and effects for popular consumption. They understood what appealed, what was comprehensible, and what dazzled, and also what was best disguised or kept concealed. Some of them also exploited their talents commercially and marketed to the public the promise that glamour was within the reach of anyone.

Although numerous men over the last two hundred years have entered the realm of glamour, the vast majority of figures of glamour have been women. The language of glamour, moreover, has been configured largely in feminine terms. It speaks mainly to women, and it addresses preoccupations about appearance more or less exclusively that are most associated with them. Even today the power of glamour is still widely regarded as a resource available to women. In an advice book, seasoned journalist Lucia van der Post praised its usefulness. 'Never underestimate the power of glamour. It's life-enhancing and even the plainest woman can be glamorous,' she enthused, adding, 'It's quite different from beauty. It depends a lot on a sense of personal style and some inner confidence, which isn't easy to come by but can be cultivated.'[1] No matter what her age, she claimed, any woman could boost her self-esteem and wow her friends by means of a new haircut, jewellery, sexy clothes, or perfume. The emphasis on the feminine in glamour occurs because of the particular distribution of gender roles in bourgeois society, but it is related to the structure of the consumption economy. In the course of this book a whole range of female figures has been considered, from Marie Antoinette to Paris Hilton. Broadly speaking, the main figures of glamour have been identified as the socially prominent, entertainers, and what might be termed the professionally decorative. Some women, such as the nineteenth-century courtesans, bridged all three categories while others have been firmly confined to one. To be glamorous, the women in them had to mobilize qualities additional to simple membership. For example, many female members of the aristocracy and upper bourgeoisie were not glamorous even though they enjoyed membership of high society. Despite their wealth and status, they lacked visibility and the qualities of beauty and sex appeal that were required to arouse the interest and identification of the mass of the people.

Over the period of this book, one important female figure, closely tied to glamour, has risen and fallen. The femme fatale took shape in the nineteenth century as a powerful, exotic woman, irresistible, and a seductive enchantress. With roots in folklore and myth dating back to the ancient world, she was the personification of evil, a merciless destroyer of men. In decadent culture, this figure was tied to fashion and the arts. It inspired powerful roles for actresses and was later taken up by cinema, especially in film noir.

Although the cultural products in which they appeared in some cases live on, and the femme fatale still resonates, for example in neo-noir films and television melodrama, essentially this figure belongs to the past. This is not due solely to socio-economic change and to women's emancipation but also to the role of mass communications in merging—or partially confusing—once separate male and female spheres. This process, which has been linked especially to television,[2] undercut the mystery that each sex held for the other and heralded the demise of ideas of subversive sexual power. By the same token, the compelling Byronic hero, as an unsettling and romantic masculine ideal, also ceased to be contemporary.

This development could be interpreted as heralding the demise of glamour as we have known it. In reality, glamour is evolving rather than declining, on account of its close links to the development of consumption and the media. The connection between glamour and the cinema stems from factors concerning the medium itself and factors relating to its audience. First, cinema developed as a popular urban entertainment that took over the appeals of theatre and was closely related to the experience of consumption. It was the first medium whose products were consumed simultaneously by vast numbers of people. It also reached its heyday during the Depression, when its dreams provided consolation and escape to masses of impoverished people. This function was performed especially by American cinema, which emerged in the years after the First World War as the most powerful film industry in the world. The United States was a country in which the ideal of self-expression and self-transformation was culturally enshrined. Hollywood cinema contributed decisively to the development of consumerism, first in the United States and then in Western Europe. The American model of mass consumption provided images, techniques, and methods that shaped European consumption from the 1920s but most especially in the years after the Second World War. After the invention of sound recording, the stars of the American film industry became more realistic. No longer exotic and extreme, they became more commonplace ideals, perfect projections of everyman and everywoman. The wider availability of goods gave people the chance to introduce elements of glamour into their own lives. Later, television and other electronic media, combined with the press, further generalized these opportunities.

One of the themes of this book has been the dialectic between European and American ideas of glamour. The rise of the United States to the position of leading economy in the world from the 1880s onwards placed it at the forefront of innovations in technology, consumption, and communication. However, American glamour was never free-standing. It constantly relied on European inputs and supports, be it the past treasures appropriated by millionaires or the contribution of European actors, directors, technicians, and costume designers to Hollywood. What the US has offered has been a sense of the mass market and populism. But the persistence of European aspects is crucial. What Europe contributed was history, monarchy, aristocracy, and a repertoire of visual distinction and sexual allure. The simple fact of the spelling of the word is indicative. Glamour is the only English word ending '-our' which has not consistently been spelt in American English with an '-or' ending (like labor, harbor, and so on). Only in the middle decades of the twentieth century did Americans spell the word more frequently as 'glamor'. However, even then it was by no means universal, and the Condé Nast magazine *Glamour* (originally *Glamour of Hollywood*), founded in 1939, was always spelt the European way. Up to the 1930s both versions appeared, with 'glamour' probably being most common. 'Glamour' became once more standard American spelling in the 1990s.[3]

Glamour today is, as it always has been, a diffuse and seductive aura that envelops and enhances personalities, places, and objects. While it is widespread, only some of those in the public eye embrace this aura fully and endeavour to shape their public image through it. One figure who explicitly opted to define herself in relation to the classic appeals of glamour is Victoria Beckham. The former member of the Spice Girls pop group, whose footballer husband David captained the England football team for six years from 2000, turned herself in the early twenty-first century into one of the most visible and envied women in Britain. She pursued not only a musical career but a strategy of celebrity that was multifaceted. Although she was closely associated with fashion, she was not presented as a style innovator. She was, *Hello!* magazine affirmed, something more powerful and lucrative: 'the supreme role model for girls who like their fashion flash and their grooming full on. She represents the millions of women and girls who are interested in fashion, but only if it's body clinging, tan revealing,

accessorised with giant sunglasses, three inch heels and a handbag that costs three figures—the ones that always want an extra half-an-inch, whether it's tighter or higher.'[4] Victoria Beckham moulded herself into an immaculate super-consumer and merchandiser of her own glossy image, positioning herself as an intermediary between designer style and the girl in the street. In this capacity, she not only turned her lifestyle into spectacle but also proposed herself as an example to others. When she moved to Los Angeles in July 2007, following her husband's decision to sign a record-breaking contract to play for LA Galaxy, the event was hailed as a new stage in the marketing of the couple. Victoria wrote a style book full of practical advice in which she was presented as living out a glamorous fantasy. She shared with readers the dreams she had cultivated as a girl and pointed to the inspiration she drew from 'the fashion icons of the last century: Grace Kelly, Jackie Onassis and my image-for-all-seasons, Audrey Hepburn'.[5] The key to her persona is the classic glamorous one of exclusivity combined with accessibility; through her, millions could imagine themselves leading a glamorous life, mingling with film stars, and married to a top footballer. In contrast to the model Kate Moss, who also acted as a style example for millions of teenage girls and young women in Britain, Beckham exhibited a consumption-driven personal life and never discarded the fantasy persona she had created. Unlike Moss, she did not step in and out of the world of fashion and publicity at will but blended her public and private personae.

Victoria Beckham first emerged from a synergy between the press, pop music, and fashion that was fast-moving and which continually produced young women with a similar profile. After the Spice Girls, girl bands flourished, propelling their members with almost assembly-line regularity from obscurity to widespread recognition. All of them paid great attention to grooming and image. 'Four years ago', OK magazine drooled in November 2006, 'Cheryl Tweedy was a wide-eyed wannabe from Newcastle, who could only dream of living a showbiz lifestyle and marrying a footballer. But now the ambitious glamourpuss will be spending her first ever Christmas as a wife and enjoying the spoils from the multi-platinum sales of Girls Aloud's greatest hits album.'[6] In these two sentences, the key to her rise was identified with three qualities: her ambition, her dreaming of a showbiz lifestyle, and her pleasing, glossy appearance.

The techniques for achieving glamour are widely propagated. Books like those by Victoria Beckham or stylist Rachel Zoe, discussed in Chapter 11, offer advice on how everyday normal lives can be glamorized, how red carpet moments can become part of the texture of ordinary lives. They point to discipline, grooming, self-presentation, ambition, and shopping. Similar qualities are exhibited by numerous women who act as role models for the young. A television presenter, actress, and model with the manner and figure of an old-time pin-up, Kelly Brook modelled in a number of lingerie and swimwear campaigns before launching her own line in 2006. Having made it into the movies and secured a Hollywood film star fiancé, she put her name to a lifestyle guide aimed at aiding young women to discover their 'inner pin-up'. In this, she claimed that her path to success began with dreaming. She recalled how, as a girl, she had dressed up in frilly pink or lilac items to act out her dreams. 'In those...numbers,' she revealed, 'I would be transported to another world: a place where women were glamorous creatures who wore pretty frocks with cherry-red lipstick and high heels. My fantasy world was a long, long way from the small town where I grew up in Kent, but I never let that deter me; I always aspired to live a more glamorous life.'[7] Like Beckham, she found inspiration in the past. In her book, she presented a selection of her own favourites that included Bettie Page, Ava Gardner, Gina Lollobrigida, Sophia Loren, Marilyn Monroe, and Brigitte Bardot.[8]

Glamour links the rare, the remote, and the desirable with the accessible. It connects the girl from Kent with the Olympus of Hollywood. Dreams are fuelled by examples, by fictions, by consumer goods, and by entertainments. It is a powerful sales tool that is mobilized by stores, clubs, advertisers, restaurants, and travel companies. As such, it has become a part of the texture of everyday life. Once, glamour was a remote fantasy that fuelled daydreams and aspirations. For most people, glamour today is an escape, less a remote fantasy than a temporary experience that can enrich the mundane. In autumn 2007 the British department store chain Debenhams launched the 'Star' range created by fashion designer Julien Macdonald. Among the items belonging to it were women's and girls' clothes, and home decorations including vases, candlesticks, cushions. Each item was black and shiny, sparkly and silver, or covered in an animal print. 'Julien Macdonald is renowned for his high glamour designer

collections and has become synonymous with celebrity première dressing,' the store's advertising announced, before reminding customers of his period as creative director at the couture house of Givenchy and his regular awards at London fashion week. 'Star', it proclaimed, is 'a collection that reflects his ability as a maestro of glitz and glam.' By means of this designer touch, a simple object such as a vase, on sale in high street stores in provincial cities, was turned into a fragment of a larger world of celebrities, style, and sex appeal. By mentioning Macdonald's brief stint at Givenchy, a connection with Parisian haute couture was evoked, while the reference to 'glitz and glam' suggested a knowing irony. By buying into the 'Star' range, customers were not turning themselves into stars, just adding a touch of sparkle to their lives.

Goods for home decoration or personal embellishment do not have to be acquired ready-made. For those of a more creative bent, Ilene Branowitz's craft manual *Create Your Own Bling: Add Glamour to Your Favourite Accessories* took glamour out of the hands of the professionals and returned it to the dreaming public.[9] A similar work, *Crowns and Tiaras: Add a Little Sparkle, Glitter and Glamour to Every Day* by Kerry Judd and Danyel Montecinos, whose premiss was simply 'every woman is a queen', contained thirty-five handicraft projects 'to organise a proper coronation'.[10] The dream of a better, more fabulous life thus turned into a do-it-yourself project for a rainy afternoon. In a real sense, such books mark an end-point of an entire cycle of glamour that began with the fabulous fantasies of Scott and Byron.

In this book, we have seen how the fabulous world of the imagination first prospered at a particular moment in history when social, political, and economic relations were in flux. Later, the transformative power of glamour was harnessed by commercial enterprises and cultural industries. Over the whole of its history, it involved large numbers of people, for whom it was not a technique for reinforcing hierarchy but rather a supremely enviable demonstration of how life could be lived by those who were rich, beautiful, sexy, and mobile. Glamour fired the imagination and boosted aspirations, while also offering industries the opportunity to produce fragments of glamorous experience for those whose aspirations remained unfulfilled. Although glamour is ever less elusive, the insatiable desire for it sustains it and reinforces its driving role in modern consumption.

NOTES

INTRODUCTION

1. Sali Löbel, *Glamour and How to Achieve It* (London: Hutchinson, 1938), 11.

2. Andrea Stuart, *Showgirls* (London: Cape, 1996), 171.

3. *Interview* (Mar. 1997), page unnumbered.

4. Löbel, *Glamour*, 14.

5. This definition follows the ideas set out in Réka C. V. Buckley and Stephen Gundle, 'Flash Trash: Gianni Versace and the Theory and Practice of Glamour', in Stella Bruzzi and Pamela Church Gibson (eds.), *Fashion Cultures: Theories, Explorations and Analysis* (London: Routledge, 2000), 332–6, and Stephen Gundle and Clino T. Castelli, *The Glamour System* (Basingstoke: Palgrave, 2006), 8–9.

6. By contrast to ideas of glamour that situate it even in the remote past, Joseph Rosa locates its origins in Hollywood cinema and the industrial design of the 1930s. While, in a memorable phrase, he notes that, 'historically, glamour has figured as the ugly stepsister to elegance', he has little to say about its existence before 1945. See Rosa, 'Introduction: Fabricating Affluence', in Rosa (ed.) *Glamour: Fashion + Industrial Design + Architecture* (San Francisco: San Francisco Museum of Modern Art, and New Haven and London: Yale University Press, 2005), 16–17.

7. My view differs in this respect from those of Ross McKibbin, *Classes and Cultures: England, 1918–1951* (Oxford: Oxford University Press, 1998), 43 and Maureen E. Montgomery, *Displaying Women: Spectacles of Leisure in Edith Wharton's New York* (New York: Routledge, 1998), 122.

8. See Colin Campbell, *The Romantic Ethic and the Spirit of Modern Consumerism* (Oxford: Blackwell, 1987).

9. On the dangers and fears of anonymous urban social encounters, see Karen Halttunen, *Confidence Men and Painted Women: A Study of Middle-Class Culture in America, 1830–1870* (New Haven and London: Yale University Press, 1982).

10. Paolo Capuzzo, *Culture del consumo* (Bologna: Il Mulino, 2006), 188–95.

11. Jürgen Habermas, *The Structural Transformation of the Public Sphere* (1962; Cambridge, Mass.: MIT Press, 2001), 195.

12. See Sophie Gilmartin, *Ancestry and Narrative in Nineteenth Century British Literature: Blood Relations from Edgeworth to Hardy* (Cambridge: Cambridge University Press, 1998), 115–18.

13. See Lucy Riall, *Garibaldi: Invention of a Hero* (New Haven and London: Yale University Press, 2007), 194–203.

14. See Arthur Marwick, *Beauty in History: Society, Politics and Personal Appearance, c.1500 to the Present* (London: Thames and Hudson, 1988).

15. Abigail Solomon-Godeau, 'The Other Side of Venus: The Visual Economy of Feminine Display', in Victoria de Grazia and Ellen Furlough (eds.), *The Sex of Things: Gender and Consumption in Historical Perspective* (Berkeley and Los Angeles: University of California Press, 1996), 113.

16. On the general aspects of this, see Daniel J. Boorstin, *The Image* (London: Weidenfeld and Nicolson, 1962).

17. Marilyn Bender, *The Beautiful People* (New York: Coward-McCann, 1967), 54.

18. See Peter Bailey, 'Parasexuality and Glamour: The Victorian Barmaid as Cultural Prototype', *Gender and History*, 25 (1990), 148–72, at 152.

19. Clive Scott, *The Spoken Image: Photography and Language* (London: Reaktion, 1999), 156. See also Réka C. V. Buckley and Stephen Gundle, 'Fashion and Glamour', in Nicola White and Ian Griffiths (eds.), *The Fashion Business: Theory, Practice, Image* (Oxford: Berg, 2000), 37–54.

20. For a full analysis of the role of colours and particular visual effects in glamour, see part II of Gundle and Castelli, *Glamour System*. On account of the exhaustive account contained in that volume, little specific attention is given to these aspects of glamour in the present book.

21. Paul Staheli, 'The Making of a Glamour Queen', *Live Wire* (Aug.–Sept. 1996), 22.

CHAPTER 1

1. Edmund Burke, *A Philosophical Enquiry into the Origins of Our Ideas of the Sublime and the Beautiful*, ed. James T. Boulton (1958; Oxford: Blackwell, 1987), 78. The lesser but related phenomenon of splendour was held to be distinct in the Middle Ages. It marked the domestic riches of wealthy merchants and traders rather than the public exhibitions of princes. See Evelyn Welch, 'Public Magnificence and Private Display: Giovanni Pontano's *De Splendore* (1490) and the Domestic Arts', *Journal of Design History*, 15/4 (2002), 211–21.

2. See Paul Roberts, 'Sir Walter Scott's Contributions to the English Vocabulary', *PMLA* 68/1 (Mar. 1953), 189–210, at 204.

3. See Richard Wilkinson, *Louis XIV* (Abingdon: Routledge, 2007), 88–9.

4. John Adamson, 'The Making of the Ancien Régime Court, 1500–1700', in Adamson (ed.), *The Princely Courts of Europe: Rituals, Politics and Culture under the Ancien Régime, 1500–1750* (London: Weidenfeld & Nicolson, 1999), 11.

5. Jonathan Dewald, *The European Nobility, 1400–1800* (Cambridge: Cambridge University Press, 1996), 122–34, at 133.

6. Joan DeJean, *The Essence of Style: How the French Invented High Fashion, Fine Food, Chic Cafes, Style, Sophistication and Glamour* (New York: The Free Press, 2005), 2.

7. Adamson, 'Making of the Ancien Régime Court', 34–5. He notes that Louis XIV was himself probably inspired by the court of his uncle Philip IV of Spain.

8. Ibid. 34.

9. Marcello Fantoni, 'The Courts of the Medici, 1532–1737', in Adamson (ed.), *Princely Courts of Europe*, 272.

10. John Adamson, 'The Tudor and Stuart Courts, 1509–1714', in Adamson (ed.), *Princely Courts of Europe*, 101.

11. G. P. Gooch, *Louis XV: The Monarchy in Decline* (London: Longman, Green, 1956), pp. vii and ix.

12. For a discussion of this issue, see Antonia Fraser, *Marie Antoinette: The Journey* (2001; London: Phoenix, 2002), 160.

13. Evelyn Farr, *Before the Deluge: Parisian Society in the Reign of Louis XVI* (London: Peter Own, 1994), 45.

14. Stefan Zweig, *Marie Antoinette: The Portrait of an Average Woman* (1933; London: Atrium, 1988), p. xi.

15. See Nancy Mitford, *Madame de Pompadour* (1954; London; Reprint Society, 1955), 83–4, 117.

16. Philip Mansel, *The Court of France, 1789–1830* (Cambridge: Cambridge University Press, 1988), 6.

17. Émile Langlade, *Rose Bertin: The Creator of Fashion at the Court of Marie Antoinette* (adapted from the French by Angelo S. Rappoport) (London: John Lang, 1913), 36–7.

18. Fraser, *Marie Antoinette*, 143.

19. Ibid. 143–5.

20. Ibid. 145.

21. Ibid. 146.

22. Zweig, *Marie Antoinette*, 92.

23. Ibid.

24. Fraser, *Marie Antoinette*, 130–1.

25. Edmund Burke, *Reflections on the Revolution in France* (1790), ed. J. C. D. Clark (Stanford: Stanford University Press, 2001), 237–8.

26. See Amanda Foreman, *Georgiana: Duchess of Devonshire* (London: HarperCollins, 1998), 40–1; Paula Byrne, *Perdita: The Life of Mary Robinson* (London: Harper Perennial, 2005), 291.

27. Caroline Weber, *Queen of Fashion: What Marie Antoinette Wore to the Revolution* (London: Aurum, 2007), 6.

28. As queen, Marie Antoinette occupied an unusual position. In the past, royal mistresses had been the object of hostility on the part of those who resented heavy taxation. Their legendary extravagance and irregular position made them easy scapegoats. Because Louis XVI did not have a mistress, Marie Antoinette came to occupy in the public mind the position not only of queen consort but also of mistress. Not unlike Louis XV's Pompadour and Du Barry, she became the whipping boy of an impoverished and hungry population. In her day, Madame de Pompadour had been the object of vitriolic attacks on her spending and her morality. The same terms were used to hit at the foreign-born queen, who was widely characterized by her critics as spoilt and debauched.

29. Burke, *Reflections on the Revolution in France*, 239–40.

30. Alan Forest, 'Propaganda and Legitimation of Power in Napoleonic France', *French History*, 18/4 (2004), 426–45, at 436.

31. Olivier Bernier (ed.), *At the Court of Napoleon: Memoirs of the Duchesse d'Abrantès* (Gloucestershire: Windrush Press, 1991) (memoirs first published, 1895), 287.

32. Philip Mansel, *The Eagle in Splendour: Napoleon I and his Court* (London: George Philip, 1987), 10.

33. Mansel, *Court of France*, 49.

34. Luigi Salvatorelli, *Leggenda e realtà di Napoleone* (1945; Turin: UTET, 2007), 73.

35. Mansel, *Eagle in Splendour*, 11.

36. David O'Brien, 'Antonio Canova's *Napoleon as Mars the Peacemaker* and the Limits of Imperial Portraiture', *French History*, 18/4 (2004), 354–78, at 376.

37. Mansel, *Court of France*, 59 and 68.

38. Salvatorelli, *Leggenda e realtà di Napoleone*, 20.

39. Louis Madelin, 'La Cour de Napoléon', *Les Œuvres libres*, NS 14 (1949), 3–42, at 32.

40. Bernier (ed.), *At the Court of Napoleon*, 293.

41. Ibid. 26.

42. Quoted ibid. 11.

43. Carolly Erickson, *Josephine: A Life of the Empress* (1998; London: Robson, 2004), 119.

44. Ibid. 118–19, 136–7.

45. Ibid. 254–5.

46. On the French Revolutionaries' attitudes to women, see Joan Landes, *Visualizing the Nation: Gender, Representation, and Revolution in Eighteenth-Century France* (Ithaca, NY: Cornell University Press, 2001).

47. Burke, *Reflections on the Revolution in France*, 240.

48. See G. M. Treveleyan, *English Social History: A Survey of Six Centuries—Chaucer to Queen Victoria* (1944; London: Longman, 1973), 492–3. For a more recent discussion, see Linda Colley, *Britons: Forging the Nation, 1707–1837* (London: Pimlico, 1994).

49. See Simon Bainbridge, *Napoleon and English Romanticism* (Cambridge: Cambridge University Press, 1995), 1.

50. Ibid. 13.

51. See ibid. 125–7 for this and the following sentences.

52. Ibid. 111–12. On Hazlitt, see ibid. 203.

53. A. N. Wilson, *A Life of Walter Scott: The Laird of Abbotsford* (London: Mandarin, 1996), 4.

54. Ibid. 147. See also Donald Sassoon, *The Culture of the Europeans: From 1800 to the Present* (London: HarperCollins, 2006), 134–40.

55. On the development of the market for fiction, see Sassoon, *Culture of the Europeans* pt. I, esp. pp. 41–53.

56. Thomas Carlyle, *Critical and Miscellaneous Essays*, iii (1839; London: Chapman, 1894), 169.

57. See Sassoon, *Culture of the Europeans*, 147.

58. Roberts, 'Sir Walter Scott's Contributions', 204–5.

59. According to Walter Skeat, editor of the *Etymological Dictionary of the English Language* (Oxford: Clarendon Press, 1924).

60. *An Etymological Dictionary of the Scottish Language* (Paisley: Alexander Gardner, 1879–87).

61. For an overview of dictionary definitions of glamour, see Stephen Gundle and Clino T. Castelli, *The Glamour System* (Basingstoke: Palgrave, 2006), 2–4.

62. *The Lay of the Last Minstrel* sold 44,000 copies, a figure that was without precedent in the history of British poetry.

63. *The Lay of the Last Minstrel*, canto iii, stanza 9, ll. 11–18.

64. Scott often included notes to explain the unusual terms he used and glamour was no exception. In a note to the text, he wrote: 'Glamour, in the legends of Scottish superstitions, means the magic power of imposing on the eyesight of the spectator, so that the appearance of a subject should be totally different from the reality. The art of glamour, or other fascination, was anciently a principal part of the skill of the *jongleur*, or juggler, whose tricks formed part of the amusement of a Gothic castle.' See Scott, *The Lay of the Last Minstrel—With Ballads, Songs, and Miscellaneous* (New York: C. S. Francis & Co., 1845), 222–5.

65. Sir Walter Scott, *Life of Napoleon Bonaparte* (1827; Edinburgh: Black 1878, 2 vols.).

66. See Sudhir Hazareesingh, *The Legend of Napoleon* (London: Granta, 2004).

67. T. Carlyle, *On Heroes, Hero-Worship, and the Heroic in History* (1841; London: Ginn and Co., 1901), 277.

68. Salvatorelli, *Leggenda e realtà di Napoleone*, 8 and 119.

69. Canto XI. 55. See Bainbridge, *English Romanticism*, 2.

70. Canto III. 36. See Bainbridge, *English Romanticism*, 9.

71. Fiona MacCarthy, *Byron: Life and Legend* (2002; London: Faber and Faber, 2003), p. x.

72. Like his rival, Byron adopted an aloofly dismissive pose towards the book business. See Peter W. Graham, 'Byron and the Business of Publishing', in Drummond Bone (ed.), *The Cambridge Companion to Byron* (Cambridge: Cambridge University Press, 2004), 27.

73. MacCarthy, *Byron*, 158.

74. Ibid. 160.

75. Byron had little time for the age of chivalry and what he called 'monstrous medieval mummeries'. Quoted in Marc Girouard, *The Return to Camelot: Chivalry and the English Gentleman* (New Haven: Yale University Press, 1981), 33.

76. Peter Cochran, 'Introduction', in Cochran (ed.), *Byron and Orientalism* (Newcastle: Cambridge Scholars Press, 2006), 2–3.

77. Particularly informative on this is Paolo Capuzzo, *Culture del consumo* (Bologna: Il Mulino, 2006), pt. I.

78. Ibid. 8–9.

79. Frances Wilson, 'Introduction', in Wilson (ed.), *Byromania: Portraits of the Artist in Nineteenth and Twentieth-Century Culture* (Basingstoke: Macmillan, 1999), 5.

80. Ibid. 4.

81. Jerome Christensen, *Lord Byron's Strength: Romantic Writing and Commercial Society* (Baltimore: Johns Hopkins University Press, 1993), p. xvi.

82. Ibid. 13, 192.

83. MacCarthy, *Byron*, 290.

84. On this development, see G. M. Trevelyan's classic *English Social History: A Survey of Six Centuries* (1942; London: Book Club Associates, 1973), 487–8.

85. Christine Kenyon Jones, 'Fantasy and Transfiguration: Byron and His Portraits', in Wilson (ed.), *Byromania*, 109.

86. J.-G. Lockhart, *The Life of Sir Walter Scott, Bart.* (abridged from the larger work) (Edinburgh: Adam & Charles, 1871), 537 and 582.

87. Wilson, *Life of Walter Scott*, 150–4.

88. Sassoon also stresses the technique Scott had for making his readers identify with his heroes. See *Culture of the Europeans*, 149.

89. Sir Walter Scott, *Ivanhoe* (1819; Harmondsworth: Penguin, 1994), 32 and 41.

90. See Michel Pastoureau, *Une histoire symbolique du Moyen Age occidental* (Paris: Seuil, 2004), 332–3.

91. On the origins of the imaginative hedonism of the middle class, see Colin Campbell, *The Romantic Ethic and the Spirit of Modern Consumerism* (Oxford: Blackwell, 1987).

92. In an essay in which he compared Scott, Racine, and Shakespeare, Hazlitt found the Scottish author to be more of a compiler than an inventer. His talent, he claimed, consisted 'in bringing the materials together and leaving them to produce their own effect'. 'Sir Walter's forte', he added, 'is in the richness and variety of his materials, and Shakespeare's in the working them up.' Whereas the latter was dramatic, Scott was descriptive; his focus was not the soul but rather 'the external imagery or machinery of passion'. William Hazlitt, 'Scott, Racine, and Shakespeare', in Hazlitt, *The Plain Speaker* (London: George Bell, 1903), 478–9, 484, 487.

93. William Hazlitt, *The Spirit of the Age 1825* (Menston: Scolar Press, 1971), 147.

94. Andrew Elfenbein, 'Byron: Gender and Sexuality' in Bone (ed.), *Cambridge Companion*, 61.

95. Ibid.

96. Quoted in Lockhart, *The Life of Sir Walter Scott*, ii. 397. Quoted in Roberts, 'Sir Walter Scott's Contributions', 209.

97. Trevelyan, *English Social History*, 488.

98. W. M. Thackeray, *Rebecca and Rowena* (1850; London: Hesperus, 2002), 5. This view was echoed by Victor Hugo. See Pastoureau, *Une histoire symbolique*, 332.

99. Scott, *Ivanhoe*, 299.

100. The seductiveness of Rebecca was a product of a blend of her beauty and also her elaborate clothing and jewellery. 'Her form was exquisitely symmetrical, and was shown to advantage by a sort of Eastern dress, which she wore according to the fashion of the females of her nation,' Scott wrote. 'Her turban of yellow silk suited well with the darkness of her complexion. The brilliancy of her eyes, the superb arch of her eyebrows, her well-formed aquiline nose, her teeth as white as pearl, and the profusion of her sable tresses, which, each arranged in its own little spiral of twisted curls, fell down upon as much of a lovely neck and bosom as a simarre of the richest Persian silk, exhibiting flowers in their natural colours embossed upon a purple background, permitted to be visible.' The reader is told nothing of Rowena's physique but Rebecca's womanly curves are subtly evoked. Sex is absent but the suggestion of sexual allure is not. 'Of the golden and pearl-studded clasps which closed her vest from the throat to the waist, the three uppermost were lest unfastened on account of the heat,' the novelist continued; and this 'enlarged the prospect to which we allude. A diamond necklace, with pendants of inestimable value, were by this means also made more conspicuous.' Rebecca is placed outside the conventional boundaries of good taste. 'The feather of an ostrich, fastened in her turban by an agraffe set with brilliants, was another distinction of the beautiful Jewess', Scott noted, that was 'scoffed and sneered at by the proud dames who sat above her.' However, the scoffing of these ladies conceals their secret envy. Scott, *Ivanhoe*, 82–3.

101. Daniel Defoe, *Roxana* (1724; Harmondsworth: Penguin, 1987). For the dance and Roxana's dress, see pp. 219–22. See Ros Ballanter, 'Performing *Roxana*: The Oriental Woman as the Sign of Luxury in Eighteenth-century Fictions', in Maxine Berg and Elizabeth Eger (eds.), *Luxury in the Eighteenth Century: Debates, Desires and Delectable Goods* (Basingstoke: Palgrave, 2003), 165–77.

102. Lockhart, *Life of Sir Walter Scott*, 786.

103. Captain Gronow, *His Reminiscences of Regency and Victorian Life 1810–1860*, ed. Christopher Hibbert (1862–6; London: Kyle Cathrie 1991), 21.

104. The gathering at St Peter's Field in Manchester in August 1819 was charged by the cavalry and resulted in eleven deaths and four hundred injured, among whom there were many women and children. This brutal action, which became known—in mock-ironic reference to the battle of Waterloo—as the Peterloo massacre, signalled the inability of the forces of order to come to terms with political reform and popular aspirations.

105. Gronow, *His Reminiscences*, 30.

106. Trevelyan, *English Social History*, 492.

107. Steven Parissien, *George IV: The Grand Entertainment* (London: John Murray, 2001).

108. Ibid. 304.

109. On the court of Elizabeth I, see R. Malcolm Smuts, 'Art and the Material Culture of Majesty in Early Stuart England', in Smuts (ed.), *The Stuart Court and Europe: Essays in Politics and Political Culture* (Cambridge: Cambridge University Press, 1996). *Kenilworth* was published in Jan. 1821 and the most magnificent segment of the novel recounts the visit of Queen Elizabeth to Kenilworth Castle. Scott evokes the celebrated splendour of the Elizabethan court in descriptions of the nobles and the pageantry that surround the visit. The queen herself is the central figure and is 'arrayed in the most splendid manner, and blazing with jewels'. Leicester, the host, 'glittered like a gold image with jewels and cloth of gold'. An equestrian cavalcade, music, torches, and floating pageants with an Arthurian theme provide a spectacle of unique beauty and suggestiveness. Together, these elements enact a 'work of enchantment' on all who witness it.

110. Of relevance here is David Cannadine, 'The Context, Performace and Meaning of Ritual: The British Monarchy and the "Invention of Tradition", c.1820–1977', in Eric Hobsbawm and Terence Ranger (eds.), *The Invention of Tradition* (Cambridge: Cambridge University Press, 1983).

111. Christopher Hibbert, *George IV: Regent and King 1811–1830* (London: Allen Lane, 1973), 191.

112. Ibid. 191–2.

113. For the development of this polemic in France, see Landes, *Visualizing the Nation*.

114. See Kenneth Baker, *George IV: A Life in Caricature* (London: Thames & Hudson, 1995).

115. See ibid. 366. Her dedication of *Emma* to him has been seen as a mark of approval. In fact it occurred at his own invitation. Saul David, *Prince of Pleasure: The Prince of Wales and the Making of the Regency* (London: Little Brown, 1998), 366.

116. William Makepeace Thackeray, *The Works*, x. *Roundabout Papers, The Four Georges: The English Humourists* (London; Smith, Elder, 1888), 353.

117. Ibid. 357.

118. Ibid. 361.

119. Ibid.

CHAPTER 2

1. Cited in G. M. Trevelyan, *English Social History: A Survey of Six Centuries—Chaucer to Queen Victoria* (1944; London: Longman, 1973), 473.

2. Ibid. 527.

3. Mary Robinson, 'Present State of the Manners, Society, etc. etc. of the Metropolis of England', *Monthly Magazine* (10 Aug. 1800), 35. The other instalments were published on 10 Sept., 10 Oct., and 10 Nov. 1800.

4. Ibid.

5. Robinson, 'Present State of the Manners', *Monthly Magazine* (10 Sept. 1800), 138.

6. Robinson, 'Present State of the Manners', *Monthly Magazine* (10 Oct. 1800), 228.

7. Sales increased steadily in the following years and by 1829 seven morning papers were selling an average of 28,000 copies while six evening papers had average sales of 11,000. Several Sunday newspapers that are still published were founded in this period, including the *Observer* in 1791, *The Sunday Times* in 1822, and the *News of the World* in 1843. See Judith Flanders, *Consuming Passions: Leisure and Pleasure in Victorian Britain* (London: Harper, 2006), ch. 4, esp. pp. 125 and 142.

8. Robinson, 'Present State of the Manners' (10 Nov. 1800), 305.

9. Ibid.

10. Flanders, *Consuming Passions*, 125.

11. William Hazlitt, 'On Londoners and Country People', *The Plain Speaker: Opinions on Men, Books and Things* (London: George Bell, 1903), 91–2.

12. Ibid. 104.

13. Maurice Guerrini, *Napoleon and Paris: Thirty Years of History* (1967; London: Cassell, 1970), 109.

14. Ibid. 119.

15. Alistair Horne, *Seven Ages of Paris* (London: Macmillan, 2002), 211–13.

16. Stella Margetson, *Regency London* (London: Cassell, 1971), 48.

17. Carolly Erickson, *Josephine: A Life of the Empress* (1998; London: Robson Books, 2004), 274.

18. Margetson, *Regency London*, 6.

19. Ibid. 127.

20. Captain Gronow, *His Reminiscences of Regency and Victorian Life 1810–1860*, ed. Christopher Hibbert (London: Kyle Cathie, 1991), 74–5.

21. Michael Levey, *Sir Thomas Lawrence* (London: Yale University Press, 2005), 52–3.

22. Sébastien Allard, 'Between the Novel and History: French Portraiture towards 1835', in Robert Rosenblum et al. *Citizens and Kings: Portraits in the Age of Revolution, 1760–1830* (London: Royal Academy, 2007), 37.

23. Gronow, *His Reminiscences*, 262.

24. T. H. White, *The Age of Scandal* (1950; Harmondsworth: Penguin, 1964), 18.

25. Robert Southey, *Letters from England* (1807; Gloucester: Sutton, 1984), 449.

26. See Alison Adburgham, *Silver Fork Society: Fashionable Life and Literature from 1814 to 1840* (London: Constable, 1983), 22–5. On p. 1 the author reports that the term was coined by Hazlitt in an essay in the *Examiner*.

27. Ibid. 1–2.

28. The most typical examples were authored by Hook; Catherine Gore; Marguerite, Countess of Blessington; and Benjamin Disraeli.

29. The novels were widely criticized for their supposed vulgarity and bad taste. 'The worst fault of such productions', comments Mr Vyvyan, a character in Catherine Gore's *Women As They Are*, 'is the distortion of their portraiture—the writers or painters generally move in so base a sphere, that their upturned and wandering eyes necessarily disfigure the object of their art' (Adburgham, *Silver Fork Society*, 171). The majority of readers probably never perceived such distortions and, if they did, they were not concerned with them. They derived in many cases similar pleasure from the novels as they gained from reading historical romances and exotic adventures.

30. 'Silver fork' novels owed something to Jane Austen. Indeed, Mrs Gore wrote in the preface to *Pin Money* that her aim was to 'attempt to transfer the familiar narrative of Miss Austen to a higher sphere of society', ibid. 211–12. While fashionable society is glimpsed in Austen and there are some striking caricatures of titled personages, provincial society and the country gentry provide most of her raw material.

31. Andrew Elfenbein, 'Silver Fork Byron and the Image of Regency England', in Frances Wilson (ed.), *Byromania: Portraits of the Artist in Nineteenth and Twentieth-Century Culture* (Basingstoke: Palgrave Macmillan, 1999), 79–80.

32. This hypothesis is advanced in Peter McNeil, ' "That Doubtful Gender": Macaroni Dress and Male Sexualities', *Fashion Theory*, 3/4 (1999), 411–48. See also, by the same author, 'Macaroni Masculinities', *Fashion Theory*, 4/4 (2000), 373–404.

33. Colin McDowell, *The Man of Fashion: Peacock Males and Perfect Gentlemen* (London: Thames & Hudson, 1997), 45.

34. Ian Kelly, *Beau Brummell: The Ultimate Dandy* (London: Hodder and Stoughton, 2005), 167.

35. Joan DeJean, *The Essence of Style: How the French Invented High Fashion, Fine Food, Chic Cafes, Style, Sophistication and Glamour* (New York: The Free Press, 2005), 161–3.

36. See Christopher Breward, *Fashion* (Oxford: Oxford University Press, 2003), 162.

37. Gronow, *His Reminiscences*, 469.

38. Richard Sennett, *The Fall of Public Man* (Cambridge: Cambridge University Press, 1977), 161.

39. Thomas Carlyle, *Sartor Resartus*, in *Works*, iii (London: Chapman and Hall, 1885), 184.

40. William Hazlitt, 'On Fashion', in *Sketches and Essays and Winterslow*, ed. W. Carew Hazlitt (London: Bell, 1912), 146.

41. Ibid. 147.

42. Trevelyan, *English Social History*, 474.

43. Robinson, 'Present State of the Manners' (10 Oct. 1800), 228.

44. Hazlitt, 'On Londoners and Country People', 89.

45. Ibid. 212. Gronow claims that the clubs were still almost exclusively restricted to the aristocratic world. See *His Reminiscences*, 76–7.

46. Gronow, *His Reminiscences*, 74.

47. Kelly, *Beau Brummell*, 268.

48. His aloofness may have been related to his sexuality, which remains a matter of speculation. Kelly suggests that he may have been homosexual and notes that he spent much time among courtesans.

49. Cited ibid. 206.

50. Southey, *Letters from England*, 291.

51. Horne, *Seven Ages of Paris*, 187.

52. Southey, *Letters from England*, 447–8.

53. This point is made by Andrew Elfenbein in 'Byron: Gender and Sexuality', in Drummond Bone (ed.), *The Cambridge Companion to Byron* (Cambridge: Cambridge University Press, 2004), 59.

54. See Venetia Murray, *High Society in the Regency Period, 1788–1830* (London: Viking, 1998), 30–1.

55. Ibid. 219–23.

56. Kelly, *Beau Brummell*, 264–5.

57. Robinson, 'Present State of the Manners' (1 Aug. 1800), 36; Hazlitt, 'On Londoners and Country People', 104.

58. Hazlitt, 'On Londoners and Country People', 104.

59. Elizabeth Burns, *Theatricality: A Study of Convention in the Theatre and in Social Life* (London: Longman, 1972), 10.

60. Fiona MacCarthy, *Byron: Life and Legend* (2002; London: Faber & Faber, 2003), 219, 256–7.

61. Flanders, *Consuming Passions*, 295.

62. Southey, *Letters from England*, 98.

63. F. W. J. Hemmings, *Theatre and State in France, 1760–1905* (Cambridge: Cambridge University Press, 1994), 123.

64. Ibid. 4.

65. Marie-Louise Biver, *Le Paris de Napoléon* (Paris: Plon, 1963), 132.

66. Charles Hindley, *The True History of Tom and Jerry* (London: Reeves and Turner, 1888), 2.

67. Ibid. 5.

68. Ibid. 11.

69. Adburgham, *Silver Fork Society*, 60–1.

70. Charles Dickens, *Sketches by Boz: Illustrative of Every-Day Life and Every-Day People* (1839; London: Oxford University Press, 1957), 55.

71. For full details of her varied career, including her rise and fall, see Paula Byrne, *Perdita: The Life of Mary Robinson* (2004; Harper Perennial, 2000).

72. Russell Jackson, *Victorian Theatre* (London: Black, 1989), 10.

73. Flanders, *Consuming Passions*, 313.

74. Jackson, *Victorian Theatre*, 2.

75. Percy Fitzgerald (1892), quoted ibid. 217–19.

76. Southey, *Letters from England*, 50.

77. Kelly, *Beau Brummell*, 190.

78. Evelyn Farr, *Before the Deluge: Parisian Society in the Reign of Louis XVI* (London: Owen, 1994), 74.

79. Flanders, *Consuming Passions*, 42.

80. Maxine Berg, 'New Commodities, Luxuries and their Consumers in Eighteenth-Century England', in Berg and Helen Clifford (eds.), *Consumers and Luxury: Consumer Culture in Europe 1650–1850* (Manchester: Manchester University Press, 1999), 63–85, at 65.

81. Maxine Berg, *Luxury and Pleasure in Eighteenth-Century Britain* (Oxford: Oxford University Press, 2005), 9.

82. See Colin Campbell, *The Romantic Ethic and the Spirit of Modern Consumerism* (Oxford: Blackwell, 1987).

83. Maxine Berg, 'Asian Luxuries and the Making of the European Consumer Revolution', in Berg and Elizabeth Eger (eds.), *Luxury in the Eighteenth Century: Debates, Desires and Delectable Goods* (Basingstoke: Palgrave, 2003), 228–40, at 230.

84. Flanders, *Consuming Passions*, 62–74.

85. Richard Sennett, *The Fall of Public Man* (Cambridge: Cambridge University Press, 1977), 146.

86. Dickens, *Sketches by Boz*, 55.

87. Hazlitt, 'On Londoners and Country People', 89–90.

88. Ibid. 91.

89. Ibid. 92.

90. Rosalind H. Williams, *Dream Worlds: Mass Consumption in Late Nineteenth Century France* (Berkeley and Los Angeles: University of California Press, 1982), 9.

91. Walter Benjamin, *The Arcades Project* (Cambridge, Mass.: Harvard University Press, 1999), 63–74.

92. Ibid. 271.

93. Ibid. 272.

94. Williams, *Dream Worlds*, 34.

95. Ibid. 17.

96. Erika Diane Rappaport, *Shopping for Pleasure: Women in the Making of London's West End* (Princeton: Princeton University Press, 2000), 5.

97. Jackson Lears, *Fables of Abundance: A Cultural History of Advertising in America* (New York: Basic, 1994), 72.

98. Jackson Lears, 'Beyond Veblen: Rethinking Consumer Culture in America', in Simon J. Bronner, (ed.), *Consuming Visions: Accumulation and Display of Goods in America, 1880–1920* (New York: Norton, 1989), 77.

99. Williams, *Dream Worlds*, 61.

100. Quoted ibid.

101. Ibid. 63.

102. Ibid. 65.

103. Ibid. 69.

104. Ibid. 71.

105. Ibid. 71.

106. Michael Miller, *The Bon Marché: Bourgeois Culture and the Department Store 1869–1920* (Princeton: Princeton University Press, 1981), 165. See also Rappaport, *Shopping for Pleasure* and Bill Lancaster, *The Department Store: A Social History* (Leicester: Leicester University Press, 1995).

107. Miller, *Bon Marché*, 167.

108. William Leach, *Land of Desire: Merchants, Power and the Rise of a New American Culture* (New York: Pantheon, 1993), 9.

CHAPTER 3

1. Lesley Blanch (ed.) *The Game of Hearts: Harriet Wilson and Her Memoirs* (London: Gryphon, 1957) (memoirs first published 1828).

2. Lesley Blanch, 'Introduction', ibid. 32.

3. See Hallie Rubenhold (ed.), *Harris's List or Covent-Garden Ladies: Sex and the City in Georgian Britain* (London: Tempus, 2005), 22 and *passim*.

4. William Makepeace Thackeray, *Vanity Fair* (1848; London: Penguin, 1985), 738.

5. Fiona MacCarthy, *Byron: Life and Legend* (2002; London: Faber and Faber, 2003), 365.

6. Tracy C. Davis, *Actresses as Working Women: Their Social Identity in Victorian Culture* (London: Routledge, 1991), p. 82.

7. Frédérique Patureau, *Le Palais Garnier dans la société parisienne, 1875–1914* (Liège: Mardega, 1991), 362.

8. Mary Robinson, 'Present State of the Manners, Society, etc. etc. of the Metropolis of England', *Monthly Magazine* (10 Nov. 1800), 305.

9. Ibid. On Robinson as a fashion icon, see Paula Byrne, *Perdita: The Life of Mary Robinson* (2004; Harper Perennial, 2005), 27–8, 178–9, 203–9.

10. Philip Mansel, *The Court of France, 1789–1830* (Cambridge: Cambridge University Press, 1988), 191.

11. Quoted in Harold Kurtz, *The Empress Eugénie, 1826–1920* (London: Hamish Hamilton, 1964), 50.

12. Polly Binder, *The Truth about Cora Pearl* (London: Wiedenfeld & Nicolson, 1986), 40–1.

13. Michelle Sapori, *Rose Bertin: Ministre des modes de Marie-Antoinette* (Paris: Éditions de l'Institut français de la mode, 2003), 118.

14. Claire Wilcox, 'Introduction', in Wilcox (ed.), *The Golden Age of Couture: Paris and London 1947–1957* (London: V&A Publications, 2007), 12. On Worth, see Diana de Marly, *Worth: Father of Haute Couture* (London: Elm Tree, 1980).

15. Sapori, *Rose Bertin*, 119.

16. Quoted in Siegfried Kracauer, *Offenbach and the Paris of his Time* (London: Constable, 1937), 175.

17. John Bierman, *Napoleon III and his Carnival Empire* (London: John Murray, 1988).

18. Kracauer's study *Offenbach* remains the most illuminating study of the composer and his place in the culture of the age.

19. See Mansel, *Court of France*, 97–112.

20. T. J. Clark, *The Painting of Modern Life: Paris in the Art of Manet and his Followers* (London: Thames and Hudson, 1990), 35–6.

21. Ibid. 66.

22. Virginia Rounding, *Grandes Horizontales: The Lives and Legends of Four Nineteenth-Century Courtesans* (London: Bloomsbury, 2003), 3.

23. The contessa was received at court in 1856. See Kurtz, *Empress Eugénie*, 94.

24. Alain Decaux, *Amours Second Empire* (Paris: Hachette, 1958), 198.

25. Ibid. 170.

26. Simone de Beauvoir, *Le Deuxième Sexe*, ii. *L'Expérience vécue* (1949; Paris: Gallimard, 1976), 444.

27. Quoted in Patrice Higonnet, *Paris: Capital of the World* (Cambridge, Mass.: Harvard University Press, 2002), 301.

28. Alexandre Dumas *fils*, *La Dame aux camélias* (1852; Paris: Calmann-Lévy, 1965), 115.

29. De Beauvoir, *Le Deuxième Sexe*, ii. 451. On La Païva, see Rounding, *Grandes Horizontales*, ch. 4.

30. Émile Le Senne, *Madame de Païva: Étude de psychologie et d'histoire* (Paris: Daragon, 1910), 16–38.

31. Ibid. 71. On her residence, see Rounding, *Grandes Horizontales*, ch. 9.

32. Jean-Marie Moulin, 'The Second Empire; Art and Society', in Arnold Jolles et al., *The Second Empire: Art in France Under Napoleon III* (Philadelphia: Philadelphia Museum of Art, 1978), 12.

33. Ibid.

34. For Kurtz, the painting, 'flattered their mediocre sense of beauty, their modest aspirations to immortality in crimson and gold'. See *Empress Eugénie*, 63–4.

35. Joanna Richardson, *La Vie Parisienne 1852–1870* (London: Studio, 1971), 71.

36. Ibid. 72.

37. Joanna Richardson, *The Courtesans: The Demi-Monde in 19th Century France* (London: Weidenfeld and Nicolson, 1967) contains accounts of twelve of the most famous courtesans of the Second Empire.

38. Philippe Perrot, *Le Luxe: Une richesse entre faste et confort xviii*ᵉ*–xix*ᵉ *siècle* (Paris: Seuil, 1995), 184.

39. As Perrot expresses the appeal of the courtesan to the banker, industrialist, or speculator: 'for the aristocracy, appearance was its reality, its necessity and often its ruin; in the bourgeois world it is above all a shop window', ibid. 189.

40. Cited ibid. 183.

41. See Dumas, *La Dame aux camélias*, 150–1.

42. Colin Campbell, *The Romantic Ethic and the Spirit of Modern Consumerism* (Oxford: Blackwell, 1987), 60.

43. Alain Corbin, *Women for Hire: Prostitution and Sexuality in France after 1850* (Cambridge, Mass.: Harvard University Press, 1990), 133–4.

44. Ibid. 96.

45. Ibid. 55.

46. Ibid.

47. Quoted ibid. 62. See also Le Senne, *Madame de Païva*, 34–6.

48. Binder, *Truth about Cora Pearl*, 40, 66.

49. Many authors have tried to identify the principal source, Decaux opting for Anna Deslions—largely on the basis of her unredeemed vulgarity—while Jean Chalon prefers the statuesque beauty Valtesse de la Bigne. Richardson deploys several authorities including, indirectly, Zola himself, to support Blanche d'Antigny. See Decaux, *Amours Second Empire*, 139; Jean Chalon, *Liane de Pougy: Courtisane, princesse et sainte* (Paris: Flammarion, 1994), caption to illustration; Richardson, *Courtesans*, 9. The reigning queen of Offenbach's operettas, Hortense Schneider, has also been indicated as the main inspiration since she had in common with Nana a stage career and a liaison with the Prince of Wales (thinly disguised as 'the Prince of Scotland' in *Nana*). See Douglas Parme, 'Introduction' to Émile Zola, *Nana* (Oxford: Oxford University Press, 1992), p. xiv.

50. Zola, *Nana*, 274.

51. Ibid. 306.

52. Ibid. 360.

53. Ibid. 358.

54. Ibid. 353.

55. Ibid. 355–6.

56. Ibid. 274–5.

57. Ibid. 274–6.

58. Dumas, *La Dame aux camélias*, 231.

59. See Alan Krell, *Manet and the Painters of Contemporary Life* (London; Thames and Hudson, 1996) chs. 2 and 3.

60. Anon., 'Journal d'un fantasiste: Sur la galanterie', *Gil Blas*, 3 July 1895, p. 1.

61. See Noémi Hepp, 'La Galanterie', in Pierre Nora (ed.), *Les Lieux de mémoire*, iii (Paris: Gallimard, 1997), 3702.

62. Lucinda Jarrett, *Stripping in Time: A History of Erotic Dancing* (London: HarperCollins, 1997), 35.

63. Paul Derval, *The Folies Bergère* (London: Brown Watson, 1955), 14.

64. Javier Figuero and Marie-Hélène Carbonel, *La Véritable Biographie de La Belle Otero et de la Belle Époque* (Paris: Fayard, 2003), 106.

65. Quoted in Massimo Grillandi, *La bella Otero* (Milan: Rusconi, 1980), 142.

66. La Belle Otero, *Souvenirs et vie intime* (1926; Monaco: Sauret, 1993), 240.

67. Colette, *Mes apprentissages, La treille musicale, Colette, une vie une œuvre* (Paris: Club France Loisirs, 1997) (*Mes apprentissages* first published 1936), 16–18. See also Judith Thurman, *A Life of Colette* (London: Bloomsbury, 1999), 66–7.

68. See Albert Flament, *Le Bal du pré-Catalan* (Paris: Fayard, 1946), 107: 'Otero induces nostalgia for Seville, but, like a flower, Liane de Pougy fuels love for France.'

69. Jean Cocteau, *Reines de la France* (Paris: Grasset, 1952), 142.

70. Jean Cocteau, *Reines de la France* (Paris: Grasset, 1952), 30.

71. See Enrico Lucherini and Matteo Spinola, *C'era questo, c'era quello* (Milan: Mondadori, 1984), 27.

72. Jean Chalon, *de Pougy*, 85–100.

73. Jean-Yves Tadié, *Marcel Proust I* (Paris: Gallimard, 1996), 75.

74. Max Beerbohm, *Zuleika Dobson, or An Oxford Love Story* (1911; London: Folio Society, 1966).

75. La Belle Otero, *Souvenirs et vie intime*, 35.

76. Quoted in Charles Castle, *La Belle Otero: The Last Great Courtesan* (London: Michael Joseph, 1981), 113.

77. This anecdote first appeared in Hugo, *Vingt ans maître d'hôtel chez Maxim's* (Paris: Amiot Dumont, 1951), 32–3. Armand Lanoux quotes from this source in *Amours 1900* (Paris: Hachette, 1961), 167–8, and so does James Laver in *The Age of Optimism: Manners and Morals, 1848–1914*

(London: Weidenfeld & Nicolson, 1966), 238–9. In Chalon, *Liane de Pougy* the scene is not Maxim's but the Casino in Monte Carlo (pp. 73–4). The source is Albert Flament who, according to his own testimony, was an eyewitness of the scene, that took place on 6 Feb. 1897. Curiously, two biographers of Otero reverse the story and suggest that it was their subject who delivered the humiliation by appearing devoid of jewels. See esp. Grillandi, *La bella Otero*, 228. Castle, in *La Belle Otero*, 64, also has Otero as the winner, but her victim is not de Pougy but another lesser known courtesan, Diane de Chandel. It is impossible to separate fact from legend here but, given her reputation for excessive use of jewellery, it is reasonable to suppose that the victim of the prank was indeed Otero.

78. Chalon, *de Pougy*, 76.

79. De Beauvoir, *The Second Sex* (1949; London: Everyman's Library, 1993), 597.

80. Abigail Solomon-Godeau, 'The Other Side of Venus: The Visual Economy of Feminine Display', in Victoria de Grazia with Ellen Furlough (eds.), *The Sex of Things: Gender and Consumption in Historical Perspective* (Berkeley and Los Angeles: University of California Press, 1996), 131.

81. The quality of sexual 'awarishness' is examined in Maria-Elena Buszek, 'Representing "Awarishness": Burlesque, Feminist Transgression and the 19th-century Pin-up', *Drama Review*, 43/4 (1999), 141–62.

82. Umberto Notari, *Signore sole: Interviste e ritratti delle celebri artiste* (Milan: Edizioni del Giornale Verde e Azzurro, *c.*1903), 17–24.

83. Ibid. On Cavalieri, see Stephen Gundle, ' "Venus on Earth": Lina Cavalieri and the Professionalization of Italian Beauty between the Fin-de-Siècle and the Belle Époque', *Italian Studies*, 62/1 (2007), 45–60.

84. Michael Levey, *Sir Thomas Lawrence* (London: Yale University Press, 2005), 90.

85. See Stephen Gundle, 'Mapping the Origins of Glamour: Giovanni Boldini, Paris and the Belle Époque', *Journal of European Studies*, 29/3 (1999), 269–95.

86. The reference to de Mérode originally appeared in the section of de Beauvoir, *The Second Sex* dedicated to prostitutes and courtesans, pp. 595–604. De Mérode's name was struck from later editions of the book.

87. Liane de Pougy, *Les Sensations de Mlle de la Bringue* (Paris: Albin Michel, 1904), 123. Italics and capitals occur in the original text. For de Mérode's own account of this episode, see Cléo de Mérode, *La Ballet de ma vie* (1955; Paris: Pierre Horay, 1985), 147–57.

88. *Gil Blas* printed a satirical drawing of the statue looking very lifelike, complete with pubic hair. Five women and a man are shown studying it closely. Issue of 26 June 1896, p. 5.

89. Octave Uzanne, *Parisiennes de ce temps en leurs divers milieux, états et conditions* (Paris: Mercure de France, 1910), 442.

90. Chalon, *de Pougy*, 75.

91. See La Belle Otero, *Souvenirs*, 314 for the quotation and 179 on Ollstreder.

92. Mario Praz, *The Romantic Agony* (1933; London: Oxford University Press, 1970), 207.

93. Grillandi, *La bella Otero*, 16.

94. Lanoux, *Amours 1900*, 163.

95. Hugo, *Vingt ans maître d'hôtel*, 186–220.

96. Mary Blume, *Côte d'Azur: Inventing the French Riviera* (London: Thames and Hudson, 1992), 58.

97. Ibid. 63.

98. They are still referred to occasionally in this manner. See Claude Dufresne, *Trois Grâces de la Belle Époque* (Paris: Bartillat, 2003).

CHAPTER 4

1. See Eric Homberger, *Mrs Astor's New York: Money and Social Power in a Gilded Age* (New Haven and London: Yale University Press, 2002).

2. Amanda Mackenzie Stuart, *Consuelo and Alva Vanderbilt: The Story of a Mother and Daughter in the Gilded Age* (2005; London: Harper Perennial, 2006), 57–64.

3. Maureen E. Montgomery, *'Gilded Prostitution': Status, Money and Transatlantic Marriages, 1870–1914* (London: Routledge, 1989), 49.

4. Edith Wharton, *The Buccaneers* (1938; London: Fourth Estate, 1993), 155. His circle included wealthy plutocrats, members of the 'fast set', and others considered undesirable by many staid aristocrats. One royal mistress, the socialite Alice Keppel, who controlled access to the king, was privately dubbed a latter-day Pompadour by the American Nancy Astor (née Langthorne), who dismissed her as 'bejewelled and airified'. See James Fox, *The Langthorne Sisters* (1998; London: Granta, 1999), 115.

5. James Camplin, *The Rise of the Plutocrats: Wealth and Power in Edwardian England* (London, Constable, 1978), 103; F. M. L. Thompson, *English Landed Society in the Nineteenth Century* (London: Routledge & Kegan Paul, 1963), 302.

6. See Fox, *Langthorne Sisters*, 84–5.

7. Camplin, *Rise of the Plutocrats*, 103.

8. Keith Middlemas, *Pursuit of Pleasure: High Society in the 1900s* (London: Gordon and Cremonesi, 1977), 39.

9. Vita Sackville-West, *The Edwardians* (1952; London: Arrow, 1960), 95.

10. On the programmatic nature of luxury as aggressive, exhibitionist, and demanding of recognition, see Alberto Abruzzese, 'Il lusso', in Abruzzese, *Archeologie dell'immaginario: Segmenti dell'industria culturale tra '800 e '900* (Naples: Liguori, 1988), 54–81, esp. 54–7.

11. Middlemas, *Pursuit of Pleasure*, 56.

12. Ibid. 120.

13. Montgomery, *'Gilded Prostitution'*, 71.

14. Ibid. 153. See also Eric Hobsbawm, *The Age of Empire 1875–1914* (London: Weidenfeld and Nicolson, 1987), 184–6.

15. Many impoverished and displaced aristocrats found gainful employment in this and subsequent periods by instructing the new rich and the middle classes in matters of taste or in making or selling articles and services that carried by association an elitist connotation.

16. Montgomery, 'Gilded Prostitution', 46.

17. Molly W. Berger, 'The Rich Man's City: Hotels and Mansions of Gilded Age New York', *Journal of Decorative and Propaganda Arts*, 25 (2005), 46–71, at 48 and 68.

18. Ibid. 47.

19. Thorstein Veblen, *Theory of the Leisure Class* (1899; Boston: Houghton Mifflin, 1973), 64.

20. Ibid. 106–7.

21. See Fox, *Langthorne Sisters*, 8–9.

22. Montgomery, 'Gilded Prostitution', 150.

23. Veblen, *Theory of the Leisure Class*, 96–7.

24. See Mackenzie Stuart, *Consuelo and Alva*, ch. 4.

25. Montgomery, 'Gilded Prostitution', 140–1.

26. Consuelo Vanderbilt Balsan, *The Glitter and the Gold* (London: Heinneman, 1953), 41.

27. Ibid. 42.

28. David Cannadine, *The Decline and Fall of the British Aristocracy* (New Haven: Yale University Press, 1990), 350.

29. See Ross McKibbin, *Classes and Cultures: England 1918–1951* (Oxford: Oxford University Press, 1998), 23.

30. Walter Bagehot, *The English Constitution* (1867; Eastbourne: Sussex Academic Press, 1997), 146.

31. James Laver, *Taste and Fashion: From the French Revolution to the Present Day* (London: Harrap, 1937), 19.

32. Sackville-West, *Edwardians*, 12.

33. David Sinclair, *Dynasty: The Astors and Their Times* (New York: Beaufort Books, 1984), 5–6.

34. Fox, *Langthorne Sisters*, 11 and 30.

35. Quoted ibid. 122.

36. Maureen E. Montgomery, *Displaying Women: Spectacles of Leisure in Edith Wharton's New York* (New York: Routledge, 1998), 12–14.

37. Anon., 'Society; So Called', *Los Angeles Times*, 4 July 1897, p. 10.

38. Montgomery, *Displaying Women*, 147.

39. Ibid. 130.

40. Veblen, *Theory of the Leisure Class*, 72.

41. Edith Wharton, *The Custom of the Country* (1913; London: Virago, 1995), 15.

42. The hotel was demolished, amid considerable protest, in 1929. The short lives and brusque ends of the grand New York hotels of the 1890s is examined in Bernard L. Jim, '"Wrecking the Joint": The Razing of City Hotels in the First Half of the Twentieth Century', *Journal of Decorative and Propaganda Arts*, 25 (2005), 288–314.

43. Berger, 'Rich Man's City', 68.

44. Ibid. 63.

45. Caroline Seebohm, *The Man Who Was Vogue: The Life and Times of Condé Nast* (London: Weidenfeld and Nicolson, 1982), 102.

46. Ibid. 42.

47. Erika Diane Rappaport, *Shopping for Pleasure: Women and the Making of London's West End* (Princeton: Princeton University Press, 2000), 8–9.

48. Quoted ibid. 4.

49. Seebohm, *The Man Who Was Vogue*, 165.

50. Ibid. 166.

51. Diana Vreeland, *American Women of Style* (New York: The Costume Institute of the Metropolitan Museum of Art, 1975), page unnumbered.

52. Ibid. 182. See Veblen, *Theory of the Leisure Class*, 106–7.

53. Vreeland argued that there was 'a flash of mischief in her eyes and she was thought a trifle daring for her time'. *American Women of Style*, page unnumbered.

54. Fox, *Langthorne Sisters*, 49–50.

55. Veblen, *Theory of the Leisure Class*, 185.

56. Fox, *Langthorne Sisters*, 10.

57. Ibid. 165.

58. Lois W. Banner, *American Beauty* (New York: Knopf, 1983), 28–9.

59. Stanley Olson, *John Singer Sargent: His Portrait* (London: Barrie and Jenkins, 1986), 102.

60. For a full account of the episode, see Deborah Davis, *Strapless: John Singer Sargent and the Fall of Madame X* (Stroud: Sutton, 2004), chs. 11 and 12.

61. Dario Cecchi, *Giovanni Boldini* (Turin: UTET, 1962), 174. His portrait of Donna Franca Florio, the statuesque wife of Sicilian industrialist Ignazio Florio, was rejected by the latter on the grounds that, far from confirming his wife's position as 'Queen of Palermo', it portrayed 'a beautiful woman in the act of wiggling her hips, either before a mirror or worse: before the audience of a *caf'conc'*'. Modifications were subsequently undertaken to tone down the general attitude and turn the glamorous portrait into a traditional depiction of a respectable woman.

62. Vanderbilt Balsan, *The Glitter and the Gold*, 61.

63. Alva Vanderbilt was probably ignorant of her reputation, and more especially of the fact that she enjoyed a liaison with Consuelo's father who, like other American millionaires, regularly crossed the Atlantic in his yacht *Valiant* to enjoy the pleasure of Paris. See Massimo Grillandi, *La bella Otero* (Milan: Rusconi, 1980), 167–8, 220.

64. Cecchi, *Giovanni Boldini*, 131.

65. Ibid. 274.

66. Ibid. 131.

67. See Rossana Bossaglia and Mario Quesada (eds.), *Gabriele d'Annunzio e la promozione delle Arti* (Milan: Mondadori/De Luca, 1988).

68. On d'Annunzio, see John Woodhouse, *Gabriele d'Annunzio: Defiant Archangel* (Oxford: Oxford University Press, 1998).

69. Rappaport, *Shopping for Pleasure*, 39.

70. Ibid. 184.

71. Judith Flanders, *Consuming Passions: Leisure and Pleasure in Victorian Britain* (London: Harper, 2006), 339.

72. Ibid. 122–3.

73. Quoted in Christopher Kent, 'Image and Reality: The Actress and Society', in Martha Vicinus (ed.), *A Widening Sphere: Changing Roles of Victorian Women* (Bloomington: Indiana University Press, 1977), 94.

74. Ibid. 164.

75. John Stokes, Michael R. Booth, and Susan Bassnett, 'Introduction', in *Bernhardt, Terry, Duse: The Actress in her Time* (Cambridge: Cambridge University Press, 1988), 5.

76. Ibid. 179.

77. Ibid. 183.

78. Bram Dijkstra, *Idols of Perversity: Fantasies of Feminine Evil in Fin-de-Siècle Culture* (New York: Oxford University Press, 1986).

79. Rita Felski, *Gender of Modernity* (Cambridge, Mass.: Harvard University Press, 1995), 139.

80. See Efrat Tseëlon, *The Masque of Femininity: The Presentation of Woman in Everyday Life* (London: Sage, 1995), ch. 1.

81. Camille Paglia, *The Birds* (London: BFI, 1998), 7.

82. See Joanna Richardson, *Sarah Bernhardt and her World* (London: Weidenfeld & Nicolson, 1977), 146.

83. Lucia Re, 'D'Annunzio, Duse, Wilde, Bernhardt: Author and Actress between Decadentism and Modernity', in Luca Somigli and Mario Moroni (eds.), *Italian Modernism: Italian Culture between Decadentism and the Avant-Garde* (Toronto: University of Toronto Press, 2004), 99.

84. Susan A. Glenn, *Female Spectacle: The Theatrical Roots of Modern Feminism* (Cambridge, Mass.: Harvard University Press, 2000), 12.

85. On one reception in New York, see Arthur Gold and Robert Fizdale, *The Divine Sarah: A Life of Sarah Bernhardt* (London; HarperCollins, 1992), 170.

417

86. See e.g. Corille Fraser, *Come to Dazzle: Sarah Bernhardt's Australian Tour* (Sydney: Currency, 1998).

87. Booth and Bassnett, 'Introduction', *Bernhardt, Terry, Duse*, 9.

88. See Fraser, *Come to Dazzle*, ch. 10.

89. Quoted in Anthony Glyn, *Elinor Glyn: A Biography* (London: Hutchinson, 1955), 49.

90. Edmund White, *Marcel Proust* (London: Penguin, 1999), 25 opts for the combination, broadly confirming the more nuanced account offered in Jean-Yves Tadié, *Marcel Proust I* (Paris: Gallimard, 1996). See esp. 206 and 656.

91. Marcel Proust, *Swann's Way*, in *Remembrance of Things Past I* (London: Penguin, 1983), 79.

92. Marcel Proust, *Within a Budding Grove*, ibid., 484–6.

93. See Laura Beatty, *Lillie Langtry: Manners, Masks and Morals* (London: Chatto & Windus, 1999), 234.

94. Abigail Solomon-Godeau, 'The Other Side of Venus: The Visual Economy of Feminine Display', in Victoria de Grazia with Ellen Furlogh (eds.), *The Sex of Things: Gender and Consumption in Historical Perspective* (Berkeley and Los Angeles: University of California Press, 1996).

95. Linda Nead, *Victorian Babylon: People, Streets and Images in Nineteenth Century London* (New Haven and London: Yale University Press, 2000), 188.

96. 'The last pleasure a working girl would deny herself, wrote one analyst, was the Sunday supplement, where she could find a fantasy retreat into a world of glamour, where actresses from working class backgrounds achieved fame and fortune, where chorus girls married millionaires and beauty contests gave hope to ordinary women that she, too, might be touched by glamour.' Banner, *American Beauty*, 200.

97. Peter Bailey has made a case for the Victorian barmaid as glamour icon. See his 'Para-sexuality and Glamour: The Victorian Barmaid as Cultural Prototype', *Gender and History*, 2/5 (1990). For a critique of his argument see Stephen Gundle and Clino T. Castelli, *The Glamour System* (Basingstoke: Palgrave Macmillan, 2006), 12–13.

98. Anon., 'The Stage Craze', *Los Angeles Times*, 29 Mar. 1890, p. 3.

99. Ibid.

100. Pamela Horn, *High Society: The English Social Elite, 1880–1914* (London: Sutton, 1992), 90.

101. Anon., 'Money or Beauty?', *Los Angeles Times*, 28 June 1896, p. 8.

102. Alan Hyman, *The Gaiety Years* (London: Cassell, 1975), 100.

103. Anon., 'The Chorus Girl', *Los Angeles Times*, 2 Aug. 1887, p. 9.

104. Quoted in Cecchi, *Giovanni Boldini*, 45–6.

105. Maurice Talmeyr, 'L'età del manifesto', in Simona de Iulio (ed.), *L'età del manifesto: Sguardi sulla pubblicità francese del XIX secolo* (Milan: Franco Angeli, 1996), 113.

106. Lucinda Jarrett, *Stripping in Time: A History of Erotic Dancing* (London: HarperCollins, 1997), 47.

107. On La Goulue and the Moulin Rouge, see ibid., ch. 2.

108. Linda Mizejewski, *Ziegfeld Girl: Image and Icon in Culture and Cinema* (Durham, NC: Duke University Press, 1999), 66.

109. Jarrett, *Stripping in Time*, 25.

110. Mistinguett, *Mistinguett: Queen of the Paris Night* (London: Elek Books, 1954), 58.

111. John Hollingshead, *Gaiety Chronicles* (London: Constable, 1898), 30.

112. James Gardiner, *Gaby Deslys: A Fatal Attraction* (London: Sidgwick and Jackson, 1986), 190.

113. Jacques-Charles, *De Gaby Deslys à Mistinguett* (Paris: Gallimard, 1933), 21–2.

114. Quoted in Jean-Jacques Sirkis, *Les Années Deslys* (Paris: Jeanne Laffitte, 1990), 93.

115. The former *maître d'hôtel* of the Maxim's restaurant, Hugo, included her in his notebook of available women at the price of 1,000 francs per quarter hour, although he also included the annotation 'rien à faire'. See *Vingt ans maître d'hôtel chez Maxim's* (Paris: Amiot Dumont, 1951), 204.

116. Ibid. 200.

117. Cecil Beaton, *The Book of Beauty* (London: Duckworth, 1930), 22.

118. Ibid. 22.

119. Mistinguett, *Mistinguett*, 126.

120. Ibid. 32.

121. Ibid. 127.

122. Ibid. 128.

123. Ibid. 127.

124. Maurice Verne, *Les Usines du plaisir: La Vie secrète du music-hall* (Paris: Éditions des Portiques, 1929), 145, 211–12.

125. Ibid. 84–5.

126. See Anna Held, *Mémoires: Une étoile française au ciel de l'Amérique* (Paris: La Nef, 1954).

127. Banner, *American Beauty*, 186.

128. Mizejewski, *Ziegfeld Girl*, 38.

129. Anon., 'Woman and her Beauty', *Los Angeles Times*, 25 Nov. 1908, p. 114.

130. Paul Derval, *The Folies Bergère* (London: Brown Watson, 1955), 38.

131. Ibid.

132. Octave Uzanne, *Parisiennes de ce temps en leurs divers milieux, états et conditions* (Paris: Mercure de France, 1910), 18.

133. Ibid. 20.

134. Octave Uzanne, *Sottiser les mœurs* (Paris: Émile Paul, 1911), 169.

135. Dominique Kalifa, *La Culture de masse en France 1860–1930* (Paris: La Découverte, 2001), 42–3.

CHAPTER 5

1. Patrick Balfour, *Society Racket* (London; Lang, 1933), 73.

2. David Cannadine, *The Decline and Fall of the British Aristocracy* (New Haven and London: Yale University Press, 1990), 327.

3. Ibid.

4. Roger Wilkes, *Scandal: A Scurrilous History of Gossip* (London: Atlantic, 2003).

5. See D. J. Taylor, *Bright Young People: The Rise and Fall of a Generation, 1918–1940* (London: Chatto & Windus, 2007), 40; see also, more widely on the perception of high society, Ross McKibbin, *Classes and Cultures: England 1918–1951* (Oxford: Oxford University Press, 1998), 22–43.

6. Balfour, *Society Racket*, 89.

7. Ibid. 92.

8. Whigham's personal life was tumultuous. In 1930 her engagement to the Earl of Warwick was announced but the wedding was called off when she fell for Charles Sweeney, an American golfer. She married him in 1933 and had three children. They divorced in 1947. In 1951 she became the third wife of the Duke of Argyll. However, her serial infidelity led the duke to sue for divorce in 1963. In the course of the hearing, a list was presented of eighty-eight men with whom the duchess was alleged to have had sex. Photographs were also produced that showed her fellating a naked man, whose head was obscured. It was widely believed that the man in question was either Duncan Sandys, a Cabinet minister, or Douglas Fairbanks although the identity of the 'headless man' was never revealed.

9. Alan Jenkins, *The Thirties* (London: Heinemann, 1976), 24.

10. It was even implied by the romantic novelist Barbara Cartland, who was herself a deb in the 1920s, that she employed a press agent to handle her publicity, but she denied this: 'No-one promoted or paid for the publicity…it just growed [*sic*]'. Margaret, Duchess of Argyll, '*Forget Not*' (1975; London: Wyndham, 1977), 46.

11. 'The girls of 1930 not only had good looks; they knew how to dress; and they had far more self-confidence than their predecessors', Whigham later observed. Ibid.

12. Ibid. 47. On the freelance press activities of some young members of high society, see Taylor, *Bright Young People*, 184–5.

13. Gioia Diliberto, *Debutante: The Story of Brenda Frazier* (New York: Knopf, 1987), 99. On Frazier, see Karal Ann Marling, *Debutante: Rites and Regalia of American Debdom* (Lawrence, Kans.: University Press of Kansas, 2004), 91–4. She describes her as 'the ultimate glamor girl' and lists her advertising endorsements as well as the criticism she aroused.

14. See Cleveland Amory, *Who Killed Society?* (New York: Harper & Brothers, 1960), 178–81.

15. Ibid. 112.

16. Neal Gabler, *Walter Winchell: Gossip, Power and the Culture of Celebrity* (London: Picador, 1995), p. xiii.

17. Ibid., p. xii.

18. Margaret, Duchess of Argyll, '*Forget Not*', 35.

19. McKibbin, *Classes and Cultures*, 22–43; Taylor, *Bright Young People*, 41.

20. Cecil Beaton, 'Have You Glamour?', *Sunday Dispatch*, 11 May 1930, p. 12.

21. McKibbin, *Classes and Cultures*, 38–9.

22. See Ronald Marchand, *Advertising the American Dream: Making Way for Modernity, 1920–1940* (Berkeley and Los Angeles: University of California Press, 1985).

23. Quoted in Yvonne Brunhammer, *The Nineteen Twenties Style* (London: Hamlyn, 1966), 87.

24. McKibbin, *Classes and Cultures*, 23.

25. Barbara Cartland, *We Danced All Night* (London: Hutchinson, 1971), 150.

26. Gloria Swanson, *Swanson on Swanson* (London: Joseph, 1981), 508–9.

27. Kitty Kelley, *The Royals* (New York: Warner Books, 1997), 42.

28. Stella Margetson, *The Long Party: High Society in the Twenties and Thirties* (Farnborough: Saxon House, 1974), 230. See also Taylor, *Bright Young People*, 29–30.

29. Cannadine, *Decline and Fall*, 354.

30. HRH The Duke of Windsor, *A King's Story* (London: Cassell, 1951), 187–8.

31. See Matthew J. Bruccoli, *Some Kind of Grandeur: The Life of F. Scott Fitzgerald* (1981; London: Sphere 1991), 153–4. Fitzgerald first used the term Jazz Age in 1931.

32. In the early twentieth century, in New York, Mrs Stuyvesant Fish had enlivened dinner parties with stunts, practical jokes, entertainments, and send-ups of formal rituals, all of which provided amusement for readers of the press.

33. Taylor reflects on the difficulties of determining exactly who belonged to the group—if group it was—and finds it impossible, both because of the distancing of some of those involved and because of the press's role in applying the term to random phenomena. See *Bright Young People*, 6, 10, 15, 37.

34. For the details in this paragraph, see Philippa Pullar, *Gilded Butterflies: The Rise and Fall of the London Season* (London: Hamish Hamilton, 1978), 163.

35. Ibid. 195. Taylor questions in fact how much sex and drugs there in fact was. See *Bright Young People*, 110–12.

36. Harold Acton, *Memoirs of an Aesthete* (London: Hamish Hamilton, 1948), 223.

37. See Mordaunt J. Crook, *The Rise of the Nouveaux Riches: Style and Status in Victorian and Edwardian Architecture* (London: John Murray, 1999).

38. Arthur Vanderbilt II, *Fortune's Children: The Fall of the House of Vanderbilt* (London: Michael Joseph, 1990), 8.

39. Carol Kennedy, *Mayfair: A Social History* (London: Hutchinson, 1986), 212.

40. Amory, *Who Killed Society?*, 108.

41. Balfour, *Society Racket*, 111.

42. Richard Collier, *Rainbow People* (London: Weidenfeld and Nicolson, 1984), 36.

43. Ibid. 124.

44. F. Scott Fitzgerald, *The Great Gatsby* (1925; London: Abacus, 1991), 61.

45. One of Nast's editors, Edna Woolman Chase, who worked for *Vogue* for over fifty years, says that these parties were standardized and predictable. See her *Always in Vogue* (London, Gollancz, 1954), 171–2. But their routine quality was important in making intermingling the rule rather than the exception.

46. Ibid. 137.

47. Quoted in Caroline Seebohm, *The Man Who Was Vogue: The Life and Times of Condé Nast* (London: Weidenfeld and Nicolson, 1982), 195.

48. See Josephine Ross (ed.), *Society in Vogue: The International Set between the Wars* (London: Condé Nast, 1992). For a view of British *Vogue*, see H. W. Yoxall, *A Fashion of Life* (London: Heinemann, 1966).

49. Seebohm, *The Man Who Was Vogue*, 142.

50. Cartland, *We Danced All Night*, 55.

51. In Stella Margetson's view, 'Garbo killed the synthetic, tarted up image of the film star with platinum blonde wavy hair, red lips and a pink and white doll's complexion.' See Margetson, *Long Party*, 129.

52. She also wrote an autobiographical novel, *Save Me The Waltz*, in 1932.

53. Balfour, *Society Racket*, 57.

54. Billie Melman, *Women and the Popular Imagination in the Twenties: Flappers and Nymphs* (London: Macmillan, 1988), 75. Taylor suggests two possible real-life versions of the character of Iris Storm: Doris Delavigne and Brenda Dean Paul. See *Bright Young People*, 51 and 195.

55. Acton, *Memoirs of an Aesthete*, 223.

56. Margetson, *Long Party*, 124.

57. Cartland, *We Danced All Night*, 180. One of those who was entranced and profoundly influenced was the baronet's daughter Brenda Dean Paul. See Taylor, *Bright Young People*, 26, and her autobiography, published at age 28, *My First Life* (London: Long, 1935).

58. Charles Higham, *Wallis: Secret Lives of the Duchess of Windsor* (London: Sidgwick and Jackson, 1988), 92.

59. Philip Ziegler, *Diana Cooper* (1981; London: Penguin, 1983), 206. Mrs Simpson was a fashionable figure, but not an original dresser. She patronized Chanel and Schiaparelli, a Paris-based designer who drew inspiration from the surrealists. Later, she forged a distinctive, severe look with the help of the American-born designer Mainbocher.

60. For an account of Lindbergh's fame analysed in context, see Leo Braudy, *The Frenzy of Renown: Fame and its History* (Oxford: Oxford University Press, 1986), 19–25.

61. See Ronald Blythe, *The Age of Illusion* (Oxford: Oxford University Press, 1963), 94–102.

62. See Liz Conor, *The Spectacular Woman: Feminine Visibility in the 1920s* (Bloomington and Indianapolis: Indiana University Press, 2004), 69.

63. See Constance Babington Smith, *Amy Johnson* (London: Collins, 1967), 286–7.

64. See Miranda Seymour, *The Bugatti Queen* (London: Simon and Schuster, 2004).

65. Michael J. Arlen, *Exiles* (London: Penguin, 1971), 54–5.

66. See Sheridan Morley, *A Talent to Amuse: A Biography of Noel Coward* (London: Heinemann, 1969), 82–3.

67. Beaton, 'Have You Glamour?'

68. *The Sketch*, 29 Apr. 1925.

69. Philip Hoare, *Noel Coward: A Biography* (London: Sinclair-Stevenson, 1995), 114–15.

70. W. Macqueen-Pope, *Ivor: The Story of an Achievement* (London: Hutchinson, 1951), 170–1.

71. Ibid. 294.

72. For a testimony of this, see Acton, *Memoirs of an Aesthete*, 147. Novello could play the part of the fashionable gentleman and was a welcome guest at upper-class soirées and country house weekends. In *Gosford Park*, the 2001 film of interwar upstairs and downstairs living, he is played by Jeremy Northam. As he sits at the piano and makes his way through his repertoire of songs, the guests barely notice him while the servants sneak up behind doors and curtains to catch his popular motifs.

73. Hugo Vickers, *Cecil Beaton* (London: Weidenfeld, 1933), 36–8.

74. Hoare, *Noel Coward*, 201.

75. See Woodman Chase, *Always in Vogue*.

76. See Meredith Etherington-Smith, *Patou* (London: Hutchinson, 1983).

77. Hoare, *Noel Coward*, 162–3.

78. Elsa Maxwell, *The Celebrity Circus* (London: W. H. Allen, 1964), 11. See also her *I Married the World* (London: Heinemann, 1955).

CHAPTER 6

1. Barry Paris, *Garbo* (London: Pan, 1995), 74.

2. Ibid. 88.

3. Roland Barthes, *Mythologies* (London: Paladin, 1973), 56.

4. Paris, *Garbo*, 364.

5. For example, the Austrian designer Ernst Dryden worked for stores and advertising agencies in Berlin and Paris before placing his talent at the service of Paramount studios. See Anthony Lipman, *Divinely Elegant: The World of Ernst Dryden* (London: Pavilion, 1989).

6. Neal Gabler, *An Empire of their Own: How the Jews Invented Hollywood* (New York: Anchor, 1985); Jackson Lears, *Fables of Abundance: A Cultural History of American Advertising* (New York: Basic Books, 1994).

7. Richard Schickel, *Fairbanks: The First Celebrity* (London; Elm Tree, 1976), 12–13.

8. Anon., 'Metro-Goldwyn-Mayer', *Fortune* (Dec. 1932), reprod. in Tino Balio (ed.), *The American Film Industry* (Madison: University of Wisconsin Press, 1976).

9. Douglas Gomery, *The Hollywood Studio System* (London: BFI, 1986), chs. 2–5.

10. Quoted in Robert Sklar, *Movie-Made America* (New York: Random House, 1975), 191.

11. Anon., 'Metro-Goldwyn-Mayer', 269.

12. Gorham Kindem, 'Hollywood's Movie Star System', in Kindem (ed.), *The American Movie Industry: The Business of Motion Pictures* (Carbondale: Southern Illinois University Press, 1982), 86.

13. Anne Massey, *Hollywood beyond the Screen: Design and Material Culture* (Oxford: Berg, 2000), 21.

14. On the 1925 Paris exhibition, see Tag Gronenberg, *Designing Modernity: Exhibiting the City in 1920s Paris* (Manchester: Manchester University Press, 1998).

15. Lea Jacobs, *The Wages of Sin: Censorship and the Fallen Woman Film 1928–1942* (Madison: University of Wisconsin Press, 1991), 56.

16. Bevis Hillier, *The Style of the Century 1900–1980* (New York: Dutton, 1983), 81.

17. Anon., 'Metro-Goldwyn-Mayer', 269–70.

18. Quoted in Ronald Davis, *The Glamour Factory: Inside Hollywood's Big Studio System* (Dallas: Southern Methodist University Press, 1993), 225.

19. Quoted ibid. 83.

20. Ibid.

21. Edgar Morin, *Les Stars* (1957; Paris: Seuil, 1972), 43.

22. Gertrude Aretz, *The Elegant Woman: From the Roccoco Period to Modern Times* (London: Harrap, 1932), 294.

23. Ibid. 230.

24. The perplexity derived from the novelty of sexuality being displayed without sexual favours apparently being granted (notwithstanding the casting couch). For a discussion of this transition, see Arthur Marwick, *Beauty in History: Society, Politics and Personal Appearance c.1500 to the Present* (London: Thames and Hudson, 1988), 245–9.

25. Blaise Cendrars, *Hollywood: La mecca del cinema* (1937; Rome: Lucarini, 1989), 83–4.

26. Glyn's impact is chronicled in Gloria Swanson's memoirs, *Swanson on Swanson* (London: Joseph, 1981), 159–73.

27. W. Robert Lavine, *In a Glamorous Fashion: The Fabulous Years of Hollywood Costume Design* (London: Allen and Unwin, 1981), 38.

28. Alexander Walker, *Sex in the Movies* (Harmondsworth: Penguin, 1968), 36–43.

29. Marjorie Rosen, *Popcorn Venus: Women, Movies and the American Dream* (London: Owen, 1973), 118.

30. Ibid.

31. Richard Dyer, *White* (London: Routledge, 1997).

32. On Hollywood exoticism, see Sarah Berry, *Screen Style: Fashion and Femininity in 1930s Hollywood* (Minneapolis: University of Minnesota Press, 2000), 132–41.

33. See Gaylyn Studlar, 'Barrymore, the Body and Bliss: Issues in Male Representation and Female Spectatorship in the 1920s', in Leslie Devereaux and Roger Hillman (eds.), *Fields of Vision: Essays in Film Studies, Visual Anthropology and Photography* (Berkeley and Los Angeles: University of California Press, 1995), 160–80.

34. Sklar, *Movie-Made America*, 99.

35. See Richard Dyer, *Stars* (London: BFI, 1979); *Heavenly Bodies: Film Stars and Society* (London: Routledge, 1987).

36. Sklar, *Movie-Made America*, 77.

37. David Stenn, *Clara Bow: Runnin' Wild* (1988; London: Penguin 1990), 36.

38. Swanson, *Swanson on Swanson*, 177.

39. Anne Tapert and Diane Edkins, *The Power of Style* (London: Aurum, 1995).

40. See Amy Fine Collins, 'The Man Hollywood Trusted', *Vanity Fair* (Apr. 2001), 110–23.

41. See Lavine, *In a Glamorous Fashion*, 28–30.

42. Ibid. 33.

43. Elizabeth Wilson and Lou Taylor, *Through the Looking Glass: A History of Dress from 1860 to the Present Day* (London: BBC Books, 1989), 98–100.

44. See Catherine Herzog and Jane Gaines, 'Puffed Sleeves before Tea-Time: Joan Crawford, Adrian and Women Audiences', in Christine Gledhill (ed.), *Stardom: Industry of Desire* (London: Routledge, 1991), 74–91.

45. Bruno Rémaury, 'L'Illusion et l'Apparence', in Alain Masson (ed.), *Hollywood 1927–1941* (Paris: Éditions Autremont, 1991), 217.

46. Dyer, *Stars*, 42.

47. Quoted in Anne Tapert, *The Power of Glamour* (London: Aurum, 1999), 238.

48. Quoted in Patty Fox, *Star Style: Hollywood Legends as Fashion Icons* (Santa Monica: Angel City Press, 1995), 56–7.

49. Alexander Walker, *Sex in the Movies: The Celluloid Sacrifice* (Harmondsworth: Penguin, 1966), 102.

50. Sarah Berry, *Screen Style: Fashon and Femininity in 1930s Hollywood* (Minneapolis: University of Minnesota Press, 1999), 56–7.

51. Ibid., ch. 2.

52. Ibid. 83–4.

53. Letter from Clayton T. Lang, *New York Times*, 20 May 1934, p. E5.

54. James Robert Parish and Don E. Stanke, *The Glamour Girls* (New Rochelle, NY: Arlington House, 1975), 23.

55. John Kobal, *George Hurrell: Hollywood Glamour Portraits* (London: Schirmer, 1993), 15.

56. Ibid.

57. Anon., 'Ace Cameraman Sees Stars Sans Glamour', *Los Angeles Times*, 3 Mar. 1946, p. B1.

58. Marlene Dietrich, *My Life* (1987; London: Pan, 1989), 60.

59. John Engstead, *Star Shots: Fifty Years of Pictures and Stories by One of Hollywood's Greatest Photographers* (New York: Dutton, 1978), 72. Tapert, *Power of Glamour*, 230–1.

60. Dietrich, *My Life*, 72 and 85.

61. Quoted in Parish and Stanke, *Glamour Girls*, 17.

62. Dietrich, *My Life*, 105.

63. Josef von Sternberg, *Fun in a Chinese Laundry* (1965; London: Columbus Books 1987), 224–69. In her essay discussing the way spectators were turned into voyeurs who derived pleasure from the fetishization of the female star, Laura Mulvey singles out von Sternberg's use of Dietrich as the 'ultimate fetish'. In his meticulously composed and shot films the beauty of the woman as object and the screen space coalesce: 'she is no longer the bearer of guilt but a perfect product, whose body, stylised and fragmented by close-ups, is the content of the film and the direct recipient of the spectator's look'. Mulvey, 'Visual Pleasure and Narrative Cinema', in *Visual and Other Pleasures* (Bloomington: Indiana University Press, 1989), 22.

64. Dietrich, *My Life*, 116.

65. Ibid. 119.

66. Davis, *Glamour Factory*, 27.

67. Ibid. 139–44.

68. Ibid. 144.

69. Morin, *Les Stars*, 24.

70. Ibid.

71. Charles Eckert, 'The Carol Lombard in Macy's Window', in Gledhill (ed.), *Stardom*; Douglas Gomery, *Shared Pleasures: A History of Movie Presentation in the United States* (London: BFI, 1992).

72. See Patricia Bosworth, 'That Old Star Magic', *Vanity Fair* (Apr. 1998), p. 70.

73. Cited in Jeffrey Richards, *The Age of the Dream Palace: Cinema and Society in Britain 1930–1939* (London: Routledge, 1984), 157–8.

74. Anon., 'You, Too, Can Be a Glamour Girl', *Los Angeles Times*, 18 Feb. 1940, p. G4.

75. Berry, *Screen Style*, p. 93.

76. Ibid. 106.

77. Kathy Peiss, *Hope in a Jar: The Making of America's Beauty Culture* (New York: Metropolitan/Holt, 1998), 97.

78. Schickel, *Fairbanks*, 53.

79. Sylia Weaver, 'This Glamour Business', *Los Angeles Times*, 22 Jan. 1939, p. 5.

80. Ibid.

81. Sali Löbel, *Glamour and How to Achieve It* (London: Hutchinson, 1938), 11.

82. Ibid. 14.

83. Sally Alexander, 'Becoming a Woman in London in the 1920s and 1930s', in David Feldman and Gareth Stedman Jones (eds.), *Metropolis London: Histories and Representations since 1800* (London: Routledge, 1989), 263.

84. Ibid. 264.

85. See Jackie Stacey, *Star Gazing: Hollywood Cinema and Female Spectatorship* (London: Routledge, 1994), which explores British women's memories of watching American films before and after the war. The quotation appears on p. 115.

86. See Victoria de Grazia, *How Fascism Ruled Women: Italy 1922–1945* (Berkeley and Los Angeles: University of California Press, 1992), 201–33.

87. See Stephen Gundle, *Bellissima: Feminine Beauty and the Idea of Italy* (New Haven and London: Yale University Press, 2007), ch. 4.

88. W. E. Hill, 'Glamour Boys', *Los Angeles Times*, 11 Sept. 1938, p. G4.

89. Anon., 'Farmhands Must Have Glamour to Stick It; Otherwise We Go Hungry, Congress Is Told', *New York Times*, 17 Oct. 1942, p. 13.

90. Anon., 'Cow Glamour To Be Shown', *Los Angeles Times*, 22 July 1941, p. A1.

91. Marian Manners, 'Mushrooms Add Glamour to Carrots', *Los Angeles Times*, 23 June 1938, p. A7.

92. Parish and Stanke, *Glamour Girls*, cover flap.

93. B. R. Crisler, 'A Glance at that Awful Thing Called Glamour', *New York Times*, 12 Mar. 1939, p. 154.

94. Frank S. Nugent, 'A Universal Error About Glamour', *New York Times*, 26 Mar. 1939, p. 137.

95. Kenneth Crist, 'No Glamour Needed', *Los Angeles Times*, 23 July 1939, p. 15.

96. Edwin Schallert, ' "Glamour" Due for Discard, Says Goldwyn', *Los Angeles Times*, 13 May 1934, p. A1.

97. Anon., 'Glamour Girl Called Dead By Noted Photographer', *Los Angeles Times*, 3 Jan. 1938, p. 2.

CHAPTER 7

1. Quoted in Nigel Cawthorne, *The New Look: The Dior Revolution* (London: Reed International, 1996), 106.

2. Christian Dior, *Dior by Dior: The Autobiography of Christian Dior* (1957; London: V&A Publications, 2007), 27–8.

3. Harry Hopkins, *The New Look: A Social History of the Forties and Fifties in Britain* (London: Secker and Warburg, 1963), 96 and David Kynaston, *Austerity Britain, 1945–1951* (London: Bloomsbury, 2007), 257–8. Ridealgh was elected in the Labour landslide of 1945. She was a prominent figure in the Cooperative Women's Guild. This was not her only 'anti-glamour' statement as she also intervened on cosmetics and the influence of American film. See Robert Murphy, *Realism and Tinsel: Cinema and Society in Britain, 1939–1949* (London: Routledge, 1989), 104–5.

4. Antony Beevor and Artemis Cooper, *Paris After the Liberation: 1944–1949* (London: Penguin, 1995), 315.

5. See ibid. 305–7.

6. Dior, *Dior by Dior*, 28.

7. Paul Gallico, *Flowers for Mrs Harris* (London: Penguin, 1963) (first published in 1958 under the title *Mrs Harris Goes to Paris*).

8. Quoted in Beevor and Cooper, *Paris After the Liberation*, 137.

9. Cawthorne, *New Look*, 119. Dior denied having received any explicit encouragement in this sense. See Dior, *Dior by Dior*, 4–5, 22.

10. On the appropriation of the New Look by working-class British women, see Angela Partington, 'Popular Fashion and Working Class Affluence', in Juliet Ash and Elizabeth Wilson (eds.), *Chic Thrills: A Fashion Reader* (London: Pandora, 1992), 145–61.

11. Dior, *Dior by Dior*, 36.

12. See Nicholas Drake, *The Fifties in Vogue* (London: Conde Nast, 1987), 58.

13. Dior, *Dior by Dior*, 61. See also Claire Wilcox, 'Dior's Golden Age; The Renaissance of Couture', in Wilcox (ed.), *The Golden Age of Couture: London and Paris, 1947–1957* (London: V&A Publications, 2007), 42–4. Dior was awarded a Neiman Marcus Oscar in 1947 for his contribution to fashion and he went personally to Dallas to collect it, undertaking at the same time a full American tour. His commercial verve put paid to any idea that American designers might supplant Paris in the aftermath of the war.

14. Partington, 'Popular Fashion and Working Class Affluence', 151.

15. Marie-France Pochna, *Christian Dior: The Man Who Made the World Look New* (New York: Arcade 1996), 136. Dior claimed that the Americans were always his best customers, *Dior by Dior*, 34. He said that American women, from the top to the bottom of the social spectrum, were all perfectly turned out in 1947, and had 'all the shiny brilliance of a new penny', *Dior by Dior*, 51.

16. Nantas Salvalaggio, 'Linda e Tyrone acclamati dalla folla', *Il Tempo*, 28 Jan. 1949, p. 3.

17. F.G., 'Finalmente sposi Tyrone e Linda', *Avanti*, 28 Jan. 1949, p. 3.

18. Salvalaggio, 'Linda e Tyrone', 3.

19. Linda Christian, *Linda: My Own Story* (New York: Dell, 1962), 101.

20. G.d.S., 'Linda e Tyrone hanno detto "si"', *Il Messaggero*, 28 Jan. 1949, p. 3.

21. Ibid.

22. See Adrienne L. McLean, 'The Cinderella Princess and the Instrument of Evil: Surveying the Limits of Female Transgression in Two Postwar Hollywood Scandals', *Cinema Journal*, 34/3 (1995), 36–56.

23. Elsa Maxwell, *The Celebrity Circus* (London: W. H. Allen, 1964), 29.

24. Anne Edwards, *Throne of Gold: The Lives of the Aga Khans* (London: HarperCollins, 1995), 180.

25. Barbara Leaming, *If This Was Happiness: A Biography of Rita Hayworth* (London: Sphere, 1990), 209.

26. Edwards, *Throne of Gold*, 186.

27. Cited ibid. 186.

28. For a sketch of reactions to the couple, see Kynaston, *Austerity Britain*, 243–7.

29. *Time*, 5 Jan. 1953. Quoted in Robert Lacey, *Majesty* (1977; London: Sphere, 1978), 231.

30. Ibid.

31. On the emergence of one of these magazines and the development of its upbeat, celebrity-driven formula, see Nicholas Hewitt, 'The Birth of the Glossy Magazines: The Case of Paris-Match', in Brian Rigby and Nicholas Hewitt (eds.), *France and the Mass Media* (London: Macmillan, 1991), 111–28, esp. 124.

32. Roger Wilkes, *Scandal: A Scurrilous History of Gossip* (London: Atlantic, 2002), 198.

33. Hopkins, *New Look*, 300. Also cited in Wilkes, *Scandal*, 198.

34. Quoted in Andrew Duncan, *The Reality of Monarchy* (1970; London: Pan, 1971), 213.

35. Alexis Schwarzenbach, 'Royal Photographs: Emotions of the People', *Contemporary European History*, 13/3 (2004), 255–80.

36. Hardy Amies, *Still Here: An Autobiography* (London: Weidenfeld and Nicolson, 1984), 110.

37. Cited in Tom Nairn, *The Enchanted Glass: Britain and its Monarchy* (London: Radius, 1988), 77.

38. The historian of the culture of twentieth-century European royalty Alexis Schwarzenbach asserts that sex appeal is always absent from its image: 'In official royal representation—in contrast to anti-royal pamphlets or lurid press reports—I have never found any descriptions of real queens which comment on their sexual appeal to the general male audience. Of course the beauty of real queens was often publicly displayed. Yet the aim of this was to enhance her royal status. Her sex appeal remained exclusively reserved for her husband and was not commented on in any of the cases I have analysed so far.' 'Imagined Queens between Heaven and Hell: Representations of Grace Kelly and Romy Schneider', in Regina Schulte (ed.), *The Body of the Queen: Gender and Rule in the Courtly World, 1500–2000* (Oxford: Berghahn, 2006), 317.

39. Lacey, *Majesty*, 237.

40. Norman Hartnell, *Silver and Gold* (London: Evans, 1955), 133.

41. Ibid. 135.

42. *Roman Holiday* had the advantage of a Roman setting. But the film's storyline did have a precursor in *Princess O'Rourke*, an American-set comedy drama directed by Norman Kasna in 1943 and starring Olivia De Havilland as a European (probably British, but her country is unspecified) princess who falls for and marries a simple American soldier.

43. Peter Kramer, 'Faith in Relations between People: Audrey Hepburn, *Roman Holiday* and European Integration', paper presented to 'Entertaining' seminar, Keele University, 21 May 1997, p. 12.

44. Ibid.

45. The films were *Sissi* (1955), *Sissi—Die junge Kaiserin* (1956), and *Sissi—Schicksalsjahre einer Kaiserin* (1957). They were all directed by Ernst Marischka.

46. See Schwarzenbach, 'Imagined Queens between Heaven and Hell'.

47. See Ian Woodward, *Audrey Hepburn* (London: Virgin, 1983), 184–6; see also Stefania Ricci (ed.), *Audrey Hepburn: Una donna, lo stile—a woman, the style* (Milan: Leonardo Arte, 1999).

48. Gianluca Bauzano, 'Reasons for a Style' in Ricci (ed.), *Hepburn*, 58.

49. On Cary Grant's self-invention, see Graham McCann, *Cary Grant: A Class Apart* (London: Fourth Estate, 1996). Born into the Bristol working class, Grant (whose real name was Archie Leach) modelled himself on Douglas Fairbanks on his way to becoming the epitome of masculine glamour for generations of movie-goers.

50. Bettina, *Bettina* (London: Joseph, 1965), 54–5.

51. Jackie Stacey, *Star Gazing: Hollywood Cinema and Female Spectatorship* (London; Routledge, 1994), 153.

52. Simone de Beauvoir, *The Second Sex* (1949; London: Everyman's Library, 1993), 599.

53. Ibid.

54. Elsa Maxwell, *I Married the World* (London: Heinemann, 1955), 6.

55. David Cannadine, *The Decline and Fall of the British Aristocracy* (New Haven and London: Yale, 1990), 679.

56. Cleveland Amory, *Who Killed Society?* (New York: Harper, 1960), 135. On Britain, see Cannadine, *Decline and Fall of the British Aristocracy*, 691.

57. Amory, *Who Killed Society?*, 143–4.

58. Elsa Maxwell, *The Celebrity Circus* (London: W. H. Allen, 1964), 55–6.

59. Ibid. 52.

60. Sarah Bradford, *Princess Grace* (London: Weidenfeld and Nicolson, 1984), 76.

61. Ibid. 61.

62. Ibid. 128.

63. For a more detailed examination of these issues, see Stephen Gundle, 'Il divismo nel cinema europeo, 1945–1960', in Gian Piero Brunetta (ed.), *Storia del cinema mondiale*, i. *L'Europa*, bk. 1. *Miti, luoghi, divi* (Turin: Einaudi, 1999).

64. Bradford, *Princess Grace*, 139.

65. Mary Blume, *Cote d'Azur: Inventing the French Riviera* (London: Thames and Hudson, 1992), 144.

66. Amory, *Who Killed Society?*, 243.

67. Maxwell, *Celebrity Circus*, 31.

68. Marilyn Bender, *The Beautiful People* (New York: Coward-McCann, 1967), 89.

69. Ibid. 82.

70. Annette Tapert and Diana Edkins, *The Power of Style* (London: Aurum Press, 1995), 162.

71. Gerald Clarke, *Capote: A Biography* (1988; London: Abacus, 1993), 274.

72. Paul Fussell, *Caste Marks: Style and Status in the USA* (London: Heinneman, 1984), 27.

73. Tapert and Edkins, *The Power of Style*, 162–65.

74. Bender, *The Beautiful People*, 89.

75. Tapert and Edkins, *The Power of Style*, 166.

76. Alfred Allan Lewis and Constance Woodworth, *Miss Elizabeth Arden* (London: W. H. Allen, 1973), 87.

77. See Stephen Gundle and Clino T. Castelli, *The Glamour System* (London: Palgrave, 2006), 123–34.

78. Andrew Tobias, *Fire and Ice: The Story of Charles Revson—The Man Who Built the Revlon Empire* (New York: Morrow, 1976), 223.

79. The theme of self-invention and social climbing is recurrent in Lee Israel's unauthorized biography *Estée Lauder: Beyond the Magic* (London: Arlington, 1985).

80. Ibid. 114.

81. Estée Lauder, *Estée: A Success Story* (New York: Ballantine Books, 1986), 192–3.

82. See Christopher Sykes, *Evelyn Waugh: A Biography* (London: Penguin, 1977), 341–2 for the letter Waugh received from Pansy Lamb upbraiding him on this matter.

83. Erica Carter, *How German is She? Postwar West German Reconstruction and the Consuming Woman* (Ann Arbor: University of Michigan Press, 1997), 209–25.

84. The 1955 picture is reproduced on p. 58 of Wilcox (ed.), *Golden Age of Couture*.

85. David Seidner, 'Still Dance', in Seidner (ed.), *Lisa Fonssagrives: Three Decades of Classic Fashion Photography* (London: Thames and Hudson, 1997), 20.

86. Ibid.

87. Ginette Spanier, *It Isn't All Mink* (London: Collins, 1959), 207.

88. Praline, *Mannequin de Paris* (Paris: Seuil, 1951).

89. John Glatt, *The Ruling House of Monaco: The Story of a Tragic Dynasty* (London: Piatkus, 1998), 61.

90. Jeffrey Robinson, *Rainier and Grace* (London: Fontana, 1990), 163.

91. Blume, *Cote d'Azur*, 144.

92. Ibid. 166.

93. See Antonella Boralevi, *Capri* (Bologna: Il Mulino, 2001), ch. 4. On the Mediterranean style of this period, see Diane Berger, *Riviera Style: Lifestyle & Interiors of the Riviera, from St Tropez to Capri* (London: Scriptum, 1999).

94. Conrad Hilton, *Be My Guest* (Englewood Cliffs, NJ: Prentice-Hall, 1957), 112.

95. Ibid. 191.

96. Carla Stampa, 'Si è vestita come Tarzan per pronunciare il famoso "sì"', *Epoca*, 2 June 1956, p. 58.

97. Martin Heller, 'Glamour Pictures', in Edward Quinn, *A Cote d'Azur Album* (Zurich: Scalo, 1994), 189.

98. Edward Quinn, *Stars Stars Stars—Off the Screen* (Zurich: Scalo, 1997), 7–8.

99. Ginette Vincendeau, 'Brigitte Bardot', in John Hill and Pamela Church Gibson (eds.), *The Oxford Guide to Film Studies* (Oxford: Oxford University Press, 1998), 499.

100. Brigitte Bardot, *Mi chiamano BB—autobiografia* (Milan: Bompiani, 1996), 136–7.

101. Cari Beauchamp and Henri Béhar, *Hollywood on the Riviera* (New York: Morrow, 1992), 166.

102. Bardot, *Mi chiamano BB*, 156.

103. Pierre Cendrars, *Les Séducteurs du cinéma francais (1928 –1958)* (Paris: Henri Veyrier, 1978), 116.

104. For an illuminating portrait of one of these men, see Shawn Levy, *The Last Playboy: The High Life of Porfirio Rubirosa* (London: Fourth Estate, 2005).

105. See Alexander Walker, *Elizabeth* (1990; London; Fontana, 1992), 368. See chs. 27 and 28 for a full account of the scandal.

CHAPTER 8

1. David W. Ellwood, *Rebuilding Europe: Western Europe, America and Postwar Reconstruction* (London: Longman, 1992), 229.

2. Victoria de Grazia, *Irresistible Empire: America's Advance through Twentieth-Century Europe* (Cambridge, Mass.: Harvard University Press, 2005), 3.

3. Ibid. 5.

4. Stephen Bayley, *Harley Earl* (London: Grafton, 1992), 57.

5. Thomas Hine, *Populuxe* (London: Bloomsbury, 1987), 4.

6. Stephen Bayley, *Sex, Drink and Fast Cars* (New York: Pantheon, 1986), 13.

7. See Hine, *Populuxe*, 85.

8. Ibid. 101.

9. Ibid. 91.

10. See Hine, *Populuxe*, 106.

11. Marshall McLuhan, *Understanding Media: The Extensions of Man* (1964; London: Sphere, 1967), 232–6.

12. Dichter authored several books on motivational psychology, but his ideas gained wider currency thanks to the numerous references to them in Vance Packard's best-seller *The Hidden Persuaders* (New York: McKay, 1957).

13. Russell Lynes, *The Domesticated Americans* (New York: Harper & Row, 1962), 269.

14. For one not untypical Lancashire family, the car was treated 'like the Crown jewels' and brought out for a spin once a week, on Sunday, before being washed and put away again. Dominic Sandbrook, *Never Had It So Good: A History of Britain from Suez to The Beatles* (London: Little, Brown, 2005), 113–14.

15. Kristin Ross, *Fast Cars, Clean Bodies: Decolonization and the Reordering of French Culture* (Cambridge, Mass.: MIT Press, 1995), 27.

16. A. Bellucci, 'Trenta anni fa l'Italia si ritrovò per strada: Come la Fiat 600 cambiò la nostra vita', *La repubblica*, 12 Jan. 1985, p. 17.

17. For essays on the origins and impact of the Vespa, see Omar Calabrese (ed.), *Il mito di Vespa* (Milan: Lupetti, 2000).

18. For a wide selection of publicity material, see Jean Goyard and others, *Vespa: Les Années de charme* (Paris: Moto-Légende, 1992).

19. Roland Barthes, *Mythologies* (1957; London: Paladin: 1973), 88.

20. See Ross, *Fast Cars, Clean Bodies*, 27–54.

21. For an illuminating discussion of *Z Cars* including the production team's relationship with the Lancashire Police, see Sandbrook, *Never Had It So Good*, 377–81.

22. Barthes, *Mythologies*, 71–2.

23. Daniel Boorstin, *The Image* (1962; London: Pelican, 1963), 98.

24. Harold Mehring, *The Most of Everything: The Story of Miami Beach* (New York: Harcourt, Brace and Company, 1960), 34–45.

25. Ibid. 3; Polly Redford, *Billion Dollar Sandbar: A Biography of Miami Beach* (New York: Dutton, 1970), 240–3.

26. Joseph J. Corn, *The Winged Gospel: America's Romance with Aviation 1900–1960* (New York: Oxford University Press, 1983), 89.

27. See e.g. Joseph Kastner, 'Joan Waltermire: Air Stewardess', *Life*, 28 April 1941, pp. 102–12.

28. Ibid. 103.

29. The two sides of the stewardesses' role—glamour and servitude—are explored in Kathleen M. Barry, *Femininity in Flight: A History of Flight Attendants* (Durham, NC: Duke University Press, 2007).

30. Elizabeth Grey, *Air Hostess: The Story of Joyce Tait* (London: Robert Hale, 1957), 67.

31. Barry, *Femininity in Flight*, 2.

32. Grey, *Air Hostess*, 59–61.

33. Ibid. 12 and 100.

34. Aimée Bratt, *Glamour and Turbulence: I Remember Pan-Am 1966–1991* (New York: Vantage, 1996), 12.

35. Ibid.

36. This short film is discussed in detail in Stephen Gundle, *Bellissima: Feminine Beauty and the Idea of Italy* (New Haven and London: Yale University Press, 2007), 180–1.

37. Kastner, 'Joan Waltermire', 112.

38. Ibid. 35.

39. Barry, *Femininity in Flight*, 176–7.

40. Paula Kane with Christopher Chandler, *Sex Objects in the Sky* (Chicago: Follett, 1974), 12–13.

41. Ibid. 35.

42. Ibid. 12–13.

43. J. B. Priestley and Jacquetta Hawkes, *Journey Down a Rainbow* (1955; Harmondsworth: Penguin, 1969), 50.

44. McLuhan, *Understanding Media*, 238–9.

45. William H. Whyte, *The Organization Man* (1956; London: Pelican, 1963), 288.

46. David Riesman, *The Lonely Crowd: A Study of the Changing American Character* (New Haven: Yale University Press, 1950).

47. Ibid.

48. Ibid. 265.

49. Ibid. 147.

50. Ibid. 191.

51. Raymond Williams, *Television: Technology and Cultural Form* (London: Penguin, 1974), 26.

52. McLuhan, *Understanding Media*, 341–2.

53. Ibid. 339.

54. Susan J. Douglas, *Where the Girls Are: Growing Up Female with the Mass Media* (Harmondsworth: Penguin, 1994), 200.

55. Christine Becker, ' "Glamor Girl Classed as TV Show Brain": The Body and Mind of Faye Emerson', *Journal of Popular Culture*, 38/2 (2004), 242–59.

56. See Stephen Gundle, '*Signorina buonasera*: Images of Women in Early Italian Television', in Penelope Morris (ed.), *Women in Italy, 1945–1960* (New York: Palgrave, 2007), 71.

57. Mary Margaret McBride, 'Much of Glamour Is the Unknown', *Los Angeles Times*, 25 Nov. 1953, p. B1.

58. Joe Hyams, 'Good by to the Glamour Girls', *Los Angeles Times*, 18 Sept. 1960, p. TW14.

59. McLuhan, *Understanding Media*, 342–3.

60. On this issue, see Lynn Spigel, *Make Room for TV: Television and the Family Ideal in Postwar America* (Chicago: University of Chicago Press, 1992); Denise Mann, 'The Spectacularization of Everyday Life', in Lynn Spigel and Denise Mann (eds.), *Private Screenings* (Minneapolis: University of Minnesota Press, 1992).

61. Gerold Frank, *Zsa Zsa Gabor: My Story* (1960; London: Pan, 1962), 251.

62. See Douglas, *Where the Girls Are*, 99–101.

63. Marina Coslovi, 'Il Glamour ci viene da Hollywood: L'Immagine dell' America in una rivista femminile del dopoguerra', unpublished paper, undated, p. 3.

64. See Malcolm Gladwell, 'True Colors: Hair Dye and the Hidden History of Postwar America', *New Yorker*, 22 Mar. 1999, pp. 70–81.

65. Stephen Fenichell, *Plastic: The Making of a Synthetic Century* (London: HarperBusiness, 1996), 112.

66. Ibid. 113. Helena Rubinstein offered her new face powder and rouge in a combination elegantly wrapped in cellophane. The lid of the rouge compact was held in place by a cellophane sheathing that was embossed with a 'personal' note in Helena's own hand.

67. Barthes, 'Striptease', in *Mythologies*, 85–6.

68. Barthes, 'Plastic', in *Mythologies*, 97.

69. Dea Birkett, 'I'm Barbie, Buy Me', *Guardian Weekend*, 28 Nov. 1998, pp. 13–21, at 15.

70. Ibid. 21.

71. Richard Horn, *Fifties Style: Then and Now* (London: Columbus, 1985), 118.

72. Penny Sparke, *As Long As It's Pink: The Sexual Politics of Taste* (London: Pandora, 1995), 201.

73. Barthes, 'Plastic', 99.

74. Fenichell, *Plastic*, 234.

75. Barthes, 'Plastic', 98.

76. Ibid. 197–8.

77. Joseph Rosa, 'Fabricating Affluence', in Rosa (ed.), *Glamour: Fashion + Industrial Design + Architecture* (New Haven and London: Yale University Press, 2004), 16.

78. Bill Davidson, *The Real and the Unreal* (New York: Harper, 1961), 4.

79. Ibid. 267.

80. See Richard Dyer, 'Monroe and Sexuality', in Janet Todd (ed.), *Women and Film* (New York: Holmes and Meier, 1988).

81. See Thomas Harris, 'The Building of Popular Images: Grace Kelly and Marilyn Monroe', in Christine Gledhill (ed.), *Stardom: Industry of Desire* (London: Routledge, 1991), 41.

82. One of her former charm school colleagues remembered her as follows: 'Diana Dors was fantastic—how she used to flaunt it. We used to call her Diamond Drawers. She'd arrive in low-cut gowns, with her hair piled up and all the make-up, great big high-heeled shoes and nylon stockings—which were ten shillings a pair on the black market.... I learned more from watching Diana than anything else. She could take a man into a corner and dazzle him.

She was as hard as nails but such a character: she'd tell us straight-faced that she didn't bleach her hair.' Patricia Dainton, 'Even at Charm School, Diana Dors Knew How to Dazzle a Man', *Daily Mail*, *Weekend* suppl., 19 Sept. 1998, p. 11.

83. Quoted in Sandbrook, *Never Had It So Good*, 126.

84. Elsa Maxwell, *The Celebrity Circus* (London: W. H. Allen, 1964), 11.

85. Edgar Morin, *Les Stars* (1957; Paris: Gallimard, 1972).

86. Ibid. 24.

87. Elissa Stein, *Beauty Queen* (San Francisco: Chronicle, 2006), 40.

88. Michele N. S. Bentata, 'The Beauty Contest in Women's History' (MA diss. Royal Holloway, University of London, 1993), 13.

89. On the 'Americanization' of beauty contest presentation in Britain, see Eric Morley, *Miss World Story* (London: Angley Books, 1967), 62–6.

90. Ibid. 105–6.

91. See Stein, *Beauty Queen*, 23.

92. Don Short, *Miss World: The Naked Truth* (London: Everest, 1976), 32.

93. Candace Savage, *Beauty Queens: A Pictorial History* (Vancouver and Toronto: Greystone, 1998), 9.

94. Bentata, 'Beauty Contest', 43.

95. Savage, *Beauty Queens*, p. ix.

96. Bentata, 'Beauty Contest', 41.

97. Ibid., app., questionnaire 7.

98. Ibid., app., questionnaire 10.

99. See Susan Dworkin, *Miss America, 1945: Bess Myerson's Own Story* (New York: Newmarket Press, 1987).

100. Betty Friedan, *The Feminine Mystique* (1963; Harmondsworth: Penguin, 1965), 198.

101. Riesman, *Lonely Crowd*, 146.

102. Ibid. 147.

103. Ibid. 116.

104. Friedan, *Feminine Mystique*, 231.

105. C. Wright Mills, *The Power Elite* (New York: Oxford University Press, 1959), 81.

106. Ibid. 236.

107. Rachel Shtier, *Striptease: The Untold History of the Girlie Show* (New York: Oxford University Press, 2004), 279. When Germaine Greer referred to 'the ebullient arabesques of the tit-queen', it may be assumed she had Tempest Storm and her colleagues in mind. See *The Female Eunuch* (London: MacGibbon and Kee, 1970), 45.

108. It has been reported that her lovers included Sammy Davis Jnr., Elvis Presley, and John F. Kennedy. See Steve Sullivan, *Va Va Voom! Bombshells, Pin-Ups, Sexpots and Glamour Girls* (Los Angeles: General Publishing Co., 1995), 267.

109. Quoted in John Kobal (ed.), *George Hurrell: Hollywood Glamour Portraits* (London: Schirmer, 1993), 13.

110. Susan Bernard (ed.), *Bernard of Hollywood's Marilyn* (London: Boxtree, 1993), 7.

111. Ibid. 8.

112. Cited in Jimmy McDonough, *Big Bosoms and Square Jaws: The Biography of Russ Meyer—King of the Sex Film* (London: Cape, 2005), 81.

113. Russ Meyer, *The Glamour Camera of Russ Meyer* (Louisville, Ky.: Whitestone, 195): 137–8.

114. Quoted in McDonough, *Big Bosoms and Square Jaws*, 61.

115. Bunny Yeager, *100 Girls: New Concepts in Glamour Photography* (London: Yose Ioll, 1965), 7.

116. Bill Osgerby, *Playboys in Paradise: Masculinity, Youth and Leisure-Style in Modern America* (Oxford; Berg, 2001), 146.

117. On Hefner's 'playmates', see Joan Acocella, 'The Girls Next Door', *New Yorker*, 20 Mar. 2006, pp. 144–8.

118. Osgerby, *Playboys in Paradise*, pp. 79–81.

119. Richard Hoggart, *The Uses of Literacy* (1957; Harmondsworth: Penguin, 1968), 232–3.

120. Priestley and Hawkes, *Journey Down a Rainbow*, 106–7.

121. Shtier, *Striptease*, 280.

122. Sandbrook, *Never Had It So Good*, 578.

123. For a historical analysis of the appeal of Bond, see ibid., ch. 16.

124. Graham McCann, *Cary Grant: A Class Apart* (London: Fourth Estate, 1996), 12, 122.

125. Ibid. 11.

CHAPTER 9

1. Camille Paglia, *Vamps and Tramps: New Essays* (London: Penguin, 1995), 191.

2. C. David Heymann, *A Woman Named Jackie* (1989; London: Mandarin, 1994), 254.

3. Her letter to him is reproduced in Oleg Cassini, *A Thousand Days of Magic: Dressing Jacqueline Kennedy for the White House* (New York: Rizzoli, 1995), 30.

4. Heymann, *A Woman Named Jackie*, 162.

5. Ibid. 184.

6. Quoted ibid. 220.

7. See Sarah Bradford, *Princess Grace* (London: Weidenfeld & Nicolson, 1984), 76–7.

8. See Arthur Marwick, *The Sixties: Cultural Revolution in Britain, France, Italy and the United States, c.1958–1974* (Oxford: Oxford University Press, 1998), 3.

9. Ibid. 13.

10. Guy Debord, *La Société du spectacle* (Paris: Buchet/Chastel, 1967).

11. Marwick, *The Sixties*, 18.

12. Stephen Birmingham, *Jacqueline Bouvier Kennedy Onassis* (London: Gollancz, 1979), 7–8.

13. Ibid. 178.

14. Heymann, *A Woman Named Jackie*, 138, 141.

15. The question of whether her patrician image was true or stylized was raised in Herbert Muschamp, 'Camelot's Once and Future Glamour', *New York Times*, 4 May 2001, p. E32.

16. In this sense they belonged to the most visible, lower stratum of the American upper class. See Paul Fussell, *Caste Marks: Style and Status in the USA* (London: Heinemann, 1984), 31.

17. Birmingham, *Jacqueline Bouvier*, 111.

18. Ibid. 112.

19. Wayne Koestenbaum, *Jackie under My Skin: Interpreting an Icon* (London: Fourth Estate, 1995), 70.

20. Ibid. 102.

21. Quoted ibid. 302.

22. 'She is . . . the most photogenic women in the world, infinitely more so than her infinitely more beautiful sister,' wrote Beaton in a diary entry. See Hugo Vickers (ed.), *Beaton in the Sixties* (London: Weidenfeld & Nicolson, 2003), 258. Her sister was Lee Radziwill.

23. Heymann, *A Woman Named Jackie*, 126.

24. Marilyn Bender, *The Beautiful People* (New York: Coward-McCann, 1967), 44.

25. Oleg Cassini, *In My Own Fashion: An Autobiography* (1987; New York: Pocket Books, 1990), 325.

26. Sarah Bradford, *America's Queen: The Life of Jacqueline Kennedy Onassis* (London: Viking, 2000), 506.

27. Ibid. 135.

28. Beaton did not like to think of himself as the royal photographer, yet he had been a royal favourite since before the war and was wary of pretenders to this role. At one time he feared Baron, a friend of Prince Philip's, and later Antony Armstrong-Jones. Hugo Vickers, *Cecil Beaton* (London: Weidenfeld, 1993), 367–78, 435.

29. Ibid. 499.

30. Kate de Castelbajac, *The Face of the Century* (London: Thames and Hudson, 1995), 129.

31. Bender, *Beautiful People*, 77.

32. Vickers, *Cecil Beaton*, 499.

33. Richard Martin and Harold Koda, *Diana Vreeland: Immoderate Style* (New York: Metropolitan Museum of Art, 1993), 8.

34. Ibid.

35. See Martin Harrison, *Parkinson Photographs 1935–1990* (London: Conran Octopus, 1998), pages unnumbered.

36. Anthony Haden-Guest, 'The Queen is Dead', *Observer Magazine*, 12 Feb. 2006, pp. 40–6.

37. Ibid. 95.

38. Vickers, *Cecil Beaton*, 436.

39. In his memoirs, the photographer dubbed *Queen* 'a truly revolutionary and fantastic magazine'. See Helmut Newton, *Autobiography* (London: Duckworth, 2003), 171.

40. Quoted in Haden-Guest, 'The Queen is Dead', 45. For a selection of features and photographs from the magazine, see Nicholas Coleridge and Stephen Quinn (eds.), *The Sixties in Queen* (London: Ebury, 1987).

41. For Vreeland's attitude, see Bender, *Beautiful People*, 109–10.

42. Patrick Lichfield, *Not the Whole Truth* (London: Headline 1987), 105–8.

43. Valerie Grove, 'Image Maker', *Cam*, 50 (Lent Term 2007), 11.

44. See his encounter with Prince Philip in 1960, described in Vickers, *Cecil Beaton*, 438–9.

45. Robert Glenton and Stella King, *Once Upon a Time: The Story of Antony Armstrong-Jones* (London: Anthony Blond, 1960), 13.

46. Lichfield made the point about the hairdresser in *Not the Whole Truth* (p. 90), while Aitken is quoted in Dominic Sandbrook, *White Heat: A History of Britain in the Swinging Sixties* (London: Little, Brown, 2006), 228.

47. See Jean-Noël Liaut, *Modèles et Mannequins 1945–1965* (Paris: Filipacchi, 1994).

48. Ginette Spanier, *It Isn't All Mink* (London: Collins, 1959), 198–9.

49. Bettina, *Bettina* (London: Michael Joseph, 1965), 57–8.

50. Ibid. 58.

51. See Nigel Cawthorne, *The New Look: The Dior Revolution* (London: Hamlyn, 1996), 88.

52. Ibid. 43.

53. Ibid. 42–3.

54. Jean Shrimpton, *An Autobiography* (London: Ebury, 1990), 38.

55. Ibid. 40.

56. Shawn Levy, *Ready, Steady, Go!: Swinging London and the Invention of Cool* (London: Fourth Estate, 2002), 30.

57. Ibid. 33.

58. Shrimpton, *An Autobiography*, 89.

59. Levy, *Ready, Steady, Go!*, 8–9.

60. See Coleridge and Quinn, *The Sixties in Queen*, 118–21.

61. See Anon., 'The New Class: A Postmortem', ibid. 142–5.

62. Ibid. 142.

63. David Bailey, *Box of Pin-Ups* (London: Weidenfeld & Nicolson, 1965).

64. Francis Wyndham, 'Introduction', ibid.

65. Cleveland Amory, *Who Killed Society?* (New York: Harper & Brothers, 1960), 143–4.

66. Philippa Pullar, *Gilded Butterflies: The Rise and Fall of the London Season* (London: Hamish Hamilton, 1978), 186.

67. On London nightlife in the mid-sixties, see Sandbrook, *White Heat*, 253–4.

68. The 'trickle-down' theory was formulated by Georg Simmel. See 'Fashion', *International Quarterly*, 10 (1904), 130–55.

69. For an exploration of the theme of movement and the single girl, see Hilary Radner, 'On the Move: Fashion Photography and the Single Girl in the 1960s', in Stella Bruzzi and Pamela Church Gibson (eds.), *Fashion Cultures: Theories, Explorations and Analysis* (London: Routledge, 2000), 128–42.

70. Sandbrook, *White Heat*, 232.

71. Quoted and discussed ibid. 244–6.

72. Michel Winock, *Chronique des années Soixante* (Paris:Seuil, 1987), 107.

73. Hedonism and fashion combined in sixties' New York to 'unlock the gilded cages in which some of the aristocrats had felt confined and gave the former outcasts a chance to have a whirl inside', according to Marilyn Bender in *Beautiful People*, 138–9.

74. On the culture of French youth in the 1960s, see Jean-François Sirinelli, *Les Baby Boomers: Une génération 1945–1969* (Paris: Fayard, 2003).

75. Linda Benn DeLibero compares Villeneuve to Epstein and Loog Oldham. See her essay 'This Year's Girl: A Personal/Critical History of Twiggy', in Shari Benstock and Suzanne Ferris (eds.), *On Fashion* (New Brunswick, NJ: Rutgers University Press, 1994), 41–58.

76. Twiggy, *An Autobiography* (1975; London: Granada 1976), 47.

77. Ibid. 27. On the Twiggy phenomenon, see Sandbrook, *White Heat*, ch. 15.

78. Quoted in Castelbajac, *Face of the Century*, 130.

79. See Sandbrook, *White Heat*, 224–7.

80. Twiggy, *Autobiography*, 44.

81. Clive Scott, *The Spoken Image: Photography and Language* (London: Reaktion, 1999), 145.

82. Twiggy, *Autobiography*, 74.

83. Ibid. 77.

84. Ibid. 101.

85. Mary Quant, *Quant by Quant* (London: Pan, 1966), 40.

86. Winock, *Chronique des années Soixante*, 119.

87. Alice Rawsthorn, *Yves Saint Laurent* (London: HarperCollins, 1996), 86.

88. Vickers, *Beaton in the Sixties*, 526.

89. Quoted in Vickers, *Cecil Beaton*, 511.

90. Quoted in Martin and Korda, *Diana Vreeland*, 18.

91. See Julie Kavanagh, *Rudolf Nureyev: The Life* (London: Fig Tree, 2007).

92. On the background to the film, see Levy, *Ready, Steady, Go!*, 181–6.

93. Sandbrook gives the film short shrift, claiming that it received a tepid critical and public reaction: *White Heat*, 382. In fact, it was hugely influential and more than any other single film was responsible for conveying the image of Swinging London to the world.

94. Susan Sontag, *On Photography* (1973; Harmondsworth: Penguin, 1979), 90.

95. Shrimpton, *Autobiography*, 77.

96. See Sandbrook, *White Heat*, 230.

97. Newton, *Autobiography*, 177.

98. Sontag, *On Photography*, 110.

99. Hoggart, *The Uses of Literacy*, 254.

100. Jacob Deschin, 'Glamour Across Decades', *New York Times*, 8 Aug. 1965, p. X8.

101. Corrado Morin, *Fotografia glamour* (Trieste: Edizioni Tec Foto, 1969).

102. Ibid. 28.

103. Rayment Kirby, *Glamour Photography* (London: Focal, 1983), 88.

104. Ibid.

105. Jon Stratton, *The Desirable Body: Cultural Fetishism and the Erotics of Consumption* (Manchester: Manchester University Press, 1996), 108.

106. Sandbrook, *White Heat*, 377–8.

107. Francis Wyndham, 'A Day With Elizabeth Taylor VIP', in Coleridge and Quinn, *The Sixties in Queen*, 96 and 101.

108. Winock, *Chronique des années Soixante*, 145–6.

109. Kathleen M. Barry, *Femininity in Flight: A History of Flight Attendants* (Durham, NC: Duke University Press, 2007), ch. 4.

110. Anita Colby, *Anita Colby's Beauty Book* (New York: Prentice-Hall, 1952), 2; Helen Hugh, *Glamour School* (London: Daily Mirror, undated *c.*1955), 5–6.

111. Princess Luciana Pignatelli, *The Beautiful People's Beauty Book* (New York: McCall, 1970), 16.

112. Ibid. 46 and 78.

113. Ibid. 81.

114. Birmingham, *Jacqueline Bouvier*, 167.

115. Bender, *Beautiful People*, 54

116. Ibid. 53.

117. Ibid. 44–6.

118. Ibid. 46.

119. Bradford, *America's Queen*, 439.

120. Ibid. 71.

121. Ron Galella, *Off-Guard: Beautiful People Unveiled before the Camera Lens* (New York: Greenwich House, 1987), 125.

122. Ibid. 124.

123. Sontag, *On Photography*, 67.

124. See Koestenbaum, *Jackie under My Skin*, 168–9.

125. Barbara Seaman, *Lovely Me: The Life of Jacqueline Susann* (London: Sidgwick & Jackson, 1988), 283.

126. Jacqueline Susann, *Jacqueline Susann's Dolores* (London: W. H. Allen, 1976), 27.

127. Ibid. 58.

128. Ibid. 55.

129. Koestenbaum, *Jackie under My Skin*, 248.

130. Ibid. 248.

131. See Scott, *Spoken Image*, 156–7.

CHAPTER 10

1. Mark Francis and Margery King (eds.), *The Warhol Look: Glamour, Style, Fashion* (Boston: Bullfinch Press, 1998), 36–7.

2. Interview in Patrick Smith (ed.), *Andy Warhol's Art and Films* (Ann Arbor: UMI Research Press, 1986), 458.

3. Ibid. 127.

4. For Juan A. Suárez, Warhol's superstars were 'a parodic simulacrum' in the void left by the decline of the star system. *Bike Boys, Drag Queens & Superstars* (Bloomington: Indiana University Press, 1996), 228.

5. Roger Baker, *Drag: A History of Feminine Impersonation in the Performing Arts* (1968; London: Cassell, 1994), 14–15.

6. Andy Warhol, *The Philosophy of Andy Warhol: From A to B and Back Again* (London: Cassell, 1975), 54.

7. Ibid. 54–5.

8. Ibid. 68.

9. Ibid. 54.

10. Richard Schickel argued that Warhol was 'a sort of demented Louis B. Mayer' who turned himself into 'the dumb blonde of Hollywood lore, displaced but distinctly reincarnated'. See *Intimate Strangers: The Culture of Celebrity* (Garden City, NY: Doubleday and Co., 1985), 237–8.

11. Fred Guiles, *Loner At The Ball: The Life of Andy Warhol* (London: Bantam, 1989), 53–4.

12. Schickel, *Intimate Strangers*, 157.

13. Ibid. 71.

14. See Jeffrey L. Meikle, *American Plastic: A Cultural History* (New Brunswick; Rutgers University Press, 1995). See also Peter Wollen, 'Plastics', in Francis and King, (eds.), *Warhol Look*, unnumbered page.

15. Warhol, *Philosophy of Andy Warhol*, 53.

16. Richard Schickel referred to Warhol's 'bland translucency' like 'frosted glass' and quoted him as once saying, 'If you want to know about Andy Warhol, just look at the surface of my paintings and films and me, and there I am. There is nothing behind it.' See *Intimate Strangers*, 236–7.

17. Warhol, *Philosophy of Andy Warhol*, 85.

18. See Justin Kaplan (ed.), *Barlett's Familiar Quotations* 18th edn. (New York: Little, Brown, 1992), 758.

19. Ibid. 56.

20. Ibid. 61.

21. Baker, *Drag*, 246–7.

22. Philip Auslander, *Performing Glam Rock: Gender and Theatricality in Popular Music* (Ann Arbor: University of Michigan Press, 2006), 122.

23. Ibid. 48. See also Baker, *Drag*, 241.

24. Baker, *Drag*, 206.

25. Barney Hoskyns, *Glam! Bowie, Bolan and the Glitter Rock Revolution* (New York: Pocket Books, 1998), 23.

26. Auslander suggests that some glam rockers also appropriated musical motifs from Elvis, Gene Vincent, and other 1950s rock and rollers. See *Performing Glam Rock*, 56–7.

27. Karal Ann Marling, *Graceland: Going Home with Elvis* (Cambridge, Mass.: Harvard University Press, 1996).

28. On the early years of Roxy Music, see Michael Bracewell, *Re-Make/Re-Model* (London: Faber, 2007) and his article 'Look Back in Languor', *Guardian Weekend*, 14 June 1997.

29. Bracewell, 'Look Back in Languor', 20.

30. Quoted ibid.

31. Ibid.

32. Ibid. 22.

33. 'I guess I have not been very good at timing in my career. In most cases I was a little early, but then I was too late for the glamorous Hollywood period. Maybe if I had woken up in Travis Banton's shoes, I would have done just fine, but there are not that many Marlenes around.' Antony Price, quoted in Iain R. Webb, 'Price of Perfection', *Independent Magazine*, 24 June 2006, p. 33.

34. Bracewell, 'Look Back in Languor', 25.

35. David Riesman, *The Lonely Crowd: A Study of the Changing American Character* (New Haven: Yale University Press, 1950).

36. Christopher Lasch, *The Culture of Narcissism* (1979; London: Abacus, 1980), 166.

37. Ibid. 174.

38. See Tom Wolfe, 'The Me Decade and the Third Great Awakening', in Wolfe, *Mauve Gloves & Madmen, Clutter and Vine* (Tornot: Bantam, 1977). These positions coincided in general terms with the perspective developed a few years earlier by the French situationist Guy Debord, who wrote: 'Behind the glitter of the spectacle's distractions, modern society lies in thrall to the global domination of a banalizing trend that also dominates it at each point where the most advanced forms of commodity consumption have seemingly broadened the panoply of roles and objects available to choose from. The vestiges of religion and of the family... can now be seamlessly combined with the rhetorical advocacy of pleasure in *this life*.' See *The Society of Spectacle* (1967; New York: Zone Books, 1995), 38.

39. In a critique of Lasch's narcissism thesis, Russell Jacoby argued that narcissism harboured protest in the name of individual health and happiness against the ethic of sacrifice. See 'Narcissism and the Crisis of Capitalism', *Telos*, 44 (1980), 58–65. For his part, Stuart Ewen suggested that narcissism was not new; consumerism from the late nineteenth century had undermined traditional group bonds in favour of the satisfaction of needs. See 'Mass Culture, Narcissism and the Moral Economy of War', *Telos*, 44 (1980), 74–87. This process gradually made the individual more subject to the media, whose products, even if they were consumed collectively, were interiorized individually.

40. For a sustained reflection on surface and depth in fashion and appearance, see Alexandra Warwick and Dani Cavallaro, *Fashioning the Frame: Boundaries, Dress and the Body* (Oxford: Berg, 1998), ch. 4.

41. Gerald Clarke, *Capote: A Biography* (1988; London: Abacus, 1993), 541.

42. Bracewell, 'Look Back in Languor', 25.

43. See Michael Bracewell, 'The Return of the Glamour Boy', *ES Magazine*, 31 Mar. 2000, p. 20.

44. On early London discotheques, see Dominic Sandbrook, *White Heat: A History of Britain in the Swinging Sixties* (London: Little, Brown, 2006), 248–50.

45. Alicia Drake, *The Beautiful Fall: Fashion, Genius and Glorious Excess in 1970s Paris* (London: Bloomsbury, 2006), 119–20.

46. See Anthony Haden-Guest, *The Last Party: Studio 54, Disco and the Culture of the Night* (New York: Morrow, 1997).

47. Cited ibid. 50.

48. Ibid. 63.

49. Ibid. 52.

50. Truman Capote, *Unanswered Prayers: The Unfinished Novel* (London: Hamish Hamilton, 1988). Sections of the novel were published in *Esquire* in 1975 and 1976. The chapter entitled 'La Côte Basque', based on the personal life of CBS owner William Paley and his stylish wife Barbara 'Babe', one of Capote's confidantes, was seen as a betrayal. The author exposed

the glamorous life of the rich as a shark pool of confidence tricksters and sexual predators. In consequence, his one-time friends closed their doors to him.

51. Pat Hackett (ed.), *The Andy Warhol Diaries* (London: Simon and Schuster, 1989), 101.

52. Kennedy Fraser, *The Fashionable Mind: Reflections on Fashion 1970–1981* (New York: Knopf, 1981), 73.

53. Hackett (ed.), *The Andy Warhol Diaries*, 94.

54. Francis and King, *Warhol Look*, 248.

55. On the dawn of the style culture of the 1980s in Britain, see Dylan Jones, 'Hello Gorgeous', *The Sunday Times, News Review* suppl., 4 Apr. 1999, pp. 1–2.

56. The 15,000 clients that bought couture in the post-war years had shrunk, by the later 1960s, to just to 3,000. The number of couturiers in Paris was also shrinking, from around one hundred, they were down to forty by 1965. See Alice Rawsthorn, *Yves Saint Laurent* (London: HarperCollins, 1996), 84–5.

57. Ibid. 116–17.

58. The American model Pat Cleveland, who worked for the Paris house Chloe in the early 1970s, claimed to have introduced a new show-off element to modelling. Even though she was modelling in-house, in the time-honoured way, she discarded her usual poses: 'I started to smile, I started to move my legs. I was doing all sorts of poses on the stairs, I was doing every movie star I ever knew, Marilyn, Jane Russell, blowing kisses; I was touching my hair, touching my body and people were screaming and standing up, applauding and trying to touch me.' Her attitude was similar to that of Warhol's wannabe superstars: 'we had grown up with movies and movie star attitude and we were there to be stars, superstars. We wanted to shine day and night,' she recalled. Quoted in Drake, *Beautiful Fall*, 118–19.

59. Italian photographer Oliviero Toscani noted that Newton, who died at age 83 in Jan. 2004, had experienced a star's death, at the wheel of a Cadillac on Sunset Boulevard. Among the tributes offered by Newton's colleagues in French magazine *Photo*, he controversially observed that the late photographer's work was paradoxical. Despite his Jewish origins, 'it seems to me that the near totality of his photos bear the stigmata of the Third Reich', Toscani asserted. 'His models, his celebrated female nudes, seemed to me to be variants of a virtual Brunhilde, of an entirely Wagnerian Walkyrie. His imagination was concentrated on bodies that exhibit a sculptural immobility; he captured their potential cruelty and their inaccessible character. I am under the impression that in this he owed much to Leni Riefenstahl and to her Aryan models.' *Photo* (Spécial Helmut Newton) (Apr. 2004), 88–90. In his *Autobiography* (London: Duckworth, 2003), Newton confessed his great admiration for Riefenstahl (whom he met on several occasions) as a film-maker and photographer (p. 274).

60. See Karl Lagerfeld, 'Sa vie', *Photo* (Spécial Helmut Newton) (Apr. 2004), 28.

61. See Sean O'Hagan, 'The King of Kinky', *Observer Magazine*, 7 Aug. 2005, p. 20.

62. Newton, *Autobiography*, 189.

63. The photographer never bothered to counter criticism. Indeed, in his autobiography, he declared: 'I have always been very interested in prostitution, since I saw Red Erna at the age of seven. There is something about buying a woman that excites me. One of the things that used to excite me was the concept that the woman was like merchandise.' See ibid. 158.

64. He claimed never to consider what might excite the public: 'if I were to do that, I would never take a picture. No, I just please myself,' he stated (ibid. 241). However, when he took a picture of actress Hannah Schygulla as Lili Marlene for German *Vogue* in which her underarm hair was on view, he found that there were boundaries to his freedom. 'In the world of *Vogue*, there is no underarm hair, ever,' he was forced to acknowledge (ibid. 235).

65. Newton admitted that he had done some privately commissioned pornographic work. See ibid. 261.

66. See Natalia Aspesi, 'Lei, signora senza rimpianti', *La Repubblica*, 14 Mar. 1999, p. 38.

67. On Deneuve and Chanel, see Judith Williamson, *Decoding Advertisements: Ideology and Meaning in Advertisements* (London; Marion Boyars, 1978), 27–30.

68. Lasch, *Culture of Narcissism*, 166.

69. See Riesman, *Lonely Crowd*. His analysis is referred to in ch. 8.

70. Boussac in fact failed to deal with the changes of the 1970s as well as he had those of the post-war world. He went bankrupt in 1978.

71. Drake, *Beautiful Fall*, 129.

72. Steven Gaines, *Simply Halston: The Untold Story* (New York: Putnam's, 1991), 8.

73. Fraser, *Fashionable Mind*, 114.

74. Georgina Howell, *Sultans of Style: Thirty Years of Fashion and Passion 1960–1990* (London: Ebury, 1990), 80.

75. Drake, *Beautiful Fall*, 163.

76. Steven Gaines and Sharon Churcher, *Obsession: The Lives and Times of Calvin Klein* (1994; New York: Avon 1995), 85–7.

77. Ibid. 93. See also Caroline Rennolds Milbank, *New York Fashion: The Evolution of American Style* (New York: Abrams, 1989), 242.

78. Ibid. 191.

79. Richard Morais, *Pierre Cardin: The Man Who Became a Label* (London: Bantam, 1991), 91.

80. Ibid. 150.

81. Gaines, *Simply Halston*, 239.

82. This process is analysed at length in Colin McDowell, *The Designer Scam* (London: Hutchinson, 1994).

83. Gaines and Churcher, *Obsession*, 235.

84. Ibid. 101.

85. Drake, *Beautiful Fall*, 66.

86. Ibid. 139–40.

87. Ibid. 130.

88. On these controversial episodes, see Michael Gross, *Genuine Authentic: The Real Life of Ralph Lauren* (New York: HarperCollins, 2003), 153–4, 176.

89. Graham McCann, *Cary Grant: A Class Apart* (London: Fourth Estate, 1996), 3.

90. Ibid.

91. See Colin McDowell, *Ralph Lauren: The Man, The Vision, The Style* (London: Cassell, 2002), 136–40.

92. See McDowell, *Designer Scam*, 176–80.

93. Ibid. 206.

94. Ibid. 11.

95. Ibid. 74.

96. Ibid. 122.

97. This difference was present in the mind of Esther Shapiro, one of the show's creators. See Jostein Gripsrud, *The Dynasty Years: Hollywood Television and Critical Media Studies* (London: Routledge, 1995), 34–5. In some ways Blake Carrington resembled the show's producer, Aaron Spelling.

98. Joan Collins, *Past Imperfect* (London: Coronet, 1978), 47.

99. Gripsrud, *Dynasty Years*, 152.

100. Patricia A. Cunningham, Heather Mangine, and Andrew Reilly, 'Television and Fashion in the 1980s', in Linda Welters and Patricia A. Cunningham (eds.), *Twentieth-Century American Fashion* (Oxford: Berg, 2005), 222.

101. Debora Silverman, *Selling Culture: Bloomingdale's, Diana Vreeland and the New Aristocracy of Taste in Reagan's America* (New York: Pantheon, 1986), 152.

102. David Cannadine, *The Decline and Fall of the British Aristocracy* (1990; New Haven and London: Yale University Press, 1996), 689.

103. John Fairchild, *Chic Savages* (New York: Simon and Schuster 1989), 88.

104. By 1996, the figure was $500 m. See Colin McDowell, 'Get a Life, Viv', *The Sunday Times, Style* suppl., 22 Sept. 1996, pp. 10–11.

105. Gross, *Genuine Authentic*, 227.

106. McDowell, *Ralph Lauren*, 136.

107. Ibid. 136–8.

108. Gaines and Churcher, *Obsession*, 389. Although drug addiction would shortly force him into re-hab, he returned to cultivate an image of a conventional lifestyle. On his drug addiction, see ibid. 217–19.

109. Thorstein Veblen, *Theory of the Leisure Class* (1899; Boston: Houghton Mifflin, 1973), 72.

110. See McDowell, 'Get a Life, Viv'. British designers, he argues, did not grasp this at all.

111. Joshua Meyrowitz, *No Sense of Place: The Impact of Electronic Media on Social Behaviour* (New York: Oxford University Press, 1986), 99.

112. See Rennolds Milbank, *New York Fashion*, 275.

113. Fairchild, *Chic Savages*, 78.

114. Fraser, *Fashionable Mind*, 154.

115. See Stephen Gundle, 'Hollywood Glamour and Mass Consumption in Postwar Italy', *Journal of Cold War Studies*, 4/3 (Fall 2002), 95–118.

116. See McDowell, *Designer Scam*, 54–6.

117. Quoted in Bob Colacello, 'Nan in Full', *Vanity Fair* (Apr. 2005), 183.

118. Ibid. 178.

119. See Fairchild, *Chic Savages*.

120. Ibid. 66.

121. Michael Specter, 'The Kingdom', *New Yorker*, 26 Sept. 2005, p. 126.

122. Quoted in Antonella Amapane, 'Valentino seduce con pizzi e drapeggi', *La stampa*, 10 July 2000, p. 14.

123. Quoted in Anon., 'Guardate questa meraviglia: È la ricca casa romana di Valentino, il sarto delle stelle', *Gente*, 25 Jan. 1993, p. 81.

124. William Middleton, 'Prince Val', *W* (Apr. 1997), 50.

125. Ibid. 135.

126. Howell, *Sultans of Style*, 27.

127. Nicholas Coleridge, *The Fashion Conspiracy* (London: Heinemann, 1988), 223.

128. The house was first displayed in the press in Anon., 'Guardate questa meraviglia', 80–3.

129. *Time*, 14 (1982). The cover read: 'Giorgio's Gorgeous Style', while the accompanying article praised his role in reshaping and restructuring the way people dress.

130. See, for example, Meredith Etherington-Smith, 'Smooth Operator', *Telegraph Magazine*, suppl. to *Daily Telegraph*, 23 Aug. 2003, p. 27.

131. See Cunningham, Mangine, and Reilly, 'Television and Fashion in the 1980s', 212.

132. Drake, *Beautiful Fall*, 129–30. See also John Colapinto, ' "You'll Think I'm a Madman" ', *Observer Magazine*, 27 May 2007, pp. 19–20.

CHAPTER 11

1. So insatiable was the thirst for pictures of her and so lucrative were the rewards for them that she became quite literally a prey for dozens of paparazzi photographers. Her death in Paris while seeking to evade their insistent attentions was, it was observed, like 'a ghoulish re-run of *La Dolce Vita*', the film in which these celebrity hunters first came to public attention and acquired their name. Simon Jenkins, 'No law could have shielded her', *The Times*, 1 Sept. 1997, p. 24.

2. Paul Johnson, 'The Two Sides of Diana', *Daily Mail*, 1 Sept. 1997, p. 4.

3. Bryan Appleyard, 'Diana, First Lady of the Global Village', *The Sunday Times*, *News Review*, 7 Sept. 1997, p. 6. Compare his observation with Stuart Ewen's view that 'photogenic beauty rests its definition on a smooth, standardised and lifeless modernism, a machine

aesthetic in the guise of a human.' See *All Consuming Images: The Politics of Style in Contemporary Culture* (New York: Basic Books, 1988), 89.

4. Quoted in Georgina Howell, *Diana: Her Life in Fashion* (London: Pavilion, 1998), 151.

5. Ibid. 204.

6. Tina Brown, *The Diana Chronicles* (London: Century, 2007), 210.

7. Sarah Lincoln, untitled testimony, 'The day I met Diana', *Observer*, 7 Sept. 1997, p. 17.

8. Sarah Bradford, 'Princess of All Our hearts', *Mail on Sunday, Night & Day* suppl., 7 Sept. 1997, p. 6.

9. The most illuminating reflections on these aspects of Diana, which the author ties closely to her gender, are contained in Naomi Segal, 'The Common Touch', in Mandy Merck (ed.), *After Diana: Irreverent Elegies* (London: Verso, 1998), 131–45.

10. See the reflections on this point of the historian Ross McKibbin in 'Mass Observation in the Mall', in Merck (ed.), *After Diana*, 15–24.

11. The princess met and took some advice from Princess Grace and, when no one else in the royal family volunteered, she attended the latter's funeral in 1982. She compared herself to Jackie Kennedy and imitated the latter's crisp elegance and the simplicity of line of her evening gowns. She wore Versace's pastiche versions of Jackie's pastel suits and pillbox hats. Howell, *Diana*, 166–8.

12. Ibid. 165.

13. Ibid. 72. Brown, *Diana Chronicles*, 198–9.

14. Johnson, 'Two Sides of Diana', 4.

15. Lesley White, 'Only Dodi the outsider would do', *The Sunday Times, News Review* suppl., 7 Sept. 1997, p. 5.

16. She was careful to adjust the glamour quotient of her appearance to circumstances—for example, pumping it up to full blast for charity fundraising bashes in the US and toning it down several degrees when visiting AIDS patients or pensioners—and was also seeking to add substance and depth to her involvement in campaigns and charity work.

17. Brown, *Diana Chronicles*, 337.

18. Sociologists referred to these currents as post-materialism and detraditionalization. The concept of post-materialism, meaning a shift from primary to secondary (or post-materialist, quality of life) goals, was developed by Ronald Inglehart in *The Silent Revolution: Changing Values and Political Styles among Western Publics* (Princeton: Princeton University Press, 1977). Detraditionalization is investigated in Paul Heelas, Scott Lash, and Paul Morris (eds.), *De-Traditionalization: Critical Reflections on Authority and Identity at a Time of Uncertainty* (Oxford: Blackwell, 1996). The important role of electronic media in weakening the relationship between physical place and social 'place' is explored in Joshua Meyrowitz, *No Sense of Place: The Impact of Electronic Media on Social Behaviour* (New York: Oxford university Press, 1986).

19. See Paul Ginsborg, *The Politics of Everyday Life* (New Haven and London: Yale University Press, 2004), sect. 2.

20. Ulrich Beck, *Risk Society: Towards a New Modernity* (London: Sage, 1992), 95.

21. 'Her worldwide fame made Britain shine more greatly.... I am no royalist, but even I can see it was her—not Oasis, Stella Tennant or Terence Conran—who made Britain glamorous,' Nigella Lawson, 'Why the nation is right to share family's grief', *The Times*, 1 Sept. 1997, p. 23.

22. Brown, *Diana Chronicles*, 245–6.

23. A typical feature in the new-style *Tatler* was 'Swankly, my dear, we don't give a damn' (July 1998) (pp. 106–52), which transformed Rhett Butler's famous retort to Scarlett O'Hara in *Gone With The Wind* into a suggested response of the rich to the rest. The feature endorsed material ostentation so long as it was tempered with style and sophistication.

24. The phenomenon was noted in *The Sunday Times, Style* suppl., 29 Sept. 1996, pp. 4–5. Three reporters covered its manifestations in London, New York, and Moscow.

25. Attending such events was described by the British columnist India Knight as deplorable 'ligging' (i.e. 'the act of turning up at some slightly embarrassing bash simply because you have been asked'). 'Here's Looking at Me', *The Sunday Times, News Review*, 18 Apr. 1999, p. 3. By contrast, Joshua Gamson sees it as an example of the industrial nature of celebrity work. Such events are part of the assembly line of the manufacture of fame. See *Claims to Fame: Celebrity in Contemporary America* (Berkeley and Los Angeles: University of California Press, 1994), 61.

26. See Meyrowitz, *No Sense of Place*, p. ix.

27. Cathy Horyn, 'Diana Reborn', *Vanity Fair* (July 1997), 84.

28. See Dana Thomas, *Deluxe: How Luxury Lost its Lustre* (London: Allen Lane, 2007), 44–9, 60–1.

29. Stefania Saviolo, 'Brand and Identity Management in Fashion Companies', Research Division, SDA BOCCONI, Working Paper 02–66 (Milan, 2002), 9. See also, on brands as a key example of American business practice, Victoria De Grazia, *Irresistible Empire: America's Advance through Twentieth Century Europe* (Cambridge, Mass.: Harvard University Press, 2005), 184–225.

30. The model illustrated in this paragraph is set out in C. M. Moore and G. Birtwistle, 'The Nature of Parenting Advantage in Luxury Fashion Retailing: The Case of Gucci', *International Journal of Retail and Distribution Management*, 33/4 (2005), 256–70.

31. According to Andrea Stuart, Las Vegas was the last home of the kitsch flamboyance of the showgirl. See *Showgirls* (London: Cape, 1996), 208.

32. Thomas, *Deluxe*, 235–45.

33. Ibid. 41, 221, 241.

34. See Réka C. V. Buckley and Stephen Gundle, 'Flash Trash: Gianni Versace and the Theory and Practice of Glamour', in Stella Bruzzi and Pamela Church Gibson (eds.), *Fashion Cultures: Theories, Explorations and Analysis* (London: Routledge, 2000).

35. *Sunday Telegraph*, 24 July 1994.

36. Denise Pardo, 'Filosofia della vistosità', *L'espresso*, 24 July 1997, p. 52.

37. For a discussion of the nature of Elizabeth Hurley's celebrity, see Lee Barrow, '"Elizabeth Hurley is More than a Model": Stars and Career Diversification in Contemporary Media', *Journal of Popular Culture*, 39/4 (2006). On the dress itself, see Richard Martin, 'Gianni Versace's Anti-Bourgeois Little Black Dress (1994)', *Fashion Theory*, 2/1 (1998), 95–100.

38. On the history of the catwalk, see Caroline Evans, 'The Enchanted Spectacle', *Fashion Theory*, 5/3 (2001), 271–310. For an insider testimony, see Marie Helvin, *Catwalk: The Art of Model Style* (London; Pavilion, 1985), 87.

39. Daniel Boorstin, *The Image* (1962; London: Penguin, 1971), 21–3.

40. Colin McDowell, *The Designer Scam* (London: Hutchinson, 1994), 119.

41. The cover read 'Supermodels: Beauty and the Bucks'. However, only Naomi Campbell was pictured. *Time*, 16 Sept. 1991.

42. See Anon., 'Avedon and Versace's Top Show', *Elle Top Model*, 6 (1994), 14–21.

43. The number of 'supermodels' is not easy to estimate since the term was applied to many. One journalist estimated in 1995 that around thirty had joined 'the super club class'. See Peter Martin, 'Superpower', *Mail on Sunday, Night & Day* suppl., 13 Aug. 1995, p. 13.

44. See Anon., 'Linda Evangelista, Miss Sublimissima', *Elle Top Model*, 6 (1994), 33.

45. For Andrea Stuart, 'She, like the showgirl, is exaggerated and overblown, custom-built to meet our society's need for a glamorous icon whose desirability lies in her impossibility and inaccessibility,' *Showgirls*, 222.

46. Quoted in Michael Gross, *Model* (1995; London: 1996), 360.

47. Quoted in Ibid. 505.

48. Ibid.

49. Anon., 'Beauty Knows No Border', *Elle Top Model*, 1 (1994), 5.

50. Jay McInerney, *Model Behaviour* (1998; London: Bloomsbury, 1999), 1.

51. Colin McDowell, 'The Show Must Go On', *The Times Magazine*, 6 Dec. 1997, p. 42.

52. Ibid.

53. Brenda Polan, 'Is glamour glitter—or a graceful line?', *Financial Times*, 31 Dec.–1 Jan. 1995, *Weekend* suppl., p. vii.

54. Len Prince, *About Glamour* (New York: Simon and Schuster, 1997); Serge Normant, *Femme Fatale* (New York: Viking, 2001).

55. Gamson, *Claims to Fame*, 6. His work is an intelligent reflection on celebrity in general and on the debates that it has aroused.

56. 'The Limelight Club', *The Times Magazine*, 24 Aug. 1996.

57. Lesley-Ann Jones, *Naomi: The Rise of the Girl from Nowhere* (London: Vermillion, 1993), 19.

58. Anon., 'The Place the Mini-Tops Call Home', *Elle Top Model*, 4 (1994), 40–3.

59. Italian lawyer Auro Varani quoted in Gross, *Model*, 325. Sarah Doukas, founder of the Storm model agency, revealed that film stars would ring her requesting to meet the girl they had seen in this or that campaign. '"It makes me giggle", she says, "when I get a call from a

household name. If the girl is under 16, I'd really think hard about passing the number on to her, but if she's older, I don't have much choice. And you know they are going to be impressed".' Quoted in Lydia Slater, '10 Years On: The Changing Face of the Model Agency', *Daily Telegraph*, 29 Aug. 1997, p. 20.

60. Gross, *Model*, 460.

61. Ibid.

62. See Michael Gross, 'Coming Apart at the Seams', *Tatler* (May 1995), 146–9.

63. The role of voice coach Peter Settelin is discussed in Sally Bedell Smith, *Diana: The Life of a Troubled Princess* (1999; London: Aurum, 2007), 246–7. He recalled his hooker suggestion in a television documentary.

64. Toby Young, *How to Lose Friends and Alienate People* (2001; London: Abacus, 2002), 290.

65. B. B. Calhoun, *Party Girl* (London: Red Fox, 1994), 5.

66. Judi James, *Supermodel* (London: HarperCollins, 1994), 163.

67. Gross, *Model*, 507.

68. See Gaia De Beaumont, 'Come…', *Vogue* (Italia) (Sept. 1994), 357–9.

69. Gross, *Model*, 485–6.

70. Ibid.

71. Anon., 'Glamour as it was and is', *Creative Review* (May 1996), 72–3.

72. In her introduction to a collection of Unwerth's photographs, Ingrid Sischy highlights the apparent spontaneity of her images. See 'WHOOPS, It's Ellen von Unwerth', in Ellen von Unwerth, *Snaps* (Santa Fe, N. Mex.: Twin Palms Publishers, 1995), page unnumbered.

73. However, Bert Stern threatened legal action when Meisel posed Madonna in the style of his late photographs of Marilyn Monroe.

74. See, among others, John Kobal (ed.), *Film Star Portraits of the Fifties* (New York: Dover, 1980) and *The Art of the Great Hollywood Portrait Photographers 1925–1940* (London: Allen Lane, 1980).

75. See Liz Jobey, 'Helmut's Second Coming', *Independent on Sunday*, 13 Nov. 1994, pp. 52–5.

76. Anon., 'Spy Beauty', *Vogue* (UK) (Oct. 1994), 241.

77. Liz Smith, 'Gotta Have Glam', *She* (Nov. 1994), 136.

78. Ibid. 137–8.

79. Polan, 'Is glamour glitter?', p. vii.

80. Sarah Mower, 'Now playing a major role in fashion and beauty, movie star glamour celebrates femininity', *Vogue* (UK) (Oct. 1994), 217.

81. Quoted in Roger Baker, *Drag: A History of Female Impersonation in the Performing Arts* (1988; London: Cassell, 2nd rev. edn. 1994), 258.

82. On Madonna's connections with the showgirl tradition, see Stuart, *Showgirls*, 211–13.

83. See e.g. Cathy Schwichtenberg (ed.), *The Madonna Connection: Representational Politics, Subcultural Identities and Cultural Theory* (Boulder, Colo.: Westview, 1993).

84. David Tetzaleff, 'Metatextual Girl >patriarchy>postmodernism>power>money> Madonna,' in ibid. 242.

85. Christopher Anderson, *Madonna Unauthorized* (London: Michael Joseph, 1991), 131.

86. Stuart, *Showgirls*, 218.

87. Photograph caption, *Photo* (French edn.) (Apr. 2005), 56.

88. See, for example, Vicki Woods, 'Forever Joan', *Vogue* (UK) (May 1996), 138–43. The article is illustrated with Mario Testino's photographs of the actress playing the glamour queen.

89. Sarah Gristwood, 'Whatever It Takes', *Guardian, Weekend* suppl., 5 Dec. 1998, p. 25. However, Stone was not always so and in fact turned up to one gala occasion wearing and old skirt and a turtleneck sweater from Gap. The implications of this are considered in Rebecca L. Epstein, 'Sharon Stone in a Gap Turtleneck', in David Desser and Garth S. Jowett (eds.), *Hollywood Goes Shopping* (Minneapolis: University of Minnesota Press, 2000), 179–204.

90. Curiously, in many beauty and fragrance advertisements the stars were airbrushed almost beyond recognition, with the result that it was necessary to print their names on the page to reassure potential customers that it was indeed Sharon Stone or Hilary Swank who was pictured.

91. Gucci's Tom Ford was allegedly appalled to see Victoria Beckham wearing his label, while Burberry suffered after troubled British television actress Daniella Westbrook was pictured dressed head-to-toe in its famous check. Bentley, Cristal champagne, and other prestige brands were also appropriated by footballers and pop stars in a process that came to be dubbed 'getting chavved' (after the youth subcultural group known as Chavs, whose members were distinguished by their use of selected prestige accessories, notably Burberry baseball caps). 'The beauty of watching bastions of privilege getting chavved is that it dispels the myth of entitlement surrounding essentially commercial transactions,' wrote Nick Curtis in 'You've Been Chavved', *Evening Standard* 26 July 2006, pp. 30–1.

92. For a discussion of the 'ghetto fabulous' style in film, see Stella Bruzzi, *Undressing Cinema: Clothing and Identity in the Movies* (London: Routledge, 1997), 103–7.

93. After Victoria Beckham was publicly disowned by Tom Ford, she was courted by Cavalli, who even recruited her for his catwalk shows. On Italian fashion and bling, see Stephen Gundle, 'Lo stile e la merce: La ricezione della moda italiana in Gran Bretagna e negli Stati Uniti', *Memoria e ricerca*, 23 (Sept.–Dec. 2006), 95–116.

94. On English football's encounter with Italian fashion, see Stella Bruzzi, 'The Italian Job: Football, Fashion and That Sarong', in Bruzzi and Church Gibson, *Fashion Cultures*, 286–97.

95. Jerry Oppenheimer, *Front Row: Anna Wintour—the Cool Life and Hot Times of Vogue's Editor in Chief* (New York: St Martin's Press, 2005), 204.

96. Ibid. 205.

97. Young, *How to Lose Friends*, 270.

98. Quoted in Pat Booth, 'A Man For All Seasons: Snowdon', *Photoicon*, 2/2 (2007), 51.

99. Andrew Billen, ' "A Lot of Me is Dirty and Seedy. I like Sex. I Don't Think I am a Goody-Goody Person" ', *Evening Standard*, 23 Jan. 2002, pp. 23–4.

100. Jared Schiller, 'An Unappealing Superficial World', *Morning Star*, 5 Feb. 2002, p. 9.

101. Marianne Macdonald, 'How I Made a Model of Diana', *Daily Mail*, *Night & Day* suppl., 22 Aug. 1999, p. 9.

102. Mario Testino, 'My Life in Pictures', *Independent*, *Extra* suppl., 3 Feb. 2006, p. iii.

103. See Sante D'Orazio, *Pamela Anderson: American Icon* (New York: Schirmer, 2005).

104. On striptease revivals in particular, see Rachel Shteir, *Striptease: The Untold History of the Girlie Show* (New York: Oxford University Press, 2004), 3.

105. Dita von Teese, *Burlesque and the Art of the Teese* (New York: Regan Books, 2006). In a magazine article, she declared, 'I wanted to be like Marlene Dietrich, Betty Grable and Rita Hayworth. But it struck me that you never saw those actresses shaving their head or going without makeup for a role. They were all perfectly made-up all the time. I was, like, "Wow"—any woman can create this glamour, it's not something you have to be born with.' See Camilla Kay, 'Glamour Goddess', *In Style*, Oct. 2007, p. 205. Von Teese, following Ru Paul, became a testimonial for MAC's Viva Glam range.

106. Von Teese, *Burlesque and the Art of the Teese*, cover flap and p. xi.

107. Dita von Teese, *Fetish and the Art of the Teese* (New York: Regan Books 2006), 29–41. It should be noted that this volume is the back half of *Burlesque and the Art of the Teese* turned upside down and endowed with its own title and cover.

108. Gamson, *Claims to Fame*, 74–96.

109. Thomas, *Deluxe*, 123–4.

110. Lina Das, 'The Stylist Who Shrank the Stars', *Mail on Sunday*, *You* magazine, 7 Oct. 2007, pp. 48–52.

111. Rachel Zoe with Rose Apodaca, *Style A to Zoe: The Art of Fashion, Beauty and Everything Glamour* (New York: Little, Brown, 2007).

112. Das, 'Stylist Who Shrank the Stars', 51.

113. Zoe, *Style A to Zoe*, 3.

114. Ibid. 11.

115. Ibid. 166.

116. Ibid.

117. Krista Smith, 'The Inescapable Paris', *Vanity Fair* (Oct. 2005), 149–233.

118. On the fascination of the heiress, see Cesare Cunaccia, 'The Glam and the Heiress', *Vogue* (Italia), *A Couture Dream* suppl. (Sept. 2006), pages unnumbered.

119. See Jerry Oppenheimer, *House of Hilton: From Conrad to Paris* (New York; Crown, 2006).

120. Paris Hilton, *Confessions of an Heiress*, with Merle Ginsberg (London: Pocket Books, 2004), 120.

121. Ibid. 93.

122. Ibid. 8.

123. See e.g. Judy Mazel, *The Beverly Hills Style* (New York: Stein & Day, 1985), which was translated into several languages, including Italian.

124. *Sun*, 5 June 2007, p. 4.

CONCLUSION

1. Lucia van der Post, *Things I Wish My Mother Had Told Me: Lessons In Grace and Elegance* (London: John Murray, 2007), 27.

2. Joshua Meyrowitz, *No Sense of Place: The Impact of Electronic Media on Social Behavior* (New York: Oxford University Press, 1986), 222–3.

3. At the start of the new century, Ralph Lauren even launched a fragrance named 'Glamour-ous,' a curious misspelling that was clearly intended to ensure that the adjective retained the European connotation of the '-our' ending.

4. Shane Watson, 'Britain's Most Photographed Woman Victoria Beckham Reveals Her Secrets', *Hello!*, 12 Sept. 2006, p. 76.

5. Victoria Beckham, *That Extra-Half Inch: Hair, Heels and Everything in Between* (London: Penguin, 2006), 6.

6. Anon., 'Cheryl Cole', *OK*, 17 Oct. 2006, p. 47.

7. Kelly Brook, *Life Style: How to Pin Down the Pin-up Within You* (London: Orion, 2007), 9.

8. Ibid. Victoria Beckham, Cheryl Cole, and Kelly Brook were not included in the list of seventy-three glamorous personalities featured in a special 'glamour issue' of British *Vogue* in Dec. 2007. For an explanation of the magazine's view of glamour, see Anon., 'Who's Glamorous Now?, *Vogue* (UK) (Dec. 2007), 71. Also relevant is Alexandra Shulman, 'Editor's Letter', *Vogue* (UK) (Dec. 2007), 17. The list included wealthy socialites, figures from the fashion world, actors, architects, a handful of other professionals, and a few young aristocrats who could have walked the length of Oxford Street without fear of being recognized, plus the Dowager Duchess of Devonshire and no less a figure than Queen Elizabeth II. The majority of nominees were experienced and worldly. The list contained just seven men, all of whom were deemed to be the supporting half of a glamorous couple. Nearly all those featured were British or British-based. Everyone mentioned enjoyed some reputation for dressing well, although not in a showy way for, the magazine affirmed, 'ostentation is a very different beast from glamour'. The magazine's list would have been considered backward and parochial even in the 1920s, by which time Hollywood stars, entertainers, sportsmen and -women, and pilots were all considered glamorous. It made the mistake of exchanging style for glamour and in so doing stressed exclusivity at the expense of accessibility. In consequence, glamour was stripped of all its accessible low cultural vivacity and presented as a feature of the social elite, widened for the occasion to include some selected creative talents. It was seen simply as a manifestation of that elite's superiority in matters of style, appearance, and taste. In this book a completely different and less elitist view of glamour has been set out.

9. Published by Krause Publications, Iola, Wisconsin, 2007.

10. Published by Lark Books, Asheville, North Carolina, 2007.

PHOTOGRAPHIC
ACKNOWLEDGEMENTS

akg-images, London 16; Album/akg-images, London 18; author's collection 2, 4, 6; author's collection/© Reutlinger Studio 5, 7, 8; © Christie's Images Ltd. 9; © Bettmann/Corbis 10; © Gene Blevins/Corbis 24; © The Condé Nast Archives/Corbis 11; © Tim Graham/Corbis 23; © Hulton-Deutsch Collection/Corbis 20; © Underwood & Underwood/Corbis 14; RKO/The Kobal Collection 15; Riama-Pathé/The Kobal Collection 17; United Artists/The Kobal Collection 12; ARJ/Photos12.com 3; Collection Cinéma/Photos12.com 13; Paul Massey/Rex Features 22; Richard Young/Rex Features 21; © The Royal Pavilion, Libraries & Museums, Brighton & Hove 1; Courtesy of Southwest Airlines 19.

The publisher and the author apologize for any errors or omissions in the above list. If contacted they will be pleased to rectify these at the earliest opportunity.

INDEX

Frangio, Manuel 238
Fraser, Antonia 24, 25
Fraser, Kennedy 322
Frazier, Brenda Duff 144–5
Freidan, Betty 259
French, John 280–1, 282
French Revolution 18, 19, 20, 22–3, 26, 32, 38, 56
Friedan, Betty 258
Fussell, Paul 219

Gable, Clark 266, 307, 366
Gabor, Zsa Zsa 224, 249–50, 385
Gaines, Steven 330
Galanos, James 328
Galella, Ron 302–3
Gallico, Paul 200
gambling 66, 80, 93
Garbo, Greta 88, 160, 161, 173–4, 179,
 187, 188, 250, 272, 273, 307, 324, 366
Gardner, Ava 202, 214, 242, 365, 366, 395
Garibaldi, Giuseppe 10–11
Gaultier, Jean-Paul 346
Gautier, Théophile 97, 107, 125
Gautreau, Virginie 121
General Motors (GM) Corporation 234
George, Prince (later George VI) 154
George III, King 45, 46–8, 52
George IV, King (formerly Prince
 Regent) 45, 46–50, 55–6, 61, 65, 68, 69
George V, King 152
George VI, King 207
Gere, Richard 370
Getty, Paul and Talitha 324
Ghika, Georges 101
Giammetti, Giancarlo 341
Gibbons, Cedrick 177
Gibson, Charles Dana 119–20
Gil Blas 98, 102
Gilbert, John 174
Gish, Lilian 181
Givenchy, Hubert de 213, 272, 357, 358, 396
Glyn, Elinor 127, 128, 181–2, 184, 186
Goldwyn, Samuel 186, 198
Goncourt brothers 88, 94
Gore, Catherine 60
gossip journalism 58–9, 69, 142, 215–16,
 228, 229, 319, 321, 322, 343

La Goulue (Louise Weber) 133
Grable, Betty 174, 176, 260, 315
Grace, Princess (formerly Grace
 Kelly) 216–17, 220, 222–3, 254, 269,
 271, 304, 334, 341, 351
Graham, Karen 220
Grant, Cary 179, 213, 223, 266, 298, 300,
 334, 335
Grant, Hugh 1, 360
Grauman's Chinese Theater, Los Angeles 193
Grazia, Victoria de 232
Green Hat, The 161, 166
Green, Martin 209
Griffith, D. W. 181
Gronow, Captain R. H. 45, 57–8, 64
Gross, Michae 367, 370
Gucci fashion house 373
Guest, C. Z. 218
guides to fashion and beauty 3–4, 187,
 299–300, 391, 395
Guilbert, Yvette 104
Guinness, Alec 216
Guinness, Gloria 218
Gully, Richard 186

hairstyles 180, 195, 288, 289, 299, 313, 317
Hall, Jerry 317
Halston (Roy Halston Fowick) 268, 320,
 329–30, 332
Hammond, Celia 284
Hardy, Françoise 288
Harlow, Jean 180, 253, 307, 366
Harper's Bazaar 158, 221, 274
Hartnell, Norman 153, 210
Haussmann, Baron Georges-Eugène 85, 86, 87
haute couture 85, 104, 135, 162–3, 186, 189,
 199–202, 213–14, 222, 268, 278, 280, 323,
 328, see also individual designers
Hayes, Helen 198
Hayworth, Rita 202, 205–7, 213–14, 215, 253,
 260, 343, 344
Hazlitt, William 35, 43, 54, 55, 62, 63,
 66, 72–3
Head, Edith 187, 188, 216
Headfort, Marchioness of 131
hedonism 153–5, 170, 184, 319, 321
Hefner, Hugh 263–4